Palgrave Studies in Prisons and Penology

Series Editors
Ben Crewe, Institute of Criminology, University of Cambridge, Cambridge, UK
Yvonne Jewkes, Social & Policy Sciences, University of Bath, Bath, UK
Thomas Ugelvik, Faculty of Law, University of Oslo, Oslo, Norway

This is a unique and innovative series, the first of its kind dedicated entirely to prison scholarship. At a historical point in which the prison population has reached an all-time high, the series seeks to analyse the form, nature and consequences of incarceration and related forms of punishment. Palgrave Studies in Prisons and Penology provides an important forum for burgeoning prison research across the world.

Series Advisory Board
Anna Eriksson (Monash University)
Andrew M. Jefferson (DIGNITY - Danish Institute Against Torture)
Shadd Maruna (Rutgers University)
Jonathon Simon (Berkeley Law, University of California)
Michael Welch (Rutgers University)

Dominique Moran · Yvonne Jewkes ·
Kwan-Lamar Blount-Hill · Victor St. John
Editors

The Palgrave Handbook of Prison Design

Editors
Dominique Moran
School Geography, Earth
and Environmental Sciences
University of Birmingham
Birmingham, UK

Kwan-Lamar Blount-Hill
Arizona State University
Phoenix, AZ, USA

Yvonne Jewkes
Social & Policy Sciences
University of Bath
Bath, Somerset, UK

Victor St. John
Saint Louis University
St Louis, MO, USA

ISSN 2753-0604 ISSN 2753-0612 (electronic)
Palgrave Studies in Prisons and Penology
ISBN 978-3-031-11971-2 ISBN 978-3-031-11972-9 (eBook)
https://doi.org/10.1007/978-3-031-11972-9

© The Editor(s) (if applicable) and The Author(s), under exclusive license to Springer Nature Switzerland AG 2023, corrected publication 2023
This work is subject to copyright. All rights are solely and exclusively licensed by the Publisher, whether the whole or part of the material is concerned, specifically the rights of translation, reprinting, reuse of illustrations, recitation, broadcasting, reproduction on microfilms or in any other physical way, and transmission or information storage and retrieval, electronic adaptation, computer software, or by similar or dissimilar methodology now known or hereafter developed.
The use of general descriptive names, registered names, trademarks, service marks, etc. in this publication does not imply, even in the absence of a specific statement, that such names are exempt from the relevant protective laws and regulations and therefore free for general use.
The publisher, the authors, and the editors are safe to assume that the advice and information in this book are believed to be true and accurate at the date of publication. Neither the publisher nor the authors or the editors give a warranty, expressed or implied, with respect to the material contained herein or for any errors or omissions that may have been made. The publisher remains neutral with regard to jurisdictional claims in published maps and institutional affiliations.

Cover illustration: © OOIIO Architects

This Palgrave Macmillan imprint is published by the registered company Springer Nature Switzerland AG
The registered company address is: Gewerbestrasse 11, 6330 Cham, Switzerland

Praise for *The Palgrave Handbook of Prison Design*

"Asking the question *'what works in prison design'* and often in response chronicling what doesn't, this comprehensive volume provides a detailed and nuanced review of the progression of penal architecture over the last two hundred years culminating in recent designs centred around a utopian vision of the rehabilitative institution. With a mirage of individual perspectives carefully selected and combined into this wide-ranging handbook, it is set to become a key reference source for researchers, architects and custodial jurisdictions going forward."
— Alex Newman, *RAIA B.Arch BA Arch, Director, Xsquared Architects, Australia*

"Prison design is a moral maze, plagued by questions such as whether such a thing as a good prison is even possible. Yvonne Jewkes and Dominique Moran, Britain's pre-eminent prison scholars team up with experts from the US, Kwan-Lamar Blount-Hill and Victor St John to edit a compendium of cross-disciplinary knowledge that explores these questions with rigour and insight. Historically, prison design has been selective about the critical theories that it has attempted to incorporate

so that even well-intentioned strategies have meant that human misery is baked into the architecture of one of the least adaptable types of building. By bringing together contributions from a much broader range of knowledge than ever before a new, more intellectually agile approach emerges that offers practical methods of inquiry rather than solutions. Like all good design, the further one takes this inquisitive approach, the more sophisticated and responsive the outcome will be. Throughout, the question of whether designing an inherently harmful space in a better way is a good or bad thing is at the fore. Whatever the reader's conclusion, they should not reach it before reading this book."

— Roland Karthaus, *Associate Professor in Architecture, University of East London, UK*

"*The Palgrave Handbook of Prison Design* offers a broad and varied set of perspectives on the design of detention environments. It includes many chapters that need to be read by anyone who is a designer of prisons, or who hires and sets policy for such facilities. Chapters by important scholars address difficulties encountered in historical and current prison design (such as *That Time We Tried to Build the Perfect Prison, What works least, Architecture and Design of the Communist and Post-Communist Prison*) as well as thoughtful essays on positive approaches (*The Creative Prison Revisited, Designing a Rehabilitative Prison Environment, Guidelines for Designing Health-Promoting Correctional Environments*). The various sections of this volume consider why detention facilities are the way they are, how they can be evaluated and studied, and how they can be made better. They include primary data from case studies as well as literature reviews and conceptual models. Issues critical to environment and behavior in total institutions are addressed, such as the importance of access to nature for people in restrictive settings. Since incarceration is often the end product of the way western legal and justice systems operate, an important chapter also considers an alternative approach of rehabilitative justice. Questions about designing for youth and considerations of gender in detention facilities have been too little considered in the design-research literature, so the attention given to these here is very welcome. Youth facility issues are the focus of three chapters, and another discusses "gender inconsiderations of carceral space." This book

offers the kind of thoughtful discussion about difficult issues that goes beyond simple prescriptions for spatial layout and features, in ways that should be important to anyone who is interested in how we incarcerate people—which is really all of us as citizen-owners of these facilities."

— Richard Wener, *Ph.D., Professor Emeritus of Environmental Psychology, Tandon School of Engineering, New York University, USA and author of* The Environmental Psychology of Prisons and Jails

Contents

1 Introduction .. 1
 Yvonne Jewkes, Dominique Moran,
 Kwan-Lamar Blount-Hill, and Victor St. John

Part I The History and Philosophy of Custodial Design

2 That Time We Tried to Build the Perfect Prison:
 Learning from Episodes Across U.S. Prison History 21
 Ashley T. Rubin

3 Defining the Mechanisms of Design:
 An Interdisciplinary Approach .. 51
 Melissa Nadel

4 Custodial Design: Collective Methods 79
 Kevin Bradley and Rohan Lulham

5 What Works Least Worst? A Personal Account of Two
 New Prison Design Projects ... 105
 Yvonne Jewkes

6	The Creative Prison Revisited Saul Hewish	129
7	Prison Design: Between Pragmatic Engagement and the Dream of Decarceration Roger Paez with Kwan-Lamar Blount-Hill	159
8	Prison Architecture in Chile: A Critical Realist Analysis of Prison Architectural Outputs Through the Lens of Organised Hypocrisy Theory Alberto Urrutia-Moldes and Fionn Stevenson	191
9	The Architecture and Design of the Communist and Post-Communist Prison in Europe Judith Pallot and Olga Zeveleva	227

Part II Determining the "Effectiveness" of Custodial Design

10	Challenges and Solutions in Establishing the Impact of Custodial Design Melissa Nadel	263
11	Evaluating Correctional Environments: A Critical Psychosociospatial Approach Todd Levon Brown	283
12	Towards a Dignified Design: O-T-I, S-L-S, and Experience in Carceral Space Kwan-Lamar Blount-Hill	313
13	A Model for the Design of Youth Custodial Facilities: Key Characteristics to Promote Effective Treatment Matthew Dwyer and Sanne Oostermeijer	339
14	Designing a Rehabilitative Prison Environment Jennifer Galouzis, Andrew Day, Stuart Ross, and Diana Johns	385

Part III Designing for Imprisoned Populations

15 How Prison Spaces Work on Bodies: Prison Design in the Norwegian Youth Units — 413
Elisabeth Fransson

16 Does Design Matter? An Environmental Psychology Study in Youth Detention — 443
Rohan Lulham

17 Prisoners with Severe Mental Illnesses and Everyday Prison Interior (Re)design — 481
Kathryn Cassidy, Wendy Dyer, Paul Biddle, Louise Ridley, Toby Brandon, and Norman McClelland

18 Autoethnographic Analyses of Prison Design's Impacts — 513
Douglas N. Evans, Abdullah Al-Muwahid, Sincere Allah, Michael Bright, Sean Kyler, Ibn Loyal, Anthony Martin, Shantai Rogers, Aaron Sheppard, and Harold Thompson

19 Culture Change Within Facilities that Incarcerate — 537
Hugh D. Lester and Christine Tartaro

20 Gendered Inconsiderations of Carceral Space — 563
Lindsay Smith

21 A Cultural Competence Framework for Corrections in Hawai'i — 603
Cathi Ho Schar

Part IV Custodial Design for Spaces and Functions

22 From Grey to Green: Guidelines for Designing Health-Promoting Correctional Environments — 623
Julie Stevens, Amy Wagenfeld, and Barb Toews

Contents

23 Does Nature Contact in Prison Improve Wellbeing? Greenspace, Self-Harm, Violence and Staff Sickness Absence in Prisons in England and Wales 657
Dominique Moran, Phil I. Jones, Jacob A. Jordaan, and Amy E. Porter

24 Designing Green Prisonscapes in Norway: Balancing Considerations of Safety and Security, Rehabilitation and Humanity 679
Berit Johnsen

25 Prioritizing Accountability and Reparations: Restorative Justice Design and Infrastructure 703
Barb Toews

26 Made in Prison: Understanding Knowledge Exchange, Co-design and Production of Cell Furniture with Prisoners to Reimagine Prison Industries for Safety, Well-Being and Sustainability 733
Lorraine Gamman and Laura Caulfield

Correction to: From Grey to Green: Guidelines for Designing Health-Promoting Correctional Environments C1
Julie Stevens, Amy Wagenfeld, and Barb Toews

Index 769

Notes on Contributors

Biddle Paul is Research Fellow in the Department of Social Sciences at Northumbria University. His research interests include prisons and punishment, the punishment and rehabilitation of mentally disordered and older offenders, prison responses to ADHD, mental health liaison and diversion services, plus police responses to domestic abuse. Paul has undertaken research and written about mental health in prisons, domestic abuse, liaison and diversion services, and mental health street triage. Paul's undergraduate teaching on criminology includes exploration of criminological theory, research methods and prisons and punishment.

Blount-Hill Kwan-Lamar is an assistant professor of criminology and criminal justice at Arizona State University. He previously served as the first Director of Research and Data Analytics for the Kings County District Attorney's Office in Brooklyn, New York, and, before this, as a policy researcher for the New York City Mayor's Office of Criminal Justice and John Jay College of Criminal Justice's Research and Evaluation Center. Dr. Blount-Hill was a firefighter then a police officer for nearly four years in Cayce and Charleston, South Carolina. In his

research, he examines the intersection of marginalized group identity and experiences or interpretations of justice, including how power and dominance relations are signalled through justice architecture. Dr. Blount-Hill has worked in contexts and communities across the United States, in Eastern Europe, in Southeast Asia, and in Southern Africa. He is a co-editor of this collection.

Bradley Kevin is a practising Architect and sessional tutor in architectural design at the University of Technology Sydney, where he earned his doctorate. His practice, research and teaching centre on design enabling social change across justice and housing sectors. His practice seeks to explore standpoint methods that challenge and are a viable alternative to the historic design practices that manifest as the warehouse function and aesthetic of modern institutional architecture.

Brandon Toby is Professor of Mental Health and Disability in the department of Social Work, Education and Community Wellbeing at Northumbria University, UK. He has a long-standing interest in empowerment, inclusion, and engagement, regionally developing a network of contacts including Cumbria, Northumberland and Tyne and Wear NHS Foundation Trust and third sector organizations, such as ReCoCo, Chilli Studios, Disability North and The Lawnmowers Independent Theatre Company. His research focuses on participatory and co-productive methodologies, which in practice means working with groups of people with lived experiences of mental distress and disability to evaluate and evidence service improvements. This has included topics such as mental health recovery, shared decision-making, care coordination, and more recently formulation. He leads on modules within the relatively new academic field of Mad Studies and Public Involvement and Co-production in Research. He publishes on mental health, advocacy, hate crime, and the design of participatory methodologies.

Brown Todd Levon trained as an architect, and is an environmental psychologist whose research lies primarily at the intersection of critical [race] theory and the built environment. His work explores how physical spaces are produced, perceived, and evaluated as racialized and embodying other social qualities with a goal of furthering social justice

and socioracial sustainability in urban design. He has published these topics in academic journals, technical reports, conference papers, and now, a book chapter. As an interdisciplinary scholar, he has taught in various programs in psychology, architecture, public health, and urban studies at numerous institutions including the University of Illinois at Chicago, Hunter College, Queens College, City College of New York, the Fashion Institute of Technology, Columbia University and the University of Texas at Austin. Dr. Brown received his B.A., M.P.H., and M.Arch. from the University of Illinois at Chicago and his M.A., M.Phil., and Ph.D. from the CUNY Graduate Center.

Cassidy Kathryn is Professor in the Department of Geography and Environmental Sciences at Northumbria University, UK. Kathryn joined Northumbria as a senior lecturer in 2013 from the School of Geography at Queen Mary University of London, where she worked from 2010, initially as a teaching fellow and later as a lecturer. She completed her Ph.D. at the University of Birmingham in 2011. From 2019 to 2021 she held a Leverhulme Trust research fellowship exploring the role of border regimes in disordering UK public institutions. From 2013 to 2018, Kathryn was a senior research fellow on the EUBorderscapes project exploring border and immigration regimes in everyday contexts through an intersectional lens. Her research interests centre on the intersections of bordering practices and processes with institutional geographies, carceralities, and the criminal justice system. She has carried out ethnographic research in the UK, France, Ukraine, and Romania.

Caulfield Laura is Professor and Founding Chair of the Institute for Community Research and Development at the University of Wolverhampton, UK. Laura is a psychologist and criminologist and her research focuses on the impact of interventions in criminal justice, with a particular focus on the role of creativity and arts. At the time of writing Laura leads the evaluation of the West Midlands Violence Reduction Unit, funded by the Home Office. Laura has been undertaking research with public, private, and third-sector agencies since 2001, and is an expert in bridging the gap between evidence, policy, and practice. She is the author of two books: *Criminological Skills and Research for Beginners* (Routledge) and *Forensic Psychology* (Pearson).

Day Andrew is an Enterprise Professor in Criminology at the University of Melbourne, Australia. He is a forensic and clinical psychologist having previously worked in criminal justice settings in both the UK and Australia. His research interests centre around the development of services that support the rehabilitation and reintegration of people in prison and how personal, social, and structural drivers of crime are relevant to personal change.

Dwyer Matthew is an architectural graduate, design researcher, and tutor, working in Melbourne, Australia, on the traditional lands of the Wurundjeri people of the Kulin nation. His work focuses on how design interconnects with other disciplines and fields—with particular regard towards the social and ecological implications inherent in the design of environments. He won the Victorian Design Challenge in 2018 with Dr. Sanne Oostermeijer for their work on how architecture can affect and best contribute to positive outcomes in the Victorian Youth Justice system. He has been awarded a Churchill Fellowship to extend his research in this field.

Dyer Wendy is Senior Lecturer in Criminology at Northumbria University, UK. Her research focuses on Complex Realist understandings of the health and care of 'mentally disordered offenders', including the dynamic care/control and transcarceral relationship between the Welfare-Criminal Justice/Penological complex. She has 20+ years of research experience including bidding (e.g., Research Council, national Government agencies such as the Ministry of Justice, Department of Health and National Health Service, and regional Criminal Justice System and NHS Health Trusts) and complex cross-faculty and multi-disciplinary project management. She has been Research Coordinator for the 'Prison and Offender Research in Social Care and Health' (PORSCH) network of 500+ academic, policy, and practice colleagues from a variety of disciplines, since 2013. She is a member of the panel of experts for the National Institute for Health Research; a member of the Editorial Board for the International Journal of Social Research Methodology; and chairs numerous research steering groups.

Evans Douglas N. is an associate professor of Criminology at Fairleigh Dickinson University, US. He teaches college courses in multiple secure facilities, seeking to cultivate a critical analysis of the criminal legal system that acknowledges the impact of race and social class on system contact, guiding students through use of the research process to answer important questions about human biases regarding racism and the stigma of a criminal record, and advocating for a revisionist approach to the system that is both class and race-neutral and hinges on penal abolition. His research explores the impact of higher education in prison and challenges that formerly incarcerated persons face when they come home from the prison system.

Fransson Elisabeth holds a Ph.D. in sociology and works as Professor in Social Work at VID Specialized University in Oslo, Norway, and as Professor II at the University College of Norwegian Correctional Service (KRUS). Her research interests are prison studies, prison architecture and child welfare services. Her current research projects are: 'Atonement and Reconciliation', a collaboration between The Church of Norway and KRUS, 'Adverse Childhood Experiences' financed by the Norwegian Research Council and 'Institutional Spaces, Technologies and the Body', a research collaboration between TESIS Firenze, Østfold University College and VID. Fransson is one of the authors of *'Prison Architecture and Humans',* an open access book from Cappelen Damm Akademisk.

Galouzis Jennifer is the Assistant Commissioner, Offender Management and Programs, Corrective Services NSW, Australia. Jennifer is also a current Ph.D. candidate with the University of Melbourne and her thesis is titled *'A rehabilitative prison environment and the possibility of therapeutic prisons'*. Jennifer's research interests are in the social and cultural climate of prisons and the measurement of prison performance. She has published papers in the areas of violence, sex offender treatment and risk of re-imprisonment.

Gamman Lorraine is Professor of Design at Central Saint Martins and Director of University of the Arts London's Design Against Crime Research Centre (DACRC), which she founded in 1999. An authority

in applied social design practice, she is co-creator of a range of award-winning anti-crime product design interventions, online resources and numerous academic essays that interpret and address offender techniques from a design perspective. She has co-led and co-curated at least 20 national and international design exhibitions and design justice projects, a number of which include prisoners and draws on creative teaching and learning methods to co-design against crime with them. Gamman has also co-written over 50 academic design papers and a number of books including *Tricky Design: The Ethics of Things*, Bloomsbury 2019, and continues to work with policymakers, crime prevention practitioners, students, and communities to co-design change.

Hewish Saul is one of the UK's leading practitioners in the use of drama and theatre with people in prison. He was a founder member, and former director, of Geese Theatre (UK) (est. 1987) and in 1999 he co-founded *Rideout* (Creative Arts for Rehabilitation) for whom he is currently the artistic director. In addition to his work with Rideout, Hewish is a part-time teaching fellow in theatre practice at University of Warwick, and a previous recipient of a Butler Trust Certificate Award, a national UK award which recognizes exceptional work by staff in HM Prison Service.

Jewkes Yvonne is Professor of Criminology at the University of Bath, UK and Honorary Visiting Professor of Criminology at the University of Melbourne, Australia. She teaches both criminology and architecture students and has worked as an expert consultant on numerous prison Design and Build projects and prison refurbishments around the world. Yvonne has won two prestigious prizes for her work on prison architecture and design—the ESRC Celebrating Impact Prize for Societal Impact in 2020, and the Market Research Society's President's Medal 2021. Yvonne has published extensively on the potential of architecture to rehabilitate rather than punish and she is currently writing a non-academic book for a general audience. *Beneath the Yellow Wallpaper: A Memoir of Prison and Home*, will be published by Scribe in 2024. She is a co-editor of this collection.

Johns Diana is a senior lecturer in Criminology in the School of Social and Political Sciences at the University of Melbourne, Australia, where

she researches and teaches across the domains of prisons and punishment, children/young people and the criminal legal system, and criminal justice knowledge production. Her work is focused on the effects of criminalization, the impacts of imprisonment, and the possibilities of restorative and relational justice practices. Her book *'Being and Becoming an Ex-Prisoner'* was published by Routledge in 2018. She is co-author of two new books, *'Race, Place and Politics: The Anatomy of a Law and Order Crisis'* (Weber et al., 2021, Emerald Insight), and *'Coproduction and Criminal Justice'* (Johns et al, 2022, Routledge).

Johnsen Berit holds a Ph.D. in sport and is a research professor at the University College of Norwegian Correctional Service—KRUS, Norway. She has been involved in several studies of leisure activities, sport, bodies, and movement in prison. It is in the interdisciplinary approach and cooperation that characterize these projects that she finds potential and inspiration for research. Johnsen has published on different topics within the field of penology. She is a member of the Carceral Geography network and a member of the Prison, Architecture and Humans (PriArcH) network.

Jones Phil I. is a cultural geographer based at the University of Birmingham, UK. He runs the university's Playful Methods Lab which specializes in developing innovative research methods through the use of novel technologies. After helping to establish Digital Geographies Research Group of the Royal Geographical Society he subsequently served as its chair. He has written extensively on research methods, technology, creativity, and urban geographies and has produced six books, the most recent of which is *Virtual Reality Methods: A Guide for Researchers in the Social Sciences and Humanities* published by Policy Press.

Jordaan Jacob A. is Assistant Professor in Economics at the Utrecht University School of Economics, in the Netherlands. Having been trained as an economic geographer at the London School of Economics (Ph.D.) and Utrecht University (M.Sc.) his research is highly multidisciplinary, linking research fields as diverse as international economics, regional economics, human geography, sociology, development studies, and geographical information systems. His main research interests

include the operations and regional effects of multinational enterprises in developing and emerging economies, drivers of location processes of multinational enterprises, the empirical identification of the level and spatiality of agglomeration economies, the importance of inter-relationships between culture, social values, and institutions in processes of economic growth and the impact of physical geography on human well-being.

Kyler Sean is an operations manager for the Advocacy and Partnerships Department at the Vera Institute of Justice, US. During his 24 and a half years of incarceration he earned a bachelor's degree from Mercy College via Hudson Link for Higher Education in Prison and a master's degree from New York Theological Seminary. He currently lives in New York City.

Lester Hugh D. works for Urbahn Architects, PLLC of New York City, US, leveraging his portfolio of jails, prisons, and courthouses ranging from $1.5M to $1.5B. The focus of his work is improving conditions of confinement through architecture and security systems engineering, with an overall goal of improving outcomes for the justice system involved, as well as staff. Example projects include the Governor George Deukmejian Courthouse (Long Beach, CA) the Joint Regional Correctional Facility (Ft. Leavenworth, Kansas) and the James A. Musick Jail (Irvine, CA). Recent ones include all the juvenile beds in New York City and the first 400 beds of the NYC Borough-based Jail System at Bellevue, Woodhull, and North Central Bronx hospitals. His watchwords are optimization, efficiency, and attention to detail; nothing less will do when peoples' lives are at stake. He is also an adjunct professor at Stevens Institute of Technology.

Lulham Rohan is a senior lecturer in Design at the University of Sydney, Australia. His research explores the capacity of design to create social change and growth with a focus on the criminal justice system. With a background in psychology and architecture, and experience working as a psychologist in youth justice, Rohan's research often intersects across design, criminology, and psychology with affect a core construct. Developing new knowledge through undertaking practice-led design research

projects is an important aspect of his research. Over the last decade Rohan has led projects on prison education, prison industries, community legal services, prison-court video links, therapeutic youth justice units, acute mental units, and prisoner access to digital technology. Looking to create impact and build pathways to alternative approaches to criminal justice, he is an active member of the ICPA where he advocates for inclusive, participatory design in realizing more humane and productive systems of justice.

McClelland Norman is Senior Lecturer/Programme Leader for Mental health at Northumbria University, UK. After training as a mental health nurse, Norman worked in this field for his entire NHS career of 36 years. He worked in secure settings, chaired the National Forensic Nurses Association, and published on areas such as nursing response to patient violence, risk assessment and minimizing seclusion/restraint. He has presented at conference nationally and internationally and completed his Ph.D. in 2002 examining core skills/ competencies of Forensic mental health nurses working in secure settings. His NHS career included work as an Associate Director in Teesside and Deputy Director of Nursing in Leeds, and Head of Collaborative Research in Leeds University. As Senior Lecturer at Northumbria University, Norman has collaboratively secured funding for research into the education, training and development needs of Prison Officers and Nurses involved in the establishment of an innovative mental health service in HMP Durham.

Moran Dominique is Professor of Carceral Geography in the School of Geography, Earth and Environmental Sciences at the University of Birmingham, UK. She researches the design and experience of carceral spaces and has held four ESRC grants to support this research across the UK, Russia, and Scandinavia. Her work has translated into changes to designs for new prisons, and renovation of existing prisons, both in the UK and internationally. She is currently working across three areas: the persistence of Victorian-era prisons in the UK; the relationship between greenspace and well-being in carceral settings; and connections between prison and the military. She is author of *Carceral Geography* (2015), and co-editor of *Carceral Spaces* (2013), *The Historical Geography of Prisons*

(2015), *Carceral Spatiality* (2017) and *The Palgrave Handbook of Prison and the Family* (2019). She is lead editor of this collection.

Nadel Melissa is an Associate at Abt Associates in Cambridge, Massachusetts, US. She primarily conducts criminal justice related research, with an emphasis on corrections. Her current projects include an experimental study of probation and parole field work practices and their impact on recidivism, the management and analysis of state level U.S. prison data collected for the Bureau of Justice Statistics' National Corrections Reporting Program, and serving as Project Director for the 2016 Survey of Prison Inmates Statistical Support Center. Her past work includes studies on community and individual predictors of sentencing, the impact of mental health on recidivism, evaluations on the efficacy of a juvenile diversion programme, and the impact of prison design on inmate behaviour.

Oostermeijer Sanne is a Research Fellow in the Centre for Mental Health, Melbourne School of Population and Global Health at the University of Melbourne, Australia. She lives and works on the traditional lands of the Wurundjeri people of the Kulin nation. Her work involves national evaluation projects and policy-based research in both the youth justice system and the mental health care system. After winning the Victorian Design Challenge in 2018, she has been working with architectural graduate Matthew Dwyer to study how the design of youth justice facilities can best support positive outcomes for justice-involved young people in Victoria.

Paez Roger is an architect, professor, and researcher. Architect (ETSAB, Hons.), M.S. AAD (Columbia University, GSAPP Honor Award for Excellence in Design), Ph.D. (UPC, Excellent Cum Laude). Professional experience in the studios of Alison+Peter Smithson (London) and Enric Miralles (Barcelona). He is Founder of AiB (www.aib.cat) and lead designer of the Mas d'Enric Penitentiary in Catalonia, selected for the FAD Prize 2013 and finalist for Catalunya Construcció 2013 Award. He is Research leader and MEATS director at ELISAVA Barcelona, architectural design professor at ETSALS, guest professor at universities worldwide. Author of *Critical Prison Design* (Actar, 2014), *Operative*

Mapping: Maps as Design Tools (Actar, 2019) and *Plug-ins: Design for City Making in Barcelona* (Actar, forthcoming). He works at the intersection of design, architecture, and the city, focusing on temporality, experimentation, and social impact.

Pallot Judith is Emeritus Professor at the University of Oxford, UK, and leads ERC Advanced grant No. 788448 *GULAGECHOES* (2018–2024) and Academy of Finland grant, *The History of the Yugoslavian Penal System* (2021–2025) at the University of Helsinki, Finland. Both examine the impact of legacies of systems of penalty developed under extreme conditions of political repression and war. She has been researching and teaching Russian Area Studies for four decades; now honorary vice-president of the British Association for Slavonic and East European Studies, she served as president 2016–2019. Since 2005 she has researched the treatment of difference in the Russian Penal System and Soviet legacies in Russian penal culture. She is author/co-author of *Land Reform in Russia, 1906–1917* (1999); with Tatyana Nefedova, *Russia's Unknown Agriculture* (2007); with Laura Piacentini and Dominique Moran, *Gender, Geography and Punishment: Women's Experiences of Carceral Russia* (2012) and with Elena Katz, *Waiting at the Prison Gate: Women and Prisoners in Russia* (2016).

Porter Amy E. is a doctoral candidate in Classical Archaeology at University of Birmingham, UK. Her research focuses on the region of South East Arkadia and North West Lakonia in the Peloponnese, Greece. She specializes in the use of GIS methodologies by examining the similarities and differences in the material culture in these two neighbouring regions, utilizing archaeological, literary, and epigraphic evidence.

Ridley Louise is Senior Lecturer in Criminology at Northumbria University, UK, and has taught criminology for over twenty years. Her research interests centre upon the prison environment and the impact that imprisonment can have on individuals and those who try to support both the offender and the process. Her earlier career, working in prisons with mental health agencies and organizations supporting ex-offenders, formed the basis for this continuing interest. Her recent work has focused

on older men in prison. Presently she is exploring the impact and consequences of the increase in the prison population of older men on both those in prison and on the organizations aiming to support them. She is also currently working on a research project which aims to explore the victim perspective of 'acid attacks' in North East England and Cumbria.

Rogers Shantai was born and raised in Utica, New York, US. She comes from a background of mental illness, physical, and sexual abuse, and multiple prison bids, and her family has spent a combined 200 years in the prison system. She worked on her degree while incarcerated and became the first person in her family to earn a college degree when she completed her Associates in Liberal Arts from Mercy College. She also holds a bachelor's degree in Human Services with a concentration in Counselling from Post University.

Ross Stuart is Enterprise Professor in Criminology in the School of Social & Political Sciences at the University of Melbourne, Australia, and sits on the Master of Criminology Advisory Board. In this capacity, Stuart has provided consultancy research and evaluation services to a range of State and Commonwealth agencies, both directly and in partnership with other universities and consulting firms. Prior to joining Criminology at the University of Melbourne, he was Director of the National Centre for Crime and Justice Statistics in the Australian Bureau of Statistics. Until June 2019 he was also General Manager of Research and Development at Caraniche, a forensic psychology company. His recent research work has been focused on reforms to family violence programs and policy, evaluations of a range of court programs and digital innovations in criminal justice. Dr. Ross has been Chief Investigator on a number of Australian Research Council projects and is a member of the Melbourne Research Alliance to End Violence against women and their children.

Rubin Ashley T. is an associate professor of sociology at the University of Hawai'i at Mānoa, US. She holds a Ph.D. in Jurisprudence and Social Policy. Rubin's research examines the dynamics of penal change throughout US history. In particular, she uses organizational theory, law and society, punishment and society, and prison sociology to understand

prisoner behaviour, administrative behaviour in penal organizations, and penal trends more broadly. Her research has been published in *Law & Society Review*, *Law & Social Inquiry*, *Punishment & Society*, *Theoretical Criminology*, *British Journal of Criminology*, and *Annual Review of Law and Social Science*, among other venues, and her TEDx talk on the how sending people to prison became normal is available on YouTube. Rubin is the author of *The Deviant Prison* (Cambridge University Press, 2021) and *Rocking Qualitative Social Science* (Stanford University Press, 2021), and she is currently writing a book on the history of American prisons.

Schar Cathi Ho is an assistant professor at the University of Hawai'i at Mānoa School of Architecture, US, and the inaugural director of the University of Hawai'i Community Design Center (UHCDC), where she focuses on public sector, public-interest teaching and practice. Under her direction, the Center evolved into a collaborative platform that operates at the intersection of the university, government, and community. In 2021, Cathi was elevated into the AIA College of Fellows. Her collaborative and multidisciplinary efforts with her peers were also recognized with a 2020 ACSA/AIA Practice & Leadership Award, 2020 ACSA Collaborative Practice Award, 2021 ACSA Annual Meeting Best Project Award, 2021 ACSA New Faculty Teaching Award, and 2021 ACSA Course Development Prize. Cathi was born and raised in Honolulu. She received her BA. from Stanford University and M.Arch. from UC. Berkeley.

Smith Lindsay is a doctoral student in the Criminology, Law, and Society department at George Mason University in Virginia, US. She currently works as a Graduate Research Assistant at the Center for Advancing Correctional Excellence! (ACE!) under the direction of Dr. Faye S. Taxman and Dr. Danielle S. Rudes. She previously earned her Bachelor of Art's degrees in Psychology and Sociology from the University of Missouri and her Master of Art's in Criminology, Law, and Society from George Mason University. She studies correctional issues with an emphasis on reintegration success, gender-based violence, and sexual victimization.

St. John Victor is a criminology and criminal justice scholar who examines the causes and consequences of criminalization, as well as strategies

to mitigate the associated harms. St. John's knowledge primarily span the areas of race, conditions of confinement in jail and prison, juvenile justice, re-entry, community corrections, and policing. He is Assistant Professor of criminology and criminal Justice at Saint Louis University, US. St. John also has experience supervising youth correctional facilities; providing oversight for a large jail system; facilitating cognitive-based interventions with incarcerated youth; and providing evaluations, trainings, and technical assistance related to interventions that serve communities impacted by crime and the criminal legal system. St. John holds a bachelor's degree from SUNY Old Westbury, a master's in criminal justice with a specialization in criminal law from John Jay College of Criminal Justice, and a doctorate from John Jay College of Criminal Justice, CUNY Graduate Center. He is a co-editor of this collection.

Stevens Julie is an associate professor in the Department of Landscape Architecture at Iowa State University, US, where she has developed an innovative student design-build service-learning programme. Beginning in 2011, Stevens has established a multi-year partnership with the Iowa Department of Corrections to create therapeutic environments for prisons, including gardens for prison staff and incarcerated individuals. The team of Iowa State students, prison staff and incarcerated individuals at the Iowa Correctional Institution for Women (ICIW) received the Award of Excellence in Community Service from the American Society of Landscape Architects (ASLA) in 2015 for the ICIW outdoor classrooms and a decompression deck and the 2018 ASLA Award of Excellence in Community Service for the Children's Garden, a visiting garden for incarcerated women and their visitors. Professor Stevens is developing a trauma-informed design programme focused on bringing the healing powers of nature to underserved and institutionalized children and adults.

Stevenson Fionn was previously Head of School of Architecture at the University of Sheffield, UK, where she held a Chair in Sustainable Design. She was a member of the 'Design, Engagement and Practice' research group and the University's Energy Institute. She was also Campaigns Director for the Building Performance Network UK and has previously held academic positions in five other UK Universities. Her

research and consultancy work focuses on developing innovative building performance evaluation and occupancy feedback, in order to improve sustainable building design and develop new policy and practice. She has held visiting professorships in Canada and Poland. As a principal and co-applicant, she has obtained and managed over £8 million in research funding, derived primarily from government agencies and the EU. She has over 120 publications to date including her seminal book: Stevenson, F. (2019) *Housing Fit For Purpose: performance, feedback and learning.* RIBA Publishing, London pp.1–225.

Tartaro Christine is a Distinguished Professor of Criminal Justice at Stockton University, US, and the author of *Suicide and Self-Harm in Prisons and Jails*, 2nd edition (Lexington Books) and several articles and book chapters on prison and jail conditions. Dr. Tartaro has a Ph.D. in Criminal Justice from Rutgers University. She has worked as a researcher for the New Jersey Department of Corrections and as a research consultant for the New Jersey Juvenile Justice Commission. She does consulting and expert witness work in the area of suicide in custody. Her research interests include new generation jails, suicide in correctional facilities, mental health, and prisoner re-entry.

Toews Barb is Associate Professor in criminal justice at University of Washington Tacoma, US. Her research focuses on restorative justice- and trauma-informed design and its impact on victims, offenders, and justice professionals. Barb has numerous journal articles and technical reports related to design, including Trust-Building through environmental design: A design toolkit, a collaboration with Designing Justice+Designing Spaces (DJDS). Earlier collaborative work with DJDS and incarcerated men and women was featured in a national exhibit curated for the Cooper Hewitt, Smithsonian Design Museum (2015–2021). Her most recent book is *Learning from life: 22 lifers, 25 years later* (2022), co-authored with Howard Zehr.

Urrutia-Moldes Alberto holds a Ph.D. in prison architecture from the University of Sheffield, UK. He is a lecturer in Construction in the partnership program of the University of Bath Spa and GBS in Manchester, UK, and a Lecturer in prison-built environments at the Centre for Public

Innovation in Latin America (Innova Publica). In his book, Urrutia-Moldes, A. (2020, Routledge) *Health and Well-Being in Prison Design A Theory of Prison Systems and a Framework for Evolution*, Alberto investigates how the health and well-being of prison users are addressed by designers, prison services' authorities, and international prison advisers in eight countries across Europe, North America and South America. He worked for fifteen years at the Chilean prison service, where in 2012 he co-organized the first conference in prison architecture held in Chile, and co-edited the book *1st Seminar of Prison Architecture for Social Reinsertion*, published by the University of Bio-Bio.

Wagenfeld Amy has roles as an occupational therapist include therapeutic and universal design consultant, educator, researcher, and author. She is on the faculty of Boston University's Post-Professional Occupational Therapy Doctoral programme and the University of Washington's (US) Department of Landscape Architecture, and is Principal of Amy Wagenfeld IDesign, a therapeutic design consulting organization. She is a Fellow of the American Occupational Therapy Association, holds evidence-based design accreditation and certification (EDAC) through the Center for Health Design, specialty certification in environmental modifications (SCEM) through the American Occupational Therapy Association, and certification in Healthcare Garden Design through the Chicago Botanical Garden. She co-authored the award-winning book, *Therapeutic Gardens: Design for Healing Spaces* published by Timber Press and is contracted with Routledge, Inc. to write a book about inclusive outdoor playspace design and with SLACK, Inc. to write a book about reconceptualizing how therapy can be provided outdoors.

Zeveleva Olga is a post-doctoral research fellow at the Aleksanteri Institute, University of Helsinki, Finland. She is a political sociologist focusing on the theory and practice of social control. She defended her doctoral thesis in sociology at the University of Cambridge in 2019, and also holds a Ph.D. in sociological theory and methods from the Higher School of Economics (2016). In 2019 she joined the GULAGE-CHOES project which brought her to Helsinki where she works on

social control in the context of penal systems. She employs qualitative methods across multiple field sites to explain how and with what consequences ethnic, civic, and political self-identification form among prisoners in the Russian and Estonian prison systems. She is the author of articles in leading sociological journals.

List of Figures

Fig. 3.1	Custodial design causal logic model	71
Fig. 4.1	Reference project workflow: Qualitative to design-oriented scenarios Ph.D. project (Bradley—2021)	86
Fig. 4.2	The public entry building (Bradley—2020)	90
Fig. 4.3	The urban setting of the public buildings (Bradley—2020)	91
Fig. 4.4	Visits reception (Bradley—2020)	92
Fig. 4.5	Visits. Working with current seating types (Bradley—2020)	94
Fig. 4.6	Visits reimagined. Courtyard and native vegetation (Bradley—2020)	95
Fig. 4.7	Learning centre. 'Design-oriented scenario: Collegial' sketch (Bradley—2013)	100
Fig. 6.1	Prison overview	136
Fig. 6.2	View of cells	139
Fig. 6.3	Houseblock overview	141
Fig. 6.4	Artist impression of houseblock exterior with mesh	143
Fig. 6.5	3-D overview	154

List of Figures

Fig. 7.1	Mas d'Enric Penitentiary. AiB arquitectes + Estudi PSP Arquitectura, 2012	168
Fig. 7.2	Koepel Arnhem, diagram showing volume of the new program as socle below old panopticon. OMA (Rem Koolhaas, Stefano de Martino), 1981	169
Fig. 7.3	Mas d'Enric Penitentiary, map exploring potential inmate activities. Roger Paez, 2014	170
Fig. 7.4	Student projects, prison design. Glen Santayana, 2013 (above), Saif Mhaisen, 2012 (bottom left) and Martin Gjoleka, 2016 (bottom right)	172
Fig. 7.5	Koepel (Netherlands). OMA. 1980 (design). https://oma.eu/projects/koepel-panopticon-prison	175
Fig. 7.6	Can Brians (Catalonia). Bonell i Gil Arquitectes+ Brullet + Rius. 1986 (design), 1993 (construction). https://www.arquitecturacatalana.cat/ca/obres/centre-penitenciari-can-brians	176
Fig. 7.7	Leoben (Austria). Hohensinn Architektur. 2004 (construction). https://www.hohensinn-architektur.at/project/justizzentrum-leoben-2/	177
Fig. 7.8	Mas d'Enric (Catalonia). AiB arquitectes + Estudi PSP Arquitectura. 2005 (design), 2012 (construction). https://www.aib.cat/en/projects/191CAT	178
Fig. 7.9	Halden (Norway). Erik Møller Architects + HLM Arkitektur. 2010 (construction). https://www.architecturenorway.no/projects/culture/halden-prison-2009/	180
Fig. 7.10	Nuuk (Greenland). Schmidt Hammer Lassen Architects + Friis & Moltke Architects. 2013 (design), 2019 (construction). https://www.shl.dk/new-correctional-facility/	181
Fig. 7.11	Puketutu (New Zealand). AiB arquitectes. 2013 (design) (This text is adapted from Paez, 2014: 228–233). https://www.aib.cat/en/projects/315OPP	182
Fig. 7.12	Recent prison repurposing. Haarlem Koepel as temporary housing for asylum-seekers (top left), citizen participation in Barcelona Model to propose future uses (bottom left), Långholmen Hotel in Stockholm's old Kronohaktet prison	185
Fig. 8.1	Critical realist ontology	195

List of Figures xxxiii

Fig. 8.2	San Carlos Prison, Chile, built in 1940. Official capacity: 124 inmates	202
Fig. 8.3	Yungay prison, Chile, built in 1960. Official capacity: 102 inmates. Photograph taken during reparations works due to damages after an earthquake in 2010	203
Fig. 8.4	Yungay Prison, Chile, built in 1960. Official capacity: 102 inmates. Photograph taken during reparations works due to damages after an earthquake in 2010	204
Fig. 8.5	Typical prison module ground floor layout. Outlining made by Chilean architect Andrés Rodriguez-Ravanal with guidance from the authors based on the information collected during the fieldwork	205
Fig. 8.6	Typical prison module cells' floor layout. Outlining made by Chilean architect Andrés Rodriguez-Ravanal with guidance from the authors based on the information collected during the fieldwork	206
Fig. 8.7	Typical individual cell footprint. Built-up area per cell: 6m^2 including in-cell bathroom	206
Fig. 8.8	Interior of treble-bed cell in PPP "Bio-Bio" prison. Built-up area: 10m^2 including in-cell bathroom	207
Fig. 8.9	Reinforced concrete furniture, PPP "Bio-Bio" prison, Concepción, Chile	208
Fig. 8.10	In-cell bathroom, PPP "Bio-Bio" prison, Concepción, Chile	209
Fig. 8.11	Cause-effect loop diagram for the Chilean Prison service (Urrutia-Moldes, 2022)	212
Fig. 8.12	View from a prison cell at CCP Bio-Bio prison, Concepcion, Chile	215
Fig. 8.13	Windows in juvenile module at CP Valparaiso	216
Fig. 9.1	Model design of the living and administrative zone of a gulag labour camp from 1930s (plan by Sofia Gavrilova)	236
Fig. 9.2	Model design of the paramilitary security zone of a gulag labour camp from 1930s	237

Fig. 13.1	European precedent facilities. (*Notes* *Photographs marked with asterisk, credit: P. Gunasekera, 2017. 'Returning Citizen Rehabilitation: Understanding Best Practices in Germany, the Netherlands and Norway; Arriving at Bergen and Bjørgvin Fengsel'. Accessed 11/9/20. https://pgwcmt.wordpress.com/)	351
Fig. 13.2	Facility size. Facility size is characterised by the footprint, number of beds, number of units and unit size. Staff-resident ratios of each facility provided for reference	354
Fig. 13.3	Facility siting: Location of facility relative to major transport node. In the absence of the specific locations which individual young people and family/carers travel to and from, the central transport node is considered as a proxy measurement to indicate the facility's access to the general community. Access routes are overlayed upon a map of built-up areas to provide an indication of the distance separating the facility from population and activity centres. For consistency, potential route options for all facilities were measured within a 675 m radius (Bergen, farthest distance to access, excluding Castilla la Mancha due to impractical distance). Trip frequency is measured on a weekday morning, for the access point that is closest to the facility, in the direction of the major transport node only—drawn as the 'primary route'. Carmona, Cordoba, and Bergen are located at the periphery of built-up areas, with public transport access and frequency less than what is available within the urban areas. Amsterdam is located within the built-up area of the city, with frequency and access similar to that available throughout the urban area. (*Source* Carmona: Consorcio de Transporte Metropolitano - Area de Sevilla. Accessed 10/8/20. https://siu.ctas.ctan.es/es/; Cordoba: Aucorsa - Autobuses de Cordoba. Accessed 10/8/20. https://www.aucorsa.es; Bergen: Skyss. Accessed 11/8/20.	

	https://reise.skyss.no; Amsterdam: GVB Amsterdam. Accessed 11/8/2020. https://en.gvb.nl/; Car routes: Map data ©2020 Inst. Geogr. Nacional and Google; Builtup area map: Corbane, Christina; Sabo, Filip [2019]: ESM R2019—European Settlement Map from Copernicus Very High Resolution data for reference year 2015. European Commission, Joint Research Centre (JRC) [Dataset] https://doi.org/10.2905/8BD2B792-CC33-4C11-AFD1-B8DD60B44F3B)	357
Fig. 13.4	Facility siting: Land-use zoning within 1 km radius. Land-use planning zones provide an indication of the types of environments immediately surrounding the facilities. Zones have been grouped with similar types to show general similarities between jurisdictions, despite variation in specific planning rules. Note that Bergen's 'Other Constructions' zone includes a wide-range of land uses. Non-urban residential areas within this zone have been grouped with residential zones from other jurisdictions. The facility is located adjacent to an adult prison, though care has been taken to screen this from view within the youth unit. (*Notes* Source: Carmona: Ayuntamiento De Carmona, 2012. Plan General De Ordenacion Urbanistica. B.01 Ordenación Estructural, C.03 & C.21 Ordenacion Pormenorizada. Accessed 17/8/2020. http://carmona.org/pgou/; Cordoba: Gerencia Municipa de Urbanismo, Ayuntamiento de Cordoba, 2001. Planos De Calificacion Usos Y Sistemas: CUS31W, CUS32W, CUS24W. Accessed 27/7/2020. www.gmucordoba.es/planos/calificacion-usos-y-sistemas; Castilla la Mancha: Ayuntamiento De Fernan Caballero, 2002. Plan de Ordenacion Municipal. Planeamiento Municipal de Castilla-La Mancha. Accessed 27/7/2020. https://castillalamancha.maps.arcgis.com/; Bergen: Bergen Kommune.	

	Kommuneplanens Arealdel 2018. Accessed 27/7/2020. https://bergen.maps.arcgis.com/; Amsterdam: Gemeente Amsterdam, 2017 Land Use. Accessed 27/7/2020 https://maps.amsterdam.nl/grondgebruik/; Underlay satellite imagery: Amsterdam: Esri, EsriNL, Rijkswaterstaat, Intermap, NASA, NGA, USGS	Esri Community Maps Contributors, Kadaster, Esri, HERE, Garmin, GeoTechnologies, Inc, METI/NASA, USGS	Beeldmateriaal.nl, Maxar, Microsoft; Spain: Esri, Intermap, NASA, NGA, USGS	Esri Community Maps Contributors, Instituto Geográfico Nacional, Esri, HERE, Garmin, GeoTechnologies, Inc, METI/NASA, USGS	Gobierno de España, Maxar, Microsoft; Bergen: Esri, Intermap, NMA, USGS	Esri, HERE, Garmin, GeoTechnologies, Inc, METI/NASA, USGS	Maxar, Microsoft)	358
Fig. 13.5	Visible physical security infrastructure. The physical security infrastructure across jurisdictions shows an absence of 'aggressive' deterrent measures with spatial characters that are school- and home-like. (*Notes* *Photographs marked with asterisk, credit: Niels Bleekemolen)	362						
Fig. 13.6	Shared kitchen and dining areas. Kitchen and dining areas serve as an important focus in each facility for informal activities between staff and young people. The Diagrama Autonomy unit contains a full domestic kitchen, similar to Amsterdam and Bergen, whereas the earlier units in the model contain dining areas only. (*Notes* *Photographs marked with asterisk, credit: Niels Bleekemolen)	363						
Fig. 13.7	Spatial use and boundaries. Boundaries between areas which are used for residence and more predominantly staff/procedural uses provide an indication of how the design encourages either distancing or close interaction between staff and young people	364						

Fig. 13.8	Therapeutic design features. Each jurisdiction provided an environment incorporating many design features known to have mental healthHealth benefits, contributing to the overall sense of a home-like environment. (*Notes* *Photographs marked with asterisk, credit: Niels Bleekemolen)	374
Fig. 14.1	Conceptual model of the causal power of the prison environment	393
Fig. 15.1	YU West seen from the outside	420
Fig. 15.2	YU West seen from inside	421
Fig. 15.3	A decorated cell door in YU West	422
Fig. 15.4	A prison cell in YU West	423
Fig. 15.5	A cell door	424
Fig. 15.6	YU East seen from outside	425
Fig. 15.7	The outdoor space in YU East	426
Fig. 15.8	A prison cell in YU East	428
Fig. 15.9	Hobby room in YU East	429
Fig. 15.10	Security equipment	432
Fig. 16.1	Full panoramic images and approximations of experts' ratings of the three visualised accommodation spaces	454
Fig. 16.2	Typical ACT semantic differential scales and the revised scales used in this study	455
Fig. 16.3	Screen set out of fundamental sentiment questions	457
Fig. 16.4	Examples of full-screen and half-screen presentations of the JDC unit visualisations	458
Fig. 16.5	Behaviour likelihood questions	459
Fig. 16.6	Illustration of how the word selection and scaled word size relate to the evaluation affective rating scale	464
Fig. 16.7	Graphical representation of the mean fundamental sentiment values for young people and staff participants	465
Fig. 16.8	Graphical presentation of the mean impression values for young people and staff participants in the three accommodation unit conditions	467
Fig. 16.9	Graphical presentation of the mean evaluation ratings for staff participants' fundamental sentiments, and impressions in each condition, for *other staff* and *themselves*	470

Fig. 16.10	Graphical presentation of the mean behaviour likelihood values for young people and staff participants in the three accommodation unit conditions	472
Fig. 17.1	The downstairs communal area on the Unit	494
Fig. 17.2	Pool table and table football on the ground floor of the Unit	497
Fig. 20.1	High security-level women's block layout	586
Fig. 21.1	Diagrams by Fall 2017 ARCH 415 students	606
Fig. 21.2	Cultural competence framework development	611
Fig. 21.3	Culturally integrative capital improvement project process	612
Fig. 21.4	Loʻi Kalo	614
Fig. 21.5	Loko iʻa	614
Fig. 21.6	Ahupuaʻa	615
Fig. 22.1	Despite being relatively new, the Iowa State Penitentiary missed nearly every opportunity to bring biophilia and biophilic design prinicples into the facility design (*Credits*—Photographs: Julie Stevens. Graphic Layout: Victoria Troutman)	634
Fig. 22.2	The Multipurpose Outdoor Classroom at ICIW balances biophilic design in the landscape with security to provide nature exposure for incarcerated individuals (*Credits*—Photographs: Kris Gaspari [left] and Julie Stevens [right] Graphic Layout: Victoria Troutman)	637
Fig. 22.3	The Attention Restoration Theory was a critical framework for the design of the landscape at ICIW (*Credits*—Photograph: Julie Stevens Graphic Layout: Victoria Troutman)	638
Fig. 22.4	Guidelines for developing health-promoting custodial environments	639
Fig. 23.1	Identifying greenspace within the prison envelope Mastermap topographic layer showing a prison (upper left); prison perimeter highlighted, with boundary exaggerated for clarity (upper right); polygons within the prison envelope isolated (lower left); all areas of greenspace within the prison wall identified (lower right). (*Source* Contains OS data © Crown copyright and database right [2020])	662

Fig. 24.1	Prisonscape, Froland department (*Photo* Author)	686
Fig. 24.2	Prisonscape, Mandal department (*Photo* Author)	687
Fig. 24.3	Yard, Mandal department (*Photo* Author)	694
Fig. 25.1	Collage of magazine images created by incarcerated men to depict justice based on punishment (left side) and love (right side) (Designing Justice + Designing Spaces, 2015)	710
Fig. 25.2	Photograph representation of a respite space selected by violence survivors that includes elements of restorative justice design (Toews, 2020; image from Peace and Justice Cards designed by Designing Justice + Designing Spaces)	717
Fig. 26.1	Items from the whitewood range of prison furniture currently in use in UK prison cells. DACRC researchers took these pictures at a Category C prison in 2019	736
Fig. 26.2	A metal single bed and mattress in an intake cell. Also, a metal bunk bed and other furniture being stored in a UK category C prison awaiting transfer to a refurbished cell	737
Fig. 26.3	The existing plastic cell chair, photographed in a UK Category C prison visited by the DACRC team in 2019	738
Fig. 26.4	Prison metal bunk bed included in a full-scale mock-up cell located at Central Saint Martins in 2019 as a student empathy tool for design research	739
Fig. 26.5	Prisoner co-design participants pitching their co-designed cell furniture ideas to HMP staff and the design team using prototypes they created during the design workshops	745
Fig. 26.6	A 3D rendering of the Flip Chair in the full-scale mock-up cell located at Central Saint Martins in 2019. The chair can be flipped to be used as either a low-height lounge chair or a desk chair. This concept was developed with prisoners staff in Spring 2019 and at the time of writing is undergoing prototyping and testing with HMPPS	750

Fig. 26.7 A cardboard prototype of an adjustable chair co-designed with prisoners in 2019, that was later developed into the Flip Chair 751

List of Tables

Table 3.1	Architectural features perceived to be associated with staff and inmate behaviour	65
Table 13.1	Observations of therapeutic design characteristics	369
Table 15.1	An ideal-typical model illustrating the two prisons	419
Table 16.1	Counts and percentages for young people demographic items	460
Table 16.2	Counts and percentages for staff length of employment in Youth Justice facilities	460
Table 16.3	Number of staff and young people in each condition	462
Table 23.1	Drivers of prisoner wellbeing	669
Table 23.2	Drivers of prison staff absence	672
Table 25.1	A comparison of justice questions (Zehr, 2015)	705

1

Introduction

Yvonne Jewkes, Dominique Moran, Kwan-Lamar Blount-Hill, and Victor St. John

This *Handbook on Prison Design* is intended to offer insights into the construction of custodial facilities, alongside consideration of the critical

Y. Jewkes
Social & Policy Sciences, University of Bath, Bath, UK
e-mail: yj629@bath.ac.uk

D. Moran (✉)
School of Geography, Earth and Environmental Sciences, University of Birmingham, Birmingham, UK
e-mail: d.moran@bham.ac.uk

K.-L. Blount-Hill
Arizona State University, Phoenix, AZ, USA
e-mail: kbh@asu.edu

V. St. John
Saint Louis University, St.Louis, MO, USA
e-mail: victor.stjohn@slu.edu

questions any policymaker should ask in commissioning the building of a site for human containment. Chief among these questions is the one we almost chose as the title of this volume: *What Works in Prison Design?* This proved the central—and thorny—question with which so many of the authors grappled. Its simplicity is deceiving. Yet centring this foundational concern caused many of us to return to basic questions about the nature, purpose, and outcomes of punishment. As a result, the *Handbook* is a testament to what can be achieved if we discard historical blueprints and abandon old ideas about what prisons *are supposed* to look like in favour of a more imaginative and humane response to people in prison—a consideration of what these facilities *should* look like. The question of 'what works' is not a bad one because it forces us to think about all the well-meaning (and not so well-meaning) architectural experiments that have been tried over the last two centuries, and the pros and cons of different carceral configurations of space.

For criminologists, however, the phrase 'what works?' is problematic because it has been famously answered: 'nothing'. The scholar responsible for this gloomy prognosis was liberal American sociologist Robert Martinson, and his aim in propagating the idea that 'nothing works' was to support a reduction in the use of imprisonment (Martinson, 1972, 1974). The well-known phrase now indelibly connected to his name arose from a debate on the 'treatment' of offenders, rather than the architecture within which they are incarcerated, yet the balance of evidence supporting 'rehabilitation' during imprisonment—as measured by recidivism rates or beleaguered by flawed metrics and hollow promises—arguably points us towards the same conclusion, as many of our contributors underline. However, Martinson's somewhat amorphous stance (e.g. Martinson, 1974) was seized on by conservatives to validate calls for longer sentences, more brutal regimes, and more fortress-like designs. A similar risk lies in reformists' promotions of 'good' prison design, a point that several of the contributing authors reflect on in this *Handbook*. Namely, that thoughtfully designed prisons which incorporate a rehabilitative, rather than punitive, aesthetic and symbolise a rejection of the retributive ethos of past traditions, may nonetheless be used to justify the continued and growing incarceration of ever more people and construction of yet more prisons. Moreover, these 'attractive'

prisons may also mask, to external observers, the pains of imprisonment inherent in any form of coercive confinement.

For those of us who research architecture and design, then, the question of what works will always be contentious because the prison is, on multiple levels, a statement of societal failure that inevitably perpetuates and reproduces that failure. As architectural historian Tom Wilkinson (2018) observes, 'However humane its approach, penal architecture is essentially cruel'. Even the most imaginatively conceived prisons are experienced as profoundly painful by many of the men, women, and children held in them because, aside from execution, imprisonment is the ultimate psychic and bodily violation, and loss of liberty remains the most profound pain of imprisonment. Philosopher Alain de Botton says in *The Architecture of Happiness*, 'buildings are able to solve no more than a fraction of our dissatisfactions… Architecture, even at its most accomplished, will only ever constitute a small, and imperfect…protest against the state of things' (De Botton, 2008: 9).

Increasingly, then, we might find ourselves in a quandary about where we stand on attempts to create 'better' prisons. The professional practitioners who win commissions to design custodial facilities frequently seem imbued with a utopianism common to most architects and architectural theorists, often describing how 'life-enhancing' buildings and structures have the capacity to 'entice and emancipate' perceptions, thoughts, and experiences (Pallasmaa, 1997: 12). There is a sense that buildings, if only better designed, can make people better. After all, there are many examples of good practice in prison planning and design around the world, as this edited collection demonstrates.

It is undeniable, then, that for many prisoners, an imaginatively planned, human-centred prison will be a more enriching experience in numerous ways than a more conventional 'institutional' facility. Some architects believe that a particularly creative and thoughtfully designed facility—and many such exemplars are described in the pages that follow—might even inspire convicted offenders to want to 'make good' in order to attain a similarly pleasing environment of their own when they leave custody. That was the ambition of the architects who designed Halden Prison in Norway, for example, which is referred to several times throughout this volume.

More fundamentally, perhaps, as Fyodor Dostoevsky famously wrote, 'the degree of civilisation in a society can be judged by entering its prisons'. We might enter many prisons in the world and conclude that the jurisdictions they are located in are not very civilised at all. However, as our contributors testify, while 'people-change' (that is, rehabilitating offenders through the design of carceral buildings) is a tall order, 'context-change' is an achievable goal—and that includes the society in which any new prison is conceived and built. In other words, when a prison communicates positive attributes, the design challenges the cultural stereotype of what a prison is—and, through this, who prisoners are. Taking this a step further, if, through design, the idea of housing people in a 'prison' is not significantly different from housing people in any other kind of 'normal' social environment, it may not be a huge conceptual leap to instead pursue forms of justice that can be achieved while offenders remain in the community (Jewkes, 2018; Jewkes & Lulham, 2016).

These are themes that underpin *The Handbook on Prison Design*, and they are taken forward by a diverse range of authors—academic researchers, architects, practitioners, and those with lived experience—who in many cases bring these different perspectives together as chapter co-authors, or as individuals with experience spanning more than one of these identities. They present insights derived from establishments in Australia, Chile, Estonia, Ireland, New Zealand, Norway, Russia, the United Kingdom, and the United States—jurisdictions that vary widely in terms of the history and development of their prison systems, their punitive philosophies, and the nature of their public discourse about the role and purpose of imprisonment. Given this diversity of both perspective and context, and the positionality of authors, the editors have chosen to refrain from altering the terms used by authors in describing custodial settings and persons confined. The editors have also encouraged that, where possible, authors provide clarity in the definition of terms that may be common in their region, but uncommon in others. In doing so, the authors of the chapters variously refer to persons held within the custodial setting as incarcerated persons, prisoners, inmates, or justice-involved persons. Similarly, the custodial setting may be referred to as

prison, jail, correctional setting, and other nomenclatures specific to geography and author(s') positionality.

The *Handbook* is divided into four parts. Part I presents work on the *History and Philosophy of Custodial Design*. In the opening chapter (Chapter 2), Ashley T. Rubin sets the scene with a contribution provocatively titled '*That Time We Tried to Build the Perfect Prison: Lessons from repeated episodes across US prison history*'. Rubin examines reformist endeavours within prison architecture from a historical perspective, going back to John Howard in the eighteenth century. According to Rubin the last two centuries have featured several attempts at 'perfecting' prison design—some well-meaning and benign, others retributive and meanspirited. Ultimately, Rubin argues, our inability to recognise the limitations of penal institutions may be the single most important reason for our recurring failures. Despite attempts to make prisons healthier and more humane—some impressive, creative, and positively impactful on those detained within them—these efforts must be seen within the context of a very long line of failures, not least because ideals change over time. The possibility that aims and desires might shift means that attempts to design and construct something that 'works' at present may elide into something that does *not* work as thinking evolves, priorities change and the goals of punishment take on ever more punitive guises in many jurisdictions. If we remain wedded to the idea that correctional facilities are the most effective way of punishing offenders, we must let go of the ideal of the perfect prison and accept instead imperfect prisons—prisons that harm, that cause pain, that fail to achieve much more than misery. Accepting this fate is what would show that we have finally learned from our history.

In Chapter 3, Melissa Nadel's primary focus is on prisons in the United States, and she outlines how classic behavioural theories from criminology and sociology support architectural mechanisms designed to eliminate maladaptive behaviours (emphasising security, deterrence, and punishment) rather than enhance positive qualities such as emotional well-being. The assumption in these design discourses seems to be that risk can be 'designed out' of a building through a 'hardening' of architecture, making safe buildings rather than relying on safe individuals. The collateral impact is that the people held within these prisons

behave accordingly. Impermeable construction and vandal-proof furniture common in custodial facilities communicate that residents are problematic, powerless, and distrusted, which can become a self-fulfilling prophecy, producing behaviours consistent with those expectations. Drawing on a qualitative study exploring the impacts of various types of 'hard' and 'soft' architecture, and anticipating some of Bradley and Lulham's conclusions in the following chapter, Nadel suggests that more fragile spaces actually necessitate a need for caretaking that enhances safety by nurturing feelings of agency, purpose, and well-being within residents.

Speaking to themes emergent in Nadel's chapter, Kevin Bradley and Rohan Lulham follow her work with an argument that architects fail to think imaginatively about the individual lived experience because they are preoccupied with the way prisons have always been designed, and tend to exclude end users from their planning. In their chapter, Bradley and Lulham advocate a 'collective methodology' as an alternative approach to traditional and contemporary custodial design procurement. Combining their practical architectural knowledge, which includes designing educational and visiting spaces for prisons in Australia, with academic research in the same country, Bradley and Lulham critique the tendency to view prisons as affecting 'people-change' and use of the blunt measurement of 'recidivism' rates as to determine the social value of design blueprints. Architecture that is broadly understood to have a 'people-changing' purpose within the empirical practices of 'what works', they say, perpetuates the ill effects of prison on the individual, with deleterious impacts felt through generations. Rehabilitation might only be regarded as a reasonable goal if custodial design is re-orientated to being 'context-based' in the sense of offering people in prison an alternative context in which to imagine their futures. With this in mind, they set out to include the voices and concerns of those directly impacted by the design of custodial environments, including those detained, through their 'collective methodology' and challenge to conventional 'what works' design procurement.

Yvonne Jewkes endorses the previous contributors' exhortation for involving the individuals most directly impacted by prison design in the design process and for involving researching in empirically testing these

impacts in Chapter 5, about her experience as an academic consultant on two prison design projects in New Zealand and the Republic of Ireland. What the two projects shared, she tells us, is that each was commissioned in socially and politically conservative countries with powerful popular media narratives that create and perpetuate negative stereotypes about people in prison. The projects' divergences, however, were stark. One—a women's prison in Limerick—was commissioned by a prison service keen to underpin the design with evidence from Jewkes' own academic research. These administrators were prepared to take risks, including holding a design competition of the kind more typical of countries in northern Europe. As part of the consultation process, Jewkes discussed the new prison's design with women already held in Irish female prisons, Limerick and the Dóchas Centre, Dublin. The other project—Auckland East maximum-security prison for adult males—was likewise commissioned in an atmosphere of reform and perhaps a little idealism. Yet, when the design team presented their plans to New Zealand's Department of Corrections, they were met with resistance to everything prioritising prisoner rehabilitation over security. The deeply entrenched view that men in maximum security are dangerous 'others' who must be held in sensorially depriving, austere places of punishment and retribution (and certainly not consulted in their design), ultimately resulted in a newer, shinier version of the supermax it was replacing.

In Chapter 6, Saul Hewish revisits The Creative Prison—a project that was all about core end-user engagement. Led by RideOut and architect Will Alsop, and co-conceived by prisoners at HMP Gartree in the English Midlands, The Creative Prison was an attempt to re-imagine prison from the perspectives of those with experience of living and working in prison environments. Hewish describes it as a provocation, an art project designed to stimulate new thinking about contemporary responses to imprisonment. The creative team set out to present an alternative vision of what a prison could be, especially if the starting point for the prison is not security but rather the facilitation of education, creativity, and rehabilitation. The chapter updates the original project and is a fitting tribute to Alsop, who died in 2018.

In Chapter 7, in collaboration with Kwan-Lamar Blount-Hill, Roger Paez writes from experience as a professional architect faced with the

daunting task of designing a custodial facility. His task is made more difficult by his simultaneous role as a professor of sociology, all too cognisant of the harms that prison inflicts. As he says, the prison as an institution reflects a failure of the social contract, which makes it an uncomfortable subject for contemplation or public discourse. After reviewing important theoretical influences on his work, Paez presents seven case studies of carceral facilities that, he asserts, are, at least in some ways, exemplars of good design—including his own design of a high-security facility in Catalonia. Like other writers, Paez cautions that prison design must avoid uncritically reproducing existing solutions and instead continuously problematise the purpose of prison. A primary goal is to get away from the constraints of designing for security and surveillance and to embrace innovation as a core design principle. This, he says, is what his chosen case studies do.

With the preceding chapters having already taken readers on a tour of six different jurisdictions in which innovative prison design is occurring, Alberto Urrutia-Moldes and Fionn Stevenson turn our attention to Chile. The authors analyse the country's prison architecture using a critical realist perspective to understand the causes and mechanisms that have prevented a move towards the kind of human-centred and rehabilitation-driven custodial design encountered in the chapters so far. To bolster their observations, Urrutia-Moldes and Stevenson present data from their research entitled 'Designing to meet physical, psychological and social well-being needs in prison', which explored how designers and prison services' authorities address health and well-being in prison design in different countries.

The final chapter in this first section of *The Handbook* beckons the reader to the other side of the world, offering historical and contemporary perspectives on Soviet socialist prison architecture. Judith Pallot and Olga Zeveleva discuss the Soviet model, before examining modifications of this style of prison architecture in the thirty years since the USSR's collapse. Their focus in Chapter 10 is on two countries that arrived at contrasting decisions on the way forward post-1991—Estonia, the former Soviet republic that was incorporated into the USSR at the end of the Second World War, and the Russian Federation. While there may be various indicators that both countries have shifted from communist-era

penality in their criminal legal systems, change (or its absence) in prison architecture provides, they say, the greatest symbolic demonstration of transformations in discourse and in practice. Drawing on empirical data, Pallot and Zeveleva testify to the importance of hearing prisoners' voices, presenting excerpts from interviews with research participants in Estonia to reveal compelling evidence that different forms of penal architecture can prompt differing behavioural changes. Both historic GULAG-style colonies and new 'European' style prisons are connected by a belief in the power of spatial structures and material infrastructure to re-educate, control, and shape the biographical trajectories of prisoners. Where old-style Soviet facilities gave rise to informal power hierarchies that elicited widely varied outcomes, new 'Europrisons' are highly rule-bound and managerialist in nature.

In Part II, the authors turn to questions about how we measure and assess what works in carceral design. Under the title *Determining the "Effectiveness" of Custodial Design*, contributors address the issue by taking a variety of approaches, from collaborative methodologies and design competitions to promoting key values, including moral justice, dignified design, therapeutic philosophies, and rehabilitation strategies. In the first chapter of this section, Melissa Nadel argues for empirical academic research as key to establishing the causal relationships between custodial design and the myriad behavioural or systemic outcomes prioritised by prison officials. She outlines advantages of, and barriers to, researcher-practitioner cooperation. From the researcher's point of view, she asserts that cooperating with custodial agencies has tangible benefits for advancing the study of custodial design, allowing researchers to better understand the intent behind different designs and incorporate the practical experience of prison officers theorisation on the impacts of carceral architecture. Nadel's work in Chapter 10 emphasises that, when successful, collaborative partnerships between academics and practitioners can produce deliverables bridging the gap between theory and practice. She cautions that scholarly articles often hold a good deal of information that might be useful for policy or practice but are often not easily accessible to practitioners, and even when they are, do not clearly distil practical implications. In other words, there is a need for collaborative relationships whereby researchers learn from the expertise of prison

staff (and, we hope, the expertise of prisoners themselves) and then feed evidence, ideas, and examples of good practice back to professional practitioners in ways much more easily digested and implemented.

In Chapter 11, Todd Levon Brown discusses a wide range of socio-spatial issues in his call for more effective assessments of the environmental conditions of correctional (and other institutional) spaces. He says that qualitative interviewing should be a primary methodological approach for gauging the perceptions of, and experiences in, carceral custodial spaces among prisoners, staff, and visitors. Brown discusses the value of prison design competitions through the lens of his own experience as a member of a team that participated in a competition to design new community-based jails. He explicates a series of recommendations regarding post-occupancy evaluations (POEs) of poorly performing correctional facilities with the aim of implementing spatial changes that 'foster restorative and just environments in custodial design'. A key focus is suicide; he begins his work recollecting an infamous story of Kalief Browder—a young man who took his life after serving time in jail on Rikers Island in New York as a teenager, a sombre illustration of the unnecessary emotional and physical harm occurring in the wake of solitary confinement. Still, Brown builds from this powerful example to cast an analytical net more widely, considering how carceral spaces impact even prisoners' families during and after a visit.

Like Todd Levon Brown, Kwan-Lamar Blount-Hill begins his discussion in Chapter 12 with Rikers Island; the bleak, outdated architecture of which stands as a useful reminder of moral beliefs about 'what justice is and what justice demands'. Blount-Hill draws on original, empirical data to demonstrate, through real-world examples, how moral choices are embedded in custodial design. With this understanding, he then presents and integrates comprehensive correctional design frameworks conceived to respect human dignity, enhance perceptions of fairness, and facilitate justice. Blount-Hill's analysis blends environmental psychology, prison sociology, and moral philosophy to shed light on the conceptual and theoretical overlaps between architecture and symbolic justice. Outlining the conception of 'dignified design' leads to a more holistic understanding of 'just' architecture (including the siting of prisons) and what is involved if architects are to be held more fully to account for

what carceral buildings communicate in 'signs, symbols, affordances and constraints'.

Next, Matt Dwyer and Sanne Oostermeijer attend to youth custody and the characteristics of facilities that can promote effective treatment. Their therapeutic design model focuses on the size and siting of youth facilities, and a change from a 'traditional' to relational approach to security. In Chapter 13, they describe three facilities in Spain, Norway, and the Netherlands, reflecting on 'what works' about them. Like Blount-Hill, they draw attention to the significance of prison location, as well as the nature of prison occupancy, highlighting smaller scale, minimal presence of 'aggressive' security and a 'home-like' environment featuring daylight and natural lighting, comfortable acoustics, access to green space, privacy and the potential for personalisation.

Finally, Jennifer Galouzis, Andrew Day, Stuart Ross, and Diana Johns embark on a conceptual discussion of rehabilitation, conceiving it as a process occurring at the intersections of the physical, social, and psychological spaces of prison. In Chapter 14, the authors draw attention to the active role that an incarcerated person plays in the process of rehabilitation but say that, in addition to this personal enterprise, rehabilitation can be assisted, or hindered, by the physical environment. In explicating the proposition that a holistic and multidisciplinary approach is required when researching the prison environment, Galouzis and colleagues propose three causal mechanisms by which prison rehabilitation occurs—self-determination, the development of new skills and knowledge, and identity transformation—and use theory to explain how these mechanisms might underpin the design of a rehabilitative prison environment.

Part III is entitled, *Designing for Imprisoned Populations*. Elisabeth Fransson begins this section with Chapter 15, in which she analyses how prison space influences occupants' bodies by reference to youth facilities in Norway. It may well come as a shock to readers from other nations, like the United States, that Norway has just two Youth Units, each holding four individuals and approximately 30 'well-educated' staff from a variety of professional backgrounds. Fransson, notes, however, that there is sometimes a gap between the rhetoric of Nordic 'exceptionalism' and the reality, in the sense that there are young people under

the age of 18 housed in adult prisons in Norway. Drawing on ethnographic research in both Youth Units, which differ in numerous ways, Fransson interrogates the notion of a custodial design that supports 'the best interest of the child' and the principle of 'normality'. She notes that custodial design must consider how materiality affects people physiologically as well as psychologically. Since research cannot tell us 'what works' in a specific situation, she argues, we need to focus on what we think is right and moral, and aim to provide dignity and assist a positive change in the lives of young people in custody.

In Chapter 16, Rohan Lulham continues the exploration of design in youth custody; this time in Australia, using affect control theory to examine *if*, *how*, and *what about* design matters in interactions between staff and young people in detention. The imprisoning of children and young people is one of the most controversial topics of current times, with politicians in many jurisdictions willing to whip up moral panics about youth offending and to build prison-like institutions to appease the then-panicked electorate, rather than addressing the multiple levels of neglect, trauma and economic, social and racial disadvantage that many of these young people have experienced. Affect control theory allows Lulham to analyse behavioural outcomes that emanate from human feelings about the environment based on the interaction of immediate impressions and past experience. This innovative methodological approach, employing 'dynamic visualisation' and survey methods, adds new knowledge to our understanding of what works in the design of youth custody, but is ultimately used by Lulham to call for the dismantling of carceral facilities for young people.

In the next chapter, the authors turn their attention to specialist mental health units in prison. Kathryn Cassidy, Wendy Dyer, Paul Biddle, Louise Ridley, Toby Brandon, and Norman McClelland note that much existing literature on the harms that custodial environments inflict on their occupants' mental health focuses on emotional wellbeing rather than acute mental illness. In their contribution, Cassidy and her colleagues examine a specialist unit commissioned by the health service in England which was built over a century ago and has since been adapted multiple times, most recently with the addition of a new healthcare wing in 2017. The authors outline the process of adapting

the prison setting to meet the needs of persons who are mentally unwell in Chapter 17, work undertaken in the small mental health unit in a building constructed in the 1990s, holding eleven patient-prisoners and two prisoner peer workers. They focus on the re-design and adaptation processes that took place within the unit, some on an ad-hoc, pragmatic basis; others with collaborative input from the residents. While adaptations of existing buildings to accommodate the needs of new populations with specialist needs is not ideal and designing-for-purpose is always a better solution for people with acute mental health needs, the authors argue nonetheless that small, incremental, co-designed improvements can make a significant difference to professional practice and patients' quality of life.

Many of the contributions in this *Handbook* emphasise the need for planners and architects to consult with serving and/or ex-prisoners or, preferably, to engage them in co-design opportunities. In Chapter 18, current and formerly incarcerated men and women collaborate with a prison educator to speak from their own experiences about the impact and effects of carceral design. Abdullah Al-Muwahid, Sincere Allah, Michael Bright, Sean Kyler, Ibn Loyal, Anthony Martin, Shantai Rogers, Aaron Sheppard, and Harold Thompson give us a unique autoethnographic perspective on the architecture of incarceration, drawn from class discussions with their instructor, Douglas N. Evans. They give us intimate responses to the realities, for example, of living in a tiny space in close confinement with a toilet (frequently broken or unclean), of visiting rooms with insufficient space and privacy, of communal areas that assault the senses, and of solitary confinement cells the experience of which justify the nicknames 'hole' or 'box'. The authors suggest alternatives to these traditional carceral spaces, emphasising the need for positive interpersonal relationships to be supported by architecture, and for design that encourages mindfulness and connections with the world outside. They also address the age-old dilemma faced by all of us who work in this field: in advocating for reform and improvement, do we risk contributing to an over-reliance on imprisonment? Their view is that resources would be better spent on community initiatives to help people not offend in the first place and to assist those returning to society on release from custody. But, of course, this is not a zero-sum equation. One message

running throughout this volume is that decarceration policies and better carceral design are not mutually exclusive endeavours.

In Chapter 19, Hugh D. Lester and Christine Tartaro return the reader to Rikers Island Jail in New York, currently undergoing a phasing-out process that will see the notorious institution closed down and replaced by smaller jails better fit for purpose. The authors remind us that constructing new facilities does not, in and of itself, create the necessary change required to improve the lives of prisoners and assist in rehabilitative efforts. Correctional environments, they say, are people-driven and cultural change is a necessary prerequisite for meaningful reform. Like other contributors to this volume, they highlight the risk of old practices being imported into replacement facilities, undermining good design intentions. The authors chart paradigm shifts in design that occurred in the 1970s yet still have relevance for prison planners and designers today. For instance, whether a negative or positive prisoner behaviour model is adopted determines whether direct or indirect supervision units are built and whether fixtures and fittings are security-determined and vandal-resistant or 'normalised' and accommodating. The authors discuss podular direct supervision as an exemplar, using several facilities in the United States as an illustration, though, ultimately, we are reminded that the most well-designed prison is only as effective as its operational culture and the staff running it.

In Chapter 20, Lyndsay Smith discusses 'gendered inconsiderations' in relation to the women's prison estate in the United States, arguing that a kind of gender-blindness afflicts the female prison system. Designed by men, often for men, the correctional facilities in which women are held frequently overlook the particular nature of women's trauma experience and are unnecessarily concerned with security and order rather than issues such as maintaining contact with family, offering appropriate medical services and providing transferrable work skills. Smith reviews the literature on better approaches to the incarceration of women, before discussing a specific case study in which she conducted empirical research. Like Lester and Tartaro, she emphasises that architecture alone does not make a successful, rehabilitative prison, but it can influence regimes and culture.

In Chapter 21, the final contribution of this section, Cathi Ho Schar writes of the imprisonment of indigenous peoples and, more specifically, the over-representation of native Hawaiians and Pacific Islanders in Hawai'i's prison population. Hers is a 'call to action' to design correctional facilities according to cultural, indigenous and decolonising principles, borrowing from a host of literatures of theory and praxis. For example, the 'decolonising cities' perspective emphasises the reorganisation of political relationships and cultural revitalisation. Using innovative methodologies and an inclusive approach, Schar sought insights into alternative practices to punishment and how they could be implemented. This resulted in the Cultural Competence Framework for Corrections and a practical toolkit that Schar outlines will support the design of a equitable system, just processes, and restorative environments. Schar suggests the application of this work to proof-of-concept designs is forthcoming and concludes with some takeaways to demonstrate the benefits of a culturally attuned approach to carceral design.

The fourth and final section of the *Handbook* features authors writing about *Custodial design for spaces and functions*, with the first two chapters containing discussions on nature and green space using qualitative and quantitative research perspectives, respectively. The authors in both chapters note that landscapes are frequently omitted from prison plans because of concerns about how their inclusion will be interpreted by the public. Yet, far from being a privilege or luxury, Julie Stevens, Amy Wagenfeld, and Barb Toews argue in Chapter 22 that green spaces should be essential to prison planning policies because access to and views of nature, they suggest, are not only a basic human right, but could help to achieve custodial and rehabilitative goals. Going from 'grey to green' means more than providing a patch of lawn or the odd flower bed. Gardens and landscapes in which prisoners can interact with nature, as well as views from inside of natural green spaces, have been shown to have a wide range of positive outcomes. The authors discuss six features that can contribute to the biophilic design in custodial settings and say that failure to incorporate them constitutes a 'missed opportunity'. Cynics might argue that an absence of biophilic elements in prisons represents a knowing and deliberate strategy of deprivation and punishment, but Stevens and colleagues assert that incorporation of green

spaces into places of confinement can only be a positive step towards rehabilitation and improving quality of life. Their guidelines for health-promoting custodial environments will be invaluable for prison planners and designers.

Dominique Moran, Phil I. Jones, Jacob Jordaan, and Amy E. Porter continue in a similar vein in Chapter 23. These authors present research demonstrating a 'statistically robust relationship between green space and emotional well-being' for prisoners and prison staff. Much work on the value of green spaces thus far has been speculative or 'common sense' in its approach and tone, so that the quantitative analysis conducted by Moran, Jones, Jordaan, and Porter, using novel, macro-level methodological approaches, is a welcome rejoinder to prison services and corrections departments that require 'scientific' evidence of nature's benefits for meeting administrative goals and targets. Moran and colleagues find that greenspace is not only beneficial to prisoners but has positive outcomes for prison staff too, reducing sickness and absenteeism and the effects are found even in facilities with high levels of violence perpetrated against the self or others.

In Chapter 24, Berit Johnsen explores the use of green spaces in Norway. Her work foregrounds two closed (high-security) prison departments, Mandal and Froland, situated 120 kms apart and forming parts of the split-site Agder Prison. Johnsen charts changing attitudes on the part of Norwegian authorities since Halden—the famous high-security prison situated in a forest—was built in 2010. Her commentary on Mandal and Froland includes reflection on the benefits of access to nature, though she also highlights the complexities of including greenspace in custodial sites, especially when they are used as part of the regulatory infrastructure of a prison.

In Chapter 25, Barb Toews discusses the design for restorative justice (RJ). She first explains the principles of RJ and why custodial facilities as currently configured are not conducive to successful healing or for positive transformation to occur. Toews emphasises that RJ takes place not simply between perpetrators and victims, but can involve multiple persons and, indeed, whole communities. As in her work with Stevens and Wagenfield in Chapter 22, Toews devises a useful set of principles to guide planners, commissioners, and designers when thinking about

good practice. They bear a strong resemblance to guidelines concerning Trauma-Informed (TI) design, though the main difference (and, perhaps, selling point) is that, where TI initiatives focus on offenders' past trauma, the ultimate goals of RJ, are to help heal those harmed by crime and make society safer.

The final chapter of the volume, Chapter 26, was composed by Lorraine Gamman and Laura Caulfield. In it, the authors describe a project they led under the auspices of the UK Ministry of Justice-funded Design Against Crime Research Centre (DACR), which aims to engage prisoners and prison staff in co-creating design initiatives. This cell furniture design project originated from safety concerns arising from the murder of Zahid Mubarek by his racist cell-mate, who bludgeoned the young Asian man with a table leg in their shared cell at HMP Feltham Young Offenders Institution. The collaborative project team, involving prisoners, prison staff, designers, and design students, set for itself the challenge of designing furniture that would have a positive impact on prisoners mental well-being and used prison workshops to manufacture the furniture. Gamman and Caulfield's proposed new approach to cell furniture includes using sustainable materials that are comfortable and easy to clean and maintain. In addition to recommendations about the furniture, the authors discuss obstacles to a participatory democratic approach to design, which include a 'one size must fit everybody' policy that required the design of all furniture for suitability in high-security risk units. However, the authors also describe successes that democratise design participation and give some prisoners meaningful training and transferable skills to take away from prison at the end of their sentences. Despite the frustrations they encountered in the process, then, Gamman and Caulfield end the *Handbook* on a positive note, with a design initiative that 'works' on multiple levels and that has considerable potential for future development.

The Handbook of Prison Design serves as a comprehensive investigation and consideration of the well-meaning (and not so well-meaning) architectural experiments that have been tried over the last two centuries, and the pros and cons of different configurations of carceral space.

Taken together, this volume offers readers theories, frameworks, historical accounts, design approaches, methodological strategies, empirical research, and practical approaches to consider *what works?*

References

De Botton, A. (2008). *The architecture of happiness*. Vintage.
Jewkes, Y. (2018). Just design: Healthy prisons and the architecture of hope. *Australian & New Zealand Journal of Criminology, 51*(3), 319–338.
Jewkes, Y., & Lulham, R. (2016, June 27–30). *Provoking criminal justice reform: A presentation in the Empathy "Things" Workshop*. 50th Anniversary Design Research Society Conference—"Future focused thinking".
Martinson, R. (1972). Paradox of prison reform. *The New Republic, 166*(6), 15.
Martinson, R. (1974). What works?—Questions and answers about prison reform. *The Public Interest*, pp. 22–54.
Pallasmaa, J. (1997). *The eyes of the skin: Architecture and the senses*. Wiley.
Wilkinson, T. (2018). *'Typology: Prison', The Architectural Review*. https://www.architectural-review.com/essays/typology/typology-prison. Accessed 11 May 2022.

Part I

The History and Philosophy of Custodial Design

2

That Time We Tried to Build the Perfect Prison: Learning from Episodes Across U.S. Prison History

Ashley T. Rubin

One of the most encouraging trends in prison reform today is the ongoing effort to make prisons more humane by mitigating some of their most "prison-like" features. Borrowing from design decisions and architectural plans aimed at wellness and healing in other fields, prisons around the world (including some U.K. and Scandinavian prisons) are being redesigned or built to incorporate light, nature, space, and other features that have rarely been associated with prisons, which are too often dark, dank, institutional, overcrowded, punitive, and even cruel (e.g. Augustine et al., 2021; Jewkes, 2018).

I thank David Johnson, Malcolm Feeley, and Dominique Moran for their helpful feedback on earlier versions of this paper.

A. T. Rubin (✉)
Department of Sociology, University of Hawaii at Manoa, Honolulu, HI, USA
e-mail: atrubin@hawaii.edu

My genuine reaction is that these developments are fascinating, impressive, and will (hopefully) achieve many of their goals to make prisons into more humane spaces and reduce the harm that many believe is inevitable therein. I also have a more jaded reaction, stemming from my work studying the history of punishment, especially penal reforms over time.[1] That more jaded reaction views these efforts as the latest in a long line of attempts to construct the "perfect prison"—a kind of fantasy version of prison, varying in its ambition and elaboration, that would achieve certain goals in particular ways, smoothly, seamlessly, and efficiently. Any given perfect prison may be a new vision of what prisons can achieve or a vision that fixes the most glaring problems of the last big reform so that the prison can finally be left alone to do whatever it is supposed to do.[2]

My jaded reaction already unfairly conflates two distinct endeavours: the harm reduction goal of making prisons less terrible and the arguably naive, almost cartoonish goal of perfecting prison. While I recognize that these are distinct endeavours, I also see them as part of a larger continuum of penal reform efforts. Each reform attempts to bring the prison closer into alignment with a vision of the perfect prison—an existing view of what the prison ought to be or an entirely new vision of what the prison can be. Connecting reform efforts in this way, I believe, allows us to reflect upon two important questions: First, what are the different ways that the "perfect" (or idealized) prison has been imagined—what are different visions of the perfect prison? Second, what does this history tell us about prison development, especially ongoing and future efforts to improve the prison?

To investigate these questions, I draw on multiple examples in which penal reformers, politicians, and prison administrators worked to envision, construct, and manage their version of the perfect prison. I borrow these examples from the secondary literature, which tends to focus on

[1] This reaction is a hazard of the job. For similar reactions, see Feeley (1983).
[2] Stripped of its rhetorical flourish, the concept of the perfect prison is another term for a prison "template", or essentially an idealized model of how a prison or prison regime should be designed or managed (Rubin, 2019b). However, I use the term "perfect prison" here to emphasize the frequently high expectations associated with the introduction of new templates before efforts to implement the template, translating theory into practice, go awry.

firsts, bellwethers, and extraordinary cases (Rubin, 2015, 2019b), which are exactly the types of cases that reflect the ongoing effort to perfect the prison. I also draw on my own research as well as primary sources from the late eighteenth through mid-nineteenth century with which I am most familiar. To be clear, I do not seek to offer a carefully constructed comparative design, but rather a more inductive approach drawn from well-known cases of incredibly optimistic actors with high expectations for their version of prison.

From this analysis, I find three major conclusions that inform our answers to these questions. First, the desire to build the perfect prison has been with us since the prison's origin. However, over time, our vision of the perfect prison narrowed from the expansive, multifaceted visions with very high expectations common at the beginning to more specific visions with fewer goals and lower expectations. Second, our varied visions of the perfect prison have elements in common (especially recurring themes and goals), including the use of prisoner labour to defray maintenance expenses or achieve profit, the expectation that prisons should keep their prisoners alive and healthy and generally not mistreat them, a prison regime intended to rehabilitate prisoners to reduce crime, and a desire to control prisoners during their confinement to avoid misbehaviour, nuisances, violence, and escape. Finally, our perfect prisons also tend to fail in similar ways. These failures often result in a short-term acceptance of the prison's status quo as "good enough" and a recalibration of what commentators think the prison is capable of, which is often reflected in the new vision. I believe each of these findings has important implications for how we critically assess the desire to build or manage a new perfect prison and how we think about prisons more generally moving forward. I discuss each of these findings in turn and then I close by reflecting on their implications for current and future efforts to improve prisons.

Before proceeding, it is worth stating at the outset some caveats about the notion of the perfect prison. First, by perfect, I do not mean "flawless" (although certainly, that is the picture some accounts suggest), but a prison design (including architecture and regime) that seems to match our goals using the structures we believe are best. Like the perfect romantic partner, the perfect prison will have flaws, but they are perfectly

compatible with the dimensions that we value most. Second, criminal justice policies and practices are always fragmented across time and place, while attitudes will always vary substantially across groups and individuals (e.g. Goodman et al., 2017). Consequently, a particular "perfect prison" will not necessarily be everyone's choice. In what follows, I refer to specific prisons, states, or regions when possible to avoid overly generalizable statements that can be easily threatened by regional variation. More difficult to confront is the variation of opinions across and within groups of penal reformers, prison administrators and staff, politicians, and other commentators, as even apparent consensuses can be misleading (Goodman et al., 2017; Rubin & Phelps, 2017). Instead, I pre-emptively acknowledge that this is the case (even highly supported perfect prisons were not unanimously supported) while I try to be specific, where possible, about who made what case.

Finally, an especially tricky point: to what extent did supporters of the prisons I discuss actually believe them to be "perfect"? There are some commentators I discuss whom I suspect genuinely believed their exalted claims about a particular vision of the perfect prison; others, I strongly suspect, used exalted language to gain support for their preferred policy but had more realistic expectations that they did not express publicly. Few people who work in and around criminal justice are as naive as some of their claims sound if taken too literally. In that sense, as well, I do not mean for the concept of the perfect prison to be taken too literally, or as strongly as other commentators perhaps did intend in their uses when discussing the search for perfect criminal justice system components.[3] Instead, as we shall see, the concept of the perfect prison can become quite watered down, but that is also the point. Reformers at various times have reached for the stars and at other times they are satisfied by touching the ceiling; yet both what they are searching for and how they fail to achieve it have important things in common that, along with the process of watering down expectations, future reformers must take into account.

[3] See, for example, Langbein (1978), Fleming (1974), and Feeley (2018).

The Desire to Build the Perfect Prison at the Origin

While scholars debate where and when the prison emerged as we would recognize it today (see, e.g. Spierenburg, 1991), the general consensus places the American origin of prison in the 1780s and 1790s (Hirsch, 1992; McLennan, 2008; Meranze, 1996; Rubin, 2016, 2018). To understand the significance of this development, however, requires making a clear distinction between what are commonly known (within the United States) as jails and prisons.

Historically, most societies that used incarceration prior to the late eighteenth century used it for primarily administrative purposes: these facilities (called "jails", "gaols", or "county prisons" in the English-speaking world) held a mix of people including people awaiting trial, people awaiting their punishments, people who had already been punished but who still owed fees and fines, as well as debtors (and their families), vagrants, and sometimes even witnesses held over until trial (Rubin, in prep). Many European jurisdictions followed a dictate that incarceration could not be used as punishment (Peters, 1998). By contrast, the modern understanding of a prison as a place of punishment for people convicted of serious crimes emerged in the late eighteenth century. Some of the earliest, and certainly the most popular and influential, visions of the prison imagined a truly incredible (and novel) facility. These visions were some of the first versions of the perfect prison.

John Howard's Vision

John Howard's vision of the prison, elaborated in his *The State of the Prisons in England and Wales* (1777), was by far the most influential vision for the nascent United States. It also laid a foundation for a pattern that we will see repeatedly throughout prison history: Howard's vision stemmed from a critique of the existing carceral facilities (jails) and is thus a reactive vision, one that constructs his idea of perfection as the opposite of what existed or, more specifically, as a new facility that fixes the glaring problems of the old.

In his treatise, Howard related his own experiences managing a county jail and travelling to visit other county jails and "prisons" of Great Britain and some other countries. The treatise offered a detailed imagery of the horrific conditions in which so many people were held—variously milling about unregulated or weighted in place by heavy shackles. Howard wrote of insufficient and bad food and water that left prisoners sick or emaciated. He decried the cohabitation of different categories of prisoners (men and women, young and old, debtors and felons, the sane and insane, etc.), often left idle and to their own violent and vice-laden inclinations; Howard complained that those who entered jail left it more thoroughly entrenched in the criminal lifestyle. The most memorable parts of his treatise described the threat of disease (especially jail fever, now called typhus), which was exacerbated by overcrowding, stale air, poor ventilation, and exposed raw sewage in British jails and county prisons. The air in these jails was so foul that jailers themselves often would not enter them; after he visited these facilities, Howard's clothes and notebook would reek (Howard, 1777, 13). Poignantly, Howard reminded his readers of the "Black Assize", the 1577 court session at which everyone present (more than 300 people), "died within forty eight hours" after becoming infected by prisoners brought in for trial (Howard, 1777, 18). Contemporary jails were quite literally poisonous to society.

After condemning this state of affairs, Howard outlined his own vision of the perfect prison. This vision was designed to achieve what he saw as the most salient goals: namely, how to achieve morality, security, health, and economy within jails. Howard outlined a new, healthy, and safer design for jails—well-ventilated, regularly cleaned, and located in healthful locations—that separated prisoners by category (criminality, gender, illness, etc.) and that would be managed by a better class of jailer who would also follow specific protocols for ensuring the health, safety, and reformation of the prisoners (Howard, 1777, 42–77). Howard noted that, while these facilities would ensure "the most humane treatment of the prisoners", the inclusion of "such strict regulations in preventing all dissipation and riotous amusements" meant that "confinement in a prison, though it may cease to be destructive to health and morals, will not fail to be sufficiently irksome and disagreeable, especially to the idle and profligate" (Howard, 1777, 76–77). Thus, his perfect prison

balanced its responsibility to protect its prisoners' health and wellbeing with its responsibility to ensure the experience was not enjoyable.

Although Howard also drafted (with William Blackstone) Britain's Penitentiary Act of 1779, calling for the creation of state-run prisons and the widespread replacement of capital punishment with incarceration, England failed to see significant change at the national level until a half-century later. However, Howard's ideas were tremendously influential in creating the first generation of county-level "penitentiary houses" in the 1770s on (Ignatieff, 1978, 96–109). His ideas were even more influential in the new United States where they formed the basis of the first major reforms that led to the most popular model of prison (Meranze, 1996; Rubin, 2018).

Benjamin Rush's Vision

As in England, concerned Americans began confronting decrepit, overcrowded, dingy, and disease-infested jails—jails that were becoming more heavily relied upon as capital and corporal punishments were increasingly criticized and, in some cases, written out of new penal codes passed in the Revolution's wake (Hirsch, 1992; Meranze, 1996; Rubin, 2016). Americans were strongly influenced by John Howard's treatise and ideas, but they also added their own spin. Among these refurbished visions of the perfect prison was Benjamin Rush's influential vision presented in 1787 at the Society for Promoting Political Enquiries:

> Let a large house be erected in a convenient part of the state. Let it be divided into a number of apartments, reserving one large room for public worship. Let cells be provided for the solitary confinement of such persons as are of a refractory temper. Let the house be supplied with the materials, and the instruments for carrying on such manufactures as can be conducted with the least instruction, or previous knowledge. Let a garden adjoin this house, in which the culprits may occasionally work, and walk. This spot will have a beneficial effect not only upon health, but morals, for it will lead them to a familiarity with those pure and natural objects which are calculated to renew the connection of fallen man with his creator. (Rush, 1798, 150)

Labour and solitary reflection in a sanitary setting would aid reformation and individual improvement. Additionally, as jail keepers were notoriously corrupt, inept, unsavoury characters, the new facility, Rush prompted, would be run by virtuous, upstanding gentlemen. And since jails were removed from the public eye and their keepers had full autonomy over their management, the new facility, as Rush imagined it, would be open "at all times to the legislature, or courts of the state" for their inspection (Rush, 1798, 150–151).

Like Howard, whose ideas he drew on, Rush's vision was again reactive: the elements he emphasized were the mirror opposites of the very elements deemed failures at the time. Indeed, even its name should signal how Rush's vision differed from what came before: "Let the name of this house convey an idea of its benevolent and salutary design, but let it by no means be called a prison, or by any other name that is associated with what is infamous in the opinion of mankind" (Rush, 1798, 150). The "prison" (really, jail) as it then existed desperately needed a new model.

But Rush's vision also wove together another strand that reappears throughout prison history: the idea of a self-actuating prison, or a prison whose very existence ensures certain goals would be achieved. In Rush's case, this goal was a gothic version of general deterrence:

> I cannot conceive any thing more calculated to diffuse terror through a community, and thereby to prevent crimes.... Children will press upon the evening fire in listening to the tales that will be spread from this abode of misery. Superstition will add to its horrors: and romance will find in it ample materials for fiction, which cannot fail of increasing the terror of its punishments. (Rush, 1798, 151–152)

Essentially, within the prison, prisoners would be cared for, healthy, occupied, and undergoing reformation, but the prospect of the prison would be so terrifying that it would ensure others would avoid crime to avoid the possibility of being so interred.

In introducing this strand, Rush reflected this period's optimism: it was not just that reformers were working to create carceral facilities that do not kill or make ill their inmates and that prevent prisoners from preying on one another. These prisons would go further and accomplish

great things like reformation. But they were even more powerful: simply by existing, they would work. Simply by removing criminals from their bad environments and holding them in carefully designed facilities, reformation was almost guaranteed—just as guaranteed as the fact that others beyond the prison would be deterred.

Jeremy Bentham's Vision

Jeremy Bentham's new design, the Panopticon (1791), was even more optimistic.[4] Bentham promoted an architectural and management plan for a prison, jail, or workhouse, in which prisoners' cells were housed within an outer ring and faced inward to a central guard tower. Through a manipulation of lighting, blinds, and glass, the guard could see the prisoners but could not be seen himself. Bentham argued that this design would require prisoners to always be on their best behaviour lest they be caught by the guard, who may or may not be watching. It was the height of efficiency, moreover, because it only required one guard, rather than the dozens that became common. Not only would this be an efficient prison, but it would also be applicable to "any Sort of Establishment, in which Persons of any Description are to be kept under Inspection" including factories, hospitals, and schools (Bentham, 1791, i).

Bentham's vision represents the apotheosis of the self-actuating prison, one whose very design ensures the goals the prison is designed to achieve. Prisoners would automatically improve—as Michel Foucault (1977) later explained, they would be inculcated with self-discipline after practising such behaviour under the on-going surveillance of the Panopticon. Indeed, the salesman that he was,[5] Bentham promised a lot: "Morals reformed—health preserved—industry invigorated—instruction diffused—public burthens lightened—Economy seated as it were upon a rock—the Gordian knot of the Poor-Laws not cut but untied—all by a simple idea in Architecture!" (Bentham, 1791, iii). The perfect prison indeed.

[4] The design was actually his brother's design (Bentham, 1791, 2), but Bentham promoted and popularized it.
[5] Bentham offered his own services for running this prison.

The First Prisons

These three are the most famous visions of the prison that (mostly) preceded the actual first prisons of this era. In the United States, the first prisons came in two waves: the first generation spanned roughly 1785–1821 while the second generation spanned roughly 1816–1865. To what extent were these and other prisons shaped by Howard, Rush, and Bentham? Bentham had limited impact on British and European prison design at the time (one second-generation prison in the United States was apparently built on his model), and many commentators dismissed him as something of an entrepreneurial crackpot. But Bentham had an outsized impact in subsequent history, standing in as a synecdoche for much of the ideation and optimism about prison reform at the time (e.g. Foucault, 1977), but also having a direct impact on prison design in later eras (such as the famous Stateville Prison in Illinois). Rush's words helped motivate the prison reform movement that led to the construction of the first-generation prisons, but his ideas would be less impactful on their actual design than on certain second-generation prisons (Rubin, 2021). However, Howard's ideas would almost immediately be enshrined in law across U.S. states.

By 1794, the United States had three distinct working models of prisons in Massachusetts, Connecticut, and Pennsylvania, the latter of which—Walnut Street Prison—was the most influential (Rubin, 2018, 2021). It was also almost entirely modelled on Howard's plan and strongly lobbied for by Rush. Under this "American system" or "penitentiary plan", the late colonial era Walnut Street Jail in Philadelphia was reformed to separate inmates by status (convicted criminals separated from non-criminals and accused criminals awaiting conviction), by gender, and to some extent by age or perceived level of criminality. Prisoners were held in dormitories that were cleaned regularly—so carefully that several bouts of yellow fever were held at bay while they swept through the city. Prisoners were put to work so that they could help offset the costs of their maintenance or even generate revenue for the state. Finally, the prison's management shifted: the jailer was no longer paid by fees and bribes from the incarcerated but by the state, and he was supervised (and eventually replaced) by a group of upstanding citizen

"inspectors" who also officially controlled the prison's policy (Meranze, 1996; Rubin, 2021). This model spread across the country, becoming the basis of most first-generation prisons (Rubin, 2021, n.d.).

Importantly for my purposes, Walnut Street and its penitentiary plan was a highly lauded facility. Within its first decade, multiple commentators devoted entire pamphlets to singing its praises and proselytizing the importance of adopting it elsewhere (Lownes, 1793; Rochefoucauld-Liancourt, 1796; Turnbull, 1797). According to these commentators, Walnut Street had successfully replaced a disorderly facility with a perfectly orderly facility, turned a profit and enabled prisoners to make money to support their families at home, virtually eradicated disease within the prison, and apparently stopped recidivism in all but a few cases—and was even responsible for the apparent downturn in crime in Philadelphia. From their perspective, Walnut Street was truly a perfect prison; many other states were sufficiently convinced and copied its model.

From visions of prison expressed by early reformers and penal theorists to the actual bricks-and-mortar instantiation of these designs, the idea that we could construct a perfect prison has been with us since the beginning. As we shall see, even after these visions came to life and then proved disappointing, it is a belief that we have repeatedly returned to. As this tendency moved through prison history, it repeated some of the themes established in these very first visions: the reactionary vision designed to fix the flaws of existing facilities and the vision of the prison as self-actuating such that something about the prison's nature or design would ensure that it would achieve whatever goal was assigned to it. In each case, reformers would be disappointed.

Responding to Failure: Recurring Efforts to Redesign the Prison

Almost as soon as these first prisons were established, they began to fail, visibly and dramatically (McLennan, 2008; Meranze, 1996; Rubin, 2015, 2021). Beginning in the late 1810s, the second generation of prisons (generally referred to as modern prisons or Jacksonian-era

prisons) were explicitly designed in response to the first-generation prisons' flaws. And thus continued the recurring history of the prison's failure and reinvention as a reactive vision designed to fix the failures. In this section, we see that the impulse to create the perfect prison was not simply with us *at* the origin of the prison as we would recognize it today, but *since* that origin: the United States has a lengthy, ongoing history of trying to construct the perfect prison.

Common Elements of the Perfect Prisons

In one sense, U.S. prison history offers a wide range of visions for the perfect prison. From Eastern State Penitentiary (f. 1829) that kept prisoners in round-the-clock solitary confinement along with in-cell labour, education, and visitation (Rubin, 2021) to Alcatraz (1934–1963), the ostensibly escape-proof U.S. Penitentiary in San Francisco Bay (Ward, 2010). From Auburn State Prison (f. 1821), in which prisoners worked silently in large factory-like rooms during the day and marched to solitary cells at night, to the much larger Big House prisons, designed to contain thousands of prisoners, that continued the Auburn System in the 1920s and 1930s. From plantation-style prisons (f. 1900s–1910s) that offered a legal continuation of slavery (Oshinsky, 1997) to the correctional institutions that used psychotherapy, education, and vocational training to rehabilitate criminals (Cummins, 1994). From the brief experiment in the 1910s with the Prisoner Welfare League at New York's Sing Sing prison, where prisoners were invited to run the prison, at least in theory (McLennan, 2008; Rothman, 1980) to the contemporary "supermax" prison that holds prisoners in solitary confinement to incapacitate the allegedly "worst of the worst" (Reiter, 2016). These model prisons or prison regimes are some of the best known, but they are not exceptions. They are different versions of the perfect prison, according to people in different times and different places. As much as these versions have varied, however, they share some common themes or elements—not all at the same time or in the same model, but as recurrences that appear as part of different "assemblages" (Maurutto & Hannah-Moffat, 2006). As different generations imagine the latest perfect prison, they seemingly

draw from the same box of tools and goals over time. This subsection reviews the most common recurring elements across these models.

The Desire for Prisons That Profit (and Prisoners Who Work)

The first element is the desire for prisons that profit or, at the very least, defray their own expenses, especially through prisoners' labour. Profitable prisoner labour was a major factor in U.S. prisons until the Second World War (McLennan, 2008). Indeed, this element was embedded in the penitentiary system at Walnut Street Prison and was one of the highly lauded points identified by its proselytizers (Rubin, n.d.).

Labour was also foundational to the modern prisons of the 1820s, including the Pennsylvania System showcased at Eastern State Penitentiary (Pennsylvania) as well as the Auburn System pioneered at the Auburn State Prison (New York). In these prisons, as at Walnut Street, labour was viewed as having a reformative element to it, in which prisoners would learn industry, discipline, and good habits (Meranze, 1996); however, proponents also understood labour as potentially profitable to the state as incarcerated workers could pay for their upkeep (at the very least) and, perhaps, more. In fact, the perceived profitability of the Auburn System-style prisons was likely the most important factor behind their rapid dominance over the Pennsylvania System, which was ultimately only adopted (temporarily) by three other prisons, while every other U.S. prison during this period adopted the Auburn System (McLennan, 2008; Rubin, 2015, 2021). Despite the lore, however, states rarely profited from their prisons in the nineteenth century (McLennan, 2008; Rothman, 1971). Even so, belief that prisoner labour could be profitable persisted. This commitment to profitable labour recurred in a later iteration of the Auburn System in the Big House model of prisons that dominated in the early twentieth century (Bright, 1996).

Using prisoner labour to avoid expenses associated with prisoners' upkeep was also a significant factor behind various iterations of post-Civil War Southern carcerality. Prisoners were initially leased out to entrepreneurs who paid the state to use prisoner labour. Later, prisoners

in chain gangs made state roads. Finally, they worked in the fields of plantation-style prisons (LeFlouria, 2015; Lichtenstein, 1996; Oshinsky, 1997).

While labour has not entirely disappeared from prisons today (Gibson-Light, 2019), a variety of legal and then economic changes made prisoner labour unprofitable and impractical in many states (McLennan, 2008). Instead, we see the desire for mitigating the prison's costs (especially to recoup bloated prison systems' fiscal losses), or for profiting from prisons, in specific prison policies that charge prisoners and, in some cases, their families for basic services (e.g. phone calls, basic toiletries, sending care packages) (e.g. Aviram, 2015; Lynch, 2010). Concern about keeping prison costs low, recurring throughout history (Rubin, 2019a), persists even while states continue to spend inordinate amounts of money on prisons. The desire to reduce prison costs has never been an uncomplicated goal.

The Desire for Prisons That Keep Prisoners Healthy (Generally, Humanitarian Prisons)

A second recurring element is the desire for prisons to keep their prisoners healthy, or more generally the desire for humanitarian prisons. As we have seen, this was a major motivation in Howard's proposal, as well as an important part of Rush and Bentham's plans. Unsurprisingly, it was also a major component of Walnut Street Prison's penitentiary system. Walnut Street's hygienic routines, and its initially low rate of disease and death, were detailed in commentators' descriptions (Lownes, 1793; Rochefoucauld-Liancourt, 1796; Turnbull, 1797).

Humanitarianism was an even bigger factor in the second-generation or modern prisons of the 1820s after disease and death posed significant challenges to new models. New York and Maine's early experiments with complete solitary confinement, in which prisoners spent the duration of their prison sentences in tiny cells with little room for movement and little-to-no mental stimulation, led to disasters: numerous prisoners suffered from muscle atrophy, disease, mental decompensation, self-mutilation, suicide attempts, and death. At Pennsylvania's Western

State Penitentiary, prison administrators avoided such outcomes by abandoning their plans for total solitary confinement, allowing prisoners to leave their solitary cells and exercise, talk, and work in the prison yard.

Penal reformers, legislators, and other commentators trying to design new prison regimes questioned whether long-term confinement was humane or even possible (or if it would always result in mental illness, disease, and death). Ultimately, they believed it was possible—with the proper design. The new Auburn System kept its reliance on solitary confinement, but only at night; to avoid the worst features of solitary confinement, prisoners left their cells during the day for congregate but silent work in large factory-like settings. The revised Pennsylvania System also kept its use of solitary confinement, but worked to alleviate possible harms—and the prospect of torturing its prisoners by depriving them of social contact—by giving them work within their cells and visits from prison staff and approved guests (local penal reformers) who would instruct prisoners in their work, education, and morality or religion. The relative healthfulness of each approach was thoroughly discussed throughout the nineteenth century's first half and was another contributor to the unpopularity of the Pennsylvania System, which was viewed as incapable of avoiding harm to prisoners' mental and physical health and too close to torture (Rubin, 2021).

Surprisingly, many Southern punishments, including chain gangs, were touted as healthy and good for prisoners. Supporters claimed it was beneficial and healthy for prisoners to spend their days in the fresh air, working in sunlight rather than cooped up in stuffy, fume-filled factories as they were in the North. It was an apparent point of pride for many defenders of Southern punishments otherwise decried as racist and cruel (Lichtenstein, 1996).

As with profit and cutting costs, managing a sufficiently humane prison has never been uncomplicated. While the Auburn System was viewed as the more humane of the two available options, commentators often dismissed its use of whipping and rapidly normalized the rate at which prisoners fell ill, became insane, or died in prison (Rubin, 2021). More obviously, Southern punishments found various ways of replicating slavery—often with a higher mortality rate, earning some of these practices the title "worse than slavery" (cited in Lichtenstein, 1996). Over the

last half-century or more, courts have also intervened when mortality rates got too large or to insist that prisons avoid torturing their prisoners—efforts that prison and state officials have sometimes fought (e.g. Feeley & Rubin, 2000; Lynch, 2010; Schoenfeld, 2018; Simon, 2014).

The Desire for Prisons That Reform

Another common element has been prisons that "fix" their prisoners through various incarnations of rehabilitation. Indeed, rehabilitation as a concept is notable for its evolution over time and its ability to persist, even during otherwise punitive eras that outwardly reject rehabilitation as unworthy (Goodman, 2012). In early prisons like Walnut Street, Auburn, and Eastern State, rehabilitation—then referred to as reformation—entailed physical or social solitude to encourage prisoners to reflect on their wrongs and what led them to prison, labour to instil discipline, and a combination of vocational training, religious exposure, and education to make it easier for prisoners to avoid crime by earning gainful employment after their incarceration. For the reformers and administrators who encouraged these prison regimes, the perfect prison prepared prisoners for a life without crime—a life in which they no longer needed to rely on crime to survive—and that would transform them into "honest, industrious, and useful" citizens.[6]

During the Progressive Era, rehabilitation took a different shape. At New York's Sing Sing Prison in the 1910s, the prisoners formed, under the warden's encouragement, a Mutual Welfare League in which the prisoners governed themselves. Representatives were elected, various duties were assigned, and prisoners could make and enforce their own rules (and determine punishments). The League was perhaps the most concrete version of a larger effort among Progressive reformers to make prisons more like communities; they believed that prisons were inherently harmful and that it was short-sighted to keep prisoners in facilities so different from the community to which they would eventually return (e.g. Rothman, 1980). One version of this era's perfect prison—there

[6] This was a common phrase at the time. See Rubin (2021, 46, 51, 204) for some examples. See also Meranze (1996).

were several, in fact—replicated many elements of being part of a community in order to prepare prisoners for the reality to which they would return.

Perhaps the most elaborate versions of rehabilitative prisons occurred in the mid-twentieth-century correctional institutions, especially those in California. Given institutional names that did not sound like prisons (e.g. California Institute for Men, California Men's Colony, California Correctional Center) and built in bucolic settings, these prisons combined various forms of psychotherapy (including group theory and bibliotherapy) under the assumption that prisoners were abnormal and deviant, which "treatment" could cure. Prisoners would spend unspecified periods (ranges of years) in prison; the exact duration was however long it took to cure the prisoner of their criminality (e.g. Cummins, 1994; Kruttschnitt & Gartner, 2005). The perfect prison in this era was partially modelled on a hospital and governed by medical wisdom.

As with profit and humanity, rehabilitation was also a complicated goal in practice. It is most important to acknowledge that, throughout U.S. prison history, extensive physical and mental torture as well as civil rights violations were justified in the name of rehabilitation (e.g. Berger, 2014; Cummins, 1994; Meranze, 1996; Rubin, 2021). Racist and sexist ideals and beliefs about what was "normal" shaped perceptions about who could be rehabilitated (e.g. Berger, 2014; Cummins, 1994; Kruttschnitt & Gartner, 2005; Rafter, 1985; Rubin, 2021). The rehabilitative prison thus did not necessarily mean a softer, kinder, or better prison. Additionally, many staff and administrators resisted rehabilitative policies, even at the height of the so-called rehabilitative era (e.g. Goodman et al., 2015; Jacobs, 1977; Lynch, 2010). Indeed, the extent to which liberals and conservatives, prisoners and prison administrators, alike condemned rehabilitation in the 1970s is a testament to its difficulty to pin down, implement, and satisfy (Allen, 1981).

The Desire for Total Control

A final recurring element throughout prison history has been the basic mandate of confining prisoners and generally ensuring they do not escape

or injure staff and fellow prisoners. Over time, we see this theme manifest in escalating attempts at the total control of prisoners. Prisons have used various architectural efforts to reduce the prevalence of escape. From nineteenth-century prisons' giant stone walls to the miles of open fields surrounding plantation-style prisons where escaped prisoners can be chased easily with dogs or simply die trying to escape. From the island fortress of Alcatraz to late-twentieth-century prisons' barbed-wire-capped cyclone fences.

Within prisons as well, administrators have sought to control the movement of prisoners more tightly through solitary confinement in various instantiations (Rubin & Reiter, 2018). Solitary confinement was a staple at many prisons throughout the nineteenth century, from the short-lived total solitary confinement used at Auburn State Prison to its use only at night under the Auburn System, to the round-the-clock version under the Pennsylvania System (McLennan, 2008; Rubin, 2021). Although solitary confinement never entirely went away, perennially used to punish and control the more refractory prisoners even in more open regimes (Rubin & Reiter, 2018), more significant uses of solitary confinement returned in the twentieth century's second half. When Alcatraz closed in 1963, its prisoners were moved to the federal prison in Marion, Illinois. Both Alcatraz and Marion were said to house the worst, most dangerous prisoners in the federal system, which often meant the most prone to escape attempts. To avoid such escapes, Marion's prisoners spent their time in solitary confinement (Ward & Werlich, 2003). In the 1970s, states like California also began "lockdown" measures—effectively instituting solitary confinement—for their most troublesome (especially political) prisoners. But it wasn't until the 1980s when Arizona and then California created special units designed for solitary confinement variously called supermax prisons, secure housing units, secure management units, or other names (Lynch, 2010; Reiter, 2016). In the most sophisticated versions, prisoners were moved to and from their cells by electronic switches and monitored on closed-circuit video by guards (Reiter, 2016). In these versions, the perfect prison is one that perfectly controls its prisoners and prevents unwanted behaviour, from escape to political rabble-rousing, and from violence to obnoxious nuisances.

This fantasy of perfect control has always failed (Rubin & Reiter, 2018). Nineteenth-century prisoners often found ways to violate the prison's rules or even escape, often with the help of the prison staff or (unwittingly) the prison regime itself (McLennan, 2008; Rubin, 2017b). In many facilities that ostensibly relied on solitary confinement and other forms of control like the rule of silence, from Eastern State Penitentiary to Auburn State Prison to Alcatraz, those policies were frequently violated by prison staff and administrators themselves such that prisoners were given more freedom and chances to socialize than publicly stated (McLennan, 2008; Rubin, 2021; Ward, 2010). Even in supermax prisons, there is great variability in the actual conditions in which prisoners are held—in some facilities prisoners are entirely closed off while others allow prisoners to communicate with one another; notably, prisoners in one of California's supermaxes helped organize a state-wide prison protest (Reiter, 2014). More generally, prisoners continue to find ways to use whatever is at their disposal, even their bodies, to create nuisances for the prison staff (Reiter, 2016; Rhodes, 2004).

The Trajectory of the Perfect Prison

It is worth highlighting that notions of the perfect prison began fairly expansively and then contracted over time. The first highly promoted prison, Walnut Street Prison, was touted as a crime reducing, financially self-sufficient, virtually disease-free, orderly prison—in direct contrast to the (perceived-to-be) crime-causing, corrupt, disease-infested, chaotic colonial jails. This prison, and those modelled on it, failed soon after these claims were first issued. Their most important failure was their internal order: around the country, prisoners escaped, rioted, set the prison workshops on fire, and the prisons themselves were once again believed to be responsible for a crime wave. Experience showed reformers the limits of their abilities. Subsequent prisons promised less. Invariably, one or two concerns would dominate the new vision of perfection—especially control, self-sustaining, or prisoner reformation—while other concerns might fade into the background or disappear entirely from the next iteration (only to reappear in a generation or more). While each

new perfect prison was associated with renewed optimism about what the reimagined prison could accomplish, the scope of what it could accomplish was less expansive than in the earliest versions.

To some extent, this reactive narrowing itself created feedback loops that kept this tendency going. As each new perfect prison was designed to achieve a newly dominant concern (often a past version's failure), other concerns were overlooked, creating new problems once the model was implemented. For example, in the quest for perfect order, prison designers have often turned to solitary confinement. As we have seen, solitary is a recurring technique throughout U.S. prison history and is particularly popular after periods of internal chaos, disorder, and violence (Rubin & Reiter, 2018). It was what prison reformers promoted after the first-generation prisons imploded and what prison administrators turned to in the wake of the prison riots and prisoner–staff violence of the 1960s and 70s. But in the quest for order, prisoner health and wellbeing was overlooked. The first experiments with solitary confinement had to be terminated because prisoners were physically and mentally unwell, experiencing muscle atrophy, disease, insanity, suicide attempts, and death. In the 1980s and 1990s, the growing use of solitary confinement led to multiple court cases challenging conditions as tortuous and unconstitutional; while each court case provided a chance to redesign prisons' use of solitary confinement, mental and physical health problems have persisted—and expanded—as long-term solitary confinement became institutionalized in contemporary supermax prisons (Reiter, 2016). The recurring way in which new concerns create blind spots for previous concerns that become problems (yet again) speaks to these models' reactivity, facilitating the ongoing search for another perfect prison. This reactivity also helps explain the same elements' reappearance over time.

Reflections

I now return to the questions I began with: "First, what are the different ways in which the 'perfect' (or ideal) prison has been imagined or what are different visions of the 'perfect' prison?" As we have seen, these visions throughout history run the gamut. While these diverse

visions of the perfect prison tell us much about the concerns of the (most influential) penal actors of their time and place, it is striking how much these disparate visions have in common: profitable or at least cost-cutting prison regimes, especially by requiring prisoners to labour; regimes designed to keep their prisoners healthy and treat them humanely; prisons that rehabilitate their prisoners (across a variety of rehabilitative techniques); and prisons that maintain control over their prisoners, especially through solitary confinement. "Second, what does this history tell us about prison development as well as ongoing and future efforts to improve the prison?" This chapter draws our attention to the recurring nature of the quest for the perfect prison, as well as the way in which that vision narrows over time as our expectations lower.

This tendency invites further questions about why the quest for the perfect prison repeatedly fails (such that we find ourselves looking for yet another version of the perfect prison) as well as what explains our ongoing optimism that we can, in fact, perfect prison? Ultimately, it encourages us to question whether the concept of the perfect prison is worthwhile. I reflect on these additional questions below.

On Failure

Why did these perfect prisons fail? It bears acknowledging that one could say they did not. After all, many of these prisons continued to function for decades and some are still in operation. For decades or more, they succeeded at the bare minimum of keeping most of their prisoners alive and contained. But I refer to these prisons and their models as failures both because that is how reformers and administrators always ultimately perceived them and because none lived up to their promises. Instead, at best, most of these facilities, and the others they influenced, could claim to be "good enough".[7]

Why was good enough the best outcome? Translating an idea into practice is never easy and always leaves something to be desired, as I outlined above; however, U.S. prisons throughout history have also

[7] Despite widespread criticism of U.S. prisons, in many ways they are just that—good enough, at least on certain measures by current standards (Gaes et al., 2004).

faced a recurring set of challenges that further jeopardized the quest to implement the perfect prison. I have already mentioned prisoner misconduct (often aided by staff misconduct): through simple rule violations to full-scale protests and riots, prisoners have helped to destabilize and delegitimize various prison regimes (e.g. McLennan, 2008; Rubin, 2017a; Thompson, 2016). Perhaps more surprising is the role of official misconduct: some of the most ostensibly committed reformers-turned-administrators have been some of the most nefarious in this regard. Scandals around embezzling or particularly heinous torture were somewhat common in the nineteenth century. Indeed, some of the most highly anticipated prisons failed because the well-respected penal actors in charge continued to engage in traditional (publicly discredited) behaviour and corruption (e.g. Pisciotta, 1994; Rubin, 2021).

There have also been challenges that can continue to plague reforms today—and will in the future. One of these challenges includes the difficulty of translating ideas into practice within a penal organizational setting. Penal organizations suffer from multiple competing and often conflicting goals; administrators necessarily prioritize some elements at the expense of others (Rubin, 2019a). For example, an emphasis on ensuring a profitable prison often hurts the prison's humanitarian goals. Another challenge involves what may be considered the "one-shot" disadvantage: in many cases, the original template for a prison—frequently an expensive and time-consuming endeavour—is effectively tested on a single facility. Necessarily, given the nature of many prisons, especially at the high end of the control spectrum (large, expensive buildings), small mistakes in planning or construction are not apparent until the prison is filled with its human population and the regime implemented. By that time, the time and expense of the undertaking have already been lost, and stakeholders are often unwilling or unable to expend more resources; any repairs they can make require yet more time and money. Finally, strategies for the perfect prison tend to be reactive, as I have highlighted. Moments of crisis trigger new calls for the perfect prison— often designed in such a way that whatever flaw existed in the previous system is over-emphasized in the next iteration with insufficient regard

to other common concerns.[8] Together, these factors (among others) have been responsible for each failed perfect prison.[9]

On Belief

Why do we (or people throughout history) believe we can perfect the prison—or, stated more accurately, that we can fix the prison's severe, possibly endemic problems by rejiggering its elements into something different and more effective? One obvious answer is that no one has ever succeeded in building the perfect prison, so we keep trying. But then the question is why do we persistently believe perfection—a prison that needs no more reforms and that we can live with, without too much guilt or compromise—is possible or worthwhile, given its difficulty. I think one answer to this question must recognize the extremely high stakes involved: at various points of significant reform, various penal actors (reformers, administrators, politicians) were facing perceived or real increases in crime, prisoners' illness and death, inordinate costs, and matters of justice, variously defined. Of course they—and now we—want to get it right (and have strong views about what is right)! Or perhaps just as the frustration humans face with impending death breeds myths about sources of longevity and immortality, so too do reformers, faced with failed and failing carceral facilities, believe that a perfect prison exists out there, somewhere, if only we were creative enough to imagine the proper formula to bring it into being.

Elsewhere, however, I have argued that the recurring impulse to reimagine the prison—instead of reimagining a criminal justice system that does not have a prison at its centre—is a consequence of how prisons emerged in the late eighteenth and early nineteenth centuries. I argue that our faith in our ability to fix broken prisons became institutionalized in reformers' efforts to build the first prisons. As we have

[8] It is worth realizing that the prison is far from unique in this regard. The same analysis can be conducted on capital punishment, supervision, and monetary sanctions with similar findings of a recurring belief in our ability to design better penal institutions despite ongoing histories of failure.
[9] For a similar list of reasons why various court reforms have failed, see Feeley (1983).

seen, in both the United States and England, the first state prisons were intended to replace the decrepit, disease-infested, overcrowded, corrupt, and dangerous early modern county jails that had been the primary source of incarceration in each country to date. Indeed, in the United States, every subsequent model of prison was designed to address the failures of the model that came before it. Each time, the model or models that came before would be the negative inspiration—the new models of prison would be designed to fix however the previous prisons had failed. Quite simply, we have developed a mindset, with us since the beginning, that we can tweak the prison—improve its staff, its implementation, or its design—rather than jettisoning the concept of keeping human beings in long-term captivity. Collectively, we never truly reconciled with the idea that—maybe—prisons can't be fixed (Rubin, in prep).[10] Even those who believe the perfect prison can never be attained recognize that there is still widespread support for retaining prisons, so we might as well make them as good as possible; in that way, their perfect prison becomes the model that does the least harm.

Moving Forward

The history that I have summarized generates my scepticism about efforts to reimagine or redesign prisons so they can be places that inspire wellbeing because this vision is just another instantiation of how we might imagine the perfect prison—something we have done over and over again with, at best, little and short-lived success. However, I am far from the only scholar to have this jaded reaction and there are other reasons, beyond the lessons from history, to be sceptical (see especially the other contributions in this volume).

Over the last decade or so, scholars have demonstrated the ways in which even the most benevolently designed prisons have unintended and unexpected manifestations of the classic "pains of imprisonment" (Hancock & Jewkes, 2011; Shammas, 2014; Sykes, 1958) or generally

[10] This is not to say that abolitionists throughout history have not made this argument. Rather, this argument has never been taken seriously on a large scale, even while abolitionism occasionally makes its way into the mainstream as has occurred over the last several years.

dissatisfaction among incarcerated people and staff (Augustine et al., 2021). Scholars have also warned about the extent to which seemingly benevolent reforms become "symbolic" or little more than "window dressing" (Augustine et al., 2021; Jewkes & Moran, 2015). Additionally, a number of scholars have critically analysed the highly praised Scandinavian prisons and penal systems. In response to the myth of Scandinavian exceptionalism (generally described as an admirable humanitarian status), ample research has illustrated that these prisons or the systems in which they sit are racist, harmful, and otherwise problematic (Barker, 2013; Dullum & Ugelvik, 2012; Reiter et al., 2018). While in many ways, these facilities are still far better than their U.S. counterparts, that superiority is part of what makes them so difficult to criticize: the people within them report that the expectation that these prisons are better facilities almost makes it worse when they do experience traditional pains (Crewe & Ievins, 2021). Even these perfect prisons are, in fact, far from it.

So we are left with the question of what to do. And what to do with these lessons of the past. While past failures should not discredit continued efforts for improvement, such efforts should not proceed without learning from our repeated mistakes (see also Hancock & Jewkes, 2011). At the most basic level, this may require adjusting our expectations of how we define success and failure. Our inability to recognize the limitations of our penal institutions—carceral facilities especially—may be the single most important reason for our recurring failures. We must let go of the idea of the perfect prison and embrace the imperfect prison.

The imperfect prison is the prison that harms and is painful, the prison that will fail often to achieve its goals, and the prison that cannot be reformed to the point where it will eliminate any of its inherent challenges. Embracing the imperfect prison means recognizing that reforms will fail to achieve their objectives; this should be understood as a given, rather than necessarily the result of a bad or flawed reform (although there will be flawed reforms, too). By recognizing the limitations of the prison as a complicated organization that is often incompatible with the goals assigned to it, reformers and administrators can seek out the prisons' organizational aspects that continue to work against reforms

(Rubin, 2019a) rather than abandoning the latest reform attempt as a failure and moving on to the next ill-fated, overly optimistic plan for the perfect prison. This shift in how we view prisons, and how we reform them, would show that we have finally learned from our history.

References

Allen, F. (1981). *The decline of the rehabilitative ideal: Penal policy and social purpose.* Yale University Press.

Augustine, D., Barragan, M., Chesnut, K., Pifer, N. A., Reiter, K., & Strong, J. D. (2021). Window dressing: Possibilities and limitations of incremental changes in solitary confinement. *Health & Justice, 9*(1), 9–21.

Aviram, H. (2015). *Cheap on crime: Recession-era politics and the transformation of American punishment.* UC Press.

Barker, V. (2013). Nordic exceptionalism revisited: Explaining the paradox of a Janus-faced penal regime. *Theoretical Criminology, 17*(1), 5–25.

Bentham, J. (1791). *Panopticon: Or the inspection house.* Thomas Byrne.

Berger, D. (2014). *Captive nation: Black prison organizing in the civil rights era.* University of North Carolina Press.

Bright, C. (1996). *The powers that punish: Prison and politics in the era of the "Big House", 1920–1955.* University of Michigan Press.

Crewe, B., & Ievins, A. (2021). 'Tightness', recognition and penal power. *Punishment & Society, 23*(1), 47–68.

Cummins, E. (1994). *The rise and fall of California's radical prison movement.* Stanford University Press.

Dullum, J., & Ugelvik, T. (2012). *Penal exceptionalism?: Nordic prison policy and practice.* Routledge.

Feeley, M. M. (1983). *Court reform on trial: Why simple solutions fail.* Basic Books.

Feeley, M. M. (2018). How to think about criminal court reform. *Boston University Law Review, 98,* 673.

Feeley, M., & Rubin, E. (2000). *Judicial policy making and the modern state: How the courts reformed America's prisons.* Cambridge University Press.

Fleming, M. (1974). The price of perfect justice. *Judicature, 58,* 340.

Foucault, M. (1977). *Discipline and punish: The birth of the prison.* Vintage Books.
Gaes, G. G., Camp, S. D., Camp, S. D., Saylor, W. G., & Nelson, J. B. (2004). *Measuring prison performance: Government privatization and accountability* (Vol. 2). Rowman Altamira.
Gibson-Light, M. (2019). *The prison as market: How penal labor systems reproduce inequality* [PhD thesis]. University of Arizona.
Goodman, P. (2012). "Another second chance": Rethinking rehabilitation through the lens of California's prison fire camps. *Social Problems, 59*(4), 437–458.
Goodman, P., Page, J., & Phelps, M. (2015). The long struggle: An agonistic perspective on penal development. *Theoretical Criminology, 19*(3), 315–335.
Goodman, P., Page, J., & Phelps, M. (2017). *Breaking the pendulum: The long struggle over criminal justice.* Oxford University Press.
Hancock, P., & Jewkes, Y. (2011). Architectures of incarceration: The spatial pains of imprisonment. *Punishment & Society, 13*(5), 611–629.
Hirsch, A. J. (1992). *The rise of the penitentiary: Prisons and punishment in early America.* Yale University Press.
Howard, J. (1777). *The state of the prisons in England and Wales, with preliminary observations, and an account of some foreign prisons.* William Eyres.
Ignatieff, M. (1978). *A just measure of pain: The penitentiary in the industrial revolution, 1750–1850.* Pantheon Books.
Jacobs, J. B. (1977). *Stateville: The penitentiary in mass society.* University of Chicago Press.
Jewkes, Y. (2018). Just design: Healthy prisons and the architecture of hope. *Australian & New Zealand Journal of Criminology, 51*(3), 319–338.
Jewkes, Y., & Moran, D. (2015). The paradox of the 'green' prison: Sustaining the environment or sustaining the penal complex? *Theoretical Criminology, 19*(4), 451–469.
Kruttschnitt, C., & Gartner, R. (2005). *Marking time in the golden state: Women's imprisonment in California.* Cambridge University Press.
Langbein, J. H. (1978). Torture and plea bargaining. *The University of Chicago Law Review, 46*(1), 3–22.
LeFlouria, T. L. (2015). *Chained in silence: Black women and convict labor in the New South.* University of North Carolina Press.
Lichtenstein, A. (1996). *Twice the work of free labor: The political economy of convict labor in the New South.* Verso.

Lownes, C. (1799 [1793]). *An account of the alteration and present state of the penal laws of Pennsylvania, containing also, an account of the gaol and Penitentiary House of Philadelphia—And the interior management thereof*. Young & Minns.

Lynch, M. (2010). *Sunbelt justice: Arizona and the transformation of American punishment*. Stanford University Press.

Maurutto, P., & Hannah-Moffat, K. (2006). Assembling risk and the restructuring of penal control. *British Journal of Criminology, 46*(3), 438–454.

McLennan, R. M. (2008). *The crisis of imprisonment: Protest, politics, and the making of the American Penal State, 1776–1941*. Cambridge University Press.

Meranze, M. (1996). *Laboratories of virtue: Punishment, revolution, and authority in Philadelphia, 1760–1835*. University of North Carolina Press.

Oshinsky, D. (1997). *Worse than slavery: Parchman Farm and the ordeal of Jim Crow justice*. Free Press.

Peters, E. M. (1998). Prison before the prison: The ancient and medieval worlds. In N. Morris & D. J. Rothman (Eds.), *Oxford history of the prison: The practice of punishment in Western society* (pp. 3–48). Oxford University Press.

Pisciotta, A. (1994). *Benevolent repression: Social control and the American reformatory-prison movement*. New York University Press.

Rafter, N. (1985). *Partial justice: Women in state prisons, 1800–1935*. Northeastern University Press.

Reiter, K. A. (2014). The Pelican Bay hunger strike: Resistance within the structural constraints of a U.S. supermax prison. *South Atlantic Quarterly, 113*(3), 579–611.

Reiter, K. A. (2016). *23/7: Pelican Bay Prison and the rise of long-term solitary confinement*. Yale University Press.

Reiter, K., Sexton, L., & Sumner, J. (2018). Theoretical and empirical limits of Scandinavian exceptionalism: Isolation and normalization in Danish prisons. *Punishment & Society, 20*(1), 92–112.

Rhodes, L. (2004). *Total confinement: Madness and reason in the maximum security prison*. University of California Press.

Rochefoucauld-Liancourt, F. A. D. d. l. (1796). *On the Prisons of Philadelphia: By an European*. Moreau de Saint-Mery.

Rothman, D. J. (1980). *Conscience and convenience: The Asylum and its alternatives in progressive America*. de Gruyter.

Rothman, D. J. (2002 [1971]). *The discovery of the Asylum: Social order and disorder in the New Republic*. AldineTransaction.

Rubin, A., & Phelps, M. S. (2017). Fracturing the penal state: State actors and the role of conflict in penal change. *Theoretical Criminology, 21*(4), 422–440.

Rubin, A. T. (2015). A neo-institutional account of prison diffusion. *Law & Society Review, 49*(2), 365–399.

Rubin, A. T. (2016). Penal change as penal layering: A case study of proto-prison adoption and capital punishment reduction, 1785–1822. *Punishment & Society, 18*(4), 420–441.

Rubin, A. T. (2017a). The consequences of prisoners' micro-resistance. *Law & Social Inquiry, 42*(1), 138–162.

Rubin, A. T. (2017b). Resistance as agency? Incorporating the structural determinants of prisoner behaviour. *British Journal of Criminology, 57*(3), 644–663.

Rubin, A. T. (2018). The prehistory of innovation: A longer view of penal change. *Punishment & Society, 20*(2), 192–216.

Rubin, A. T. (2019a). The birth of the penal organization: Why prisons were born to fail. In H. Aviram, R. Greenspan, & J. Simon (Eds.), *The legal process and the promise of justice* (pp. 23–47). Cambridge University Press.

Rubin, A. T. (2019b). Punishment's legal templates: A theory of formal penal change. *Law & Society Review, 53*(2), 518–553.

Rubin, A. T. (2021). *The deviant prison: Philadelphia's Eastern State Penitentiary and the origins of America's modern penal system, 1829–1913*. Cambridge University Press.

Rubin, A. T. (in prep). *The magic box: A history of U.S. prisons*. Oxford University Press.

Rubin, A. T. (n.d.). *Innovation and diffusion: Theorizing penal change before and after the ideal type*. Manuscript in Progress (Available by Request).

Rubin, A. T., & Reiter, K. (2018). Continuity in the face of penal innovation: Revisiting the history of American solitary confinement. *Law & Social Inquiry, 43*(4), 1604–1632.

Rush, B. (1806 [1798]). *Essays, literary, moral & philosophical*. Printed by Thomas and Samuel F. Bradford.

Schoenfeld, H. A. (2018). *Building the prison state: Race and the politics of mass incarceration*. University of Chicago Press.

Shammas, V. L. (2014). The pains of freedom: Assessing the ambiguity of Scandinavian penal exceptionalism on Norway's prison island. *Punishment & Society, 16*(1), 104–123.

Simon, J. (2014). *Mass incarceration on trial*. The New Press.

Spierenburg, P. (1991). *The prison experience: Disciplinary institutions and their inmates in early modern Europe*. Rutgers.

Sykes, G. M. (2007 [1958]). *The society of captives: A study of a maximum security prison*. Princeton University Press.
Thompson, H. A. (2016). *Blood in the water: The Attica uprising of 1971 and its legacy*. Pantheon Books.
Turnbull, R. J. (1797). *A Visit to the Philadelphia Prison*. Printed. Reprinted by James Phillips & Son.
Ward, D. (2010). *Alcatraz: The gangster years*. University of California Press.
Ward, D. A., & Werlich, T. G. (2003). Alcatraz and Marion. *Punishment & Society, 5*(1), 53–75.

3

Defining the Mechanisms of Design: An Interdisciplinary Approach

Melissa Nadel

There is an extensive literature delineating diversity in custodial, or more commonly referred to in the US as correctional, design. From the emergence of incarceration as punishment in the twelfth century, the design of custodial facilities has evolved from mere holding cells to complex total institutions (Foucault, 1977; Goffman, 1961; Johnston, 2000; Wener, 2012). Inherent in this historical literature is the assumption that these differences in architecture are anticipated to have tangible effects on individual and systemic outcomes. However, other than these historical examinations, custodial design is left largely unexplored.

In recent years disciplines such as criminology, environmental psychology, architecture, urban planning, and geography, have delved into the logic and evidence behind this presumed relationship. Yet this

M. Nadel (✉)
Cambridge, MA, USA
e-mail: Melissa_Nadel@abtassoc.com

field still lacks a clear framework elucidating the logic of why and how architectural differences are anticipated to impact individual behaviour and overarching correctional goals. It is difficult to assess the validity of a theorized association without first establishing what we expect differences in design to accomplish, and how those are anticipated to occur.

The impact of custodial design is most often discussed in terms of the anticipated behaviour of inmates, particularly the assumption that the architecture of a facility reduces maladaptive behaviours, such as violence or vandalism. However, what is often lacking in these discussions is the overarching impact of design on well-being. Although studies in corrections often equate well-being with simply a lack of maladaptive behaviour, it is in fact a complex amalgamation of factors, including physical and mental health, attitudes and beliefs, coping mechanisms, and overall behaviour, of which maladaptive is only a small part. These aspects of well-being are intrinsically intertwined, and design cannot affect one aspect without affecting the others. However, most studies relating to custodial design tend to focus primarily on those maladaptive behaviours, and not the other elements of well-being that are essential to long-term individual and systemic outcomes.

Drawing from existing theories and evidence from criminology and other associated disciplines (with a primary focus on prison facilities in the U.S.[1]), this chapter proposes an initial framework from which we can identify the mechanisms by which the design of custodial facilities is anticipated to impact an individual's physical and mental well-being, as well as larger systemic correctional goals. The chapter reviews the goals associated with corrections, theoretical explanations for why architecture is anticipated to impact these goals, and the resulting mechanisms that facilitate that relationship between architecture and individual behaviour. Finally, the chapter ends with a discussion of a small qualitative study intended to supplement theory with real-world observations.

[1] Custodial facilities encompass a wide variety of institutions intended to hold individuals for a set time, including jails, detention centres, residential facilities, and prisons. For simplicities sake, this chapter focuses primarily on prisons.

Outcomes Associated with Custodial Design

To start, what it is we expect custodial design to accomplish? Here, we can likely draw from the goals of incarceration: safety, deterrence, punishment, rehabilitation, and cost-efficiency. Safety is of primary concern, including the safety of the public, staff, and inmates (Cullen et al., 2014; Foucault, 1977). In a review of mission statements for U.S. state departments of correction, Gaes and colleagues (2004) found that over 96% of departments listed the safety of the public, staff, and inmates as a core value of the corrections system. Facility design is easily related to this goal, as references to the security of a facility often revolve around physical constructs such as fencing, construction materials, the use of bars or locks on doors, and surveillance through line-of-sight or the placement of CCTV (Wener, 2012). Those same aspects of the built environment are related to another common goal of incarceration: deterrence. Deterrence can be defined as the mechanism by which punishment, or the threat of punishment, discourages individuals from engaging in future criminal behaviours (Bierie, 2012; Paternoster, 2010). Physical security measures, such as those described above, as well as generally unpleasant or uncomfortable environments, are theorized to discourage deviant behaviours, both while inmates are incarcerated and after they are released (Paternoster, 2010). Existing historical literature on custodial design often cites deterrence (either directly or obliquely) as motivation for design choices. Foucault's (1977) book *Discipline and Punish* describing the Panopticon is a prime example.

Punishment is often another goal of custodial design, especially in older facilities. Essentially, prisons are intended to provide an unpleasant experience for the offender (Garland, 2001; Sykes, 1958). Modern facilities typically achieve this effect through deprivations of liberty, goods, services, and comfort (Steiner & Wooldredge, 2017). US Prisons are required to provide humane conditions, but only to the bare minimum that the law requires. Most prisons—informally in the US, but more formally in the UK and other countries—operate under the doctrine of less eligibility, which argues that the conditions of prison should not exceed the living conditions of the poorest free man (Jewkes et al., 2016).

In contrast, however, custodial institutions are also tasked with rehabilitating offenders (Cullen et al., 2014; Irwin, 2005). As most inmates will eventually be released, there is an expectation that the corrections system will attempt to reform criminal behaviour (Naylor, 2016). Successful rehabilitation would then contribute to not only the safe and efficient operation of prisons but also the safety of the community as a whole. Custodial design's part in this goal is often associated with deterrence, i.e. reducing maladaptive behaviours by limiting opportunities while inside the facility and discouraging those behaviours after release. However, it can also be conceptualized as promoting positive outcomes rather than reducing negative ones. The provision of programming spaces and attempting to "deinstitutionalize" the prison environment are both cited as examples of prisons promoting well-being (Farabee, 2005).

Finally, a goal often related to design is cost efficiency (Fairweather & McConville, 2000; Wener, 2012). Although many corrections agencies list the incapacitation or reformation of offenders as their primary goals (see Gaes et al., 2004), prisons are also driven by practical constraints. They must not only be functional, but affordable (Mears, 2008). Staff expenses are typically the largest portion of the custodial budget, accounting for approximately 75% of yearly expenses (Kirchoff, 2010). Thus design is often used to improve cost-efficiency by increasing the number of inmates that can be housed while decreasing the number of staff needed to supervise them (Marrero, 1977).

Why Custodial Design is Anticipated to Effect Outcomes

Outside of criminology, there is extensive research supporting the association between built environments and behaviour (Kaplan, 2001; Mazumdar et al., 2018). This work is typically focused on workplaces, homes, or schools, yet the association between environment and behaviour is likely even more prevalent in correctional institutions Prisons are often cited as examples of total institutions, i.e. facilities where residents are anticipated to spend most or all of their time, and thus receive nearly all their needs and stimulus from that environment

(Goffman, 1961). When restricted to one location, the characteristics of that place take on even greater importance. Prisons, while not entirely impregnable (Baer & Ravneberg, 2008; Ellis, 2021; Schliehe, 2016), closely approximate this scenario, as inmates are typically not allowed to leave the confines of the prison, and day-to-day life is limited to that one physical environment.

The majority of research in corrections focuses on the characteristics of the individual detainee. For example, importation theory—the argument that in-prison deviant behaviour is a result of the characteristics inmates develop before they are incarcerated—is the primary impetus in most corrections research. However, past decades have seen a growing recognition that the overarching environment of the facility also plays a vital role in determining behaviour. First introduced through Gresham Sykes' deprivation model (1958), the theory argues that the very nature of prisons resulted in several "pains of imprisonment" including the loss of liberty, autonomy, and security. Sykes argued that these pains would subsequently produce maladaptive coping behaviours in the incarcerated population, namely violence (Sykes, 1958). As such, inmate behaviour, particularly misconduct, can be viewed as a natural adaptation to the prison environment (Sommer, 1974; Steiner et al., 2014).

Since the model's original introduction, the factors that contribute to the "pains of imprisonment" have evolved to include a variety of prison characteristics. Modern iterations include elements such as crowding, inmate-to-staff ratios, prison programming, or visitation practices (Steiner et al., 2014). While the impact of each factor on inmate behaviour has received mixed support (overcrowding for example), most studies find that, in general, the prison environment significantly impacts inmate behaviour (Gendreau et al., 1997; Griffin & Hepburn, 2013; Steiner et al., 2014).

Existing research largely defines the environment by social or cultural influences. The management perspective, for example, argues that the management style in a facility contributes to the presence—or absence—of prison order (Morgan, 2009). Effective management is integral to maintaining social control, and the subsequent safety of both inmates and staff. As such, prison violence, or more generally disorder, is argued to be the result of prison management failures (Griffin & Hepburn,

2013). However, the built environment can help or hinder these efforts by influencing feasible management activities, staff actions, and inmate behaviour. Accordingly, elements of the built environment have been introduced in corrections research in recent years, including the facility size, age, and capacity.

How Custodial Design Impacts Outcomes

Working from the assumption that the architecture of custodial facilities does indeed impact behaviour and systemic correction goals, then the question becomes, how? Existing literature on the built environments suggests that it primarily exerts indirect effects on behaviour (Gifford, 2002; Sommer, 1974, 2007). For example, a study of high-rise buildings found them to be associated with decreases in resident mental health (Evans, 2003). The limited space in these buildings does not allow for many communal gathering areas, and the lack of opportunity for socialization produced diminished social bonds and subsequent increases in resident stress (Evans, 2003). In effect, although the layout of the building did not directly cause emotional distress, its indirect long-term effects nevertheless contributed to reduced well-being. Thus, to understand design's impact, we need to understand the mechanisms by which it occurs.

Increase or Reduce Opportunity

Perhaps one of the most straightforward explanations for the impact of design is the provision or restriction of opportunities. Opportunity can be construed in either a positive or negative light, i.e. opportunities for rehabilitation versus opportunities for deviance. Traditionally, studies on the prison environment have emphasized opportunities in relation to inmate misconduct, rather than those more associated with well-being (a discussion of these opportunities is included later in the chapter). Routine activities theory (also referred to as the situational perspective) argues that the confluence of three factors—a motivated

offender, a vulnerable victim, and the absence of a suitable guardian—creates ideal opportunities for criminal behaviour to occur (Cohen & Felson, 1979). The built environment acts as a crime prevention tool by addressing that third factor—the presence of a guardian (Wortley, 2002). For example, cities will attempt to "design out" unwanted behaviours by constructing an environment that makes that behaviour difficult to achieve. For example, the placement of floodlights in high-risk areas is intended to increase viability and thus to reduce opportunities for theft (Clarke, 1997; Perkins et al., 1993). This logic also applies in custodial facilities.

By their nature, prisons place a large number of offenders within close proximity, increasing both the number of motivated offenders and suitable targets within one location (Cullen et al., 2014; Wortley, 2002). Two recent criminological studies included the architecture of a facility as a form of guardianship, arguing that the way a facility is designed can limit or increase opportunities for violence through supervision (Steiner & Wooldredge, 2017; Wooldredge & Steiner, 2014). Facilities with a podular building design, which typically includes an open floorplan, were found to have fewer blind spots, allowing guards to better observe and prevent wrongdoing (Steiner & Wooldredge, 2017; Wooldredge & Steiner, 2014).

Another form of architectural guardianship is the impermeability of the building itself, or the use of "hard architecture". As the name suggests, hard architecture consists of designs that are cold, impersonal, rigid, and impervious. Ranging from prisons to airports, these facilities are intended to be strong, both in material and visual aesthetics, and generally resistant to human imprint (Sommer, 1974). The assumption is that risk can be "designed out" of a building, hence making a safe building rather than relying on safe individuals (Biejersbergen et al., 2016). One method by which facilities discourage vandalism is through concrete and steel construction materials, rather than softer materials such as wood or brick (Sommer, 1974). The logic follows that if the building is indestructible, then inmates cannot deface or weaponize it. However, instead of discouraging unwanted behaviour, hard architecture can challenge people to engage in it (Carp & Davis, 1989; Irwin, 2005; Sommer, 1974). An unbreakable facility inevitably encourages

someone to try and break it. Anecdotal accounts of prison life have shown that the "harder" the building materials, the more dangerous the potential weapons. Prisoners have made knives from steel bedsprings that are meant to be impenetrable (Sommer, 1974). Hard architecture is associated with another mechanism of custodial design: communication.

Communication or Provision of Information

Environmental psychology operates under the fundamental assumption that our physical surroundings are a determinant to behaviour (Archea, 1977; Bell et al., 1978). Much as our behaviour changes when we are around different people, it can also change when in different environments. These shifts are partially attributed to design's ability to provide users with information (Gifford, 2002). Building layout, for one, can control the amount of information available by either facilitating or limiting an individual's ability to engage with and evaluate that environment (Archea, 1977; Gifford, 2002). Spaces that are large and open allow users to take in more information from a single vantage point, thereby providing easy access to visual cues about the environment. However, if a building is instead segmented with walls or furniture that obstruct a person's view, the information they can glean from any one position is limited (Biejersbergen et al., 2016). A study in a New Mexico prison found that the facility's design allowed visibility to be used as a method of controlling inmates; both by forcing inmates to be seen and limiting what those inmates could see themselves (Sibley & van Hoven, 2009).

The cues provided by the built environment provide users with indications of the meaning or purpose of that environment (Botton, 2006; Jewkes, 2018). However, it is not only the perception of this information that is important, but also our interpretation of it (Gifford, 2002). Over time, through observation and experience, we develop mental pathways to facilitate easy processing of new information. When presented with new stimulation (i.e. new surroundings), we tap into these heuristics to quickly assign meaning to those situations or environments (Wener, 2012). To demonstrate, a study in Italy explored whether the design of a

courthouse influenced expectations of a more punitive outcome; participants were given a hypothetical scenario of accompanying a (wrongly accused) friend to trial in either a modern or an older courthouse (Maass et al., 2000). The older building was painted in warm colours with large windows in a residential setting, while the newer building was large, grey, and closed off. The modern courthouse elicited greater discomfort from participants, and the subsequent perception that the friend would be convicted (Maas et al., 2000).

The perceived meaning taken from a building's design then influences how people behave within that environment: "Belief in the significance of architecture is premised on the notion that we are, for better or worse, different people in different places" (Botton, 2006: 13). The impermeable construction and immovable furniture common to correctional facilities communicate the expectation that residents are problematic, powerless, and distrusted (Sommer, 1974), which in turn creates a self-fulfilling prophecy, producing behaviours consistent with those expectations (Evans & McCoy, 1998; Goffman, 1961). This assumption is partially supported by criminology's labelling theory, which argues that once an initial deviant label is applied, typically through contact with the justice system, the stigma and consequences of that label, including internalization of a deviant identity, increase the likelihood of future deviance (Bernburg, 2019). Sociology's identity theory further advances this association, arguing that it is the interaction of self-perception and the perceived views of others (reflected appraisal) that influences identity and subsequent behaviour. In a study of a California correctional rehabilitation programme, researchers found a significant impact of the reciprocal relationship between self-perception and the perceived views of significant others and peers on changes to the internalized "criminal identity" (Ascenio & Burke, 2011).

The expectations communicated by the built environment are anticipated to exert a similar effect: a hard environment can create hard individuals. This same logic also suggests a softer design can engender positive identities and healthier behaviour. While hard architecture is tough, cold, and impenetrable, soft architecture is flexible, permeable, and yielding, employing windows, breakable furniture, and softer materials such as wood (Marrero, 1977; Sommer, 1974). Providing a setting

that is soft and breakable removes the potential challenge to inhabitants to break it. Subsequently, security comes from encouraging safe behaviour from the individual, rather than demanding it from the environment (Kumar et al., 2009; Wener, 2012). These spaces are designed under the assumption that more fragile environments, rather than encouraging vandalism, actually encourage caretaking, which both enhances the safety of the institution, and encourages greater well-being in its residents (Carp & Davis, 1989).

A common example of this concept in custodial settings is normalization, or the attempt to design a custodial facility to resemble the outside world as closely as is fiscally and securely possible. Prisons, in both their design and routine, are substantially different from everyday life. The transition can be shocking and living long-term in that environment can be detrimental to mental and physical health (Wener, 2012). Practitioners and academics alike argue that designing corrections environments to approximate a normal living situation, such as including soft and moveable furniture, carpeting, windows, or colourful walls, has tangible benefits (French et al., 2014; Kaplan, 2001; Maass et al., 2000; Mazumdar et al., 2018; Moran, 2015; Sommer, 1974). Normalized environments are anticipated to reduce stressors associated with transitioning to prison as well as improve inmates' eventual transition back into society. However, it is worth noting that what is considered as "normal" is variable, and is often dependent on individual experience (Shabazz, 2015).

Strain

In line with these concepts is the idea that the built environment can either enhance or alleviate strain. Agnew's general strain theory (1992) argues that criminality occurs when a person is presented with a "noxious" situation—primarily focused on relationships with others—and is unable to escape from it, subsequently generating a negative affect leading to unhealthy coping mechanisms. The argument that negative relationships and stressful life events are associated with increases in delinquent behaviour has found considerable empirical support (Agnew

et al., 2002; Ganem, 2010). Within corrections, it is argued that the deprivations inherent to prisons naturally incur strain for incarcerated individuals, and subsequently increase the likelihood they will respond with maladaptive coping mechanisms, namely misconduct (Morris et al., 2012).

One mechanism by which environmental design can produce or alleviate strain is the architectural concept of space, defined by four key tenets: territoriality, personal space, privacy, and control. *Territoriality* is the perceived, attempted, or actual control of a definable, physical, and stationary space (Perkins et al., 1993). People tend to define an area as their own in a new space through physical marking, consistent occupation, personalization, or defence of that space (Bell et al., 1978; Sommer, 2007). When space is limited, there is an increased need to defend a defined territory, particularly when it is violated (Sommer, 1974). The inability to carve out a space for oneself—a common problem in institutional settings—is associated with aggression as well as decreases in mental or physical well-being (Evans & McCoy, 1998; Jewkes et al., 2019; Perkins et al., 1993).

Personal space can be viewed as another form of territory; it is the invisible boundaries we carry around ourselves with the expectation that no one will violate that border without our permission (Sommer, 2007). Personal space serves two primary purposes, (1) as a protective factor, and (2) as a tool for communication (Bell et al., 1978). It is protective in that it creates a barrier against any potential physical or emotional threats, allowing us to regulate our social interactions and control not only who we interact with, but also how closely we do so (Bell et al., 1978; Sommer, 2007). In effect, personal space alleviates overstimulation. Studies in institutional settings—asylums, homeless shelters, prisons, etc.—where space is often limited by crowding, find a lack of personal barriers is a consistent concern (Berens, 2017; Gifford, 2002). Indeed, the inability to maintain personal space is associated with several deleterious effects, including increased stress and aggression (Berens, 2017; Carp & Davis, 1989; Raffaello, & Maass, 2002). Studies interviewing inmates often find a commonly cited pain of imprisonment is the lack of personal space or privacy (Martin et al., 2012; Pogrebin & Dodge, 2001; Sibley & van Hoven, 2009), and an article on the design

of "healthy" prisons emphasized that the provision of personal space is vital for creating a safe environment (Jewkes et al., 2019).

Closely related to personal space is the concept of *privacy*. Defined as the select control of access to the self, privacy is both visual and physical protection against others (Gifford, 2002; Sommer, 2007). It encompasses both the ability to cut off access to oneself through a physical barrier, as well as regulate that access (Gifford, 2002). In this manner, privacy is important to feelings of independence, autonomy, dignity, and identity within a given environment, which in turn exerts a considerable impact on reactions to that environment (Berens, 2017). The limitations on privacy within corrections settings are well documented (Bierie, 2012; Martin et al., 2012; Sibley & van Hoven, 2009). Privacy is frequently sacrificed in favour of safety and security, and the loss of privacy is even described as an intended part of the punishment process (Ingel et al., 2021). Yet, studies also show that too little or even too much privacy, such as an isolation cell, can produce stress and subsequent maladaptive behaviours. For example, a study comparing biochemical indicators of stress and perceived crowding among inmates in either single cell or dormitory housing, found that inmates housed in single cells reported less crowding and exhibited lower biochemical indicators than those in dormitories (Schaeffer et al., 1988).

Finally, *control* is defined as the ability to alter the physical environment or regulate exposure to various aspects of the surroundings (Berens, 2017; Jewkes, 2018). Designs that allow individuals either real or perceived control over their environment promote a greater sense of personal wellness (Evans, 2003; Fairweather & McConville, 2000; Kumar et al., 2008; Ulrich, 2004). One example is the association between control and reactions to crowding. In a study on crowding in homeless shelters, the perception that one was choosing to be in that space helped alleviate the stress typically associated with a lack of personal space (Berens, 2017). Alternatively, designs that limit individual control can magnify stress (Evans & McCoy, 1998; Jewkes, 2018). In fact, deprivation theory cites a lack of control as pain of imprisonment. The inability of prisoners to make decisions about their day-to-day lives, even the food they eat or the clothes they wear, exerts considerable stress (Sykes, 1958). Several design elements limit control in prisons, including

inflexible spatial arrangements, lack of temperature or lighting controls, uniformity of materials, and restrictions on personalization (Sommer, 1974).

Aesthetic features are also associated with mood, behaviour, and overall well-being. An extensive literature has emerged supporting the use of "healthy buildings" to improve the condition of individuals they house. Sick Building Syndrome (SBS) for example is defined as a collection of factors related to a particular space that negatively affect physical and psychological well-being (Ghaffarianhoseini et al., 2018). Features of the built environment, including temperature, lighting, noise, and lack of access to nature, are associated with stress, aggression, productivity, behavioural problems, and physical illness (Ghaffarianhoseini et al., 2018; Jewkes et al., 2019; Kaplan, 2001; Kumar et al., 2008; Ulrich, 2004). In a study of Federal prisons in the US, for example, poor physical conditions of a facility were significantly associated with increased incidents of violent misconduct (Bierie, 2012). Yet when implemented well, these features can improve well-being. A recent study of prisons in England found that more greenspaces within the facility perimeter were associated with fewer sickness call outs from prison staff, even when controlling for factors such as facility custody level and rates of assaults against staff (Moran et al., 2022).

The Role of the Individual

Thus far this chapter has focused primarily on how the built environment impacts the individual, however, underlying all these perspectives is the understanding that any effect of the environment is moderated by the existing experiences and characteristics of the individual. Across disciplines, individual-focused theories—particularly importation theory from the incarceration perspective—emphasize the importance of personal traits and experiences in determining behaviour. Two different people may be exposed to the same environment, yet have disparate reactions to the same stimuli. Take the concept of normalization for example; what is considered a "normal" environment is dependent upon personal

preferences and experiences. Rashad Shabazz's (2015) work on the acclimation of young Black men to carceral environments, for example, suggests that because a disproportionate percentage of young black men are raised in public housing, the deprivations of the prison environment actually approximate normality. Thus an environment that engenders comfort or normalcy to one person, may feel foreign and uncomfortable to another. Personal traits and past experiences influence how we think and behave in new environments, moderating how we interpret and interact with new environments (Fairweather & McConville, 2000; Rapoport, 1982).

In addition, the behaviours of others in the same environment can mediate its effect. Staff spend their days in prisons alongside inmates. Consequently, the way corrections officers interact with their environment will inevitably affect how they interact with incarcerated populations. A hard, or strain-inducing environment with opportunities for misbehaviour is likely to provoke stress and unhealthy coping mechanisms in staff as well as inmates, contributing to poor staff discipline, distrust between staff and inmates, and high staff turnover (Carlson & Thomas, 2006; Martin et al., 2012).

Exploring Mechanisms in a Small Qualitative Study

A qualitative study examined the anticipated effects of custodial design from the practitioner perspective. The mechanisms elucidated above are grounded in theory, but not necessarily real-world application. Interviews with 19 prison administrators and architects in the US who had extensive experience working in and across various corrections facilities were used to explore the mechanisms of prison architecture (for full study see Nadel, 2018).[2]

[2] The primary goal of this study was to examine the intent behind carceral design decisions, and thus focused on higher level administrative interviewees, rather than inmates or correctional staff. The latter group could provide valuable insight into the actual effects of these design decisions, regardless of intent, however that was beyond the scope of the current study.

Respondents were first asked what features of prison architecture they felt most influenced inmate or staff behaviour. Over forty different elements emerged across the interviews (a full listing of these features can be seen in Table 3.1). However, many of these characteristics can be condensed into four overarching categories: facility layout, housing type, visibility, and aesthetics.

Respondents were also asked not only what are the specific features that are expected to impact prison experiences and/or behaviour, but also *how* they are anticipated to help or hinder these goals. The responses generally lined up with existing theory. For example, all four categories of features mentioned above were anticipated to impact *opportunities* for inmates to engage in misconduct. Linear facility layouts have more blind spots and require more movement of inmates across the compound for services, thereby creating more situations where inmates are given the opportunity to engage in dangerous behaviours. Alternatively, dormitory housing types can reduce the opportunities for misconduct by increasing supervision by corrections staff. However, they can also increase opportunities when too many inmates are in one area, limiting an officer's ability to see everything going on at once. As a result, visibility is another feature respondents related to misconduct: "part of the deterrent for negative

Table 3.1 Architectural features perceived to be associated with staff and inmate behaviour

Facility layout	Housing types	Visibility	Aesthetic features
Linear	Locking features	Openness	Lighting
Campus	Cells	Cameras	Acoustics
Podular	Dorms	CCTV	Concrete
Openness	Open Bays	Line-of-sight	Steel
Direct supervision	Crowding	Blind spots	Durability
Location	Bunks	Direct supervision	Air-conditioning
Facility size	Cubicles		Access to nature
Facility age	Facility size		Fresh air
Hallway size	Supermax		Windows
Hallway length			Glazing
Programme space			Dark
Recreation space			Dungeon-Like
Centralized services			Normalized
Work Release			Colour
			Murals

behaviour from inmates is the ability of staff to be able to see them and then also the ability of the inmates to be able to see the staff". Placement of cameras as well as open floorplans that allow officers to view most inmates unobstructed, limit opportunities for misconduct to occur unseen. Certain aesthetic features of the prison, namely the harder architecture, are also intended to limit misconduct. The durability of a prison's construction—i.e. concrete, steel, bulletproof glass, and barred windows—is intended to prevent behaviours such as escape attempts, vandalization of the facility, and the creation of weapons out of building materials. By incorporating more durable materials, architecture is anticipated to deter dangerous or inappropriate behaviour.

Several respondents also described how prison architecture could provide opportunities for positive behavioural reforms. Both the layout of the facility as well as the housing types were indicated as influencing these mechanisms. Facility layout was cited as influencing behaviour primarily in terms of providing space for rehabilitative programming within the facility. Housing type was cited as influencing behavioural reform primarily through open bay dormitories. The openness of the dorms has the potential to foster a sense of independence within inmates in terms of their ability to take care of themselves and facilitate their daily activities. A common concern with prisons is that the strict control and routine of prison life will lead to institutionalization, rendering the inmate unprepared to dictate their own life choices after release. Allowing inmates freedom within the confines of a secure environment can help develop independence and personal responsibility. In addition, one respondent suggested the group setting of open bay dormitories encourages social interaction, giving inmates the opportunity to practice communicating in a healthy manner:

> "the dorm makes people, if they have a problem with somebody else, they talk it out, they talk it through, where in a cell, if they get mad at someone they can just go in their cell and lock the door, and then they don't learn how to communicate very well, they don't learn how to work [out] their problems through conversation, where in a [dorm], you have nowhere to go..."

However, it is worthwhile to note that several other respondents believed that the use of single person cells allowed inmates a sense of privacy and personal space that dormitories could not, and thus allowed for healthier coping to the strains of prison.

Another concept that emerged from the interviews was *ease of movement* throughout the facility, or the ability for inmates to move from their cells to other areas of the facility without needing an escort. This feature was cited not only as an important contributor to positive inmate behaviour by allowing greater autonomy and programme participation, but also as a tool to mitigate dangers to facility staff. Several architectural elements impact this mechanism.

By their nature, linear designs often require excessive movement to get inmates to any services, whether that's programming, medical services, or the cafeteria. This movement requires constant escorts by prison staff, increasing manpower and reducing staff safety. Podular designs tend to be more open with centralized services. It is the centralization of services that has the most impact on inmate movement. One respondent described its effect in terms of designing a school:

> "In a classroom environment, [same as] in a prison, in say an education building, the same rules apply… Do you want a restroom in the classroom? You probably do. It has nothing to do with the fact that it's a prison, it is just that you probably need it. You need water fountains close by, because say you're in a [pre-university] environment, escorting students every time they want a drink of water, well that's time-consuming right? Same thing applies in prisons".

When facilities include programming space or meal areas in a centralized location, it is easier to both limit and control movement, in effect allowing inmates more freedom without increasing risk. In this same vein, the types of housing that facilities employ can also hinder or facilitate movement based on the openness of the design. Even in a campus layout, if the housing style incorporates cells in a more linear style, there is still a necessity for greater staff involvement in escorting inmates around the facility. However, in a dormitory style environment,

inmates can move freely around the common areas under general supervision from staff, without necessarily needing to be escorted. Increased autonomy for inmates as well as the ability to safely incorporate programming is anticipated to provide opportunities for behaviour reform, which inevitably increases safety for staff, inmates, and the general community upon the inmate's release. In addition, facilities designed for easy movement require fewer to maintain a safe and secure environment, reducing the overall operating cost of a facility.

Finally, feelings of stress, agitation, or fear were some of the most commonly cited mechanisms across respondents. Several aspects of prison architecture are influential in either creating or alleviating these feelings. Several respondents discussed how housing style can decrease stress by providing opportunities for privacy or communication. Cell housing, especially single person cells, allow inmates a space away from the rest of the facility, giving them a modicum of privacy and personal space. On the other hand, dormitory style housing has a more open structure that allows staff to roam freely among the inmates. This contact between officers and inmates fosters communication and trust, easing potential tensions:

> "…if [prisoners] feel like there are issues occurring inside the institution that require somebody to be reported… then we have a mutually respectful environment, it's open and not secretive, and there's more likelihood of those things being reported and investigated and corrected, then there's less fear and mistrust between the staff and prisoners, and when there's less frustration and fear and tension, then I think that there's less opportunity for violence".

However, direct supervision also has the potential to make officers feel less safe if not implemented properly. Several respondents noted that officers prefer indirect supervision because it places a physical barrier between themselves and the inmates.

Other architectural features promoting visibility can also reduce stress and fear. The increased visibility in open floorplans can help staff feel safer, as they are less likely to be attacked when the attack is easily seen. In addition, respondents argued that knowing officers are constantly

watching can make inmates feel safe from attack or abuse from fellow inmates. They also note that the use of cameras engenders less fear and more trust as they can corroborate any reports of abuse, either from staff or inmates. In holding both groups accountable, it is presumed there is less fear of victimization from either group. On the other hand, the constant surveillance does not allow for much privacy or personal space, which could act as a stressor. It's worthwhile to note here that existing research suggests that rather than preventing abuse, the placement of cameras just displaces these incidents to blind spots not covered by CCTV (Hancock & Jewkes, 2011).

The aesthetics of a facility were also widely cited as contributing to stress among both staff and inmates. The two most referenced elements were the provision of natural light through windows and a facility's noise level. Several subjects described their own personal experiences working in prisons with and without these features. In prisons where windows were installed, they describe a notable decrease in the stress levels of both inmates and staff, and subsequent improvements in behaviour. On the other hand, the common use of harder materials in prisons, such as concrete, amplify noise, creating a constant undercurrent of sound:

> "If you make these things as ultimately durable as they need to be, that's a lot of hard surface, which creates a din that is unnerving, and I can be in there for thirty minutes and it starts to affect my view of the world. I start to get agitated and uncomfortable and on edge. Well imagine living in that for twenty-four hours".

Another feature was temperature. During the summer months, the heat and humidity that builds in these facilities can be stifling. These conditions make an already stressful environment even more so, potentially resulting in shorter fuses during hostile situations.

The final aesthetic aspect that appeared consistently across the interviews was the concept of normalization. The transition to prison can be shocking and living long-term in that environment can be detrimental to both mental and physical health. As stated by one subject, "the physical structure, it's dark and more concrete and doesn't have the softer edges if you will, lead to some very poor behaviour of its own making".

Several respondents noted that including features such as soft furniture, carpeting, windows, or wall murals can have psychological benefits for facility occupants. In the words of one administrator, "I am absolutely convinced that the more humane we make the facility, the more human the inmate". In addition, by reducing these stressors, respondents observed that inmates were less likely to engage in misconduct, and more willing to participate in rehabilitative activities.

It was also widely noted that the impact of architecture on inmates is often dependent upon the behaviours of corrections staff. A prison can be built to facilitate direct supervision, but if the officers choose to stay in the control centre (as many respondents indicated was likely to occur) then the model is likely to fail. In another example, a facility may have an "unhealthy" design, but if the corrections staff is communicative, fair, and protective of inmates, the poor aesthetics may have only a limited impact. As one respondent stated: "the architecture is either accentuated or diminished by the kind of staff we have available".

Creating a Theoretical Framework for Custodial Design

From these theories and evidence, we can construct an initial framework to inform future research in this field, delineating our current understanding of how custodial design is intended to impact justice-involved persons and corrections goals. A custodial design logic model was developed, identifying inputs, activities, outputs, outcomes, and impacts. This model is provided in Fig. 3.1.

The *inputs* for custodial design encompass the features of the built environment that are anticipated to have an impact, and here are grouped into four categories: (1) Building layout—the overarching architecture of a facility, including internal layout that impacts visibility; (2) Housing Type—the type of space where inmates are housed; (3) Hard or Soft Design; and (4) Aesthetics. Next, *activities* refer to the actions that are intended to occur with the design inputs, such as supervision, exposure to natural elements, communication between inmates and guards, provision of programming, or inmates' ability to control

3 Defining the Mechanisms of Design: An Interdisciplinary ...

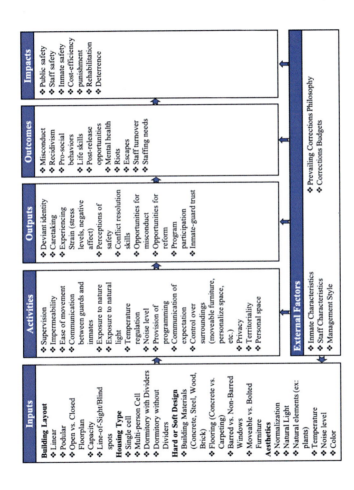

Fig. 3.1 Custodial design causal logic model

aspects of their physical surroundings. *Outputs* refers to the expected consequences of those actions, namely the provision or limiting of opportunities for different behaviours, experiences of strain, changes to self-perception, and the tenor of relationships among inmates and staff in the facility. Resulting from these outputs is then the initial *outcomes* that are anticipated to occur including misconduct, positive behaviours such as improved life skills, or staff-specific outcomes such as reduced turnover. Over time, those outcomes are then anticipated to produce long-term macro-level *impacts*, which here encompasses overarching corrections goals. Finally, several *external factors* are included that are likely to moderate these relationships, including individual characteristics and a facility's management style. Ideally, this model would be broken down even further based on the type of architectural designs that are being manipulated (layout, aesthetics, housing, etc.), however for simplicity's sake, the model encompasses design in general.

Next Steps

This model is an initial attempt to codify existing theory and research from various disciplines into a single consistent framework from which researchers can evaluate the efficacy of custodial design in impacting offender behaviour and system goals. However, this framework is only the beginning. Moving forward, researchers should confirm the relationships outlined in this model accurately represent the intent of different designs, while also expanding upon the model to make it as comprehensive as possible. Given the relative newness of this field, these steps are best accomplished through exploratory approaches. Researchers should consult with individuals that are more directly involved with prison design and the prison environment, namely policymakers, practitioners, architects, corrections staff, and inmates.

As the intended logic behind these relationships is defined, the next step is to attempt to confirm those associations. A custodial design logic model is only useful if it represents the actual impact of design, not just the intent. Developing evidence for these effects means testing the efficacy of various design elements in (1) creating or contributing to

the intervening mechanisms (i.e. self-perception, opportunity, privacy, strain, etc.), and (2) impacting intended outcomes through those mechanisms. By empirically testing these relationships, we can build a solid base of evidence for what works and what doesn't in custodial design.

References

Agnew, R., & White, H. R. (1992). An empirical test of general strain theory. *Criminology, 30*(4), 475–500.

Agnew, R., Brezina, T., Wright, J. P., & Cullen, F. T. (2002). Strain, personality traits, and delinquency: Extending general strain theory. *Criminology, 40*(1), 43–72.

Archea, J. (1977). The place of architectural factors in behavioural theories of privacy. *Journal of Social Issues, 33*(3), 116–133.

Asencio, E. K., & Burke, P. J. (2011). Does incarceration change the criminal identity? A synthesis of labeling and identity theory perspectives on identity change. *Sociological Perspectives, 54*(2), 163–182.

Baer, L. D., & Ravneberg, B. (2008). The outside and inside in Norwegian and English prisons. *Geografiska Annaler: Series b, Human Geography, 90*(2), 205–216. https://doi.org/10.1111/j.1468-0467.2008.00287.x

Bell, P. A., Fisher, J. D., & Loomis, R. J. (1978). *Environmental Psychology*. W.B. Saunders Company.

Berens, M. J. (2017). A review of research: Designing the built environment for recovery from homelessness. *Design resources for homelessness: An online knowledge solution.*

Bernburg, J. G. (2019). Labelling theory. In *Handbook on crime and deviance* (pp. 179–196). Springer.

Biejersbergen, K. A., Dirkzwager, A. J. E., van der Laan, P. H., & Nieuwbeerta, P. (2016). A social building? Prison architecture and staff-prisoner relationships. *Crime & Delinquency, 62*(7), 843–874.

Bierie, D. M. (2012). Is tougher better? The impact of physical prison conditions on inmate violence. *International Journal of Offender Therapy and Comparative Criminology, 56*(3), 338–355.

Botton, A. D. (2006). *The Architecture of Happiness*. Vintage Books.

Carlson, J. R., & Thomas, G. (2006). Burnout among prison caseworkers and corrections officers. *Journal of Offender Rehabilitation, 43*(3), 19–34.

Carp, S. V., & Davis, J. A. (1989). *Design Considerations in the Building of Women's Prisons*. U.S. Department of Justice.

Clarke, R. V. G. (Ed.). (1997). *Situational crime prevention* (pp. 225–256). Criminal Justice Press.

Cohen, L. E., & Felson, M. (1979). Social change and crime rate trends: A routine activity approach. *American Sociological Review, 44*(4), 588–608.

Cullen, F. T., Jonson, C. L., & Stohr, M. K. (2014). *The American Prison: Imagining a Different Future*. Sage Publications.

DiIulio, J. J. (1987). *Governing Prisons: A Comparative Study*. The Free Press.

Ellis, R. (2021). Prisons as porous institutions. *Theory & Society, 50*, 175–199. https://doi.org/10.1007/s11186-020-09426-w

Evans, G. W. (2003). The built environment and mental health. *Journal of Urban Health, 80*(4), 536–555.

Evans, G. W., & McCoy, J. M. (1998). When buildings don't work: The role of architecture in human health. *Journal of Environmental Psychology, 18*, 85–94.

Fairweather, L., & McConville, S. (2000). *Prison Architecture: Policy, Design and Experience*. Architectural Press.

Farabee, D. (2005). *Rethinking rehabilitation: Why can't we reform our criminals?* American Enterprise Institute.

Foucault, M. (1977). *Discipline and punish: The birth of the prison*. Random House.

French, S., Wood, L., Foster, S. A., Giles-Corti, B., Frank, L., & Learnihan, V. (2014). Sense of community and its association with the neighborhood built environment. *Environment and Behavior, 46*(6), 677–697.

Gaes, G. G., Camp, S. D., Nelson, J. B., & Saylor, W. G. (2004). *Measuring Prison Performance: Government Privatization & Accountability*. AltaMira Press.

Ganem, N. M. (2010). The role of negative emotion in general strain theory. *Journal of Contemporary Criminal Justice, 26*(2), 167–185.

Garland, D. (2001). *Mass Imprisonment: Social Causes and Consequences*. Sage Publications.

Gendreau, P., Goggin, C. E., & Law, M. A. (1997). Predicting Prison Misconducts. *Criminal Justice and Behaviour, 24*(4), 414–431.

Ghaffarianhoseini, A., AlWaer, H., Omrany, H., Ghaffarianhoseini, A., Alalouch, C., Clements-Croome, D., & Tookey, J. (2018). Sick building

syndrome: Are we doing enough? *Architectural Science Review, 61*(3), 99–121.

Gifford, R. (2002). *Environmental Psychology: Principles and Practices*. Optimal Books.

Griffin, M. L., & Hepburn, J. R. (2013). Inmate misconduct and the institutional capacity for control. *Criminal Justice and Behaviour, 40*(3), 270–288.

Goffman, E. (1961). *Asylums: Essays on the Social Situations of Mental Patients and Other Inmates*. Anchor Books.

Hancock, P., & Jewkes, Y. (2011). Architectures of incarceration: The spatial pains of imprisonment. *Punishment & Society, 13*(5), 611–629.

Ingel, S., Richards-Karamarkovich, A., Bietsch, S., & Rudes, D. S. (2021). Privacy violations and procedural justice in the United States prisons and jails. *Sociology Compass, 15*(2), e12847.

Irwin, J. (2005). *The Warehouse Prison: Disposal of the New Dangerous Class*. Roxbury Publishing Company.

Jewkes, Y. (2018). Just design: Healthy prisons and the architecture of hope. *Australian & New Zealand Journal of Criminology, 51*(3), 319–338.

Jewkes, Y., Bennet, J., & Crewe, B. (2016). *Handbook on Prisons* (2nd ed.). Routledge.

Jewkes, Y., Jordan, M., Wright, S., & Bendelow, G. (2019). Designing 'healthy' prisons for Women: Incorporating trauma-informed care and practice (TICP) into prison planning and design. *International Journal of Environmental Research and Public Health, 16*(20), 3818.

Johnston, N. (2000). *Forms of Constraint: A History of Prison Architecture*. University of Illinois Press.

Kaplan, R. (2001). The nature of the view from home: Psychological benefits. *Environment and Behaviour, 33*(4), 507–542.

Kirchoff, S. M. (2010). *Economic impacts of prison growth*. Congressional Research Service.

Kumar, R., O'Malley, P. M., & Johnston, L. D. (2008). Association between physical environment of secondary schools and student problem behaviour: A national study, 2000–2003. *Environment and Behaviour, 40*(4), 455–486.

Martin, J. L., Lichtenstein, B., Jenkot, R. B., & Forde, D. R. (2012). "They can take us over any time they want": Correctional officers' responses to prison crowding. *The Prison Journal, 92*(1), 88–105.

Maass, A., Merici, I., Villafranca, E., Furlani, R., Gaburro, E., Getrevi, A., & Masserini, M. (2000). Intimidating buildings: Can courthouse architecture

affect perceived likelihood of conviction? *Environment and Behaviour, 32*(5), 674–683.

Marrero, D. (1977). Spatial dimensions of democratic prison reform: Human space and political participation in prison. *The Prison Journal, 57*, 31–42.

Mazumdar, S., Learnihan, V., Cochrane, T., & Davey, R. (2018). The built environment and social capital: A systematic review. *Environment and Behaviour, 50*(2), 119–158.

Mears, D. P. (2008). Accountability, efficiency, and effectiveness in corrections: Shining a light on the black box of prison systems. *Policy Essay, 7*(1), 143–152.

Moran, D. (2015). *Carceral geography: Spaces and practices of incarceration*. Routledge.

Moran, D., Jones, P. I., Jordaan, J. A., & Porter, A. E. (2022). Nature contact in the carceral workplace: greenspace and staff sickness absence in prisons in England and Wales. *Environment and Behavior, 54*(2), 276–299.

Morgan, W. J. (2009). The major causes of institutional violence. *American Jails, 23*(5), 62–70.

Morin, K. M. (2015). The late-modern American jail: Epistemologies of space and violence. *The Geographical Journal*. https://doi.org/10.1111/geoj.12121

Morris, R. G., Carriga, M. L., Diamond, B., Piquero, N. L., & Piquero, A. R. (2012). Does prison strain lead to prison misbehaviour? An application of general strain theory to inmate misconduct. *Journal of Criminal Justice, 40*, 194–201.

Morris, R. G., & Worrall, J. L. (2014). Prison Architecture and Inmate Misconduct: A Multilevel Assessment. *Crime & Delinquency, 60*(7), 1083–1109.

Nadel, M. R. (2018). *Designing corrections: The theoretical and empirical evidence for an impact of prison architecture on inmate behaviour*. Doctoral Dissertation, Florida State University. https://fsu.digital.flvc.org/islandora/object/fsu%3A650733

Naylor, B. (2016). Implementing Human Rights in Prison. *Advancing Corrections Journal, 1*, 95–100.

Paternoster, R. (2010). How much do we really know about criminal deterrence? *The Journal of Criminal Law and Criminology, 100*, 765–824.

Perkins, D. D., Wandersman, A., Rich, R. C., & Taylor, R. B. (1993). The physical environment of street crime: Defensible space, territoriality and incivilities. *Journal of Environmental Psychology, 13*(1), 29–49.

Pogrebin, M. R., & Dodge, M. (2001). Women's accounts of their prison experiences: A retrospective view of their subjective realities. *Journal of Criminal Justice, 29*(6), 531–541.

Raffaello, M., & Maass, A. (2002). Chronic exposure to noise in industry: The effects on satisfaction, stress symptoms, and company attachment. *Environment and Behaviour, 34*(5), 651–671.

Rapoport, A. (1982). *The Meaning of the Built Environment: A nonverbal Communication Approach*. Sage Publications.

Schaeffer, M. A., Baum, A., Paulus, P. B., & Gaes, G. G. (1988). Architecturally mediated effects of social density in prison. *Environment and Behaviour, 20*(1), 3–19.

Schliehe, A. K. (2016). Re-discovering goffman: Contemporary carceral geography, the "total" institution and notes on heterotopia. *Geografiska Annaler: Series b, Human Geography, 98*(1), 19–35.

Shabazz, R. (2015). Spatializing blackness: *Architectures of confinement and black masculinity in Chicago*. University of Illinois Press.

Sibley, D., & Van Hoven, B. (2009). The contamination of personal space: Boundary construction in a prison environment. *Area, 41*(2), 198–206.

Sommer, R. (1974). *Tight Spaces: Hard Architecture and How to Humanize It*. Prentice-Hall Inc.

Sommer, R. (2007). *Personal Space: The Behavioral Basis of Design*. Bosko Books.

Steiner, B., Butler, H. D., & Ellison, J. M. (2014). Causes and correlates of prison inmate misconduct: A systematic review of the evidence. *Journal of Criminal Justice, 42*, 462–470.

Steiner, B., & Wooldredge, J. (2017). Individual and Environmental Influences on Prison Officer Safety. *Justice Quarterly, 34*(2), 324–349.

Sykes, G. (1958). *Society of Captives: A study of Maximum Security Prison*. Princeton University Press.

Ulrich, C. (2004). A place of their own: Children and the physical environment. *Human Ecology, 32*(1), 11–14.

Wener, R. E. (2012). *The Environmental Psychology of Prisons and Jails: Creating Humane Spaces in Secure Settings*. Cambridge University Press.

Wooldredge, J., & Steiner, B. (2014). A bi-level framework for understanding prisoner victimization. *Journal of Quantitative Criminology, 30*, 141–162.

Wortley, R. (2002). *Situational Prison Control: Crime Prevention in Correctional Institutions*. Cambridge University Press.

4

Custodial Design: Collective Methods

Kevin Bradley and Rohan Lulham

Introduction

Traditional design procurement methods that prescribe, either explicitly or implicitly, how and what is designed have long dominated custodial design practice (Consoli, 2012). Examples such as Berwyn in the UK and the new youth justice facility in Melbourne Australia speak little of the intent or craft of an architect nor of those within. 'What works' is constrained and dominated by procurement's arbitrary and overwhelmingly quantitative design parameters based largely on what has always

K. Bradley
University of Technology Sydney, Sydney, NSW, Australia
e-mail: Kevin.Bradley@uts.edu.au

R. Lulham (✉)
University of Sydney, Sydney, NSW, Australia
e-mail: Rohan.Lulham@sydney.edu.au

been built, operated, and accountable to penal practices (Nadel & Mears, 2018; Scharff-Smith, 2015; Tubex, 2015).

The following chapter outlines a 'Collective Methodology' as an alternative approach to traditional and contemporary custodial design procurement (UNOPS, 2016). It draws from the literature that contests architecture's capacity to measurably affect change in a person. In particular, the Scharff-Smith (2015) argument that historically prisons are viewed as affecting 'people-change' and their social contribution being interpreted in the metrics of 'recidivism' rates (Department of Justice, 2021). He (and many others see [Bauman, 2000; Fairweather & McConville, 2000, pp. 20–1; Garland, 1990, pp. 7–10; Wolf, 2014, pp. 20–1]) argue there is overwhelming evidence that prisons are more harmful to those that experience them and further serve to exacerbate inequality and division throughout society. In Scharff-Smith's view, custodial architecture that is broadly understood to have a 'people-changing' purpose within the empirical practices of 'what works' perpetuates the ill effects of prison on the individual and has ongoing impacts through generations (Baggio et al., 2018, p. 16). He advocates for custodial design to be re-oriented to being 'context-based' to affect reform as the current system of 'what works' in terms of person–environment design is failing to support people in seeing themselves in a context other than being part of the criminal class (Turner, 2012).

The alternative methodology presented in this chapter was developed as part of a Ph.D. in custodial architecture at the University of Technology Sydney Australia that was near completion at the time of writing. It is a hybrid methodology of phenomenological and interpretive methods that seeks to make visible what would never be made visible in a traditional design procurement process. It starts with a social concern about how the notion of citizenship would manifest in custodial architecture. This concern is put to a stakeholder participant cohort that work and live in three prisons in New South Wales—Australia. It was also put to a number of external participants that have direct interest in prison design, including prisoner advocates, ombudsman staff, designers, and others.

The methodology in the research study (and the example in this chapter) transitions from a qualitative method of engaging with stakeholders, through interpretive methods to ultimately employ design methods of sketching and textual description to achieve a suite of context-changing 'design-oriented scenarios' (Manzini et al., 2015, p. 129). The aim of the methodology is to assist in making the concerns of the invisible visible (Drake in Scharff-Smith, 2015, p. 35). In doing this, the methodology is intended to bring new understandings emergent from the collective social concerns of stakeholders about a proposed custodial facility (or interventions to an existing one) to the forefront as a context of the design procurement process. We will refer to this technique within the design process as 'context change'.

To give context to the origins of the Collective Method, mention needs to be made of another research project undertaken as a collaborative design project that inspired the Ph.D. research study and initiated the development of the method that is the focus of this chapter. Following the brief discussion of the reference project as context, the theory and practice of the methodology will be framed and outlined. After this discussion, an example of what the method achieved as conceptualising design in the research will be presented to demonstrate how 'context-changing' was achieved with respect to the research topic.

The chapter concludes with a critical reflection on the methodology and a projection of engaging collectively in the future. This discussion centres on the extent it might be viable into the future as a way of conceptualising prison environments as having a context-changing capacity to assist an individual's journey to desistance and the broader wellbeing of society.

The Reference Custodial Project of Collaborative Design

The background to developing the Collective Method can be traced back to 2012 with a collaborative project with Corrective Services NSW (CSNSW) and University of Technology Sydney (UTS). The project involved the design and construction of a learning centre in an existing

correctional centre in New South Wales. The design procurement was a collaborative venture that involved all the stakeholders that had an interest in the design and function of the project. A UTS research team employed a workshop methodology that enabled management, teaching staff, and prisoners to be part of the design process. The workshops were held at UTS Design Architecture and Building Faculty around 2013 with staff. Prisoners supplied sketches that expressed their intentions and needs for a learning space.

A couple of years after the completion and opening of the learning centre project and having undertaken several projects of different types and scales in various custodial environments across New South Wales, it became increasingly apparent that methods for involving people with an existential interest in custodial environments, as had been done in the learning centre project, was not widely practised in general custodial environments. This gap in custodial architectural research/practice was part of the reason for developing a 'collective' methodology in a practice-led research study. The other contribution from the research is the establishment of new knowledge in custodial architecture specific to the nature and relationship of citizenship and design. In total, there are two outcomes of the Ph.D. study—A methodology that gives voice to stakeholders who have a direct interest in the qualities and performance of prison environments, and a new understanding of prison architecture in the context of 'citizenship'.

Because the Ph.D. project was practice-led and part of a live architectural practice, the methodology developed in it is not a 'fixed' solution and is intended for ongoing development. It served a purpose in the Ph.D. study and will likely take on a different structure and methods in the future as the nature of the questions that are to be solved change. It was, and will continue to be a work in progress and the intention is to develop it in further projects with different design questions, scales, and contexts. Regardless of future project contexts, the development of the method retains a central objective to explore future custodial worlds with those who are impacted by them—particularly those that are on a journey towards desistance and a return to society (Maruna, 2001). 'Nothing about us, without us!' (Costanza-Chock, 2020).

Framing—Theory and Practice

The theoretical framing for the Collective Methodology was in part based on the concern for how prisons are conceived in custodial design practice and the opacity of the design procurement process. These concerns are held in the practice context of the prison having an enduring function in society (Maurer in Baggio et al., 2018, p. 6), but their design being questionable in terms of effectiveness to meet their intended function (Bauman, 2000; Department of Justice, 2021; Nadel & Mears, 2018; Scharff-Smith, 2015). The practical framing of the methodology is intended to establish new ways to characterise custodial environments that are informed by existential concerns rather than a description of a prisoner demographic provided by a justice agency. Through a combination of the methodology and the subsequent findings as new design, It is hoped that this new way to procure design from existential input might hold a mirror to the body politic (from within architectural practice) to show there are opportunities through alternative methods other than the prison being imagined from a 'what works' paradigm (Brown et al., 2013).

The methodology recognises the complex and systemic social forces (including the pre-reflective meaning of prison and its tacit association with social inequality) that contribute to why people find themselves in prison (Wirsu, 2021). It also recognises that the lived experience of prison is a pain that is felt throughout society and not only by the person serving time as punishment. This sensing of the prison and its effects are pervasive across time and people (Hancock & Jewkes, 2011, p. 623). In any architecture, the effect of an environment, time, relationships, material, and human scale is part of design along with location specific considerations. In prison architecture, all these things matter no less (ICPA, 2021). The dilemma for the custodial architect is that these factors are not directly accessible (Consoli, 2012) as they would be in other projects. Custodial design is heavily dependent on the justice agency's documentation (Smith, 2008) that characterise the prisoner and the material parameters of the proposed facility. There is a clear gap between architecture practice in general and custodial architecture practice in that the former has a mandate to design for the human

condition and the latter being required to design to a prescribed condition for humans (Perez-Gomez & Pelletier, 1992, p. 27). The Collective Methodology was developed to bridge that gap.

In practice the methodology operates through four phases as follows;

- *Qualitative*—the documenting of lived experience through semi-structured interviews with stakeholder participants and thematic treatment of the interview data to develop fields of concern about the research topic 'citizenship'. The qualitative components of the method are the first and second parts of the reference project workflow diagram Fig. 4.1.
- *Hermeneutic/interpretive*—this phase relies on making connections and interpretation of the data from the qualitative phase (Creswell & Poth, 2016; Crotty, 1998; Porter & Robinson, 2011). In the research, this action of interpretation is a mechanism termed 'scripts' (Stephan, 2015). A 'script' is a narrative mechanism that draws out the essence of the emergent concerns from the data from the first qualitative phase.
- *Visualisation*—Visualisations are directly related to a prison function. The designer combines one or more of the scripts into design interventions that relates to the essence of the stakeholder concerns. These design interventions are termed 'design-oriented scenarios' (Manzini et al., 2015) that are predominately visualisations of a possible design intervention (or could be a mixture of both visual and textual content) (Goble, 2011). A design-oriented scenario may be a combination of scripts, that together relate to concerns for part/whole of the prison or function. The purpose of the design-oriented scenarios (both visual and textual) aligns with Yee (2010) as being 'firstly a reflection and exploration tool; second, as an analysis and knowledge generation tool; third, as a communication, facilitation and discussion tool'.
- *Exhibition*—The methodology generates both textual and graphic artefacts by the designer. It will have produced one or a number of design-orientated scenarios to inform the procurement of a new prison facility or an intervention to an existing one. The design documentation can be presented or reviewed depending on the nature of a project and the design procurement process. It could be used for public exhibition/validation, stakeholder feedback, or meshed into the

design procurement process as standalone artefacts that designers need to incorporate into their design. In the case of the Ph.D. study, they were publicly exhibited online for validation (Creswell & Poth, 2016).

Example Workflow

The aim of the following workflow (Fig. 4.1) is to give an overview of the process of the Collective Method used in the Ph.D. study. Due to the limitations of the chapter, it is only possible to skip through the process with examples of each 'qualitative data', 'Scripts, and 'Design-orientation scenario' steps. The final step of the method which is to exhibit or share with a relevant audience will not be included as it depends on how the design-oriented scenarios are used in the future design procurement process. As mentioned earlier, these were exhibited publicly online in the research study.

Qualitative Data

The following selection of quotes are taken from the Ph.D. study. They are a small selection that speaks about a particular aspect of 'citizenship' that involves social connectivity, family, punishment, architectural appearance, and function.

> If we do the time—the family always does the time with us. They probably do more time and harder time than we do (Prisoner—2019)
> the last fucking thing you want is the kids relating to their father who is in fucking prison – in a negative environment they've felt. (Prisoner—2019)
> I wouldn't have them here—I would fucking miss them. Just for the sake that they don't have to come and feel the spiritual energy that this place has. The negativity that's created in a place like this. (Prisoner—2019)
> I'm a bit torn with the whole visits thing because I don't think it's fair to normalize this as a weekend routine for a child. But at the same token, is it fair to them to not have access to their parent? And you know, it's, it

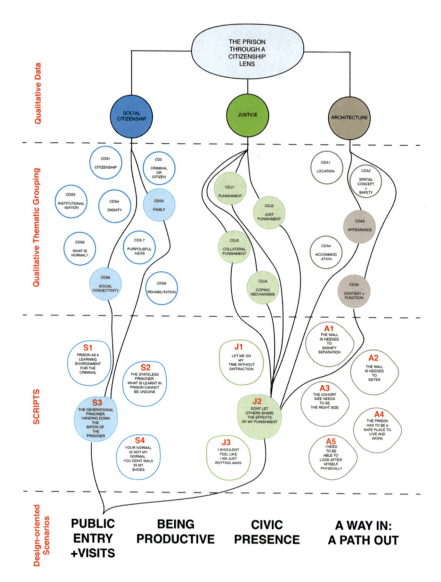

Fig. 4.1 Reference project workflow: Qualitative to design-oriented scenarios Ph.D. project (Bradley—2021)

can be traumatic. It can be very traumatic for a young child who doesn't get it. It's not big enough to understand what's happening (Staff—2019)

It's also punishing the family in a way, especially if they've got kids, you know—to see their dad through glass screen. It's like down the track it'll play with their mind as well (Staff—2019)

I think most important to most inmates is having an ability to have a relatively normal interaction with their family and friends when they come to visit (External—2019)

first of all, it (prison) separates the person from all the support and people that they have. They lose any connection that holds them in the community that keeps them stable (External—2019)

Scripts

The role of scripts in the Collective Methodology is a translation mechanism between the qualitative method and the visualisations of the design-oriented scenarios that respond to the essence of share concerns held across the stakeholder cohort. Depending on the nature of the project, scripts can evoke a design initiative as a standalone entity, or they can be combined to create a deeper narrative. There is no one right combination of scripts and it depends on the nature/complexity of the project and the design processes as to how many would be generated. The following scripts are taken from the Ph.D. study.

Script title: The generational criminal: Concern for the handing down of the baton of the "prisoner"
Script title: The collateral damage of punishment: Don't let others share the effects of my punishment

The nature of these two scripts being related to people lean towards the functions of the prison where people approach the prison, enter, are 'processed' for a visit, move through, and meet with prisoners. These two architectural functions—the prison entry for the public and the visitor's space—are central to the design-oriented scenarios. The visualisations and textual description of these scenarios are titled for this chapter as; 'Approaching the prison' and 'Visits reimagined'. Both are concerned

with the enduring effect of the prison as a representation of the stakeholders views and concerns about the collateral and generational effect of coming into contact with the prison environment.

Both prisoners and staff were concerned that, somehow, the prison as a building had a kind of agency to pass on its meaning to those that experience it. The way it was discussed was that being near or in the prison was enough that, in some way, the building became part of the person that had come in close enough proximity. This sensing of the carceral is similar in how Crewe (2011) refers to the contemporary prison experience. Perez-Gomez (1984) alludes to this 'sensing' indirectly when he discusses the 'functionalization' of architecture in modern times and how it has lost its reference with 'philosophy and cosmology'. He argues that 'architecture has been reduced to a self-referential system whose elements must be combined through mathematical logic and therefor pretend that its meaning is derived from the system itself'. He argues that this removes any reference to the 'perceived world' and indeed, this world would unlikely have a place in the metrics of 'what works' (Scharff-Smith, 2015). The perception that a building could impart a kind of imprint of its nature onto those that come withing its influence is to my mind, a powerful force to imagine. Particularly, given the concerns raised in the research that prison can impart something like a virus fragment that is not noticeable, but possible to emerge at a later date—even across generations. This 'perception' of an insidious effect of the prison manifest in concerns for those beyond the walls and into the future. The scripts are established to articulate these notions and to evoke design-orientated scenarios that address these concerns for the prison environment.

Design Orientation Scenario. "Approaching the Prison"

This scenario represents the concern of the stakeholders in the research for the collateral effect of the prison on others. The concerns for others to share a sense of shame, indignity, fear when attending a prison is central to the design approach to seek an alternative architectural aesthetic and function for the public entry to prison. The scenario offers a shift in

function, spatial sequencing, form, scale, material, and setting. In effect, the scenario involves a new public-facing building that is positioned external to the prison wall. It has a smaller scale than what would be expected of an institutional building and is intentionally integrated into native landscape. The look, feel, and material application would suggest a modern public building similar to a library or community centre. The intention is to introduce an architectural style that integrates with other public buildings so that their similarity reduces the culture shock of approaching and entering a prison (Figs. 4.2 and 4.3).

The concept is a dedicated public entry building that is situated on the outside of the prison walls. This concept is to make the building a formal entry point to the prison but without the binary sense of being inside or outside. Situating a dedicated public entry building external to the wall has the effect of it being part of the surrounding urban fabric (if located in a built-up area), and less oppressive as it is not read as part of the prison wall. Important to note that the sally port function would be a separate facility to the public entry building.

Design Orientation Scenario. "Visits Re-Imagined"

The 'visits reimagined' scenario is intended to make a shift from the ubiquitous voluminous 'visitor centre' aesthetic (even the most modern ones) that marks the experience. The concern that the buildings will impact on children is addressed in an aesthetic that include natural elements that recall semi-formal park settings not dissimilar to what could be experienced in urban settings. Visits spaces are organised around a courtyard that is open to the sky to allow visual connection to the weather.

The concept image (Fig. 4.4) is a reception area that services visits. Notable in the design are the clear sightlines for both arriving families and relatives, and also the staff. These clear sightlines are intended to assist staff for security, but also for the visitors to be able to visually assess what is before them. It enables pre-processing the journey through the space rather than interrupted visual access that requires a person to consistently assess and adjust as they move through a space to where they need to be.

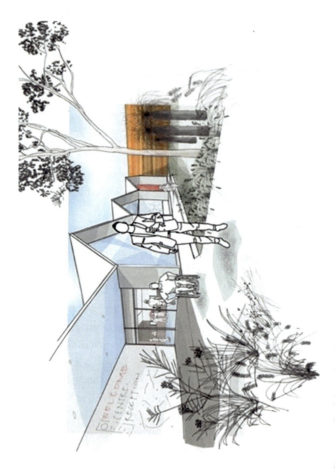

Fig. 4.2 The public entry building (Bradley—2020)

4 Custodial Design: Collective Methods 91

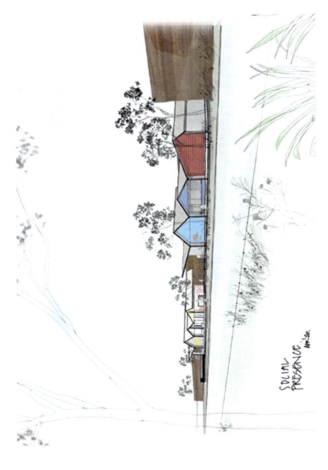

Fig. 4.3 The urban setting of the public buildings (Bradley—2020)

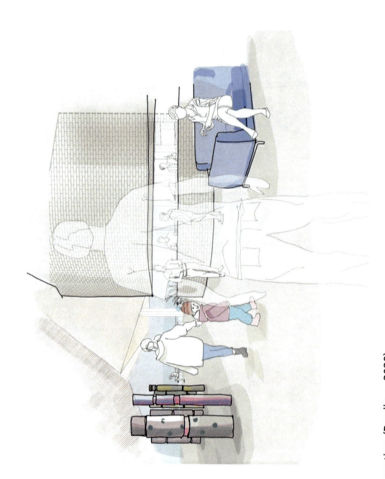

Fig. 4.4 Visits reception (Bradley—2020)

The context that this visualisation is addressing is a take on familiar circulation cues of a movie theatre box office reception, a small museum/art gallery reception, or community space. The referencing of these alternative spaces was to make spatial connections with commonly experienced environments external to the prison and broadly understood by the general public. These reference spaces are useful as they are familiar, but not something of the everyday. They involve semi-formal activities that include going to an event, being met by staff, and then receiving instructions for the next movement on the path to the event. In this case, the destination is the visits space and the event is meeting a loved one (Figs. 4.5 and 4.6).

Discussion

In this chapter, we have sought to introduce a methodology that addresses a historical deficiency in how prison architecture is conceived in design procurement practice by proposing an alternative that includes the input of people who were otherwise excluded in the process. We argue the historic 'evidence-based' self-referential practices of 'what works' that is relied on in many jurisdictions to justify contemporary custodial environments has limited capacity to recognise the nuanced needs and concerns of the human condition rendering prisons the domains of 'non-people' (Jewkes et al., 2017). The reason for the development of an alternative custodial design methodology is a response to the traditional methods of conceiving architecture rigidly through an 'evidence-based' lens to affect change in people (Scharff-Smith, 2015). That architecture has a direct causal link to affecting behaviour is widely contested in theory (Perez-Gomez, 1984) but remains a substantial justification for conceiving custodial design. Though it is understandable that governments want to link large capital expenditure to changes in reoffending outcomes, it becomes problematic when there is little theory or evidence of how the design will achieve this. It is both rhetoric and tacit denial to support what has always been done even when it is clear that it hasn't worked.

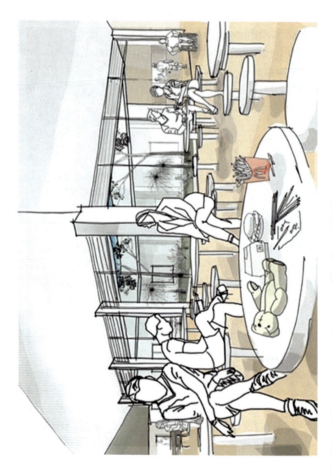

Fig. 4.5 Visits. Working with current seating types (Bradley—2020)

4 Custodial Design: Collective Methods 95

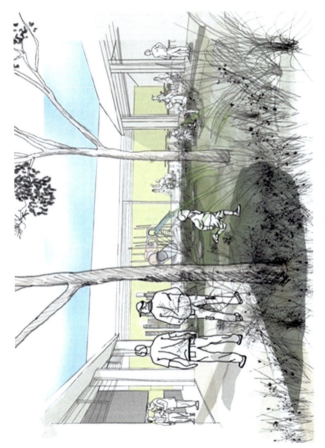

Fig. 4.6 Visits reimagined. Courtyard and native vegetation (Bradley—2020)

While the metrics and promise of 'rehabilitation' underlies the justification for new correctional centres, that recidivism remains around 50% (for many liberal democracies) is itself evidence that the design of these buildings and the associated systems are not working. The original arguments that underpin the design of a prison were said to be based on 'evidence' of 'what works' and then, after years of budget development, securing funding, design procurement process, design, construction, operation, are buried and unreconcilable decades later as statistics of recidivism remain consistent (Smith, 2008, p. 180). And, so the wheel of custodial design turns to arrive back where it started (Kerr, 1988). 'Targets' as a justification for a new facility are set, governments and society are in tacit agreeance that the targets are good and the new facility is justifiable. The design brief is drawn up and substantiated by 'evidence', an architect wins the job and designs based on a second-hand description of the people that will live in their design, and the project is constructed and operates—without the input from people that are directly impacted by the design.

The Collective Methodology for conceiving new custodial environments in this chapter is not intended to be the answer to the whole of custodial design procurement. Given the complexity of a new prison facility, this would not be feasible. It is intended to challenge conventional 'what works' design procurement to include the voices and concerns of those that are directly impacted by the design of custodial environments and for this information to creatively engage and query the justice agency's brief for a proposed prison (Moran et al., 2019, p. 75). Through the visualisations of 'design-oriented scenarios', the method offers the opportunity for the justice agency and the public to engage on issues that are significant prior to the locking in of the design brief (Goble, 2011; Moran et al., 2019). Given the social sentiment that has developed in recent times with the rise of De-fund the Police towards the power structures of justice (ICPA, 2021), custodial design is likely to change from the justice agency's articulation of what is just and safe to a shared and possibly dispersed function beyond the prison walls and into community. The rising sentiment for having a say in how societies

function indicates design procurement methodologies like the 'Collective' that engages stakeholder involvement will become more relevant into the future.

A proposal for collective methods in custodial design is not an argument that is going to dramatically change current procurement systems. Indeed, to some extent prisons will continue to be required for specific functions in most societies (Maurer in Baggio et al., 2018, p. 6; United Nations, 2015; UNOPS, 2016). But the intention is it will create change through the type and extent of different design information that the Collective Method is expected to contribute to established design procurement. It may change the nature of the custodial design procurement process by opening up and including the possibility for creative outcomes in ways similar to those discussed by Cross (2006, pp. 43–44):

> In creative design, it is not necessary that such a radical shift of perspective has to occur in order to identify a "creative leap" and, creative design is not necessarily the making of a sudden "contrary" proposal, but is the making of an "apposite" proposal. Once the proposal is made, it is seen to be an apposite response to the given, and explored, problem situation.

A Place for the Collective Method

To conclude this discussion, we will look to find a place for the collective methodology in the contemporary practices of custodial design procurement. We have spoken about the conventional 'what works' attitude to design procurement and the reliance on 'targets' and 'quantification' as justification of a design. There are other entities such as the International Committee for the Red Cross that have published on prison design that call for design practice towards 'Humane Prisons' (Baggio et al., 2018). Even in the ICRC publication, participation in design is mentioned as a general approach, but not expanded on greatly in terms of stakeholder viewpoint is the basis for design or ways to make their involvement explicit. Where the proposed collective methodology and broader conventional societal objectives (such as recidivism rates)

can coexist, is if we view the method as a way to identify and collectively solve aspects of a broader aim such as reduction in recidivism. So, rather than the architect designing in some abstract way to achieve an abstract goal of 'reducing recidivism', the collective method would identify a group of stakeholders and engage with them on the topic of recidivism. This would include directly engaging with current and former prisoners, staff, families, advocate groups, and government agencies (including Ombudsman, health, housing) to establish a number of design-oriented scenarios or visualisations of the collective response to the architecture of 'recidivism'. The visual nature of the method is not intended to be prescriptive in terms of *'this is the answer, and this is what a new prison will look like',* but a mechanism to share and critique a collective vision for things that will contribute to the higher aims of 'reducing recidivism'.

The method also reduces some of the opacity in conventional custodial design by being inclusive in its operation and engaging in sharing the results through visual means. The main issue with this is the reticence that most liberal democratic governments have to be tagged as being 'too soft' on criminals and them having an 'overriding assumption that the public and media punitiveness must be both slaked and appeased at all cost' (Brown & Wilkie, 2002, p. xx). As Wilkie further argues, 'a major problem generated within such a political imperative is that neither the discourse nor the constituencies of public support for penal reform are built up' (Ibid, 2002, p. xxi). While the reticence of governments to do anything 'positive' in the prison space, there is a perfect storm brewing for governments—particularly those that represent liberal democratic societies. The broad view to 'keep prisons off the front page' and to provide custodial facilities in an opaque manner (Brown & Wilkie, 2002; Jewkes et al., 2017) is starting to be indirectly questioned by global social movements that are challenging institutional forms of power such as 'De-fund the Police' (ICPA, 2021). In light of recent years of social upheaval (de-fund the police, me too, climate activism, Black Lives Matter), the era of governments facilitating punishment in a complete veil of opacity is likely to be nearing an end and the architecture of the prison will represent the new era of shared social understanding of the general will for the common good (ICPA, 2021). The practice

of custodial architecture will no doubt change from the old world to the new and the architect has an opportunity to be less a service provider and more a social facilitator of collective methods to arrive at shared visions of the future.

To finish we return to where this journey of exploring socially inclusive methods as part of design practice by revisiting the Learning Centre in New South Wales—Australia. Two unrelated opportunities presented themselves so the collective design practice could be explored. Both are significant for the future development of similar methods. The first opportunity was working with a Client representative from Corrective Services NSW for the Learning Centre. She had the vision for the space and an openness to design that was participatory. The second opportunity was to enter a Ph.D. as a practising architect undertaking independent research without the restrictions of commercial design practice or having to be fearful of public or media attitude (that's not to say that there was no fear). Both opportunities appear to be good fortune in that there was an intelligent and caring Client for the Learning Centre, and in the case of the Ph.D., independence from the various external forces that contribute to the making of custodial environments.

For us, as researchers and design practitioners, these opportunities were not simply good fortune. We *actively* work as researchers and practising design professionals in the interstitial spaces that exist between the justice institutions, academia, commercial practice, and stakeholders. We seek out opportunities to work with others in the contested nature of the prison environment. We claim that space to make a change and it is these spaces in between entities that we see the value in making connections and solving complex 'wicked' problems—like reconciling the qualities/meaning/function of penal environments and their intrinsic role in contributing to the wellbeing of society. We do not underestimate the role that we have as designers, nor the generosity of those that we work with both within the walls, in the community, and in the meeting rooms of government clients. We contend that the 'collective' methods we employ both in practice and research that rely on 'lived-experience' are unique and also complimentary (rather than a substitution) contribution to the established body of knowledge of 'what works' and the future for conceptualising prison environments in practice (Fig. 4.7).

100 K. Bradley and R. Lulham

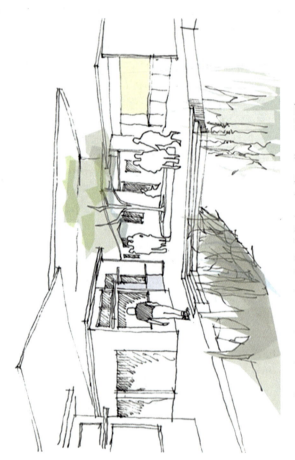

Fig. 4.7 Learning centre. 'Design-oriented scenario: Collegial' sketch (Bradley—2013)

It is not inconceivable in the near future that governments will be wanting/needing to establish ways to be socially inclusive (and accountable) in how they conceive, design, and operate major public functions like the prison. The shift in the power relationship we have seen in recent times (and acknowledged by the International Corrections and Prisons Association [2021]) between the public and their government will mean future opportunities for design. The space between government and the public is a place where design can play a connective role so the voices that were once unheard now are part of the design process of custodial environments and contribute to the wellbeing of society. The design community will need to mobilise and establish new strategic allegiances with other professions and stakeholders to meet the challenges of new world and shape future custodial design.

Bibliography

Baggio, A., Ballon, V., Chesla, E., Deman, C., Farbstein, J., Giesen, V., Goble, R., Marambio Avaria, A.E., McBride, L., Miller, R., Murphy, M., Olabegoya, R., Paurus, M., Preya de Alba, A., Sen, S., Snell, S., Team, D.O.C. & Wener, R. (2018). *Towards humane prisons. A principled and participatory approach to prison planning and design*. International Committee of the Red Cross.

Bauman, Z. (2000). Social issues of law and order. *British Journal of Criminology, 40*(2), 205–221.

Brown, D., Hogg, R., Finnane, M., Pratt, J., & Eriksson, A. (2013). Review essay: John Pratt & Anna Eriksson (2013). Contrasts in punishment: An explanation of anglophone excess and nordic exceptionalism. *International Journal for Crime, Justice and Social Democracy, 2*(3), 120–134.

Brown, D., & Wilkie, M. (2002). *Prisoners as citizens: Human rights in Australian prisons*, Federation Press.

Consoli, G. (2012). The architect's dilemma: A self reflection in understanding prison design and construction in private prison projects. *Australasian Journal of Construction Economics and Building, 6*(2), 1.

Costanza-Chock, S. (2020). *Design justice: Community-led practices to build the worlds we need*. The MIT Press.

Creswell, J. W., & Poth, C. N. (2016). *Qualitative inquiry & research design: Choosing among five approaches* (4th ed.). Sage Publications.

Crewe, B. (2011). Depth, weight, tightness: Revisiting the pains of imprisonment. *Punishment & Society, 13*(5), 509–529.

Cross, N. (2006). *Designerly ways of knowing* (1st ed.), Springer.

Crotty, M. (1998). *The foundations of social research: Meaning and perspective in the research process.* Sage Publications.

Department of Justice. (2021). *Reducing recidivism in the prison population.* NSW Government. viewed 04 June 2021. https://www.nsw.gov.au/premiers-priorities/reducing-recidivism-prison-population.

Fairweather, L., & McConville, S. (2000). *Prison architecture: Policy, design and experience.* Architectural Press.

Garland, D. (1990). *Punishment and modern society: A study in social theory.* Clarendon Press.

Goble, E. (2011). Dwelling between word and image: Using images in phenomenological writing. *interdisciplinary.net*, p. 14.

Hancock, P., & Jewkes, Y. (2011). Architectures of incarceration: The spatial pains of imprisonment. *Punishment & Society, 13*(5), 611–629.

ICPA. (2021). *ICPA planning & design webinar: Prisons of the future.* International Corrections and Prisons Association. viewed 27 May 2021. https://icpa.org/events/icpa-planning-design-webinar-prisons-of-the-future.

Jewkes, Y., Slee, E., & Moran, D. (2017). *The visual retreat of the prison non-places for non-people,* Taylor and Francis.

Kerr, J. (1988). *Out of sight, out of mind: Australia's places of confinement, 1788–1988.* National Trust of Australia (NSW), Melbourne.

Manzini, E., Coad, R., Friedman, K., & Stolterman, E. (2015). *Design, when everybody designs: An introduction to design for social innovation.* The MIT Press.

Maruna, S. (2001). *Making good. How ex-convicts reform and rebuild their lives.* American Phsychological Association.

Moran, D., Jewkes, Y., & Lorne, C. (2019). Designing for imprisonment: Architectural ethics and prison design. *Architecture Philosophy, 4*(1), 67–81.

Nadel, M. R., & Mears, D. P. (2018). Building with no end in sight: The theory and effects of prison architecture. *Corrections, 5*(3), 188–205.

Perez-Gomez, A. (1984). Architecture and the Crisis of Modern Science. *The Journal of the School of Architecture University of Illinois as Urbana-Champaign, 2*(1), 6.

Perez-Gomez, A., & Pelletier, L. (1992). Architectural representation beyond perspectivism. *Perspecta, 27,* 20.

Porter, S. E., & Robinson, J. C. (2011). *Hermeneutics: An introduction to interpretve theory*. Eerdmans Publishing Co.
Scharff-Smith, P. (2015). Reform and research: Re-connecting prison and society in the 21st Century. *International Journal for Crime, Justice and Social Democracy, 4*(1), 33–49.
Smith, P. (2008). *Punishment and Culture*. University of Chicago Press.
Stephan, P. (2015). Designing 'matters of concern' (Latour): A future design task? pp. 202–226.
Tubex, H. (2015). Reach and relevance of prison research. *International Journal for Crime, Justice and Social Democracy, 4*(1), 4–17.
Turner, J. (2012). Criminals with 'Community Spirit': Practising citizenship in the hidden world of the prison. *Space & Polity, 16*(3), 321–334.
United Nations. (2015). *The United Nations minimum rules for the treatment of prisoners*, V.16–00193, UNODC justice section, division for operations. viewed 06 April 2017.
UNOPS. (2016). Technical guidance For prison planning. In United Nations Office for Project Services—UNOPS (ed.), UN. viewed 06 April 2017. https://www.unops.org/SiteCollectionDocuments/Publications/TechnicalGuidance_PrisonPlanning.pdf
Wirsu, P. (2021, June 30). Do we jail people for being poor and disadvantaged? *Justice deep dive, series*, Australian Broadcasting Commission.
Wolf, G. (2014). *Prisons*, Clog.
Yee, J. S. R. (2010). Methodological innovation in practice-based design doctorates. *Journal of Research Practice, 6*(2), 14.

5

What Works Least Worst? A Personal Account of Two New Prison Design Projects

Yvonne Jewkes

Introduction

In this chapter, I will relate two personal experiences of being part of teams planning and designing new prisons. One was in Auckland, New Zealand, the other in Limerick, in the Republic of Ireland. What the two share in common, apart from my engagement as a consultant on both projects, was that they were each commissioned in what could be characterised as conservative social and political countries with powerful popular media that create and perpetuate negative stereotypes about people in prison. The projects' divergences, however, were starker. In many ways, these new prisons sit at opposite ends of the spectrum, in terms of their geographic location on opposite sides of the globe; their function, one being a 260-bed maximum-security men's prison,

Y. Jewkes (✉)
Social and Policy Sciences, University of Bath, Bath, Somerset, UK
e-mail: yj629@bath.ac.uk

the other, a 50-bed medium-security women's facility; and in relation to their divergent paths from commissioning to outcome, for although neither had entirely smooth journeys to materialisation, one (Limerick) was the winner of a design competition, while the other (Auckland East) was the only entry in a competitive tendering process. Only one of the facilities is likely to turn out to be an example of imaginative, humane thinking in contemporary prison design, even though both prisons were initially conceived as such. Put simply, where Auckland East fell foul of a highly risk-averse and security-obsessed corrections culture, Limerick has benefitted from a prison service prepared to take risks and commission a design that is underpinned by research evidence and international best practice. I will tell the story—or, rather, my story—of these two new prisons in this chapter. But first, a bit of context from my perspective as a criminologist with abolitionist leanings.

A Statement of Failure

The title of this Handbook was originally going to be *What Works in Custodial Design?* hence the title of this chapter, 'What works least worst?' While certain kinds of prison architecture and design may appear (to an outsider) more oppressive or progressive than others, the extent to which prisoners *feel* oppressed, or otherwise, is an empirical question (Jewkes & Laws, 2020). Even those prisons universally held to be among the best designed in the world may be experienced as profoundly painful by those who inhabit them and it is unfortunate that in recent years, penal architecture and design have become regarded as symbolic indicators, not only of rehabilitative intentions, but of rehabilitative outcomes. The conflation of these two things is unhelpful and potentially dangerous. Exaggerated claims are made by architects and academics about the role that the built environment can play in positively shaping the experience of coercive confinement and contributing to future desistance from offending. Scandinavian prisons—especially Halden in Norway—have become shorthand for rehabilitation-by-design; fetishised by commentators, many of whom have never visited these facilities, or have only been given the 'official' tours by the prison's Director. As I

say elsewhere, those who champion Halden as a 'model prison' tend to overlook the basic fact that it is a high-security facility containing people who have had violent, chaotic lives characterised by substance misuse and mental illnesses—and, in the case of approximately 40% of them, are incarcerated in a country that is not their home (Jewkes, in press).

More fundamentally even than that, though, *any* conditions of coerced confinement can potentially be felt as inherently painful and dehumanising. In research conducted at Halden in 2016 with Dominique Moran and Jennifer Turner,[1] we found that among the grievances voiced by prisoners there were: that the officers are young and inexperienced; that staff decision-making is arbitrary; that there is excessive monitoring of phone calls and letters; that the prison has a weak commitment to rehabilitation; that the regime is too 'strict'; that movement is highly restricted; and that there is insufficient access to outdoor space, which is limited to one hour per day for many prisoners. Another example of a prison that is lauded by external commentators, but experienced with more ambivalence by its occupants, is Storstrøm Prison in Falster, Denmark. Dominique and I interviewed the lead architects in 2016, who told us of their ambitious aims to produce something approaching the architecture and atmosphere of an urban environment that would be familiar to the mostly young men from cities who would be held there, but at the same time would feel like a pleasant and even aspirational place to live. Storstrøm opened in December 2017 to much fanfare, heralding it the world's most humane high-security prison. But it has since reportedly suffered many problems, including chronic staff shortages, meaning extended periods of lock-up, poor prisoner–staff relationships, and a lack of meaningful activity for prisoners.

The imaginative architecture of Storstrøm and Halden may be little compensation for the perceived problems of staffing, regime, and culture, then. In fact, it is possible that facilities like these inflict a kind of double punishment, and that the high-quality designs, and lofty claims made about them, themselves generate pain and frustration—an unfulfilled promise of something other than coercive confinement (Jewkes, in

[1] ESRC Standard Grant ES/K011081/1: 01/01/2014–30/06/2017, '"Fear-suffused environments" or potential to rehabilitate? Prison architecture, design and technology and the lived experience of carceral spaces'.

press). It may be that an aesthetically pleasing public 'face' simply does a more effective job of masking pain within, bringing its own 'insidious form of control' as it camouflages the fact of deep-end incarceration (Hancock & Jewkes, 2012: 613). Indeed, several of our research participants on the ESRC project intimated that the normalised aesthetics and natural beauty of Halden were experienced as a kind of sleight-of-hand, taunting them with a small sense of freedom, that ultimately is denied. As one man put it:

> [Before transferring here from another prison] I heard about how it looked, up in this forest and…I really like nature, so I thought to myself "why not?", because I haven't touched grass in two years…[But] it's a little bit disappointing because I can't walk in the woods; I just have to look at it. *That's more painful, actually,* because, you know, I miss the smell and the touch and how it affects me, it makes me calm…So, yeah, it's more like they put a meal in front of you, but say you can't touch it…

Increasingly, then, I find myself on shifting sands in this debate. For several years I have championed countries in northern Europe, and in particular, Scandinavia, that have experimented with designs which are explicitly linked to efforts to rehabilitate prisoners by designing prisons with attractive landscapes, colourful interiors, living spaces that approximate 'normal', domestic settings in which prisoners can cook for themselves and each other, and workshops where meaningful work provides transferable skills for use in the community on release. I have also praised those architects who have tried to design imaginative, inspiring prison spaces, that exploit the classical link between beauty and civilisation and have lamented the fact that when such plans have been submitted to prison design competitions, they have frequently lost out to proposals that look more like conventional penal institutions. At the same time, I have written about the problems inherent in the architecture and design of new prisons constructed in England and Wales. I have been critical of their size, geographical remoteness, bland external visual appearance, corporate aesthetic and excessive security paraphernalia (e.g. Jewkes, 2012; Jewkes et al., 2017). With Dominique Moran, I have argued that the restriction of space for architectural creativity and

the managerialist, regulatory and risk-averse context of prison procurement has meant that even the most benign and well-intended design decisions can get vetoed at an early stage (Jewkes & Moran, 2017). I have also advocated an 'architecture of hope' for new prisons, following pioneering designs in healthcare (Jewkes, 2018).

However, I worry that making generalised assumptions about the positive effects of a well-designed environment inhibits us from interrogating the distinctive ways in which particular individuals or groups of prisoners experience confinement. In fact, it is impossible to say with any certainty that humane, progressive custodial architecture has positive effects on its occupants because it is very difficult to extrapolate an individual's surroundings from everything else that makes up their identity, internal world, and the narratives they tell about themselves. The numerous examples of 'good' custodial design described in the chapters of this *Handbook* have undoubtedly been conceived with the best of intentions. But as I am rather too fond of saying, the road to Hell is paved with good intentions. Good intentions do not automatically result in good outcomes, and the capacity of architecture to carry, sustain and nurture hope, and give any individual in prison a future orientation (surely prerequisites of rehabilitation), is limited by all the social and structural disadvantages they face. Terry Eagleton (2015) notes that sometimes individuals' hopes will come to nothing, simply because the force of the past proves stronger than the pull of the future. In this context, even the most empathetically and imaginatively designed prisons may be experienced as places of hopelessness for those who have multiple reasons to despair.

This is not to deny that, for some prisoners, a well-designed, progressive, and humane prison may be a more enriching experience in numerous ways than a more conventionally 'institutional' facility; or at the very least it may be, in some ways, less painful than life would be in other prisons. In fact, American psychologist James Gilligan (1999) has argued that one of the reasons it's hard to 'prove' that enlightened design can have a positive impact on prisoners is that so few prisons exist that can be described as enlightened in their design. By and large, in most of the world, the only custodial environments available, especially in 'closed' or high-security prison estates are brutalising. If prisons were

more humane, Gilligan says, it would be easier for many of the men and women held in them to recognise that the source of their distress is not in their environment, bad as that may be, but in themselves, i.e. in their memories of past experience, and in the means by which they attempt to protect themselves from the pain of that experience: 'This is one reason why a humane environment is an absolute prerequisite for the healing of violent men, and why punitive environments only perpetuate the violence of the criminals who are placed in them' (Gilligan, 1999: 51).

Good prison design has wider, societal repercussions too. Radical reform of criminal justice and punishment is never likely to happen as long as prisons are ugly, spartan and over securitised, because they communicate to the public that people in prison are dangerous 'others'. When a prison conveys positive attributes (e.g. decency, trust, empathy, respect), the design challenges the cultural stereotype of what a prison is and who prisoners are, and it becomes considerably harder to hold the view that prisoners deserve to be held in brutal conditions (Jewkes & Moran, 2017). I certainly would not argue against designing more humane and imaginative prisons, then. As architectural historian Tom Wilkinson (2018: n.p.) says, the worst prisons not only confine, but they also torture and kill. In this context, 'however insidious the Ikea-furnished mind-control of the Swedish system, for instance, it would still seem preferable to spend a stretch there than banged up in ADX Florida'.

So, given my conviction that pain is an inevitable characteristic of imprisonment, and that I do not think it has to be matched by additional, unnecessary harm, the opportunity presented to me in 2014 to be involved in the design of a new prison in New Zealand, and to assist the team in conceiving a maximum-security environment that would be humane, healing, pro-social and culturally sensitive to the Māori and Pacific Islander men who made up 52% of the prison population (as compared with 16% of New Zealand's general population), seemed one that I could accept. I will say upfront, though, that it was a salutary experience.

(i) **Paremoremo/Auckland East**

Paremoremo Correctional Facility in Auckland, New Zealand was originally designed in the 1960s by JRP Blake-Kelly, an architect who favoured the Brutalist style and was inspired by early super-max prisons in the United States. By the time it was closed in 2018, exactly fifty years after it first opened, Parry as it was always known, had long since been declared unfit for purpose. I initially visited the facility in Spring 2015. I immediately could see that the purpose of the prison's architecture was to instil total psychic and bodily control over prisoners with monotonous repetition of form, hermetically sealed interiors, almost total physical separation of prisoners and officers, and minimal access to green space. Windows were positioned too high to see out of, or they looked onto bare, desolate patches of earth, and the men were confined to dark cells. Paremoremo contained one wing that was especially notorious for containing the 'worst of the worst' as described by everyone who mentioned it—D-Block. Here was where the solitary confinement cells were located, and the bleakness of the spatial environment, aesthetics and atmosphere cohered to enhance the totality of this total institution.

The replacement maximum-security facility was to be called Auckland East and, like its predecessor it has 260 beds. It was procured under a PPP (Public Private Partnership), with the contract awarded to the only bidder, Next Step Partners (NSP), led by Fletcher, one of New Zealand's biggest construction companies. I was contacted by NSP after some of the team, including the project manager and lead architect, attended a keynote lecture I gave at an Informa professional/practitioner conference held in Melbourne, Australia, in December 2014. The ethics of designing a maximum-security establishment are obviously deeply contentious and initially, I had huge misgivings about being involved in the project, but I was somewhat reassured by the New Zealand Department of Corrections' ambitions for Auckland East, as expressed in the early tender documents. They were not, they said, seeking to replace like with like. The 1960s design of the existing facility reflected an operating model focused solely on the containment of difficult prisoners, and while safe and secure constraint was to remain a critical requirement of the new facility, they were now seeking:

a flexible and innovative design that will encourage and provide for meaningful engagement between prisoners and staff, greater prisoner participation in rehabilitation, education, and employment activities, and a multi-disciplined approach across the custodial, health and psychology staff working within the facility (New Zealand Department of Corrections, 2013: ii).

Ultimately, I considered it better to be involved than not, and I believe that the team benefitted from having someone with a prison research background and criminological expertise though, in fact, the NSP team was several steps ahead of where I thought they'd be in their thinking about progressive architectural design. A group of experienced, ambitious, and very forward-thinking professionals, had previously designed a medium-security prison, then called Wiri, now Auckland South, which has a design that rewards compliance by providing incrementally better living accommodation that prisoners can progress to or regress from, depending on their behaviour.[2] The team was keen to be pushed further and I felt I had the experience and expertise to do this. I was encouraged by NSP's assurance that I was not engaged to merely critique the architects' ideas. I was expected to be closely involved in the design process and was encouraged to develop a relationship with the project team based on trust and openness. My job was to get them to consider creative solutions that were not part of their current practices and bring examples of best international practices from territories such as Scandinavia. The old Paremoremo was by far the most oppressive and volatile prison I have ever been in and the opportunity to replace it with something that looked rather more like, say, Halden prison, seemed too important not to participate.

What I didn't know when I visited Paremoremo, however, was that it was not always the violent, hellish institution it had become. I knew that it was a copy of the fearsome maximum-security prison near Marion, in southern Illinois, built to replace the infamous Alcatraz in San Francisco,

[2] Although, like Storstrøm, Auckland South's design has been hugely compromised by staffing problems and operational decisions. It is overcrowded and contains many rival gang members, which has all but nullified its original design intent. Now, the logistics of accommodating more prisoners than it was designed to hold, and keeping gangs apart, means that the original regression-progression model is untenable.

which closed in 1963. Not only considered the most secure federal jail in the US, following the murder of two prison officers, all the men held at Marion over the next 23 years were kept in permanent lockdown. Yet, as I learned later, while the architects of Paremoremo copied the telegraph-pole design, razor-wire-topped walls, and watchtowers (complete with armed guards) of Marion, Parry's early life was very different. Indeed, accounts of its first years illustrate that even externally violent and sadistic architecture can be mitigated by thoughtful design or appropriation of interiors, purposeful activity, and meaningful human relationships.

Someone who served time there, Daniel Luff, has charted this early progressiveness, noting that the prison was conceived in a relatively liberal era and was hailed as, not only the most technologically advanced prison in the world when it opened in 1968, but one of the most rehabilitative too. Designed to promote humane living and provide as much freedom as possible within the secure perimeter, its open, barred cell-fronts, naturally lit corridors and verdant countryside views saw it labelled by some as too cushy and it became known as one of the best prisons in the country to serve time in. Prisoners were unlocked at 7 am and were not returned to cells until 13 h later. Each unit consisted of four corridors of twelve cells, which were all unlocked at the same time, allowing 48 prisoners to associate together (at the new prison the men are rarely allowed to mix in groups of two or three). Supplementing the open regime, a great deal of work, training, education, and recreational activities were provided. The gym was built to a high standard, with a sprung wooden floor and adjacent weights room, and the library was large and well-stocked with educational material as well as fiction. Contact visits were permitted for up to two hours per week. There were well-equipped workshops, a weight room and gymnasium, a chapel, and multiple hobby rooms. Activities included debating, flax weaving, bone and wood carving, kapa haka and rugby league; inter-unit competitions were a regular occurrence, and prisoners could work and study on computers in their cells. The corridors were filled with plants, caged birds, and fish tanks (Luff, 2018, n.p.).

But by the time I was there, Parry had become a brutal dog-eat-dog world shaped by internecine gang conflict, a pervasive sense of claustrophobia and high rates of mental illness. Auckland's psychiatric hospitals

would not accept referrals from the prison and with only two part-time psychiatrists working at the prison, and no separate facilities for individuals with severe psychiatric issues, Paremoremo was ill-equipped to deal with the violence and self-harm it was itself generating. In 1988, the New Zealand Government was prompted to set up a committee of inquiry into mental health services, headed by Judge Ken Mason, which reported that in the previous five years, 126 Paremoremo prisoners had mutilated themselves, 13 had attempted hanging, and 13 had killed themselves. Most of the severest cases of psychiatric illness were among Māori prisoners.

The need for a new facility with a healthier environment and dedicated mental health treatment unit had been evident to the Department of Corrections for some time, so NSP were optimistic that they would be able to push them as far as possible in imagining a custodial environment incorporating plenty of innovative 'healing', and aesthetically pleasing design cues. I shared my research findings about the effects of prison design, which admittedly were embryonic, so were supplemented by my knowledge and understanding of the sociological prison literature and by my observations from nearly twenty years of visiting prisons. Accordingly, our original masterplan was for a prison that could truly be described as a humane, 'open' and therapeutic environment (in a holistic as well as clinical sense) within a secure perimeter. The plan included staff work stations that were accessible to prisoners and were not so comfortable that officers would be tempted to stay within them, rather than coming out from behind their desks to talk to prisoners. It had bright, open-plan spaces at the end of wings for association and plenty of day rooms for prisoners and staff to relax and chat, play board games or watch TV together. There was to be a therapeutic garden and abundantly planted outdoor spaces for reading, one-to-one chats or quiet contemplation. We also incorporated well-equipped rooms for education, art, work and training, plus numerous flexible spaces that could be used for multifarious purposes. As far as we could, in every part of the prison, we incorporated design cues that would instil hope, not fatalism.

Unfortunately, the courage and creativity shown by NSP was matched by the risk aversion and security obsession that pervaded the New Zealand Department of Corrections. Senior corrections personnel were

unable to endorse an architecture of hope because their perception of maximum-security prisoners was essentially hopeless. The narrative that prisoners in New Zealand are *especially* violent is a peculiar but powerful trope that is deeply embedded in NZ Corrections and the entrenchment of this view leads to a shocking overuse of solitary confinement in prisons across the country. In the year to 30 Nov 2016, there were 16,370 recorded instances of segregation in New Zealand. With an average prison population of 9798 people, this equates to 167 instances of isolation per 100 prisoners. To put it in perspective, England and Wales, itself a high user of segregation, has a rate of 37 instances per 100 prisoners, meaning that, on average, New Zealand segregates prisoners over four times more often than England and Wales.

Every design innovation was a battle that had to be won, but nonetheless, I always believed that we would get our innovative plans over the line. The process was one of consultation between NSP and Corrections throughout, and it felt as if we were all moving roughly in the same direction. Ultimately, however, although they appeared to be on board with a design that would lower violence, reduce self-harm, nurture pro-social relationships, and diminish a sense of institutionalisation, when presented with the drawings, the Department decided that what they wanted was simply a newer, shinier version of the supermax they already had. So, the plans were undone and the architect delivered what the client asked for. A crushing sense of defeat was shared across the design team.

Nonetheless, when I visited the prison one year after it opened, at the invitation of New Zealand Corrections, the initial impression was reasonably favourable. Auckland East, which opened in 2018, is in many ways a safer, more humane environment than Paremoremo. The cells are 9.09 sq m, compared with the former 5.81 sq m cells, and each is fitted with a shower, so the men no longer have to use communal facilities on the landings, which were not provided every day in the old prison. Ceilings are higher, corridors are wider, more light comes in. The timber-clad buildings and landscaped frontage are other marked improvements on its predecessor. While superficially 'nicer', however, the new prison presented many disappointments. Everything is now brought to the units, including meals (there's no central kitchen) and all cells are

on the ground floor, with staff areas above, meaning that prisoners' movement is extremely limited on both horizontal and vertical planes, neither of which are physiologically good for human beings. Our bodies need to walk up and down inclines to prevent muscle atrophy and cardiovascular problems.

Cells are sterile, exercise yards are covered in thick steel mesh. The Assessment Unit is hardly better than Parry's old D Block in some ways, but not because of the design (though the design has many limitations), so much as the regime and culture. At the time of his eight-day inspection in early 2020—written up and published as *Final Report on an Unannounced Inspection of Auckland Prison Under the Crimes of Torture Act 1989*—the Chief Ombudsman (equivalent to our Chief Inspector) reports that five cells were not operational due to damage caused by prisoners, and that there were long delays in getting them repaired, meaning a cell could remain out of service for many months. Two of the prisoners had been in the unit for over a year, three had been there for nine months, and nine for longer than three months. Of the 22 prisoners there at the time of the inspection, 14 were handcuffed every time they left their cell. And despite being called an 'Assessment Unit', in practice, the focus is on containment, with one Custodial Officer commenting to Inspectors, *they'll be here for life*.[3]

As Alison Liebling (forthcoming) argues, officers *create* rather than maintain order. Prisoners start out sceptical and staff must convince them that a legitimate form of order can be produced if they all work at it together. But in New Zealand Corrections a 'them and us' attitude is deeply ingrained and there is no sense of them being in it together. At Auckland East there were 55 uses of force in the second half of 2019, over a quarter of which involved pepper spray.[4] Twenty-two incidents involved four prisoners. Three of those prisoners had mental health concerns and were being managed in the Special Needs Unit. During

[3] https://www.ombudsman.parliament.nz/sites/default/files/2020-12/Final%20report%20on%20an%20unannounced%20inspection%20of%20Auckland%20Prison%20under%20the%20Crimes%20of%20Torture%20Act%201989.pdf.

[4] https://www.ombudsman.parliament.nz/sites/default/files/2020-12/Final%20report%20on%20an%20unannounced%20inspection%20of%20Auckland%20Prison%20under%20the%20Crimes%20of%20Torture%20Act%201989.pdf.

my visit to the new facility, I discovered that the open workstations for staff in the middle of the accommodation units that we'd designed to promote interaction and conversation between prisoners and officers, have been encased in toughened glass at the request of staff who said they feared violent assault. The communal day rooms where prisoners and staff were intended to be able to relax, chat and play boardgames were being kept permanently locked because, again, staff said they felt unsafe using them. In the timber-clad visiting hall, wooden chairs for visitors had been designed to 'soften' the space. Why, then, were the seats that the prisoners had to sit on during visits, small, hard, metal stools? A senior officer said without a trace of irony, *so they know they're second-class citizens*. Worst of all, the therapeutic garden I'd fought so hard for was not open to prisoners because a water feature had been declared a health-and-safety hazard. The fear was that prisoners could hurl themselves at the rough-hewn stone base, splitting their heads open in deliberate acts of self-harm. But, once again, the real problem was that officers had refused to escort prisoners into the garden because they said they felt unsafe.[5] For me, all these examples demonstrate the real harm of the rhetoric of violence that pervades NZ Corrections. It has become desperate, despairing and, worst of all, a self-fulfilling prophecy.[6]

The NSP team all believed we could make a positive difference to the lives of men at the deepest end of the carceral estate in New Zealand, but we came up against a pugilistic and risk-averse staff culture—from the CEO of Corrections who felt unable to sign off on the initial forward-thinking design, to the prison officers on the wings who felt empowered only when operating an authoritarian, security-focused operating model and when protected by bullet-proof glass. The belief that this prison was built to house the worst of the worst, and that prisoner–staff relationships could never be anything but a brutal war of attrition, has been

[5] This was still the case in 2020 when the Chief Ombudsman's report said the sensory garden was 'spacious, well maintained and well stocked with a variety of plants' but the Inspectors did not observe the sensory garden being used.

[6] All prison officers in all NZ prisons wear stab-proof vests. I found their rationales for doing so ridiculous (I was told that the vests helped to protect officer's heads if they were pushed over!) Just as vandal-resistant fixtures and furniture can reinforce negative labels, I believe that stab-proof vests support prison officers' preoccupation with safety and risk and may invite assault.

carried over from the old Parry and become deeply entrenched in the new prison.

Auckland East illustrates that architecture is synergetic with power and authority, and those who commission, design or sanction places of confinement can enact social and political censure through bodily control and invasion. State violence and the infliction of physical and psychological pain ensure that penal policy and practice remain wedded to retributive intentions that seem almost Medieval in intent. For the white supremacist gunman who killed 51 people at two mosques in Christchurch in March 2019, life-without-parole at Auckland East will be bleak. Talking to a friend who was a senior member of the NSP team about the case a few days after the sentence was passed, he said had the perpetrator been incarcerated at the old Paremoremo, he would not have survived: *'it would have been a badge of honour for someone to take him out'*. The hermetically sealed environment of the new segregation cell he is in, with no contact necessary between him and a single other human being, is a very different kind of Hell, as my friend contemplated:

> Imagine living in those cells that are completely soulless, with no contact with anyone. A tiny exercise yard with concrete rocks as soft furnishings. He'll barely be able to see the sky. And that's his life as a 30-year-old man. To live a life without any hope whatsoever. To know he's going to die in that box.

Officers will control his living conditions—in-cell temperature, lighting, power—from remote consoles. His light is likely to be kept on 24 h a day. The combination of sensory deprivation and sensory overload, together with the brutal blandness of Auckland East's interior—for even the bits that weren't made of concrete were painted the colour of concrete—puts me in mind of Vidler's (1999) argument that, in forcing him to abandon his spatial markings (imaginary and real), the torturer wants his victim to regress, he wants to demean his prey, to make him lose his identity as a subject. Or, as prison sociologist Gresham Sykes (1958: 6) put it, 'a man perpetually locked by himself in a cage becomes semi-human'.

(ii) Limerick women's prison

Having described the disappointment of Auckland East (and more detail about the prison and my involvement in its design will be in my forthcoming, as yet untitled, book) I now turn to a happier story—my role in a new custodial design which, on some levels at least, looks as if it might 'work'. Built to replace one of the oldest operating prisons in Europe, having been built between 1815 and 1821, the new Limerick women's prison is due to open in the summer of 2022. In the 'old' Limerick prison cellular accommodation is poor, with all prisoners held in catacomb-like cells, with tiny, heavily barred windows and inadequate ventilation. Access to natural daylight is scarce and the exercise yards are small concrete spaces enclosed by high walls topped with razor wire. Following a 2003 Irish Inspectorate report, which described the environment and accommodation as 'deplorable', the Irish Prison Service undertook to refurbish the women's unit, installing toilets in cells and replacing double-bunks with single beds. But the wisdom and humanity of having an open toilet within a few inches of the pillows on which female prisoners at Limerick rest their heads at night was always a source of embarrassment and contention, and IPS were welcoming of the idea of incorporating innovative thinking into their plans for a new women's unit that would take the accommodation from 24 cells to 50, thus easing the pressure not only on Limerick but on Ireland's other women's facility, the Dóchas Centre in Dublin.

Like my initial contact with NSP, my introduction to the Irish Prison Service (IPS) came via a keynote lecture I gave; also, as it happens, in Melbourne. This time, it was the then Director General Michael Donnellan who attended my plenary, 'Designing Punishment: Balancing Security, Creativity and Humanity in Contemporary Correctional Systems', at the International Corrections and Prisons Association (ICPA) conference in October 2015. He followed up by sending his senior management team to hear me give a further keynote on 'Prisons and Humanity', at The Hague, in March 2016, and in the same month, I was asked to present to IPS's Capital Projects Oversight Board in Dublin. I was then formally engaged in the project and was asked to write the design brief that would be given to competing contractors. In fact, I

was asked to advise on several projects for IPS—extensions and/or refurbishments to Limerick men's prison, Wheatfield, Clover Hill, Mountjoy and the Dóchas Centre for women—but it was the brand-new Limerick women's prison that was to be my main focus.

As one of IPS's senior managers said in a joint conference presentation we later gave, they were already some way into the design process when they attended my lectures, and the original plans for Limerick were, in his words, 'highly prescriptive', 'innovative to a slight degree' and driven by 'engineering and security' considerations—a 'prison with a "soft" edge but primarily a prison' that had 'no architectural empathy with prisoners'. When they heard my presentations, IPS 'tore up the design and started again with a blank sheet of paper' (quotes from slides prepared by Ciarán Nevin in a joint presentation we gave; 'Prioritizing Innovation in the Design of a New Prison in Ireland', at ICPA, London, 2017). As with the team in Auckland, I encouraged IPS to be bigger and bolder in their ideas, and to think what an 'architecture of hope' might look like. Crucially, I persuaded IPS to hold a design competition, as was more common in northern Europe.

Four consortia of contractors were shortlisted and I presented my research at several specially convened workshops that also included IPS managers and prison governors at Portlaoise Prison Staff College and in Cork. Among the exemplary designs, I showed them was the new national facility for women planned at Inverclyde to replace the much-criticised Cornton Vale. HMP Inverclyde was never actually built. Following an Inquiry headed by Dame Elish Angiolini QC, it was announced that the planned 300-bed prison was to be shelved in favour of a 'bolder' and 'more radical and ambitious approach' to female offenders in Scotland, which would attempt to divert women away from carceral spaces rather than creating new institutions for their confinement. The proposals and plans for the unrealised Inverclyde, however, remain among my small compendium of 'exemplars' of radical, bold and ambitious prison design. Although mired in controversy because 300-beds for a national female prison population of around 400 would have been a large prison with all the attendant problems associated with location and visiting, Inverclyde was nonetheless ground-breaking in many aspects. The design team was unusual in the UK context,

bringing together several senior prison service personnel and architects who were all working towards creating a therapeutic, trauma-sensitive and innovative prison environment.

One of the lead architects who Dom, Jen and I interviewed for the project, admitted that he had learned a huge amount from prison service colleagues on the design team about the complex lives and challenging needs of the women who would be accommodated at Inverclyde and he expressed sadness that the prison was not going ahead, while being entirely understanding of the ethical arguments for its non-materialisation. I shared his disappointment, simply because HMP Inverclyde looked like something other than a prison. It was light, bright, and avowedly 'normal' in feel. In fact, when I showed the architects' renders for Inverclyde to women in the Dòchas centre in Dublin (as part of a consultation process to gain ideas from serving prisoners regarding what they would like to see in the new Limerick women's facility), their responses to the images of the pastel-coloured cells were poignant: 'Wow, that's the nicest room I've ever seen'; 'That's nicer than my bedroom at home'.

At Limerick, I attended mid-tender clarification meetings hosted by IPS, at which the competing contractors presented their preliminary design schemes. Along with the personnel on the assessment team, I provided each consortium with detailed feedback to assist them in fully meeting our expectations regarding architectural innovation in their final design specifications. In February 2018, I spent seven days in Limerick on the Quality Assessment Panel (which numbered ten people, including personnel from the procurement and project management company, IPS managers, the Governors of Limerick prison and the Dóchas Centre, and a prison project manager from Scotland) for the final evaluation, in which each of the four competing consortia presented their design schemes. We scored them against a list of criteria and selected the winning contractor—PJ Hegarty. The successful design for Limerick women's prison is a radical departure for IPS and was, highly unusually, the second most expensive submission shortlisted, underlining that it was design, not cost, that was prioritised.

The 'winning' design includes many of the cues I encouraged them to incorporate. The colour palette is similar to that of the unbuilt Inverclyde

with lots of pale (but not insipid) shades of lilac and blue in the living spaces. Getting away from the institutional feel of long straight corridors and sharp corners with their inevitable blind spots, the architects have introduced as many curves into the structure as possible. There is a large oval skylight that allows natural light to flood into the social spaces in the middle of the accommodation units in the manner of some of the architecturally pioneering Maggie's Cancer Care Centres, many of which are designed by 'starchitects' including Frank Gehry, Richard Rogers and Zaha Hadid (Jewkes, 2018). Also, like Maggie's Centres, the furniture in Limerick prison is domestic—sofas and armchairs—and bedrooms are decorated in neutral colours and furnished similarly to a student hall of residence. There are no bars on any of the large windows. All the bedrooms look on to a garden full of mature trees, lush planting, and lots of seating. The visiting room, reached via a welcoming reception area, is bright and avowedly 'normal' in feel—more like the kind of café you would find in John Lewis, say, than a typical prison visitation space. The visits room also has outdoor space including a play area with climbing frame and slide for children.

As a result of my involvement in Limerick women's prison, I won the ESRC Celebrating Impact Prize 2020, which highlights the 'real world' impact of academic research that has been supported by the ESRC. As part of the award, a short video[7] was made about my research, which entailed a visit to the construction site with a filmmaker in October 2020. Various prison service personnel and the lead contractor did pieces for camera about the influence of my research on the winning design. The prison was about two-thirds built at the time and was little more than a concrete shell with no roof (it was raining on the day I was there and was fast becoming a swimming pool as I was given a tour of the site). Nonetheless, it was genuinely exciting to see the building coming to realisation. It is fair to say that I am somewhat biased in thinking that Limerick is a good design. However, I am conscious that our plans could look like architectural utopianism. Mindful of prison scholar Pat Carlen's (2008) notion of 'imaginary penalities', I have seen the concepts

[7] https://esrc.ukri.org/research/celebrating-impact-prize/previous-years-winners/impact-prize-winners-2020/.

of 'rehabilitative cultures', 'normalisation' and 'trauma-informed' gain speedy traction within prison circles, only to fall out of favour when they don't quite live up to their heady promise. They fail not because they don't make a difference to the quality of everyday life, but because there is little they can do to address the broader, long-term, structural conditions that make rehabilitation and understanding of trauma necessary. 'Normal' for many women who end up in prison is poverty, men's violence, an absence of resources outside of the prison, and the penal system's failure to enable prisoners to imagine a law-abiding future. In other words, these well-intentioned initiatives probably make the people who implement them feel better than the people on the receiving end of them.

I have discussed elsewhere the problem at the core of creating 'beautiful' prisons—the 'lipstick on a pig' syndrome, whereby a kind of false consciousness is created, the pains of imprisonment are masked, and the imagined 'progressiveness' and 'attractiveness' of these thoughtfully designed prisons somehow become part of the justification to build yet more prisons (Jewkes, 2018, forthcoming). Warning against the seduction of 'sanctified, Zen-like principles of toleration, respect and understanding', Joe Sim says, the often 'physically grim, psychologically lacerating and spiritually withering reality of prison life is quite different from the imaginary, inclusive prison' (Sim, 2008: 143). It's also the case that my years of research experience have taught me to expect that, when open, Limerick women's prison, will reveal many compromises from the architects' renders to the completed project. The result is that new custodial buildings never look quite like the early visual images. For one thing, you rarely see any people in architects' computer-aided images—or, if you do, they are shadowy, idealised figures whose presence seems fleeting and acquiescent. This professional convention always strikes me as particularly odd when it comes to prisons because the numbers of bodies that occupy those spaces and the sheer corporeality of carceral settings, where bodily fluids and heightened emotions frequently mingle in messy, unpredictable ways, are so at odds with the norms of architects' renders, which tend towards the anodyne. Few would deny that in prisons, architecture and people constantly transgress each other's rules, implicitly and explicitly.

In short, then, I am not expecting the prison that eventually opens in Limerick to look exactly like the calm and imaginative spaces visualised in the artistic renders and I am all too aware of the charges of utopianism that could be thrown my way. However, as historian Russell Jacoby (2005) notes, *reform depends on utopian dreaming—or at least utopian thinking drives incremental improvements*. IPS managers also report that they're holding the contractor—who inevitably will try and cut corners to save money and make more profit—to account on delivering the design promised. As my friend said, it is such a radical departure for them, that *even if they only get 80% of it over the line, it will be massive*. Their commitment indicates that Limerick is not simply a one-off experiment, but that through deep engagement in my research over an extended period, the Irish Prison Service has come to view prisons as potentially transformative environments that can have positive impacts on the lives and futures of traumatised and criminalised women. I hope that when I return to Limerick to conduct further research funded by my ESRC Impact prize money, I will find a facility that is recognisable as the humane, imaginative, and therapeutic environment we chose in the design competition.

Conclusion

What these experiences underline for me is that architecture and design can only go so far in creating a rehabilitative culture in prison. Gilligan's advocation of humane prisons as an absolute prerequisite for the healing of violent men so goes against the grain of populist political opinion in conservative, risk-averse jurisdictions that some offenders seem destined to remain trapped in a cycle of brutalisation, violent crime, and incarceration. England and Wales is no better than New Zealand in this respect. When Priti Patel became Home Secretary in 2019 she said she wanted criminals to 'literally feel terror' at the thought of breaking the law. Less than a year later, the 23-year-old brother of the man who detonated a bomb at the Manchester Arena in May 2017 killing 22 people, was sentenced to at least 55 years—a record for a determinate

sentence. Violence has become the rejoinder to violence; terror is the UK government's response to terror.

Prison officers actively reproduce such attitudes when they abuse their authority with corporeal violence and spatial violation. The New Zealand Chief Ombudsman noted that one man at Auckland East has his cell searched three times every day. Further illustrating the disproportionality of aggressive force, this time against female prisoners in Auckland, a New Zealand media report from November 2020 headlined '*Gassed in their cells, "begging" for food at Auckland Women's prison*' describes multiple humiliations and assaults inflicted on female prisoners, which breach the International Convention Against Torture. In just one example, the report tells of how prison officers deployed four cans of pepper spray beneath the cell door of a woman with asthma. The woman concerned had been held in solitary confinement for four months. The segregation unit is intended to hold individuals for no more than two weeks, and if someone is to be kept there longer than 14 days, the prison must have the permission of the Chief Executive. To keep a prisoner there for more than three months, a judge must visit the facility. In court, the prison's Deputy Director admitted she didn't know these rules existed.

Meanwhile, there are numerous examples of prisons around the world that attempt to be innovative, normalised, even aspirational in their design. It is hard to argue that they are anything other than appropriately civilised environments in which to hold people who have been convicted of crimes. However, when the logic of 'better design makes people better' is applied to the architecture of incarceration it becomes highly problematic. Put simply, it is a tough ask of the built environment to change a person's outlook and sense of their own capabilities and prospects. In a nutshell, whatever opportunities an individual establishment offers to help prisoners cope with life in confinement, including through attractive, aesthetically pleasing environments, removing another human's liberty, autonomy, and choice (including who they live with) are still near-universally felt as violent, eviscerating acts.

Furthermore, even architects who believe they can be a force for good, and who create aesthetically pleasant living and working environments for the majority of a prison's occupants appear to have less success—and I would say less interest in—designing progressive or 'normalised'

environments for those individuals held in solitary confinement for their own protection or as punishment. The only prison design that I've come across where an attempt had been made to 'civilise' segregation was once again at HMP Inverclyde. Here, the 'Separation and Reintegration' unit had a mixture of 'timber effect' floors and carpets, together with a feature wall with decal graphic of a bluebell forest, intended to calm prisoners as they entered. Again, though, one must wonder whether this would alleviate the stress of what, for many, would be a traumatising environment whatever colour it was painted. The 'rehabilitative' prison may thus be an oxymoron or even a smokescreen for the pains that all incarceration inflicts (Hancock & Jewkes, 2012). In this context it seems justifiable to ask, not what works best, but what works least worst?

References

Carlen, P. (Ed.). (2008). *Imaginary penalities*. Routledge.
Department of Corrections. (2013). *Invitation for expressions of interest: Auckland prison PPP project*. Dept. of Corrections.
Eagleton, T. (2015). *Hope without optimism*. University of Virginia Press.
Gilligan, J. (1999). *Violence: Reflections on our deadliest epidemic*. Jessica Kingsley.
Hancock, P., & Jewkes, Y. (2012). Penal aesthetics and the pains of imprisonment. *Punishment and Society, 13*(5), 611–629.
Jewkes, Y. (2012). Penal aesthetics and the art of prison architecture. In L. Cheliotis (Ed.), *The arts of imprisonment: Essays on control, resistance & empowerment*. Ashgate.
Jewkes, Y. (2018). Just design: Healthy prisons and the architecture of hope [John V. Barry endowed memorial lecture]. *Australian and New Zealand Journal of Criminology [by Invitation of the Editors], 51*(3), 319–338.
Jewkes, Y. (2020). "An Iron Fist in a Silk Glove": The pains of Halden prison. In B. Crewe, A. Goldsmith, & M. Halsey (Eds.), *Power and authority in the modern prison: Revisiting the society of captives*, Clarendon Press.
Jewkes, Y., & Laws, B. (2020). Liminality revisited: Mapping the emotional adaptations of women in carceral space. *Punishment & Society, 23*(3), 394–412.

Jewkes, Y., & Moran, D. (2017). Prison architecture and design: Perspectives from criminology and carceral geography. In A. Liebling, S. Maruna & L. McAra (Eds.), *Oxford Handbook of Criminology* (6th edn). Oxford University Press.

Jewkes, Y., Slee, E., & Moran, D. (2017). The visual retreat of the prison: Non-places for non-people. In M. Brown & E. Carrabine (Eds.), *The Routledge handbook of visual criminology*. Routledge.

Liebling, A. (forthcoming) to be added.

Luff, D. (2018). A view from the inside. Available https://www.pressreader.com/australia/north-south/20181112/283643940962301. Accessed 30th July 2021.

Sim, J. (2008). Pain and punishment: The real and the imaginary in penal institutions. In P. Carlen (Ed.), *Imaginary penalities*. Routledge.

Sykes, G. (1958). *The society of captives*. Princeton University Press.

Vidler, A. (1999). *The architectural uncanny*. MIT Press.

Wilkinson, T. (2018). Typology: Prison. *Architectural Review* 11th June 2018. Available at https://www.architectural-review.com/essays/typology/typology-prison. Accessed 30th July 2021.

6

The Creative Prison Revisited

Saul Hewish

Gartree prison is currently divided into 5 cell blocks of approximately 100 cells each. Because this is perceived to be a significant number capable of starting a riot, at night when there is reduced staff, the prisoners are 'banged up' (locked in their cells) at 8.00pm until 8.00am. They spend twelve hours incarcerated in tiny spaces that are too hot in summer and too cold in winter. They look at a lavatory from their pillow which lies on a bed which is too short, with no space for a proper table to draw, read or write. This is not good enough.

We have developed an outline scheme that proposed a series of much smaller cell blocks of twelve to thirteen people. At the base of the prison villa there is a sitting room, kitchen, large table, secure external garden area and television. Each cell would have its own balcony where the growing of plants is encouraged. In this way a sense of ownership and

S. Hewish (✉)
Stoke-on-Trent, UK
e-mail: Saul@rideout.org.uk

responsibility is created within a group that is small enough to relate to. These villas are distributed within the landscape surrounded by a secure boundary.

<div style="text-align: right">Will Alsop, in Johnston and Hewish, (2006, p. 28)</div>

In 2005–2006, prison arts specialists Rideout (Creative Arts for Rehabilitation) teamed up with the internationally renowned architect Will Alsop, building specialist Wates Construction Ltd, artists Shona Illingworth and Jon Ford, and staff and prisoners at HMP Gartree, to produce The Creative Prison. This was an attempt to reimagine prison from the perspectives of those with experience of living and working in such an environment. It set out to present an alternative vision of what prison could be, especially if the starting point for the prison is not security but rather the facilitation of education, creativity and rehabilitation. This vision was presented in an exhibition that toured between 2006 and 2008 to venues in Birmingham, Nottingham, London and Wakefield. Included in the exhibition were: architectural designs and artist impressions; films reflecting on both the current experience of prison and what a future prison could be; and several large-scale conceptual artworks made by the prisoners involved in the project. In addition, Rideout produced two documents articulating the design, and setting out the case for greater 'service user' consultation in the development of new prison designs.[1]

The Creative Prison was very much a provocation; an arts project designed to stimulate new thinking about contemporary responses to imprisonment. There was never an expectation that it would be built. At the same time, however, it was not intended to be a complete utopia. The involvement of John Eynon, who was then a principal design manager at Wates, allowed architectural ideas to be tested in respect of cost and viability.

[1] The Creative Prison: Creative Thinking in the Prison Estate (2006) and The Creative Prison: Inside the Architecture - The Role of Consultation (2007).

On first sight, the designs by Will Alsop are breathtaking. There is a genuine wow factor here, but once you look beneath the surface of the presentation gloss, it is possible to see what I think is essentially a practical buildable scheme with great potential… This project isn't just about the final design but more about the ideas and discussion behind the designs.

John Eynon, in Johnston and Hewish (2006, p. 29)

It is these ideas and principles, enshrined as they were in the imagined design, that still have much relevance to prison design today, some fifteen years on. This chapter presents a reflection on the core document, *The Creative Prison: Creative Thinking in the Prison Estate* (Johnston & Hewish, 2006). These reflections are offered from the viewpoint of an artist specialising in facilitating work in prison rather than necessarily from a criminological perspective. In presenting edited sections of the original document, the decision has been taken to amend some of the language; principally that of ceasing to use the term 'inmate' in favour of 'prisoner'. Furthermore, the chapter is dedicated to the memories of Chris Johnston and Will Alsop who have both sadly died since the document's original production.

The Creative Prison project was born, in part, out of Rideout's frustration experienced over many years of running theatre projects in prisons, in spaces that were never designed for that purpose. These spaces included chapels, dining rooms, visits rooms, gyms, prison wings, converted cells and countless Portakabins. As anyone who has ever facilitated any kind of groupwork will know, the space in which that work takes place has an enormous impact on the work itself. If, for example, the space is too small (or too large), too hot (or too cold), too bright (or too dark), the quality of the experience can be impaired. It struck us that if we were struggling to deliver work in these conditions, how many other people were having similar experiences? How much was the built environment of prison helping or hindering those within it to make good on notions of rehabilitation and 'purposeful activity'? And what of the prisoners' experience? It led to the formation of a project that would

attempt to deconstruct, and then reconstruct prison from the ground up, by working with the people who know prison the best—prisoners and prison staff. We set out our stall accordingly:

> Our current prison stock is characterised by ideas of criminal justice that are plainly outmoded and ineffective. In a twenty first century society, we want and require for our prisons to do more than simply incarcerate its prisoners and inflict upon them a regime that cultivates distrust. Many prison governors and staff are endeavouring to create more humanitarian, safer, learning-centered regimes. But much of this good work is compromised, not just by unworkable criminal justice policies, but by the legacy of old, Victorian prison buildings. New initiatives cannot any longer ignore the crucial relationship between mental health and environment. If prisoners are to leave prison and not return, their time inside must be spent in activities that are conducive to good mental health as well as to learning and rehabilitation. These issues are crucially informed by considerations such as light, views, space and appropriateness of architectural design to facilitate good staff-prisoner relationships.

When Rideout embarked on its consultation to explore the issue of prison design, we had a number of key questions to orientate us.

- How effectively do current prison conditions inform a desire to effect personal change?
- What might a prison look like that made priorities of education and rehabilitation?
- How would staff and prisoners imagine such a prison?

In order to realise such a consultation, we were keen to work with people who had significant lived experience of prison. We felt that life sentence prisoners would have much to offer in this regard, especially those who had been incarcerated for a number of years. We posited they would have served time in a series of different types of prisons and so could draw on positives and negatives of that experience. We were also extremely fortunate that the Governor at HMP Gartree at the time of our initial approach, Rannoch Daly, had a personal interest in architecture and so was supportive of the initiative from the outset. As stated previously, this project was intended to be a provocation so we needed an architect with an international reputation who would bring something unique to both

the conversations and the design. We were aware of Will Alsop through his work with Jubilee Arts on the development of The Public, a large-scale community arts centre in West Bromwich, Birmingham. He was renowned both for the radical nature of his design (as exemplified for example in his design for OCAD University's Sharp Centre, Toronto, or the Peckham Library, London, for which he won the Stirling Prize for Architecture in 2000), but also for his design process which involved extensive consultation sessions with those that would likely be future users of the building. Furthermore, with Alsop onboard, we were also able to attract the interest of Wates Construction who provided support both in respect of materials and professional design expertise.

> Prior to articulating any ideas for an imagined prison, it was essential to critique the extant prison estate—to gauge the responses of staff and prisoners to existing prison conditions. What surprised us immediately was the high level of agreement between staff and prisoners at HMP Gartree over the primary issues.
>
> Both sides expressed views often supported by the other, particularly in respect of how extant prison architecture failed to assist positive interactions between staff and prisoners. The concerns these contributors perceived as the primary failings of the prison estate were:
> - the deterioration of staff-prisoner relationships
> - the unnecessary stresses placed on staff
> - the depersonalisation of prisoners
> - the dehumanising means of lock-up
> - the lack of consistency in staff
> - the absence of meaningful work practice
> - the writing of reports on the prisoners based on inadequate information
> - the inadequate facilities within the cells
> - the poor design of houseblocks
> - the problem of noise pollution throughout the house blocks
> - the inability of prisoners to control lights in their own cells
> - the absence of work-to-employment courses
> - the poor design of basins, beds, tables, etc.
> - the problem of eating food next to an open toilet.

What became clear very quickly during the initial design workshops was the impact of institutionalisation on participants—prisoners and staff alike. When asked to make initial drawings of what people thought a new kind of prison might look like, they essentially drew what they already had, albeit with bigger cells. Participants' notions of what a prison could be were so heavily influenced by their experience of living or working in prison, it was difficult for them to go beyond what they already knew. It was necessary for us to challenge this orthodoxy. Alsop posed the questions, 'Who defines what a prison looks like? Does a prison need to look like a prison?' Gradually, participants began to expand their vision, prompted by further questions about the kinds of views they would like to see out of their windows, the kinds of activities and opportunities they felt ought to be available for prisoners, and the core principles that would govern the regime of the prison.

HMP Paterson, named after former prison commissioner Sir Alexander Paterson[2] (1884–1947), is envisaged as a 500 bed, 'super-enhanced' prison for adult males who are currently designated as Category 'C'; relatively low-risk prisoners who had already been on 'enhanced status'[3] for a significant length of time, probably a minimum of one year. This status of prison was chosen in order to explore how prison resources might be used in favour of prisoners who had demonstrated a willingness to engage with a more serious course of re-education. The prison would function like a 'Secure College', operating on the basis of 100% education or training. For five days a week, prisoners would engage full-time in one or both of those activities. The prisoner attending would need to have at least two years to run on his sentence.

To enter the prison, prisoners would need to make an application from another prison, as currently happens if a prisoner wants a transfer to a prison with a therapeutic community within it. On arrival, the prisoner

[2] The original document contained an appendix about Paterson, written by Professor Alyson Brown, Edge Hill Univerity. It has not been included here in the interests of brevity, but it is worth noting that Paterson's famous phrase, 'Men come to prison as a punishment not for punishment' was extremely influential upon this project.

[3] 'Enhanced status' refers to the Prison Service's Incentives and Earned Privileges system of rewards and punishments.. A prisoner who achieves 'enhanced status' is someone who has demonstrated a high level of engagement in the prison regime and maintained good behaviour over a set period of time.

would stay for two days within the Induction and Resettlement Unit[4] in order for the details of the educational and training elements within his sentence plan to be finalised, and to confirm consent to the obligations of the regime. The basics of the education plan would already have been approved as part of the admission process.

Attendance at HMP Paterson would be for two years minimum, three years maximum. Should a prisoner cease to comply with the regime rules or withdraw from the education programme, that prisoner would, subject to procedures, be removed back to a mainstream prison. Once excluded, it would not be possible to return. It would be recognised that both governors and staff also would need to be highly motivated and committed to the principles of this institution.

The key principles are identified as:

- Social integration achieved through the creation of managed 'micro-communities'
- A balance of rights and responsibilities
- 100% education or training
- Security achieved through a balance between co-operation and compulsion, and the use of technology
- The maintenance of good staff-prisoner relationships through effective design
- The prison making a contribution to, not placing a burden on, the local community (Fig. 6.1).

These key principles were proposed and agreed upon relatively early on in the process in order that the design could most effectively respond to participants' wishes. It is worth noting that many of these principles are similar to those operating within therapeutic communities. However, when we made this observation, the prisoner participants were very keen to re-assert that this was not a 'therapy prison'. Their desire was very much that this should be a prison where the focus is on learning and practising 'life' skills rather than a place for deeper personal reflection,

[4] The Induction and Resettlement Unit as envisaged for HMP Paterson was conceived as something similar to those existing in contemporary English prisons. Similar to 'intake units' in US prisons, it would house the reception area and a number of rooms for prisoner accommodation, and would be the first port of call for any prisoner entering the prison, as well as where prisoners go before they leave the prison, either for release or for transfer to another institution.

136 S. Hewish

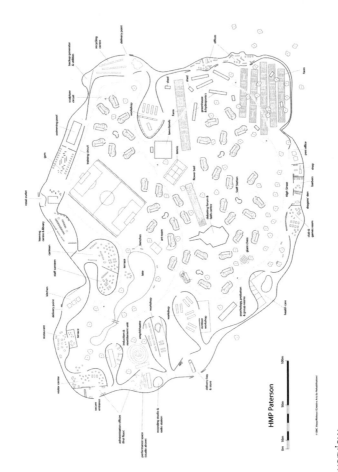

Fig. 6.1 Prison overview

although they did feel there should be a facility for helping people with mental health concerns, hence the inclusion of a psychology unit. The key elements of the prison in addition to accommodation and staff offices were a learning centre, healthcare centre, a farm, a multi-faith centre and debating forum, recycling centre, workshops, a prison shop, a restaurant serving members of the public, a visits centre incorporating a small motel for prison visitors, extensive landscaped grounds including sports facilities and a small lake, a gym with attached swimming pool, and an arts centre including performance space. It is worth noting that outside of the motel for prison visitors, and perhaps the lake, all such facilities have existed in prisons in England at some point in the last 50 years, although by no means in the same individual prison.

The most evolved element of the design within the Creative Prison is the houseblock (or 'villa' as Alsop referred to them). In part, this was because it was where we began our discussions, but also, at the time of conducting the consultations, was the place where prisoners spent most of their time. It was also the place where many of the key principles of life in the new prison were expected to be practised.

> The cell proposed for the Creative Prison is significantly larger than modern conventional prison cells. The latter measure approximately 2.1 m × 3.5 m floor[5] area whereas within our proposed prison, the dimensions are 2.7 m × 9.5 m long with an additional 2 m on the length for the balcony. The purpose of this enlargement is to diminish resentments that are often a by-product of cramped conditions. It also allows the prisoner to carry out a wider range of activities within the cell; personal exercise, showering, reading and writing. The notion that cramped conditions exist as a further punishment was regarded as intellectually and morally unsustainable by our contributors.
>
> Each individual (non-disabled) cell would contain:
>
> - a single bed approximately 2.2 m by 1 m (current beds sizes were found in our study to be grossly inadequate and failing to conform to prison guidelines)
> - a wet room for showering, washing and the use of a toilet

[5] This was the average size of new build single prison cells in England at the time of original publication.

- a table and chair, with the table large enough for books to spread, and shelving
- a television/computer monitor with access to an intranet system
- adequate cupboard space for clothes, books, etc.
- a view on to the prison grounds (not just on to the back of another building)
- means to control the in-cell lighting.

The disabled cell on the ground floor, adjacent to the association area, would additionally contain:

- disabled toilet facilities with increased access to alarms, ergonomically designed fixtures and furnishings.

Private space is also of course, potentially, a lonely space. The presence of a terminal within the cell allows direct contact on a 24 hours basis with appointed 'Listeners'[6] in order to reduce depression or impulses to self-harm (Fig. 6.2).

Shared facilities within the houseblock on the ground floor would include

- an association area with a communal table and chairs
- a kitchen, adequately equipped with cooking and laundry facilities a dining area

Figure 6.3 shows two overview images. The image on the left is the ground floor showing the kitchen and lounge area with access to a garden area, along with the disabled accessible cell. The image on the right shows an overview of one of the floors. Each house block has a total of six floors containing two cells per floor.

[6] 'Listeners' are prisoners who have been trained to provide emotional support for peers. The Listener Scheme is run by The Samaritans, a well known UK charity that offers 24 hour telephone support for anyone in distress. The Listener Scheme was first established in 1991 and is present in almost all prisons in the UK.

6 The Creative Prison Revisited

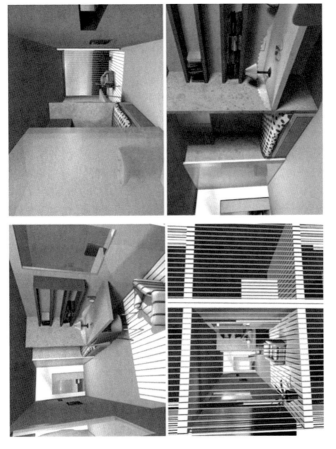

Fig. 6.2 View of cells

To facilitate the inculcation of a sense of social responsibility, the prison is organised so that the individual's relationship to others is clearly demarcated. While within HMP Paterson there are greater freedoms available than in other prisons, there are also greater responsibilities. Not in the banal terms of cleaning corridors or working the gardens but in the task of finding social equilibrium with others through negotiating shared rules and procedures. This invariably means consistently having to gauge and negotiate with others who have different priorities.

We proposed a number of levels of community that is born out in the design. Each level is conceived to help prisoners take responsibility for their lives within the prison. It was felt that this responsibility was necessary to help people prepare for release.

First Level of Community: The Houseblock

A houseblock would number 12 prisoners—or 13 if the ground floor cell intended for disabled access was occupied. Each group of prisoners within a houseblock would have the shared right to determine certain aspects of their living arrangements. This would need to be done collectively. These aspects would include:

- the right to create rules for the houseblock
- the right to make decisions about the running of the shared recreational area
- the right to control the shared provisions required such as decorations, cooking products, etc.
- the right to control the garden area for growing of vegetables, flowers or for recreational use
- the right to call houseblock meetings, adjudicated by the Houseblock Officer.
- the right to spend money from the houseblock budget.
- the right to elect a Houseblock Representative who will have access to the Governor via the Committee structure.
- the right to initiate mediation proceedings in the event of conflict that could not be resolved another way. In this event, the Houseblock Officer would supervise a conflict resolution process.

6 The Creative Prison Revisited 141

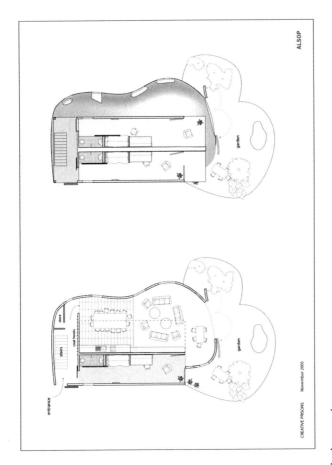

Fig. 6.3 Houseblock overview

- the right to request the removal from the block of any prisoner failing to respect the rules of the block. This would require a two-thirds majority and the process would be adjudicated by the Houseblock Officer.

The houseblock group would have control of a sum of money, held within an account for disposal by the group. Each houseblock group would also have the right to elect a Houseblock Representative. These representatives would form a Prisoner Council that would meet in the Debating Forum to raise wider matters regarding the management of the prison, and to put matters before the Governor who would be obliged to attend subject to availability. Representatives would be empowered to make proposals on prison matters such as the content of training in the workshops, organisation of weekend and evening recreational activities, and organisation of events.

In the event of a prisoner breaking the rules of the prison or earning the equivalent of a 'nicking', under certain circumstances this would redound to the disadvantage of all in his houseblock either by deduction of money or withdrawal of access to sports or recreational facilities for those in that block.

It was not intended that staff would have a permanent presence within the houseblock but rather that they would be available to visit throughout the day. Each houseblock would be managed by allocated Houseblock Officers who would take on the responsibility for liaising with prisoners on a day-to-day basis. These staff would have their own offices within a number of 'staff stations', interspersed within clusters of houseblocks (Fig. 6.4).

Second Level of Community: The Cluster

Houseblocks would be grouped into 'Clusters' with between 84 and 92 prisoners in each cluster. The Houseblock Representatives would vote for

6 The Creative Prison Revisited

Fig. 6.4 Artist impression of houseblock exterior with mesh

two of their eight to be the Cluster Representatives. The emerging ten individuals would have access to private meetings with the Governor where a wider range of issues could be discussed including discipline issues, staffing issues, prison management and education. There would be an officer responsible for each cluster.

The Governor would run an incentive scheme on a monthly basis whereby the cluster group with the least number of reported infringements would earn that cluster an additional financial allocation to all the blocks within it.

Third Level of Community: The Prison in Its Entirety

The modes of interaction with this level would be through weekend sport and recreational activities, the education and training programmes and the canteen. The individual prisoner would also interact with others within the Debating Forum where different topic-based events would bring together prisoners on the basis of shared interests. The Debating Forum would exist for the whole prison, where issues key to the good management of the prison would be debated. Additionally, the prisoner representative groups would function within this building. These different forums would not only feed back into the good management of the prison the views of prisoners, they would also help to ferment skills in listening, articulacy, logic, debate, dialectics and reasoning. It would be possible for certain debates to be broadcast throughout the prison via the prison intranet and the cell monitors.

Fourth Level of Community: The Community Beyond the Prison Walls

It would be understood that prisoners had a responsibility to this community through the provision and maintenance of those facilities that are shared with the local population. These include the swimming pool, performance spaces, restaurant and training workshop. The performance centre will allow for prisoners to present performances to the community or to invite community groups for interactive workshops, perhaps those with additional learning needs or disabilities. The recycling centre aims to offer a recycling service of goods in ways not provided by the local council.

The physical design of HMP Paterson was deliberately radical. The perimeter of the prison is made up of a series of linked buildings that together create a secure 'wall'. The cladding of this wall is made up of dozens of geometric black and white shards that are not dissimilar to those found on the 'Dazzle Ships' of World War 1. Its look is unmistakably 'Alsop'. Alsop was known for his bold use of colour, geometric shapes, and most famously for his use of blobs, curves and buildings that seem to float. This stems from the fact that his architectural practice was much more rooted in painting and sculpture than necessarily technical drawing and engineering. 'The opportunity for the architect to consider environments for learning is a wonderful opportunity but the initial tools of visioning should not be constrained by conventional idea. Architects are well placed to imagine the unimaginable, to dream the impossible and think the unthinkable' (Alsop, 2004). We wanted the Creative Prison to feel unlike any other prison people had lived or worked in. We wanted the landscape and fabric of the built environment to excite the mind, but also be a place that people cared for. In our companion publication, The Creative Prison—Inside the Architecture (2007), we noted,

> A number of researchers have looked at the relationship that situational factors such as architecture and design can have on violence and vandalism within prison. These include the style and nature of cell groupings, (O'Donnell & Edgar, 1996), and the role traditional linear design of older prisons plays in contributing to violence, especially when combined with an indirect staff supervision model (Farbstein & Wener, 1991; Zupan & Menke, 1991). The 'New Generation' philosophy, embodied within the 'direct supervision' approach, has resulted in a growing body of evidence supporting the importance of design in mediating behaviour within prison. Researchers argue that architecture which is designed to be resistant to physical attack conveys a message that prisoners are therefore expected to misbehave. (Resser, 1989; Wener et al., 1993). New generation environments are therefore characterised by furnishings which are designed for 'normal' behaviour as opposed to 'abnormal' behaviour. These will include comfortable furniture and a tile or carpet floor, ample telephones, television sets, and recreation areas. (Wener et al., 1985).
>
> Johnston and Hewish (2007, p. 28)

We wanted the physical design of HMP Paterson to challenge and inspire people to think and feel differently about who they were, both prisoners AND staff.

> My intention is to introduce above all a sense of beauty to the prison campus because ultimately it is the raising of spiritual values which leads to better citizenship. Outside, in the so called real world, we can observe that ugliness generally leads to bad behaviour, but sadly the powers that be consider this to be expensive. It is of course not.
> Will Alsop, in Johnston and Hewish (2006, p. 28)

We also wanted to create a prison about which word would spread, especially amongst prisoners. We knew from many years of working in prison, that prisoners become acutely aware of conditions in prisons other than the one they are currently in, either because they have been in these other prisons or they have heard from other prisoners who have. We wanted to create a prison that was something that prisoners from across the country could, and would, aspire to go to. A prison with a reputation for having an excellent regime but also a prison that looked unlike any other. Furthermore, at the core of the project was an intent on our part as artists to trigger a debate about the purpose of prison amongst the general public. What better way to capture people's attention by the creation of a design for prison which begins not with an aesthetic of punishment, as was the desire of the prisons built in the latter part of the nineteenth century, but with an aesthetic of invention?

> HMP Paterson acknowledges that if prisoners have little or no power to influence their environment, a sense of powerless may impede their rehabilitation... If prisoners are to be prepared for release, they need be entrusted with some measure of freedom within the prison and in negotiation with officers, determine their journey towards discharge. In return they must be expected to exercise responsibilities alongside. In this way, the prison reflects something of the balance of responsibilities and rights that are co-dependent in the outside world. If responsibilities are not

fulfilled, the rights may be taken away. The ultimate sanction is removal back to a main prison.[7]

The responsibilities of problem-solving, decision-making and managing resources need to be made real and live throughout the establishment in return for the relative freedoms offered. They will be kept live here through a number of means:

- the responsibility of collectively managing the houseblocks with their attendant financial and other tasks.
- the requirement to staff representative structures through which prisoners can manage their areas and influence the regime.
- the requirement to fulfil positions including both 'Listener' and 'Mediator' positions. The former is well established through the Samaritans Listener Scheme. The latter would involve prisoners being trained to function as mediators in the event of conflicts between prisoners, where appropriate working alongside prison officers trained in conflict resolution.
- the responsibility of taking other jobs such as within the kitchens, the gardens and elsewhere, without which these micro-projects would not function.

In return for taking these responsibilities, the prisoners will have freedoms within the Creative Prison not necessarily available in comparable institutions:

- freedom of movement within the prison grounds and within the houseblock.
- freedom to negotiate a sentence plan that reflects the vocational aspirations of the prisoner.
- access to the internet within the learning areas and intranet within the cells.
- access to a higher standard of education with a wider potential range of courses through utilisation of the internet.

[7] This principle of removal is the same as that practised in prison-based therapeutic communities where one can be 'deselected' or, for those familiar with system of 'open' prisons in England, the same if a prisoner breaks the rules of the open conditions and they are returned to a 'closed' prison.

The physical layout, as well as the individual elements of the prison regime, is all designed to embody these rights and responsibilities. The positioning of the houseblocks and staff stations spread out through the interior of the perimeter building allowing for much more of a campus feel lends itself much more to an environment built for learning, training and creativity rather than punishment.

> Within the prison, education and training are conceived holistically, with the vocational needs of the prisoner balanced with the needs of the work industries beyond the prison. Prisoners participating in the Rideout consultation, along with staff, bemoaned the absence of educational programmes that were configured along the lines of the prisoner's interests, and also of work practice that was non-robotic. Repetitive and mundane work was seen not just as demeaning but as a disincentive to more creative engagement with the world of work. The reason prisoners subscribed to such work programmes was solely for the meagre wages they offered. They wanted to earn money through working but found the monotonous, repetitive work of making light mouldings or packing socks dispiriting.
>
> Within the consultation, prisoners expressed the desire to explore subject areas that were closer to their personal enthusiasms. Emerging proposals for the education scheme centred around a number of ideas:

1. Education and training would acknowledge and anticipate the eventual release of the prisoner, from day one. This means not just orthodox learning and the acquisition of skills for employment but also 'survival training'; issues of money management, banking, finding and renting accommodation, and dealing with civic authority structures.
2. Learning would be conceived as taking place throughout the prison, not just in the Learning Centre.
3. Each prisoner would negotiate a curriculum with the Head of Learning as part of his 'Sentence Plan'.
4. Learners would have internet access within the Learning Centre. The Council of Europe recommends that 'Education for prisoners should be like the education provided for similar age groups in the outside

world, and the range of opportunities for prisoners should be as wide as possible' (Council of Europe, 1990). With controlled and monitored internet access in the learning areas, the prisoner could access study material via their in-cell terminal.

5. Each cell is part of a 'virtual classroom'. Each cell would contain a multi-purpose terminal that gave access to

- study material accessed within the Learning Centre and sent electronically to the prisoner's in-cell computer.
- an email system allowing the prisoner to communicate with study tutors outside the prison, relatives and others beyond the prison walls.
- the prisoner's Personal Officer as well as current teachers.

6. Certifications. Prisoners would be able to work towards a wide range of accredited academic and vocational qualifications.
7. Relationships with local companies would be established, aided by the post of a Community Liaison Officer. This officer, based within the Learning Centre and with responsibility for maintaining links with local companies, would effectively create a bridge with the outside community. Working with the Workshops Manager, the officer would organise training to reflect the needs of local companies, bringing in individual tutors or managers from those companies, for visits or classes.
8. Visits to the prison by inspirational speakers from industry, science, humanities and the arts.
9. Workshops would be managed by Workshop Managers who had the power to negotiate contracts with local companies. When the furniture repair workshop was closed down at HMP Gartree, it left the tutors regretting the loss of a scheme that had successfully balanced local need with vocational learning. Prisoners had acquired skills in furniture restoration and carpentry. Chairs, tables, wardrobes and bureaus had been saved from waste disposal to function again within local households. Given scope to generate innovative prison–company relationships, Workshop Managers would have the opportunity to seek collaborations such as that between HMYOI

Aylesbury and Toyota where the company has helped to establish a modern, fully equipped training garage.[8]

10. Prisoners would be encouraged to address issues of professional self-reliance, anticipating departure from prison.
11. Prisoners are identified as not just learners but also teachers. Thousands of prisoners throughout the country's jails have expertise, knowledge and qualifications that never get shared with those men or women that surround them. Prisoners would be encouraged to give regular or occasional classes for which there would be token additional payments into their accounts.

During our consultations there was much discussion about the ongoing tension in existing prisons between the needs of the prison versus the needs of the prisoner. Broadly speaking this focused on issues of security and management of behaviour.

On commencing consultations with staff and prisoners at HMP Gartree, we met initially with both groups separately. However, the very first point made by both sides concerned staff-prisoner relationships. Both groups felt that the relationships had suffered as a result of poor decisions in both prison design and management of staff training. A particular example cited in respect of the former, was the new wing offices within the houseblocks. These were designed in such a way as to inhibit any easy, manageable reception of prisoners who were coming forward with queries. An example in terms of the latter was the way in which staff changed so frequently that the result was, relationships became characterised by impersonality and casualness. In our discussions, neither side particularly bore resentments against the other; it was rather that both held resentments against the system, which not only made relations difficult but also made these difficulties needlessly.

In our planning therefore, we looked at how design might complement the need expressed on both sides for easy interaction and shared problem-solving. At present a variety of interactions between staff and prisoners have to be initiated by the prisoner who has to go and find the officer concerned. At that time the officer may be engaged with other

[8] Whilst no longer running in 2020, there are now many examples of similar initiatives, perhaps the most successful of which has been the partnership between Railtrack and the Prison Service.

business. It's a flashpoint situation potentially. Many such requests could be handled electronically once the prisoner has intranet access within his cell. Such requests might include:

- applications for a visitor to visit the prison
- the placing of an order for goods
- the request to attend a particular class or event
- to report a problem
- to get information about goods ordered.

There was a feeling that in order that prisoners can learn to function better in the free world, they need to be given more space (both physical and psychological) to practise doing that. Hence we created an environment where there was much more freedom of movement than might be found in an ordinary prison of a similar security level. In addition to extensive use of CCTV through the interior of the prison and including heat sensing equipment within cells to monitor the presence of prisoners at night time, access to buildings in the prison is therefore determined not by staff with keys but by prisoners themselves using RFID tags.[9]

> A notable feature of the Creative Prison is the use of the 'prison wall' as a multi-purpose building. Within its confines are a restaurant, training workshops, a retail unit and sports facilities. The use of all these is shared with the local public. At such times as these facilities are used by the public, the line of security would 'pull back' to exclude prisoners from those areas. Outside of public use time, the line of security would 'pull forward'.
>
> Principles of regulation would include the following:
>
> - the 'tag' system of identification would permit prisoners access to those parts of the prison they were entitled to enter as outlined above. The individual entrance doors would be programmed on a daily basis to admit entrance to designated individuals.

[9] These ideas were very much informed by technology available at the time. Examples of RFID—Radio Frequency Identification tags include those found on certain items in supermarkets.

- Prisoners would have certain privileges available to them as a matter of course but these would be withdrawn in situations of adjudged indiscipline. Such rights would include; the right to sell made goods through the retail unit, the right to have access to houseblock association areas until 11 pm, the right to extended visits, and the right to access sports facilities and the Debating Forum at weekends.

The understanding that the prisoner exists within a web of relationships has to inform any evolving rehabilitation. To encourage steady and consistent contact with family, partner or friends, email addresses could be submitted for approval by a prisoner to a Houseblock Officer. Prisoners could then send emails to and receive them from, these approved addresses. Emails would be monitored as letters are now.[10] The use of email in this way will take the pressure of the need to gain access to a telephone. However, a telephone adapted for smart card use would also be available in each houseblock.[11]

Within the prison wall, the Visitors Centre would provide adequate facilities not just for able-bodied adult family members but for children and older people as well as the disabled. While clearly it is preferable for family to be local, it has to be recognised that this is not always possible. So above the Visitors Centre will be accommodation provided for those visitors who have to travel a long distance to the prison. Basic, hotel-style rooms with disabled facilities would be provided at a modest rate. Visits would take place during the weekends and evening times to allow for prisoner education to continue uninterrupted.

It should be stressed that our intention in advocating for the increased use of technology to aid security and communication was not to reduce the presence of prison officers but rather to free up their time and allow them to develop better relationships with prisoners, more akin to that of a mentor intent on helping them in their personal development. We

[10] Since the original publication of the document, a limited version of such a scheme, EMAP (Email A Prisoner), has been introduced in most prisons across the UK. This scheme currently allows family members and friends to email a prisoner via a website. These emails are then printed out and given to the recipient. Some prisons enable the opportunity of a reply but not all.

[11] Again, this thinking was informed by what was available in prison at the time of the consultation. In all likelihood we would now advocate for telephones to be available in all cells.

envisaged the role of the officer would evolve, very much akin to the 'Key Worker' scheme that has been introduced across prisons in England and Wales in the last couple of years. The principal of this is that each Key Worker is assigned 5 or 6 prisoners for whom they are responsible, and through weekly meetings they facilitate prisoners in their journey through prison identify any concerns, help them with issues related to their previous offending, and by enabling additional support from all other areas of the prison (Fig. 6.5).

I am not sure any of the artists involved in the project were expecting the legacy of The Creative Prison to last as long as it did. Clearly, as we had hoped, the involvement of Will Alsop as our architect had a considerable impact, not only on the look and feel of the intended prison but also subsequently in the media (we hadn't even issued a press release before it made the news in some of the building industry press). We were fully expecting an onslaught from the tabloids but outside of the Daily Express, 'Jail of future: No locks, nice balcony and non-stop sports',[12] the response was much more measured and reasoned. The project was reported in an array of different media ranging from the national mainstream TV and press, through to international design and architectural publications, and even a couple of academic journals (Williams (2006) and Fiddler (2013)) Much of the coverage made use of the striking imagery, but more important to us was the discussion of the ideas behind the design. It also became clear amongst visitors to the exhibition, that everyone who came had an opinion. These ranged from the outraged to the enlightened (at least from our perspective).

In addition to publicising and discussing the project in the media, we hosted a special seminar event to coincide with the launch of the exhibition, and a series of follow-up consultation events for invited audiences of personnel from the Prison Service Estates Department, NOMS, private sector contractors, and architectural firms whose interest lay in prison design (namely Capita Symonds and HLM). We believe the dissemination of the ideas at these events was vital in informing the thinking of a number of designers. Whilst it is impossible to know for sure how direct this impact was, we became aware in the years following

[12] Daily Express, 1 June 2006, P.30.

Fig. 6.5 3-D overview

the project of a number of concept designs that drew on similar ideas to those explored in the Creative Prison, especially in respect of prisons sharing facilities with members of the local community (Mellor, 2010). Furthermore, the Norwegian prison system is internationally famous for its strong focus on rehabilitation of prisons and for housing prisoners in small units built around a kitchen and lounge set up similar to HMP Paterson, especially at Halden and Bergen. I am not suggesting this project was directly influential on those designs but I would argue that the Creative Prison encapsulates an approach to imprisonment which is increasingly shared by progressive regimes across the world.

Furthermore, the process of consultation with people living and working in prison, that was fundamental to our approach, has clearly gained traction. Whilst we weren't the first group to do this in a prison context (Hilary Cottam's consultations took place a couple of years prior to ours (Cottam et al., 2002), the practice of 'service user' involvement in new prison design was, in 2005, considered extremely unusual. Contrary to the comments we had at the time from people outside of the project who expected prisoners to fill the place with ways to escape, the reality was much more mundane. It was this aspect of the work that our project funders at the Paul Hamlyn Foundation and Tudor Trust were keen to see us explore further in the subsequent Creative Prison publication, *Inside the Architecture* (2007). Subsequent work by Muir and Loader (2010) and more recently Matter Architecture's excellent *Wellbeing in prison design* (Bernheimer et al. (2017)), demonstrates this is fundamental to developing better designed institutions. It was surprising to us in the facilitation of the Creative Prison how much time we ended up talking not just about what a prison could look like, but more fundamentally, the way that prison needed to be run. Listening to both prisoners and staff talk about their needs informed the proposed regime, which in turn informed the design. It was impossible to separate one from the other and so it is pleasing therefore to see these principles of user consultation have informed HMPPS more recent comments about new prison design as part of their Prison Estate Transformation Programme (Beard, 2019). Whether this optimism is well placed, only time will tell.

Bibliography

Alsop, W. (2004). Schools for the future: DfES Exemplar school design solutions, Secondary Team F January 2004 Compendium. Alsop.

Beard, J. (2019). The prison estate *Briefing Paper Number 05646* House of Commons, London. Available at http://researchbriefings.files.parliament.uk/documents/SN05646/SN05646.pdf (Accessed 3 August 2020).

Bernheimer, L., O'Brien, R., & Barnes, R. (2017). *Wellbeing in prison design: A guide*. Matter Architecture.

Council of Europe. (1990). Recommendation No. R (89) 12 adopted by the Committee of Ministers of the Council of Europe on 13 October 1989 and explanatory memorandum. *Education in Prison*. Council of Europe, Strasbourg.

Cottam, H., Henley, B., Horne, M., & Comely, G. (2002). *Learning works: The 21st century prison*. Do Tank Ltd.

Farbstein, J., & Wener, R. (1991). A comparison of direct and indirect supervision correctional facilities. *Forum on Corrections Research, 3*(2), 7–11.

Fiddler, M. (2013). Interview: Saul Hewish. *Prison Service Journal, 210*, 39–43.

Johnston, C., & Hewish, S. (2006). The creative prison: Creative thinking in the prison estate. Rideout. Stoke-on-Trent.

Johnston, C., & Hewish, S. (2007). The creative prison: Inside the architecture—The role of consultation. Rideout. Stoke-on-Trent.

Mellor, P. (2010). Powerpoint presentation on community prison concept, personal correspondence with author.

Muir, R., & Loader, I. (2010). *Tomorrow's prisons: Designing the future prison estate*. Institute for Public Policy Research.

O'Donnell, I., & Kimmett, E. (1996). *The extent and dynamics of victimisation in prison*. Centre for Criminological Research, Oxford University.

Resser, J. P. (1989). The design of safe and humane police cells. Royal commission into Aboriginal deaths in custody.

Wener, R., Frazier, W., & Farbstein, J. (1985). Three generations of evaluation and design of correctional facilities. *Environment and Behavior, 17*(1), 71–95.

Wener, R., Frazier, F. W., & Farbstein, J. (1993). Direct supervision of correctional institutions. In National Institute of Corrections (Ed.), *Podular, direct supervision jails*. NIC Jails Division.

Williams, C. A. (2006). The creative prison exhibition. *Crime, Media, Culture, 2*(3), 353–356.

Zupan, L. L., & Menke, B. A. (1991). The new generation jail: An overview. In Joel A. Thompson, & G. Larry Mays (Eds.), *American jails: Public policy issues*. Nelson Hall.

7

Prison Design: Between Pragmatic Engagement and the Dream of Decarceration

Roger Paez with Kwan-Lamar Blount-Hill

Introduction

In a volume about recommendations for 'better', 'more humane' prison design, the following text is meant to offer a different view. Discussion of custodial reform and attendant changes in custodial architecture implies taking the aims and purposes of a justice system as a given (Grant & Jewkes, 2015; Jewkes & Johnston, 2012). No matter its rehabilitative aim, the invariable security of custodial facilities is supported by a logic of incapacitation (e.g., Binder & Notterman, 2017; Craig, 2004), and

R. Paez (✉)
Barcelona, Catalonia, Spain
e-mail: rpaez@aib.cat; rpaez@elisava.net

K.-L. Blount-Hill
Arizona State University, Phoenix, AZ, USA
e-mail: kbh@asu.edu

facilities devoid of normalcy hearken to retributive notions of the need for punishment and penitence (see Phelps, 2011). The rehabilitative programming within custodial facilities implicitly assumes a corrupted state in need of repair (e.g., Sundt et al., 2002). Here, I present a critical review of contemporary architectural practice in custodial design, using the concept of *critical prison design* as its cornerstone. Critical prison design is premised on the notion of mitigation. In essence, I encourage questioning custodial justifications and instead recognise incarceration as a reaction to societal failure, a need to mitigate the harm of that failure as revealed by 'criminal' reactions to it, and a consideration of how we can we make custody less harmful and, perhaps, eliminate its use entirely. For this discussion, rather than relying solely on a scholarly approach, I write as the personal voice of the professional designer faced with the daunting task of designing a custodial facility.

The text is organised in three main sections. In the first section, I review the intrinsically problematic nature of prison design, including as discussed in scholarly literature from a critical carceral perspective. To state the conclusion plainly: The act of custodial design in general, and prison design in particular, is intrinsically problematic (Agamben, 2005; Moran, 2015; Wacquant, 2009). This is so for two main reasons. On the one hand, the prison as an institution reflects a failure of the social contract (Brown, 2008; St. John & Blount-Hill, 2019; Rousseau, 1999/1755). On the other hand, this reality is not so lost on many architectural designers who are put off by the unkind nature of the programme and tend to reject prisons as objects of design (Lawston & Meiners, 2014; McLeod, 2015). Jails, prisons, penitentiaries, and correctional facilities are nonetheless designed and built. It is architects who do so, but in this case mostly under the direction and auspices of corporations or firms that treat their design as a strictly technical problem. Architecture generally associates a desire for creativity with the pleasure and enjoyment of the end user front of the mind (e.g., Murtagh et al., 2016; Sang et al., 2009). Custodial architecture hardly addresses any of those concerns and instead tends to treat its subject as an engineering problem (Consoli, 2005, 2006)—How do we keep these people contained?

In what follows, I present a succinct review of work which critically engages the underlying logic of the punitive apparatus and which inspired the development of my critical perspective in the first section. The second section spells out the implications of addressing prison design critically. From my point of view, engaging in critical prison design implies addressing three fundamental concerns. First, it entails actively pursuing the visibility of current and visionary penitentiary realities through incorporating prison design into general design discourses. Second, it means using design to generate significant improvements in the living conditions of inmates, workers, and visitors. Third, revealing my own socio-political standpoint, albeit shared by many engaged designers, this design approach involves problematising confinement and actively working towards decarceration. This last concern lends itself to two very relevant avenues of design-based research: (i) innovative and experimental design proposals to challenge dominant views on detention; and (ii) a push for the adaptive reuse of existing custodial facilities, suggesting socially desirable uses for the prison's heterotopic qualities. The third and last section offers insight on seven case studies, which, to a greater or lesser degree, successfully address critical prison design. These contemporary examples include five built facilities: Can Brians (Catalonia), Leoben (Austria), Mas d'Enric (Catalonia), Halden (Norway), and Nuuk (Greenland)] plus two experimental designs: Koepel (Netherlands), and Puketutu (New Zealand).

The chapter's fundamental aim is to present the possibilities (and limitations) of architectural design as a critical practice in the context of custodial design, actively contributing to a progressive debate on custodial spaces, institutions, and practices. Let me clarify, from the outset, that this text will concentrate on democracies with a separation of powers and social scrutiny in place (imperfect though they may be), and it will not address the realities of countries under the yoke of authoritarian rule or without rule of law. This is not intended to dismiss the relevance, and indeed urgency, of addressing the many abuses committed against individuals and groups in such places using a sham judiciary-penitentiary apparatus but is simply due to a lack of knowledge on my part. Two additional caveats need to be spelled out. First, I will specifically avoid discussing prison design in countries, however democratic they may be,

that still impose capital punishment, as I deem this legal framework and practice to be incompatible with the drive towards humane and non-punitive prisons. Second, as recent history in my own country all too clearly shows, even some supposedly consolidated democracies and European Union member states fall extremely short of what is expected from a desirable and mature democracy, using the penitentiary system (in close alliance with the police and judiciary) to curb legitimate and pacific civil disobedience and political dissidence (one flagrant case in point being the imprisonment of social leaders, elected politicians, engaged activists, and ordinary citizens following the Catalan independence referendum held on 1 October 2017).[1]

The Problematic Nature of Prison and Its Effect in Design

> Penal measures and institutions have social determinants that have little to do with the need for law and order, social effects that go well beyond the business of crime control, and a symbolic significance that routinely engages a wide population, making it inappropriate to think of them in purely instrumental terms. Garland (1991: 117)

Prisons are an uncomfortable subject. In many countries, citizens, and indeed scholars in the social sciences and professionals in architecture, prefer to avoid addressing custodial policy, management, and design. Even incumbent politicians and civil servants may tread these troubled waters carefully. The reasons behind this generalised reaction are quite clear: The penitentiary apparatus harshly displays the failure of the social contract, and no one likes to be reminded of that. According to social contract theory, individuals give up a portion of their freedom in exchange for the security of food, shelter, protection, etc., promised by

[1] See, for instance Amnesty International's statement from November 19, 2019. https://www.amnesty.org/en/latest/news/2019/11/spain-conviction-for-sedition-of-jordi-sanchez-and-jordi-cuixart-threatens-rights-to-freedom-of-expression-and-peaceful-assembly/.

full and equal membership in a polity (Boucher & Kelly, 1994). Custodial facilities often serve as houses for those with whom the state has broken its part in this promise. Chief explanations for criminal activity punishable by incarceration include impoverished quality of life and unsatisfied need (Pare & Felson, 2014), frustrated and inequitable opportunity (e.g., Hannon, 2002), insecure and unstable social environments (Wemmers et al., 2018)—all heavily determined by societal structure, a reality that most tend to ignore. Even sociobiological or individual psychological explanations of crime refer to the mentally straining or epigenetic effect of social and physical environments that may activate traits associated with crime, but which might have lain dormant in more caring environs (e.g., Leshem & Weisburd, 2019). Imagine a more robust attention to supplying the security promised in the social contract. In this ideal world, there would be no need for prisons of any kind. Or would there?

Regardless of the answer, the factual truth remains that most societies—certainly all so-called developed, urban societies—have constructed a complex penitentiary system to tackle specific forms of social conflict. Although there are very significant differences between penitentiary systems in mature democracies (compare, for example, Scandinavian systems with that of the United States), certain underlying similarities persist, including recourse to involuntary confinement of inmates serving a judicial sentence. From that simple fact it follows that the buildings purposed for this confinement will need to be designed, erected, and managed—this is the field of custodial design. The challenge is whether this can be done in such a way as to not constitute a further breach of the social contract and, instead, to mitigate the harms of previous social breaches. That architects debate this question so infrequently is surprising. Optimal custodial design was a central topic among architects during 1780–1830. Nearly all the most important architects of British neoclassicism worked on prison design, including Dance the younger, Robert Adam, James Wyatt, John Nash, John Soane, Robert Smirke and William Wilkins (Evans, 1982: 408). Yet, since Modernism

and with only a few notable exceptions, architects have hardly taken any interest in addressing this huge societal challenge.[2]

In contrast, scholarly contributions from philosophy and the social sciences related to prisons and the judiciary-penitentiary apparatus are rich and extensive. The concept of the 'total institution' (Goffman, 1961), together with 'institutions for deviants' (Rothman, 1971), 'heterotopia' and 'disciplinary diagram' (Foucault, 1979), and 'social control' (Ignatieff, 1978), are the foundations of contemporary critical thought on prisons (and, often indirectly, prison design). Throughout these writings, the authors articulate, in various ways, how the original bargain of liberty-for-security between citizen and state is violated and ultimately overtaken by a corrosive carcerality. More plainly, governments of elites take advantage of citizen grants of power to suppress liberty in favour of security in the face of supposed, but often false, insecurity. Moreover, while architects have been silent on this matter, their work product has been a critical tool in this process. Evans' (1982) *The Fabrication of Virtue* offers a highly original illustration of this phenomenon and quite possibly remains the most seminal prison-related work in the history of architectural criticism. Evans posits a radical imbrication between the birth of the reformed and model prisons and the birth of modern architecture: 'Architecture [...] became not just the container, but the organizer of human functions: an active agency in the formation of experience and morality' (Evans, 1982: 222). Principally, these constructions sought to convey state power and to structure orderly existences on the part of citizen occupants, a 'necessary' strategy for preserving the order owed via the social contract. Between the end of the eighteenth century and the beginning of the nineteenth, architecture took on the role of fabricating virtue by reforming 'deviant behaviour' through disciplinary tools and the agency of architecture. Indeed, modern prison design consciously exploited architecture's power to organise behaviour—an implicit power that comes from the rationality and abstraction of orthographic projection and the physicality

[2] Koolhaas serves as one such notable exception, whose work is 'constantly projecting new layers of "civilization" on old systems of supervision' (Koolhaas, 1995: 241) and takes once again seriously the social responsibility of architecture, seemingly abandoned since high Modernism, adding a much-needed layer of uncertainty and irony.

of architecture, rather than the representative power of its image. This consciousness of architectural agency to organise behaviour, highlighted first in English penal reform, had enormous effects. By the late nineteenth century, hospitals, factories, barracks, schools, but most importantly, town planning and housing, illustrated a similar kind of design approach: using architecture to 'shap[e] experience through the medium of the building' (Evans, 1982: 404). Evans' arguments remain relevant over a generation later, as attested to by Joe Day's fascinating account of the cross-pollination between prisons and museums in the contemporary US (Day, 2013).

Three contemporary concepts, Wacquant's (2009) 'carceral continuum', Agamben's (2005) 'state of exception', and Moran's (2015) 'carceral geography', deepen our understanding of the extension of the carceral apparatus well beyond the justice system and into the whole of society, emphasising its problematic character. Wacquant's (2009) work posits that the punitive turn in (most) advanced societies has generated a 'carceral continuum' that links social ghettoes and deprived neighbourhoods with the prison system in a closed loop cycle that encapsulates the total state response to its poor. In *State of Exception*, Agamben (2005) contends that the state of exception, in which governments extend their power beyond their constitutional limits and legal and human rights are diminished or superseded as happened in many societies post-9/11, is not an anomalous situation but rather lies at the very core of contemporary biopolitical power. The generalisation and incipient normalisation of the state of exception blurs the distinctions between state territorial sovereignty, in which 'citizens' can demand some sort of accountability from the state apparatus, and deterritorialised punishment (as epitomised by Guantánamo Bay), where humans become 'noncitizens', bodies without political agency. Indeed, from 9/11 to COVID-19 society has witnessed a generalisation of the state of exception, to the point that we are starting to confront exceptional measures as the new normal, often with disastrous implications. Agamben's work situates the carceral within a larger framework, suggesting a disconnect between law and punishment, as evidenced by extra-legal custodial practices permitted by the state of exception. Moran's (2015) *Carceral Geography: Spaces and Practices of Incarceration* creates a perfect link between the theoretical

and practical approaches to custodial design. Her approach invites questions more than provides answers as a critical exploration of punitive discipline, surveillance, and confinement allows for discovering new forms of banishment and carceral economies.

While individually fascinating, collectively, these writings provide their readers with frameworks for identifying the creeping carcerality through which elite governments (and the corporations or wealthy elite that support them) control citizenries and diminish liberties while dulling constituents' perceptions of this loss. Powerholders legitimate aggregation of control through subtly socialising compliance into citizens with penal-inspired architectures while connecting poverty and powerlessness not with the state's failure to provide but instead to crime, threat of crime, and insecurity. The threat of instability is rooted in individual 'disorder' as opposed to societal dysfunction, disorder which the state needs evermore power to quell but which it is never responsible for. In time, it seems that avoiding disorder is enough to win society's quiet complicity in the means to achieve it (e.g., custody and its threat), though the means are discomforting enough to also engender silence. Custodial houses represent the apex of this dynamic, where liberty loss is at its highest and yet where none but the locked away and their loved ones give attention to why incarceration is necessary in the first place. Rooting incarceration as a phenomenon in this framing brings to fore the question: Considering that custody is often a tool to suppress citizen liberty in contravention of the social contract, can architecture and interior design ever succeed in constructing 'humane' prisons?

Critical Prison Design

> The very fact that the studio took on the job [of designing a prison] is a political act—a way of facing the problems of detention and confinement that have once again become so extreme in contemporary culture.
> Easterling (2014: 41)

Are there ways to design prisons in a critical, engaged, and responsible way? I believe so. Obviously, there are a number of practitioners (Sperry et al., 2005) who claim that designers should not get involved in custodial design as a matter of principle, arguing that it is degrading and demeaning. That is the case, especially in the United States, where the penitentiary reality is much harsher (e.g., the death penalty and long-term solitary confinement) than in Europe, and custodial design is all but limited to corporations with vested interests in the commercial exploitation of prisons (Dolovich, 2005). Nevertheless, however respectable, this maximalist position may cater to the designer's peace of mind, but it does not contribute to ameliorating a reality in dire need of betterment. Not addressing the problem will not make it go away; quite the opposite. If socially engaged designers forego this responsibility, who will pick up the task? The answer is large-scale consortiums and faceless corporations with little to no accountability. Moreover, this reinforces the tendency towards the privatisation of the penitentiary system, which further erodes public auditing and social scrutiny, provoking a pernicious disconnect between penitentiary reality and social reality at large. As Gottschalk (2016) explains, this has been the sad reality of US penitentiary policy since the 1980s. Indeed, there are many powers that be with a clear interest in furthering this disconnect. The more the carceral sphere is perceived by a majority of the population as an isolated, autonomous reality unrelated to 'society at large', the more it can go unchecked. It is crucial to put a stop to this tendency and actively claim responsibility for our penitentiary systems from all points of view, including design (see Moran et al., 2019). Avoiding engagement with this urgent, far-reaching and important (however uncomfortable) social problem is an authorially safe but politically cowardly position to take: 'denial may be the only trap or cell that is impossible to escape' (Easterling, 2014: 41). Returning to the question that began this section, we may now venture a tentative response.

Although what we call 'critical prison design', addressed more broadly in the author's book *Critical Prison Design* (Paez, 2014), identifies an attitude more than a methodology, three general questions frame a potential critical approach to prison design in particular and custodial facilities in general (Figs. 7.1, 7.2 and 7.3). First, critical prison design pursues

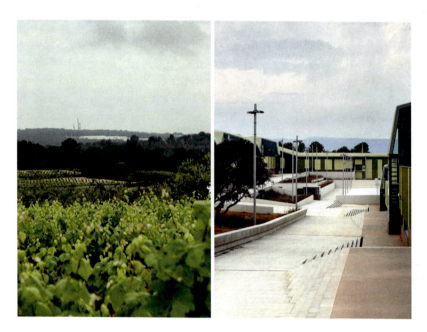

Fig. 7.1 Mas d'Enric Penitentiary. AiB arquitectes + Estudi PSP Arquitectura, 2012

visibility: Architects must make visible the current penitentiary reality so that it may be understood and contested, but also give visibility to novel social approaches and innovative design solutions that may change the current conditions for the better. Incorporating custodial architecture into public discourse is a necessary first step in addressing this wicked problem from as many angles as possible. In doing so, on the one hand, we can recognise, as a society, our own limits and failures, and, on the other, we can strive to overcome them. Second, critical prison design foregrounds betterment—actual improvement of the living conditions of inmates, workers and visitors. This may seem an obvious statement but placing quality of life first is far from common practice in custodial design, too concerned with the exacting demands of security and surveillance. The penitentiary, as an institution, has to respond to two seemingly contradictory tasks: custody and reinsertion. This legal double bind permeates all penitentiary system, including its architecture. Yet, if

Fig. 7.2 Koepel Arnhem, diagram showing volume of the new program as socle below old panopticon. OMA (Rem Koolhaas, Stefano de Martino), 1981

we recognise that custody often reflects societal failure to fulfil the duties of its social contract, we bind ourselves to prioritising mitigating unjustness by mitigating further harm to the detained. Third, to some engaged designers, critical prison design points towards decarceration.[3] While assuming responsibility as designers for, on the one hand, visualising and, on the other hand, improving the current penitentiary realities, these designers (myself included) assume the task of actively problematising confinement as such and advancing towards decarceration.

One may see this complex task as three aspects of the same question. The first effect of a critical approach to custodial design is to identify and visualise an undesirable yet existing reality and submit it to social

[3] Not all designers fall into this camp though. May et al. (2014) is a good example of a very different approach to contemporary prison design.

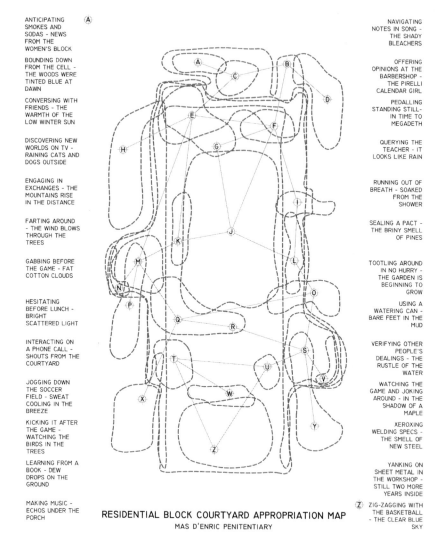

Fig. 7.3 Mas d'Enric Penitentiary, map exploring potential inmate activities. Roger Paez, 2014

debate. The second effect is to improve on that existing reality so that it advances humane and respectful attitudes. The third effect is to imagine and actively work towards a future in which critical prison design would have no role to play, because prisons would no longer be needed. I will address the implications of this last question and related avenues of design-based research in my conclusions.

Case Studies

> Far from being about creating 'softer' or 'prettier' prisons, a focus on designing humanising prison spaces that are focused on supporting rehabilitation and desistance could be a vital component in achieving radical justice reform, including de-carceration. Jewkes and Moran (2017: 2)

Many papers have described relevant best practices in custodial design and prison architecture (Bensimon, 2020), and some of them (Vessella, 2017) have even proposed a list of the aspects that characterise new ways of conceiving the prison, or even full design guides (Matter Architecture et al., 2017: 129ff). While we do not deny the interest and usefulness of these contributions, we will proceed otherwise. We will not offer detailed descriptions of the case studies discussed, as they are already widely available in scientific literature and design reviews. Nor will we attempt a decalogue of sorts as a shortcut to designing prisons successfully, as it is our position that addressing prison design critically necessarily entails a very precise understanding of the context, with its socio-cultural, urban-spatial and legal-regulatory frameworks. It follows that no standard recipes are possible, but each design has to be individually approached in a careful, humble, and also ambitious way. Moreover, and precisely because of its contested nature, prison design should avoid uncritically reproducing existing solutions and must be continuously problematised—which is exactly what our case studies show.

Our approach to the case studies will be based on identifying relevant and innovative design features for each case, with the aim of offering a synthetic overview that focuses on conceptual approaches to critical

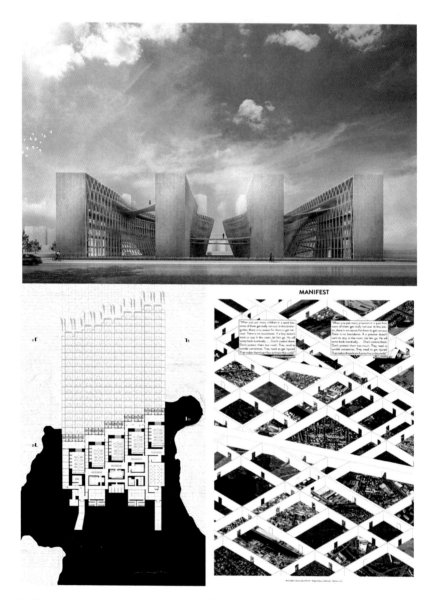

Fig. 7.4 Student projects, prison design. Glen Santayana, 2013 (above), Saif Mhaisen, 2012 (bottom left) and Martin Gjoleka, 2016 (bottom right)

prison design, rather than on pure descriptions of architectural solutions. We are in no way attempting to compile a systematic analysis of best practices, but simply trying to expand the ways in which prison design can be understood. It is our firm belief that, above and beyond the restricted framework of specialised typological and technical solutions, prison architecture should be perceived and studied as what it actually is: architecture. The main aim of this move is to bring the prison back into a wider architectural debate, in a broad and critical sense, focusing on its socio-cultural value while steering clear of dominant technocratic conceptions. As has been the case with hospitals or schools or housing, once self-contained areas of inquiry, 'the prison is a reality that needs to be visualized and addressed so that it can be included in the broadest possible architectural, social [and political] debate, allowing for it to evolve in keeping with society's demands' (Paez, 2014: 20).

To justify our choice of case studies, a few points need to be made. First, all case studies are prisons. We have avoided introducing remarkable custodial but non-penitentiary buildings (such as the Vordernberg Pre-Deportation Centre, designed by Franz&Sue). Second, we have attempted to showcase trailblazing designs and avoid very interesting but derivative examples (such as Storstrøm Prison, designed by C.F. Møller Architects). Third, we have restricted our research to professional design studios, although there are very interesting attempts to address prison design critically in academia (such as Adrià Carbonell's 2012 studio for AUS Sharjah or Glen Santayana's 2013 Harvard GSD thesis) (Fig. 7.4). Fourth, and finally, we have decided to showcase mainly built examples, as critical prison design does not stop at the drawing board but encompasses the very complex process of detailing and building progressive and innovative prisons. However, we also have included two examples of unbuilt, highly explorative, or outright visionary designs in order to remind us of the need for blue-sky approaches to critical prison design.

OMA's proposal for the transformation of the old panopticon prison in Arnhem into a contemporary penitentiary is a seminal contribution to critical prison design. For the first time in over a century, one of the world's most relevant architects took on the responsibility of addressing the problematic subject of prison design. The value of Koolhaas' approach is that it squarely places the penitentiary debate within the

socio-cultural sphere from which it should never have strayed. Eschewing technocratic views and processes, the designers ask themselves many uncomfortable questions and attempt to address them through architectural design rather than solely through discourse, thus achieving a bond between the utilitarian and conceptual levels: 'The discredited claim for architecture as being able to directly intervene in the formation of culture - and to achieve through its crystallisation, the resolution of hopelessly contradictory demands - freedom and discipline - was for once vindicated on the edge of dystopia'. Programmatically, adding 'a communal, almost public dimension to the life of the prison' through new facilities for work, leisure, educational and commercial activities is a major step forward, but, perhaps, the most relevant advancement proposed by the project is the necessity of an ongoing revision of the prison itself. Positing culture as a system of paradigms that is continuously being revised, 'the scheme projects a layer of modernity on [100 years of penitentiary] experience without making claims of being definitive' (Koolhaas, 1995) (Fig. 7.5).

Implicitly responding to Foucault's concept of heterotopia, Can Brians proposes a relevant shift in the way prisons were understood architecturally, designed as a walled village rather than as a pavilion compound. The architects use the analogue of the abbey, the monastery, or the acropolis to link Can Brians with traditional building typologies that gave specific form to the idea of an enclosed world with inner workings that differ from, yet somehow reproduce in an abstract way, the workings of society at large. The analogy is not merely metaphorical but operative, as it provides a new spatial lexicon that effectively organises the building: the entrance 'square', akin to the acropolis's *propylaea* or a village square; the internal 'street', resonating with an abbey's deambulatory or a village street; and the central 'tower', resembling a monastery's belfry or a village's parish church clocktower. These urban situations, however similar in spatial organisation, do not perform the civic functions they do in cities: the square does not allow for informal meetings; the street serves to separate rather than communicate. That crucial shortcoming notwithstanding, Can Brians manages to associate the aesthetics of urban architecture with prison design, effectively introducing the architecture of the prison into the realm of architecture proper and,

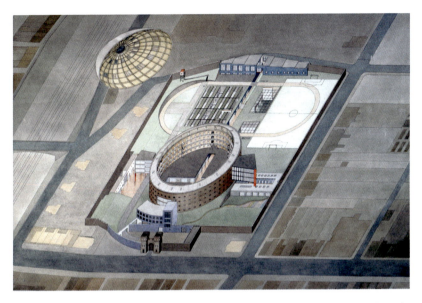

Fig. 7.5 Koepel (Netherlands). OMA. 1980 (design). https://oma.eu/projects/koepel-panopticon-prison

most relevantly, allowing inmates, workers and visitors to relate with their physical environment through familiar urban logics, downplaying the narrative of confinement and generating a rarefied yet familiar living space (Fig. 7.6).

Loeben Justice Centre proposes a volumetric, functional, and, most importantly, symbolic relationship between the prison and the courts. The architects decide to build a palace-like structure, with the imposing glass façade of the courts towards the town and the more prosaic bulk of the prison, organised in three volumes within a continuous security perimeter, behind it and connected with an elevated bridge. Beyond the programmatic advantages that such adjacency may have, treating a mixed-use compound that includes a penitentiary as a case of public architecture, with all the representational and civic values typically attributed to it, contributes to the visualisation of prison as an existing reality that needs to be addressed. However, the dominant physical location on a slight slope facing the town centre, the clear-cut physical disconnect between the courts and the prison buildings, and, mostly the

Fig. 7.6 Can Brians (Catalonia). Bonell i Gil Arquitectes+ Brullet + Rius. 1986 (design), 1993 (construction). https://www.arquitecturacatalana.cat/ca/obres/centre-penitenciari-can-brians

somewhat excessive formalisation of the courts building in comparison with the prison buildings, implying a value difference between them, make Loeben more a rhetorical contribution to critical prison design than a substantial one. Although Loeben's rather conventional use of monumentality remains problematic, its mixed-use programme and its urban location, well-communicated and within walking distance to the town's centre, are bold and honest moves contributing to public debate about the judiciary-penitentiary system (Fig. 7.7).

Prisons should heal, not punish. Mas d'Enric's design works towards that goal by exploring the prison as a place permeated by the outside, celebrating openness at the heart of detention. Mas d'Enric's design efficiently solves the custodial demand but devotes most of its design efforts to addressing the demand for rehabilitation. Ensuring a secure perimeter allows for designing and managing the interior of the prison in a much freer way, guaranteeing security without monumentalising it. A

Fig. 7.7 Leoben (Austria). Hohensinn Architektur. 2004 (construction). https://www.hohensinn-architektur.at/project/justizzentrum-leoben-2/

mat building typology is used so that most of the perimetral wall is integrated into the extensive and porous building. Besides limiting views of the security perimeter from within the prison, this move generates a series of generous open spaces at the core of the prison. These internal voids become a very important setting for prison life: the carefully designed courtyards prompt free appropriation of common spaces and nurture a certain sense of belonging, while the expansive central promenade becomes the theatre of (confined) collective life and a (substitute) public space where inmates and workers coincide daily as they go about their business (work, education, leisure, visits and health). In addition to its programmatic use as a space for circulation and relation, the internal open space plays an important role both perceptually and a symbolically: the sun's path and the varying elements cause its appearance to change continually, introducing a much-needed sense of variation in a

confined environment. Its vegetation sways, hisses and welcomes songbirds; and because of its adaptation to a rugged terrain, it allows ample views of the surrounding landscape. The notion of 'outside' is crucial in Mas d'Enric's main design decisions: the construction of an appropriable, non-oppressive environment, the introduction of a maximum number of vectors of exteriority, and the generation of open spaces that are central both formally and conceptually (Fig. 7.8).

Halden and Mas d'Enric show two different responses to the same design question: how to respond simultaneously to the prison's seemingly contradictory demands of custody and rehabilitation. While Mas d'Enric stresses sociality, providing a southern, urban solution where collective (equipped courtyards) and public (central promenade) spaces are crucial, since cells are only used at night-time and activity also takes place outdoors, Halden stresses intimacy, presenting a northern, domestic solution where private spaces (cells) and shared spaces (common rooms) are

Fig. 7.8 Mas d'Enric (Catalonia). AiB arquitectes + Estudi PSP Arquitectura. 2005 (design), 2012 (construction). https://www.aib.cat/en/projects/191CAT

fundamental, since most inmate life is concentrated indoors. Halden's design explores the idea of a penitentiary enclave defined by a security perimeter that encloses all the prison buildings, plus a sizeable amount of wooded terrain. Although the perimeter wall is very much present from the interior of the compound, the wooded landscape helps to subdue its aggressive effect. The buildings are autonomous volumes organised around an inner circular road, with the explicit purpose of reproducing, within the prison walls, movements that mimic the everyday movements between home, work and educational and leisure activities that happen in a typical Norwegian town, characterised by low density and autonomous buildings rather than the close-knit urban fabric of central and southern Europe. The most remarkable aspect of Halden, however, is the effort the architects devote to making the prison an intimate, quasi-domestic experience. Interior design is key to achieving this goal. The individual cells, the communal kitchens and the shared halls are designed, both in layout and material palette, very much like a modest hotel. Educational or religious spaces are carefully designed to provide a close substitute for those spaces found outside the prison. Treating the prison as a welcoming domestic environment prompts a sense of belonging in a culture that mostly lives indoors because of the cold climate (Fig. 7.9).

Nuuk's Correctional Facility is located on the outskirts of Greenland's capital, a small town of 16,000 inhabitants that nonetheless concentrates a fourth of Greenland's population. The prison's huge hinterland, as well as the extreme climate of its location, are addressed in a design that prioritises a strong relation between the prison's users (inmates, workers, and visitors) and the surrounding landscape. The barren, harsh and beautiful setting of Nuuk prison is the absolute protagonist of the design. The layout is organised in autonomous yet interrelated volumes that follow the slope of the terrain and use this natural gradient to connect the different buildings through semi-underground spaces, so circulation is possible while avoiding outdoor spaces most of the year. The fact that one can see the same rocky landscape on both sides of the perimeter wall greatly reduces its visual and emotional impact. Internal spaces are arranged to face the grand views, and common rooms and collective spaces feature large glazed façades to welcome the arctic light and take in the scenery. The contemplative use of landscape has beneficial effects on

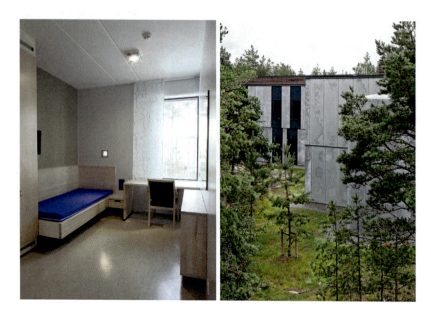

Fig. 7.9 Halden (Norway). Erik Møller Architects + HLM Arkitektur. 2010 (construction). https://www.architecturenorway.no/projects/culture/halden-prison-2009/

prison inhabitants, as it provides sensory richness and a constant perceptual variety that contributes to palliating the psychologically negative effects of confinement. Perceptual variety, indeed, 'fulfills the psychological function of promoting a kind of exercise for the senses, counteracting the boredom that can be so characteristic of prison life. Sensory variety is an aesthetic strategy rooted in an ethical concern: it is intended to improve prisoners' quality of life' (Paez, 2014: 74) (Fig. 7.10).

Puketutu Island Penitentiary is a speculative exploration of prison design based on two concepts: planned obsolescence and an intensified relationship with both society and milieu. The designers devised a nomadic prison—a pop-up penitentiary of sorts. As opposed to an environment where sentences are calculated in terms of lost time and physical confinement, contemporary prisons should act as a restorative motor, providing direct benefits to society through their beneficial

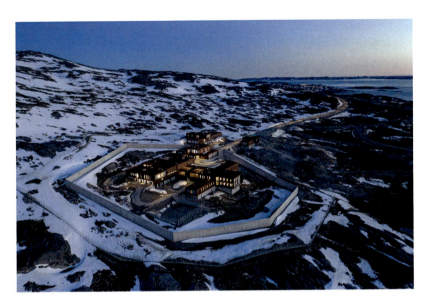

Fig. 7.10 Nuuk (Greenland). Schmidt Hammer Lassen Architects + Friis & Moltke Architects. 2013 (design), 2019 (construction). https://www.shl.dk/new-correctional-facility/

effects on inmates. The prison is designed to solve an existing environmental problem while carrying out the main task of inmate custody and reinsertion. The western half of Puketutu island, heavily affected by open-air quarries, is restored and transformed into an equipped public park for the eventual enjoyment of all of Auckland's inhabitants. The inmates are responsible for a significant part of the restoration work, directly contributing to the betterment of society while engaging in a fulfilling task that provides them with a true sense of purpose as it leaves positive traces behind. This nomadic prison is designed to operate on the site for a limited period, after which it will be relocated, leaving behind pristine, equipped public grounds where there was once a derelict quarry. This radical design aims to promote a close relationship between the prison and society at large in order to tackle two problems: reinsertion (within) and social betterment (without). Avoiding excessive isolation and facilitating a degree of permeability between inside and outside helps to give the inmates a vital horizon, which is

crucial in order to achieve the prison's main programmatic aim of reinsertion. On the other hand, the fact that the programme produces a very tangible betterment of the milieu in its temporary location transforms the prison into a desirable neighbour. Radically incorporating time into the design equation by providing inmates with non-alienating and fulfilling work, generating a direct positive impact on the sites it occupies, and turning the prison into a temporary desirable asset to improve peri-urban communities, the prison becomes three-times restorative—on penitentiary, environmental and social levels. Dismantling the more problematic aspect of prisons—their (apparent) permanence—compels policymakers, designers and citizens to incorporate temporality and the adaptive reuse of prisons from the outset (Fig. 7.11).

Fig. 7.11 Puketutu (New Zealand). AiB arquitectes. 2013 (design) (This text is adapted from Paez, 2014: 228–233). https://www.aib.cat/en/projects/315OPP

Conclusions

In 2014, I published a text called 'Somewhere Lions Still Roam' (Paez, 2014: 20–33), which served as the conceptual backdrop for the Mas d'Enric Penitentiary. These were its closing remarks:

How prisons should evolve is a problem that we all need to have a hand in deciding. The decisions to be made are not easy, nor can they be resolved once and for all. The difficulty of the task, however, does not justify failing to take it on. Mas d'Enric is an architectural foray into this open front. The prison is a mirror of society, but society is not a rigid and immobile framework; it is a joint construction in a permanent state of change. All spheres of knowledge and political sensibilities need to be implicated in proposing all possibilities for improving the prison. All of them, including its disappearance.

In this next decade, I still subscribe to this simple yet radical idea. Probably, the best ways to move forward in critical prison design in democratic societies are two: To develop and test innovative and experimental design proposals that challenge dominant views on detention; and to push for the adaptive reuse of existing custodial facilities, suggesting socially desirable uses for the prison's heterotopic qualities.

The first direction is pragmatic and urgent and should be applied universally. It points towards finding other ways to address detention, going to the root of the question, asking ourselves what kind of custodial spaces (if any) our societies need, and creatively reacting to these needs, rather than uncritically reproducing typologies from the past. This implies, among other issues: removing all the unnecessary accoutrements that relate, functionally or aesthetically, to punishment; avoiding the use of solutions that refer back to undesirable penitentiary imagery; designing for temporality, flexibility and change, incorporating experiential and time-related approaches in both the design and the use of custodial spaces; and, fundamentally, keeping an open mind and actively exploring and testing creative solutions to ensure a desirable evolution of custodial practices. In a nutshell, it implies using the agency of design to replace retributive justice with restorative justice. In order to do that, it is important to involve non-specialised designers to address prison design. Indeed, it is very telling that all the case studies discussed

are the work of architects who do not specialise in custodial design. Unencumbered by technocratic protocols and regulatory frameworks, non-specialised designers have a degree of open-mindedness that allows for a fresh approach to prison design, offering significant advancements by addressing prison design with the same demands and standards of excellence—in conceptual, technical and social terms—as any other kind of public architecture.

The second direction is visionary, and it should be tested locally to assess its effects. It addresses the question of how to take advantage of the many qualities penitentiaries and other custodial spaces may have once their detention function is removed. The negative qualities associated with penitentiaries can be transformed into highly desirable and positive qualities following a change in use. My own concept of 'prison as architectural paradigm' (Paez, 2014), proposes reading the tension between the (programmatic) need for confinement and the (ethical) desire for openness in prison design as characteristic of architecture in general, which uses known and defined spatial delimitations to prompt unknown and open-ended active appropriations, advocating for 'an architecture that, based on determination, opens up toward proliferation: an architecture that promotes the effective broadening of human life' (Paez, 2014: 27). There are a handful of relevant examples of the adaptive reuse of prisons (Porter, 2016; Preuss, 2010; Santo, 2015; Szuta & Szczepański, 2019), but so far they are still quite limited in programmatic scope, and there is a lot of untapped potential to repurpose prisons for innovative and socially beneficial uses (Fig. 7.12). Yet, let us imagine for a second what a brave new world we could build if the dream of decarceration came true and penitentiaries and custodial facilities could be transformed into exciting new spaces to foster (however grandiose it may sound) a better society. Some parts of the world are slowly moving in this direction; they should be followed. Let's make the dream of decarceration a reality, one step at a time.

Design and architecture are powerful tools to shake consciousnesses, as they offer alternative visions of reality and thus contribute to galvanising society to achieve them. The visionary abilities of the spatial design disciplines need to be harnessed to stretch the limits of our current way of dealing with detention. While the demand for custody is clearly

Fig. 7.12 Recent prison repurposing. Haarlem Koepel as temporary housing for asylum-seekers (top left), citizen participation in Barcelona Model to propose future uses (bottom left), Långholmen Hotel in Stockholm's old Kronohaktet prison

addressed through technically vetted active and passive security systems, the demand for reinsertion, being of a complex socio-psychological nature, is much harder to address. Keeping in mind that prison design does not stop at ensuring proper custody is an obvious yet fundamental point. Some practising architects (OMA, Erik Møller Arkitekter, AiB, Schmidt Hammer Lassen, Franz&Sue, Matter Architecture) and many researchers (Bensimon, 2020; Grip et al, 2018; Jewkes & Moran, 2017) have comprehensively studied the imbrication between architecture and design and penitentiary services, showing a high rate of success in social rehabilitation and less recidivism when the design is posited as an active life-affecting agent rather than a simple spatial container. The range of possibilities is enormous: we can use design as a way to call attention to a problematic current condition or tendency through dystopian exacerbation; we can use design to suggest and communicate desirable futures as

end-games towards which to advance; we can use design to realistically solve professional commissions in unexpected ways, rather than reproducing known solutions that consolidate an undesirable state of things; or we can use design as a mediator to facilitate multidisciplinary debate around the subject.

References

Agamben, G. (2005). *State of exception.* Chicago University Press.

Bensimon, P. (2020). *L'impact de l'architecture carcérale sur le personnel des prisons.* Aix-en-Provence: Délinquance, justice et autres questions de société.

Binder, G., & Notterman, B. (2017). Penal incapacitation: A situationist critique. *American Criminal Law Review, 54*, 1.

Boucher, D., & Kelly, P. (1994). *The social contract from Hobbes to Rawls* (1st ed.). Routledge.

Brown, G. (2008). White man's justice, Black man's grief: Voting disenfranchisement and the failure of the social contract. *Berkeley Journal of African American Law and Policy, 10,* 287.

de Certeau, M. (1984). *The practice of everyday life.* University of California Press.

Consoli, G. G. (2005). Prescriptive versus non-prescriptive prison design briefs: Architect responses to interpreting Australian private prison design briefs. *Facilities, 23*(5/6), 216–225.

Consoli, G. (2006). The architect's dilemma: A self reflection in understanding prison design and construction in private prison projects. *Construction Economics and Building, 6*(2), 1–10.

Craig, S. C. (2004). Rehabilitation versus control: An organizational theory of prison management. *The Prison Journal, 84*(4_suppl), 92S–114S.

Day, J. (2013). *Corrections and collections: Architectures for art and crime.* Routledge.

Dolovich, S. (2005). State punishment and private prisons. *Duke Law Journal, 55*, 437–546.

Easterling, K. (2014). Confined. In R. Paez (Ed.), *Critical prison design* (pp. 40–43). Actar.

Evans, R. (1982). *The fabrication of virtue: English prison architecture, 1750–1840.* Cambridge University Press.

Foucault, M. (1979). *Discipline and punish: The birth of the prison.* Vintage Books.

Garland, D. (1991). Sociological perspectives on punishment. *Crime and Justice, 14,* 115–165.

Goffman, E. (1961). *Asylums: Essays on the social situation of mental patients and other inmates.* Anchor Books.

Gottschalk, M. (2016). *Caught: The prison state and the lockdown of American politics.* Princeton University Press.

Grant, E., & Jewkes, Y. (2015). Finally fit for purpose: The evolution of Australian prison architecture. *The Prison Journal, 95*(2), 223–243.

Grip, L., Caviezel, S, & Öjes E. (2018). *How architecture and design matter for prison services: A rapid review of the literature.* Kriminalvården.

Hannon, L. (2002). Criminal opportunity theory and the relationship between poverty and property crime. *Sociological Spectrum, 22*(3), 363–381.

Ignatieff, M. (1978). *A just measure of pain: The penitentiary in the industrial revolution, 1780–1850.* Pantheon Books.

Jewkes, Y., & Johnston, H. (2012). The evolution of prison architecture. In *Handbook on prisons* (pp. 204–226). Routledge.

Jewkes, Y., & Moran, D. (2017). Prison architecture and design: Perspectives from criminology and carceral geography. In A. Liebling, S. Maruna, & L. McAra (Eds.), *Oxford Handbook of Criminology* (pp. 541–561). Oxford University Press.

Koolhaas, R. (1995). Revision. In R. Koolhaas & B. Mau, S, M, L, XL. Rotterdam: 010 Publishers, pp. 235–253.

Lawston, J. M., & Meiners, E. R. (2014). Ending our expertise: Feminists, scholarship, and prison abolition. *Feminist Formations,* 1–25.

Leshem, R., & Weisburd, D. (2019). Epigenetics and hot spots of crime: Rethinking the relationship between genetics and criminal behavior. *Journal of Contemporary Criminal Justice, 35*(2), 186–204.

Matter Architecture, Bernheimer, L., O'Brien, R., & Barnes, R. (2017). *Wellbeing in prison design: A guide,* viewed 15 April 2020. http://bit.ly/MatterPrisonWellbeingV1

May, K., Hout, J. van den Reidel, J., Coates, A. L. IV & Franklin, J. (Eds.). (2014). *CLOG: Prisons.* CLOG.

Murtagh, N., Roberts, A., & Hind, R. (2016). The relationship between motivations of architectural designers and environmentally sustainable construction design. *Construction Management and Economics, 34*(1), 61–75.

McLeod, A. M. (2015). Prison abolition and grounded justice. *UCLA Law Review, 62*, 1156.

Moran, D. (2015). *Carceral geography: Spaces and practices of incarceration.* Ashgate Publishing.

Moran, D., Jewkes Y., & Lorne, C. (2019). Design for imprisonment: Architectural ethics and prison design. *Architecture Philosophy, 4*(1), 67–82.

Paez, R. (2014) *Critical prison design.* Actar.

Pare, P. P., & Felson, R. (2014). Income inequality, poverty and crime across nations. *The British Journal of Sociology, 65*(3), 434–458.

Phelps, M. S. (2011). Rehabilitation in the punitive era: The gap between rhetoric and reality in US prison programs. *Law & Society Review, 45*(1), 33–68.

Porter, N. D. (2016) Repurposing new beginnings for closed prisons. *The Sentencing Project*, viewed 15 August 2020. https://www.sentencingproject.org/publications/repurposing-new-beginnings-closed-prisons/

Preuss, S. (2010). Ten incredible repurposed prisons. *Recycle Nation*, viewed 15 August 2020. https://recyclenation.com/2010/10/recycling-repurposed-prisons/

Rothman, D. J. (1971). *The discovery of the Asylum: Social order and disorder in the New Republic.* Little, Brown and Company.

Rousseau, J. J. (1999). *Discourse on the origin of inequality.* Oxford University Press. (Original published in 1755).

Sang, K., Ison, S., Dainty, A., & Powell, A. (2009). Anticipatory socialisation amongst architects: A qualitative examination. *Education+ Training, 51*(4), 309–321.

Santo, A. (2015) *Converted Cellblocks. The Marshall Project*, viewed 15 August 2020. https://www.themarshallproject.org/2015/01/29/converted-cellblocks

Sperry, R., Bierbaum, A., Calaf, J., Kearney, K., and Monroe, K. (2005, November). Prison design Boycott: A challenge to the professional business of incarceration. *Prison Legal News.*: 1.

St. John, V. J., & Blount-Hill, K. (2019). Place, space, race, and life during and after incarceration: Dismantling mass incarceration through spatial and placial justice. *Harvard Kennedy School Journal of African American Policy, 2018–19*, 46–54.

Sundt, J. L., Dammer, H. R., & Cullen, F. T. (2002). The role of the prison chaplain in rehabilitation. *Journal of Offender Rehabilitation, 35*(3–4), 59–86.

Szuta, A. F., & Szczepański, J. (2019). The difficult heritage. The reuse of former prison buildings. *Technical Transactions, 8*, 71–82.

Vessella, L. (2017). Prison, architecture and social growth: Prison as an active component of the contemporary city. *The Plan Journal, 2*(1), 63–84.

Wacquant, L. (2009). *Punishing the poor: The neoliberal government of social insecurity.* Duke University Press.

Wacquant, L. (2012). The punitive regulation of poverty in the neoliberal age. *Centre for Crime and Justice Studies, Num., 89*, 38–40.

Wemmers, J. A., Cyr, K., Chamberland, C., Lessard, G., Collin-Vézina, D., & Clement, M. E. (2018). From victimization to criminalization: General strain theory and the relationship between poly-victimization and delinquency. *Victims & Offenders, 13*(4), 542–557.

Wilcox, P., & Cullen, F. T. (2018). Situational opportunity theories of crime. *Annual Review of Criminology, 1*, 123–148.

8

Prison Architecture in Chile: A Critical Realist Analysis of Prison Architectural Outputs Through the Lens of Organised Hypocrisy Theory

Alberto Urrutia-Moldes and Fionn Stevenson

Introduction

The biggest program for prison reform in Chilean history was launched in 2000 as a response to an outdated prison infrastructure and a steady increase in the prison population. By using a public–private partnership scheme, Chilean authorities promised a breakthrough to update the country's prison infrastructure, providing purpose-built buildings, up-to-date security and increasing the quality and quantity of rehabilitation programs while ensuring compliance with human rights standards (Banco Interamericano de Desarrollo and Fundación Paz Ciudadana,

F. Stevenson
Manchester, UK

A. Urrutia-Moldes (✉)
Global Banking School (GBS), Manchester, UK
e-mail: urrutiamoldes@gmail.com

2013). Authorities' intentions were to make a qualitative leap in prison infrastructure, while designers made efforts to provide more humane and rehabilitative prison environments. However, designers' and authorities' expectations have not yet been met.

Reviewing the geo-historical context surrounding the Chilean case is crucial to understanding the causes and mechanisms that have prevented prison reform. Moreover, because it is often possible to generalise from a single case, and case studies organised around specific cultural paradigms can be seen as representative because they highlight more general characteristics of the societies in question (Flyvbjerg, 2006), analysing the failed Chilean reform can help designers and reformers understand the mechanisms behind social events in prison services from similar cultural paradigms, providing more effective and lasting policies and designs.

Sayer argues that social events arise from the working of mechanisms that take place within geo-historical contexts (Sayer, 2000, p.15). This geo-historical context must be understood as the relevant circumstances surrounding specific events, taking into consideration that, when looking for explanations, what causes an event to happen is the combination of causal mechanisms involved, identifying which have been activated, under what conditions and "in what ways may the external contingency affect the events that have occurred" (Easton, 2010, p. 121). Therefore, when analysing the incapacity of the social entities involved to meet the objectives of a prison program for reform, the key questions are: what are the internal and external contextual forces that are preventing prison reform goals from being met, and in what way are those contextual forces conditioning the outcomes?

This chapter will interrogate the Chilean prison system and aim to understand the causes and mechanisms that have prevented the evolution of the prison system towards a human-centred and rehabilitation-driven entity, based on the two research questions identified above. It will start by briefly explaining Critical Realism (Bhaskar, 1975) as the research ontology. It will continue with an explanation of the research approach, and the Organised Hypocrisy Theory (Brunsson, 2007) as additional theoretical lenses to interrogate the data. Then, the Chilean case will be presented, by addressing the geo-historical context, its architectural evolution, and the public–private partnership prison program. Finally,

it will be shown how organisational hypocrisy has a major role in the outcomes of the reform attempt, how it works, and how it can be destabilised to unlock evolution.

Critical Realism

Critical Realism (CR) is a philosophy of science developed by Roy Bhaskar (1975, 1979, 2008) and expanded on by others (Archer, 1995; Archer et al., 1998; Sayer, 2000; Danermark et al., 2002). It holds that there is an objective world of entities that have causal properties which result from the necessary relations between their constituent parts (Bhaskar, 1975). Entities can be material (e.g. buildings), Biological (e.g., a human being), social (e.g., a prison service). So, for example, a prison service has the power to imprison people. However, it cannot incarcerate someone without a judicial order to do so. Entities, in turn, are composed of sub-entities, which have their powers and liabilities. So, organisations rely on departments, which rely on sub-units of resources and people. Similarly, buildings contain walls, which rely on being made of bricks, and so on. When two or more entities interact, they tend to produce events, which are the result of the fit of their specific set of powers and liabilities. So, for instance, riots in prisons can be the result of a different combination of previous events, such as bad physical conditions in prison, an increase in abuse of power from prison officers, or internal fights among prisoners (Useem and Kimball, 1991). In CR terms, how the individual powers and liabilities of an entity are combined when interacting with another to produce an event is called causal mechanism. Therefore, events are the simultaneous operation of multiple causal mechanisms associated with the interaction of multiple entities.

Events can be physical, or social. Physical events are commonly found in the world of natural sciences, in which material entities interact. Social events, in turn, occur by the interaction of people, with their rational thinking powers and liabilities, and social entities, with their legal, social, technical, economic, and cultural powers and liabilities. For CR, regardless of whether events are perceived or not, they occur in the objective

world, which exists independently of people's perceptions (Archer, 1995). However, how part of that objective world is perceived and experienced by the observer, is influenced by subjective interpretations (O'Mahoney et al., 2014). Therefore, the CR world is divided into three ontological domains: The Empirical, the Actual and the Real (O'Mahoney et al. 2014).

The "Empirical" domain is the place where only the events that can be experienced and perceived by human senses, exist (O'Mahoney et al., 2014). The "Actual" domain, in which the Empirical domain is encased, is the place that contains all the physical and social events and the unseen mechanisms that produce them. Therefore, when events are outside the inner domain of the Empirical, they occur even if they are not experienced or interpreted, and these true occurrences are often different from what is observed at the empirical level (Danermark et al., 2002, p. 20). Actualised events (the physical and the social events which are observable or not) are the result of the interaction of hidden mechanisms driven by the actualisation of causal powers (Owens, 2011). However, non-events also occur as a result of inaction or non-actualisation of forces. The "Real", the most profound ontological domain, in which the Actual (and therefore the empirical) is encased, is where these non-events are located, as the "underlying potential but unactualised" causal mechanism of objects (Owens, 2011, p.7). The observable and perceivable domain of the "Empirical" is thus encased in the "Actual", which in turn is encased in the "Real" (see Fig. 8.1).

For CR, the existence of social events does not provide a complete explanation of the causal forces that produce them. So, for example, a perceivable increase in prison violence, cannot be explained solely based on the observation of the entities visibly involved, such as the inmates, the prison staff, or the prison's built environment. Similarly, the failure of achieving the expected goals of a policy cannot be explained only by observing the political, technical, and legal entities involved.

CR provides a useful lens, to understand the working mechanisms that produce social events and the causal properties of multiple entities involved, such as the events produced by the interaction of prison organisations, governments, designers, politicians, and society.

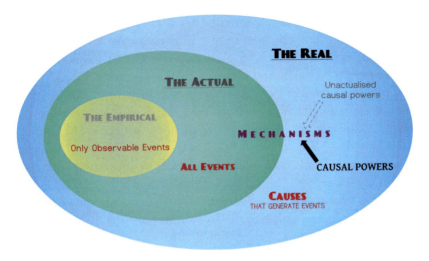

Fig. 8.1 Critical realist ontology

Research Approach

The data for this Chapter was taken from recent research called "*Designing to meet physical, psychological and social well-being needs in prison,*" which explores how designers and prison services' authorities address health and well-being in the process of prison design in different countries (Urrutia-Moldes, 2022). 28 interviews were carried out between September 2016 and March 2017 with prison policy advisors from the United Nations in addition to prison designers and prison authorities from Chile, the USA and Scandinavia (Norway and Finland). The interviews which were semi-structured and conducted in-person lasted 45 min on average. Initially, data was condensed by using a pre-coding book, with predetermined concepts. When the coding process looks for the appearance of a particular word or certain behaviour that is on the surface and easily observable, the process is referred to as Manifest Content Analysis (MCA) (Potter & Levine-Donnerstein, 1999). A second analysis was performed by using latent coding, which involves an interpretation of the underlying meaning of the text. This process is known as Latent Content Analysis (LCA) (Braun & Clarke,

2006). Interviews' data were contrasted against additional photographic and documentary data obtained from non-participatory observations in prisons and archival research in each country. Causal loops diagrams (CLDs), were used to illustrate the dynamics operating in each case. CLDs provide a language to articulate the findings of dynamic, interconnected situations, where variables and their causal relationship can be deployed as sentences telling a coherent story (Williams & Hummelbrunner, 2010).

By using a critical realist ontology, data from this study will help to unveil the underlying causal forces which could explain the Chilean failed prison reform attempt while accepting that this is never a complete account of the "Real" (Bhaskar, 1975). However, for CR the world is theory-laden but not theory-determined (Bhaskar, 1975), meaning that we can gain knowledge "in terms of theories, which can be more or less truthlike" (Danermark et al., 2002, p. 10), and that approaching reality requires the use of additional pertinent theories that can further reveal the causal mechanisms driving social events. Those theories, however, should be selected using rational judgement of social events (Archer et al., 1998, p. xi). For this reason, organised hypocrisy theory is used as an additional theoretical lens to find a plausible explanation of why this phenomenon of incongruence between apparent aims and actual aims occur, why it persists, and how it can be destabilised.

Brunsson (1993, 2007, 2019) developed the concept of organised hypocrisy to address the inconsistencies between organisational rhetoric and behaviour. For Brunsson, organised hypocrisy is the capacity of an organisation to talk, independently of their decisions or actions, satisfying a variety of conflicting interests, as a response to a world of conflicting values, ideas, and demands, while maintaining the status quo. When an organisation's actions are contrary to what they have said or decided, the result is organised hypocrisy. Brunsson uses the term "organised" as organisational actions which may or may not be intentional. Similarly, he argues that organised hypocrisy lies outside the moral realm and cannot be understood as something good or bad but as a result of the decoupled structures of organisations, and their uncoordinated responses to conflicting demands (Brunsson, 1993).

The Chilean Case

The Chilean Geo-Historical Prison Context

In the eighteenth century, Chile, like many Latin American countries, was a highly militarised society due to recent independence campaigns and the demand from the small Creole aristocracy for controlling the economy in the countries' regions as well as ensure the exploitation of slaves and illiterate lower-classes to their benefit (Bethell, 1985; Salazar, 2012). Although the educated elites introduced prisons as an instrument of civilised and modern sanctions, they also felt a deep mistrust towards the illiterate dark-skinned rural masses as barbarous, ignorant, and incapable of civilisation, who needed a form of incarceration at times (Aguirre 2009). This aristocratic penitentiary approach arrived first in Chile in 1843, while still maintaining existing punitive practices of punishing the poor and dissidents, which resulted in the perpetuation of the cruel, severe, and disproportionate punishment on prisoners.

This aristocratic social approach that dominated the consolidation of Latin American countries has been historically conditioning the evolution of the Chilean penal system, preventing the actualisation of a prison system geared towards rehabilitation, and the respect for the human nature of people in prison. Indeed, the deeply rooted punitive and contemptuous social attitude has been transmitted for several centuries by the ruling classes to the rest of the population (Salvatore & Aguirre, 1996). Security-related entities, including the prison system, have acted since their conceived of the State as instruments of mass control and subordination (Salazar, 2012). The custody of inmates in Chilean prisons during the nineteenth century was undertaken by battalions dependent on the army. Punishment at the time, had as a central element the humiliation of the prisoners, to intimidate future criminals, and show the power of the State before the citizens (Gendarmería de Chile, 2016).

Individual prisons were organised in a national militarised entity in 1911. Gendarmería de Chile as it is the prison service known today was created in 1930. During the 1940s prison personnel were demilitarised and became penitentiary technicians with specialised training, politically transforming the prison system into a civilian branch of the

administration (Hathazy, 2016). Nevertheless, the prison act DL.2859 of 15/09/1979, passed during the military dictatorship changed the prison administration back from a "social service" into a pseudo-military, "hierarchical, uniformed, disciplined and obedient" entity (Ministerio de Justicia, 2013, Art.1). After several amendments, today the act classifies personnel into Commissioned Officers, Non-commissioned Officers (called *Gendarmes*), and a series of non-uniformed positions, stating, nevertheless, that "the command corresponds by nature to the Penitentiary Commissioned Officer" (Ministerio de Justicia, 2013, Art.12), meaning that only they can become prison governors, regional directors or be in charge of the national operative sub-direction. In practice, this act prevents any person who is not a Penitentiary Commissioned Officer from heading prison facilities or regional directorates regardless of their professional capacities and expertise. Similarly, it allows that any Commissioned Officer can assume these roles despite their experience and knowledge. This legal constraint has important consequences in the distribution of powers and the actualisation and non-actualisation of causal properties, which could partially explain the perpetuation of Empirical events, such as the overwhelming importance attributed to security over rehabilitation. The significance of this power imbalance is illustrated by an interviewed prison authority from the Technical Sub-Directorate (the national rehabilitation area) of the Chilean prison service, saying:

> today we have some participation [in the decision-making process of prison design projects], from the rehabilitation point of view, from what is the Technical National Sub-directorate. But not from the beginning. We are suddenly called to an opinion when designs are already made. The possibility of modification in this stage always implies greater expense; then it becomes difficult. HLS-H01

In Chile, prison policies are not driven by rehabilitation-related knowledge. A decision-making process based on respect for the human nature of people in prison is a Non-event. It is, a potential but not actualised event that results from the failure to activate the causal powers of rehabilitation-related entities, due to the overwhelming influence of

the causal properties of the security-related ones. This failure is seen by one security-related authority interviewee as deriving from the lack of evidence or technical elements presented by rehabilitation-related entities, allowing authorities to prioritise security in prison design and operation rather than health and well-being and rehabilitation:

> But it is clear that there is a lack of technical knowledge that prevent us to have a definition of these elements of health and well-being well developed, as deep as I have for the security ones. HLS-H-02

The emergence of additional entities during the twentieth century help developing mechanisms to protect and promote human rights. In 1948, a series of legal instruments promulgated by the Organisation of American States (OAS) structured a potential counterweight mechanism against abuses of power in prisons, being the most recent example the inter-American agreement called: *"Principles and Best Practices on the Protection of Persons Deprived of Liberty in the Americas"* (Organisation of the American States, 2008). The document was drafted by the Inter American Commission on Human Rights (IACHR), a sub-entity of the OAS, as a non-binding legal entity, providing for humane treatment and normal life in prison.

Despite the international recognition of the OAS causal powers, the non-binding character of the *Principles and Best Practices* as a legal entity undermine its powers to effectively prevent abuses and overpopulation in prison. The intrinsic liabilities of this legal entity, impede the actualisation of the legal accountability of any country that, as in the case of Chile, do not recognise the agreement as legally binding. For example, although the document establishes that the maximum prison capacity shall be measured according to international standards and that exceeding this capacity should be prohibited by law (Organisation of the American States, 2008, Principle XVII), the latter indication does not occur in Chile. The Chilean law does not prohibit the prison service from overpopulating its facilities. Then, prison overcrowding remains an unwanted event, and an endemic problem (Safranoff & Kaiser, 2020). Documentary analysis revealed that in 2018 Chilean prisons had levels of overcrowding high enough to create alarm among the Justice Ministry

authorities. A report issued by the Supreme Court to the President of Chile, showed the concern of the Judicial power about the overcrowding and poor carceral conditions existing in several parts of the country. One of the cases exposed was the oldest prison in the country, the "CDP Santiago Sur" prison, built in 1843 (with an original capacity of 800 inmates, and a current official capacity of 2,384 inmates) but housing 4,486 inmates at the time of the judicial report, almost double its official capacity (Supreme Court of Chile, 2018).

An interviewed prison authority—whose role is professional and technical but primarily political—acknowledged that the prison population is being punished by placing them in overcrowded prisons, by locking them out in cold dormitories and cells, with insufficient daylight and poor hygiene. They also know that toilets in prison are a focus for disease and that the physical and psychological integrity of inmates is always at risk:

> Nowadays, there are conditions where, from the point of view of the place where inmates sleep, some places have footage of 0.48 m^2 per-inmate. That is absolutely insufficient. That is not worthy. That is not to value the people who are deprived of liberty and [neither does it] promote a different behaviour. HLS-H-03

Nevertheless, authorities and internal entities face inner forces that prevent them from bringing the situation to the light and actualise the necessary events to solve it effectively. This is a clear example of the conflict between causal powers and liabilities of interacting social entities with conflicting demands, wanting to provide better living conditions for people who, nevertheless, have been sent to "suffer" a sentence. It is perhaps also, the fears of being seen as defending the inmates' rights, in a society led to believe that the punishment has to be harsh enough to deter other people from committing a crime. This internal struggle makes it hard for rehabilitation-related staff to resist the security-driven approach, and for prison reformers to succeed in gaining support for improving both prison architecture and prison conditions. However, upgrading the Chilean prison infrastructure has rarely responded to reform movements. Most new prisons in Chile have been built as a result of unexpected

and irreversible damage of the previous facility, without the intention of reform from the prison service. The unavoidable events and the specific emergency context, however, provided favourable conditions for improving security systems and mechanisms of control, as discussed next.

The Prison Architecture Evolution in Chile and the Transition to the Public–private Partnership Prisons

Most of the Chilean prisons facilities that are in operation today were built during the twentieth century after powerful earthquakes. An 8.3 Richter magnitude earthquake in south-central Chile in 1939 toppled most of the old mudbrick buildings, including many detention facilities, acted as a major causal mechanism renewing the prison real estate. As a result, several new purpose-built prisons were erected entirely of wood, using a two-story rectangular typology building with a central corridor on the ground floor (see Fig. 8.2), and two opposing lines of double-occupancy cells of 4.5 m^2 each with no access to in-cell sanitary installations.

This is similar, at least in the layout, to the wings of many Victorian-era English prisons, which only permit an "intermittent supervision," because guards only are aware of what happened in the cell when are close to them (see Johnston, 2000, p. 37). Most of these prisons are still operative in Chile. Again, a 9.6 magnitude earthquake in 1960, provided the causal mechanisms for building a new set of prisons. This time, technological context allowed to build the facilities out of brick and reinforced concrete. This generation of rectangular prisons followed two different approaches. Some prisons were designed with multiple large dormitories, spanning from 50–90m^2 per dormitory and usually without direct access to a toilet. The other double-occupancy approach utilised 4.5m^2 cells on the first floor, with workshops, toilets, and dining rooms on the ground floor (see Figs. 8.3 and 8.4). Nevertheless, they maintained the intermittent supervision, and their design capacities rarely exceeded 100 people due to geographical and technical contextual restrictions.

Fig. 8.2 San Carlos Prison, Chile, built in 1940. Official capacity: 124 inmates

The implementation of a neoliberal economy and the dismantling of welfare state policies, promoted by the dictatorship, was followed by a series of laws that contributes to the increase in the number of people in prison and longer custodial sentences. The prison population increased from 15,270 inmates in 1980 to 32,000 in 2000 (Salinero Echeverría, 2012). To address this phenomenon, authorities promoted the construction of prisons with a large capacity, such as Valparaiso (Cap: 1,919 inmates), Colina I (Cap: 2,056 inmates) or Colina II (Cap: 1,490 inmates) (Gendarmería de Chile, no date). In 2000, authorities announced the political decision to implement a public–private partnership (PPP) program, to build ten new prisons over the course of seven years to deal with the problems (Arellano, 2003). The announcement promised an increase of 16,000 new beds, enhancing efficiency and security, and improving the prison regime, both in terms of increasing the quality and quantity of rehabilitation programs while ensuring compliance with human rights standards (Banco Interamericano de Desarrollo & Fundacion Paz Ciudadana, 2013). However, as exposed next, designers and authorities' expectations have not yet been met.

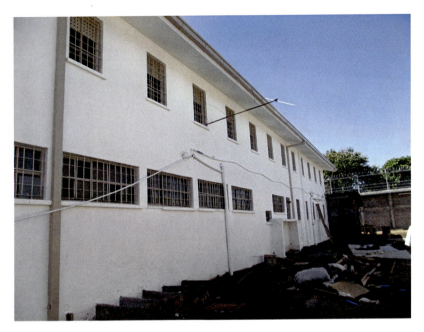

Fig. 8.3 Yungay prison, Chile, built in 1960. Official capacity: 102 inmates. Photograph taken during reparations works due to damages after an earthquake in 2010

Public–Private Partnership Prisons: Expectations Versus Outcomes

In 2000, governmental entities announced the implementation of a public–private partnership program to address an outdated and insufficient prison infrastructure which was seen as the causal mechanism for prison overcrowding, with all its consequent complications, including violence, human rights violations, and poor working conditions for prison staff (Martínez-Mercado & Espinoza-Mavila, 2009). The PPP program promised a major breakthrough to update the country's prison infrastructure, providing new and purpose-built buildings, securing maintenance budget, and up-to-date security and surveillance equipment. The design briefs set out the same design principles. Prison complex entities were expected to house between 1100 to 2500 inmates

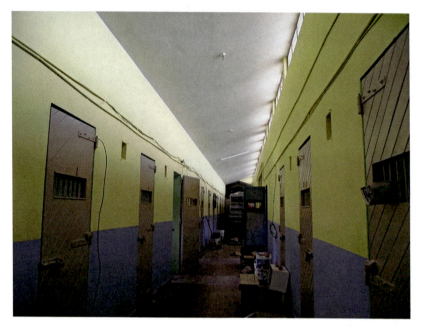

Fig. 8.4 Yungay Prison, Chile, built in 1960. Official capacity: 102 inmates. Photograph taken during reparations works due to damages after an earthquake in 2010

in several units, designed to house 50 to 80 inmates in individual cells and a small percentage of treble-bed dormitories (see Figs. 8.5 to 8.10). These principles established for the first time a physical standard of habitability that designers could refer to. The standard consisted of 6m^2 floor space per inmate in individual cells and 12m^2 floor space for treble-bed collective cells. Each prison block was to have a courtyard, visit area, dining room, a galley kitchen, classrooms, and offices for professionals, in addition to facilities for guards to control the block (see Fig. 8.6). Cells were to have built-in reinforced concrete and metal beds, desk, closet, and an in-cell bathroom with toilet, sink and shower (see Figs. 8.7 to 8.10).

Living conditions in PPP prisons are objectively better due to the incorporation of new elements, usually absent in the traditional system, such as individual cells with in-cell bathrooms, centralised laundry, and

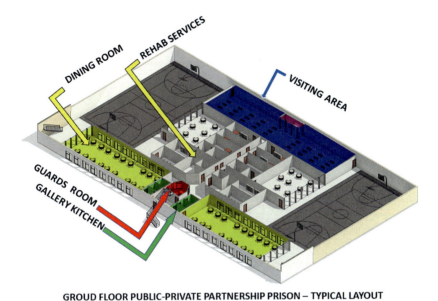

GROUD FLOOR PUBLIC-PRIVATE PARTNERSHIP PRISON – TYPICAL LAYOUT

Fig. 8.5 Typical prison module ground floor layout. Outlining made by Chilean architect Andrés Rodriguez-Ravanal with guidance from the authors based on the information collected during the fieldwork

the inclusion of classrooms, working areas, visiting rooms, and dining rooms, all inside the prison block. Nevertheless, studies conducted by Sanhueza & Pérez, 2017) have shown that inmates in PPP prisons perceive greater levels of violence of staff against inmates ($p = 0.0$; $t = -2.2$; 95%), a higher prevalence of disciplinary measures ($p = 0.0$; $t = -2.5$; 95%), and lower quality of staff-inmate relationship ($p = 0.0$; $t = -3.5$; 95%), than inmates in traditional prisons, despite the apparent design enhancements. Additionally, a study of the causes of an increase in 76,9% in the number of suicides between 2009 and 2010 found that 39.39% of suicides were committed in PPP prisons (Chávez-Hernández et al., 2016), which coincides with the fact that approximately 40% of the total prison population is housed in these prisons. This could be understood as a failure of PPP prison designs to improve safety and prevent suicide. Moreover, in a recent study, Sanhueza et al. (2020)

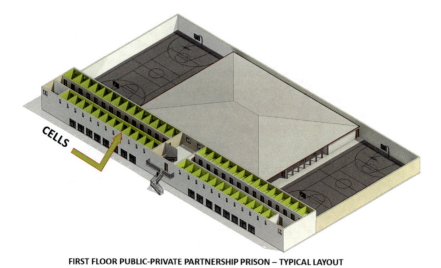

FIRST FLOOR PUBLIC-PRIVATE PARTNERSHIP PRISON – TYPICAL LAYOUT

Fig. 8.6 Typical prison module cells' floor layout. Outlining made by Chilean architect Andrés Rodriguez-Ravanal with guidance from the authors based on the information collected during the fieldwork

Fig. 8.7 Typical individual cell footprint. Built-up area per cell: 6m^2 including in-cell bathroom

Fig. 8.8 Interior of treble-bed cell in PPP "Bio-Bio" prison. Built-up area: 10m^2 including in-cell bathroom

analysed the level of violence, including collective violence and inmate-to-inmate assaults, suggesting that, in three out of four years analysed, being in a PPP prison can be seen as "the most influential predictor of inmate-to-inmate violence" (Sanhueza et al., 2020, p. 16).

As seen above, empirical evidence suggests that the original intentions of designers and authorities involved in the PPP prison program to promote rehabilitation, improve living conditions, and eliminate overcrowding has not been actualised. To reveal deeper mechanisms and unseen causal powers that could explain the failure of the official intentions of the program, the rest of this chapter will discuss the findings using the lens of organised hypocrisy theory.

Fig. 8.9 Reinforced concrete furniture, PPP "Bio-Bio" prison, Concepción, Chile

Organised Hypocrisy

For Brunsson, the level of engagement of an organisation with hypocrisy will be affected by the visibility of their actions and the level of tolerance to hypocrisy shown by the communities (Brunsson, 2007). The wider the spectrum of stakeholders and the more aware they become about what is happening inside the organisation, the lower the level of tolerance to hypocrisy, and the more unstable the hypocritical style of management becomes.

In critical realist terms, all three talk, decisions and actions are events. When only one or two of them are perceivable, therefore situated in

Fig. 8.10 In-cell bathroom, PPP "Bio-Bio" prison, Concepción, Chile

the Empirical domain, and others are situated in the Actual domain, out of sight, there are favourable conditions for engaging in organised hypocrisy.

Organised hypocrisy theory has been applied in a wide range of studies, such as the performance of European Commission on environmental policy (Knill et al., 2020), the peacekeeping missions of the UN in post-Cold War (Lipson, 2007), or the social responsibility of corporations (Christensen et al., 2013). The following discussion sections help to understand how the revealed hypocritical organisational behaviour of the Chilean prison system can be destabilised to help implement architectural design based on human dignity and rehabilitation.

Organised Hypocrisy Theory and the Chilean Prison Service

Prison services are organisations subject to strongly conflicting demands. They have to interact with inmates and other entities such as the Judicial

system, politicians, the media, social organisations, and the community in general. They are also accountable to all these entities in a democracy. Therefore, their communication departments specialise in *talking* to external entities (e.g. the community) and internal entities (e.g. the prison service staff), explaining the *what* and *why* of current strategies and decisions to satisfy the specific demands of each entity. For example, the prison service use communication strategies, such as the creation of a YouTube channel, to promote the feeling among staff of doing meaningful work by highlighting the organisational talk and decisions regarding the treatment and rehabilitation of inmates, despite that people in prison are overcrowded, with 19 out of the total 83 prison facilities in Chile showing critical occupancy levels, it is, higher than 140% (INDH, 2018), and that prisons have little impact in reducing reoffending, with recidivism rates of 50,5% (Morales Peillard et al., 2012). As expressed by Brunsson, "talk and decision have value as a kind of output created by organisations" (Brunsson, 2007, p. 115). The analytical CRT cause-effect loop diagram for the Chilean Prison service in Fig. 8.11 shows how the various entities and their causal mechanisms for keeping staff morale high, and fulfil the governmental needs for avoiding communal pressure or disapproval over their management of security matters, create conflicting demands in the Chilean prison service. The diagram shows that the lower the health and well-being levels of prison staff (A), the lower their morale (B), which in turn will lead to a decrease in quality. of the staff-inmate relationship (C), resulting in lower levels of health and well-being for inmates (D). Furthermore, a long-term condition of low levels of staff morale (B), or low staff-inmate relations (C), or low levels of inmate well-being (D), can accumulate sufficient causal powers to trigger, at some point in the future, the occurrence of critical violent and dangerous events (E). In turn, the more common the occurrence of critical events, the lower the health and well-being of both staff (A) and inmates (D). Also, the occurrence of critical events produces an alert in the community, increasing feelings of insecurity and growing disapproval of how the government handles security. One way to improve the staff morale is by showing them that their work is meaningful (G) and that it is recognised by the community. In this regard, the creation of a Youtube channel seems to be designed to fulfil this function, without the need of

objectively improving staff's working conditions, or addressing any other variable.

The diagram also shows that the governmental reaction to communal pressure is to increase security measures in prison, at the sacrifice of both the living conditions of inmates and the facilitation for the presence of external monitors while incentivising hermeticism. This reaction reduces the level of transparency and therefore the accountability of individual entities among the prison service, which in turn provide more incentive to the hermeticity of prison operations.

This is important because the degree of transparency or hermicity of the prison service will directly affect the level of tolerance to hypocrisy. After all, the community cannot compare the prison service talk and its actions. Indeed, the less operational transparency there is, the more significant the gap between *what the prison service says, what decisions it makes, and what its daily actions are.*

One example of this is where the Chilean prison service states in its Prison Organic Law that they aim to take care, monitor, and contribute to the social reintegration of people in prison (Ley Orgánica de Gendarmería de Chile, D.L. No. 2859, 1979). However, a governmental designer interviewee when asked to what extent is important to consider health and well-being in the design of prison cells, comments:

> Here, 12 square metre cells have been designed for 4 people, 3 square meters per person, including the bathroom. I consider promoting wellness in cell design to be very important. But if you ask the security department, for them the important thing is the wall, the watchtower, and hopefully they have all kinds of advanced technology so that no one ever escapes. GD-H-03

This perception of lack of interest from uniformed personnel regarding the well-being of inmates is shared by other designers interviewed and also by some authorities, as expressed by one authority interviewed:

> I believe that [health and well-being must be considered] from the beginning. No, I can not- I do not think that this can be modified later. [However], I feel that there is a predetermined approach to privilege what is security in any of the situations. HLS-H-01

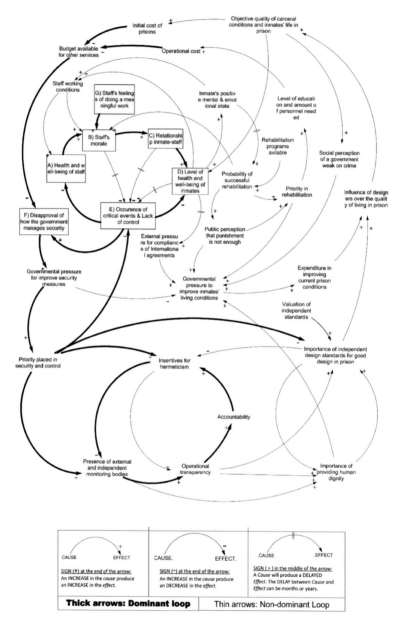

Fig. 8.11 Cause-effect loop diagram for the Chilean Prison service (Urrutia-Moldes, 2022)

However, in a scenario of almost total absence of external and independent monitoring bodies, the provision of health and well-being is justified only because it can minimise the probability of occurrence of critical events and the inconvenience they produce rather than to provide human dignity. This can be observed in the words of a security-related authority interviewed:

> "Without a doubt, in terms of security [considering the well-being of the prisoners] is very relevant, the better conditions I have for the prison population, the less problems I will have." … "If we had the level of investment that the United States has, we would not have this type of problem, such as 81 prisoners dying in the San Miguel prison fire. That is what we do not want to repeat, but it will probably be repeated because of the conditions of our infrastructure. HLS-H-03

The interviewee refers to the case of the San Miguel prison, where a fight between inmates in 2010 resulted in a fire with 81 inmates dead and 14 suffering life-threatening burns, in a prison with 197% occupancy and non-existent fire extinguishing network. In this case, although nobody were found guilty in any way, scholars argue that "the omissions in the duty of care of the agents of the State and the obligation of the Judicial System to sanctions constitute serious violations of human rights of the persons deprived of liberty and their families" (Neira Fernández & García Fregoso, 2015, p. 135).

For the Chilean Prison service, the fear of legal and political consequences for the occurrence of critical events seems to be more critical than providing inmates with dignity or their rehabilitation. Therefore, design guiding principles are focussed on security, control of movements, and avoiding escape rather than the health and well-being of inmates. Additionally, in clear opposition to their public discourse about their commitment in promoting rehabilitation and changing people's lives, the allocation of most of its annual budget is towards security, surveillance and control equipment, strengthening a semi-militarised prison-guard structure (what is done) (Saavedra-Olivares, 2018). In this way, the organisation keeps the occurrence of critical events controlled, and their adverse political effects, while satisfying the government needs to control community reactions.

How Hypocrisy Works in Prison Design

Due to the limited possibilities for external entities in Chile to be transparently involved in observing the prisons daily routine, the level of tolerance to hypocrisy is high because the contradictions between official statements and actions are hidden. For example, the "talk" of improving safety and the well-being of inmates through better access to daylight in the design on PPP prisons was "satisfied" by actively reducing as much as possible the width of the windows, to reduce the chances of escape, despite the psychological effect of confinement and the resulting reduction in natural light (see Fig. 8.12). This situation is worse in old prisons, where windows are heavily reinforced with obstructive bars or metal mesh (see Fig. 8.13). Interviewees acknowledge the need to provide more appropriate access to natural light but argue that a change in this hypocritical mindset is needed to prioritise an adequate allocation of budget for genuinely rehabilitative daylighting purposes. Due to the limited impact of the actions of external entities, such as independent regulatory bodies of design, on the prison services and government policy, it is in the interest of the prison service to create and support—through a lack of operational transparency—the spectator's impression that "talk" is an accurate description of decisions and actions. In Brunsson's words, if they are "successful" as projected through talking and publicity, everyone is happy—except perhaps, in this case, the inmates—and thus the status quo can continue.

Stability and Destabilisation of Hypocrisy

The idea that talks, decisions, and actions should be consistent is a widespread norm in society, and organisations are not supposed to engage in hypocrisy. If organisations can be proven to be hypocrites, and the tolerance to hypocrisy is minimum, they can be censured according to this norm (Brunsson, 2007, p. 124). This gives a strong incentive towards the secrecy of organisations such as prison services surrounding their empirical actions.

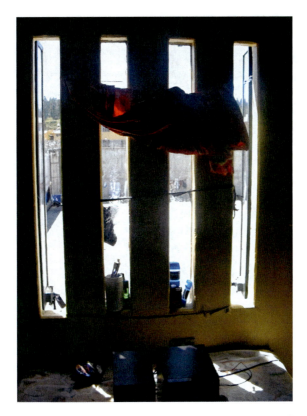

Fig. 8.12 View from a prison cell at CCP Bio-Bio prison, Concepcion, Chile

Time as a Stabiliser

Time is one of the key stabilisers of hypocrisy in Chile. By adding a time dimension, and deferring actions to the distant future, it becomes easier to create tolerance for the incongruences between talk, decisions, and actions (Brunsson, 2007). Decisions affecting the financial dimension for the long-term such as 10- or 20-years development planning can create the hope that one day what is said will be consistent which what is done. Moreover, changes in the political arena or the economic conditions can easily help to perpetuate the hypocrisy. This "change and perpetuation" process is clear in the Chilean case prison service and the implementation

Fig. 8.13 Windows in juvenile module at CP Valparaiso

of the public–private partnership program. The initial promise of the concession system was the creation of a strategic alliance between the public and private sectors to generate flexible, profitable, efficient prison systems, of higher quality and lower cost than traditional prisons—thus being financially optimal. (Sanhueza et al., 2017). Ten years *after* the end of the initial seven-year deadline, only seven prisons were built and the cost of imprisonment was three times higher than the original prison system (Arriagada, 2013).

Despite that an eighth additional prison was opened in August 2013 (Gobierno Regional de Antofagasta, 2013), Chilean prison capacity was increased only in 12,435 beds, rather than the 16,000 new places in ten prisons originally promised, with no significant difference in the perception of inmates between the habitability of the old traditional prisons and the new PPP prisons (Sanhueza & Pérez, 2017). Today the Chilean prison service still has a high level of overcrowding, an insufficient staff in rehabilitation, inadequate physical conditions in traditional prisons

affecting the health of inmates (INDH, 2018; Sánchez Cea & Arriagada, 2015), and harsh environments in both these systems which affect the well-being of both inmates and prison staff (Supreme Court of Chile, 2018). However, the prison service still maintains in its mission statement that the institution must contribute to the social reintegration of inmates. At the end of this long-term planning period, when critical events caused a shock in public opinion, the Chilean prison services and governments reacted with new talks—repeated in cycles—about the crisis of the prison system. This was the case in 2010 after the San Miguel prison fire, where President Sebastian Piñera described the prison system as "inhumane" and said reforms should be speeded up (BBC News, 2010). This can partly explain why the prison—as an institution—is in permanent crisis and has been the object of penal reform since its very birth (Foucault, 1975).

Creating Change as a Stabiliser

Another factor that makes hypocrisy more tolerable is the extent to which the prison service is perceived as a group of different entities with different interests, rather than a single accountable actor. In this regard, the more unstable a prison service is, the higher the level of tolerance for hypocrisy. This is illustrated in the Chilean case, where the heads of the prison service only remain in office 1.7 years on average, often for political reasons (Ley Orgánica de Gendarmería de Chile, D.L. No. 2859, 1979). The head of the prison service is thus seen separately from the institution, and therefore because there are doubts as to whether the prison service is really a single actor, the prison service does not pay much attention to the incongruencies. The new prison head also inherits the old administration incoherencies with little time to deal with them, and thus the inconsistency between words and actions is tolerated as a result of these factors. Internal actors such as staff and designers, accept the current hypocritical conditions as inevitable, reproducing old and ineffective decisions, solutions, and designs. Importantly, external observers "tend to think that a new actor has been created, and interpret what has

happened as an inconsistency between actors rather than the hypocrisy of one actor" (Brunsson, 2007, p. 130).

Destabilising Hypocrisy in Prison Services

There are potentially two ways to destabilise such hypocrisy in the Chilean prison service, as an exemplar, and improve the situation for prison design and management: Justification and Consistency. Justification means ensuring that talks and decisions match what the prison service is really doing—their actions. However, when actions have a negative connotation or are morally unacceptable, this is not a socially acceptable option. For example, the Chilean prison service decided to justify their actions of placing inmates in overcrowded and unhealthy places by redefining the overcrowding limit. The way to destabilise this particular situation would be to expose the missing elements (ie: independent spatial norms related to prison occupancy and application of international standards) from the prison service narrative to the public and disrupt the self-serving rationale here, demanding a more appropriate form of justification.

The second way to destabilise hypocrisy in the Chilean Prison service, as an exemplar, is by applying the norm of consistency—the norm that actors should not be hypocrites. However, this requires two additional elements. First, the hypocritical prison service must be exposed as such. To make organisational hypocrisy visible requires monitoring and reporting of organisational behaviour. It is easy to forget what was once said and what was once decided upon, and it is not always easy for one individual to know about all the talk, decisions, and actions of an organisation (Brunsson, 2002). These monitoring entities could be the media, but they also could be interrelated NGOs or unrelated government organisations that interact with the monitored prison service. Among prison services, in addition to the media, these entities can be a formally organised association of families of inmates, or interrelated organisations working inside the prison service—and therefore, aware of the prison service actions—such as governmental institutions hierarchically independent from the prison service and even from the Ministry

of Justice. Second, for monitoring to be effective as an action to destabilise hypocrisy, there must be an associated sanction. Once hypocrisy has been discovered, its stability is dependent on the extent to which is tolerated and sanctioned. For example, if the overcrowding of prisons were prohibited by law, as proposed by the international agreement regarding called *Principles and Best Practices on the Protection of Persons Deprived of Liberty* (Organisation of the American States, 2008), the Chilean State would take careful attention to what is happening in its prisons, ensuring they are not overcrowded. Likewise, Chilean prison conditions could be different today if the authorities responsible for the San Miguel fire had been effectively sanctioned by the Chilean justice system due to their omissions regarding their responsibility to improve prison conditions in terms of physical infrastructure, staffing sufficient, and implement adequate emergency plans and equipment. If there is a superordinate hierarchical level that can sanction hypocrisy, instability increases (Brunsson, 2002, 2007).

Conclusions

This chapter has demonstrated that despite the desire of the social entities to meet the objectives of a prison reform program in Chile, their efforts have been conditioned and, in some cases, impeded by the interaction of their causal properties. The hypocritical style of management of the Chilean prison service, as an example of Prison services operating in Latin America has played a major role in preventing the actualisation of causal powers of external and internal entities. By observing the different entities involved and considering the historical context, we have shown how the deeply rooted punitive social attitude, inculcated by the ruling classes for generations has been historically conditioning the evolution of the Chilean penal system. In turn, the analysis of the legal context showed how, by avoiding conferring legal status on the norms and good practices for the treatment of inmates, previously agreed upon by the country in the Organization of American States, the Chilean government has managed to avoid being held responsible for the overcrowding of their prisons. The contextual analysis has also revealed how the power

granted by law to the Penitentiary Commissioned Officers, pointing to them as those in command of the organisation generated an imbalance of forces that positioned security approaches far above rehabilitation. Through the use of critical realism and organised hypocrisy theory, we have also revealed the underlying causal mechanisms operating in the Chilean Prison system which exist to stabilise hypocrisy, such as the use of communication strategies to keep high the morale of prison staff, or maintaining a hermetic operational style, preventing the intrusion of external entities to avoid access to operational knowledge, and therefore accountability. The use of time was exposed as one of the main strategies of stabilisation of hypocrisy. It was shown that the longer the process proposed for the reform, the more difficult is for the community to compare with the previous situation, and the less accountable the actors for the breach of promises. It was also exposed how the instability of the position of National Director of the penitentiary service, due to the politicization of the position has further promoted the stabilization of the hypocritical style of management, since the community and the rest of the actors cannot see an incoming Director as responsible for inconsistencies, and they assume discrepancies between talks, decisions, and actions as inevitable.

Finally, we have discussed how to destabilise the hypocritical style of management of prison services, as a necessary step to meet the objectives of a prison program for reform. The exposition of the missing elements from the official discourse is essential, to evidence the lack of basis and dismantling the official argument. Additionally, the inclusion of external actors in the process of prison design, as well as during the operation, can play a vital role in forcing organisational consistency. More crucially, politicians and the community have the responsibility to create efficient mechanisms to effectively hold authorities accountable for their actions and omissions regarding human rights and international law.

Although this is a single case study, the indicative findings have wider implication for prison services beyond Chile. Indeed, it is often possible to "generalise from a single case, and the case study may be central to scientific development via generalisation as a supplement or alternative to other methods" (Flyvbjerg, 2006, p. 12). The Chilean system has much in common with other Latin American prison systems (de

Leon Villalba, 2018; Safranoff & Kaiser, 2020), and also with other prison systems in countries that rely on hypocrisy to stabilise. Organised around specific cultural paradigms, this case can be seen as representative because they highlight more general characteristics of the societies in question(Flyvbjerg, 2006). It does NOT apply to more repressive government regimes and prison services where hypocrisy is not necessary because their actions—although morally unacceptable—have become consistent with their talk and decisions.

From a design point of view, this case study has revealed the hidden forces that prevent designers from being able to actualise policies and which maintain them in a hypocritical position. This is important because it means that simply providing prison design guidance (such as overcrowding limits, levels of daylight, etc.) will not be effective unless the causal context and forces at play are understood first and means to ensure that the design guidance can be followed are developed.

However, no reform will be possible if hypocrisy is not destabilised. In light of the above, the following are a set of key recommendations considered as essential to creating the conditions that will move the Chilean prison system, and others other systems around the same paradigm, towards a more humane and rehabilitation-driven prison approach:

First, it is necessary to establish the health and well-being of inmates as an institutional strategic goal of the prison service.

Second, to promote *operational transparency*, with the participation of other governmental, communal, or non-profit entities, in the daily work inside prisons. This would help to permanently monitor whether the public discourse of prison services is aligned with their actions, concerning prison operating procedures and their design and maintenance.

Third, international agreements in human rights and the treatment of people in prison should be recognised as legally binding documents.

Fourth, the prison system direction and the administration should be separated from political contingencies and associated with leadership capacities, excellence, and knowledge, rather than rank and time in service.

Finally, it is particularly necessary to promote the improvement of the level of education of prison officers who need to be trained as coaches rather than as armed guards, and demilitarise its structure.

References

Archer, M. S. (1995). *Realist social theory: The morphogenetic approach thus not only rejects*. Cambridge University Press.
Archer, M., Bhaskar, R., Collier, A., Lawson, T., Norrie, A. (Ed.). (1998). *Critical realism: Essential readings*. Taylor and Francis.
Archer, M., Bhaskar, R., Collier, A., Lawson, T., & Norrie, A. (2013). *Critical realism: Essential readings*. Routledge.
Arellano, J. (2003). Reforma Penitenciaria: El caso del programa de concesiones en infraestructura penitenciaria en Chile. *Seminario Justicia y Gobernabilidad Democrática del Centro de Estudios de Justicia de las Américas y Ministerio de Justicia de Chile*, 6.
Arriagada, I. (2013). Cárceles privadas: La superación del debate costo-beneficio. *Política Criminal. Universidad De Talca, 8*(15), 210–248.
Banco Interamericano de Desarrollo and Fundacion Paz Ciudadana (2013) Evaluación del sistema concesionado versus el sistema tradicional en la reducción de la reincidencia delictual.
BBC News. (2010). *Chile prison fire kills scores of inmates*. BBC News. Available at: https://www.bbc.co.uk/news/world-latin-america-11949543. Accessed 16 April 2021.
Bethell, L. (Ed.). (1985). *The Cambridge history of Latin America (Vol 10)*. Cambridge University Press.
Bhaskar, R. (1975). *A realist theory of science*. Leeds Books Ltd.
Bhaskar, R. (2008). *Dialectic: The pulse of freedom*. Routledge.
Braun, V., & Clarke, V. (2006). Using thematic analysis in psychology. *Qualitative Research in Psychology, 3*(2), 77–101.
Brunsson, N. (1993). Ideas and actions: Justification and hypocrisy as alternatives to control, *Accounting. Organizations and Society*. Oxford University Press, *18*(6), 489–506.
Brunsson, N. (2002). *The organization of hypocrisy: talk, decisions and actions in organizations* (2nd ed.). Abstrakt, Liber: Business School Press.

Brunsson, N. (2007). *The consequences of decision-making*. Oxford University Press.

Brunsson, N. (2019). *The organization of hypocrisy: Talk, decisions, and actions in organizations* (3rd ed.). Wiley.

Chávez-Hernández, A.-M., et al. (2016). Suicide in Chilean prisons during the 2006–2015 decade. *Revista Criminalidad, 58*, 101–118.

Christensen, L. T., Morsing, M., & Thyssen, O. (2013). CSR as aspirational talk. *Organization, 20*(3), 372–393.

Danermark, B., Ekström, M., Jakobsen, L., & Karlsson, JC. (2002). *Explaining society. An introduction to critical realism in social sciences*. Routledge.

Flyvbjerg, B. (2006). Five misunderstandings about case-study research. *Qualitative Inquiry, 12*(2), 219–245.

Foucault, M. (1975). *Discipline and punish: The birth of the prison*. Gallimard.

Gendarmería de Chile. (2016). *Gendarmería de Chile, 105 Años trabajando por una sociedad más segura: Antecedentes históricos y legales sobre el origen institucional*. Gráfhika.

Gendarmería de Chile. (no date). Web page Gendarmería de Chile. Available at: https://www.gendarmeria.gob.cl/estadisticaspp.html. Accessed 1 September 2020.

Gobierno Regional de Antofagasta. 2013. Ministra de justicia inaugura nuevo centro penitenciario de Antofagasta, Gobierno Regional de Antofagasta. Available at: https://www.goreantofagasta.cl/goreantofagasta/stat/api_anteriores/index.php/sesiones/sesion?id=877&cateid=gobierno-regional. Accessed 17 April 2021.

Hathazy, P. (2016). Remaking the prisons of the market democracies: New experts, old guards and politics in the carceral fields of Argentina and Chile. *Crime Law Soc Change, 65*, 163–193.

INDH. (2018). *Estudio de las condiciones carcelarias en Chile 2018*. Santiago de Chile.

Johnston, N. (2000). *Forms of constraint: A history of prison architecture*. University of Illinois.

Knill, C., Steinebach, Y., & Fernández-i-Marín, X. (2020). Hypocrisy as a crisis response? *Assessing Changes in Talk, Decisions, and Actions of the European Commission in EU Environmental Policy, Public Administration, 98*(2), 363–377.

de Leon Villalba, F. J. (2018). Imprisonment and Human Rights in Latin America: An introduction. *The Prison Journal, 98*(1), 17–39.

Lipson, M. (2007). Peacekeeping: Organized hypocrisy? *European Journal of International Relations, 13*(1), 5–34.

Martínez-Mercado, F., & Espinoza-Mavila, O. (2009). Concesioned prisons in Chile: A pathway for privatization? *Revista Debates Penitenciarios, 9*(June), 3–15.

Ministerio de Justicia. (2013). *Ley Organica De Gendarmeria De Chile.* Santiago de Chile.

Morales Peillard, A. M. et al. (2012). *La Reincidencia en el Sistema Penitenciario Chileno.* Santiago: Fundacion Paz Ciudadana.

Neira Fernández, K and García Fregoso, NC (2015) The fire of San Miguel prison: It's veredict of acquittal and the international obligation to protect the involved human rights. *Anuario de Derechos Humanos* 11 (2015): ág-135., (11), pp. 135–145. Available at https://iamr.uchile.cl/index.php/ADH/article/download/37494/39174

Organisation of the American States. (2008). *Resolution 1/08 Principles and Best Practices on the Protection of Persons Deprived of Liberty in the Americas.*

O'Mahoney, J., & Vincent, S. (2014). Critical realism as an empirical project: A beginner's guide. In: O'Mahoney, J., Vincent, S., Edwards, PK. (Ed.). *Studying organizations using critical realism: A practical guide.* Oxford University Press.

Owens, J. (2011). *An introduction to critical realism as a meta-theoretical research perspective.* Center for Public Policy Research.

Potter, W. J., & Levine-Donnerstein, D. (1999). Rethinking validity and reliability in content analysis. *Journal of Applied Communication Research, 27*, 258–284.

Saavedra-Olivares, F. (2018). *Sistema de control de gestión gendarmería de chile.* Universidad de Chile.

Safranoff, A., & Kaiser, D. (2020). Violencia en América Latina: ¿Qué factores aumentan el riesgo de ser victimizado dentro de la prisión? *Revista Latinoamericana De Estudios De Seguridad, 28*, 88–99.

Salazar, G. (2012). Movimientos sociales en Chile: Trayectoria histórica y proyección política. *Critical Reviews on Latin American Research, 3*, 47–49.

Salinero Echeverría, S. (2012). ¿Por qué aumenta la población penal en chile? Un estudio criminológico longitudinal. *Ius Et Praxis, 18*(1), 113–150.

Salvatore, R. D., & Aguirre, C. (1996). *The birth of the penitentiary in Latin America: Essays on criminology, prison reform, and social control, 1830–1940.* University of Texas Press.

Sánchez, M. and Piñol, D., (2015). Condiciones de vida en los centros de privación de libertad en Chile. *Análisis a partir de una encuesta aplicada a seis países de Latinoamérica. Santiago, Chile.*

Sanhueza, G. E., Pérez, F., Candia, J., & Urquieta, M.A. (2021). Inmate-on-inmate prison violence in Chile: The importance of the institutional context and proper supervision, *Journal of interpersonal violence, 36*(23–24).

Sanhueza, G., Brander, F., & Fuenzalida, F. (2018). First survey on prison life in Chile: A social work call for prison reform. *International Social Work, 61*(6), 1139–1153.

Sanhueza, G. E., & Pérez, F. (2017). Cárceles concesionadas en Chile: Evidencia empírica y perspectivas futuras a 10 años de su creación. *Política Criminal, 12*(24), 1066–1084.

Sayer, A. (2000). *Realism and social science*. SAGE.

Supreme Court of Chile. (2018). *Report on main problems detected during the prison visits carried out in 2018 by Judicial Prosecutors*. Santiago de Chile.

Urrutia-Moldes, A. (2022). *Health and well-being in prison design: A theory of prison systems and a framework for evolution*. Routledge.

Useem, B., & Kimball, P. (1991). *States of siege: US prison riots, 1971–1986*. Oxford University Press.

Williams, B., & Hummelbrunner, R. (2010). *Systems concepts in action A practitioner's toolkit*. Stanford University Press.

9

The Architecture and Design of the Communist and Post-Communist Prison in Europe

Judith Pallot and Olga Zeveleva

Introduction

In the 1990s and early 2000s, most of the newly emergent sovereign states in East Central Europe and the former Soviet Union in Europe

The research leading to these results has received funding from the European Research Council (ERC) under the European Union's Horizon 2020 research and innovation programme (Grant Agreement N° 788448).

J. Pallot (✉) · O. Zeveleva
Aleksanteri Institute, University of Helsinki, Helskinki, Finland
e-mail: judith.pallot@helsinki.fi

O. Zeveleva
e-mail: olga.zeveleva@helsinki.fi

were admitted to the Council of Europe.[1] In becoming members, they agreed to set out on a path towards harmonisation of their domestic legislation, policies, and practices with regard to the ECHR and European Prison Rules, and to subject their detention facilities to Committee for the Prevention of Torture inspections. For all, this was an opportunity to effect a fundamental change in a prison system that was noted for its inhumanity, disregard for human rights and retributive principle. It was a system that had been in place since the time of the Bolshevik revolution of 1917, or the dying years of World War II in the case of East Central Europe. Communism, through revolution or foreign occupation, had brought to an abrupt halt the birth of the modern prison, as understood in western penal literature, to the countries east of the river Elbe and as far as the Pacific coast. The cellular prison was replaced by the 'Soviet penal model', based on the principles of collectivism, prisoner self-government and re-socialisation through compulsory labour. The pure forms of both the 'western' and 'Soviet' model exist only in the imagination of prison historians, but the binary they represent has framed policy decisions made by every one of the sovereign states that were created, or gained their independence, after communism's collapse in Europe. In both the regulatory and discursive sphere, all post-communist countries have set out on a path that has moved their system of penality away from the Soviet-era model, while at the same time retaining legacy elements from communism. The result is the emergence of a series of hybrid forms that, contrary to the linear conception of penal development, are *sui generis* rather than in transition to the model western-type prison.

There are numerous and varied indicators of the transformation away from the communist-era system of penality but, among them, prison architecture has the greatest symbolic value both in discourse and in practice. In this chapter, we discuss the original Soviet model of socialist prison architecture before examining modifications to this model in the thirty years since communism's collapse. We do this in relation to

[1] The exceptions among former Soviet states in Europe are Belarus and Kosovo in the former Yugoslavia. The successor states of the USSR in Central Asia are also not Council of Europe members, including Kazakhstan the western regions of which are considered part of Europe by some institutions. On 16th March 2022 the Council of Europe expelled the Russian Federation for its invasion of Ukraine after 26 years of membership.

two countries that came to contrasting decisions on the way forward post-1991. These are Estonia, the former Soviet republic that was incorporated into the USSR at end of WWII, and the Russian Federation. Among the countries of East Central Europe, Estonia has introduced the most far-reaching reforms to distance its prisons from Soviet-era penality. This has been symbolised by the decommissioning of all facilities inherited from the USSR and their replacement by three brand new prisons that conform to European standards and are designed to cement Estonia's return to the European family of nations. The Russian Federation, in contrast, has retained many of the features of Soviet-era facilities, while introducing measures aimed at bringing the treatment of prisoners and conditions of detention in line with European minimum standards. This has been achieved both by modifying and re-coding practices inherited from the USSR (Pallot, 2015a).

Between the 'extremes' we discuss, the other communist successor states in Europe are arrayed along a spectrum of the distance travelled from the 'Soviet model'. We are hesitant to label the resultant hybrid penal forms as constituting the 'post-socialist' system of penality in counter distinction to modern 'western' and post-colonial systems, but we acknowledge the commonalities in the challenges they have faced since 1989–1991. In the aftermath of communism's collapse, none of the countries of East Central Europe or the former Soviet Union had the resources or public support needed to launch ambitious structural prison reforms or to develop the alternatives to incarceration called for by their membership of the Council of Europe. Meanwhile, all faced an expansion in the numbers of convictions in the courts and changes in offender profiles associated with the emergence of new patterns of criminality following the opening of their borders. Finally, all countries have had to overcome the legacies of a harsh penal culture that was fundamentally at odds with the welfarist and progressive principles informing the development of new penal architectures, the punitive turn notwithstanding, in other Council of Europe jurisdictions (O'Neill, 2012; Symkovych, 2018, 2020). In responding to these challenges, the criminal justice system and prisons have often been put to the service of defining ethnic, religious, and political insider and outsider status as the new sovereign states have

sought to re-position themselves in the international division of labour (Haney, 2016; Zsolt et al., 2015).

The Globalisation of Prison Design and Shifts Towards Cellular Confinement

In analysing the symbolic and architectural steps away from communist-era prisons, an imagined 'European penality' has emerged as a new reference point for many policy-makers in post-Soviet countries. The Council of Europe and European Union have attempted to create a common area of security, human rights, democracy and justice, which has involved calling for a more cohesive approach to punishment across member-states (Baker, 2013; Slade & Vaiciuniene, 2018: 219; Van Zyl Smit & Snacken, 2009).

Scholars have conceptualised such processes as the multi-level governance of penality (Piacentini & Katz, 2017; Van Zyl Smit & Snacken, 2009; Vaughan & Kilcommins, 2007), the convergence or diffusion of penal policy (Macaulay, 2013; Wacquant, 2009; Zeveleva & Nazif-Munoz, 2021), or as the globalisation of punishment (Bowling & Sheptycki, 2012; Downes, 2001; Giddens, 1990; Jones & Newburn, 2002; Karstedt, 2002; Martin, 2017; Melossi et al., 2011; Wacquant, 2009, 2013). The mechanisms by which penal policies cross national borders vary from de-facto tutelage of one government over another as in the case of US-led prison reform in Colombia in the 2000s (de Dardel & Söderström, 2018), to international networking among penal policy-makers, to politicians' rhetorical nods towards adherence to 'Western' conceptions of human rights in detention facilities. Much of this literature focuses on practices and models exported to other jurisdictions from the USA, particularly the supermax prison design (de Dardel & Söderström, 2018; Macaulay, 2013; Martin, 2017; Rhodes, 2014; Ross, 2013; Rubin & Reiter, 2017; Wacquant, 2013). The importation of American penal design is often analysed by scholars through the prism of increasing punitiveness and toughening detention conditions (de Dardel & Söderström, 2018: 834) and 'symbolic, economic, and political power asymmetries' (de Dardel & Söderström, 2018: 858).

The diffusion of European norms across jurisdictions is less discussed in the literature, despite numerous efforts by European institutions to codify, recommend, implement, and monitor conditions of detention. This reflects not only the dominance of the USA on the global arena, but also the Anglo-American centrism of penal scholarship (Brangan, 2020).

Against this backdrop, it comes as no surprise that there has been little scholarly interest in the potential for the diffusion of practices and models in the opposite direction—from global South and East to global North. This is reflected in recent discussions about the use of dormitory accommodation as a solution to prison overcrowding. It will be recalled that UN Mandela rules and European Prison Rules strongly recommend single-cell accommodation while recognising that there are circumstances when multiple occupancy of sleeping space cannot be avoided. In such cases, the advice is that care should be taken in the placement of co-habitants and appropriate levels of surveillance provided to ensure safety. The 'honor dorms' at the Maryland House of Correction, USA, introduced as a reward for good behaviour, are held up as an example of where shared sleeping space can be made to work towards rehabilitation (Peguese & Koppel, 2003). The default assumption about dormitory accommodation, however, is negative. There are, in fact, few studies of prison dormitories and they are dominated by the experience of the USA and Australia, where the dormitory is used in response to the culturally-specific needs of aboriginal prisoners (Grant & Memmott, 2008; Grant, 2013: 51–52). The consensus of this research is that prisoners housed in dormitories are vulnerable to bullying, sexual assault, loss of control over their personal space, lack of privacy, invasive noise, and hyper-surveillance, which undermine their mental and physical health and feelings of autonomy.[2] However, as Paulus (2012) and Wortley (2002) have observed, much depends upon the level of occupancy and purpose of different domiciliary arrangements. The literature examining

[2] In Australia, the NSW government came in for citicsm from the left for plans for rapid-build dormitory accommodation to solve prison overcrowding. The report of the Community Justice Coalition, 2018, "Rapid build dormitory prison plans: An unacceptable pressure cooker" 22/02/2018, summarised the objections. These are much the same as those against rapid-build dormitory pods/cubicles summarised in Matter Architecture's pamphlet "Well-being in Prisons", 2016.

prisoners' responses to dormitories demonstrates their agency in neutralising the boundary and privacy issues through group-making (Narag & Jones, 2020; Pallot et al., 2012), physical modification of the environment (Sibley & van Hoven, 2009), the importance of cultural factors (Milhaud & Moran, 2016), and, as in the research we present below, the structure of prisoner society.

In the former communist countries, the movement towards 'European' images of punishment has been associated in official discourse with a shift towards cellular accommodation and away from dormitories. In the Russian Federation this shift has been inconsistent. Only in Belarus have arguments for the single cell been unequivocally rejected in favour of Soviet-era 'carceral collectivism' (Pallot, 2021a). The scholarly literature on prison architecture from within the region is largely descriptive, classifying 'western' prison architecture and interior design from the perspective of re-socialisation (Tretyak, 2017) or securitization (Azarkhin, 2017; Sorokin & Sorokina, 2016). By comparison, historical studies of prison architecture associated with the 'birth of prison' prior to the imposition or embrace of communism is well-developed in the region (Ackermann, 2018; Goga, 2015; Kyrychenko et al., 2020). The message the historical studies send is of a shared European architectural heritage which can now be reclaimed.

In the sections below, we turn to an analysis of prison reform trajectories, problematizing the proclaimed penal policy moves 'away' from 'Soviet' standards 'towards' a 'European' model, and analysing the hybrid systems that emerge. We reject the notion that there is a continuum of penal design, with 'Soviet' at one end of the spectrum and 'European' design at the other, and discuss the varying manifestations of 'Europeanness' in the architecture of prisons in different places and at different times. In doing so, our contribution shows that rhetorical adherence to 'European' norms of punishment can in fact serve the purpose of making a statement about political alignments. We begin by offering an analysis of the 'Soviet model' as the starting point from which more penal recent reforms began.

The Soviet Model

In referring to the 'Soviet model', we have in mind the type of penal facility that originated in Main Administration for Camps, known by the acronym GULAG (*Glavnoe Upravlenie Lagerei*), from the late 1920s in the USSR. It was developed to accommodate the vast numbers of prisoners charged with criminal and political offences during the Stalin repressions who provided labour for the forced industrialisation of the USSR. After Stalin's death, the GULAG administration was dissolved and most, but not all, camps were closed. The nomenclature of those that remained changed from camp (*lager'*) to 'correctional labour colony' (*ispravitel'naya trydovaya koloniya*). As this renaming implied, correctional labour colonies, like their predecessors, had a production function. They continued to contribute to the state's five-year plans right to the end of the USSR (Averkieva, 2014, 2015). While some of the more odious features of the GULAG were eliminated or faded away in the last three decades of Soviet rule, many practices developed in the labour camps were carried forward or modified. The result was the emergence over time of a distinctive prison architecture and approach to prisoner management that dominated an area stretching from the river Elbe in the west to the Pacific Ocean in the east. It was a system that proved resilient, even during the turbulent years of the1990s, and in some parts of the region it remains in place today (Moran et al., 2011; Pallot, 2015b; Piacentini, 2012; Piacentini & Pallot, 2014; Piacentini & Slade, 2015; Touraine & Oleinik, 2017).

The inspiration for the original design of the labour camp was the early Soviet idea of the workers-commune or house-commune (Peshkov, 2015; Willimott, 2011, 2016, 2017). Caroline Humphrey (2005: p.1) describes the ideology of the commune—that material structures would promote new patterns of socialist living—as an act of 'breathtaking audacity'. In the reductionist version of Marxism that informed the Soviet belief system, the material structure of the commune provided an infrastructural 'base' for the development of the socialist 'superstructure'. Transferred to the penal context, the material structures of socialist commune were designed to provide the setting within which all, bar the most determined political offenders, would be transformed

into ideologically-sound citizens fit to be returned to society. In the early days of the GULAG this process was described as the 'reforging' (*perekopka*), and later as the 're-education' (*perevospitanie*) and 'correction' (*ispravlenie*) of the offender. Subordinating the self to the collective, forced labour and cultural-educational work were the combined instruments chosen to return the offender to the correct path (Kharkordin, 1999: 88–89). The model camp or colony was designed to promote collectivism in all aspects of prisoners' everyday life, whether they were at work or participating in cultural-educational work.

Camps were territorially complex structures with a headquarters, sub-divisions and command stations dispersed over a wide area. The communal barracks which might be a stand-alone structure deep in the forest or one of many in the central headquarters of a large camp, was the linchpin of every camp complex. Inhabitants of barracks worked, slept, and ate alongside one another. A head prisoner liaised with the administration and oversaw the maintenance of order and hygiene in the barracks. The last was of particular importance because of the epidemics that ravaged camps, one of the negative consequences communal living (Nakonechnyi & Pallot, 2022). Depending upon the production activities of a camp, work brigades formed from barracks' members would work in manufacturing, construction, mining, forestry, and agriculture under armed guard or, if trusted, as so-called 'non-convoy' labour.

Figure 9.1 is the general plan or *genplan*[3] of the main corpus of the headquarters of a camp from the 1930s. Figure 9.1 shows the assemblage of buildings that made up the main territory of a camp, and 9.2 the adjacent VOKhR (*voenizirovanaya okhrana*) or paramilitary security enclosure. The prisoners' accommodation on the main site is in the eight single-storey barracks each with its own external privy. The barracks are arranged at right-angles to the parade ground, assembly hall and canteen situated at the centre of the camp enclosure. Three areas—the quarantine block in which all new arrivals were assessed before being allocated to a barracks, the medical complex, and the disciplinary cells—are

[3] A *genplan* was a model design for different types of building projects that were typically used in construction projects across the USSR and accounted for the uniformity of the built environment.

shown fenced off from the main living complex and there are separate freestanding structures for the communal bathhouse, the facility for disinfecting prisoner clothes, a mobile medical unit, cobbler, and bread stall. The administrative buildings, consisting of the headquarters and the operations and communication department are located to the left of the main camp entrance. Separate from this complex is the assemblage of buildings of the VOKhR consisting of administrative offices, the bakery and canteen for staff, cordoned off areas for stables and dog kennels, and storehouses for weaponry, food, and uniforms. At the head of the parade ground of the paramilitary security zone, there is a barracks for 120 guards. The unoccupied areas between buildings in the model camp are beautified by shrubbery, trees, and flower beds (Fig. 9.2).

The most visible carceral features of the camps were the barbed wire and wooden perimeter fences with watchtowers that enclosed the living and service zones, although it is true that industrial sites and military bases were similarly securitised in the USSR. Here is how a prisoner described arriving in a column of 5,000 prisoners in Yavas the capital of the Mordovyan gulag, a medium-sized forest camp in the Volga-Ural region, in 1937. This was the year of the Great Terror when there was a massive expansion in the gulag population:

> Beyond the fence we saw enormous wooden barracks – very long, single-storeyed …They put [some of us] … in the barracks to the left of the gate and others to the right. One of the barracks contained the kitchen and canteen and beyond it, was the bathhouse. Between the bathhouse and the dining room there was a large fenced off well with a big wooden bucket that was lowered into it by a rope. Right there by the well there were two water troughs, one for the canteen and the other for the bathhouse.[4]

In the 1930s, the columns of newly arrived convicts passed under the entrance arch displaying the slogan that adorned all gulag camp headquarters: 'Labour in the USSR is a matter of honour, glory, valour and heroism' and a 12-m-high billboard with a portrait of Stalin. As the camp lay in the forest, wood was the construction material, but the open spaces

[4] http://zubova-poliana.narod.ru/me-ocherk-dubravlag996.htm, accessed 30 May, 2021.

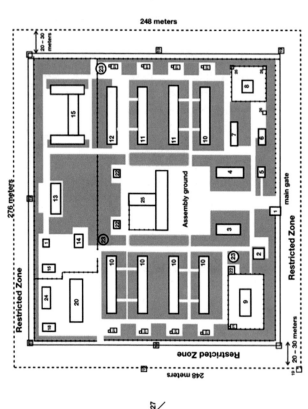

Fig. 9.1 Model design of the living and administrative zone of a gulag labour camp from 1930s (plan by Sofia Gavrilova)

(1) Guard post (2) Operations and post department (3) Camp headquarters (4) Mobile medical unit (5) Bread stall (6) Shoemaker and tailor (7) Storage room (8) Punishment cells Cells (9) Quarantine barrack (10) Barrack for 220 prisoners (11) Barrack for 138 prisoners on privileged conditions of detention (12) Barrack for 140 prisoners of the engineer-technical department (13) Infectious Disease Ward (14) Hospital kitchen Kitchen (15) 75-bed hospital (16) Hospital laundry (17) Morgue (18) Disinfection chamber (19) Guard tower (20) Bathhouse & laundry (21) Outside toilet (22) Water-heating point (23) Fire pond (24) Communal Lavatory (25) Canteen & clubhouse (26) Guards' barrack (27) Towards the VOKhR compound.

9 The Architecture and Design of the Communist ... 237

(1) Headquarters, canteen (2) Bakery (3) Barrack for 120 guards and personnel (4) Lavatory (5) Fire department (6) Barn (7) Stables (конюшня) (8) canine food preparation (9) Dog kennels (10) Gatehouse (11) Weapons store (12) Vegetable store (13) Vegetable storehouse (14) Ice storage (15) Uniform and clothing store (16) Food store (17) Watch tower (18) Well (19) Parade ground.

Fig. 9.2 Model design of the paramilitary security zone of a gulag labour camp from 1930s

and main buildings were adorned with masonry statues and banners advertising the achievements of Soviet socialism. In steppe and semi-desert regions, the communal and administrative buildings in GULAG headquarter camps were constructed of brick or adobe. In time, the prominent buildings in camps were reconstructed to imitate the popular neoclassical designs of Stalinist urban architecture. Communal services in camps were primitive, most having no running water, sanitation systems, or mains electricity, and thus it remained for the facilities that were retained to the end of the USSR.

It barely needs observing that the reality of the GULAG camps was that they were more likely to break their victims than transform them into examples of the new Soviet man or woman. Latest estimates put the total mortality in the GULAG at 12–14 million, largely attributable to starvation and disease that spread like wildfire in the overcrowded barracks (Nakonechnyi, 2020, 2021). Barracks designed for up to 220 convicts often housed two or three-times that number, with four convicts assigned to each of the plank bunks (*nary*) fixed to the two long sides of the barrack. While responsibility for order and discipline within a barrack lay with the prisoner collective, security in the wider camp territory was maintained by the armed guard, or *okhrana*.

Despite the human cost of the Stalinist forced labour camps, there was no retreat from the principles that had informed their architecture after the formal ending of the GULAG. Indeed, in the years that followed Stalin's death, reforms introduced by Nikita Khrushchev, the new Communist Party leader, 'rediscovered' the ideological rationale for communal accommodation at both the discursive and institutional level (Hardy, 2016). The USSR defended its use of the dormitory to the international community (Hardy, 2012a, 2012b: 94–96). Reforms introduced from the late 1950s formalised many of the ad hoc practices that had arisen in the gulag. Prisoners newly arriving to serve sentences at correctional labour colonies were allocated to a 'detachment' (*otryad*), which was both physical space and social community. Detachments of prisoners were managed collectively for the purpose of discipline, security, education, and rehabilitation through labour by the prison administration, while prisoner self-government was institutionalised as the vehicle for the maintenance of order in the barrack.

The size of detachments was fixed at between 75 and 200 prisoners.[5] Each was allocated its own space in the two- or three-storey brick and concrete dormitory blocks that gradually replaced the wooden barracks of the gulag. Typically, several detachments would occupy physically discrete parts of the barrack, each with its own entrance and *lokalka*, a partitioned off external yard. The floor of each detachment was subdivided into functional spaces consisting of the communal dormitory, a common room, pantry, bathroom, drying rooms for outer garments, and an office for the officer-in-charge of the *otryad* and a single bedroom for the liaison prisoner, now given the title orderly or caretaker (*dneval'nyi, zavkhoz*).

Most correctional labour colonies in the post-war USSR consisted of up to twelve detachments which, together with communal and service buildings, made up the domestic or living zone. This was now physically separate from the administrative zone, the size of which expanded in response to a proliferation of functional departments within the prison service. There was similarly an expansion of the territory occupied by the production zone. Prisoners were still escorted into the forests to fell timber or to work on the state's large infrastructure projects, but increasingly manufacturing industries were developed on the territories of correctional labour colonies themselves. The three zones—domestic, administrative, and production—were separated by high wire fences.

Inevitably, in the hostile atmosphere of the Cold War, the USSR's prison system attracted only the opprobrium of Western commentators. Attention was focussed primarily on the use of prison to suppress political dissent and, in the late Soviet period, nationalist opposition. Questions about what sort of penal system had replaced the GULAG and the type of premises in which 'ordinary criminal offenders' were held were simply not asked. Censorship and lack of access to prisons across the communist countries meant that they remained a *terra incognita*. Prisoners' testimonies from the 1960s and 1970s and interviews with people who served sentences in the 1970s and 1980s indicate that there were few changes in the design of the facilities and that this design was imported

[5] https://www.alexanderyakovlev.org/fond/issues-doc/1009166, accessed 30 May, 2021.

into East Central Europe.[6] By the late 1960s architects in the USSR had become technicians producing a industrial commodity working in state design offices where they functioned as engineers and managers, rather than creative designers. The emphasis was on typification, standardisation, and mass production architectural design across the whole communist region including the eastern bloc (Zarecor, 2014) Correctional labour colonies and their equivalents in the satellite prison systems of East Central Europe were not the only type of detention facility in the communist world. All countries had police cells and temporary detention centres, remand prisons, high-security prisons built around the isolation cell, and the mobile prisons of the *etap* or penal transportations. These latter delivered prisoners from East European or the USSR's metropolitan remand prisons to correctional labour camps in the peripheries (Moran et al., 2012, 2013a). In other words, the iconic labour camps and colonies designed around the communal barracks were just one link in a chain of carceral institutions, through which criminal and political suspects and offenders passed from their arrest to release or death.

There is one country in Europe where the Soviet model in its pure form can still be found. This is in Belarus, in which according to the World Prison Brief on 1st October 2018, there were 32 500 prisoners in pre-trial and correctional institutions, giving it an imprisonment rate of 383 per 100 000 placing it, in quantitative terms, at the harsh end of the punishment spectrum.[7] Continuity from Soviet-era penality in Belarus is expressed in the maintenance of a strict geographical division of labour between remand prisons, located in the metropolitan centres, and correctional labour colonies located in the rural and semi-urban peripheries and at the micro level in the retention of all the essential features of the Soviet model, including the tri-partite zoning of territory and communal

[6] In the GULAGECHOES project we have been able to interview people who were imprisoned during the last three decades of Soviet power. This research is ongoing, and interviews will remain embargoed until the end of the project in 2023.
[7] https://www.prisonstudies.org/country/belarus Belarus leads all other post-Soviet states for the rate of imprisonment with the one exception of Turkmenistan which in 2018 was estimated to be 552.

accommodation of prisoners in detachment units. In line with President Lukashenko's campaigns against 'parasitism', work is obligatory in Belarussian colonies. However, in a nod towards welfarist goals, the Soviet-era slogan over the entrance of correctional colonies today reads 'In every person it is possible to find something good, if you look hard enough' (*V kazhdom cheloveke mozhno naiti shto-to khoroshoe esli khorosho ego obyskat'*). The rituals of the Soviet-era correctional colonies have also been preserved in Belarus; prisoners passed fit to work are marched from the central parade ground to the industrial zone to the accompaniment, according to one of our respondents, of Tchaikovsky's 'Slavonic March' and the prisoner's day is subject to a detailed temporal and spatial choreography designed to keep everyone occupied during their waking hours. In Belarus, as it was in the USSR, compliance with the daily timetable is achieved through the system of prisoner self-government in the form of the official prisoner hierarchy in each detachment, underwritten by harsh penal backup.

Unlike other communist successor states in Europe, Belarus has not become a member of the Council of Europe. It, therefore, did not have to make the decision that confronted all the countries of East Central Europe and former Soviet states in 1989/1919 of how to adapt their prisons to conform with European norms. All countries have implemented reforms, which have potentially far-reaching implications for the material structure of the penal estate. As we observed above, decisions about the direction of travel they were to take were made against the backdrop of universal economic, political, and social crises. But the 1990s also heralded a period of experimentation when architects and planners could break free from the constraints that had produced the uniform and standardised built environment of the communist era. In towns, this was manifest in postmodern skyscrapers, boutique hotels, shopping malls, and gated communities for the new rich, and in invitations to western architects to design prestige buildings. In some of the post-communist countries, the new opportunities spilled over into the design of prisons that would meet an approach to punishment based on the principles individualisation and humanisation. Among the post-communist states Estonia has taken the boldest steps in this direction.

Narratives of Reform in Estonia

In 2002, there were ten correctional institutions inherited from Soviet times in Estonia; by 2020, these had all gone and had been replaced by three brand new prisons. These latter are box-like structures with cellular accommodation often dubbed 'Europrisons' by former prisoners. This section of the chapter examines penal policy discourse and reform trajectory of Estonia by drawing on official documents as they relate to penal architecture.[8]

Estonia began to reform its prisons in the early 1990s, shortly after gaining independence. The reform has been explained in Estonian policy discourse as a necessary step towards diminishing the power of criminal subcultures, breaking up informal relationships between prisoners and staff, decreasing inter-prisoner violence, and increasing chances for resocialization. One of the major reference points for reform is historical: the sources consistently present the argument that Soviet legacies have made some elements of the penal system difficult to improve. A key manifestation of Soviet legacy in the Estonian prison system, according to the documents, is barracks-style communal living. This is held directly responsible for inter-prisoner violence and hampering rehabilitation of prisoners. The Prison System yearbook from 2004 quotes Murru Prison Director Olavi Israel, who also outlines this causal link: '*Big number of prisoners, shortage of prison officers and the soviet time prison architecture make it relatively difficult to achieve the goals of imprisonment – to bring the person back to the society as a law-abiding citizen*' (Estonian Prison System Yearbook, 2004: 26). Policy discourse also links Soviet legacies to the informal governance of prisons by prisoners and argues that it is incompatible with rehabilitation:

> The employment in the colonies fulfilled the need for public works in the USSR to a large degree. Normal correctional work was sacrificed for large-scale production and the system was conceived to cater to the interest

[8] These documents include official responses submitted by the Estonian government to reports of the European Committee for the Prevention of Torture and Inhuman or Degrading Treatment (CPT); annual national Prison Services yearbooks (published in both Estonian and English); and notes from a meeting held with two Ministry of Justice representatives.

of fulfilling quotas of the Economic Plans. Criminals were appointed as foremen and «authority men» and in return for securing 'order' and production, their violations of the basic rights of the detainees were often condoned. This developed a negative attitude among inmates towards the law and the regime brought with it a growth of recidivist crime in the middle of the eighties.

(Estonian government response to CPT, 1998, pages 1–2.[9])

This idea is echoed in the 1998 response of the Estonian government to the CPT (pages 20–21): '*Until there is a possibility to do away with the camp-type institutions, inherited from the Soviet Union, some inter-prisoner violence is unavoidable.*' The government's 1998 response to the CPT report also stresses that there is a correlation between prisoner subculture (i.e. structures run by criminal "authority men") and lack of respect for the law, and other documents quoted above argue that this causes recidivism and makes prisoner rehabilitation impossible.

Estonian officials have claimed that the solution to break with these Soviet-era legacies is to abandon correctional colonies and replace them with new cell-based prisons with conditions in line with the recommendations of European Prison Rules. As stated in the 1998 government response to the CPT, '*…the only way out of the present difficulties is to transform former [Soviet] camp-style prisons into cell-type prisons. After that the supervision of the inmates should improve substantially.*'[10] The Prison System Yearbook of 2004 reiterates that '*the transfer from soviet time colonies to cell-type prisons has been started with the aim to enable re-socialisation.*'[11] The architectural transformation was therefore accompanied by the introduction of a wide array of experts into the punishment and re-socialisation process: when the new Viru prison opened in 2008, not only did it become the workplace of more than 240 correctional

[9] Estonian government response to CPT, 1998, pages 1–2: https://rm.coe.int/CoERMPublicCommonSearchServices/DisplayDCTMContent?documentId=090000168069573c.

[10] https://rm.coe.int/CoERMPublicCommonSearchServices/DisplayDCTMContent?documentId=090000168069573c.
 Responses of the Estonian Government to the CPT report, 1998, pages 20–21 https://rm.coe.int/CoERMPublicCommonSearchServices/DisplayDCTMContent?documentId=090000168069573c

[11] Page 10, section on "The Objectives of the Estonian Prison System": (https://www.vangla.ee/sites/www.vangla.ee/files/elfinder/dokumendid/estonianprisonsystemyearbook2004.pdf).

officers and over 100 administrative and support personnel (for just over 1000 prisoners), but it also employed psychologists, social workers, and youth counsellors.[12]

The new Viru prison was designed by Tallinn-based architectural firm Kalle Roomus AB. It features 14 buildings on 40 acres of land and includes housing units for different category offenders, a unit for juvenile and young adult (18–21 years) offenders convicted and on remand, a unit for 'high risk' prisoners, a remand unit, and buildings for education, a space for workshops, and rehabilitation programmes, a library, a church, and an administrative area. The prison has a total capacity for 1,075. Cells are dual occupancy, and different parts of the prison are connected by raised walkways, which the prisoners we interviewed referred to as 'tunnels' that are reminiscent of a 'video game'. According to a news report, the walkways reduce security risks by controlling movement between various parts of the prison.[13] The perimeter consists of two metal fences, a concrete wall, and electronic surveillance system. There are 200 video surveillance installations that monitor movement within the prison. Outside the main territory of the prison there is a separate enclosure for the open prison.[14]

Interviews with former prisoners reveal ambivalent and critical attitudes towards reform among those who have had experiences of incarceration in both the Soviet correctional colonies and the Estonia's new 'Europrisons'. The change in prison architecture, we were told, had major implications for the everyday life of prisoners. If the narratives of former prisoners who served sentences in the old-style Soviet facilities are rife with references to the power of informal hierarchies (stories of prisoners having prison guards drive them out to the beach for barbeques, murders taking place in the 1990s within the prison, drugs readily available), they describe new style prisons as extremely rule-bound and governed by the administration, which no longer coordinates its plans and interventions

[12] Correctional News, 2008: https://correctionalnews.com/2008/07/27/estonia-unveils-120-million-detention-complex/.

[13] Correctional News, 2008: https://correctionalnews.com/2008/07/27/estonia-unveils-120-million-detention-complex/.

[14] Correctional News, 2008: https://correctionalnews.com/2008/07/27/estonia-unveils-120-million-detention-complex/.

with the prisoners. Some elements of prison subculture remain, including intense stigmatisation of LGBTQ + prisoners and the use of subculture language of *fenya*, while other elements, such as avoidance of work in prison among prisoners who identify with the subculture, seem to be dissipating. Most notably, however, governance in the newly reformed prisons is imposed top down by prison administrations, and prisoners have lost much of the agency they previously had in negotiating how a prison is run.

The power of the traditional subculture was not the only element of prison life that changed with architectural reform. For instance, many former prisoners noted that the replacement of dormitories by cells was accompanied by a reduction of opportunities for socialising with other prisoners. They complained that association areas are unavailable because administrations wish to cut down their interactions with other prisoners, although we were unable to confirm this with the prison authorities. Prisoners also complain of being allowed outside for only one hour a day:

> At X [old] prison, I could leave at 6 in the morning, not come back even for lunch, just be outside till 10 in the evening. A woman who owned the company (where I worked as a prisoner) respected me, and once I asked her, 'Galya, can I have my own garden?' And she said 'Yeah, you can do that.' And I said 'I need two trucks. I have a deal with people on the outside, they can bring black soil,' because it was just sand there. She made a pass [for them], and they brought in the trucks to the prison, they dumped the soil. And with my bare hands I put all of it together. Then this owner, she brought me seeds… And I had onions, dill, garlic, radish. And when we went to lunch, I'd bring the fresh green stuff in a bag, and [proudly] throw that bag down on the table. Because prisoners don't get enough vitamins in prison. And all that stuff is healthy. Just imagine a prisoner in this [new] prison having a garden [laughter].
>
> (Male, early 50s, Interviewed in Joehvi, Estonia, July 2020)

Another criticism of the new arrangements among our research participants is the emergence of new modes of bureaucratised communication between prisoners and the administration by-passing prisoner intermediaries. Communication in the post-reform Estonian prison with the

administration has been formalised, so that requests and complaints now have to be made by telephone or in writing. Many former prisoners describe this as an imposition of greater 'distance' between prisoners and guards:

> They're replacing the old guards with new guards, youth. They figured that these old police guys, the old guard, do a lot of stuff the new ones don't do. Because the old ones were used to having good relations with prisoners, [but] the administration wants rigidity, so that the guards have distance from the prisoner, so they don't have this familial stuff, like 'hey are you feeling unwell?' to a prisoner… and 'hey, you'll be okay'. They don't want that. They want distance… no commiseration, just rigidity. He's police, you're a prisoner."
> (Male, late 30s, Interviewed in Joehvi, Estonia in July 2020)

The complaints by the Estonian research participants spoke to the concept of 'tightness' in Ben Crewe's (2011) revision of the pains of imprisonment. It is striking how people who had served sentences under the previous regime were nostalgic for the old-style correctional colony, despite its association with physical violence and a punitive regime. Lori Sexton's call for closer attention to the differences between what lawmakers define as punishment and what incarcerated people experience as punishment is helpful here (Sexton, 2015, 118): a prisoner who experienced the old regime in Estonian prisons may respond differently to the design of the 'Europrisons' because their expectations of punishment were informed by the pre-reform penal order. In this way, Europeanizing reforms are not received as humanising by some prisoners, but are in fact experienced as a new pain of imprisonment. This trend is not unique to Estonia: in Georgia, another post-communist country that has been reforming its penal system in line with Council of Europe recommendations, deadly prison riots took place in protest against the move towards cellular accommodation at the Ortachala facility of Tbilisi in 2006 (Piacentini & Slade, 2015: 191).

Narratives of Reform in Russia

The Russian Federation shared the general breakdown of order or *bespredel* in prisons across the region and, as in Estonia, the 1990s saw the consolidation of the power of criminal subcultures in prisons. Unlike Estonia, the Prison Service resisted the idea the problem lay with the correctional colony, but new justifications had to be found for its foundational pillars—collectivism, self-government, and compulsory labour—that avoided any references to socialism.

The head of the prison service (2004–2009), Yury Kalinin, took on the western cellular prison in a conference presentation in March 2005:

> The fundamental difference is that our conditions of detention are, as we say, semi-free. The type of unit in which criminal punishment is executed is a correctional colony. In them, people live as in ordinary hostels, they can communicate with each other and hold joint events. In the West, people are held … in a cell, which makes it difficult for them to communicate. I believe that this strains the human psyche and creates more depressing conditions for serving a sentence. Of course, the material conditions in Western prisons are better than in ours. However, recently the state has been allocating enough funds for us to improve material and technical conditions … I cannot yet say that we have reached western standards but where the psychological load [on prisoners] is concerned, our conditions are much better than in the West."[15]

Kalinin did not support his argument with empirical evidence, but the equivalence argument gained traction with prison service insiders. Responding to a question about the detachment system, for example, one prison officer we interviewed insisted,

> They [the prisoners] should get used to living in society. We are preparing them for life outside. They cannot live as if they are on a desert island. They will be exposed to people and they will need to be able to communicate with them. They must learn to respect those around them. They

[15] http://www.garant.ru/interview/10127/.

must learn to understand other people and learn how to have relationships. So, they learn a lot by living in the detachment unit. (Interview with head of a detachment, 2007)

Other justifications drew on cultural tropes, such as the philosophical concept of *sobornost'* (the Russian spiritual community that stands in opposition to western individualism) and the *obshchina* (the traditional peasant commune) to explain Russians' apparent preference for living together. The justification for handing supervision of everyday life in the detachment to the prisoners, by contrast, draws on western penological concepts such as responsibilization and dynamic security. As for forced labour, this now became 'skills training' by the simple process of renaming the factories and workshops in colony production zones, 'centres of labour adaptation' (Pallot, 2016: 308).

Prisoners' verdicts on dormitory accommodation have remained generally positive in post-Soviet Russia. The reasons given by research participants vary. Juvenile respondents fear that it would be 'lonely and scary' to be confined in a cell by themselves (Piacentini et al., 2009). For the large number of migrant workers from Central Asia who commit offences that result in their imprisonment in Russia, the dormitory allows them to reconstitute street- and ethno-religious-based support groups (Urinboyev, 2020). Rank-and-file prisoners can feel protected by becoming a low-ranked member, or *muzhik*, of detachment power hierarchy, and all prisoners rely on the subculture for access to drugs and mobile phones, the market for which thrives in the context of the dormitory (Piacentini & Katz, 2018; Slade & Azbel, 2020). It goes without saying that subculture leaders welcome the status that their power over detachment members gives them, which helps them secure leverage with the prison authorities. Opposition to the detachment is confined mainly to women, for example:

> They should have smaller rooms; that would make life easier for women. They have been brought up in different conditions on the outside, each has her own room. Here there are those who are ill, those who don't wash much, or look after themselves, the beds close together means they can't escape if one coughs, or another snores. Of course, it's difficult and taxing

living in the detachment. (Interview with woman serving a sentence in 2009)
and
There are one hundred and twenty people in the *otryad*. You can't even be alone in the toilet! And sometimes you think – God, will there ever be peace? Isn't there anywhere I can be alone? (Interview with woman serving a sentence in 2009)

These latter comments speak to the concerns about privacy that resonate with the western research, while other respondents complained about feelings of physical vulnerability as a result of lack of supervision at night-time.

All the while that the traditional penal colony was being defended in official discourse, alternative more radical futures were being planned for Russia's prison estate by progressive-minded officials in the Ministry of Justice. The assumption of Dmitry Medvedev to the Presidency in 2008, followed by his appointment of a new Minister of Justice, Aleksander Konovalov, gave these tendencies a boost. In 2010, a reform entitled 'Concept for the Development of the Prison System to the year 2020' (*Kontseptsiia razvitiia ugolovno-ispolnitelnoi sistemy Rossiiskoi Federatsii do 2020*)[16] was announced. Introducing the reform, Konovalov made a scathing attack on the colony system which he declared was, "… *partly the legacy of the GULAG, partly of the former convict system from the times of the Russian Empire*". In public fora he repeatedly referred to the negative impact of the Soviet legacy:

> As for the legacy of the Stalinist era, it seems to me that this is a deeply flawed idea. And the most important thing is that now the mentality of people has changed. … [D]riving them into detachments, making them walk in formation singing patriotic songs and doing push-ups and shouting 'we love the prison service, and we love the Ministry of Internal Affairs' reinforces their disfigurement, and does not help their correction.

In making these comments, Konovalov placed the design of the material environment back on the agenda. Under the 'Concept', the

[16] http://ukrprison.org.ua/articles/1264936781 accessed August 14, 2021.

correctional colony was to be abolished and replaced by a two-tier system of cellular prisons (*tyurma*) reserved for the most serious offenders, and colony-settlements (*koloniya-poselenie*) a low category collectivist colony, for all the others. The change was to be achieved by 're-purposing' correctional colonies and some new builds. Western commentators praised the reform, seeing in it a commitment to modernise the penal estate through the introduction of western-type prisons. Konovalov conceded that Russia could learn from western experience, but he believed that it was possible to achieve a 'golden mean' between western-style prisons and Soviet-era colonies that would preserve the all-important principle of rehabilitation through labour and some degree of multiple occupancy. The projected cellular prisons and colony-settlements, while abandoning the mass dormitory, would have prisoners sleeping in groups of four to eight.

In the event, within two years of the Concept's publication, plans to abolish the correctional colony were shelved. The official explanation was lack of funds and changed priorities, but grassroots opposition from staff who stood to lose access to the shadow market in drugs and telephones, with which they supplemented their incomes, also played a part. Stripped of the eye-catching prison restructuring, the other elements of the Concept took centre stage in the battle against subcultures. These included the widespread introduction of CCTV, and strengthened disciplinary measures to enforce the regime. The past decade has also seen investment in upgrading facilities—bathrooms, visiting rooms, kitchens, and industrial plants—in colonies to 'Euro standards', and every colony has acquired a Russian Orthodox Church. Today, the cupola of a Russian Orthodox church 'built by the prisoners themselves', visible above the barbed wire topping the outer wooden fences or walls, is the iconic image of the post-Soviet correctional colony in Russia.

Reviewing the new reform concept ten years later, it is striking that the criticisms of the Soviet model that prompted the reform have, under Putin, now been ruled out of court. In an 2016 article, for example, one prison service insider criticises the 2010 reform on the grounds that its clear 'western orientation' was promoted by civil society orgnaisations that now have been uncovered as 'foreign agents'. Cellular prisons are inappropriate for the Russian mentalité because, following Putin,

the population believes 'the thief belongs in jail' (Demichev, 2016: 52). Accordingly, West–East knowledge transfer on prison design in the Russian-language literature focuses largely on security, where experts acknowledge Russian lags behind in the analysis of relationship between different design concepts and the internal securitization of penal space.

The story of possible architectural reform has not ended, however. In the wake of a series of very public scandals that began to surface from 2018 involving high-level corruption, reports of torture, mass protests and widespread circulation of narcotics and illegal electronic devices, the abolition of colonies was put back on the agenda. An updated 'new concept' to be realised by 2030 reprises some of the thinking of its predecessor, in that it proposes a two-tier system of closed and open prisons.[17] The closed prison in the latest concept is a multi-functional facility designed to hold 3,000–4,000 prisoners (both on remand and convicted), court facilities, and suites of rooms for investigators. Convicted offenders not sentenced to one of these multifunctional hybrids will be placed in an open-type facility. These latter facilities will either be a fixed correctional centre (*ispravitelnyi tsentr*) where prisoners under licence can work in a private or state enterprise or mobile labour detachments, attached to projects of national importance, such as the construction of the Baikal Amur railroad in the Far East and clearing up oil spills in the Arctic. More than one hundred 'correctional centres' have already been opened on the territory of correctional colonies and the prison service is negotiating contracts with the state and private agencies to hire out penal labour. The prison service describes the centres as delivering an alternative to incarceration, but they are no less carceral than open or low category prisons in western jurisdictions (Pallot, 2021a, b). Prisoners must return to the centre every night and while not under armed guard, are subject to supervision and surveillance to ensure conformity to 'regime rules' and timetables.

Meanwhile, the prototype of the hybrid prison already exists in the recently opened the 'New Kresty' prison, in the St Petersburg suburb of Kolpino. This is the facility for 4,000 remand prisoners and 500 convicted prisoners, the latter making up a 'housekeeping detachment'.

[17] https://www.garant.ru/products/ipo/prime/doc/400639567/ accessed August 14, 2021.

The remand prisoners are accommodated in two, four and eight person cells fitted out 'to European standards', with 7m² space at the disposal of each, and separate sanitary facilities. The wards are contained in two eight-storey cruciform buildings, inter-connected by underground tunnels and covered walkways. The walls are painted in pastel colours and furniture is anti-vandal. The administrative offices and courthouse are in a separate building, and there is also a shooting range, sports hall, sauna, separate dormitories and canteens for the housekeeping detachment and guards, an officers' canteen, a kennel for 40 dogs, a medical centre, parking, storage facilities and three Russian Orthodox churches (one for personnel, one for convicted prisoners and one for remand prisoners). The territory of the 'New Kresty' covers 26 hectares and is enclosed by five-metre-high walls. There are open spaces yet to be landscaped, but the network of secure walkways and exercise yards on the roofs and in small yards at the end of each ward at floor level means that prisoners never leave the buildings.

The prison is the model for the multifunctional super-facilities of the future but its design history recalls the Soviet era, as it is the product of a collective of managers, engineers and designers employed by FSIN. Multifunctional prisons are already projected for a number of regions including Moscow, whose chief architect has expressed his belief that the new multifunctional prison, with its reinforced windows instead of bars and pastel colours, instead of demeaning and frightening offenders will help return them, reformed individuals, to society.[18]

Concluding Comments: The Resilience of the Architecture of Collectivism in the Post-Communist Realm

The cases of Estonia and Russia counter the linear conception of prison development towards a harmonised imagined 'European' model of punishment. We cannot easily place these cases on a continuum with 'Soviet' on one end and 'European' on the other, despite the policy

[18] https://pasmi.ru/archive/267523/, accessed August 14, 2021.

discourses that often frame penal reforms in these countries as moving away from the Soviet model. Multiple and contradictory ideas of punishment coexist within Europe, within each country, and they can also coexist within policy implementation in post-Soviet countries. However, as we have shown in our analysis, prison design should be viewed in terms of wider geo- and domestic- political purpose and positionings as well as its proclaimed aims, whether of prisoner welfare, rehabilitation, labour mobilisation, security, and/or cost reduction. The way in which a prison is built, and especially the way in which a prison is *re-built*, reflects not only the state's relationship with its criminalised population, but also makes a statement about a country's political alignments on the international arena and its chosen path of modernization.

Despite the revolution in penal architecture in Estonia and Russia's ambitious, but surely unrealistic plans to furnish every one of its 85 regions with super-large prisons designed around the cell, the architecture of collectivist punishment remains dominant across Eurasia. The plans for correctional centres 'used as a alternative to deprivation of freedom' underlines the enduring attachment in Russia to the principle of collectivism. The dominance of collective accommodation for prisoners from the GULAG onwards in Russia and its spread throughout Eurasia and into jurisdications in Eastern Europe was largely a function of expediency in the face of costs, shortages of prison personnel, and practical questions of labour mobilisation, but the ideological commitment under Soviet communism that every human group had to turn itself into a collective according to a set of organisation rules, always hovered in the background and shaped the chosen solution to problems of mass incarceration as they arose. Inevitably, the issues of privacy, autonomy, and individual rights associated with dormitory accommodation that concern twenty-first-century prison reformers, were simply not part of the calculus in the Soviet model. This model is now in retreat across Eastern Europe and the former republics of the Soviet Union, although the less so in Central Asian successor states (Slade, 2018; Slade & Azbel, 2020). But the possibility that a recalibration of the balance between security, cost, welfare could produce a more 'benign,

pastoral and supportive culture of communality' should not be written off (Piacentini & Slade, 2015: 196).

References

Ackermann, F. (2018). Territorialisation and incarceration: The nexus between solitary confinement, Religious Praxis and imperial rule in nineteenth-century Poland and Lithuania. *Acta Poloniae Historica, 118*, 5–37.

Averkieva, K. V. (2014). Geograficheskoe polozhenie kak factor raznoobraziya tyurem'noi ekonomiki [Geography as a factor in the variation of the prison economy]. In S. S Artoboloveskii & V. N. Streletskii (Eds.), *Raznoobrazie kak factor i uslovie territorial'nogo razvitiya, ChIM* (pp. 254–269): Eslan.

Averkieva, K. V. (2015). Territorial'naya organisatsiya ispravitel'nykh uchrezhdenii Rossii [Territorial organisation of penal facilities in Russia]. *Izvestiya Rossiiskoi Akademii Nauk, Seriya Geograficheskaya, 3*, 19–34.

Azarkhin, A. V., & Useev, R. Z. (2017). Arkhitekturnaya tipologiya i fortifikatsiya mest ispolneniya i otbyvaniya otdel'nykh vidov nakasanii i mer presecheniya v obespechenii bezopasnosti UIS [Architectural typology and fortification of different penal facilities and measaure to secure the safety in the correctional system]. *Yuridicheskaya naukaiI Praktik: Vestnik Nizhegorodskoi AkaDemii MVD Rossiya, 2*(38), 52–57.

Baker, E. (2013). The emerging role of the EU as a penal actor. In T. Daems, D. Van Zyl Smit, & S. Snacken (Eds.), *European penology?* (pp. 77–112). Hart.

Barenberg, A., & Johnson, E. (2021). *Rethinking the Gulag: Identities, Source and Legacies*. Indiana University Press.

Bowling, B., & Sheptycki, J. (2012). *Global policing*. Sage.

Brangan, L. (2020). Exceptional states: The political geography of comparative penology. *Punishment & Society, 22*(5), 596–616. https://doi.org/10.1177/1462474520915995

Crewe, B. (2011). Depth, weight, tightness: Revisiting the pains of imprisonment. *Punishment & Society, 13*(5), 509–529.

de Dardel, J., & Söderström, O. (2018). New punitiveness on the move: How the US prison model and penal policy arrived in Colombia. *Journal of Latin American Studies, 50*(4), 833–860.

Demichev, A. A. (2016). Evropeiskie penitentsiarnye pravila i ikh rol' v ugolovno-ispolnitel'noi politike Rossiiskoi Federatsii [The role of the EPR in penal policy of the Russian federation]. *Penitentsiarnoe Pravo: Yuridicheskaya Teoriya i Pravoprimenitel'naya Praktika, 2*, 25–29.

Downes, D. (2001). The 'macho' penal economy: Mass incarceration in the United States – A European perspective. *Punishment & Society, 3*(1), 61–80.

Estonian Prison System Yearbook for 2003, Tallin, 2004. https://www.vangla.ee/sites/www.vangla.ee/files/elfinder/dokumendid/estonianprisonsystemyearbook2004.pdf

Giddens, A. (1990). *The Consequences of Modernity*. Stanford University Press.

Goga, C. I. (2015). The transformation of detention in Romania: From exile to main punishment. *International Letters of Social and Humanistic Sciences, 56*, 58–63.

Grant, E. (2013). Approaches to the design and provision of prison accommodation and facilities for Australian indigenous prisoners after the royal commission into aboriginal deaths in custody. *Australian Indigenous Law Review, 17*(1), 47–55.

Grant, E., & Memmott, P. (2008). The case for single cells and alternative ways of viewing custodial accommodation for Australian Aboriginal peoples. *The Flinders Journal of Law Reform, 10*(3), 631–646.

Haney, L. (2016). Prisons of the past: Penal nationalism and the politics of punishment in Central Europe. *Punishment & Society, 18*(3), 346–368.

Hardy, J. S. (2012a). Gulag tourism: Khrushchev's "Show" prisons in the Cold War context, 1954–59. *The Russian Review, 71*(1), 49–78.

Hardy, J. S. (2012b). "The camp is not a resort": The campaign against privileges in the Soviet Gulag, 1957–61. *Kritika: Explorations in Russian and Eurasian History, 13*(1): 89–122.

Hardy, J. S. (2016). *The Gulag after Stalin: Redefining punishment in Khrushchev's Soviet Union, 1953–1964*. Cornell University Press.

Humphrey, C. (2005). Ideology in infrastructure: Architecture and Soviet imagination. *Journal of the Royal Anthropological Institute, 11*(1), 39–58.

Jones, T., & Newburn, T. (2002). Learning from Uncle Sam? Exploring US Influences on British Crime Control Policy. *Governance, 15*(1), 97–119.

Kharkhordin, O. (1999). *The collective and the individual in Russia*. University of California Press.

Karstedt, S. (2002). Durkheim, Tarde and beyond: The global travel of crime policies. *Criminology and Criminal Justice, 2*(2), 111–123.

King, R., & Piacentini, L. (2005). The Russian correctional system during the transition. In W. A. Pridemore (Ed.), *Ruling Russia: Law, crime, and justice in a changing society* (pp. 261–281). Lanham.

Kyrychenko, V., & Sokalska, O. (2020). Western penitentiary tradition in the Kingdom of Poland. *Journal on European History of Law, 20*, 124–135.

Macaulay, F. (2013). Modes of prison administration, control and governmentality in Latin America: Adoption, adaptation and hybridity. *Conflict, Security & Development, 13*(4), 361–392. https://doi.org/10.1080/14678802.2013.834114

Martin, L. (2017). The globalization of American criminal justice: The New Zealand Case. In *Australian & New Zealand Journal of Criminology*. https://doi.org/10.1177/0004865817745938

Melossi, D., Sozzo, M., & Sparks., R. (Ed.). (2011). *Travels of the criminal question: Cultural embeddedness and diffusion*. Hart Publishing.

Milhaud, O., & Moran, D. (2016). Penal space and privacy in French and Russian prisons. In *Carceral spaces* (pp. 179–194). Routledge.

Moran, D. (2013). Between outside and inside? Prison visiting rooms as liminal Carceral spaces. *GeoJournal, 78*(2), 339–351.

Moran, D., Pallot, J., & Piacentini, L. (2011). The geography of crime and punishment in the Russian Federation. *Eurasian Geography and Economics, 52*(1), 79–104.

Moran, D., Piacentini, L., & Pallot, J. (2012). Disciplined mobility and carceral geography: Prisoner transport in Russia. *Transactions of the Institute of British Geographers, 37*(3), 446–460.

Moran, D., Pallot, J., & Piacentini, L. (2013a). Privacy in penal space: Women's imprisonment in Russia. *Geoforum, 47*, 138–146.

Moran, D., Piacentini, L., & Pallot, J. (2013b). Liminal transcarceral space: Prison transportation for women in the Russian Federation. In *Carceral spaces: Mobility and agency in imprisonment and migrant detention* (pp. 109–124). Ashgate.

Nakonechnyi, M. (2020). 'Factory of invalids': Mortality, disability and early release on medical grounds in GULAG, 1930–1955. PhD. Dissertation. University of Oxford.

Nakonechnyi, M. (2021). "They won't survive for long": Soviet officials on medical release procedure. In A. Barenberg & E. Johnson (Eds.), *Rethinking the Gulag: Identities, source and legacies*. Indiana University press.

Nakonechnyi, M., & Pallot, J. (2022). Silences and omissions in reporting epidemics in Russian and Soviet Prisons, 1890–2021. *Journal of the History of Medicine*.

Narag, R. E., & Jones, C. (2020). The Kubol effect: Shared governance and cell dynamics in an overcrowded prison system in the Philippines. In J. Turner & V. Knight (Eds.), *The prison cell, embodied and everyday spaces of incarceration* (pp. 71–94). Palgrave Macmillan.

O'Neill, B. (2012). Of camps, Gulags and extraordinary renditions: Infrastructural violence in Romania. *Ethnography, 13*(4), 466–486. https://doi.org/10.1177/1466138111435742

Pallot, J. (2012). Changing symbolic and geographical boundaries between penal zones and rural communities in the Russian Federation. *Journal of Rural Studies, 28*(2), 118–129.

Pallot, J. (2015a). The Gulag as the crucible of Russia's 21st-century system of punishment. *Kritika: Explorations in Russian and Eurasian History, 16*(3), 681–710.

Pallot, J. (2015b). The topography of incarceration: The spatial continuity of penality and the legacy of the Gulag in twentieth-and twenty-first-century Russia. *Laboratorium. Журнал Социальных Исследований, 7*(1), 26–50.

Pallot, J. (2016). The Gulag as the crucible for Russia's twenty-first century system of punishment. In M. David-Fox (Ed.), *The Soviet Gulag: Evidence, interpretation and comparison*, 286–315. University of Pittsburgh Press.

Pallot, J. (2021a). *What awaits convicted protesters sentenced to the Zona in Belarus*. https://blogs.helsinki.fi/gulagechoes/2020/11/20/what-awaits-convicted-protesters-sentenced-to-the-zona-in-belarus/

Pallot, J. (2021b). The cool logic of forced labour in Russia. *Riddle 6/08/2021b* https://www.ridl.io/en/the-cold-logic-of-forced-labour-in-russia/

Pallot, J., Piacentini, L., & Moran, D. (2012). *Gender, geography, and punishment: The experience of women in Carceral Russia*. Oxford University Press.

Paulus, P. (2012). *Prisons crowding: A psychological perspective*. Springer Science & Business Media.

Peguese, J., & Koppel, R. (2003). Managing high-risk offenders in prison dormitory settings. *Corrections Today, 65*(4), 82–85.

Peshkov, I. (2015). The communal apartment under "Special Surveillance": The legacy of the Soviet Gulag in multiethnic criminal subcultures in Eastern Siberian PrisonCamps. *Laboratorium. Журнал Социальных Исследований, 7*(1), 71–91.

Piacentini, L. (2006). Prisons during transition: Promoting a common penal identity through international norms. In *Perspectives on punishment: The contours of control* (pp. 101–118). Oxford University Press.

Piacentini, L. (2012). *Surviving Russian prisons*. Routledge.

Piacentini, L., & Katz, E. (2017). Carceral framing of human rights in Russian prisons. *Punishment & Society, 19*(2), 221–239.

Piacentini, L., & Katz, E. (2018). The virtual reality of imprisonment: The impact of social media on prisoner agency and prison structure in Russian Prisons. *Oñati Socio-Legal Series, 8*(2).

Piacentini, L., & Pallot, J. (2014). 'In exile imprisonment' in Russia. *British Journal of Criminology, 54*(1), 20–37.

Piacentini, L., & Slade, G. (2015). Architecture and attachment: Carceral collectivism and the problem of prison reform in Russia and Georgia. *Theoretical Criminology, 19*(2), 179–197.

Piacentini, L., Pallot, J., & Moran, D. (2009). Welcome to Malaya Rodina ('Little Homeland'): Gender and penal order in a Russian penal colony. *Social & Legal Studies, 18*(4), 523–542.

Randall, C. D. (1891). *The Fourth International Prison Congress, St. Petersburg, Russia*. No. 2. US Government Printing Office.

Rhodes, L. A. (2014). Postscript: Future directions for global prison research. *Focaal, 68*. https://doi.org/10.3167/fcl.2014.680106

Ross, J. I. (Ed.). (2013). *The globalization of Supermax prisons*. Rutgers University Press.

Rubin, A. T., & Reiter, K. (2017) Continuity in the face of penal innovation: Revisiting the history of American solitary confinement. *Law & Social Inquiry, 43*(4), 1604–1632. https://doi.org/10.1111/lsi.12330

Sexton, L. (2015). Penal subjectivities: Developing a theoretical framework for penal consciousness. *Punishment & Society, 17*(1), 114–136.

Sibley, D., & Van Hoven, B. (2009). The contamination of personal space: Boundary construction in a prison environment. *Area, 41*(2), 198–206.

Slade, G. (2012). Georgia's war on crime: Creating security in a post-revolutionary context. *European Security, 21*(1), 37–56.

Slade, G. (2016). Violence as information during prison reform: Evidence from the post-Soviet region. *British Journal of Criminology, 56*(5), 937–955.

Slade, G. (2018). Unpacking prison reform in the former Soviet Union. *The Journal of Power Institutions in Post-Soviet Societies*. Pipss.org, 19.

Slade, G., & Azbel, L. (2020). Managing drugs in the prisoner society: Heroin and social order in Kyrgyzstan's prisons. *Punishment & Society*. https://doi.org/10.1177/1462474520956280

Slade, G., & Vaičiūnienė, R. (2018). In comparative perspective: The effects of incarceration abroad on penal subjectivity among prisoners in Lithuania. *European Journal of Criminology, 15*(2), 217–234. https://doi.org/10.1177/1477370817726716

Sorokin, M. V., & Sorokina, O. E. (2016). Tyuremnaya arkhitektura kak element penitentiarnoi besopasnosti (Prison architecture as an element of penitentiary safety). *Vestnik*, 35–43.

Symkovych, A. (2018). The 'inmate Code' in Flux: A Normative system and extralegal governance in a Ukrainian Prison. *Current Sociology, 66*(7), 1087–1105. https://doi.org/10.1177/0011392117744596

Symkovych, A. (2020). Negative visibility and 'the defences of the weak': The interplay of a managerial culture and prisoner resistance. *Theoretical Criminology, 24*(2), 202–221. https://doi.org/10.1177/1362480618779404

Touraine, A., & Oleinik, A. (2017). *Organized crime, prison and post-Soviet societies*. Routledge.

Tretyak, Y. (2017). Principles of formation of the subject-spatial environment for prisoners. *Theory and Practice of Design*, (11): 193–203.

Urinboyev, R. (2020) *Muslim prisoners in Russia during the Covid-epidemic*. https://blogs.helsinki.fi/gulagechoes/2020/06/17/muslim-prisoners-in-russia-during-the-the-covid-19-pandemic/

Van Zyl Smit, D., & Snacken, S. (2009). *Principles of European Prison Law and policy: Penology and human rights*. Oxford University Press.

Vaughan, B., & Kilcommins, S. (2007). The Europeanization of human rights. *European Journal of Criminology, 4*(4), 437–460.

Wacquant, L. (2009). *Punishing the poor: The neoliberal government of social insecurity*. Duke University Press.

Wacquant, L. (2013). Forward. In J. I. Ross (Ed.), *The globalization of supermax prisons*. Rutgers University Press.

Walmsley, R. (2018). *World prison population list* (12th ed.). ICPR. https://www.prisonstudies.org/sites/default/files/resources/downloads/wppl_12.pdf

Willimott, A. (2011). The kommuna impulse: Collective mechanisms and commune-ists in the early Soviet state. *Revolutionary Russia, 24*(1), 59–78.

Willimott, A. (2016). *Living the revolution: Urban communes & Soviet socialism, 1917–1932*. Oxford University Press.

Willimott, A. (2017). 'How do you live?': Experiments in revolutionary living after 1917. *The Journal of Architecture, 22*(3), 437–457.

Wortley, R. (2002). Situational prison control: Crime prevention in correctional institutions.

Zarecor, K. E. (2014). Architecture in Eastern Europe and the Former Soviet Union. In E. Hadda & D. Rifkind (Eds.), *A critical history of contemporary architecture, 1960–2010* (pp. 255–274). Ashgate.

Zeveleva, O., & Nazif-Munoz, J. I. (2021). COVID-19 and European carcerality: Do national prison policies converge when faced with a pandemic? *Punishment & Society*. https://doi.org/10.1177/14624745211002011

Zsolt, B., Szabó, G., Bartha, A., Medve-Bálint, G., & Vidra, Z. (2015). Politically driven: Mapping political and media discourses of penal populism—The Hungarian case. *East European Politics and Societies, 29*(4), 871–891. https://doi.org/10.1177/0888325414557026

Part II

Determining the "Effectiveness" of Custodial Design

10

Challenges and Solutions in Establishing the Impact of Custodial Design

Melissa Nadel

Custodial facilities, such as jails or prisons, are complex environments that are influenced not only by their physical design, but by their residents—staff and inmates alike. As such, it is often difficult to isolate which elements of the institutional environment may impact behaviour or general well-being. Criminological theories alone attribute behaviour to everything from biological determinants to changing demographic trends (Akers et al., 2020). When we also incorporate the impact of the built environment, it is exceedingly difficult to identify which person, social, or environmental determinants are contributing to specific behaviours. This difficulty in establishing causality is one of the reasons the growing field of custodial design has limited empirical contributions. With an emphasis on U.S. prison systems, this chapter explores the most

M. Nadel (✉)
Abt Associates, Inc., Cambridge, MA, USA
e-mail: Melissa_Nadel@abtassoc.com

common challenges in conducting research, especially causal research, on prison architecture, followed by a discussion of potential solutions that might allow future studies to surmount those challenges.

Challenges in Establishing Causality

Although there are numerous difficulties in establishing a causal relationship, especially within studies of custodial or correctional design, this chapter focuses on three primary concerns: (1) operationalizing custodial design and its intended outcomes, (2) collecting comprehensive data, and (3) distinguishing the effects of the physical environment from other influences.

Operationalizing Key Concepts

Before we can establish whether the physical design of a correctional facility impacts inmate and staff behaviour or other corrections-related goals, we must first define what aspects of design are anticipated to have an effect. Within existing research, custodial design or architecture, is most frequently defined by the layout of a facility. While the prominent design types vary across jurisdictions, there are a few key typologies that are widely described and accepted by scholars. These typically include linear (encompasses rectangular, courtyard, and telephone-pole designs), podular or campus designs, high rise, panopticon, and dedicated supermax facilities in the US (Fairweather & McConville, 2000; Jewkes et al., 2016; Johnston, 1973, 2000; Nadel & Mears, 2020; Wener, 2012). The different typologies are well defined in the current literature, however, building layout is a relatively simplistic definition of architecture. There is a large and diverse range of elements that have the potential to impact the operation of custodial facilities as well as the behaviour of the individuals housed inside. These include cell type, presence of blind spots, housing structure, aesthetics, noise, open vs. closed concepts, barred windows vs no windows, access to nature, building material, temperature control, and location of services to name a few.

The difficulty often lies in defining and subsequently collecting data on these features.

Some characteristics are more easily operationalized (e.g., cell type, centralization of services, open or closed guard station), while many others are not (e.g., line-of-sight, noise levels, light levels, access to nature). Take access to nature as an example; there are numerous studies highlighting the benefits of natural elements in building design to more positive or prosocial behaviours (Kaplan, 2001; Nadkarni et al., 2017; Snell et al., 2019). Yet, there are several options by which we may operationalize this concept within a prison setting: are there windows that allow views of the outdoors, and if so, how many; are there plants within the facility, how many, and what types; are inmates allowed to spend time outdoors, how much time, and what are the natural surroundings of the facility, are there virtual options for accessing nature? Even when we do settle upon a specific definition, for example, the number of outdoor facing windows, data on these features is typically non-existent. Another example that is often of great concern to practitioners is the level of visibility within a facility. A building's architecture determines how easily someone can see the surrounding space from any single point (Archea, 1977; Evans et al., 1996; Gifford, 2002). When space is less open or includes several elements that block visibility, blind spots emerge. In a prison context, blind spots are of particular concern as these spaces are where misconduct is most likely to occur (Weinrath et al., 2016; Wener, 2012; Wortley, 2002). Despite its importance, visibility is rarely if ever included as a measure in-prison studies, likely because there is no clear or easy way to operationalize that factor.

Even the seemingly more straightforward architecture measure, facility layout, is difficult to operationalize in practice. While the typologies of correctional facility layouts are relatively well defined, fitting existing facilities into these typologies is not always so straightforward. With the design and construction of new facilities, practitioners may draw upon the common design types, but they will also adjust that design based on prevailing corrections philosophies and their own needs. Even if the original design of a building neatly fits into a single category, prisons are in operation for decades, and can be remodelled or have new additions

included that alter the overarching design. Consequently, many facilities are hybrids of multiple design types.

In determining how to define architecture, researchers must also take into consideration the anticipated effects of design, or the outcomes of interest. Architecture in this concept is important because we anticipate that differences in features will have tangible effects. Thus, we must also define exactly what it is that architectural differences are intended to accomplish. Evidence of these expectations is scant. While we can draw from literature on architecture theories from sociology, psychology, and criminology, there is little research on the logic or justification that policymakers employ in the design and build of new prison facilities. Drawing from literature on the goals of incarceration, we can conclude that at least some of the justifications for differences in design is for the purpose of promoting these goals, namely security, deterrence, incapacitation, rehabilitation, and punishment (Cullen et al., 2014; Gaes et al., 2004; Nadel & Mears, 2020). The majority of existing research on prison design has focused largely on outcomes related to safety, such as misconduct, riots, suicide rates, victimisation, or recidivism (Morris & Worrall, 2014; Steiner & Wooldridge, 2017; Tartaro, 2003). While reducing these behaviours is certainly an important goal of the justice system, and corrections especially, this focus tends to overlook potential positive outcomes. One of the goals of incarceration is rehabilitation, which, while it can be conceptualised as the cessation of criminal activity, is often contingent on other important outcomes, including programming, prosocial relationships and behaviours, healthy coping skills, post-release employment, housing, educational attainment, and self-sufficiency (Cullen et al., 2014; St. John et al., 2019; Moran & Disney, 2018; Wener, 2012).

Although this limitation is not restricted to studies of custodial design and is in fact relatively common in corrections research, in many ways it is particularly salient for architecture studies. When we review existing literature on the impact of design in non-criminal justice settings, we often see that architecture has an indirect effect on factors such as stress or communication, which subsequently impacts behaviour (Sommer, 2007). Exposure to nature and light is associated with stress reduction (Ghaffarianhoseini et al., 2018; Kaplan, 2001; Snell et al., 2019),

closed off or compartmentalised building design is associated with poor social contacts and communication (Evans, 2003; Evans et al., 1996; Mazumdar et al., 2018). It stands to reason then, that design, rather than directly impacting misconduct or recidivism, more indirectly impacts them through more positive mediating variables. However, as it currently stands, it is unclear whether custodial designs are actually developed with the intent of influencing these factors. It is feasible that researchers could reliably define and measure these outcomes as well as custodial design, as long as there is the ability to collect the necessary data. However, it is this necessity that introduces another challenge: data availability.

Lack of Data Availability

Data on custodial design itself is not readily available. In the US for example, there are no public databases on the architectural features of correctional facilities, or even a comprehensive list of the prisons and/or jails in the country. While there are a few facility level data collections available, the closest these come to offering architectural data is a variable for facility age. In effect, any research on custodial design necessitates some form on data collection on the part of the researcher, an often costly and lengthy pursuit. This difficulty is likely one of the reasons that most studies thus far have relied on layout as the primary measure of design. Layout can be, and often is, determined through the examination of satellite photos of correctional facilities. Beyond this, any study of custodial design would require obtaining cooperation from the relevant corrections agency to either utilise information they may already have (blueprints of facilities for example) or conducting a direct collection of data within the facilities under study. Unfortunately, many agencies are reluctant to allow this type of data collection due to potential security concerns.

When we can collect data on design, whether that be facility layout or more detailed measures, there is then the challenge of obtaining a diverse set of outcomes. Common to corrections studies in general is the relatively small number of outcomes readily available through administrative data sets. The majority of these are primarily related to safety, including

misconduct counts or incidents of in-prison violence (Morris & Worrall, 2014; Steiner et al., 2014). However, other outcomes likely associated with design, such as perceptions of safety, staff-inmate relationships, programme participation, or cost-efficiency are not as readily available. These types of outcomes are typically not collected within administrative data, or if they are collected, are not made available outside of agency use. One exception might be programme participation, though while typically collected by corrections agencies, it is usually conceptualised as whether an inmate was enrolled in a programme, and in rare cases, if they completed said programme, rather than the types of programmes, length of participation, and performance.

Beyond the key measures associated with design and relevant outcomes, it can also be difficult to collect sufficiently detailed facility and offender level data. There are a number of publicly available data sets on the US prison and jail populations that could support these studies (see BJS, ICPSR), but they have several key limitations. The majority of these data collections will only collect basic demographic and offence characteristics for offenders, and, while these are certainly important indicators, they are notably lacking in detail. A few collections, the Survey of Prison Inmates for one, use surveys to collect far more in-depth information on the characteristics and experiences of the imprisoned population (BJS, 2016). However, the data is cross-sectional, making it difficult to associate a particular behaviour with a particular environment, and as facilities are selected as part of random sampling during each iteration, it is difficult to examine longitudinal trends as well. Tangential to this concern, is that the majority of these data collections do not release data indicating the facility in which a survey respondent was housed, making it impossible for researchers to determine where an offender was at the time of the interview, and thus what environmental indicators to apply.

Isolating the Effects of Design from Other Influences

The lack of detail in existing data is particularly relevant in isolating the effects of prison architecture on inmate behaviour from other potential influences. To establish a causal effect of one factor on another, it is

incumbent upon the researcher to account for any other determinants to the outcome, so that whatever effects which remain can be reliably attributed to the predictor of interest, in this case, design. The preferred method for establishing causality is an experimental design, where staff or inmates could be randomly assigned to one design type or another. However, these are difficult to implement in criminal justice, and are rarely attempted. Concerns about the ethics of randomly assigning this vulnerable population to potentially negative conditions, the difficulties in securing cooperation or permission from relevant agencies, and a historical lack of fidelity to randomisation procedures, have typically made this design untenable (Weisburd, 2000). Instead, researchers typically use quasi-experimental designs.

Within these methods, one of the most important factors in establishing causality is the ability of the study to control for potential confounding factors. To evaluate whether different aspects of design impact the behaviour of confined individuals or facility staff, then other likely influences on behaviour need to be accounted for as well. Much of this is standard for current research. For example, most studies on inmate behaviour include controls for factors such as demographic characteristics, offence type, and criminal history. But other likely predictors of behaviour—mental and physical health, prosocial contacts, education level, family support, substance abuse—are often unavailable in public data sources.

We add in additional complications when considering the impact of the custodial environment on behaviour. The potential factors to consider among these macro-level influences are just as numerous and diverse as those at the individual level. Excluding for a moment the role of the physical environment, individuals housed in correctional facilities are still impacted by social and cultural factors such as crowding, racial and ethnic diversity, and real or perceived levels of safety (Gendreau et al., 1997; Steiner et al., 2014), as well as factors relating to facility management, namely management style, inmate-staff ratios, racial and ethnic make-up of staff, and trust between corrections officers and inmates (Biejersbergen et al., 2016; Martin et al., 2012). Currently accessible data resources rarely include this level of detail. For some of these variables, however, it is likely that in some capacity the information is collected by

the supervising corrections agency. However, a researcher must (1) know that the data exists, and (2) obtain permission and cooperation form that agency to use said data. Even at that, most facility level information that does exist is still relatively minimal, typically limited to facility capacity or staffing levels and demographics. Without controlling for these various influences at both the individual and facility level, it is difficult to assert that any aspect of custodial design is responsible for a particular outcome.

Another important factor for causality is timing: the cause must occur before the effect. A facility's design cannot be associated with an offender's violent behaviour if the behaviour occurred prior to ever stepping foot in the building. Establishing the order of events typically requires longitudinal or time-dependent data. However, if the proposed cause is a stable influence, such as building design, then usually we can be confident that the building impacted the behaviour, and not the other way around. Yet the correctional environment once again makes things more complicated. In the US system, incarcerated individuals are often housed in more than one facility for the extent of their stay (Bales & Miller, 2012; Kiegrl & Hamilton, 2016). They are often transferred multiple times for a multitude of reasons. To determine which custodial design impacted a person's behaviour, we need to know the facility they were in when the behaviour occurred, as well as what other environments they may have been subjected to previously. Most corrections-associated data releases are cross-sectional, and even those that are longitudinal are measured on an annual basis, greatly limiting a researcher's ability to control for these movements and develop an accurate picture of where someone was and when. Without this information, it is difficult to determine whether an inmate's history of misbehaviour was influenced by the first facility, the second, or none of them at all.

Most studies attempt to compensate for this issue by only including the beginning of an inmate's sentence before they are moved between facilities. The Morris and Worrall (2014) study of telephone-pole versus campus design facilities only included inmates' first misconduct incident in their outcome. A study on the relationship between prison architecture and staff-inmate relationships in the Netherlands focused solely on

intake facilities (Biejersbergen et al., 2016). These strategies, while sound in methodology, necessarily ignore a large portion of the inmate's prison experience.

Solutions

Despite the somewhat bleak picture painted thus far, these challenges can be, and in some cases have been, surmounted. Focusing on the issues addressed above (operationalization, data availability, and isolating effects), there are three key goals that future work in this field should address: (1) A consistent definition of custodial design and its elements that are of most importance; (2) Collection of more detailed data on custodial facilities, their staff, and the individuals confined within them; and (3) Distinguishing the impact of design from other potential influences. These goals can largely be addressed through two overarching strategies: establishing partnerships and collaborations with corrections agencies, and the use of mixed methods and advanced statistical approaches.

Collaborations/Partnerships

Collaborations with corrections or other custodial agencies have tangible benefits for advancing research on custodial design. First, it allows researchers to better understand the intent behind different designs and thus better apply existing theory to a model of the impact of carceral architecture on behaviour. Corrections officials and prison architects are best situated to define the intent behind the various prison designs implemented in their jurisdictions. As previously discussed, many studies that use layout as a measure of design draw their information from satellite images of prison facilities. However, the internal structure of these facilities cannot be determined through these photos. Corrections officials can provide much needed insight into these characteristics, including for example, the inner layout of the facilities (e.g., open-concept or closed off hallways), the style of guard stations (e.g., open to inmates or sealed

off), the types of housing (dorms vs. shared cells vs. single cells), and potentially why these design decisions were made.

For example, as part of an NIJ funded project, researchers in Ohio collaborated with members of both the Ohio and Kentucky state corrections departments to collect data on prison victimisation (Steiner & Wooldredge, 2017). As a result, they were able to incorporate not only layout, but also housing style in their measure of architecture. They found that assaults on staff were more likely to occur in linear style designs that incorporated cell housing, while linear designs with dormitory housing and campus facilities with either cell or dormitory housing had no association with staff victimisation (Steiner & Wooldredge, 2017). Agencies may also be able or willing to provide more direct access to data, such as allowing researchers to visit a facility and code design elements themselves, or even providing the blueprints for common design types in use.

Second, these partnerships allow researchers to obtain better, more detailed data, and potentially employ more rigorous research methodologies. Relying solely on publicly available data sources is a severe limitation in the pursuit of rigorous research on prison architecture. Developing relationships with corrections-focused policymakers and practitioners can help facilitate both our understanding of existing custodial designs, as well as the collection of these essential data. As mentioned previously, the preferred method of establishing causality is through an experimental research design. Yet, due to the difficulties associated with this method, this is rarely done in criminal justice research. However, one of the strongest potential benefits of developing a collaborative partnership with corrections agencies is the increased likelihood of successfully implementing this research design. Partnerships can help further quasi-experimental studies as well. Universities and private research agencies will sometimes partner with federal, state, and local agencies to obtain detailed administrative data that is not frequently made available outside of that agency. The fruits of these labours can be seen in studies on in-prison treatment programmes, restrictive housing, correction officer well-being, and countless other projects (Braga et al., 2009; Lowen et al., 2019; Pedneault et al., 2017; Scaggs et al., 2016).

Beyond the collection of more comprehensive administrative data, developing collaborative relationships with corrections agencies also facilitates new data collections, such as surveys or focus groups with inmates or prison staff. These types of data collections also allow researchers to explore outcomes outside of safety-related behaviours. Biejersbergen and colleagues (2016), for example, collected survey data from Dutch prisoners to examine whether prison design impacted inmate relationships with facility staff. They found inmates housed in a panopticon facility were significantly more likely to report a negative relationship with prison staff, while inmates housed in a campus facility reported the most positive relationships (Biejersbergen et al., 2016).

The benefits of these partnerships are numerous, however, successfully pursuing these collaborations is often difficult. There are, however, strategies by which researchers can successfully collaborate with correctional institutions and advance research into carceral design. One example is the use of utilisation-focused evaluations.

Utilisation-focused evaluations operate under the premise that the quality of an evaluation should be based in its utility and actual use to the practitioner (Patton, 2003). Therefore, every step of an evaluation should be cognizant of how it will impact the use of the evaluation results. One of the key benefits of this model is that it makes sure that the study conducted is useful to both the researcher and the practitioner, and allows policymakers to feel involved in the process. Agencies across the US are growing more reliant on the use of evidence-based practices, and as such, are more amenable to supporting research within their respective facilities (Bales et al., 2014; Bucklen, 2020). However, any collaborations with researchers necessarily requires time, effort, and even risk on the part of these agencies. By approaching them from the context of utilisation-focused study, whereby these agencies have some assurance that they will receive some benefit from their time and effort, researchers are more likely to be successful in developing these partnerships (Patton, 2012; Ramirez et al., 2013). It is important to work with agencies to determine what they need, what type of information is important to them, and make sure the study incorporates those elements.

The Pennsylvania Department of Corrections (PA DOC), for example, has been conducting experimental evaluations for the past

15 years, and recently started working with an organisation called BetaGov, which assists agencies with evaluating new policies or practices by implementing rapid-cycle experiments that are completed within three to six months (Bucklen, 2020; http://www.betagov.org/index.html). One experiment they undertook was tangentially related to design. Operating under the theory that certain colours promote more relaxed or positive behaviours than others, the PA DOC randomly assigned one cellblock within a facility to receive white bedsheets (the control condition) and another to receive green bed sheets. They found that inmates who received green sheets had fewer misconduct incidents than those that received the normal white sheets (Shaefer, 2018). In effect, there is a clear willingness on the part of corrections to engage in this research. However, in approaching these agencies, it is important to emphasise that the relationship is collaborative, whereby researchers work directly with policymakers or practitioners to determine what they need and what type of information is important to them, and then make sure the study incorporates those elements (Pesta et al., 2016).

Another element of successful partnerships is producing deliverables that bridge the gap between theory and practice. Research articles often hold a good deal of information that could be useful in the development of corrections policy or practice. However, these studies are often not easily accessible to practitioners, and even when they are, the articles are typically written with a research-based audience in mind, making it difficult to glean practical recommendations. Translation criminology, for example, argues that if we want to prevent or reduce crime, the researchers have to be able to translate scientific discoveries into policy and practice (National Institute of Justice, 2011). In a study of two state correctional agencies in Florida, researchers examined the mechanics behind the successful translation of knowledge between academic research and policy changes and practices (Pesta et al., 2016). They found that the development of reciprocal relationships between academics and policymakers, the use of informative research that makes specific recommendations, research reports that were easy to understand, and active efforts from academics to reach out to practitioners were all associated with an improved use of research to inform corrections policy and practice.

Finally, a frequent barrier to researcher-practitioner cooperation is the issue of funds. Studies require financial support for both the researcher and the agency partner, funding both the time and effort of all involved, but also any data collection that needs to occur. These costs grow even higher when attempting to conduct an experimental design, especially ones that may involve alterations to the physical environment. However, several private organisations and government agencies exist to provide the finances necessary to engage in this research. Applying for funding from one of these agencies to support a researcher-practitioner partnership makes it easier to convince correctional administrations to support collaboration, as they get the benefits of the research products without having to sacrifice their often limited resources. In addition, funding agencies, such as the National Institute of Justice (NIJ) and Arnold Ventures have recently placed an emphasis on funding evaluations that employ experimental designs, therefore adding additional incentives for corrections agencies to engage in this method of research. Arnold Ventures, for example, recently dedicated 17 million dollars to support prison reform in the U.S., including funds to support both experimental and quasi-experimental studies of facility design and its role in rehabilitation of inmates (Arnold Ventures, 2019).

Mixed Methods and Advanced Statistical Analyses

As discussed above, developing partnerships allow researchers access to improved data sources, both qualitative and quantitative. Understandably, evidence drawn from quantitative studies typically forms the basis for establishing causality. However, in fields that are relatively new, such as custodial design, there is a need for more exploratory research before more rigorous causal studies can be reliably done. Defining the important elements of prison architecture, what outcomes they are intended to impact, and the mechanisms by which we anticipate these relationships to occur are essential first steps in this process. Without the framework this information provides, quantitative studies will typically lack the necessary context to understand or validate any relationships we may

find. For example, when evaluating the impact of linear vs. podular designs on the likelihood of an inmate being written up for having contraband, if there is no association, is that because there really is none, or because layout is not anticipated to stop contraband, whereas another design feature would be, such as improved external security (fencing, CCTV, etc.). On the other hand, if there is an association, is it because layout directly inhibits procuring and hiding contraband, or is it instead working through some other mechanism, such as surveillance? Mixed methods approaches are helpful in defining the key concepts that should be evaluated—i.e., design features, mechanisms, and outcomes—and how those concepts are anticipated to interact. Defining this model can be partially accomplished through a systematic review of existing theories and research. However, the intent behind variations in modern custodial designs is not well established. By engaging with individuals that are housed in, work at, or operate these facilities, researchers can develop a standardised model that is reflective of current custodial thought and practices. This model can then more efficiently guide future quantitative studies.

Empirical studies are key to establishing evidence of a causal relationship between custodial design and behavioural or systemic outcomes. However, these studies require access to detailed data on facilities and their inhabitants. These data are necessary to (1) develop measures for various aspects of design, (2) reliably test for changes in a wide variety of outcomes, and (3) control for potential confounding influences. The more detailed data available, the greater the likelihood that a researcher can employ a more rigorous analysis that isolates the effects of a facility's physical environment from other influences.

Again, partnering with corrections agencies is one method of obtaining these data. Existing studies on corrections have included several variables that would be useful in studies of custodial design. Examples include inmate scores on risk assessment instruments, records of visitation while incarcerated, programme participation, evidence of social bonds (e.g., gang membership, marriage, children, education, pre-arrest employment, etc.), mental and physical health, and housing at time of arrest (Aranda-Hughes et al., 2020; Shaffer et al., 2019; Wooldredge & Cochran, 2019; Wooldredge & Steiner, 2014). These data can

also allow for the consideration of the timing of events. Corrections agencies are responsible for knowing where each inmate under their care is at all times. Therefore, they keep detailed records of what facility an inmate is in on a given day and when they are moved out of that facility. These movement files can be used to determine where an inmate was housed at the time of the behaviour of interest (misconduct or programme participation are two examples), rather than having to limit analyses to only the first event or the beginning of an inmate's stay (see Morris & Worrall, 2014; Biejersbergen et al., 2016). Records of inmate transfers also allow researchers to determine an inmate's exposure to various environments, and therefore control for these prior experiences. With these data, multilevel modelling techniques can account for the timing of events, dynamic confounding factors (such as receiving a visit within the past thirty days), individual characteristics, and facility characteristics (Nadel & Mears, 2020).

Yet, even without this level of administrative data, there are still options that successfully incorporate publicly available data to examine elements of the physical carceral environment. In the US, state corrections departments will often include details about their detention facilities that aren't typically collected in large-scale data collections or administrative records. This information can be culled to develop proxy measures of design, such as the primary housing type within a facility (dormitory or cells), provision of spaces for special populations, or the presence of various rehabilitative programmes. The address associated with the facility allows researchers to not only define building layout types through satellite imagery, but also the natural environment where the facility is located (i.e., rural vs. urban, greenery vs. empty space). Collecting these data at state or national levels allows researchers to then look at wider trends in design. A recent study of prisons in the UK used Geographical Information Systems methodology to calculate the percentage of greenery within a prison's perimeter as a proxy for exposure to nature for inmates and prison staff (Moran et al., 2020, 2021) Using these data, they were able to find a significant association between greenspace and inmate well-being as measured by instances of self-harm (Moran et al., 2020) and the health of prison staff, measured by use of sick leave (Moran et al., 2021). In effect, thorough and creative use of

existing data sources, whether official collections or other public-facing websites and tools, researchers can overcome or circumvent many of the challenges associated with custodial design research.

Conclusion

Interest in reforming current US prison practices and the impact of prison architecture has grown steadily in recent years. Whether through funding from state budgets or resources from external grants, state corrections agencies are embracing small and sometime large changes to how prisons are designed and operated. Whether it's incorporating nature-inspired murals on prison walls (Raemisch & Wasko, 2015; Utah Department of Corrections), installing scenic rooms where inmates can virtually experience nature (Nadkarni et al., 2017), or constructing new housing blocks to reflect Scandinavian corrections practices (Arnold Ventures, 2019), there is more opportunity for research and reform in-prison design with each passing year. In developing partnerships with practitioners, using mixed methods to develop a cohesive model of the relationship between design and pertinent outcomes, and the continued pursuit of more and diverse studies in this field, the challenges that have hampered this research can be surmounted.

References

Akers, R. L., Sellers, C. S., & Jennings, W. G. (2020). *Criminological theories: Introduction, evaluation, and application* (8th ed.). Oxford University Press.

Aranda-Hughes, V., Turanovic, J. J., Mears, D. P., & Pesta, G. B. (2020). Women in solitary confinement: Relationships, pseudofamilies, and the limits of control. *Feminist Criminology.* https://doi.org/10.1177/1557085120961441

Archea, J. (1977). The place of architectural factors in behavioral theories of privacy. *Journal of Social Issues, 33*(3), 116–133.

Arnold Ventures. (2019, May 15). *Arnold Ventures dedicates $17 million to support fundamental prison reform*. https://www.arnoldventures.org/newsroom/arnold-ventures-dedicates-17-million-to-support-fundamental-prison-reform/

Bales, W. D., & Miller, C. H. (2012). The impact of determinate sentencing on prisoner misconduct. *Journal of Criminal Justice, 40*(5), 394–403.

Bales, W. D., Scaggs, S. J., Clark, C. L., Ensley, D., & Coltharp, P. (2014). Researcher–practitioner partnerships: A case of the development of a long-term collaborative project between a university and a criminal justice agency. *Criminal Justice Studies, 27*(3), 294–307.

Biejersbergen, K. A., Dirkzwager, A. J. E., van der Laan, P. H., & Nieuwbeerta, P. (2016). A social building? Prison architecture and staff-prisoner relationships. *Crime & Delinquency, 62*(7), 843–874.

Braga, A. A., Piehl, A. M., & Hureau, D. (2009). Controlling violent offenders released to the community: An evaluation of the Boston Reentry Initiative. *Journal of Research in Crime and Delinquency, 46*(4), 411–436.

Bureau of Justice Statistics (BJS) (2016). Survey of Prison Inmates (SPI). https://bjs.ojp.gov/data-collection/surveyprison-inmates-spi

Bucklen, K. B., National Institute of Justice (NIJ), US Department of Justice, Office of Justice Programs, & United States of America. (2020). *Conducting randomized controlled trials in state prisons*.

Cullen, F. T., Jonson, C. L., & Stohr, M. K. (2014). *The American prison: Imagining a different future*. Sage.

Evans, G. W. (2003). The built environment and mental health. *Journal of Urban Health, 80*(4), 536–555.

Evans, G. W., Lepore, S. J., & Schroeder, A. (1996). The role of interior design elements in human responses to crowding. *Journal of Personality and Social Psychology, 70*(1), 41–46.

Fairweather, L., & McConville, S. (2000). *Prison architecture: Policy, design and experience*. Architectural Press.

Gaes, G. G., Camp, S. D., Nelson, J. B., & Saylor, W. G. (2004). *Measuring prison performance: Government privatization & accountability*. AltaMira Press.

Gendreau, P., Goggin, C. E., & Law, M. A. (1997). Predicting prison misconducts. *Criminal Justice and Behavior, 24*(4), 414–431.

Ghaffarianhoseini, A., AlWaer, H., Omrany, H., Ghaffarianhoseini, A., Alalouch, C., Clements-Croome, D., & Tookey, J. (2018). Sick building syndrome: Are we doing enough? *Architectural Science Review, 61*(3), 99–121.

Gifford, R. (2002). *Environmental psychology: Principles and practices*. Optimal Books.

Jewkes, Y., Bennet, J., & Crewe, B. (2016). *Handbook on prisons* (2nd ed.). Routledge.

Johnston, N. (1973). *The human cage: A brief history of prison architecture*. The American Foundation.

Johnston, N. (2000). *Forms of constraint: A history of prison architecture*. University of Illinois Press.

Kaplan, R. (2001). The nature of the view from home: Psychological benefits. *Environment and Behaviour, 33*(4), 507–542.

Kigerl, A., & Hamilton, Z. (2016). The impact of transfers between prisons on inmate misconduct: Testing importation, deprivation, and transfer theory models. *The Prison Journal, 96*(2), 232–257.

Lowen, M., Vanko, E., Roberts, S., & Chaitoo, N. (2019). The safe alternatives to segregation initiative: Findings, recommendations, and reforms for the Nevada department of corrections. *Vera Institute of Justice*.

Martin, J. L., Lichtenstein, B., Jenkot, R. B., & Forde, D. R. (2012). "They can take us over any time they want": Correctional officers' responses to prison crowding. *The Prison Journal, 92*(1), 88–105.

Mazumdar, S., Learnihan, V., Cochrane, T., & Davey, R. (2018). The built environment and social capital: A systematic review. *Environment and Behavior, 50*(2), 119–158.

Moran, D., & Disney, T. (2018). 'You're all so close you might as well sit in a circle…' Carceral geographies of intimacy and comfort in the prison visiting room. *Geografiska Annaler: Series B, Human Geography, 100*(3), 179–194.

Moran, D., Jones, P. I., Jordaan, J. A., & Porter, A. E. (2020). Does nature contact in prison improve well-being? Mapping land cover to identify the effect of greenspace on self-harm and violence in prisons in England and Wales. *Annals of the American Association of Geographers*, 1–17.

Moran, D., Jones, P. I., Jordaan, J. A., & Porter, A. E. (2021). Nature Contact in the Carceral workplace: Greenspace and staff sickness absence in prisons in England and Wales. *Environment and Behavior*. https://doi.org/10.1177/00139165211014618

Morris, R. G., & Worrall, J. L. (2014). Prison architecture and inmate misconduct: A multilevel assessment. *Crime & Delinquency, 60*(7), 1083–1109.

Nadel, M. R., & Mears, D. P. (2020). Building with no end in sight: The theory and effects of prison architecture. *Corrections, 5*(3), 188–205.

Nadkarni, N. M., Hasbach, P. H., Thys, T., Crockett, E. G., & Schnacker, L. (2017). Impacts of nature imagery on people in severely nature-deprived environments. *Frontiers in Ecology and the Environment, 15*(7), 395–403.

National Institute of Justice. (2011, November 2). *What is translational criminology?* nij.ojp.gov. https://nij.ojp.gov/topics/articles/what-translational-cri minology

Patton, M. Q. (2003). Utilization-focused evaluation. In T. Kellaghan, D. L. Stufflebeam (Eds.), *International handbook of educational evaluation* (Kluwer International Handbooks of Education, Vol. 9). Springer. https://doi.org/10.1007/978-94-010-0309-4_15

Patton, M. Q. (2012). *Essentials of utilization-focused evaluation.* Sage.

Pedneault, A., Hamilton, Z., Kigerl, A., Pimley, N., & Choi, E. (2017). *Evaluation of Washington State Department of Corrections (WADOC) Second Chance Act–Continuum of Care Pilot Program Process, Outcome and Cost-Benefit Evaluation.*

Pesta, G. B., Ramos, J., Ranson, J. A., Singer, A., & Blomberg, T. G. (2016). *Translational criminology, research and public policy: Final summary report.* Florida State University.

Raemisch, R. F., & Wasko, K. R. (2015). *Open the door, segregation reforms in Colorado.* Colorado Department of Corrections.

Ramirez, R., Brodhead, D., Solomon, C., Kumar-Range, S., Zaveri, S., Earl, S., & Smith, M. (2013). *Utilization focused evaluation: A primer for evaluators.* Southbound, Penang, MY.

Scaggs, S., Bales, W. D., Clark, C., Ensley, D., Coltharp, P., & Blomberg, T. G. (2016). An assessment of substance abuse treatment programmes in Florida's prisons using a random assignment experimental design. Report submitted to the National Institute of Justice Office of Justice Programs US Department of Justice. Florida, US: The Florida Department of Corrections and Florida State University College of Criminology and Criminal Justice.

Shaefer, M. A. (2018, March 1). Yoga and aromatherapy behind bars? Pa. prisons try wellness initiatives. The Philadelphia Inquirer. https://www.inq uirer.com/philly/health/wellness-yoga-pennsylvania-prisons-aromatherapy-inmates-virtual-reality-20180301.html

Shaffer, J. S., Russo, J., Woods, D., & Jackson, B. A. (2019). Managing the seriously mentally Ill in corrections. RAND.

Snell, T. L., McLean, L. A., McAsey, F., Zhang, M., & Maggs, D. (2019). Nature streaming: Contrasting the effectiveness of perceived live and recorded videos of nature for restoration. *Environment and Behavior, 51*(9–10), 1082–1105.

Sommer, R. (2007). *Personal space: The behavioral basis of design.* Bosko Books.

St. John, V. J., Blount-Hill, K.-L., Evans, D., Ayers, D., & Allard, S. (2019). Architecture and correctional services: A facilities approach to treatment. *The Prison Journal, 99*(6), 748–770. https://doi.org/10.1177/0032885519877402

Steiner, B., & Wooldredge, J. (2017). Individual and environmental influences on prison officer safety. *Justice Quarterly, 34*(2), 324–349.

Steiner, B., Butler, H. D., & Ellison, J. M. (2014). Causes and correlates of prison inmate misconduct: A systematic review of the evidence. *Journal of Criminal Justice, 42,* 462–470.

Tartaro, C. (2003). Suicide and the jail environment: An evaluation of three types of institutions. *Environment and Behavior, 35*(5), 605–620.

Utah Department of Corrections. (n.d.). New mural brings images of nature to Olympus facility. Retrieved on September 28, 2020. https://corrections.utah.gov/index.php/home/alerts-2/1130-new-mural-brings-images-of-nature-to-olympus-facility

Weinrath, M., Budzinski, C., & Melnyk, T. (2016). Visualizing prison life: Does prison architecture influence correctional officer behaviour? An exploratory study. *The Annual Review of Interdisciplinary Justice Research, 5,* 291–311.

Weisburd, D. (2000). Randomized experiments in criminal justice policy: Prospects and problems. *Crime & Delinquency, 46*(2), 181–193.

Wener, R. E. (2012). *The environmental psychology of prisons and jails: Creating humane spaces in secure settings.* Cambridge University Press.

Wooldredge, J. (2020). Prison culture, management, and in-prison violence. *Annual Review of Criminology, 3,* 165–188.

Wooldredge, J., & Cochran, J. C. (2019). Equal or not? Private versus public corrections services, programming, and climate. *Criminology & Public Policy, 18*(2), 295–321.

Wooldredge, J., & Steiner, B. (2014). A bi-level framework for understanding prisoner victimization. *Journal of Quantitative Criminology, 30,* 141–162.

Wortley, R. (2002). *Situational prison control: Crime prevention in correctional institutions.* Cambridge University Press.

11

Evaluating Correctional Environments: A Critical Psychosociospatial Approach

Todd Levon Brown

Introduction

On June 6, 2015, Kalief Browder, a 22-year-old Bronx, New York, native, hung himself, ending his life primarily as the result of the mental and physical abuse that he had endured over a three-year period while being held at Rikers Island. Just as disturbing was the fact that he had been held for so long, simply because he could not afford bail, although he maintained his innocence on the charges of robbery, grand larceny, and assault for which he was being held (Time: The Kalief Browder Story, 2017). Although his suicide was committed two years after his ultimate release (without conviction), the fact that his earliest attempts began while he was incarcerated—as well as the fact that he developed severe depression while in Rikers—elucidated the onset of

T. L. Brown (✉)
The University of Texas at Austin, Austin, TX, USA
e-mail: todd.brown@austin.utexas.edu

severe psychosocial issues that many inmates experience while behind bars (Gonnerman, 2014). Community outrage and activism around the Browder case led to several protests that, in November 2015, culminated in the formal "Campaign to Shut Down Rikers" (Glum, 2015). This campaign garnered much attention from many local and national politicians and criminal justice reform advocates alike and became the impetus for New York City Mayor Bill DeBlasio's 10-year "Roadmap to Closing Rikers" plan (Roadmap to Closing Rikers: De Blasio Administration to Close Two Jails Next Year, 2019). Browder's death and the resulting mayoral initiative have helped to spark critical discussion and debate across the nation about criminal justice reform and a deeper examination of the nature of our prison system. From legal scholars to environmental psychologists to architects, experts in a variety of fields have begun to examine the multifaceted aspects of our penal institutions and facilities, uncovering the flaws that permeate this complex system.

As we understand that jails and prisons are still needed in many countries like the United States, whose penal state is a fixture of society (Garland, 2013; Alexander, 2020), recently the conversation has begun to focus more on the design of the correctional facilities themselves. Within the last three years, from the writing of this chapter, discussion of design strategies for alternative facilities—such as community-based jails that promote healthy, supportive, and rehabilitative environments—have led to competitions exclusively devoted to these goals: most notably the Van Alen Institute's *Justice in Design* competition (Justice in Design, 2017). While such initiatives promise to be beneficial in the creation of new, more humane correctional environments, it is highly possible that such innovations may have little to no impact on the numerous sociospatial issues—e.g., quality of confinement, upkeep, and cleanliness, safety, operations, etc. (Brakel, 1988; Logan, 1991)—extant in existing facilities.

The purpose of this chapter will be to propose some of the most viable evaluative methodologies for elucidating and remediating the flawed spatial and aesthetic design qualities of custodial environments. A critical exploration and problematization of the various sociospatial factors that generate psychological and physical trauma within correctional institutions will be used for both context and justification of

such methodological approaches. Techniques for the critical psychosocial evaluation of these environments will also be explored, primarily with consideration of an enhanced post-occupancy evaluation (POE) methodology. This chapter will also attempt to illustrate how occupant/user feedback—that incorporates psychosocial inquiry with critical spatial analysis—is essentially useful and necessary in addressing and optimizing the perceptions and experiences of all those who interact with correctional environments: inmates, staff, and visitors. The ultimate goal of this chapter will be to recommend comprehensive strategies for the evaluation of poorly performing correctional facilities with the aim of implementing spatial changes that foster restorative and just environments in custodial design.

Towards an Enhanced Participatory "Post-occupancy" Evaluation of Correctional Environments: Improving Design and Operations

British criminologist Alison Leibling (1999) poignantly states that "the pains of imprisonment are tragically underestimated by conventional methodological approaches to prison life" (p. 165). This acknowledgement should resonate with any critical researcher studying any aspect of prison life. American social psychologist Craig Haney (2018) further argues that "conventional approaches encourage us to conceive of prisons as more or less traditional research settings and prisoners as mere specimens to be objectively assessed" (p. 366). These critical understandings underline the fact that employing traditional objective approaches are likely to limit or inhibit the acquisition of useful insights into prison life or the accurate representation of the experience of those living inside (Haney, 2018).

When it comes to the evaluation of carceral geographies (the physical spaces associated with the incarceration or detainment of inmates)—particularly in the context of their psychosocial outcomes—critical, comprehensive, and interdisciplinary strategies must be utilized in order

to effectively problematize and improve negative spatial conditions that do little to rehabilitate and reform the incarcerated and may actually further exacerbate negative psychological and social affect among these populations and others, such as the staff or visitors who interact with them.

Currently the criminal justice reform movement—especially in the United States and other Western societies—is making tremendous progress towards rethinking the spatial qualities of correctional environments, realizing that far too often these physical environments, as socially produced spaces, serve to materialize dehumanization and other psychosocial injustices. The 2017 Van Alen Institute Justice in Design Competition positioned the architectural design and programming of custodial spaces at the centre of the conversation (Justice in Design, 2017). I was fortunate to be a part of one of the teams that entered this competition, submitting a proposal for new and improved community-based jails that would serve as a beacon of social consciousness and challenge the disparities and inequalities that are prevalent in most traditional correctional facilities. All of the teams, along with the winning submission, proposed designs for "Justice Hubs" that—in accordance with the competition guidelines—would be responsive to the needs of all stakeholders involved (detainees, officers, lawyers, visitors and community members). This project, in addressing the issue of conditions of jails in New York City, sought to create healthy environments and support rehabilitation for incarcerated or detained individuals—those awaiting trial or convicted and awaiting sentencing—while simultaneously providing neighbourhoods with new public amenities (Gallagher et al., 2017). Such initiatives are small yet important steps in creating new psychosocially sustainable carceral spaces. However, they will most likely do little to address existing correctional environments, especially in facilities such as state or federal prisons where inmates often serve sentences that are decades long. The humanization of these environments must also become a priority and each such facility will present unique challenges and opportunities for identifying, evaluating, and transforming their physical characteristic into restorative settings. Systematically and comprehensively assessing each of these spaces will be necessary in order to understand the spatially and operationally corrective changes that

need to be implemented both generally and specifically in correctional facilities.

A Brief History of POE: Problems and Potential

For over 50 years, post-occupancy evaluation (POE) has served as the principle methodology for empirically assessing the performance of existing buildings, structures, and spaces for designers, planners, and building administrators so that they can learn from mistakes (Zeisel, 1984). Historically, since its inception in the 1960s, POE methodology has been associated with the assessment of non-domestic buildings:

> [i]nstitutional settings such as mental hospitals, nursing homes and correctional facilities were of the most concern as it was thought that the performance of these building types was having a negative effect on the proper rehabilitation of inmates and patients. (Brown, 2018, pg.185)

The most pressing and prioritized problems of concern were issues of health and safety, security, poor signage and way finding, poor air circulation and temperature control, handicapped accessibility, lack of storage and aesthetics (Preiser, 1995). During the early stages of POE, there was also considerable application to institutional residential environments with some of the earliest studies of the 1960s focusing on university dormitories and carried out by Sim van der Rijn of the University of California, Berkeley and Victor Hsia of the University of Utah (Preiser & Nasar, 2008). Modern post-occupancy evaluations, as we know them today, emerged from such evaluations which were predominantly carried out as singular case studies (Brown, 2018). During the earlier era of the 1960s, the practice of architecture in the United Kingdom adopted this methodology as both necessary and viable to the field, recognizing that a lack of "scientific exploration" existed to evaluate the successes and failures of construction projects (Riley et al., 2009). The Royal Institute of British Architects (RIBA) incorporated POE methodology into its first handbook in 1965, including it in the final stage of "Plan of work", Part M: feedback. This evaluation stage was regarded as critically essential and as a cost-effective way of improving service to future clients

(Riley et al., 2009). Riley and his colleagues also report that in the 1970s and the 1980s, POE evolved into cross-sectional studies which evaluated multiple buildings in similar categories, making it a widely established model within the field of construction and design. However, this success was short-lived, and implementation waned due to the associated fees, insurance, liability and its failure to be seen as an architect's responsibility (Cooper, 2001). The result was the removal of Part M, by RIBA, from their handbook, as it was noted that clients were not particularly agreeable to paying additional costs for the POE service and RIBA did not want to imply that this phase of the design and construction process was obligatory (Preiser & Vischer, 2005). As a response to this decline in professional acceptance by architects, academics—particularly in the field of environmental psychology—decided to develop POE further with the goal of widening the availability of scientific knowledge (Cooper, 2001). Wolfgang Preiser and Jack Nasar (2008) attribute the first official publication with the term "POE" to Herb McLaughlin of KDM Architecture in San Francisco. His studies, focusing on hospitals in Utah and San Francisco, were published in the AIA Journal issue of 1975. Due to this renewed interest in POE and the consequent changing industry perceptions and approaches to sustainability, in 2006 RIBA reintroduced Part M to their plan of works section (Bordass & Leaman, 2005). However, the reinstatement of POE methodology in recent practice has placed an overwhelming emphasis on the technical performance of physical space with nearly all formal and official POE studies being restricted to assessing technology-focused metrics (such as CO_2 emissions, energy use, thermal comfort and onsite water management) of building performance (Brown, 2018). Such measurements are easily quantifiable and more readily translated into "dollars and cents", therefore a focus on these aspects of technological and economic feasibility of building performance can be justified in terms of costs, while the less prioritized social aspect have been neglected (Brown, 2018).

Rethinking POE for Correctional Environments

I argue for an enhanced POE that incorporates a critical psychosocial dimension in the assessment of a variety of designed spaces—in this case, correctional environments. POE approaches that rethink the considerations of the already implemented occupant/user survey—a standard component of this technique—to include the perceptions and experiences of its users have the potential to be truly transformative.

I intend to provide examples of projects that span both research and practice efforts and are illustrative of how one might critically address sociospatial issues within the built environment, specifically focusing on institutional—primarily correctional—spaces. Essentially all of the research projects that I will present are, in essence, forms of post-occupancy evaluations because their primary purposes have been to evaluate physical spaces that have been occupied for their intended use. One of the main barriers to rethinking the applications of POE methodologies to include the psychosocial dimensions of physical environments is the fact that it becomes difficult to evaluate a building according to metrics that were not central during the design process (Brown, 2018). It is highly apparent that historically, most architects whose practices focus on custodial institution design had primary agendas of discipline and punishment (Malacrida, 2005, 2012) rather than rehabilitation and restoration. However, even within inhumane carceral environments there is a tremendous potential to redesign these spaces so that they become supportive settings with attributes that resemble life on the outside and better prepare inmates for reintegration into civil society after release. The projects I present provide evidence of how innovation at the intersection of social and behavioural sciences and architectural/environmental design can lead to simple yet effective sociospatial transformations.

I intend to draw a connection between these exemplary projects with relevant real-world examples of the psychosocial traumas experienced by individuals placed in negative prison (and other institutional) environments, demonstrating how a re-envisioning of POE methodology might be employed to reduce or prevent such dismal outcomes.

Spatializing Trauma and Safety: Documenting Dehumanizing Physical Spaces in Correctional (and Other Institutional) Facilities

The Possible Link Between Suicide and Experiences in Custodial Environments

Unfortunately, stories like that of Kalief Browder occur far more frequently than one might imagine. While Browder's case was shrouded in media coverage due to the resultant community activism that it generated while he was detained at Rikers and after his release, there are countless other similar incidents that rarely, if ever, receive media attention. According to a technical report from the Vera Institute of Justice, researchers Pope and Delaney-Brumsey (2016) found that "suicide is the leading cause of death in local jails, accounting for over one-third of jail deaths in 2013" (p. 3). Additionally, according to an Associated Press investigative report of governmental data on US Jails,

> Suicide, long the leading cause of death in U.S. jails, hit a high of 50 deaths for every 100,000 inmates in 2014, [according to] the latest government data available. That's 2 1/2 times the rate of suicides in state prisons and about 3 1/2 times that of the general population. (Cohen & Eckert, 2019, par. 11; Binswanger et al., 2007)

A brief internet search for media stories related to suicides committed while in custody reveals that this phenomenon remains a clear and persistent problem to this day with numerous cases around the country. Such incidents range from the more notarized reported suicides of Sandra Bland (a 28-year-old Black female) in Texas in 2015 and Jeffrey Epstein (a 66-year-old White male) in New York in 2019 to many often unnamed individuals, such as an unidentified 32-year-old male in California in 2020 (Johncox, 2020; Sarat, 2020). While the circumstances, or even the factuality—as in the cases of Bland and Epstein—of suicides in jails, prisons and other correctional facilities often remain unknown or contested, what is apparent is that custody-related suicide is yet another issue that plagues an already and rightfully scrutinized

criminal justice system in the United States (Sarat, 2020). However, a critical examination of this systemic problem furthermore reveals that this issue is not bounded by the confines of the American legal system or even the physical boundaries of correctional facilities themselves but that the pervasiveness of its psychological impact often has the ability to transcend an inmate's physical confinement in a correctional institution.

Haglund et al. (2014)—a group of clinicians and researchers from Sweden and the UK—found that suicide rates of released inmates in Sweden was roughly 18 times higher than that of the general population. In general, their research demonstrated that the link between being incarcerated and an increased potential for suicidal outcomes is not unique to the United States. More importantly, it illustrates the fact that suicidal behaviour related to incarceration need not occur only while in custody but may manifest even years afterwards (up to 5 in their study). Haglund and his colleagues examined a variety of risk factors that possibly contributed to the increased rate of suicide among the released prisoners in their cohort and reported that unemployment, homelessness, previous substance abuse disorder, previous suicide attempts, and country of birth (foreign or native) were all factors that contributed to increased rates of suicide, with the latter three being statistically significant independent risk factors in their study.

A critical yet missing element in such research is a thoughtful and comprehensive examination of previous unsuccessful suicide attempts as a precursor to those that ultimately result in the death of an individual—while an active inmate, released convict, or formerly detained individual. When addressing the topic of incarceration-related suicides, particularly those occurring while in custody, the conversation usually turns towards the topic of the mental health of the inmate. However, it appears that far too often, there is a potentially unfounded presupposition that there is a pre-existing mental health disorder *before* the inmate is placed in the carceral space and not *as a result of* the sociospatial conditions imposed by such environments. Such assumptions lend themselves to the importation/deprivation debate among criminologists that seeks to explain maladaptive and self-destructive behaviours among inmates—including suicidal outcomes. As an environmental psychologist, I present that the aforementioned cases of both Sandra Bland and Kalief Browder

explicitly underline this argument and appear to support the deprivation position as a primary explanation in many, though not all, of such cases.

> The deprivation model is based on the classic work of Clemmer (1940), Sykes (1958), and Goffman (1961), and holds that mal-adaptation to prison (e.g., violence, aggression, anxiety, depression, distress, and suicide) is a product of the restrictive prison milieu. That is, depriving conditions of the prison produce aggressive or self-destructive behavior. (Huey, 2008, p. 13)

In the case of Sandra Bland, whose 2015 death was ruled a suicide, it must be noted that there are many individuals who still believe her death to actually have been a murder at the hands of local law enforcement officers due to the nature of her social media activism against police brutality towards Black people in Illinois and Texas (Blake, 2015; Keyser & Graczyk, 2015). What started as a supposedly routine traffic stop for Bland's failure to signal a lane change, turned into a somewhat violent arrest and 3 days of jail time due to her inability to post bail. On the third day, while still in custody, Bland was found dead "in a semi-standing position" and hanging in her cell (Lai et al., 2015). After a Harris County autopsy ruled the death a suicide, The Texas Department of Public Safety immediately created a narrative of Bland as a mentally unstable, drug abuser (marijuana dependency) with a history of several attempted suicides (Graczyk & Stengle, 2015; Izadi & Phillip, 2015). What was not readily reported was the fact that Bland was a college graduate, a member of an international Black sorority, had worked as a summer counsellor for three years, had volunteered for a senior advocacy group, and was regarded by some as a civil rights activist and a member of the Black Lives Matter movement (Calvin & Schuppe, 2015; Keneally, 2015; Keyser & Graczyk, 2015). A critical analysis of her particular situation must consider that *if* she did indeed commit suicide, was she pre-suicidal at the time of her detainment? Or, was her treatment by law enforcement combined with being alone in a predominantly White county jail over 1,000 miles away from her family and hometown of Naperville, Illinois the cause? Could such sociospatial conditions possibly induce or exacerbate a negative mental state over the course of three days

of isolation from supportive social interaction? It appears that the deprivation model would reasonably explain Bland's outcome, *if* a suicide did indeed occur.

> In contrast to the deprivation perspective, the importation model attributes mal-adaptation to the characteristics of inmates rather than features specific to the prison environment. Proponents of the importation hypothesis (Irwin and Cressey 1962) criticize the deprivation model as being overly narrow and ignoring the characteristics of inmates, which largely determine behavior in prison. (Huey, 2008, p. 25)

This argument posits that inmates with negative behavioural outcomes in prison environments experience them due to pre-existing personality characteristics or mental health disorders. However, Kalief Browder's case provides a clear opposition to this theory by definitively illustrating how time spent in carceral spaces, along with the severe treatment facilitated by these environments, can create unimaginable trauma for those forced to endure inhumane conditions.

Browder was only 16 years old when he was arrested and detained on charges of robbery and assault. At that time, he had only one other prior criminal offence which was joyriding in a stolen bakery truck (Time: The Kalief Browder Story, 2017). Otherwise, Browder had been described by acquaintances as a "fun guy" and "smart" (Gonnerman, 2014). He had no documented history of mental illness prior to his wrongful incarceration. In fact, after his release and before his suicide, he participated in numerous interviews where he explicitly discussed the devastating toll that his Riker's Island imprisonment had on him. In an extensive 2014 interview with Jennifer Gonnerman of *The New Yorker*, Browder emphasized that the total of nearly two years that he spent in a 12 × 7-foot solitary confinement cell at Riker's, also known as the Bing, were particularly detrimental to both his mental and physical well-being. This isolating environment allowed him to be further dehumanized, brutalized, and malnourished by prison staff. Gonnerman recounted Browder's experience of being locked in this virtual hotbox for 23 hours a day:

> Summer is the worst time of year to be stuck in the Bing, since the cells lack air-conditioning. In the hope of feeling a breeze, Browder would sleep with the window open, only to be awakened at 5 A.M., when the cell filled with the roar of planes taking off from LaGuardia, one of whose runways is less than three hundred feet from Rikers. He would spend all day smelling his own sweat and counting the hours until his next shower. (Gonnerman, 2014, par. 31)

Browder further recollected on how the secluded and unmonitored spaces of solitary confinement enabled prison guards to engage in unlawful fights with and beatings of inmates:

> At one point, Browder said, "I had words with a correction officer, and he told me he wanted to fight. That was his way of handling it." He'd already seen the officer challenge other inmates to fights in the shower, where there are no surveillance cameras. "So I agreed to it; I said, 'I'll fight you.'" The next day, the officer came to escort him to the shower, but before they even got there, he said, the officer knocked him down: "He put his forearm on my face, and my face was on the floor, and he just started punching me in the leg." Browder isn't the first inmate to make such an allegation; the U.S. Attorney's report described similar incidents. (Gonnerman, 2014, par. 35)

Browder's interview also revealed that solitary confinement, as a space of segregation from the general population, allowed him to frequently be starved:

> In solitary, food arrived through a slot in the cell door three times a day. For a growing teenager, the portions were never big enough, and in solitary Browder couldn't supplement the rations with snacks bought at the commissary. He took to begging the officers for leftovers: "Can I get that bread?" Sometimes they would slip him an extra slice or two; often, they refused. (Gonnerman, 2014, par. 36)

Undoubtedly, incidents of suicide among inmates and the formerly incarcerated are some of the most extreme and severe outcomes of enduring the negative sociospatial aspects of carceral institutions. However, the traumatic experiences of occupying any dehumanizing

spaces in correctional facilities may express themselves in a variety of unfavourable psychological and social affects. Stories like Browder's can and should be used for context when interviewing inmates or detainees in order to identify problematic spaces with in correctional environments that contribute to and facilitate negative experiences.

Beyond Solitary Confinement: Other Institutional Spaces of Dehumanization and Despair

There has been much clinical and social research on the adverse psychological effects of solitary confinement, particularly due to isolation and sensory deprivation (Grassian, 1983, 2006; Grassian & Friedman, 1986; Haney, 2018; Ogle, 2019). Solitary confinement is most often pinpointed and problematized as the culpable and exemplary physical space that produces a negative state of being among those who receive this most restrictive of punishments within correctional and institutional facilities. Because they are commonly regarded as "prisons within prisons" (Haney, 2018, p. 366), solitary confinement, as carceral geographies—the physical spaces associated with the incarceration or detainment of inmates—, receives the most attention with regard to physical spaces in correctional environments. It is easy to call attention to the fact that solitary confinement units, in most prisons and jurisdictions, share near universal spatial and aesthetic conditions which are understood—in design-related fields such as architecture and environmental psychology—to create and reinforce psychologically and socially negative environments used for punishment. Criminologist Sharon Shalev, in her *Sourcebook on Solitary Confinement* (2008), identified these common design characteristics:

> …location in a separate or remote part of the prison; the absence of, small, or partially covered windows; sealed air quality; stark appearance and dull colours; toughened cardboard or other tamper proof furniture bolted to the floor; and, small and barren exercise cages or yards….Other measures, such as feeding-slots built into cell-doors, are taken to ensure that most services can be provided to prisoners inside their cells, reducing prisoner movement in and outside the unit…. In some of the newly built

> isolation units, cells are also soundproofed and/or do not have windows, further reducing sensory stimulation. (p. 39)

It can be implied that such physical features of solitary confinement are often perceived as claustrophobic and monotonous environments, which, in turn, often have psychosocial health implications for prisoners and, to some extent, staff who work in these units (Shalev, 2008). Shalev's findings can serve as an initial checklist for a researcher-practitioner doing spatial evaluation work within any correctional facility. The common design characteristics that she highlighted can be easily identified and, in most cases, readily remediated via innovative design interventions that seek to optimize the spatial and experiential quality while not compromising safety. Many of the issues that she points to are not limited to solitary confinement spaces but are frequently prevalent in many of the common areas with prison environments. For example, the lack of windows, dull colours and barren exercise yards are elements commonly found in many penal institutions and can be improved with little to no effect on security measures. In fact, many industry leaders in correctional design, construction and operations argue that the installation of more doors and windows can actually improve "health, safety, security and efficiency" as they increase "privacy, tranquillity, vision and daylight control" (Door & Window Design Solutions Improve Security, Efficiency—Correctional News, 2015).

Additionally, it is crucially and equally important to understand that many other spaces exist within correctional facilities—jails, prisons, detention centres, etc.—that serve to demoralize, dehumanize and disparage those who reside in, and even interact with, them rather than reforming and rehabilitating—or in the case of prison staff or visitors, positively motivating—the occupants. In order to better understand this phenomenon, we turn our attention to non-carceral institutional spaces and the psychological, social, geographical, and design research that has been conducted in these environments to reveal spaces of marginalization and injustice.

Design-Build Research Techniques for Spatial Evaluation and Transformation

Beginning in the mid-twentieth century, ground-breaking research began on the environmental qualities and patient behavioural outcomes of a variety of institutional settings, focusing mainly on psychiatric facilities. During the 1970s and 80s, the ARC (Architecture-Research-Construction) Group in Ohio—comprised of architects/builders, social scientists, and researchers—was particularly instrumental in revealing the profound psychosocial effects that spatial and aesthetic characteristics of mental health facilities have on their patient occupants. Their work in a custodial ward of a mental hospital housing men described as "violent", "schizophrenic", and "chronic" or "severely regressed", demonstrated that many of the physical features and design qualities of the ward itself, directly contributed to the negative social behaviours and psychological affect of the patients (ARC, 1976; Bates, 2018). Using participatory mapping techniques (which will be discussed later) involving both patients and staff, the ARC Group was able to identify physical spaces—such as hallways, corridors, and locked/unused rooms—within the ward that facilitated negative behaviours and interactions such as excessive sleeping, extreme idleness, psychological withdrawal and isolation, aversion to social interaction and inter-patient fighting (ARC, 1976). Their approach to addressing these sociospatial problems was to first consider the ward as a neighbourhood. They proposed that spatial variation would be a key component to humanizing the monotonous and sterile environment in the facility: the environmental diversity that exists in a city should and could be replicated, or paralleled, within the mental health ward. The ward should contain "specific places, public to private, large to small, open to closed, active to quiet" that conceptually performed in the same way that the variety of spaces in an urban or suburban area do: "arenas, stores, streets, porches, houses and bedrooms"; additionally, it should be "open, accessible, visible and stimulating" (ARC, 1976, p. 27). The design interventions that they implemented included drastic changes to the physical setting of the ward including (1) seating for positive social interaction such as conversations and activities, (2) tables as controllable barriers allowing both positive communication

while protecting distance when needed, (3) community areas such as kitchens and laundry areas, for patients to develop social skills for life outside of the institution or to actively watch others participating in such activities, and (4) personal areas[1] for privacy and territory such as physical retreat or storage or personal belongings (ARC, 1976). These design responses saw decreased incidents of fighting, increased positive social interactions, an increase in engagement in activities and higher patient-resident perceptions of security and self-esteem. The ARC Group later conducted a similar research-design project in a psychiatric geriatric facility. In initially assessing the physical qualities of the facility, they determined that it was a "motel-like" environment: "fixed and static" with its residents as "passive consumers of a standardised product" (Bakos et al., 1980, p. 678). Conducting their research in a similarly participatory manner, they discovered that many physical spaces within the facility were not conducive to accommodating the various and critically essential personal needs—"for privacy and territory, for personalization, for communication, for opportunities for interaction, communication and stimulation, and for the opportunity to assume meaningful roles"— of its residents (Bakos et al., 1980, p. 678). Both the architectural and administrative/operational programming of this facility worked together to produce and reinforce such spaces of dehumanization and impersonalization. Patient interviews disclosed that many of the elderly residents were experiencing "a pervasive sense of dissatisfaction and loneliness and had a low concept of their self-worth" (p. 679) and observational mapping revealed that the day room—one of the largest communal spaces in the facility—was one of the primary physical areas responsible for this sense of despair. The analysis of this space illustrated that design/programming decisions such as the placement and arrangement of furniture and of the television contributed largely to the problem of inhibited meaningful interaction among residents. Several interventions

[1] Their research actually revealed that by providing each patients with "a territory of his own and a place to keep his personal possessions...each patient had a place to go to, to be alone or with a friend if he chose" and that this actually, and counterintuitively, led to increased *positive* inter-patient interaction. The main issue was that of having privacy control that is being able to choose when and with whom you interact: "when this choice is not available, the only option is to turn inward, to withdraw psychologically" (ARC, 1976, p. 28).

of the ARC Group included "rearranging existing furniture, constructing modular units and adding a kitchenette" (p. 680). Increasing visibility, visual stimulation, and social interaction were the overall themes for the redesign of this space. After these changes had been implemented, the researchers noted a gradual and persistent increase in patients' level of participation in community engagement, willingness to sit in closer proximity to one another, and a decrease in self-isolation (confining themselves to their bedrooms). This was particular noted among the patients who actively participated in the initial interviews and the design decision-making process (Bakos et al., 1980).

Many of the components used in the various design-build research projects conducted by the ARC group are ideal for a psychosocially critical evaluation of correctional environments. While some of their specific interventions may not be feasible for a correctional setting, many aspects of their redesign process can be replicated to produce place-specific spatial transformations that can improve the quality of life and social interactions of the inmates.

The benefits of critical participatory mapping to identify, problematize and correct physical spaces in institutional facilities has not only been demonstrated in custodial facilities. Research utilizing this methodology in educational environments has also shown the ability to determine particular spaces, places and physical design elements within schools that can facilitate negative student interactions such as bullying and peer harassment (Fram & Dickmann, 2012). There is a growing body of research that clearly indicates that violent and criminal activities tend to occur in undefined and unmonitored (or poorly monitored) spaces. The groundwork for systematically understanding this sociospatial occurrence was laid by the architect and urban planner Oscar Newman (1972) when he developed his *defensible space* theory. He noted, for example, that lobbies, stairwells, halls, and elevators tended to be spaces where criminal incidents were more likely to occur in urban residential areas. Researchers focused on school environments have found that acts of bullying and other forms of violence are most prevalent in specific poorly designed and unsupervised spaces in and around the school—the playground, hallways, lunchrooms, washrooms, corridors, stairways and hidden stairwells, entrances, vacant parking lots, dense foliage and other

nooks and crannies—making them highly unsafe spaces for students who are the targets of victimization (Kumar et al., 2008; Siann et al., 1993; Whitney & Smith, 1993). Researchers Fram and Dickmann (2012) sought to further explore how the built environment and physical characteristic of specific spaces contributed to school bullying in a suburban elementary school. Their methodology employed data collection that included staff and teacher surveys (of incidents of bullying and perceptions of safety), examination of school policy documents (on safety and bullying), and photographs of the exterior and interior spaces within the school. This triangulation approach enabled them to uncover "several themes relative to safety and surveillance" that "emerged as central to the interaction between the built environment and the users of the spaces, including movement, security, isolation, lighting, and forms of discipline" (p. 233). These themes were directly related to the physical properties (size, location, arrangement, condition, visibility, etc.) of spaces that facilitated negative interactions among students such as bullying and harassment or increased the potential for such adverse encounters to occur.

Again, the work of researchers like Fram and Dickmann and the ARC Group can serve as a blueprint for furthering a more comprehensive evaluation of prison environments. Interviewing, surveying, participatory mapping (with prisoners and guards), photography, and examining operational policy can all become part of a thorough analysis than can specify poorly designed and unsupervised spaces that compromise safety and enable negative interactions and experiences.

Non-inmate Spatial Experiences in Correctional Environments

Most people commonly understand institutional spaces in the context of the primary population which they serve or house: schools for students, hospitals for patients, prisons for inmates, etc. Nonetheless, the employees, visitors, and essentially all who interact with such institutional spaces, however brief or infrequent, often still have distinct perceptions of and experiences in these environments (Brown, 2018).

These spatial encounters have the potential to be either positive or negative and can directly influence the individual's understanding the space and of themselves in that space (Brown, 2019a). It is therefore critically important to understand how non-occupants and other users of and interactors with institutional spaces experiences these milieus.

Unfortunately, little research exists in the evaluation of institutional spaces that focuses the experiences of non-occupant or non-primary users. However, as academic fields such as environmental psychology and human geography continue to value and promote a more critical understanding of the perceptions and experiences of institutional landscapes, some work has been developed to comprehensively address how physical spaces and places can be exclusionary and marginalizing to the entire spectrum of populations who encounter them (Brown, 2018; Comfort, 2002; Moran, 2011). In my own research on perceptions of racialized architectural space, I conducted a quantitative visual study on how individuals (residents, students and workers) in the East Harlem, NY community, perceived various architectural spaces—representative of pre- or post-gentrification—in the neighbourhood as being associated with specific racial and ethnic groups and how they evaluated the social qualities of these spaces, positively or negatively (Brown, 2019b). Here, although the participants of the study merely viewed static images of these spaces, they demonstrated distinct sociospatial perceptions of the environments depicted in the photographs. My dissertation research employed a qualitative, visual, and in-situ approach to understanding how specific physical environmental cues contribute to the production of distinct sociospatial imaginaries of various spaces and places in gentrifying Central Harlem, NY. This project revealed that mere passers-by can develop a complex understanding of and relationship to physical environments, even in a matter of moments during a brief encounter with a specific landscape. Studies such as these are effective at demonstrating how anyone encountering or interacting with particular physical spaces, even if only briefly, not only have subjective perceptions of these spaces but can also have distinct experiences in such environments. Such an understanding readily lends itself to the notion that non-primary or

even non-secondary users of a space, can still develop valid and significant experiences that should be taken into consideration in the design, production, and evaluation of these environments (Brown, 2018).

Some critical work has been done that emphasizes the environmental perceptions and experiences of non-primary users of custodial spaces. The literature on visitors in correctional facilities describes how both supervisorial practices and policies as well as the physical qualities of the visitation spaces themselves can influence either positive or negative experiences among the friends and family of inmates. For example, research discussing positive visitor experiences in correctional institutions has consistently indicated that visitation spaces are perceived as pleasant when they contain aesthetics, amenities, and spatial features that parallel residential environments: such spaces help to create imaginaries of domestic or home-like atmospheres and allow for natural interaction between inmates and their visitors (Comfort, 2002; Moran, 2011). Participants in these studies noted that spatial diversity (such as separate areas for sleeping, eating, showering, etc.) interior decoration (such as furniture, artwork and plants), and the provision of amenities (such as kitchens and televisions) fostered a familiar and familial environment in which a sense of autonomy and self-efficacy was prevalent. Relatively speaking, the stays of visitors in such facilities are rather short—lasting several hours to a few days (for conjugal visits)—as compared to the inmates who are incarcerated for several months to many years. However, such reports lead one to ponder the psychosocial outcomes for prisoners themselves, if the daily spaces which they inhabit for such extended periods of time (in some cases, near permanently) were also able to incorporate elements of life on the outside. Might there be an increased sense of self-worth and self-actualization? Might there be an increase in positive social interactions and overall well-being (as was demonstrated in the aforementioned design research of the ARC Group in psychiatric facilities)?

On the contrary, previous research has also highlighted the ability of poorly designed and over-policed custodial visiting spaces to be further dehumanizing and disparaging to both inmates and visitors alike. Scholars refer to such milieus as "liminal carceral spaces" that distil a "secondary prisonization" upon their visitors (Comfort, 2003;

Moran 2011). Environmental and spatial factors that contributed to such perceptions of despair and demoralization include a variety of physical conditions—from being forced to visit incarcerated loved ones behind a plexiglass partition (with no physical contact) in short visit rooms to uncomfortable and unsanitary (e.g., lack of heat/hot water, rat and roach infestations, etc.) long visit facilities (Dixey & Woodall, 2012; Pallot, 2007; Ricordeau, 2012). Interestingly, the use of partitions and restriction of physical contact with visitors is often used as a form of punishment for inmates who have either violated guidelines on lewdness during previous visits or who have received misconduct infractions for behaviour within the prison in general (Ricordeau, 2012). In some correctional facilities, this level of restriction may be permanently reserved for inmates who are deemed particularly violent, serving life sentences, or are on death row (Reinhart, 2011).

While the presence of visitors can often, for the prisoner, "normalize the prison environment and function as a reminder of the outside world and its associated responsibilities", some friends and family members have reported increased emotional distress (anxiety, stress and worry) when seeing their loved one in an "unfamiliar and daunting" environment (Dixey & Woodall, 2012, p. 32). Such discomforts may then, in turn, be perceived by the inmates themselves so that they might not want their loved ones (especially children) to be psychologically damaged by such an antagonistic experience. The research of Dixey and Woodall (2012) suggests that these concerns might be especially prevalent when inmates perceive visitation spaces as being "designed exclusively for maintaining security, rather than for comfort or for creating some level of intimacy" (p. 37). In such cases, it was revealed that the administrative regulations combined with the physical design of these environments (e.g., chairs and tables being screwed to the floor) had a cumulative effect in producing negative perceptions and experiences during visits.

Conclusion

A wide range of sociospatial issues has been discussed in problematizing and assessing the environmental conditions of correctional (and other

institutional) spaces. A critical post-occupancy evaluation for the assessment and interventional redesign of custodial environments must be participatory. It must involve feedback from all relevant stakeholders, primarily the prisoners themselves, the staff, and visitors. In some cases, such as with urban jails, the feedback of community residents near the facility should also be of interests. As demonstrated with the Justice in Design competition, planning, urban design and architectural interventions are necessary for insuring innovative solutions that address the interstitial spaces between correctional facilities and surrounding urban communities. In fact, carceral design strategies that include positive community-engagement programming that also provides social benefits to individuals external to the criminal justice system, is a best approach for implementing more socially just correctional landscapes. Qualitative interviewing should be the first approach for gauging the perceptions of and experiences in custodial spaces by the primary groups that experience them regularly. The impressions of the inmates are generally the most pertinent because they are the ones confined to these prison environments for 24 hours a day. A critical and comprehensive approach should ask questions about the specific areas that induce feelings of isolation and despair: areas that cause negative mood states such as depression and loneliness, spaces where violence most frequently occurs (fights, attacks, etc.), overcrowding as issues of sociospatial distress and locations not conducive to positive inter-inmate and inmate-staff social interactions (Zimring, Munyon & Ard, 1988). Additionally, visitors' impressions of the environments in which they come into contact with their incarcerated loved ones are also essential to a comprehensive evaluation of correctional environments. For example, interrogating the experience of visitors by identifying the specific liminal spaces that they perceive as dehumanizing and reinforcing their own prisonization. These types of questions must be asked of the users and experiencers of correctional environments. Mapping and other forms of visual-spatial documentation are also fundamental analytic tools custodial environments. Such methods provide an ability to strategically identify problematic spaces with specificity (Blum & Secor, 2014). Annotated floorplans and footnoted photographs, for example, have all been used in the various research projects I have already summarized above and ultimately result

in a critical spatial analysis. As each correctional facility and every group of inmates will have their own unique qualities, characteristics and needs, the results of such a methodological approach will undoubtedly lead to varied evaluations that will, in turn, generate distinct recommendations for design interventions, spatial transformations and procedural changes. However, standardized baseline recommendations for humanizing carceral spaces may be surmised from the existing, although limited, body of work on the physical qualities of such custodial environments. For example, Shalev's (2008) research findings and recommendations regarding prison design and environmental factors proposes four principal considerations: (1) increased opportunities for positive social interaction, (2) spaces that enable the direct supervision of prisoners, (3) positive architecture that facilitates flexibility/adaptability, and (4) spaces that communicate a positive message via sensory stimulation.

Understandably there is an incredibly complex set of factors that must be taken into consideration when negotiating the most appropriate manners of creating carceral spaces that, for the general prison population first and foremost, are humane spaces of dignity that foster rehabilitation. A focus on surveillance and control alone ultimately fails to actually improve the lives of those whom the criminal justice system is charged with reforming, as is elucidated in the many scholarly criticisms of Jeremy Bentham's panopticon proposal (Foucault, 1977; Himmelfarb, 1965; Miller & Miller, 1987). It should be understood that due to the nature of the crimes and lack of remorse of certain inmates, the provision of carceral spaces of comfort and dignity remain highly contested topics, particularly by the families and loved ones of their victims. However, it should be equally noted that perpetrators of the most extreme violent crimes who also are remorseless or repeat offenders make up a relatively small percentage of the general prison population. The latest data from United States Federal Bureau of Prisons reports that only 14.1% of inmates in federal custody are being held for charges such as homicide, aggravated assault, kidnapping, or sexual offences (BOP Statistics: Inmate Offenses, 2020). Data on American state prisoners appears a bit bleaker with a combined total of 27.4% being sentenced for murder or rape/sexual assault (Carson, 2020). However, in neither federal nor state prisons, do the majority or even near majority of inmates constitute a

population of violent repeat offenders. When also taking into consideration the numerous local US jails that are holding countless innocent individuals or perpetrators of minor infractions, simply because of their inability to post bail, the need to transform the wide variety of carceral spaces—in the US and globally—becomes urgent. As prison abolitionist Dr. Ruth Wilson Gilmore—one of the world's foremost experts on the topic of carceral geography—emphasizes, "Where life is precious, [all] life *is* precious" (Kushner, 2019, par. 11). Gilmore argues the highly contentious position that prisons should not exist at all and that they should be systematically replaced with alternative forms of rehabilitation (Kushner, 2019). While this debate and its surrounding activism continues, what remains certain is that prisons that serve as organized forms of spatial violence are not the appropriate forms of social restitution and do little to benefit those detained or society at large (Binnall, 2008). After all, prisoners are still human beings too.

References

Alexander, M. (2020). *The New Jim Crow: Mass Incarceration in the Age of Colorblindness*. The New Press.

ARC (Architecture-Research-Construction). (1976). Behavioral change on ward 8: Physical elements and social interaction. *Journal of Architectural Education, 29*(4), 26–29.

Bakos, M., Bozic, R., Chapin, D., & Neuman, S. (1980). Effects of environmental changes on elderly residents' behavior. *Hospital & Community Psychiatry, 31*(10), 677–682.

Bates, V. (2018). 'Humanizing' healthcare environments: Architecture, art and design in modern hospitals. *Design for Health (Abingdon, England), 2*(1), 5–19. https://doi.org/10.1080/24735132.2018.1436304

Binnall, J. M. (2008). Respecting beasts: The dehumanizing quality of the modern prison and unusual model for penal reform. *Journal of Law and Policy, 17*, 161–190.

Binswanger, I. A., Stern, M. F., Deyo, R. A., Heagerty, P. J., Cheadle, A., Elmore, J. G., & Koepsell, T. D. (2007). Release from prison—A high risk

of death for former inmates. *The New England Journal of Medicine, 356*(2), 157–165. https://doi.org/10.1056/NEJMsa064115

Blake, E. (2015). *Murky death of Sandra Bland points to possible police lynching* [online] Wsws.org. https://www.wsws.org/en/articles/2015/07/17/poli-j17.html. Accessed 14 August 2020.

Blum, V., & Secor, A. J. (2014). Mapping trauma: Topography to topology. In P. Kingsbury & S. Pile (Eds.), *Psychoanalytic geographies* (pp. 103–116). Ashgate.

Bop.gov. (2020). *BOP statistics: Inmate offenses* [online]. https://www.bop.gov/about/statistics/statistics_inmate_offenses.jsp. Accessed 21 August 2020.

Bordass, W., & Leaman, A. (2005). Making feedback and post-occupancy evaluation routine 3: Case studies of the use of techniques in the feedback portfolio. *Building Research and Information, 33*(4), 361–375.

Brakel, S. (1988). Prison management, private enterprise style: The inmates' evaluation. *New England Journal of Criminal and Civil Confinement, 14*, 175–244.

Brown, T. L. (2018). A critical assessment of the place of post-occupancy evaluation in the critique and creation of socially responsible architecture. *Intelligent Buildings International, 10*(3), 182–193.

Brown, T. L. (2019a). Racialized architectural space: A critical understanding of its production, perception and evaluation. *Architecture_MPS, 15*(3), 1–34.

Brown, T. L. (2019b, May). The perception of racialized architectural space as a predictor for architectural meanings and attributes: An East Harlem study. In A. Beth (Ed.), *Environmental Design Research Association (EDRA50) Conference: Sustainable urban environments* [online]. University of Minnesota Press. Brooklyn, NY. https://cuny.manifoldapp.org/read/the-perception-of-racialized-architectural-space. Accessed 17 August 2020.

Calvin, A., & Schuppe, J. (2015). *Sandra Bland's family's lawyer details Dashcam video of traffic stop* [online]. NBC News. https://www.nbcnews.com/news/us-news/sandra-bland-familys-lawyer-details-dashcam-footage-her-arrest-n395126. Accessed 15 August 2020.

Carson, E. (2020). *Prisoners in 2018*. Bureau of Justice Statistics NCJ 253516 [online]. US Department of Justice. https://www.bjs.gov/content/pub/pdf/p18.pdf. Accessed 21 August 2020.

Cohen, S., & Eckert, N. (2019). *AP investigation: Many US jails fail to stop inmate suicides* [online]. NBC 5 Dallas-Fort Worth. https://www.nbcdfw.com/news/local/ap-investigation-many-us-jails-fail-to-stop-inmate-suicides/232912/. Accessed 14 August 2020.

Comfort, M. (2002). 'Papa's House': The prison as domestic and social satellite. *Ethnography, 3*(4), 467–499.

Comfort, M. (2003). In the tube at San Quentin: The "secondary prisonization" of women visiting inmates. *Journal of Contemporary Ethnography, 32*(1), 77–107.

Cooper, I. (2001). Post-occupancy evaluation—where are you? *Building Research & Information, 29*(2), 158–163. https://doi.org/10.1080/096132 10010016820.

Correctional News. (2015). *Door & window design solutions improve security, efficiency—Correctional news* [online]. https://correctionalnews.com/2015/12/30/door-window-design-solutions-improve-security-efficiency/. Accessed 26 July 2021.

Dixey, R., & Woodall, J. (2012). The significance of 'the visit' in an English category-B prison: Views from prisoners, prisoners' families and prison staff. *Community, Work & Family, 15*(1), 29–47.

Foucault, M. (1977). *Discipline and punish: The birth of the prison*. Pantheon Books.

Fram, S., & Dickmann, E. (2012). How the school built environment exacerbates bullying and peer harassment. *Children, Youth and Environments, 22*(1), 227–249.

Gallagher, D., Tehrani, N., Gottesfeld, S., Kubey, K., Opotow, S., & Mooney, J. (2017). *Justice in design* [online]. Van Alen Institute and The Independent Commission for New York City Criminal Justice and Incarceration Reform. https://www.vanalen.org/content/uploads/2017/07/Justice-in-Design-Report.pdf. Accessed 19 August 2020.

Garland, D. (2013). Penality and the penal state. *Criminology, 51*(3), 475–517.

Glum, J. (2015). *Kalief Browder protest at Rikers draws dozens of police officers, prison reform advocates* [online]. International Business Times. https://www.ibtimes.com/kalief-browder-protest-rikers-draws-dozens-police-officers-prison-reform-advocates-1986895. Accessed 13 July 2021.

Gonnerman, J. (2014). Before the law [online]. *The New Yorker*. https://www.newyorker.com/magazine/2014/10/06/before-the-law. Accessed 15 August 2020.

Graczyk, M., & Stengle, J. (2015). *Experts: Report shows Sandra Bland may have used pot in jail* [online]. The Seattle Times. https://www.seattletimes.com/nation-world/experts-report-shows-sandra-bland-may-have-used-pot-in-jail/. Accessed 15 August 2020.

Grassian, S. (1983). Psychopathological effects of solitary confinement. *American Journal of Psychiatry, 140*(11), 1450–1454.

Grassian, S., & Friedman, N. (1986). Effects of sensory deprivation in psychiatric seclusion and solitary confinement. *International Journal of Law and Psychiatry, 8*(1), 49–65.

Grassian, S. (2006). Psychiatric effects of solitary confinement. *Washington University Journal of Law & Policy, 22*(24), 325–383.

Haglund, A., Tidemalm, D., Jokinen, J., Långström, N., Lichtenstein, P., Fazel, S., & Runeson, B. (2014). Suicide after release from prison: A population-based cohort study from Sweden. *The Journal of Clinical Psychiatry, 75*(10), 1047–1053. https://doi.org/10.4088/JCP.13m08967

Haney, C. (2018). The psychological effects of solitary confinement: A systematic critique. *Crime and Justice, 47*(1), 365–416.

Himmelfarb, G. (1965). The Haunted House of Jeremy Bentham. In R. Herr & H. Parker (Eds.), *Ideas in history: Essays presented to Louis Gottschalk by his former students* (pp. 32–81). Duke University Press.

Huey, M. (2008). *Deprivation, importation and prison suicide: The combined effects of institutional conditions and inmate composition*. The University of Georgia.

Izadi, E., & Phillip, A. (2015). Sandra Bland previously attempted suicide, jail documents say [online]. *The Washington Post*. https://www.washingtonpost.com/news/morning-mix/wp/2015/07/22/documents-sandra-bland-previously-attempted-suicide-felt-very-depressed-on-day-of-arrest/. Accessed 15 August 2020.

Johncox, C. (2020). *Inmate dies from suicide at Oakland county jail* [online]. WDIV. https://www.clickondetroit.com/news/local/2020/04/12/inmate-commits-suicide-at-oakland-county-jail/. Accessed 14 August 2020.

Keneally, M. (2015). *Sandra Bland's death probe being treated like a murder investigation, DA says* [online]. ABC News. https://abcnews.go.com/US/sandra-bland-supporters-call-independent-investigation/story?id=32572897. Accessed 15 August 2020.

Keyser, J., & Graczyk, M. (2015). *Friend: Sandra Bland "In good spirits' before jail death* [online]. AP News. https://apnews.com/f0dff63b60cc4593821efe63cfe84c44. Accessed 14 August 2020.

Kumar, R., O'Malley, P., & Johnston, L. (2008). Association between physical environment of secondary schools and student problem behavior. *Environment and Behavior, 40*(4), 455–486.

Kushner, R. (2019). *Is prison necessary? Ruth Wilson Gilmore might change your mind* [online]. Nytimes.com. https://www.nytimes.com/2019/04/17/magazine/prison-abolition-ruth-wilson-gilmore.html. Accessed 21 August 2020.

Lai, K., Park, H., Buchanan, L., & Andrews, W. (2015). *Assessing the legality of Sandra Bland's arrest* [online]. Nytimes.com. https://www.nytimes.com/interactive/2015/07/20/us/sandra-bland-arrest-death-videos-maps.html. Accessed 15 August 2020.

Liebling, A. (1999). Doing research in prison: Breaking the silence? *Theoretical Criminology, 3*(2), 147–173.

Logan, C. (1991). Well kept: Comparing quality of confinement in private and public prisons. *The Journal of Criminal Law and Criminology, 83*(3), 577–613.

Malacrida, C. (2005). Discipline and dehumanization in a total institution: Institutional survivors' descriptions of time-out rooms. *Disability & Society, 20*(5), 523–537.

Malacrida, C. (2012). Bodily practices as vehicles for dehumanization in an institution for mental defectives. *Societies, 2*(4), 286–301.

Miller, J., & Miller, R. (1987). Jeremy Bentham's panoptic device. *October, 41*, 3–29.

Moran, D. (2011). Between outside and inside? Prison visiting rooms as liminal carceral spaces. *GeoJournal, 78*(2), 339–351.

Newman, O. (1972). *Defensible space: Crime prevention through urban design*. Macmillan.

Ogle, M. (2019). *The role of race and ethnicity in determining solitary confinement experiences in juvenile detention facilities*. Ph.D dissertation. Florida State University.

Pallot, J. (2007). 'Gde Muzh, Tarn Zhena' (Where the husband is, so is the wife): Space and gender in post-soviet patterns of penality. *Environment and Planning A: Economy and Space, 39*(3), 570–589.

Pope, L., & Delaney-Brumsey, A. (2016). *Creating a culture of safety.* Sentinel event reviews for suicide and self-harm in correctional facilities [online]. Vera Institute of Justice. https://www.vera.org/publication_downloads/culture-of-safety-sentinel-event-suicide-self-harm-correctional-facilities/culture-of-safety.pdf. Accessed 14 August 2020.

Preiser, W. (1995). Post-occupancy evaluation: How to make buildings work better. *Facilities, 13*(11), 19–28.

Preiser, W., & Nasar, J. (2008). Assessing building performance: Its evolution from post-occupancy evaluation. *Archnet-IJAR, International Journal of Architectural Research, 2*(1), 84–99.

Preiser, W., & Vischer, J. (2005). *Assessing building performance*. Elseiver Publishers and Butterworth Heinemann.

Reinhart, C. (2011). *Prison conditions for death row and life without parole inmates* (OLR Research Report 2011-R-0178) [online]. Connecticut Office of Legislative Research. https://www.cga.ct.gov/2011/rpt/2011-R-0178.htm. Accessed 17 August 2020.

Ricordeau, G. (2012). Between inside and outside: Prison visiting rooms. *Politix* [online]. *97*(1), 101–123. https://www.cairn-int.info/article-E_POX_097_0101--between-inside-and-outside-prison.htm. Accessed 17 August 2020.

Riley, M., Moody, C., & Pitt, M. (2009). *A review of the evolution of post-occupancy evaluation as a viable performance measurement tool*. BEAN Conference. (2009). BEST Research Centre (Built Environment & Sustainable Technologies). Liverpool John Moores University.

Sarat, A. (2020). *Who is responsible when an inmate dies by suicide?* [online]. The Conversation. https://theconversation.com/who-is-responsible-when-an-inmate-dies-by-suicide-121967. Accessed 14 August 2020.

Shalev, S. (2008). *A sourcebook on solitary confinement*. Mannheim Centre for Criminology, London School of Economics.

Siann, G., Callaghan, M., Lockhart, R., & Rawson, L. (1993). Bullying: Teachers' views and school effects. *Educational Studies, 19*(3), 307–321.

The Official Website of the City of New York. (2019). *Roadmap to closing rikers: De Blasio administration to close two jails next year* [online]. https://www1.nyc.gov/office-of-the-mayor/news/562-19/roadmap-closing-rikers-de-blasio-administration-close-two-jails-next-year. Accessed 13 July 2021.

Time: The Kalief Browder Story. (2017). [film] Directed by J. Furst. Bronx. Roc Nation; The Weinstein Company.

Van Alen Institute. (2017). *Justice in design* [online]. https://www.vanalen.org/projects/justice-in-design/. Accessed 14 July 2021.

Vera Institute of Justice. (2016). *Creating a culture of safety*. Sentinel event reviews for suicide and self-harm in correctional facilities. [online]. Vera Institute of Justice. https://www.vera.org/publication_downloads/culture-of-safety-sentinel-event-suicide-self-harm-correctional-facilities/culture-of-safety.pdf. Accessed 14 August 2020.

Whitney, I., & Smith, P. (1993). A survey of the nature and extent of bullying in junior/middle and secondary schools. *Educational Research, 35*(1), 3–25.

Zeisel, J. (1984). *Inquiry by design: Tools for environment-behavior research*. CUP Archive.

Zimring, C., Munyon, W., & Ard, L. (1988). Reducing stress in jail. *Ekistics, 55*(331/332), 215–229. Retrieved August 14, 2020, from www.jstor.org/stable/43623041

12

Towards a Dignified Design: O-T-I, S-L-S, and Experience in Carceral Space

Kwan-Lamar Blount-Hill

I began writing this chapter in mid-October 2020. At that time, New York City—the largest municipality by population in the United States—held over 4,300 individuals in physical custody within its local jails (New York City Board of Correction, 2020).[1] Notably, this was after a dramatic reduction in response to the worldwide outbreak of

[1] The United States has two primary categories of facilities for penological custody: "Jails" hold individuals awaiting adjudication but likely to abscond, individuals serving carceral sentences of under one year, and individuals whose trials have concluded but who await transfer to a prison. "Prisons" house those with sentences longer than one year. Typically, jails are controlled by local jurisdictions while prisons are controlled by state or national authorities.

K.-L. Blount-Hill (✉)
Arizona State University, Phoenix, AZ, USA
e-mail: kbh@asu.edu

SARS-CoV-2.[2] Early on, the pandemic disproportionately impacted those housed in the close quarters of places like the City's "notorious" Rikers Island jail facilities (Moghe, 2020), forcing the emergency release of hundreds of detainees. Since then, the held population has increased to its pre-pandemic number of over 5,000 (NYCBOC, 2020, 2021), a population total achieved only after years of policy reforms halved the City's average daily jail population (ADP) from that recorded less than five years ago (New York State Division of Criminal Justice Services, 2020). Each net increase in detention distances this City, with its estimated population of 8 million plus (United States Census Bureau, n.d.), further from the per capita imprisonment rate of other Global North/Western nations. On this comparison, it nonetheless fares favourably against the incarceration rate across New York State and the United States in general, each of which dwarfs that of similar nations (Prison Policy Initiative, n.d.). Upwards of 2 million American residents can expect to spend time in a jail or prison facility each year (Maruschak & Minton, 2020), not including those held in juvenile and immigration detention centres, civilly committed on criminal charges, or otherwise detained (Wagner & Sawyer, 2018).[3] New York City has embarked on a programme of carceral reform in recent years, accelerated in response to a (hopefully) once-in-a-lifetime pandemic; nonetheless,

[2] SARS-CoV-2 is one of many coronaviruses, each distinguished by crown-like formations of spikes seen when under microscopic view (Centers for Disease Control and Prevention, 2020a). It was only discovered in 2019, in Wuhan, China, hence "the novel coronavirus." It was officially named SARS-CoV-2 by the International Committee on Taxonomy of Viruses, because this particular coronavirus (i.e. "CoV") causes a form of severe acute respiratory syndrome and is related, but distinct from, the coronavirus that caused the 2003 SARS outbreak (hence "2," the second) (World Health Organization, 2022). Once contracted, its co-occurring conditions (i.e. syndrome) include fever, chills, coughing, shortness of breath or difficulty breathing, fatigue, aching, loss of taste or smell, sore throat, congestion or runny nose, nausea or vomiting, diarrhoea (Centers for Disease Control and Prevention, 2020b). This disease (i.e. the "dis" "ease" of experiencing this syndrome) was officially named "COVID-19" by the World Health Organization on February 11, 2020b (Centers for Disease Control and Prevention, 2020b; COVID stands for *coronavirus disease*). An infected person typically experiences one, several, or none of these (i.e. is "asymptomatic"). Even in the case where symptoms are lacking, the virus is extremely contagious, making the close quarters of a jail or prison a veritable petri dish.

[3] I use "American" to reference those associated with the United States. Though conforming to widespread use, I acknowledge that the Americas are comprised of two continents, North and South, and that the United States occupies only one piece of one of these.

over 5,000 people will sleep tonight in a custodial facility.[4] Whether or not one pines for a world without jails or prisons, I would urge some attention to the conditions in which individuals now dwell while waiting for this abolitionist promise. For those who believe the loss of liberty is punishment enough, I highlight what the pandemic has only brought more clearly to light, namely, that the setting to which one is confined can, separate from the punishment of restraint, sentence one additionally to risk of harm or death. Even if one believes that harsh and unhealthy custodial conditions are a viable punishment for a crime—earned torture—this rationale cannot justify the same for the two-thirds of those held in jails who are not yet convicted (Zeng, 2020) and are thus presumed entirely innocent by the American system of laws and international norms of justice. Whatever one's position, there remains an unavoidable truth: A society that incarcerates is dutybound to ensure humane conditions of confinement for those in its custody and to preserve their human dignity.

Conditions of confinement are heavily determined by the structure of the place in which one is confined, the maintenance of that place, its setting, its affordances, and how it impacts the others sharing that environment (St. John & Blount-Hill, 2018). The foundational nature of architecture for carceral life is demonstrated in the attention given it by criminologists. Early works on prison administration centred on the design of custodial facilities; Bentham's (1787, 2011) writing on panoptic prison design is a classic example. Traditionally, the criminological gaze has focused on "problems" from the perspective of justice administrators (Kitossa, 2012), and work on custodial design is no different. Accordingly, myriad studies examine new design models (e.g., Tartaro, 2002) and the impact of design on desistance from crime (e.g., Applegate et al., 1999), custodial violence (e.g., Porporino, 1986) and mass disorder (Montgomery & Crews, 1998), detainee injury (e.g., St. John et al., 2022), relationships between detainees and correctional officers (e.g., Beijersbergen et al., 2016), etcetera. These studies reflect an intention for custodial design to support the priorities of the criminal

[4] Here and throughout, I use the common British and European parlance of "custodial" over "correctional" as an adjective for carceral places.

legal system and the society it serves. They are physical manifestations of our beliefs about punishment and crime.

Prison sociology has more explicitly connected society to jail and prison construction as reflective of larger values. Sociologist Norman Johnston, *the* authoritative voice on the history of custodial architecture, notes that prisons have been in existence for thousands of years, shifting in form and function in response to societies beliefs about punishment and redemption (Johnston, 2009). In short, "Buildings embody societal meaning" (St. John & Blount-Hill, 2019, p. 46). Prison sociologists document how evolving mores around crime and punishment—and paradigms of managerial public administration—have been translated into prison designs (e.g., Hancock & Jewkes, 2011), as well as how those design theories have migrated across jurisdictional boundaries (Grant & Jewkes, 2015). Reviewing custodial architecture more historically and holistically has led to a greater focus on how it is experienced (Jewkes, 2018). Taken together, these bodies of work emphasize that, while the accused or convicted may leave our sight when tucked away in a custodial facility, they live daily in environments ostensibly constructed in response to our wishes. Custodial architecture is therefore not only important because it influences whether administrators are able to meet prioritized criminal legal system benchmarks, but also because it consigns the imprisoned to a particular range of possible experiences. Custodial architecture, then, is a physical and experiential statement on societies' moral norms regarding what justice is and what justice demands.

In this chapter, I review two recent efforts at embedding moral choices into comprehensive correctional design frameworks. In 2018, St. John and Blount-Hill wrote a piece for the American Correctional Association in *Corrections Today* applying to custodial facilities the open, transparent, and inclusive (OTI) design framework previously developed for police stations (Blount-Hill et al., 2017). OTI design is a thinking process meant to lead to designed "welcomeness" (or "welcomingness"), "the quality of a building's architectural and aesthetic design, maintenance, and locational settings that invite users to enter and remain there comfortably" (Headley et al., 2021, p. 2). In their work, St. John and Blount-Hill recognized that "comfort" may not be an appropriate goal of custodial design, but that facilities "can be designed to respect

human dignity, enhance perceptions of fairness and facilitate substantive justice" (2018, p. 29). Still, in a series of articles in 2019, they presented an alternative conceptualization of custodial design meant to enhance rehabilitative outcomes for detainees—the space-layout-setting (SLS) framework (St. John & Blount-Hill, 2019; St. John et al., 2019). St. John and colleagues argued that the extent of three-dimensional area an individual has access to (spatial capacity), its placement in relation to other items and places of importance both geographically (spatial location) and architecturally (layout), and its impact on the senses and general ambience (setting) would either inhibit or promote the goals of rehabilitative services such as education or counselling. These physical aspects of design were thought to influence the physical and psychological dispositions of those detained, for example, agitating, depressing, or distracting them from focusing on prosocial ends.[5]

Here, I argue that OTI and SLS are complementary frameworks for rethinking how custodial space may bring about not only a more prosocial outcome for those who are incarcerated but also engender a less harmful symbolic and subjective experience. From this view, I put forward the beginnings of a conceptual, theoretical, and moral philosophy I call "dignified design." To be *dignified* is to convey seriousness of manner, restraint, or caution, to have the quality or state of being worthy or honourable (Dignified, 2021; Dignity, 2022). While today such words may seem ill-suited in reference to places that cage human beings, I argue places constructed to house individuals during periods of legal liminality or rehabilitation and social restoration *must* embody dignity. Custodial design *might*, if rethought, reflect the secular sanctity of trial and punishment processes while maintaining the human dignity of the person held and the moral integrity of the society doing the holding. Whereas OTI focuses attention on the symbolic message of a place and SLS concerns that place's suitability for human growth and development, convergence in dignified design emphasizes how symbols themselves render physical and psychological harm through, among other things, degrading dignity.

[5] Here, "prosocial" refers to behaviour that supports and reifies social norms collectively believed to assure public, relational, and individual welfare.

To emphasize this point, I review a set of seventy-seven interviews with individuals who have had experience with local justice systems in the cities of Newark, New Jersey, and Cleveland, Ohio, in the United States. Any presentation of qualitative science must provide its readers with a clear statement of the researcher's purpose, epistemological stance, and criteria justifying transferability. Here, instead of generating theory from interview data inductively, I rely on analyses of these transcripts to illustrate important theoretical points arrived at a priori and applied through deduction. The transcripts constitute secondary data; therefore, the guiding question is not, "What are the principles of dignified custodial space derived from interviewees?" as this was not in the minds of the original researchers and thus was pursued neither in-depth nor evenly enough across the sample to provide a rigorous answer. Instead, the following sections proceed as follows: I present St. John and Blount-Hill's (2018) OTI custodial design framework alongside St. John et al.'s (2019) SLS framework, identify the shared "problem" of custodial design these frameworks address by implication and illustrated in words and themes from these seventy-seven interviews, and finally borrow from both frameworks and extant literature to arrive at unitary themes of dignified custodial design. One contribution of this work is qualitative generalization (Levitt, 2021) through identifying the nonvarying aspects in how carceral space may be experienced in similar places across personal narrative, life history, maturation phase, and historical moment.

Overlapping Openness, Transparency, Inclusivity, Space, Layout, and Sense with Dignity

Defining *justice* is a monumental task of philosophical province, though one way we might describe it is as *the fulfilment of legitimate expectation to which the individual is entitled* (Hay, 1995). Talk of entitlement conjures discussion of rights and reference to reasonableness brings considerations of relativity and shared perception. These simultaneously complicate and clarify what is meant, then, by justice and its relationship to dignity.

Dignity is a human right, the recognition of which is considered just and the violation of which is often perceived as unjust.[6] Justice is itself dignified, that is, a value deserving of due consideration, and its associated processes are equally dignified. As best I understand it, the notion of justice interacts with dignity in a circular fashion, as maintaining one's own dignity through the act of recognizing the dignity of another is an instantiation of justice, while the enactment of justice confers dignity on the actor, the acted upon, and the act. I speak of this reciprocal relationship as defined by (a) dignity-leading-to-justice and (b) justice-leading-to-dignity. However, dignified acts or enactments of justice are themselves defined by several aspects including (i) what is *done* by the actor to the acted upon and (ii) how that doing is interpreted by both actor and those impacted by the act. The architectural design frameworks proposed by St. John and Blount-Hill (2018) and St. John et al. (2019) emphasize different quadrants of this two-by-two understanding but help to elucidate how it can be applied to characterize the meaning of dignity for design.

Blount-Hill et al.'s (2017) original work in architectural design theory posited that police buildings could generate goodwill and positive affect towards police organizations if designed to be open, transparent, and inclusive (OTI) for the public.[7] They referred to this general quality as *welcomeness*, defined as the quality of conveying that one belongs. Blount-Hill et al. (2017) put forward basic principles by which a building's welcomeness might be enhanced at several stages and aspects of design. St. John and Blount-Hill (2018) then adapted this perspective to the custodial setting. Humans are concerned not only with just *outcomes* but also with *symbolic justice*, the extent to which behaviour upholds or violates shared norms and expectations, reaffirming or undermining our social status or self-concept (Goode & Smith, 2016; Okimoto &

[6] Equal dignity is among the first rights granted in the Universal Declaration of Human Rights (United Nations, n.d.).

[7] Often erroneously conflated with "emotion," affect is instead a positive or negative psychological state (i.e., mood) elicited when focused on another entity (Adey, 2008; Estrada et al., 1994). No universally accepted definition of affect exists, though it is described as more lasting than "emotion." Emotions are short-term mental states, comprised of various combinations along arousal and pleasure scales (Dazkir & Read, 2012).

Wenzel, 2008). Reframing the goals of OTI design, St. John and Blount-Hill hypothesized that custodial facilities "designed to respect human dignity" could "enhance perceptions of fairness and facilitate substantive justice" (St. John & Blount-Hill, 2018, p. 29). In other words, they suggested that dignity leads to justice through how dignified "acts"—in this case, the construction of a justice-related building with an eye to maintain human dignity—engender interpretations of justness and fairness. Of course, St. John and Blount-Hill's (2018) emphasis on the conveyed meaning of custodial places touches only one mechanism by which dignity and justice impact on detainees.

In later work, St. John and Blount-Hill (2019) write that "Justice involves both symbolic performance and objective outcome" (p. 48). St. John and colleagues (2019) used self-narratives to explore how design contributes, or detracts from, just outcomes. Explicitly embracing a rehabilitative purpose in custodial practice—in which the goal is to prepare detainees for eventual release—the researchers presented an evaluative framework by which custodial administrators could determine the conduciveness of their facilities to rehabilitation. "In recognizing the limits of rehabilitative efforts in debilitative settings," the authors wrote, "one cannot divorce counterproductive behaviours, attitudes, and perceptions from the counterproductive physical spaces in which those behaviours, attitudes, and perceptions occur" (St. John et al., 2019, p. 749). As such, they encouraged facility designers and administrators to consider space, layout, and setting (SLS) as experienced by the detained occupant. St. John and Blount-Hill (2019) connected this framework explicitly to substantive justice concerns. Originating in human geography, spatial justice is variably defined (Philippopoulos-Mihalopoulos, 2010; van Wyk, 2015), though St. John and Blount-Hill define it to include "the just situation of places across geography" (2019, p. 48). "Placial" justice (or *place-based justice*) is defined as "the ethical use of a … building's design to enhance the sense of justice by its impact on … attitudes, behaviors, and interactions" (St. John & Blount-Hill, 2019, p. 48).[8] The word "dignity" does not appear anywhere in their text.

[8] This definition of "placial justice" represents a terminological evolution in St. John and Blount-Hill's work. Earlier, they had encompassed the concept within the notion of spatial justice:

Nevertheless, especially in highlighting the disparate impact of incarceration on race and ethnic minorities, I read St. John and Blount-Hill as supporting the idea that the enactment of justice by custodial administrators can recognize and enhance detainees' dignity, at least in part, through enhancing both the quality of their carceral experience and their ability to grow and develop.

It should come as no surprise that the aspects of architecture important for symbolic justice overlap those important for substantive justice. St. John and Blount-Hill's (2018) framework, based on the earlier work by Blount-Hill et al. (2017), emphasizes symbolic justice, while St. John et al.'s (2019) emphasizes the facilitation of treatment. Symbols often correlate with substance; in fact, that is why symbols have power. Understanding this, I attempt to better integrate the two for a more holistic understanding of the potential for a dignified design as part of a just architecture.

A *Dignified* Design? Setting the Stage to Explore Dignity in Custodial Buildings

To call a design "dignified" is to insinuate that the resultant construction itself is "worthy of respect." In conservational language, the evoked feeling "respect" is often used referring to its most positive denotation, that is, "high or special regard" or esteem (Respect, 2021). Given the purpose of custodial design, it is strange to admire and hold positive affect for jails or prisons. However, the meanings of respect also include an understanding that something is important and should be handled and approached with care and due consideration. The person or thing accorded such respect may not inspire love yet requires thought and

"A spatial justice perspective considers how space can be designed to respect human dignity, enhance perceptions of fairness and facilitate substantive justice" (St. John & Blount-Hill, 2018, p. 29). Understanding spatial justice this way departed from traditional spatial justice theorists within human geography. For example, Soja (2009: 2) defines spatial justice as "fair and equitable distribution in space of socially valued resources and the opportunities to use them." The use of placial justice was developed to avoid confusion and to focus on place rather than space.

attention. Given the purpose of custodial design, it is strange *not* to devote thoughtfulness and attention, care, and due consideration to its manifestations. Therefore, in my conception, a dignified architectural design for a custodial space reflects the gravity of the decision to restrain a human's freedom; conveys the severity of the charged offence and its negative consequences for an ordered society; encourages the guilty to reflect on and process remorse; facilitates rehabilitation and/or preparation for eventual restoration to, and participation in, the community; mitigates the harm of isolation; and communicates the sanctity of the criminal legal process. In a sentence, a dignified custodial design signals its relation to a serious, sombre, virtuous process. In American Protestant ethos, the separation, dishonour, repentance, and redemption meant to occur in prison hearkens to the holy parable of the Prodigal Son and its lessons on penitence and correction (O'Hear, 2014).[9] At present, sceptics of whether carceral designs can ever be "dignified" are well-supported in their cynicism, perhaps especially in the context of the United States. Abundant evidence suggests that few—if any!—American custodial facilities are accurately described as dignified.

In 2016, the Center for Court Innovation (CCI, a criminal justice research centre based in New York City) obtained funding from the United States Bureau of Justice Administration to conduct a study of procedural justice (or the lack thereof) as perceived by individuals who had experienced the criminal justice systems of Newark, New Jersey, and

[9] This refers to the story told in the Biblical verses of Luke 15: 11–24:

> A certain man had two sons. And the younger of them said to his father, 'Father, give me the portion of goods that falls to me' …. Not many days after, the younger son gathered all together, journeyed to a far country, and there wasted his possessions with prodigal living. But when he had spent all, there arose a severe famine in that land, and he began to be in want. But when he came to himself, he said, 'How many of my father's hired servants have bread enough and to spare, and I perish with hunger! And he arose and came to his father. But when he was still a great way off, his father saw him and had compassion, and ran and fell on his neck and kissed him. And the son said to him, 'Father, I have sinned against heaven and in your sight, and am no longer worthy to be called your son.' But the father said to his servants, 'Bring out the best robe and put *it* on him and put a ring on his hand and sandals on *his* feet. And bring the fatted calf here and kill *it and* let us eat and be merry; for this my son was dead and is alive again; he was lost and is found'. (BibleGateway, 2020)

Cleveland, Ohio. The study was comprised of two parts, one which gathered survey responses from 800 individuals and a second consisting of 101 interviews with a similar, independent but not mutually exclusive, sample. Procedural justice is defined as "the perception that the processes used to make and enforce a decision or rule are fair and just (Trinkner & Cohn, 2014, p. 603). It is critical in socialization and for social cohesion, as "the nature of the interactions between individuals and legal authorities are responsible for the internalization of law-related norms and the development of positive orientations toward authority" (Trinkner & Cohn, 2014, p. 603). Shared notions of justice, Tyler (2012) explains, help individuals accept outcomes counter to short-term self-interest so long as they result from common rules for "getting what they deserve" (p. 358). Accordingly, CCI's surveys and interviews elicited responses from participants regarding the fairness and justness of processes used in their respective cities to detect crime, determine guilt, and enforce punishment. The overall study's findings are reported and published by Swaner and colleagues (2018), where fuller descriptions of the methods used are also presented.

Because I had been part of the original team of research assistants that conducted the study in Newark, I was permitted to review these interviews as a secondary data source. I have drawn on them in previous works (Blount-Hill, 2020, 2021). I was provided with two data files, one containing aggregate descriptive statistics of interview sample demographics and another containing the full transcribed text of the interviews or interviewers' notes. Of the 101 interviewees, nine were not transcribed verbatim. These were excluded from my review because interviewer notes do not recount interviewees' descriptions of carceral space with sufficient detail. Of the remaining ninety-two, most had been incarcerated, ranging from two days to twenty years, and all but fifteen gave some description of correctional space. Predominantly males of colour of lower socioeconomic status, the interviewees were reflective of populations disproportionately incarcerated in the American justice system. While the experience of incarceration is never pleasant, it is notable that several individuals seemed to acknowledge deserving punishment while complaining of the conditions of confinement: "I understand it's a punishment …. [B]ut, I mean, damn, have some

consideration" (interviewee, Takisha, pseudonym). In assessing overarching sentiment, I found these testimonies to largely indict the municipal jails and state prisons spoken of as less than dignified. Reflecting on these descriptions of *un*dignified design, I respond with the beginnings of a framework for correcting the course.

A Geographic Lens: Building Placement Within a Dignified Design Framework

To maintain human dignity, *custodial facilities should be placed in a geographic space best suited to support the legitimate aims of punishment.* Of those interviewed about facilities in Newark and Cleveland, five noted a concern with the geographic location of the facility where they were housed. Jeffrey was housed "an hour and a half" from his neighbourhood, while Jamar was kept two hours away. Aiden described his placement as "a long way" from home.[10] When asked "how far was the last prison from where you live?" Adalberto noted that only one prison was close to his hometown of Newark and he was not lucky enough to be placed there. "Everything is down south," he added. "I don't get visits because I don't have family that is close," said Jamere.

St. John and Blount-Hill's (2018) open, transparent, and inclusive (OTI) design framework for custodial spaces focuses custodial administrators' attention in something of a temporally linear fashion (accepting, of course, that design processes are usually anything but). The first step in designing a place using OTI is to consider where it will be sited, in other words, identifying the geographic location where it is to be built. Similarly, under the SLS framework, location is defined as "the physical placement of a correctional facility and its proximity to other important objects," and this is noted as an influential factor in a custodial facility's ability to be a place of rehabilitation (St. John et al., 2019, p. 751). Siting a custodial facility to maximize justice requires consideration of closeness

[10] At the time of the interview, interviewees assigned themselves a pseudonym. However, not all of these were captured in transcripts or recordings. I have assigned unique pseudonyms to all interviewees. In addition, light editing has been done for some quotations for clarity.

(distance from the detainee's important social supports) and reachability (outside of distance, the ability of detainees' social networks to access the site) (Blount-Hill et al., 2017; St. John & Blount-Hill, 2018). Just siting of custodial facilities requires they be placed in a geographic space best suited to maintain detainees' wellbeing, support their restorative and rehabilitative activities, employee morale, visitors and occupants' access, and without significantly reducing the quality of life of the surrounding community. This includes placing facilities close to important social networks and supportive services and away from odious conditions or corrupting influences. Such a facility dignifies the justice process by limiting punishment and harm to loss of liberty, providing avenues for a return to society if possible, and protecting non-detained individuals interacting with the space from undeserved harm.

There is a significant body of literature supporting the connection between positive experiences and outcomes for those detained in custodial places and their distance from loved ones, social services, and legal assistance. The maintenance of intimate connections can be critical for the healthy functioning of the incarcerated person, as illustrated in St. John et al. (2019):

> Ethnographer D recounted an instance in which facility location played a role in an incarcerated person's behavior: He was placed on suicide watch after swallowing a bar of soap. When we spoke about the root of the behavior, it was because his parental visitations kept getting rescheduled and canceled. A follow up was conducted with the parent, to find out that the location of the facility made it difficult for her to travel there (p. 760).

Moreover, staff members' agitation over long commutes may translate into the treatment of detainees.

Students of architecture may wonder why geographic placement of a building should be given such prominence in an architectural design process. Yet, scholars at the intersection of architecture and geography note the bidirectional influence of space and place on how each are perceived and experienced. A dim-coloured jail cell may be oppressive depending on how often the detainee remains there for longer stretches

without family visitation because of long distances. Tight spaces become more claustrophobia-inducing for those anxiously awaiting a talk with their lawyer, impacted by the dis-ease of unreachability. Visitation rooms conjure memories of joy but also tension when loved ones long separated are agitated by the circumstances of an arduous journey. A custodial building's placement can support or obstruct human connection, a decisional act with implications for justice that may inform how detainees interpret recognition or dismissal of their dignity and set the framing for the whole of their subjective experience of the place's architecture. On the other hand, foregrounding preservation of dignity in the siting decision provides a foundation for dignified and just design through the remainder of the design process.

Space Within Place: Assuring Adequate Capacity as a Consideration of Dignity

To maintain human dignity, *custodial facilities should provide secure private spaces for detainees and opportunities to safely move about*. This includes considering how space impedes or facilitates optimal occupant-officer ratios and areas that support the free but secure movement by visitors and non-detained occupants. Sixty-seven of the interviewees (approximately 80%) complained about their respective institutions' lack of capacity to humanely house those committed to it or to provide them with opportunities.

St. John et al. (2019) summarize capacity as "the maximum number of individuals that can be accommodated without compromising facility performance" (p. 750). Boxes are stacked; living creatures should not be. Placing individuals in spaces that were not made for them gives the impression of commodification, that their being contained is more important than their being prepared for re-entry into society. Lee says:

> You guys just want money. 2,300 [people held] and you only [have the space to] hold 21 [hundred people]? Our county jail holds 18 [hundred], and there's been times 19 [hunded], 2,000 people? Where are all of these cases coming from? What do you guys want from us?

Interviewees complained often about being confined to spaces with more humans than was intended. "It's a one-man cell. They got one man on the floor and one man on the bed," complained Jamir, "definitely crammed," added Mackenzie. Isabella's housing with another impacted her sense of safety: "There's this big box with two cells in it and there's another person in there. This lady shook. I thought she was going to tweak out on me." Lack of privacy was also a major concern implicating prison design. "Everybody is watching you. It's so … you feel so exposed," Ayana complained. In separate interviews, Uzoma almost directly quoted Ajani's description of using the restrooms: "People looking over there, where you can't even use the bathroom in peace." Tinaye described the experience as "what they call a zoo, wild animals." Overcrowding is a persistent concern in custodial settings (Ghiorzo & Blount-Hill, 2018), though I argue that facilities should not only hold no more than they were designed to, but they must also be designed to provide their occupants the capacity to maintain dignity.

Interviewees highlighted that not only were spaces overfilled, but also opportunities to leave those spaces were limited. Amari testified, "I was in a cell the whole time. Went out to another cell to use the phone and back to my cell." Administrators' knowledge that freedom of movement is needed, even if necessarily constrained by the terms of punishment, was evident in their use of evermore restrictiveness as a form of punishment. When asked what happened when rules were not adhered to, Demarcus explained, "You get locked down in your cell," which Zy'aire later describes as "A part of hell…. They feed you three times a day, but you can't come out to walk around, general exercise, anything like that." Jamir recounted one story:

> I got sat in my room once with this corny dude [a guard]…. He said, "No hanging." I was drying my boxers on the windowsill. Didn't have nowhere for them to hang. "Oh, you got something on the windowsill. Got to take that down." As soon as I take them down, I'm walking to the door, he slammed the door in my face. "Oh, you're about to be in your room for the rest of the day." "For what?" "You're not supposed to have nothing hanging in the window" …. It was petty stuff like that.

Often enough being "locked down" was imposed even outside the fault of individual detainees. "If one person do something and they don't know who that person is that done it, they will punish everybody. They have to lock the whole place down. That happens a lot and I think they use it too much," Montrell explained. Michael further explicated:

> You get what they call 'red zoned.' It's where, like, an employee, a CO [correctional officer], don't show up to work and then they lock you down. I was locked down for, like, seven days straight with no shower.... They do take you to the basketball court. They're supposed to take you, I think, four or five times a week. Sometimes, you'll go a month without going at all. You don't go outside. There's nothing. You're basically walking in circles all day.... They need to build a new [jail]. There's people in there for traffic tickets that got to deal with that. They need to, like, make one-man cells one-man cells, not throw somebody on the floor.

As service providers, St. John et al. (2019) also emphasized how space considerations can interrupt the ability of a facility to fulfil its rehabilitative purpose: "Space constraints have led to inmates sitting on tables, fighting over seats, and throwing chairs, which makes for a tense environment. Facility managers have responded by bolting furniture to the ground, which has done nothing to reduce overcrowding" (p. 759). The practice of overcrowded facilities extended from early on in the justice system process, including police facilities for temporarily holding individuals upon arrest, before their appearance in court, and, thus, before any guilt had been determined. As Jafari put it, "If fifty people get locked up that night, all fifty of y'all going to be in that room for like two, three days. Sleeping on the floor, everything. We stayed in there on that floor for, like, three days." The SLS framework incorporates *capacity* as a spatial consideration, which OTI addresses as a part of facility *maintenance*. The discrepancy reveals something of a chicken-and-egg problem in that dignified spatial use requires both that a facility be designed to provide adequate space for those anticipated to occupy it and that, post-construction, facilities hold no more than they were built to house.

Rehabilitative Places: Mitigating Harm, Facilitating Growth Through Dignified Design

To maintain human dignity, *custodial facilities should be designed to support processes of reflection, rehabilitation, and re-entry into society post-sentence, while mitigating harm and degradation during incarceration.* Justice requires that custodial buildings provide the material and environmental affordances needed to support, and not hamper, detainees' basic life, restorative and rehabilitative activities, officers' security functions, providers' service provision, and occupants' legitimate goals in visiting. When building designers fail to design with buildings' functions in mind, occupant experience will suffer. Twenty-nine of the interviewees related that the design and layouts of their institutions were unsupportive of rehabilitation. This came primarily in the form of complaints about lack of access to the outside. For example, Jafari complained about the air quality: "They [jailors] got rec[reation] on the tier and they got little things where air come through …. It's the worst." "They need to let you get some fresh air a little bit," Michael added. Julian emphasized that, in his facility, sunlight did not penetrate its concrete custodial walls: "There's no windows or anything like that. You know, you get no sun." Xoan explained, "There's a little sliver of window and you can't even see out of it. It's not clear, so you could just see the green and you could see blue…. Like when they say that 'He's going to jail, he's not going to see the light of day,' yeah, it's true." Individuals who brought up this aspect of incarceration had a uniformly negative impression of their stay in prison.

According to restorative environment theory, natural spaces can be used to improve mood, focus, psychological engagement, connectedness, and stress management through *restoration*, "renewal of intrapersonal resources" (Honold et al., 2016, p. 797). Liberty can be curtailed without separating the individual from natural experience. Capacity speaks to the issue of a facility's overall structural design. According to Blount-Hill et al.'s (2017) OTI framework, structural design encapsulates functionality (supporting the function it was built to house), legibility (design coherency and intuitiveness, including ease of identifying access points and of navigation), and security (stability and protective capacity).

Blount-Hill et al. also argue for *social facility*, structural affordance that promotes socialization over isolation. St. John and Blount-Hill (2018) adapt these concepts to custodial settings, arguing for socially facilitative designs that encourage prosocial interactions between detainees, detainee-to-officer, between officers, and between these populations and other occupants, including visiting families and friends. Similarly, the SLS framework directs designer attention to *layout*, "the arrangement of its constituent structures within its defined spatial parameters" (St. John et al., 2019, p. 752). The full menu of potential design features cannot all be here listed and, even if they could, their usefulness would not apply equally or consistently across all spaces. In the abstract, facilities that approximate these design principles dignify justice system processes by affirming the purpose of state custody, to deny freedom—and only freedom—for a time as a punishment or to ensure court appearance or public safety, and to do so safely and securely with anticipation of occupants' eventual, deserved return to outside society.

A Dignified Design, If You Can Keep It: Custodial Maintenance and Its Essentiality for Dignity

To maintain human dignity, *custodial facilities must incorporate a balance of solemnity and habitability which recognized basic rights to hygiene and peace of mind*. Building siting and design are but brief moments in the lifecycle of custodial facilities; a dignified facility may only be so if consistent work is undertaken to upkeep its quality into the future. This includes attention to the operability of its machinery and technology and the cleanliness of its spaces. Twenty-six interviewees complained about uncleanliness and maintenance within custodial facilities, while twenty-six also complained about the general correctional ambience (sixteen of which overlapped). "I wish it would be cleaner," DeAnthony noted. "I know this ain't going to be like no hotel or anything like that because you're a criminal. I mean, for health reasons …. [Y]ou want to make sure you don't catch anything." Jamir reported "boils, bumps, people getting

bit" by bedbugs. Interviewees attributed this lack of cleanliness to intentional disregard for their human dignity. "Now, dude takes a shit, smears it all over the walls, then it's not occupied for three, four months. Who's gonna clean it? They're not gonna clean it. They don't care," Alexander said. Amrit notes, "People come in and just defecate all over the place, piss all over the place. [Correctional officers] were on the outside. They were on the outside, we're caged in. They don't give a fuck about what's going on."

In terms of décor and interior design, Reagan described her bed as "the hard rock slab," and Michael recounted the following:

> When they first took me in the pod from intake, there was no mattress to put on the floor. The CO wouldn't give me a mat. He waited all day until night, and he comes with a mat that's got no stuffing in it. Somebody pulled all the stuffing out, so now I got to lay on a piece of [cloth] just to cover the floor. There's no padding in it. I got into a confrontation with him, and he told me, "You don't like it, you up to the 10th floor and go to the hold [administrative segregation]."

Despite ostensibly housing individuals to "correct" their prior misbehaviour in aim to release them back into society eventually, custodial facilities missed even basic opportunities to normalize the lives contained in their walls. Sultan was confused by this:

> The toilet didn't have a seat. I was trying to figure out how was I supposed to use it. I've never used a toilet without a seat before, so I was, like, was I just supposed to hover? I didn't know what to do. I was like, "I'm not about to sit on that. Everything falls on that." Me and my bunkie were playing a game of hold-it, who can hold it the longest. We lucked up and finally got a cool corrections officer to give us some cleaning products. At least I kniew I had cleaned it before we attempted any type of anything. But it was weird using the toilet bowl with no top. I had never had that before.

Under the concept of *setting*, the SLS framework emphasizes the sensory perception of occupants in space as important to the justness of their experience there. I define *perception* as "physical sensation interpreted

in light of experience," and map this aspect of SLS to OTI's focus on *aesthetic*/interior *design* and *maintenance* as a part of what I am calling *ambience* (i.e., the mood or character of a place). Graham et al. (2015) suggest that environments regulate moods through "visual (e.g., via items of decor), auditory (e.g., via music played on the stereo), tactile (e.g., via the materials used in furniture), olfactory (e.g., via fragrances emitted by candles), ambient (e.g., via the temperature and humidity), and social (e.g., by arranging a space to induce social interactions) channels" (p. 353). Previous discussions emanating from the OTI framework's emphasis on aesthetics tended to emphasize vision as the primary sense (Blount-Hill et al., 2017; Headley et al., 2021), but, in explicating SLS, St. John and Blount-Hill (2019) recognize the importance of others. Buildings send messages not just in how they are built but through how they are kept. One of the ethnographers among St. John et al. (2019) illustrated the symbolic import of building maintenance in the following story:

> There was a major fight between the inmates. Correctional officers got hurt, I saw an inmate get sprayed with pepper spray and continue to fight outside the classroom we were assigned ... a kid stood there bleeding, screaming about his eyes ... the next day we were placed in the same area and the dried up blood was visible. I asked an officer about it and was told that it was left there to send a message. (p. 762)

Message received. Takisha concedes, "I understand you have to be punished for the things you do." Yet she retorts, "Even though we do wrong as human beings, though we make mistakes as human beings, I don't think we should suffer that way either." In her recommendations for improvements to the justice system, Paisley draws directly on the idea of human dignity for her inspiration to reform custodial facilities:

> I understand it's punishment. They're already being punished, being away from their family for years, and they've got to sleep on a hard bench.... Being away from my son, just being in there was killing me. Then being uncomfortable was killing me. I'm dealing with two adversaries at the same time. [Regarding how the facility should be:] Not luxury, but humane.

Conclusion

In this chapter, I advance a goal of a *dignified design* of custodial spaces—design that conveys the solemnity of the justice process and preserves its moral sanctity. To building designers falls the task of deciding how that building should cause people to behave (e.g., adapting to survival challenges, utilizing affordances) and the meaning people should derive from their experience. This may be especially true for builders of places designed to house justice system processes (i.e., justice buildings), with added moral and ethical connotations, concerned, as they are, with "right" and "wrong" (for extended discussions, see Moran et al., 2016, 2019). More especially, "Correctional facilities play an important role within the criminal justice system, not just as a destination of last resort, but as the apex of state control and starkest example of how a government views its citizens" (St. John & Blount-Hill, 2018, p. 29).

Seventy-seven voices joined with mine to convey the importance of custodial design built to enhance substantive and symbolic justice. St. John and Blount-Hill (2018, 2019) attempted to outline ways for designers to consider justice throughout their design process and at multiple angles, speaking both to the system's instrumental needs and desired behavioural outcomes and to the system's purported ethical and moral foundations. My goal was to distil from their practical suggestions and general principles. Ultimately, I put forward *dignified design* as a theory, or at least philosophical framing, for designers to more fully account for what buildings "say" as they communicate in signs, symbols, affordances, and constraints. Given the sanctity of the justice process and matters of justice, crime, and punishment, custodial buildings reflect not only societies' collective voices but also our collective souls.

References

Adey, P. (2008). Airports, mobility and the calculative architecture of affective control. *Geoforum, 39*, 438–451.

Applegate, B. K., Surette, R., & McCarthy, B. J. (1999). Detention and desistance from crime: Evaluating the influence of a new generation jail on recidivism. *Journal of Criminal Justice, 27*(6), 539–548.

Beijersbergen, K. A., Dirkzwager, A. J. E., van der Laan, P. H., & Nieuwbeerta, P. (2016). A social building? Prison architecture and staff-prisoner relationships. *Crime & Delinquency, 62*(7), 843–874.

Bentham, J. (2011). *The panopticon writings (radical thinkers)* (M. Bozovic, Ed.). Verso (Work originally published 1787).

BibleGateway. (2020). *Luke 15.* Retrieved December 14, 2021, https://www.biblegateway.com/passage/?search=Luke%2015&version=NKJV

Blount-Hill, K. (2020). *Spheres of identity: Theorizing social categorization and the legitimacy of criminal justice officials.* CUNY Academic Works. https://academicworks.cuny.edu/gc_etds/4010

Blount-Hill, K. (2021). Building a social identity theory of shared narrative: Insights from resident stories of police contact in Newark, New Jersey, and Cleveland, Ohio. *Criminal Justice and Behavior, 48*(6), 810–827.

Blount-Hill, K., St. John, V. J., & Ryan, E. (2017, March). Psychology of space: Enhancing legitimacy through open, transparent, and inclusive facilities for police and the public. *The Police Chief.* International Association of Chiefs of Police.

Centers for Disease Control and Prevention. (2020a, February 15). *Coronavirus.* CDC. https://www.cdc.gov/coronavirus/types.html

Centers for Disease Control and Prevention. (2020b, May 13). *Symptoms of coronavirus.* Coronavirus Disease 2019 (COVID-19). https://www.cdc.gov/coronavirus/2019-ncov/symptoms-testing/symptoms.html

Dazkir, S. S., & Read, M. A. (2012). Furniture forms and their influence on our emotional responses toward interior environments. *Environment and Behavior, 44*(5), 722–734.

Dignified. (2021). In *Merriam Webster dictionary.* Retrieved December 14, 2021, https://www.merriam-webster.com/dictionary/dignified.

Dignity. (2022). In *Merriam Webster Dictionary.* Retrieved September 11, 2022, https://www.merriam-webster.com/dictionary/dignity.

Estrada, C. A., Isen, A. M., & Young, M. J. (1994). Positive affect improves creative problem solving and influences reported source of practice satisfaction in physicians. *Motivation and Emotion, 18*(4), 285–299.

Ghiorzo, J. C., & Blount-Hill, K. (2018). Overcrowding. In V. B. Worley & R. M. Worley (Eds.), *American prisons and jails: An encyclopedia of controversies and trends, vol. 2* (pp. 425–427). ABC-CLIO.

Goode, C., & Smith, H. J. (2016). Retribution or restoration: Symbolic justice concerns shape how victim group members react to intergroup transgressions. *Current Opinion in Psychology, 11*, 105–109.

Graham, L. T., Gosling, S. D., & Travis, C. K. (2015). The psychology of home environments: A call for research on residential space. *Perspectives on Psychological Science, 10*(3), 346–356.

Grant, E., & Jewkes, Y. (2015). Finally fit for purpose: The evolution of Australian prison architecture. *The Prison Journal, 95*(2), 223–243.

Hancock, P., & Jewkes, Y. (2011). Architectures in incarceration: The spatial pains of imprisonment. *Punishment & Society, 13*(5), 611–629.

Hay, A. M. (1995). Concepts of equity, fairness and justice in geographical studies. *Transactions of the Institute of British Geographers, 20*(4), 500–508.

Headley, A. M., Blount-Hill, K., & St. John, V. J. (2021). The psychology of justice buildings: A survey experiment on police architecture, public sentiment, and race. *Journal of Criminal Justice, 73*, 101747.

Honold, J., Lakes, T., Beyer, R., & van der Meer, E. (2016). Restoration in urban spaces: Nature views from home, greenways, and public parks. *Environment and Behavior, 48*(6), 796–825.

Jewkes, Y. (2018). Just design: Healthy prisons and the architecture of hope. *Australian & New Zealand Journal of Criminology, 51*(3), 319–338.

Johnston, N. (2009). Evolving function: Early use of imprisonment as punishment. *The Prison Journal, 89*(1), 10s–34s.

Kitossa, T. (2012). Criminology and colonialism: Counter colonial criminology and the Canadian context. *The Journal of Pan African Studies, 4*(10), 204–226.

Levitt, H. M. (2021). Qualitative generalization, not to the population but to the phenomenon: Reconceptualizing variation in qualitative research. *Qualitative Psychology, 8*, 95–110.

Maruschak, L. M., & Minton, T. D. (2020). *Correctional populations in the United States, 2017-2018*. U.S. Department of Justice, Office of Justice Programs, Bureau of Justice Statistics. https://bjs.ojp.gov/content/pub/pdf/cpus1718.pdf.

Moghe, S. (2020, May 18). *Inside New York's notorious Rikers Island jails, 'the epicenter of the epicenter' of the coronavirus pandemic*. CNN. https://www.cnn.com/2020/05/16/us/rikers-coronavirus/index.html

Montgomery, R. H., & Crews, G. A. (1998). *History of correctional violence: An examination of reported causes of riots and disturbances*. American Correctional Association.

Moran, D., Jewkes, Y., & Lorne, C. (2019). Designing for imprisonment: Architectural ethics and prison design. *Architectural Philosophy, 4*(1), 67–82.

Moran, D., Turner, J., & Jewkes, Y. (2016). Becoming big things: Building events and the architectural geographies of incarceration in England and Wales. *Transactions of the Institute of British Geographers, 41*(4), 416–428.

New York City Board of Correction. (2020). *Weekly COVID-19 update, week of September 26-October 2, 2020.* https://www1.nyc.gov/assets/boc/downloads/pdf/covid-19/BOC-Weekly-Report-9-26-10-2-20.pdf

New York City Board of Correction. (2021). *Weekly COVID-19 update, week of November 27-December 3, 2021.* https://www1.nyc.gov/assets/boc/downloads/pdf/covid-19/BOC-Weekly-Report-11-27-12-03-21.pdf

New York State Division of Criminal Justice Services. (2020). *New York state jail population.* https://www.criminaljustice.ny.gov/crimnet/ojsa/jail_pop_y.pdf

O'Hear, M. (2014). Good conduct time for prisoners: Why (and how) Wisconsin should provide credits toward early release. *Marquette Law Review, 98*, 487–553.

Okimoto, T. G., & Wenzel, M. (2008). The symbolic meaning transgressions: Toward a unifying framework of justice restoration. In K. A. Hegtvedt & J. Clay-Warner (Eds.), *Justice (Advances in Group Processes, Vol. 25)* (pp. 291–326). Emerald Group Publishing Limited.

Philippopoulos-Mihalopoulos, A. (2010). Spatial justice: Law and the geography of withdrawal. *International Journal of Law in Context, 6*(3), 201–216.

Porporino, F. J. (1986). Managing violent individuals in correctional settings. *Journal of Interpersonal Violence, 1*(2), 213–237.

Prison Policy Initiative. (n.d.). *New York profile.* State profiles. https://www.prisonpolicy.org/profiles/NY.html

Respect. (2021). In *Merriam Webster dictionary.* Retrieved December 14, 2021, https://www.merriam-webster.com/dictionary/respect

Soja, E. (2009). The city and spatial justice. *Justice Spatiale/Spatial Justice, 1*(1), 1–5.

St. John, V. J., & Blount-Hill, K. (2018, July). Spatial justice: Legitimacy through openness, transparency and inclusiveness in correctional design. *Corrections Today.* American Correctional Association.

St. John, V. J., & Blount-Hill, K. (2019). Place, space, race, and life during and after incarceration: Dismantling mass incarceration through spatial and placial justice. *Harvard Kennedy School Journal of African American Policy, 2018–19*, 46–54.

St. John, V. J., Blount-Hill, K., Evans, D. N., Ayers, D., & Allard, S. (2019). Architecture and correctional services: A facilities approach to treatment. *The Prison Journal, 99*(6), 748–770.

St. John, V. J., Blount-Hill, K., Mufarreh, A., & Lutgen-Nieves, L. (2022). Safe by design: An exploration of jail-based injury across New York City. *Journal of Correctional Health Care, 28*(3), 179–189.

Swaner, R., Ramdath, C., Martinez, A., Hahn, J., & Walker, S. (2018). *What do defendants really think? Procedural justice and legitimacy in the criminal justice system.* Center for Court Innovation.

Tartaro, C. (2002). Examining implementation issues with new generation jails. *Criminal Justice Policy Review, 13*(3), 219–237.

Trinkner, R., & Cohn, E. S. (2014). Putting the social back in legal socialization: Procedural justice, legitimacy, and cynicism in legal and nonlegal authorities. *Law and Human Behavior, 38*(6), 602.

Tyler, T. R. (2012). Justice and effective cooperation. *Social Justice Research, 25*, 355–375.

United Nations. (n.d.). *Universal Declaration of Human Rights.* Retrieved December 14, 2021, https://www.un.org/en/about-us/universal-declaration-of-human-rights.

United States Census Bureau. (n.d.). *New York city, New York.* QuickFacts. https://www.census.gov/quickfacts/newyorkcitynewyork.

Van Wyk, J. (2015). Can legislative intervention achieve spatial justice? *The Comparative and International Law Journal of Southern Africa, 48*(3), 381–400.

Wagner, P., & Sawyer, W. (2018). *States of incarceration: The global context 2018.* Prison Policy Initiative. https://www.prisonpolicy.org/global/2018.html#methodology

World Health Organization. (2022). Naming the coronavirus disease (COVID-19) and the virus that causes it. Retrieved September 11, 2022 https://www.who.int/emergencies/diseases/novel-coronavirus-2019/technicalguidance/naming-the-coronavirus-disease-(covid-2019)-and-the-virus-that-causes-it.

Zeng, Z. (2020). *Jail inmates in 2018.* Bureau of Justice Statistics, United States Department of Justice. https://www.bjs.gov/content/pub/pdf/ji18.pdf

13

A Model for the Design of Youth Custodial Facilities: Key Characteristics to Promote Effective Treatment

Matthew Dwyer and Sanne Oostermeijer

Introduction

At the core of youth justice systems, internationally, is the principle of acting in the best interests of the child (UN General Assembly, 1989, Article 3.1). This is realised to varying degrees through a breadth of different approaches and might be argued to exist largely in rhetoric within some jurisdictions. However, this explicit focus on the interests of the child provides a context in which the aspects of custodial design that support a resident's wellbeing must be fully explored and realised. Rehabilitation sits within this definition, as reducing the risk of reoffending is

M. Dwyer
Local Time, VIC, Australia

S. Oostermeijer (✉)
Melbourne School of Population and Global Health, University of Melbourne, Melbourne, Australia
e-mail: sanne.oostermeijer@unimelb.edu.au

beneficial for long-term wellbeing of both the child and society at large. While youth justice systems are founded upon this idea of wellbeing, without a clear characterisation of what this means for the design of a youth custodial facility, it becomes difficult to evaluate and learn from the designs of other jurisdictions and more likely that the mistakes of past designs are repeated.

This chapter proposes a method for characterising youth custodial facilities across jurisdictions, regimes, and cohorts, with the objective of providing well evidenced and concrete guidance for the design of youth custodial facilities.

A strong evidence-base demonstrates what works in rehabilitative interventions for justice-involved young people. By establishing the design implications which follow from this literature, a series of key characteristics emerge that define a best-practice, theoretical design model for a facility; small-scale, locally sited, and integrated with the surrounding community, designed to promote relational and differentiated security, and comprising therapeutic design characteristics. We then consider these characteristics in operation by examining facilities in three well-regarded European jurisdictions (Spain, Norway, the Netherlands). We explore the extent to which, and how the key design characteristics were operationalised in the different jurisdictions and discuss how they impacted upon the ability to provide for the approaches identified as important in the literature.

The model aims to make clear that certain design decisions (i.e., these characteristics) affect the ability to provide treatment elements that are known to be effective. It also aims to show how these characteristics are related to one another. Further, the model provides a means by which different precedent facilities can be seen to be similar (or dissimilar), which provides a basis for further research.

'What Works' for Justice-Involved Young People

There is a strong evidence-base to demonstrate what works in rehabilitative interventions for justice-involved young people. It is possible to

interpret implications for the design of custodial facilities that will either promote or impede these practices and approaches. In this way, a theoretical model can be defined: a best-possible design response for youth custodial facilities based on the available scientific literature for effective treatment. This model can then be used as a means of characterising a facility within its specific context.

The model presented here is based upon offending-specific literature and incorporates a social-ecology background. Using social-ecology as a framework provides a structure to identify important youth developmental supports that are applicable, not only to justice-involved young people, but to young people generally. In this way, the model does not consider the design of the facility in isolation, but rather within the broader social, cultural, and political context in which it is located. We begin by briefly outlining the theoretical background that underpins the model, including literature that discusses effective approaches for addressing offending behaviours and literature that identifies health-sustaining resources important for regaining, sustaining, or improving wellbeing in young people.

Addressing Offending Behaviours

The prevailing focus of youth justice research and practices has been on addressing offending behaviours directly and managing the associated risk of reoffending. Evidence from multiple, meta-analytical studies show that interventions grounded in a therapeutic approach are most successful, as opposed to solely punitive or deterrent techniques (e.g., sanction and supervision) which are ineffective in reducing recidivism, with some of these approaches potentially increasing the risk of future reoffending (e.g., youth boot camps) (Koehler et al., 2013; Lipsey & Cullen, 2007; MacKenzie, 2016; Wartna et al., 2013). Specifically, cognitive behavioural programs and 'Risk-Need-Responsivity appropriate' interventions have been shown to produce the strongest effects in reducing reoffending in youth (Koehler et al., 2013). Risk-Need-Responsivity appropriate interventions refers to interventions that correspond to the risk level of reoffending (i.e., risk), address dynamic risk

factors or 'criminogenic needs' (i.e., need), and match to the learning styles and capabilities of the young person (i.e., responsivity).

In the last two decades there has been a movement towards more strength-based approaches, leading to the consideration of protective factors which moderate or buffer the adverse effects of dynamic risk factors related to (re)offending behaviours (Lodewijks et al., 2009; Serin et al., 2015; Vogel et al., 2011). Strong social support (i.e., receiving support from at least one peer or adult in times of need and distress) and a close relationship with at least one prosocial adult (i.e., attachment) have been related to reduced offending in justice-involved young people in various settings (pre-trial, detention and pre-release) (Lodewijks et al., 2009). Other protective factors include strong commitment to school or work, prosocial friends, and positive attitudes towards treatment and authority (Lodewijks et al., 2009; Lösel & Farrington, 2012).

Despite the shift towards the consideration and inclusion of protective factors involved in (re)offending behaviours, these approaches still operate within a prevailing risk-based paradigm. They tend to be overly focused on young people's deficits and problems, resulting in an oversimplified approach, which doesn't recognise the historical, cultural, and social context of a young person's development (Johns et al., 2016; Robinson, 2015). In doing so, they fail to recognise the context, interactions, and relationships within which offending behaviours develop, persist, and are perpetuated. Rather, effective youth justice work should focus on building a trusting relationship over time, (re)building positive social interactions, fostering a young person's strengths and interests, and ultimately developing a young person's positive identity and sense of self (Johns et al., 2016). This aligns with the obligation for youth justice systems to focus on the wellbeing of the child.

In a custodial setting, the institutional climate is an important factor in the treatment of justice-involved young people which can be understood as the shared perceptions of the custodial environment (Souverein et al., 2013; Van der Helm et al., 2014). In particular, a positive and therapeutic climate provides support, facilitates personal growth, and allows flexibility in the balance between care and control. Positive custodial environments have been associated with higher treatment motivation,

lower aggression, and victimisation, and fewer mental health symptoms experienced by young people in detention (Gonçalves et al., 2016; Kupchik & Snyder, 2009; Van der Helm et al., 2012, 2014). Overall, a positive institutional climate is likely to help improve outcomes for incarcerated young people and lower the risk of reoffending (Auty & Liebling, 2020; Harding, 2014). Furthermore, in an institutional setting, staff's relationship with residents, and their knowledge and understanding of individual residents, contributes to providing a safe and secure environment (i.e., relational security) (Tighe & Gudjonsson, 2012).

Social-Ecological Approach

Further building on the need to recognise the historical, cultural and social context of a young person's development, the youth justice system may greatly benefit from adopting a social-ecological approach (Johns et al., 2016; Robinson, 2015). Such an approach encompasses a focus on the individual and also recognises the wider contexts, systems, interactions, and relationships that play a significant role in the development of the individual and their wellbeing. In doing so, it becomes evident that a young person's offending behaviour is deeply intertwined with the relationships and interactions between their environment of family, peers, school and community, as well as the broader societal, cultural and political systems they find themselves in (Bottrell et al., 2010; Johns et al., 2016).

It is well understood that justice-involved young people often come from socially disadvantaged backgrounds, are often victims of crime and experience a wide-range of mental health problems (Borschmann et al., 2020; Casiano et al., 2013; Hughes et al., 2020). As such, an understanding of what promotes wellbeing and healthy functioning despite such adversity, and how this is nurtured and maintained, is a crucial consideration for those young people. Health-sustaining resources to regain, sustain, or improve wellbeing may include family and peer support, educational opportunities, recreational and cultural programs, and mental health care (Robinson, 2015; Rowe & Soppitt, 2014; Ungar, 2008, 2013). Both the capacity of young people and their family systems

to access these resources, as well as the capacity of their family, schools, communities, service providers, and government legislators to provide these, plays an important role in the positive development of young people (Shulman, 2016; Tollit et al., 2015; Ungar, 2008). For example, involvement in school and work has shown to be an important factor for justice-involved young people and their desistance from offending (Stouthamer-Loeber et al., 2004). This involves both their own and their family's ability to navigate and negotiate the school system, as well as the schools ability to provide an accessible and supportive environment (Ungar, 2008). Identifying, providing, and strengthening meaningful health-sustaining resources should be a core element for service providers and institutions interacting with justice-involved young people, as well as those in charge of service provision (Johns et al., 2016; Robinson, 2015; Rowe & Soppitt, 2014).

To conclude, the offence-specific literature supports a focus on therapeutic, tailored approaches that build and strengthen positive youth development, social support networks, and commitment to school or work. Supportive social relationships and interactions within one's environments and context are further highlighted by a social-ecological approach. This appears as a key aspect, relating to different systems including family and carers, peers, school or work, community, service providers, and society at large. In a custodial setting, establishing a safe and positive institutional climate plays a prominent role in the treatment of justice-involved young people, which involves supportive relationships with facility staff. Given this, we must carefully consider how facility design might provide such an environment and how it affects a young person's access to health-sustaining resources.

A Design Model for Youth Custodial Facilities

To establish the theoretical design model, we considered the above elements of effective treatment approaches as a 'brief' for the design of a youth custody facility. A design brief forms the very beginning of the design process and is considered to be a major contributing factor to a successful outcome in carceral architecture (Fairweather &

McConville, 2000). We sought to identify key design characteristics that promote those tailored approaches and supportive and positive relationships identified above, while minimising aspects that act as an impediment. We found that these design characteristics were collected under four key characteristics: small-scale, locally sited, and integrated with the surrounding community, designed to promote relational and differentiated security, and comprising therapeutic design characteristics. We briefly outline these characteristics and current evidence below.

Small-Scale

In the context of adult facilities, the evidence described by Liebling (2008) indicates that smaller prisons are better able to provide a tailored and relational approach. Smaller prisons in Norway, defined as less than 50 beds, were described to have a better quality of life ratings (including staff-detainee relationships, wellbeing, personal safety, and family contact) from both staff and detainees. Furthermore, Liebling describes another evaluation of small Norwegian prisons that showed greater transparency and staff knowledge of individual detainees. This evaluation also concluded that smaller prisons were more flexible and dynamic organisations, facilitating a more tailored approach.

Little research has been conducted on the effect of size specifically in relation to youth custodial facilities. Since it has been demonstrated that youth have more complex care needs compared to adult detainees (van Dooren et al., 2010, 2013), it might be expected that small-scale facilities will have similar, if not greater, positive effects for youth.

Specific to the needs of young people, we can gather some indication by looking at literature in relation to the effect of class sizes on learning environments. Blatchford and Russell (2020) exhaustively show how class size is an environmental aspect which exerts pressures upon multiple aspects of a learning environment, including the management of those environments. They identified that smaller class sizes are a particularly important factor for supporting low-attaining children and those with special needs and disabilities, and that these groups are most negatively affected by large classes. This is worth noting given that these

are characteristics often displayed by justice-involved young people. The authors further identified that large class sizes facilitate conflicts between students, again with obvious relevance to youth justice settings. Tying back to the studies on adult facilities and the effect of size on staff, it is worth noting that it is often the teachers (i.e., staff members) who carry the additional burden of increased class size. In respect to the need for an individually tailored approach, the authors identified that large classes have a negative impact in terms of the amount of individual attention, affecting the ability to differentiate between young people.

From this evidence, it can be expected that a smaller-sized facility will have a favourable impact on the ability to provide individualised approaches, facilitate better staff knowledge of the individual risks, needs, and skills of each young person, facilitate positive relationships between staff and young people and provide a less crowded, less stressful environment more amenable to engaging with treatment.

Local Siting

As noted above, literature describing what works for justice-involved young people repeatedly highlights the importance of positive reciprocal relationships existing outside of the custodial environment to family/carers, peers, school, and community. As such, a youth custodial facility must be able to maintain and strengthen a young person's social connections and support access to community resources. This is naturally affected by the location of the facility relative to the home community of the young person, with greater distance or inaccessibility working counter-productively.

Social connection to the outside world is often considered in terms of visits received while in custody (Cochran, 2014, p. 202; For youth specifically, refer: Monahan et al., 2011; Villalobos Agudelo, 2013; Walker & Bishop, 2016). Mikytuck and Woolard (2019) found that a family's travel time to a facility both 'significantly predicted youth likelihood of receiving an in-person visit' (p. 380) and was 'significantly associated with frequency of contact' (p. 392). Young and Hay (2020) also identified that greater distance between a facility and a young person's

home community lowers both the likelihood and the frequency of visits while incarcerated. This is in line with research into distance and visitation for adult facilities (Clark & Duwe, 2017; Cochran et al., 2016). Lindsey et al. (2017) also identified an association between greater distance from home and an increased likelihood of misconduct, noting that visitation partially mediates this relationship. Importantly, the study identified that this pattern is more pronounced for young people, noting that 'prison distance is strongly associated with misconduct among the youngest inmates, such as those 16-years or 18-years old' (Lindsey et al., 2017, p. 1055). This reinforces the importance of proximity and social connection for young people in custody. Further, it follows from less involvement with a young person's family and community that staff are less able to draw upon specific knowledge of the young person's social and cultural context.

In addition to social connectedness mediated through visits, the location and surrounding context of the facility may provide a greater or lesser opportunity for developing and maintaining prosocial relationships and activities. In the context of immigration detention, Ryo and Peacock (2019) showed that facility location impacts detainees' access to services and support networks. It is possible that a similar relationship exists between a youth custodial facility and community resources in the facility's context.

If it is accepted that a facility will be small, these considerations provide a strong argument for a more localised facility relative to a young person's home environment in order to promote protective factors and health resources that can be sustained beyond time spent in custody. Aligned with these considerations, the placement of young people close to home is the key principle of recent reform in New York City, which has shown this to be a highly successful approach (NYC Administration for Children's Services, 2017).

Relational and Differentiated Security

Research shows that overly restrictive interventions are likely to increase the risk of reoffending (Bonta & Andrews, 2007; Lowenkamp & Latessa,

2005; Zoettl, 2020). This highlights the importance for interventions to be individualised, which necessarily extends to security measures within a facility. To ensure this individualised focus, we need to consider that there are multiple dimensions for the differentiation of security. Firstly, security measures need to cater simultaneously to young people who have different care and security needs. Secondly, in response to effective treatment it can be expected that an individual's risks and needs will change over time. As such, facility design is required to provide or facilitate security measures that can be differentiated over time and between individuals at any given time.

The importance of positive relationships extends to the maintenance of security in a facility, with relational security having been recognised as the most effective of security measures within a youth custodial environment (Armytage & Ogloff, 2017). Relational security is the understanding and knowledgeable staff have of residents, and how this informs the management and de-escalation of security incidents (Tighe & Gudjonsson, 2012). Therefore, the design of facility security should incorporate and contribute to familiar relationships between staff and young people, rather than relying solely on physical and procedural measures.

The design and layout of adult prison facilities have been linked to the perceptions of detained adults on their relationships with staff (Beijersbergen et al., 2016). The perception of staff-detainee relationships was measured across 32 Dutch prisons with various layouts, including panopticon, radial, high-rise, and campus layouts. Detainees housed in prisons that promote larger physical distances between staff and detained adults (i.e., panopticon and radial layouts) experienced more negative interactions with staff. Those housed in layouts promoting interaction (i.e., campus and high-rise facilities) experienced more positive relationships with staff. This gives some indication that design has the capability of actively promoting interactions and relationships between facility staff and detainees.

In relation to youth, the impact of a repressive physical environment on the institutional climate in secure residential and youth justice facilities has been recognised, however, has not been investigated separately from the social element (Van der Helm et al., 2018). Young-Alfaro

(2017) observed that the layout of prison school spaces, and their associated processes, can be configured to essentialise young students as criminals in the eyes of teachers and facility staff, contributing to the perception that young people are threats, with implications to their interpersonal interactions.

Therapeutic Design

As wellbeing is a central principle for youth custody, it is important to note that young people in custodial facilities are a particularly vulnerable group in our society. Many justice-involved young people are victims of trauma, abuse, or neglect, present with various mental health issues and experience systemic disadvantage, contributing to their engagement in offending behaviours (Borschmann et al., 2020; Casiano et al., 2013; Hughes et al., 2020).

It is well recognised that built environments can have profoundly negative impacts on the physical and mental health of residents in health care facilities (Ulrich, 2006). This research provides insight into how people react to institutional spaces where they are admitted involuntarily. Therapeutic design can be considered as design that incorporates (most, if not all) features that improve safety by reducing stress, aggression, violence, and self-harm (Ulrich et al., 2018) and contributes to mental health, wellbeing, and rehabilitation (Connellan et al., 2013).

Common therapeutic design features that have been related to rehabilitative outcomes in mental health care facilities include: access to daylight, natural lighting and glare; noise levels; adequacy of space for personal, communal, and work activities; 'home-like' (as opposed to institutional) environmental qualities; and access to gardens and nature (Connellan et al., 2013; Wener 2012). For young people, several additional key design features were highlighted: access to means of distraction in response to stress (e.g., television, telephone or music); access to recreational areas with peers (e.g., exercise rooms); an accessible kitchen; and a need for privacy (single rooms and private bathrooms) (Connellan et al., 2013). Moreover, Connellan et al. (2013) pointed out that the need for

connection with the outside world was a commonality across publications relating to the design of mental health facilities for young people. Similar therapeutic design features have been linked to the wellbeing of people detained in prison (Bernheimer et al., 2017).

The built environment has both direct and indirect effects on mental health, impacting a person's mental wellbeing through purely physical means but also by mediating the ways in which they act and interact socially (Evans, 2003). This is worth considering again, given the importance of relationship building and the need for connection with the outside world.

European Precedent Studies

To substantiate and refine our understanding of the key design characteristics, we studied these against several highly regarded facilities in three European jurisdictions—Spain, Norway, and the Netherlands (Fig. 13.1). Each jurisdiction has a different approach to the treatment of young people in custody, also involving different facility designs. Through site visits and interviews with staff and management, we sought to explore (1) the extent to which, and how the key design characteristics were operationalised in the different jurisdictions, and (2) how these design characteristics impacted upon the ability to provide for the approaches identified as important in the literature.

Background

Spain: Diagrama Facilities in Cordoba, Castilla la Mancha, and Carmona

In Spain the Juvenile Criminal Act (JCA) applies to young people aged 14–18 years old. The youth justice system has a strong focus on education and rehabilitation. The Diagrama Foundation, an international not-for-profit organisation, runs 36 'youth educational centres' which fulfil the role of youth justice facilities across Spain. Approximately 80%

13 A Model for the Design of Youth Custodial Facilities … 351

Fig. 13.1 European precedent facilities. (*Notes* *Photographs marked with asterisk, credit: P. Gunasekera, 2017. 'Returning Citizen Rehabilitation: Understanding Best Practices in Germany, the Netherlands and Norway: Arriving at Bergen and Bjørgvin Fengsel'. Accessed 11/9/20. https://pgwcmt.wordpress.com/)

of young people placed within these facilities are sentenced, with the remainder awaiting sentencing.

Each facility has closed, semi-open, and open units, and operates with a five-stage model in which young people can progress from 'Induction' through to a stage of 'Autonomy'. There are two types of staff present; mostly 'educators' who interact with the young people directly, with some guards whose role is focused on security. Educators come from a range of professional backgrounds, such as youth law, teaching, or social work.

Norway: Bjørgvin Youth Unit, Bergen

The justice system in Norway has a strong focus on the principles of restorative justice, reintegration and adopts a trauma sensitive approach. Criminal responsibility starts at age 15, operating with only one justice system for both youth and adults. A custodial sentence for youth is very much a last resort measure and is only applied to very severe offences, including murder and severe sexual offences. There are two youth facilities for young people under 18, each with room to house four young people: one in Bergen, which we visited for this study, and another in Eidsvoll, a one-hour drive from Oslo.

As the facility in Bergen was purpose-built to house young people tried for very serious offences, it operates as a high-security facility. Despite this, it employs a highly relational approach and is focused on providing individual treatment for young people. Staff consist of 50% social workers and 50% correctional staff, which is mandated by law. The social workers have at minimum a bachelor's in social work, preferably in child protection. Correctional staff are educated through a two-year bachelor program, where they are taught subjects including psychology, criminology, law, human rights, and ethics, and how these relate to their occupation.

The Netherlands: Amsterdam Small-Scale Facility

Juvenile criminal law in the Netherlands applies to young people between the ages of 12 and 18 years. Young people aged 16–23 can be convicted either as an adult or as a juvenile, under adolescent criminal law. In 2016 the Netherlands opened three small-scale community-integrated pilot facilities as part of a three-year trial exploring the future of youth custody in the Netherlands.

Following the trial, the small-scale facility in Amsterdam has become a permanent part of the youth justice system in its local region. This facility can house a total of eight young people on remand between the age of 12–18, as well as young people aged 18–23 years old who are being tried under adolescent criminal law. It offers an alternative to a high-security facility for young people remanded for their first or second offence. The focus lies on maintaining and building protective factors, such as engagement with education (at external schools), employment, and youth support services. The facility is semi-open and operates with low physical and operational security measures, depending primarily upon relational security. Most staff are 'pedagogical staff' with a degree from a vocational university and are qualified youth social workers. Some staff are more security focused, although still employing a relational/pedagogical role.

Facility Size

We observed the size of each facility in regard to the relationships between staff and young people. Facility size can be characterised by the facility footprint and the number of beds, also taking note of how many beds per residential unit. Given the importance of an individualised approach and positive relationships between staff and young people, staff-resident ratios are also identified for each facility (Fig. 13.2).

The highly individualised approach and complex cohort of the Bergen facility is reflected in the smallest number of beds across the three jurisdictions, as well as a higher staff-resident ratio. In the Amsterdam

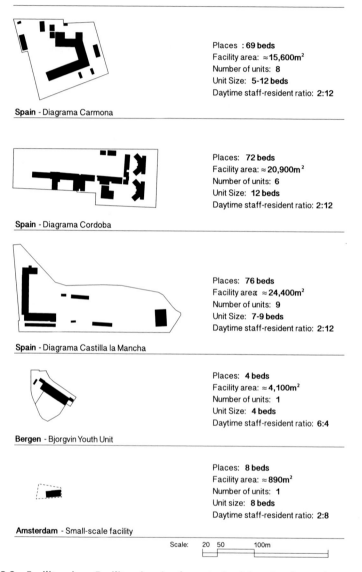

Fig. 13.2 Facility size. Facility size is characterised by the footprint, number of beds, number of units and unit size. Staff-resident ratios of each facility provided for reference

facility, staff work with a cohort of young people who access services and education outside of the facility, leading to a very small facility footprint.

The Spanish facilities are notably larger in comparison, though the size of individual units ranges between five and twelve beds. The scale of each unit in Spain is comparable to the 'single unit' facilities in Bergen and Amsterdam, but it is worth noting the great importance Spanish staff placed on each staff member being familiar with each individual young person across the whole facility. It was noted that every individual is discussed at shift hand-over meetings, and this approach was described as crucial to the Diagrama model. This indicates a way of working that, despite larger facilities, still emphasises a strong focus on providing an individualised and relational approach.

Across variation in the number of beds and staff-resident ratios, we observed staff to be working closely and in a familiar and personal manner with the young people in all five facilities. Given the substantial effort and expertise required of the Spanish staff to maintain this practice, we infer that there is an upper limit to overall facility size, above which it would be increasingly unmanageable for staff to maintain a close relationship and individual knowledge of young people in a facility. This aligns with the literature previously discussed (Liebling, 2008). As social practices and competencies vary between cultures, the upper limit of facility size may vary between cultural contexts.

Locality

We observed the location of each facility in relation to the access of external health-sustaining resources and social connections. To understand and compare the site of each facility, we sought a method that could be appropriately applied across each of the jurisdictions to provide an indication of how the facility related to its surrounding context. Access to public transport options provides an indication of the site's connectedness to the rest of the community and readiness for access to the site (Fig. 13.3), while land-use planning zones provide an indication of the nature of the environment immediately surrounding the facility (Fig. 13.4).

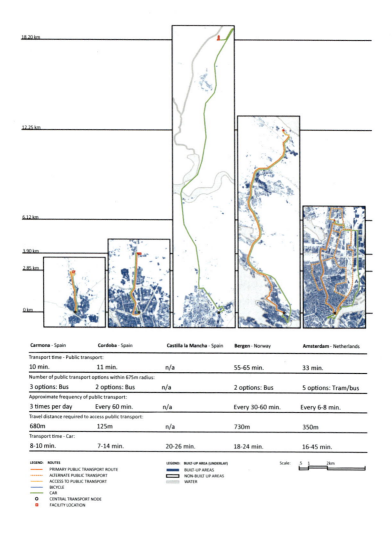

The Amsterdam facility is fully integrated with the city's public transport system, with close access to multiple different frequent public transport options. This reflects the concerted effort to build and maintain a young person's protective factors in the community. Staff also identified that bicycles (provided by the facility) are another means by which young people can travel to school or work. Young people can travel

◀**Fig. 13.3** Facility siting: Location of facility relative to major transport node. In the absence of the specific locations which individual young people and family/carers travel to and from, the central transport node is considered as a proxy measurement to indicate the facility's access to the general community. Access routes are overlayed upon a map of built-up areas to provide an indication of the distance separating the facility from population and activity centres. For consistency, potential route options for all facilities were measured within a 675 m radius (Bergen, farthest distance to access, excluding Castilla la Mancha due to impractical distance). Trip frequency is measured on a weekday morning, for the access point that is closest to the facility, in the direction of the major transport node only—drawn as the 'primary route'. Carmona, Cordoba, and Bergen are located at the periphery of built-up areas, with public transport access and frequency less than what is available within the urban areas. Amsterdam is located within the built-up area of the city, with frequency and access similar to that available throughout the urban area. (*Source* Carmona: Consorcio de Transporte Metropolitano - Area de Sevilla. Accessed 10/8/20. https://siu.ctas.ctan.es/es/; Cordoba: Aucorsa - Autobuses de Cordoba. Accessed 10/8/20. https://www.aucorsa.es; Bergen: Skyss. Accessed 11/8/20. https://reise.sky ss.no; Amsterdam: GVB Amsterdam. Accessed 11/8/2020. https://en.gvb.nl/; Car routes: Map data ©2020 Inst. Geogr. Nacional and Google; Builtup area map: Corbane, Christina; Sabo, Filip [2019]: ESM R2019—European Settlement Map from Copernicus Very High Resolution data for reference year 2015. European Commission, Joint Research Centre (JRC) [Dataset] https://doi.org/10.2905/8BD 2B792-CC33-4C11-AFD1-B8DD60B44F3B)

autonomously, with staff providing support and monitoring as needed. The facility is highly accessible to parents/carers, with no set visiting hours or areas, rather encouraging home-like interactions such as cooking and eating together. The predominantly residential adjacent land use gives a strong indication of the site's integration with the surrounding neighbourhoods.

The Bergen facility is located adjacent to an adult prison, though care has been taken to screen the adult facility from view. It is less connected via public transport options to the city, though this might be expected considering the cohort, in that routine access to external resources is less common and more likely to be conducted with staff present. A further consideration is, given that Bergen is one of only two four-bed youth custody facilities serving Norway, young people are often housed at a significant distance from their home and families. Great effort has been made in the facility design to recognise this distance, with a fully

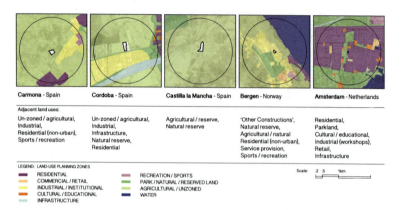

Fig. 13.4 Facility siting: Land-use zoning within 1 km radius. Land-use planning zones provide an indication of the types of environments immediately surrounding the facilities. Zones have been grouped with similar types to show general similarities between jurisdictions, despite variation in specific planning rules. Note that Bergen's 'Other Constructions' zone includes a wide-range of land uses. Non-urban residential areas within this zone have been grouped with residential zones from other jurisdictions. The facility is located adjacent to an adult prison, though care has been taken to screen this from view within the youth unit. (*Notes* Source: Carmona: Ayuntamiento De Carmona, 2012. Plan General De Ordenacion Urbanistica. B.01 Ordenación Estructural, C.03 & C.21 Ordenacion Pormenorizada. Accessed 17/8/2020. http://carmona.org/pgou/; Cordoba: Gerencia Municipa de Urbanismo, Ayuntimento de Cordoba, 2001. Planos De Calificacion Usos Y Sistemas: CUS31W, CUS32W, CUS24W. Accessed 27/7/2020. www.gmucordoba.es/planos/calificacion-usos-y-sis temas; Castilla la Mancha: Ayuntamiento De Fernan Caballero, 2002. Plan de Ordenacion Municipal. Planeamiento Municipal de Castilla-La Mancha. Accessed 27/7/2020. https://castillalamancha.maps.arcgis.com/; Bergen: Bergen Kommune. Kommuneplanens Arealdel 2018. Accessed 27/7/2020. https://bergen.maps.arcgis.com/; Amsterdam: Gemeente Amsterdam, 2017 Land Use. Accessed 27/7/2020 https://maps.amsterdam.nl/grondgebruik/; Underlay satellite imagery: Amsterdam: Esri, EsriNL, Rijkswaterstaat, Intermap, NASA, NGA, USGS | Esri Community Maps Contributors, Kadaster, Esri, HERE, Garmin, GeoTechnologies, Inc, METI/NASA, USGS | Beeldmateriaal.nl, Maxar, Microsoft; Spain: Esri, Intermap, NASA, NGA, USGS | Esri Community Maps Contributors, Instituto Geográfico Nacional, Esri, HERE, Garmin, GeoTechnologies, Inc, METI/NASA, USGS | Gobierno de España, Maxar, Microsoft; Bergen: Esri, Intermap, NMA, USGS | Esri, HERE, Garmin, GeoTechnologies, Inc, METI/NASA, USGS | Maxar, Microsoft)

contained apartment available for family or carers to stay within the facility to promote visits. We learned, however, that families generally opt to stay in a hotel nearby rather than at the facility, with the costs covered by the facility.

In Spain, the Diagrama Foundation has not had the option of choosing the site for its facilities on every occasion, instead making the best of what is available. As each facility generally has the same overall cohort and shares the same programs and approach, it is interesting to compare two facilities which are sited differently, relative to their communities. The facility in Cordoba is located immediately opposite a local bus route, eight minutes ride to the city centre, while the Castilla la Mancha facility sits 25 minutes' car drive from Ciudad Real, with no close public transport options available. During our visit, it was made clear that in Cordoba, young people in the Autonomy Unit were able to catch the bus from directly outside the facility for work or education, as per their daily activities. This autonomy was not possible at Castilla la Mancha, with staff required to arrange shuttle buses for young people to access the community.

Across the jurisdictions, location directly affects a facility's accessibility for family and carers, as well as the ability for young people to build and maintain autonomy and health-sustaining resources within the community. We also observe that as a facility becomes more separated from the community, greater resources are required of staff and the facility itself to provide opportunities and access to health-sustaining resources.

Measuring modes of transport suitable for young people, such as public transport, walking, and cycling, indicates readily available opportunities for the building of autonomous movement and access to external resources independently. This grows in importance as a young person approaches the end of their time in custody and prepares to navigate their own way to resources in the community.

Security Measures

We sought to characterise the security measures of each facility by observing: (1) the physical security infrastructure and how it influenced

spatial character; and (2) the spatial arrangement and boundaries, and how these related to patterns of shared spatial use between staff and young people.

Physical Security Infrastructure

Enclosing the Bergen facility is a heavy-duty anti-climb wire mesh fence, approximately four metres in height, sky-blue in colour, with no deterrent features atop the fence (e.g., razor wire). Doors within the residential spaces are timber or framed glass. Windows are large with no bars or mesh. Given the complex cohort, the facility includes a seclusion room with very strict policies around its use, and access to riot gear, though this was said to be very rarely used. Though security is comprehensive, the facility has the character of an ordered house within a school yard.

The Spanish facilities included either a solid perimeter wall or chain link fence. There is a preference against the use of barbed wire, which was used at only one of three facilities visited. Windows are operable and have bars; however, this is a normal feature of houses in the region. External doors are ornamented steel with timber doors internally. External spaces again primarily resemble a school yard. A few uniformed guards were present in the background, whose presence is for security.

The Amsterdam facility has no perimeter fence, rather having a front door entry that one might expect for a normal apartment building. From external appearances there is nothing to indicate that it is a secure facility. Inside, the facility has timber and glass doors, and operable windows (restricted opening) with no bars. Despite having a time-out room in the facility, this had only been used once at request of the young person, which suggests it may be an unnecessary measure. A terrace on the first floor provides an outdoor space with no additional security measures. Given that young people leave the facility for work/education throughout the day, a facility perimeter is a lower priority, resulting in a very home-like environment.

It is notable that all five facilities avoided 'aggressive' deterrent measures, instead focusing on home-like or school-like spatial characteristics (Fig. 13.5). This approach was exemplified in Amsterdam, where a perimeter was avoided altogether.

Spatial Arrangement and Boundaries

Across the facilities we saw several similarities which encouraged close interaction between staff and young people. One aspect of this, repeated in all three jurisdictions, was the arrangement of cooking and dining spaces for meals to be shared between staff and young people, noted as a key site of relationship building (Fig. 13.6).

In Amsterdam, a single kitchen, dining, and living space is shared by both the staff and young people. These areas provide an informal space for shared activities, such as leisure activities and preparing and eating meals together. This is seen to provide opportunities to cultivate positive relationships, and develop the domestic skills of young people, as well as the time and space for addressing problematic behaviours and providing learning opportunities.

Similarly, in Bergen, a domestic kitchen, dining, and living space serves as the literal and practical centre of the facility, where staff again are encouraged to interact in a normalising and informal manner.

In Spain again, the dining space and meals were seen to be an important site for relationship and skill building. Each facility included a commercial kitchen to prepare meals for both staff and young people, taken together in the dining spaces of each unit. The spatial arrangements vary however between units at different stages of the Diagrama Model. While units for earlier stages have only basic dining facilities, the Autonomy Units include a kitchen, like those supplied in Amsterdam and Bergen. Again, this kitchen serves as a site for the practising of domestic skills and a means for informal interaction between staff and young people.

A second similarity across the facilities was that no observation windows, staff podiums, or similar physical barriers that distance staff from young people were present. This can be seen in the boundaries

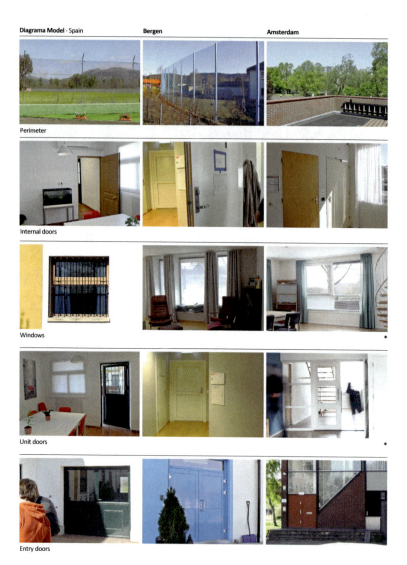

Fig. 13.5 Visible physical security infrastructure. The physical security infrastructure across jurisdictions shows an absence of 'aggressive' deterrent measures with spatial characters that are school- and home-like. (*Notes* *Photographs marked with asterisk, credit: Niels Bleekemolen)

13 A Model for the Design of Youth Custodial Facilities ... 363

Spain - Autonomy Unit

Spain - Induction Unit (dining space only)

Amsterdam

Bergen

Fig. 13.6 Shared kitchen and dining areas. Kitchen and dining areas serve as an important focus in each facility for informal activities between staff and young people. The Diagrama Autonomy unit contains a full domestic kitchen, similar to Amsterdam and Bergen, whereas the earlier units in the model contain dining areas only. (*Notes* *Photographs marked with asterisk, credit: Niels Bleekemolen)

between spaces used for staff/procedural purposes, and general living spaces (Fig. 13.7).

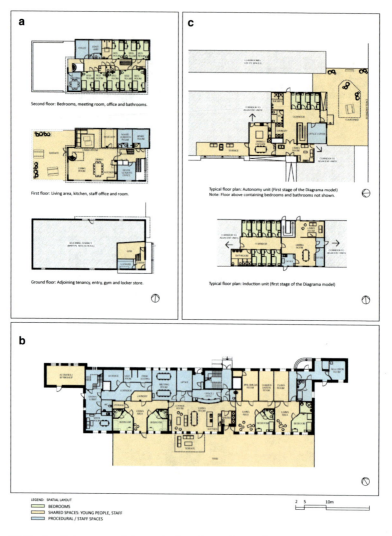

Fig. 13.7 Spatial use and boundaries. Boundaries between areas which are used for residence and more predominantly staff/procedural uses provide an indication of how the design encourages either distancing or close interaction between staff and young people

The Amsterdam facility includes minimal staff-only and procedural spaces, with none of these spaces including any observation windows. These spaces have 'normal' domestic boundaries and do not provide a privileged view of the living spaces, nor establish a hierarchical relationship between the spaces. These rooms have a single access door from the corridor, as might be expected in a normal house or office.

The Spanish facilities include a wing for procedural and office spaces for specialist staff (e.g., psychologists). A small staff office space was provided within each unit; though these resemble a storage space much more than an office; with shelves of games, books, and teaching resources taking up most of the room, over a small work desk. Again, there was no indication of a spatial hierarchy, nor any means of observing the living spaces from within the room, other than the doorway itself.

The Bergen facility was initially designed with three small observation windows (approx. 300 × 300 mm) at standing height (sill approx. 1.7 m above floor level) though these windows have subsequently been painted over during the facility's operation.

It is apparent that this boundary was carefully considered during the design process. Positioned over work desks, the location and size of the windows make them awkward to use for observation from either a standing or sitting position in the office—discouraging casual use. On the living room side, a wall mural surrounds the windows minimising their visual presence. The wall projects into the living space in a very slight arc, along the axis of the hallway. This arrangement retains the recognisable form of an observation room, though made less apparent through a design seeking to negate the hierarchical quality of this spatial arrangement where possible.

During the facility's operation, these windows have been blanked out with paint, with staff recognising that it made for a 'wrong impression'. It is worth noting again that this facility is designed as a last resort and most severe measure, containing four of only eight beds nation-wide.

Across all three jurisdictions, it is apparent that design discourages distancing between staff and young people, again promoting the shared use of spaces between staff and young people.

A third similarity we observed was the provision of some means to differentiate or provide flexibility in the way that spaces could be used and accessed, though each jurisdiction achieved this differently.

Staff in the Amsterdam facility use their knowledge of a young person to adjust the delivery of security procedures according to that young person's individual needs at the time (within set limits). From the front door, the entry procedure into the secure building is mediated by the staff member's relationship with the young person, rather than by physical barriers. As a spatial arrangement, this means the facility has an office and a small storeroom adjacent to the front door, where security procedures are carried out to the extent considered appropriate by staff (Fig. 13.7a). This arrangement promotes a more personable, normalised, and individually tailored entry to the facility, minimising adversarial or hierarchical aspects of formal procedure. Locating procedural spaces as an adjacency to paths of movement, rather than in sequence, provides staff with the ability to employ relational security methods, in addition to, or in place of standardised procedures.

Within the facility, doors are typically left open unless required otherwise, and young people are free to move around with a key to their room until curfew. The absence of hard boundaries is almost difficult to perceive as a security response—but this is seen to promote constructive relationships between staff and young people as a key measure in keeping the facility safe.

Both Bergen and Spain provide differentiated internal spaces, using different methods to suit the facility size. In Bergen the residential areas have been arranged to provide a variety of 'softly' defined spaces, alcoves, and sitting areas. Sitting areas with large windows are located outside bedrooms offset from the hallway, which removes any sense of a 'corridor' (Fig. 13.7b). Doors in between are generally left open unless required. As breakout areas from the shared central living room, this arrangement provides staff a range of both subtly and clearly defined spaces with different degrees of intimacy in relation to a young person's personal space. This flexibility is seen as an asset when working to build relationships with young people who display challenging behaviours. It is worth recognising that the small size of the Amsterdam and Bergen facilities

significantly contributes to the way security is managed relationally and flexibly.

As part of the progressive stages of the Diagrama model, the Spanish facilities provide differentiated spaces at the scale of units, which are designed to reflect the degree of autonomy that is deemed appropriate for a young person at the time. As the need for structure and supervision decreases, young people can move into units that increasingly resemble a normal student share-house. With staff permission, the final 'Autonomy Unit' can provide unsupervised access to outdoor courtyards/terraces and includes domestic laundry and kitchen facilities. Compared to the sparser furnishings of the early stages, the Autonomy Unit includes more relaxed furniture and leisure items including video games, musical instruments, and pets. Young people in the early stages of the model are housed in units which, while still home-like, are more geometrically ordered, with a greater focus on sightlines and doorways (Fig. 13.7c).

From our observations, spaces that work flexibly and provide different options for use, including aspects of security, are important in providing the conditions for relationship building between staff and young people. It also appears that the reverse is true, with strong and knowledgeable relationships allowing for the use of spaces in flexible ways.

All the facilities operate with a strong focus on relational security rather than relying solely on physical security infrastructure, encouraging staff interaction with young people as the primary means of maintaining a safe and secure environment. 'Aggressive' deterrent measures such as razor wire are avoided, while the design of the facilities contributes to the manner in which close interactions are encouraged between staff and young people, including aspects that encourage mutual activities and discourage distanced observation or monitoring. Further, the relationships between staff and young people, and the flexibility of spaces and their access, appear to be mutually reinforcing one another.

Therapeutic Design

In order to examine the architectural details of therapeutic design in each jurisdiction, we observed how each facility responded to design

features understood to have therapeutic effects from mental health and environmental psychology literature (Bernheimer et al., 2017; Connellan et al., 2013; Ulrich et al., 2018). These observations are described per jurisdiction in Table 13.1.

Each jurisdiction provided an environment incorporating many design features known to have mental health benefits, moving away from an institutional design often seen in more traditional youth custodial facilities. For example, all facilities used soft finishes and furniture in their design, had operable curtains/blinds to windows and moveable furniture. Despite 'soft' architectural finishes, none of the facilities showed signs of graffiti or damage—nor were they overly ordered, with this contributing to the sense of a home-like environment (Fig. 13.8). Each facility responded in a manner particular to its own domestic architectural context. Across the facilities, all provided ample natural daylight, domestic acoustics, and views to the natural environment such as tree canopies, distant landscapes, or forested hills. Furthermore, all facilities provided privacy through individual bedrooms, as well as opportunities for young people to personalise spaces with their own belongings such as postcards and photos. Noticeably, all facilities provided for autonomous movement by young people through spaces of differing environmental qualities, either until a curfew or contingent upon approval.

These facilities readily demonstrate that it is possible to implement these various therapeutic design features within a youth custodial context. Many of these therapeutic characteristics would be very difficult to achieve if a 'hard' approach to physical security was employed but are easily and inexpensively achieved when security is maintained effectively by social relationships. Indeed, from our observations, it appears that when security is managed primarily through constructive and respectful relationships, encouraged by the shared occupation of spaces, these home-like characteristics contribute to the maintenance of those relationships between staff and young people.

Table 13.1 Observations of therapeutic design characteristics

Characteristic	Amsterdam	Bergen	Spain
Adequate lighting and access to adequate daylight[a,b,c]	Multiple large windows (approx. 2.4 × 2 m) in multiple directions and at high angle in living areas. Clerestory window to corridor, full height windows at ends. Large windows (from 2.5 to 4 m^2) to bedrooms	Multiple large windows (approx. 1.2 × 1.8 m) to living areas, facing sun, curtains and glare reducing blinds provided. 2 large windows to each bedroom (approx. 1.5 × 1.5 m)	Multiple windows (typically 1.4 × 1 m), typically in multiple directions to living areas. 1 window (typically 1.4 × 1 m) to bedroom
Spacious communal areas with moveable furniture and homelike atmosphere[a,b]	Open plan living/dining/kitchen (120 m^2 for 8 young people) plus a terrace (93 m^2). Moveable furniture and objects to shelves and kitchen cupboards. Familiar and homelike atmosphere	Central living/dining/kitchen and adjacent living areas (200 m^2 for 4 young people) with outdoor terrace in yard Moveable furniture and objects to shelves and kitchen cupboards. Familiar and homelike atmosphere	Living/dining areas (approx. 75 m^2 per unit), plus outdoor terraces/courtyards and kitchens in Autonomy units Moveable furniture and objects to shelves and kitchen cupboards. Familiar and homelike atmosphere, more sparsely furnished in units for earlier stages
Adequate private personal space (i.e., privacy) with some sense of control over this personal space[a,b,c]	Individual bedrooms (approx. 12 m^2) incl. toilet, sink and desk. Personalised space with objects and photos, operable windows and curtains to control light. Light switches to control light	Large individual bedrooms (approx. 20 m^2) with ensuite and desk. Personalised space with objects and photos. Blinds to windows to control light. Light switches to control light	Individual bedrooms (approx. 7.5 m^2) with desk. Personalised space with objects and photos. Operable windows with blinds to control light. Light switches to control light

(continued)

Table 13.1 (continued)

Characteristic	Amsterdam	Bergen	Spain
Design to limit crowding and the subjective perception of crowding[a,b,c]	Small-scale facility of 8 beds. Single bedrooms with private toilet. Communal areas have moveable furniture. Ceilings are high and spaces are light-filled	Small-scale facility of 4 beds. Single bedrooms with private bathroom. Living areas broken into multiple spaces. Spaces are light-filled	Maximum unit size of 12 beds. Single bedrooms. Unit living spaces broken into multiple areas. Rooms and corridors are wide and spaces are light-filled
Noise reducing design and good acoustics, including the use of sound absorbing materials and a reduction of background noise[a,b,c]	Comfortable, warm domestic acoustics. Soft surfaces incl. curtains, furniture and rugs. There are plaster walls and ceilings, and timber doors internally	Comfortable, warm domestic acoustics. Soft surfaces incl. curtains, furniture and rugs. There are plaster walls and ceilings, and timber doors internally	Comfortable, domestic acoustics, some reflection from tile flooring Soft surfaces incl. curtains, furniture and rugs. Plaster ceilings and walls and timber doors internally
Access to and use of green spaces and gardens[a,b,c]	Outdoor terrace accessible with approval of staff, with view to a canal, parks and tree canopies. Young people spend time outside of the facility during most days	Outdoor yard accessible during leisure times, includes trees and lawn	Rich and varied gardens incl. lawns, hedges, trees, flowers, water features, vegetable gardens, animals. Access according to daily schedule. Access to courtyards and terraces at leisure for Autonomy unit, subject to approval of staff
Visual access to natural environments through windows with particular reference to far-reaching views[a,b,c]	Views from living room windows to tree canopies and canal. Some bedroom windows with views to treetops in the street	Views to nearby forested hills from bedroom and living room windows, as well as outdoor yard	Building mass arranged to promote views to distant landscapes (open/splayed courtyard). Upstairs units have good views to distant landscape, downstairs to gardens

Characteristic	Amsterdam	Bergen	Spain
Legible and visually distinct spaces clearly marking the different functions of spaces[a,c]	Shared spaces (incl. gym and living area) distinct by furnishings and finishes. Visually consonant overall. May be less applicable given young people leave during the day for activities	Shared spaces distinguished by furniture. Visually consonant overall	Units at different stages of model are distinguished by furniture and layout. Classrooms and activity spaces distinguished by furniture and equipment
Enriched environment with aesthetic considerations, including art, indoor plants, variation in colour and texture, and balance between visual order and complexity[a,b,c]	Large Van Gogh print on the wall, street-art graphic in the gym. Balance between warm wood tones (floor, roof structure, doors) and blues and greens for paint and curtains. Homelike material palette. Books, DVDs, photographs on shelves in living area	Wall hangings and murals, patterned soft furnishings and indoor plants. Generally neutral palette given warmth by wood tones (floor, furniture) and colours in furnishings (loosely themed to spaces). Sky blue used for external doors and fences, with brightly coloured road signs collaged as a wall to exercise area. Books and DVDs on shelves	Paintings and photographs on living area walls. Small indoor plants in certain units. Generally neutral internal palette given warmth and colour by furniture and wall hangings. Blue used for doors and window frames. Coloured vinyl flooring to Autonomy unit living spaces. Books, DVDs, personal items on shelves around living spaces
Home-like, non-institutional, non-hard architectural finishes (i.e., not vandal resistant)[a,c]	Timber floors and furniture, carpet rugs, plaster walls and ceilings, fabric furniture upholstery and curtains	Timber floors and furniture, carpet rugs, plaster walls and ceilings, fabric furniture upholstery and curtains	Domestic tile floors and in some areas as wall lining to approx. 1 m above floor height. Full plaster walls in later units. Timber and fabric furniture, fabric blinds

(continued)

Table 13.1 (continued)

Characteristic	Amsterdam	Bergen	Spain
Some degree of individual control of environmental elements, including light, noise, temperature, air quality, and movement[b,c]	Operable windows, curtains and blinds provided throughout. Young people can control lights in bedroom and have the ability to move around within facility	Blinds or curtains provided to all windows. Young people can control lights in bedroom. Good acoustic isolation and number of different rooms/alcoves provides ability to relocate away from noise	Operable windows and blinds provided to windows in bedrooms and living spaces. Light switches and heating/cooling as per normal domestic house. Young people have the ability to move around within units, which is increased for those in Autonomy unit
The ability to personalise living spaces[a,c]	Young people personalise bedrooms with personal belongings	Young people personalise bedrooms with personal belongings	Young people personalise bedrooms with personal belongings. Photographs, posters, drawings also in living spaces. Some furniture items (e.g., chairs, tables) made by young people themselves
An ability to move autonomously between spaces, particularly of different spatial qualities, within the limits of facility security[a,c]	On weekdays young people autonomously attend work/school outside facility with support as needed. Within the facility, movement is autonomous until curfew between living spaces (incl. kitchen, dining, living room) and bedroom spaces. Access to external terrace space contingent upon approval	Movement is largely autonomous within the residential area until curfew, though staff members are encouraged to spend time directly with young people. The area for autonomous movement includes the outdoor yard area, bedrooms, small-living spaces and large shared living spaces. Doorways allow for closing of movement as necessary	Movement is comparable to a school, with units inside an open yard area. Autonomy of movement in and out of units increases for later stages, with greatest freedom of movement in the Autonomy units, where young people can freely access outside courtyard and terrace spaces (contingent upon approval)

Characteristic	Amsterdam	Bergen	Spain
Ability to move between spaces to regulate social interactions or gain visual and acoustic privacy in social spaces[b,c]	Softly defined spaces in open plan living room, with some separation in social space provided by access to adjacent terrace (contingent upon staff approval)	Numerous 'softly defined' small living spaces provided throughout the residential spaces adjacent to bedrooms. These provide a degree of visual and acoustic privacy while remaining 'open' to social interactions	Unit living spaces typically divided in two, allowing a degree of separation within social space. Terrace and courtyard spaces provide separation for Autonomy unit shared spaces (contingent upon staff approval)

Source [a]Connellan et al. (2013), [b]Ulrich et al. (2018) and [c]Bernheimer et al. (2017)

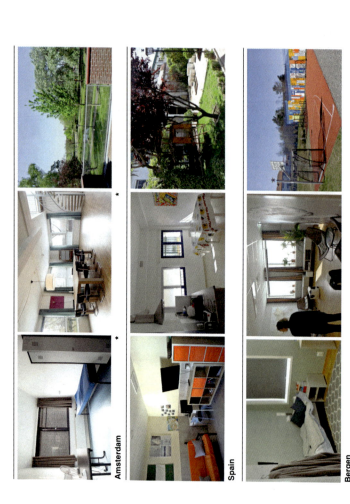

Fig. 13.8 Therapeutic design features. Each jurisdiction provided an environment incorporating many design features known to have mental healthHealth benefits, contributing to the overall sense of a home-like environment. (Notes *Photographs marked with asterisk, credit: Niels Bleekemolen)

Discussion

By establishing the design implications which follow from the literature on what works for justice-involved young people, a series of key characteristics were identified that define a best-practice, theoretical facility model: small-scale, locally sited, and integrated with the surrounding community, designed to promote relational and differentiated security, and taking account of therapeutic design characteristics. To substantiate the relevance of these key design characteristics and refine their definition, we studied highly regarded facilities in three European jurisdictions (Spain, Norway, the Netherlands). We observed how and to what extent those characteristics were operationalised, and how they impacted upon the ability to provide for the approaches identified as important in the literature.

> First, observing the size of each facility showed that unit sizes were roughly similar, between four and twelve beds. Overall facility size showed greater variation, four to seventy-six beds, and we observed that a facility's size had an influence on the ability and resources required of staff to know and relate to each individual young person. As noted above, staff worked closely and in a familiar and personal manner with young people in all five facilities. Given this, our observations suggest specifying a set number of beds might be an oversimplified way of characterising a given facility as 'small'. Instead, small-scale might be better defined, within a facility's context, by each staff member being able to know each individual young person and act on this knowledge in a constructive way. Larger facility designs make this progressively more difficult and at a certain point an impossibility. Within the range of facility sizes we studied, the Spanish facilities required substantially greater resources in order to accomplish this objective, which provides an indication of the range in which further studies might explore the effect of size.
>
> Secondly, we studied the distance from each facility to a central transport node and time taken to access public transport as a proxy measurement for a facility's accessibility and integration with the broader community. As a facility becomes more separated from the

community, greater resources are required to mitigate the impacts on accessibility for families and carers, as well as the ability for young people to build and maintain autonomy and health-sustaining resources in the community. The facility in Amsterdam, with the readiest access to public transport options, made daily use of this connectedness to accommodate the continuation of schooling and frequent involvement of young peoples' families in treatment. While prior studies clearly showed that closer facility proximity relates to increased visitation from family, given the relative mobility between adults and young people (e.g., the ability to drive), we suggest that locality might be better characterised not only in terms of visits, but by the ability for a young person (when appropriate) to travel autonomously to build and maintain health-sustaining resources in the community which can persist beyond time spent in custody.

Thirdly, all five facilities actively minimised the presence of 'aggressive' physical security infrastructure that would characterise the environment as a custodial institution and avoided physical barriers that might distance staff from young people. Instead, facility design promoted a strong focus on relational security by encouraging staff to spend time directly engaged in informal activities with young people. Furthermore, though in different manners, all facilities were designed with some capacity for flexibility in the way spaces and boundaries could be managed to suit individual needs, with this working in a mutually reinforcing manner with the relational security aspects. We observe then that a focus on these spatial arrangements and practices contributes to a facility design that can be characterised as relational and differentiated.

Fourthly, we examined the therapeutic design characteristics of the facilities by observing how each responded to design features understood to have therapeutic effects from mental health and environmental psychology literature, including: access to daylight and natural lighting; spacious communal areas; private personal spaces; limits to crowding; noise reducing design and good acoustics; access to green spaces and gardens; visual access to natural environments; an enriched environment with aesthetic considerations; 'home-like' (as opposed to institutional) environmental qualities; some degree of individual

control of environmental elements; the ability to personalise spaces; the ability to move autonomously; the ability to regulate social interactions and privacy. All five facilities demonstrate that these design features can be successfully applied within a youth custodial context, each going to great lengths to provide a 'home-like' environment.

It is noteworthy that despite differences in the studied facilities' cultural contexts, and across a breadth of regime types, that the commitment to both relational security approaches and the provision of home-like environments remained pronounced.

As we consider the extent to which the identified characteristics defined the facilities' designs, at a glance there is a degree of variation, particularly in size and locality. However, closer observation showed that these variations were consistently matched with specific procedural responses related to the desired outcomes (e.g., connection to family). The larger facilities in Spain were complemented with highly developed procedures to allow all staff members to maintain a relationship with all young people in custody. The more distant facility in Bergen was complemented by an obligation to provide or pay for costs of travel and accommodation for families visiting their child. Similarly, the more distant Spanish facilities had additional obligations to provide transport for young people to and from the community. As such, instead of this variation dismissing the importance of these design characteristics, these observations tend to reinforce them as important considerations in relation to desired outcomes.

Lastly, by observing these design characteristics in existing facilities, it becomes apparent that they are closely interrelated. As noted above, the relatively larger facilities in Spain demonstrated the interaction between facility size and familiarity between staff and young people. This familiarity, while affected by facility size, is developed within those shared spaces, such as the kitchen and dining spaces, seen in all the facilities. Proximity and familiarity between staff and young people provide a strong environmental foundation for the practice of relational security approaches, with flow on effects to physical security design as exemplified by the facility in the Amsterdam.

Further, the familiarity of staff with young people allows them to adjust the delivery of security procedures according to an individual's needs at the time. As the need for structure and supervision decreases, young people have more freedom of movement and are able to practice greater autonomy within the facility. As demonstrated in Amsterdam and Spain, if the facility is local and community-integrated, this practice can extend beyond the facility as a young person nears the end of their time in custody, or as deemed appropriate. Ultimately, this allows for the strengthening of meaningful health-sustaining resources that can be maintained beyond time spent in custody.

The characteristics of small size, local siting, and differentiated security measures, appear then to collectively influence the establishment of a tailored and relational approach within youth custodial facilities.

Furthermore, we observed a reciprocal relationship between relational security and the ability to create a home-like environment that provides for known therapeutic design characteristics. A relational security approach, encouraged by the use of shared spaces, allows for the avoidance or minimisation of 'hard' physical security measures. Additionally, this removes many of the environmental stressors to be avoided when designing therapeutically. In turn, the removal of such stressors is likely to be conducive to positive relationships between staff and young people.

Concluding, our observations across three different jurisdictions substantiate the theoretical design model and the relationship between its design characteristics and the ability to provide youth justice approaches identified as effective in current literature. From the evidence presented here, we propose that a best-practice youth custodial facility design will be small-scale, locally sited, and integrated with the surrounding community, designed to promote relational and differentiated security, and comprise therapeutic design characteristics. By considering the definitions of these characteristics, we were able to draw into view the tensions, opportunities, strengths, and weaknesses in the design of the precedent facilities, relative to their context. The model highlights the importance of carefully considering the design of youth justice facilities in terms of the desired outcomes (i.e., wellbeing, reduced risk of reoffence, school engagement, family, and community connection) as

design decisions impact upon procedures and ways of working within these facilities, in ways that are known to ultimately impact outcomes for young people. Policymakers and designers might benefit greatly from considering this theoretical design model as the basis of an architectural brief for an evidence-based facility design.

Bibliography

Armytage, P., & Ogloff, J. (2017). *Youth justice review and strategy: Meeting needs and reducing reoffending*. Part 2. Victorian Government, Melbourne

Auty, K. M., & Liebling, A. (2020). Exploring the relationship between prison social climate and reoffending*. *Justice Quarterly, 37*, 358–381. https://doi.org/10.1080/07418825.2018.1538421

Beijersbergen, K. A., Dirkzwager, A. J. E., van der Laan, P. H., & Nieuwbeerta, P. (2016). A social building? Prison architecture and staff-prisoner relationships. *Crime & Delinquency, 62*, 843–874. https://doi.org/10.1177/0011128714530657

Bernheimer, L., O'Brien, R., & Barnes, R. (2017). *Wellbeing in prison design: A guide*. Matter Architecture.

Blatchford, P., & Russell, A. (2020). *Rethinking class size: The complex story of impact on teaching and learning*. UCL Press.

Bonta, J., & Andrews, D. A. (2007). Risk-need-responsivity model for offender assessment and rehabilitation. *Rehabilitation, 6*, 1–22.

Borschmann, R., Janca, E., Carter, A., Willoughby, M., Hughes, N., Snow, K., Stockings, E., Hill, N. T., Hocking, J., Love, A., & Patton, G. C. (2020). The health of adolescents in detention: a global scoping review. *The Lancet Public Health, 5*, e114–e126. https://doi.org/10.1016/S2468-2667(19)30217-8.

Bottrell, D., Armstrong, D., & France, A. (2010). Young people's relations to crime: Pathways across ecologies. *Youth Justice, 10*, 56–72.

Casiano, H., Katz, L. Y., Globerman, D., & Sareen, J. (2013). Suicide and deliberate self-injurious behavior in juvenile correctional facilities: A review. *Journal of Canadian Academy of Child and Adolescent Psychiatry, 22*, 118–124.

Clark, V. A., & Duwe, G. (2017). Distance matters: Examining the factors that impact prisoner visitation in Minnesota. *Criminal Justice and Behavior, 44,* 184–204. https://doi.org/10.1177/0093854816667416

Cochran, J. C. (2014). Breaches in the wall: Imprisonment, social support, and recidivism. *Journal of Research in Crime and Delinquency, 51,* 200.

Cochran, J. C., Mears, D. P., Bales, W. D., & Stewart, E. A. (2016). Spatial distance, community disadvantage, and racial and ethnic variation in prison inmate access to social ties. *Journal of Research in Crime and Delinquency, 53,* 220–254.

Connellan, K., Gaardboe, M., Riggs, D., Due, C., Reinschmidt, A., & Mustillo, L. (2013). Stressed spaces: Mental health and architecture. *HERD: Health Environments Research & Design Journal, 6,* 127–168. https://doi.org/10.1177/193758671300600408

de Vogel, V., de Vries Robbé, M., de Ruiter, C., & Bouman, Y. H. A. (2011). Assessing protective factors in forensic psychiatric practice: Introducing the SAPROF. *International Journal of Forensic Mental Health.*

Evans, G. W. (2003). The built environment and mental health. *Journal of Urban Health, 80,* 536–555. https://doi.org/10.1093/jurban/jtg063

Fairweather, L., & McConville, S. (Eds.). (2000). *Prison architecture: Policy, design and experience.* Architectural Press, London; New York.

Gonçalves, L. C., Endrass, J., Rossegger, A., & Dirkzwager, A. J. E. (2016). A longitudinal study of mental health symptoms in young prisoners: Exploring the influence of personal factors and the correctional climate. *BMC Psychiatry, 16,* 91. https://doi.org/10.1186/s12888-016-0803-z

Harding, R. (2014). Rehabilitation and prison social climate: Do 'what works' rehabilitation programs work better in prisons that have a positive social climate? *Australian & New Zealand Journal of Criminology, 47,* 163–175. https://doi.org/10.1177/0004865813518543

Hughes, N., Ungar, M., Fagan, A., Murray, J., Atilola, O., Nichols, K., Garcia, J., & Kinner, S. (2020). Health determinants of adolescent criminalisation. *The Lancet Child & Adolescent Health, 4,* 151–162. https://doi.org/10.1016/S2352-4642(19)30347-5

Johns, D. F., Williams, K., & Haines, K. (2016). Ecological youth justice: Understanding the social ecology of young people's prolific offending. *Youth Justice.* https://doi.org/10.1177/1473225416665611

Koehler, J. A., Lösel, F., Akoensi, T. D., & Humphreys, D. K. (2013). A systematic review and meta-analysis on the effects of young offender treatment programs in Europe. *Journal of Experimental Criminology, 9,* 19–43. https://doi.org/10.1007/s11292-012-9159-7

Kupchik, A., & Snyder, R. B. (2009). The impact of juvenile inmates' perceptions and facility characteristics on victimization in juvenile correctional facilities. *The Prison Journal, 89,* 265–285. https://doi.org/10.1177/0032885509339505

Liebling, A. (2008). 'Titan' prisons: Do size, efficiency and legitimacy matter? In M. Hough, R. Allen, & E. Solomon (Eds.), *Tackling prison overcrowding* (1st Ed., pp. 63–80). Bristol University Press.

Lindsey, A. M., Mears, D. P., Cochran, J. C., Bales, W. D., & Stults, B. J. (2017). In prison and far from home: Spatial distance effects on inmate misconduct. *Crime & Delinquency, 63,* 1043–1065. https://doi.org/10.1177/0011128715614017

Lipsey, M. W., & Cullen, F. T. (2007). The effectiveness of correctional rehabilitation: A review of systematic reviews. https://doi.org/10.1146/annurev.lawsocsci.3.081806.112833

Lodewijks, H. P. B., de Ruiter, C., & Doreleijers, T. A. H. (2009). The impact of protective factors in desistance from violent reoffending: A study in three samples of adolescent offenders. *Journal of Interpersonal Violence.* https://doi.org/10.1177/0886260509334403

Lösel, F., & Farrington, D. P. (2012). Direct protective and buffering protective factors in the development of youth violence. *American Journal of Preventive Medicine, 43,* S8–S23. https://doi.org/10.1016/j.amepre.2012.04.029

Lowenkamp, C. T., & Latessa, E. J. (2005). Increasing the effectiveness of correctional programming through the risk principle: Identifying offenders for residential placement*. *Criminology & Public Policy, 4,* 263–290. https://doi.org/10.1111/j.1745-9133.2005.00021.x

MacKenzie, D. L. (2016). Evidence-based corrections: Identifying what works. *Crime & Delinquency.* https://doi.org/10.1177/0011128700046004003

Mikytuck, A. M., & Woolard, J. L. (2019). Family contact in juvenile confinement facilities: Analysis of the likelihood of and barriers to contact. *Journal of Offender Rehabilitation, 58,* 371–397. https://doi.org/10.1080/10509674.2019.1615600

Monahan, K. C., Goldweber, A., & Cauffman, E. (2011). The Effects of visitation on incarcerated juvenile offenders: How contact with the outside impacts adjustment on the inside. *Law and Human Behavior, 35,* 143–151.

NYC Administration for Children's Services. (2017). *Close to home* (Annual Report 2016-17). NYC

Robinson, A. (2015). The resilience motif: Implications for youth justice. *Youth Justice.* https://doi.org/10.1177/1473225415587601

Rowe, M., & Soppitt, S. (2014). 'Who you gonna call?' The role of trust and relationships in desistance from crime. *Probation Journal, 61*, 397–412.

Ryo, E., & Peacock, I. (2019). Beyond the walls: The importance of community contexts in immigration detention. *American Behavioral Scientist, 63*, 1250–1275. https://doi.org/10.1177/0002764219835269

Serin, R. C., Chadwick, N., & Lloyd, C. D. (2015). Dynamic risk and protective factors. *Psychology, Crime & Law*.

Shulman, C. (2016). Resilience in children and families. In C. Shulman (Ed.), *Research and practice in infant and early childhood mental health* (pp. 125–144). Springer International Publishing.

Souverein, F. A., Van der Helm, G. H. P., & Stams, G. J. J. M. (2013). 'Nothing works' in secure residential youth care? *Children and Youth Services Review, 35*, 1941–1945. https://doi.org/10.1016/j.childyouth.2013.09.010

Stouthamer-Loeber, M., Wei, E., Loeber, R., & Masten, A. (2004). Desistance from persistent serious delinquency in the transition to adulthood. *Development and Psychopathology, 16*, 897–918

Tighe, J., & Gudjonsson, G. H. (2012). See, Think, Act Scale: Preliminary development and validation of a measure of relational security in medium- and low-secure units. *The Journal of Forensic Psychiatry & Psychology, 23*, 184–199. https://doi.org/10.1080/14789949.2012.671336

Tollit, M., McDonald, M., Borschmann, R., Bennett, K., von Sabler, M., & Patton, G. (2015). *Epidemiological evidence relating to resilience and young people*. Victorian Health Promotion Foundation.

Ulrich, R. S. (2006). Essay: Evidence-based health-care architecture. *The Lancet, 368*, S38–S39. https://doi.org/10.1016/S0140-6736(06)69921-2

Ulrich, R. S., Bogren, L., Gardiner, S. K., & Lundin, S. (2018). Psychiatric ward design can reduce aggressive behavior. *Journal of Environmental Psychology, 57*, 53–66.

UN General Assembly. (1989). UN Convention on the Rights of the Child.

Ungar, M. (2008). Resilience across cultures. *British Journal of Social Work, 38*, 218–235. https://doi.org/10.1093/bjsw/bcl343

Ungar, M. (2013). Resilience after maltreatment: The importance of social services as facilitators of positive adaptation. *Child Abuse & Neglect, 37*, 110–115. https://doi.org/10.1016/j.chiabu.2012.08.004

Van der Helm, P., Beunk, L., Stams, G.-J., & Van der Laan, P. (2014). The relationship between detention length, living group climate, coping, and treatment motivation among juvenile delinquents in a youth correctional facility. *The Prison Journal*. https://doi.org/10.1177/0032885514524884

Van der Helm, G. H. P., Kuiper, C. H. Z., & Stams, G. J. J. M. (2018). Group climate and treatment motivation in secure residential and forensic youth care from the perspective of self determination theory. *Children and Youth Services Review, 93*, 339–344.

Van der Helm, P., Stams, G.-J., Van Genabeek, M., & Van der Laan, P. (2012). Group climate, personality, and self-reported aggression in incarcerated male youth. *The Journal of Forensic Psychiatry & Psychology, 23*, 23–39. https://doi.org/10.1080/14789949.2011.633615

van Dooren, K., Kinner, S. A., & Butler, T. (2010). Young prisoners: An important group for health research? *Journal of Correctional Health Care, 16*, 322–327.

van Dooren, K., Richards, A., Lennox, N., & Kinner, S. A. (2013). Complex health-related needs among young, soon-to-be-released prisoners. *Health Justice, 1*.

Villalobos Agudelo, S. (2013). *The impact of family visitation on incarcerated youth's behavior and school performance: Findings form the families and partners project*. Vera Institute.

Walker, S. C., & Bishop, A. S. (2016). Length of stay, therapeutic change, and recidivism for incarcerated juvenile offenders. *Journal of Offender Rehabilitation, 55*, 355–376. https://doi.org/10.1080/10509674.2016.1194946

Wartna, B., Alberda, D., & Verweij, S. (2013). Een meta-analyse van Nederlands recidiveonderzoek naar de effecten van strafrechtelijke interventies. *Tijdschrift voor Criminologie, 55*, 3–23.

Wener, R. (2012). *The environmental psychology of prisons and jails: Creating humane spaces in secure settings*. Cambridge University Press.

Young, B. C., & Hay, C. (2020). All in the family: An examination of the predictors of visitation among committed juvenile offenders. *Youth Violence and Juvenile Justice, 18*, 54–77. https://doi.org/10.1177/1541204019857123

Young-Alfaro, M. V. (2017). Students as threats: schooling inside a youth prison. *Anthropology & Education Quarterly, 48*, 301–317. https://doi.org/10.1111/aeq.12201

Zoettl, P. A. (2020). It's wrong, but that's the way it is. Youth, violence and justice in North-Eastern Brazil. *Social & Legal Studies*. https://doi.org/10.1177/0964663920915967

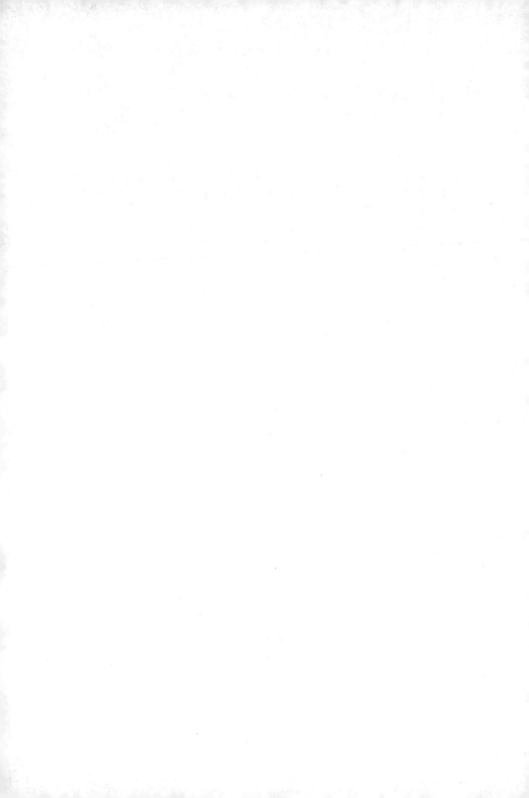

14

Designing a Rehabilitative Prison Environment

Jennifer Galouzis, Andrew Day, Stuart Ross, and Diana Johns

Introduction

What are the impacts of the built environment on those who live and work within prison, and how do these affect the rehabilitative capacity of institutions? Is rehabilitation possible in an institutional environment

J. Galouzis (✉)
Haymarket, NSW, Australia
e-mail: Jennifer.Galouzis@justice.nsw.gov.au

A. Day · S. Ross · D. Johns
University of Melbourne, Parkville, VIC, Australia
e-mail: day.a@unimelb.edu.au

S. Ross
e-mail: rosssr1@unimelb.edu.au

D. Johns
e-mail: diana.johns@unimelb.edu.au

that is often experienced as dehumanising and how can we better design rehabilitative prison environments? In exploring these questions, this chapter considers rehabilitation to be a process that occurs at the intersections of the physical, social and psychological spaces of the prison, drawing particular attention to the active role that the incarcerated person plays in the process. Rehabilitation is thus considered to be an essentially personal enterprise in so far as it is purposive but one that can be aided (or hindered) by the physical environment, the prison regime and the delivery of interventions and programmes. A rehabilitative prison environment is thus conceptualised as one where individual agency interacts with the physical, social and cultural conditions of the prison to enable positive change and personal development.

While many prisons are simply not "fit for purpose" when it comes to rehabilitative goals (Grant & Jewkes, 2015), the question remains as to what the prison-built environment should be like in order to promote well-being and affect transformation. It is our contention that applied models of rehabilitation have paid insufficient attention to how people experience the spaces and practices of incarceration and how this experience both inhibits and enables rehabilitative change. We argue that rehabilitation research has focussed too much on the individual in its efforts to examine the proximal causes of crime and the mechanisms that produce prosocial behaviour change. In doing so, it has contributed to an over-reliance on behaviour change programmes that aim to affect intrapersonal changes in cognitions, skills and knowledge that are associated with desistance from crime, with the prison environment too often reduced to simply the setting in which programmes are provided. This, we suggest, limits any possibilities for designing prisons that target social and institutional mechanisms of change.

In this chapter, we propose a multidisciplinary perspective of rehabilitation that offers an explanatory framework that explicitly links the built environment with the psychological processes of attending, acting, interpreting and remembering. In doing so we move away from viewing rehabilitation outcomes as having a linear cause and effect relationship with a single dimension of the prison experience, such as participation in behaviour change programmes. Rather we draw on the ecological systems-oriented paradigm to view it as a product of

the interaction between multiple person and environmental factors, where human behaviour is understood to be the product of interactions between an individual and the multiple structures and layers within their environment (Bronfenbrenner, 1979; McLeroy et al., 1988; Wapner & Demick, 2000; Stokols, 1992). Finally, we present a theoretical model of environment-behaviour relations that has the potential to identify new possibilities for how architectural factors might contribute to rehabilitative success. The model emphasises and engages with the heterogeneity of the built environment and the ways in which it is experienced by those who live and work within it. The result is an applied and ecologically informed model of rehabilitation that can help us to understand how and why prison environments produce different rehabilitative effects depending on the structure, function and interrelations of their component parts.

Rehabilitation as a Goal of Prison

Our starting point for this chapter is to reflect on the long and often brutal history of imprisonment in Western countries, and how this has left a legacy that even today impacts on how we conceptualise a rehabilitative custodial environment. Indeed, in the country in which we live and work, Australia, there is a well-documented history of extreme brutality in some of the earliest prisons established as part of the British Penal Colony in New South Wales. But, as Hollin (2019) has noted, the use of corporal punishment dates back much further in European countries to medieval times and is based on a rationale that draws on the classical explanation of criminal behaviour as *judicium dei*—the consequence of free and rational decision-making. This connects with the principle of *mens rea* (guilty intent) that lies at the heart of Western criminal law, whereby imprisonment is a response to individuals who must take sufficient personal responsibility for their behaviour. Since their earliest days, prisons have been designed to be places of both punishment and rehabilitation. While some of the early penitentiaries were based on the idea that rehabilitation would occur through solitary reflection, others were purposefully designed to punish. And at other times punishment

and rehabilitation have been conflated; with administrators of Victorian prisons in England arguing that "criminals can be deterred only by the terror of physical pain... ...[because] they are animals and must be treated as such'" (see Bethell, 2020, p. 14).

The advent of prison rehabilitation can be traced back to the articulation of a more utilitarian view that the purpose of punishment should extend beyond simply inflicting pain to assist—where possible—with the prevention of crime. It is now widely accepted that, in addition to punishing those who have broken the law, the State should also provide resources to help people "correct" themselves (O'Donnell, 2016). In Australia, the earliest attempts to rehabilitate occurred in 1840, when Captain Alexander Maconochie, then-governor of the prison on Norfolk Island, introduced the idea of indeterminate rather than fixed sentences, implemented a system of rewards through which prisoners could earn "marks" that counted towards their early release and advocated for a new system of community integration after release (Day, 2020). These were radical ideas, perhaps only possible to implement in such a remote setting but led directly to the development of what we now refer to as "parole" and provided the foundation for the behaviour modification approaches that were to become popular over 100 years later.

The development of rehabilitation in more contemporary prisons has been strongly influenced by psychological models of behaviour change, and, in particular, cognitive behaviour change programmes. Psychological attitudinal change models based on social learning theory underpin many modern rehabilitation initiatives and aim to reduce offending by targeting intrapersonal factors, which are both malleable and directly related to the causes of offending behaviour (see Bierie & Mann, 2017; Heseltine, Day & Sarre, 2011). The idea of *judicium dei* is implicit in these psychological models of rehabilitation and as a result service delivery is predicated on the goal of changing the individual; typically, by addressing the "defective social learning ... and skill deficits" that contribute directly to criminal behaviour (Casey et al., 2013, p. 36) as opposed to changing the social, physical or cultural aspects of the environment that have a cumulative effect on pro (or anti) social behaviour.

Even this somewhat cursory history of prison rehabilitation highlights the dominance of psychological models of "rehabilitation" that are based on the assumption of methodological individualism. As a result, the conceptualisation of rehabilitation has largely been restricted to the design and delivery of interventions that target intrapersonal factors but rarely target the physical, social and instructional components of the environment that influence behaviour. We argue that this way of thinking has constrained efforts to enact the rehabilitative ideal.

An Ecological Systems Approach to Prison Rehabilitation

The ecological systems paradigm offers a way to conceptualise rehabilitation as a process that is influenced by both individual and environmental factors and explicitly emphasises the interdependence of these factors. The transactional nature of the person-in-environment system views the rehabilitative environment as an "entity comprised of mutually defining aspects that constitute the whole ... that is, people embedded in physical, interpersonal and sociocultural environments" (Wapner & Demick, 2000, p. 26). From this perspective then, the rehabilitative prison environment is viewed as a social object that has causal powers that are not reducible to its discrete components. The specific question that arises is "what must the experience of the prison environment be like in order for rehabilitation to be possible?" Thus, providing new possibilities and opportunities for prison-based rehabilitation by delivering interventions that enhance the capacity of people who are in imprisoned as well as interventions that aim to change the expectations and characteristics of the physical and social environment (Walker et al., 2011).

The "prison environment" is defined as the micro-systems within the prison that are physically external to the person (Stokols, 1992). Adapting Bronfenbrenner (1979) and McLeroy et al.'s (1988) ecological systems models, we identify the micro-systems that operate within the boundaries of the prison as the *physical spaces*, which are defined as the material or tangible space and characteristics of the prison; the *cultural aspects*, which are defined as the shared values, expectations and

attitudes (Johnsen et al., 2011); the *instructional mechanisms*, which are defined as the policies and practices applied to induce particular attitudes and behaviours; and the *socially structured space*, which is defined as patterned relationships between people and groups as perceived by individuals within the prison (Tagiuri, 1968).

These micro-systems are also exposed to, and influenced by, a large number of external forces and events in the macro-environment (Laszlo & Krippner, 1998). While examination of the influence of macro-system factors is outside the scope of this chapter, we recognise their importance; the prison environment is clearly influenced by broader social structures such as social inequality, economic and welfare policy, policing practices and judicial systems. The physical and psychosocial expressions of punishment are recognised as *social products*, which serve certain instrumental functions, and as *cultural agents*, which create meanings, social identities and psychological satisfactions (Finnane, 2012). And, as Moran (2016) state prison-built environments reflect "the penal philosophy of the prevailing social system" (p. 115) as well as societies attitudes to prisoners. We also recognise that rehabilitation and the probability of future criminal behaviour is also influenced by ecological and micro-system characteristics of the social environments to which people return once released from prison (Wright & Cesar, 2013).

An important implication of the ecological systems approach is the need to clearly articulate the way in which rehabilitation progress and success is measured. In this chapter, we define rehabilitation success as psychological, behavioural and social changes that support prosocial lifestyles. In adopting this broad definition, we understand rehabilitation to be a "process that involves moving *away* from offending and *into* compliance with law and social norms" (McNeill, 2016, p. 148) and therefore we make a clear distinction between the psychological and structural changes that support the process of rehabilitation and the singular behavioural event (reoffending) that is commonly used as the binary measure of rehabilitative success. While behavioural events, such as reconviction or reimprisonment, are meaningful indications of prosocial change and rehabilitative success, measures of psychological and social change, such as clinically significant improvements in psychological health, changes in antisocial attitudes or changes in the social

norms, climate or culture within prison, are assumed to reflect the causal mechanisms than exist within the prison environment than enable rehabilitation to occur. In this way, measures of rehabilitation reflect the ultimate goal of desistance from crime but also recognise change as a process that is influenced by and must occur at the individual and structural levels of the prison environment.

A Multilevel Model of Prison-Based Rehabilitation

A causal model of a rehabilitative prison environment needs to offer a comprehensive and contextually sensitive way to understand environment-behaviour relations. If considered from a rehabilitative perspective, the role of the environment must be more than just the setting for specialised interventions. Instead, its role must be to produce the physical, cultural and psycho-social conditions that assist people to move towards positive and pro-social change. Consider, as an eloquent example, the spaces in prison that are made available for family visits to occur, including contact with children. While these physical spaces function to maintain family relationships, which is widely acknowledged to be important to rehabilitative success, it is unreasonable to assume that the transformative effect is produced simply because a person receives a visit. Instead, we recognise that the influence of prison visits on rehabilitative progress will differ depending on the complex interaction of multiple factors within the "socio-spatial" contexts in which visits occur (Moran, 2013). Extending this premise, we propose a causal model (Fig. 14.1) that articulates how sustainable rehabilitative progress emerges when all of the elements within the prison environment are complementary and contribute simultaneously to this goal. The prison environment is constructed as physical, cultural, instructional and social micro-systems that are both operationally applied and subjectively experienced. The model illustrates how multiple micro-systems within the prison environment interact to affect the attitudes and behaviour of those who live and work in prisons. In doing so, the focus moves from linear cause and effect relationships between singular elements, such as

prison visits or psychological programmes, and behavioural outcomes to an analysis of how the micro-systems and the relations between them allow the prison environment to generate particular outcomes.

Prison design and architecture are inherently connected to penal ideology (Frannson et al., 2018). By articulating this model, we argue for an ideology that moves away from a focus on risk (safety and security) and instead prioritises the creation of socio-spatial conditions that are supportive of rehabilitative change. We argue that a prison design that is deeply connected to a rehabilitation ideology will, by definition, be lower risk. In contrast, a design that is viewed through the lens of safety and security can operate to actively exclude the possibility of rehabilitative materialisation. What this chapter aims to do is articulate a causal model of the prison environment that will offer theoretical guidance in the design and delivery of rehabilitative prisons as well as an empirical framework to examine the relationships between the multiple environmental elements and rehabilitation outcomes.

Causal Properties

Central to our model is the hypothesis that the rehabilitative power of the prison environment is dependent on the structure (both components and relations) of its micro-systems producing three causal properties: support for basic psychological needs; prosocial skills and knowledge transfer and support for positive identity transformation. It is the emergence of these causal properties within the environment that allows the experience of prison to generate rehabilitative progress and success among those who are imprisoned. Thus, while the effects are explained at the intrapersonal level, their emergence is dependent on individual, social and institutional changes that occur as a result of the synergies between all of the microsystem elements of the environment and which are only possible when the prison design allows them to act synergistically.

In our model, we identify three causal properties through which prison rehabilitation occurs. Each causal property is assumed to build on the next in order to form a theoretical explanation of how the transactions between people and the prison environment facilitate the emergence of

14 Designing a Rehabilitative Prison Environment 393

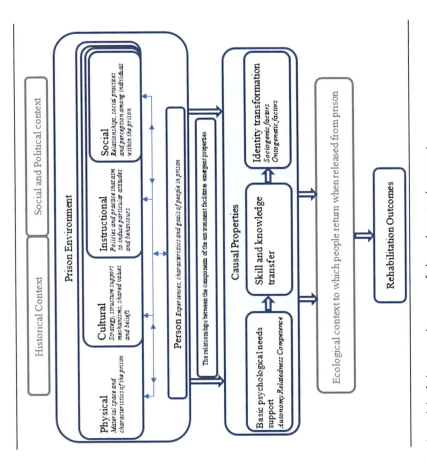

Fig. 14.1 Conceptual model of the causal power of the prison environment

rehabilitation processes and outcomes. In the remainder of this chapter, we focus on explaining each of the causal properties and how the interactions between the micro-systems within the prison environment create the conditions that allow these properties to emerge. We also provide a brief review and synthesis of empirical evidence that illustrates how this causal model can be used to integrate previously disparate research findings into a coherent evidence base for the design of a truly rehabilitative prison environment.

Psychological Need Satisfaction

The first causal property hypothesised in the model relates to individuals' motivation to initiate and persist in the process of change. The underlying assumption here is that motivation needs to be internalised in order for people to keep moving towards selected goals. This is based on strong evidence across a range of health-related behaviours (physical activity, smoking, diet and weight loss, medication adherence) that long-term or sustained behaviour change is unlikely if it is driven primary by external motivation (that is, motivation from rewards or punishments, or to avoid guilt or shame) (Gillison et al., 2019). In the prison environment, where motivation is most commonly external and imposed on people through various environmental techniques that aim to induce particular behaviours, this is a key challenge (Bunce, 2019).

Self-determination theory (SDT) (Deci & Ryan, 1985, 2000) offers the most comprehensive theoretical framework to understand how the transactions between people and their environment support or inhibit intrinsic motivation and genuine engagement in positive change. SDT proposes that when people experience a sense of autonomy, competence and relatedness to others, this in turn gives rise to high-quality forms of intrinsic motivation and engagement for activities. Conversely, when people perceive that they are being controlled or coerced, intrinsic or autonomous motivation (where actions are experienced as a result of volition and there is a sense of self-endorsement) is undermined. Thus, people are viewed as active, growth-oriented organisms who seek experiences that fulfil these fundamental needs through interaction with their

environment (Deci & Ryan, 1985). In the context of the prison environment, motivation and engagement in the process of rehabilitation are possible when the material spaces and practices provide people with opportunities to develop a sense of personal autonomy, competence and positive relationships with others.

The strength of SDT as a theoretical causal mechanism is that it "differentiates the *content* of goals or outcomes and the *regulatory process* through which the outcomes are pursued" (Deci & Ryan, 2000, p. 227). As such it shows how elements of the prison environment interact in ways that both deprive and satisfy the psychological needs of autonomy, competence and relatedness, which in turn affect individual motivation and engagement in the pursuit of goals and personal growth. Prisons are designed to deliberately control and restrict autonomy in spatial mobility, while at the same time rehabilitation professionals are often viewed as technocratic in the way they narrowly prescribe goal pursuits and achievements. These qualities of the prison environment are recognised as barriers to rehabilitation and sustained behaviour change (Graham, 2018; Hannah-Moffat, 2005). While the focus of rehabilitation programmes on addressing maladaptive attitudes and skill deficits associated with offending behaviour (Andrews & Bonta, 2010) is strongly oriented towards the psychological need for competency, it also risks inhibiting satisfaction of the needs for autonomy and relatedness that have been shown to be integral to keeping people moving towards goals (Deci & Ryan, 2000). While the prison context presents clear challenges for self-determination, ecological systems models of intervention that aim to promote self-determination have been applied to other social contexts, including public health (Zhang & Solomon, 2013), disability studies (Walker et al., 2011), and education (Waters et al., 2009), to successfully improve behavioural outcomes in other complex settings.

When the need to support self-determination is identified as a design consideration, questions of how prison architecture deliberately serves to restrict spatial and individual autonomy come to the fore. Carceral geographers conceptualise the prison environment as a space that is produced, contested and personalised. In doing so they emphasise the autonomy and social connections that people seek to find and exert even in the most controlled environments (McWaters, 2013). Thus, what matters is the

way in which those who are incarcerated can exert *autonomy* in, through and over the penal spaces they inhabit, establish a sense of *relatedness* through connections with others in the pursuit of goals and develop feelings of *competence* by knowing how to achieve progress towards goals and feeling confident in doing so (Bird, 2017; Bunce, 2019). The key question here, however, is how much is this related directly to the physical space (the buildings themselves) and how much is related to the social space (how the prison is managed and how the spaces are used)?

The ecological model proposed in this chapter hypothesises that the emergence of self-determined motivation requires both the physical and social spaces within the prison to interact in complementary and need supportive ways. This contention is supported by available empirical evidence for both the direct and indirect influence of prison design on peoples' experiences of autonomy, relatedness and competency. In 2016, Beijersbergen and colleagues explored the relationship between prison architecture and the quality of staff–prisoner relationships in Dutch prisons. Applying multilevel analyses, the study found that prisoner perceptions of relatedness with staff (characterised by perceptions of support and responsiveness to need) were significantly associated with the physical design of the prison. Prisoners reported the lowest levels of relatedness in prisons with panopticon layouts, while prisoners in campus-style prisons reported the highest levels of relatedness with staff, even after adjusting for prisoner characteristics and other site-level variables. The multilevel models developed in this study also found evidence that physical design features such as the percentage of multiple occupancy cells and the year of construction were associated with prisoner perceptions of relatedness with staff.

The interacting effect of the physical, instructional and social spaces within prison is illustrated in the detailed case study of a special handling unit for persistently violent and disruptive prisoners in Scotland, that describes how the promotion of spatial autonomy effectively fostered personal change and improved rehabilitation outcomes (Bird, 2017). Bird found that prisoner perceptions of personal autonomy and sense of relatedness (or social cohesion) were increased through the modification of the unit's existing physical space, instructional mechanisms and culture. Specifically, policies within the unit were changed to allow

prisoners increased freedom of movement within the unit and to allow physical spaces to be modified to make them more personalised and aesthetically interesting. The provision of flexibility to adjust key physical components of the unit, through the physical design, complemented by an operating philosophy and policy that afforded prisoners agency to adapt these elements to their preference, contributed to the satisfaction of the basic psychological need for autonomy. Democratic practices and principles were also implemented into the daily operation of the unit, which required prisoners and staff to develop a shared purpose and a sense of solidarity and relatedness. Through her analysis of detailed prisoner accounts of their experiences as well as administrative reports and correspondence, Bird (2017) concluded that the autonomy-enhancing elements of the unit allowed those imprisoned to experience profound gratification from their actions, through which they were able to reclaim a sense of dignity and power within the spatial restrictions of prison. This experience was associated with reduced physical assaults and incidents of disruption and facilitated "remarkable transformational stories" of desistance among some of the most persistently violent prisoners in the Scottish prison system (p. 112). The findings of this case study perhaps illustrate how the prison-built environment can influence the process of rehabilitation. However, it also demonstrates that the casual relationship between prison design and rehabilitation is not linear and is actually dependent on how the physical space interacts with the instructional and cultural elements of the environment to meet the needs of autonomy, relatedness and competence.

The role of autonomy in the process of rehabilitation is further supported by the finding that prisoners who experience and perceive a higher level of choice with regard to participation in meaningful activities reported a higher level of quality of life and that this relationship was partially explained by prisoner perceptions of volition and autonomy satisfaction (Van der Kaap-Deeder et al., 2017). Consistent with the ecological model we propose in the chapter, empirical evidence shows that prison environments are characterised by a staff culture that is less punitive, more personal and where authority is more consistently and appropriately applied, and where staff display authentic support for and belief in people's capacity to change, are more likely to be associated with

a greater sense of autonomy, relatedness and competence among prisoners. Prison environments in which people experience these contextual characteristics have been shown to be associated with improved quality of life in prison (Crew et al., 2011; Molleman & Leeuw, 2012; van Ginneken & Nieuwbeerta, 2020; van der Kaap-Deeder, et al., 2019) improved therapeutic gains (Blagden, et al., 2017; Stasch et al., 2018; van Ginneken and Niewbeerta, 2020; Woessner & Schwedler, 2014) and reduced reoffending (Auty & Liebling, 2020).

In our proposed model, prison design and regime are clearly interrelated (and we would suggest, more closely associated than is often assumed), although it is not possible to establish the relative and independent contributions that each makes to rehabilitative success in the absence of sophisticated multi-level modelling of the type that has yet to be conducted. As Karthaus et al. (2019) conclude "architecture is difficult to separate from other factors in the assessment of how successful a prison is in meeting its objectives, and perhaps for this reason it has not had the recognition it deserves" (p. 216). Nonetheless, we would argue that the capacity of the built environment to influence rehabilitation is through its contribution to the satisfaction of the basic psychological needs of autonomy, relatedness and competence. Ultimately these are questions that architects and prison designers might ask about the influence of the function, form, beauty and aesthetic of prison buildings and settings on the psychological experience of prison (see Jewkes, 2018; McConville, 2000).

Skill and Knowledge Development

The second mechanism that is hypothesised to be produced by the interaction between the multiple micro-systems within the prison environment is related to the development or transfer of skills and knowledge. Those who have a greater sense of self-determination are more likely to view formal opportunities for skill and knowledge development as positive and engage in the process (Deci & Ryan, 2000). Furthermore, while competence is about the perception of one's capabilities in achieving goals and outcomes, skill and knowledge development addresses specific

deficits that are assumed to contribute to an individual's offending behaviour as well as providing new social and vocational opportunities.

The theoretical articulation of how skill and knowledge acquisition facilitates rehabilitation is well developed (see Andrews & Bonta, 2010; McMurran et al., 2001; Polaschek, 2012) and meta-analyses have shown that prison environments that provide programmes and initiatives that facilitate skill and knowledge development produce improved rehabilitative outcomes (see Andrews & Dowden, 2006; Andrews et al., 1990). However, there is also evidence that the capacity of programmes to produce this causal mechanism varies across prison contexts (Lipsey & Cullen, 2007) and relatively little attention has been paid to questions of why and when change is most likely to occur. It is our contention that the effectiveness of these initiatives is dependent on how they interact with other elements of the prison environment.

There is currently limited empirical and theoretical research that has explored how prison spaces enable or inhibit prisoner skill and knowledge acquisition or how the physical environment affects the capacity of staff to deliver professional services (Hammerlin, 2018). In this chapter, we engage with pedagogical geography literature and specifically with the concept of "built pedagogy", which describes "the ability of the cultural, psychological and behavioural attributes of the physical space to shape both teaching and learning" (Byers et al., 2014, p. 7). This disciplinary approach offers possibilities for how the design of specific learning spaces in prison, such as classroom and group programme rooms, as well as other spaces within the prison can produce improved learning opportunities and success.

Drawing on school-based research, there is empirical evidence that modifications to traditional learning environments, on which many standard classroom and group room configurations in prison are based, can improve outcomes. Improved learning outcomes have been associated with classroom configurations that de-emphasise the front of the room and create both student-centred and instructor-centres spaces (Byers et al., 2014) and that enhance visual diversity (Barrett et al., 2015). Within a prison context, learning spaces that are more dynamic and fluid are likely to produce more democratic social relations between staff and prisoners, potentially improving social relations and learning outcomes.

These design elements are also aligned to humanistic ideals, where the value of those who are imprisoned is equal to those providing instruction and where people are perceived as being able to shape their own lives (Hammerlin, 2018).

The design principles that underpin the concept of "built pedagogy" were integrated into the design and construction of an intensive learning centre (ILC) within a maximum security prison in an Australian jurisdiction (Lulham et al., 2015) where flexibility, visual complexity and the integration of natural and outdoor spaces were integral to the design. It was recognised that the design brief for this learning centre would be considered antithetical to the regime of containment and security of a prison but that it was closely aligned to the ideals of rehabilitation. While research exploring the impact of this centre on learning and rehabilitation outcomes has not yet been undertaken, the post occupancy evaluation of the ILC found that both staff and prisoners used and experienced the learning space in ways that were distinctly different from how they experienced the broader prison (Lulham et al., 2015). In particular, the space was experienced as more relaxed, less austere and as conducive to adult learning, supporting the importance of physical design in creating learning and rehabilitative environments.

The ecological systems model of a rehabilitative environment proposed in this chapter recognises that in order for people to develop the skills and knowledge required for rehabilitative success, the principles of built pedagogy need to permeate all areas of a prison's design. The localisation of specialised learning or therapeutic spaces with a broader prison environment that is experienced as dehumanising and disempowering will inhibit the generalisation of skills and knowledge. The identification of countervailing influences within the prison context through ecological analysis improves our understanding of variations in the rehabilitative effectiveness of programmes and initiatives. Ultimately, the transfer of skills and knowledge requires synergistic interactions between the quality and content of formal learning programmes (both education and behaviour change programmes) and the material and social spaces in which learning takes place and in which it is rehearsed and reinforced.

Identity Transformation

The third mechanism articulated in the model is based on identity transformation theories of rehabilitation, which focus on those factors that are associated with prosocial change (LeBel et al., 2008; Maruna, 2001) and as an ongoing and individualised process of transition. Cognitive change and shifts in personal narratives are viewed as fundamental to the process, with sustained commitment and momentum towards leading a crime-free life thought to result from personal transformation towards a prosocial narrative and identity which is incompatible with crime and deviance. Stevens (2012) articulates the process of identity transformation as a "purposive and agentic reconstruction of identity and narrative reframing so that a new and better person emerges whose attitudes and behaviors cohere with long term desistance from crime" (p. 527).

It must be recognised that for some people who attribute their successful desistance from crime to the construction of a new pro-social identity, "their prison sentence played little role in their transformation" (Schinkel, 2014, p. 103). But for others, experiences within prison are recognised as instrumental in this transition. Phenomenological research has found that the process of identity change among people in prison is connected with the satisfaction of psychological needs of autonomy, competence and relatedness as well as with opportunities to engage in formal education, training and cognitive behavioural programs (e.g., Petrich, 2020). For Aresti (2011):

> Self-change involved the men undergoing cognitive/psychological shifts which were crucial to the progressive shift in their world view. In the very early stages of the transitional period, these subjective changes appeared to be provisional, as the successful mastery of more immediate goals were instrumental in laying the foundations for the later stabilisation of the perceptual shift. (p. 135)

To date, identity transformation theorists have had only limited engagement with questions concerning the role and influence of the physical and social prison environment (Hart & van Ginneken, 2017; Maruna & Toch, 2005; Weaver, 2019), which is recognised as counterproductive

because it breaks social bonds and imposes stigma and social exclusion, inhibiting the possibility of positive identity transformation (Hart & van Ginneken, 2017; Johns, 2018). Nonetheless, consideration of how prison spaces could be designed in ways that enable transformation is worthwhile, recognising human beings as "organisms who develop plans and intentionally modify themselves and their environments in order to achieve their goals" (Gobbels et al., 2012, p. 457).

The penal ideology of normalisation offers opportunities to inform prison design in ways that are supportive of shifts in personal narratives and identity change. Prisoner perceptions and attitudes towards the built environment within prison are likely to affect the ways in which they experience and construct the spaces within it and engage with rehabilitative possibilities. Thus, the normalisation of prison physical designs through the creation of "material, architectural and interior conditions, which aim to reduce the institutional atmosphere" (Hammerlin, 2018, p. 261) can promote the construction of a pro-social identity. When coupled with socially structured prison spaces that are informed by the principles of humanism, the social and material conditions of prison can promote normalisation to support identity transformation.

The concepts of neutral and transitional spaces (Green, 2012; Rajendran, 2014) also offer possibilities for the design of transformative prison environments. Neutral spaces are those that do not have a prescribed function or purpose, instead they allow people the freedom to choose how they engage with the space, both emotionally and behaviourally. Within a prison context, the creation of neutral spaces provides relief from the spatial emplacement created through the highly structured and controlled environment of prison (Hancock & Jewkes, 2011). As Rajendran (2014) articulates, the activities generated within these spaces "unconsciously encourages more meaningful engagement with the environment to allow a sense of identity to emerge implicitly" (p. 102). These spaces can also be places of transition, where people are able to reflect on and confront the effects of their actions on themselves and others and explore the changes that have or are occurring in one's life (Green, 2012). In this way, neutral and transitional spaces enable identities to be negotiated and (re)constructed (Bird, 2017; Rajendran, 2014).

The complex relationship between identity-people-place creates challenges in understanding the role of the built environment (Rajendran, 2014), particularly within the context of prison. However, the model proposed in this chapter offers opportunities for greater theoretical and empirical consideration of how an understanding of the physical, cultural, instructional and social micro-systems within prison interact to create spatial practices. This framework can then inform the design and operation of prisons to facilitate positive identity construction and transformation.

Conclusion

As carceral geographers have observed, representations of prison space need to acknowledge the "infinite diversity of singular experiences of 'doing time' across different contexts... so that no final meaning about prison can ever be reductively generalized" (McWaters, 2013, p. 215). This contention is supported by Moran and Jewkes (2015) who argue that a holistic and multidisciplinary approach is required when researching the prison environment. In this chapter we have observed how excessive punishment in our prisons has come to be viewed as unnecessary, inhuman and even counterproductive and, in contemporary contexts, how the notion of rehabilitation has come to assume greater prominence. However, it is also clear that prison environments are still often experienced as punitive (Arrigo & Milovanovic, 2009; Crewe, 2009; Irwin & Owen, 2005) and considerable uncertainty exists about how different types of custodial designs and regime address the competing goals of punishment and rehabilitation. We also suggest that, too often, rehabilitation research has been focussed on the functions and outcomes of imprisonment, and the context in which rehabilitation takes place is rarely considered. Just as important is the need to identify the mechanisms by which rehabilitation occurs and, in this chapter, we have presented a theoretical framework to integrate interdisciplinary research to explain how the elements of a prison environment interact to produce and support personal change. The model presented here is, however, not intended to be exhaustive but to simply serve as a device that can be

used to illustrate how the identification of different causal mechanisms can help to integrate interdisciplinary research in ways that advance our understanding of prison rehabilitation.

A key issue that has emerged in writing this chapter is the extent to which the material design of a prison is confused with the practice of prison operations. Often the two are considered to be interchangeable and yet it is apparent that it is quite possible to deliver rehabilitative regimes in inadequate settings, just as it is possible to be punitive in the very best-designed facilities. The extent to which the physical infrastructure exerts a substantive influence on the regime is an area that requires further consideration and that can be facilitated by the theoretical model presented in this chapter. Finally, we would argue that while the model presented in this chapter recognises that the experience of a rehabilitative prison environment is personal and individualistic, the proposed mechanisms that articulate how change can occur as a function of being embedded in a prison context need to be empirically tested. Nonetheless, in a context in which the very notion of correctional rehabilitation has been the subject of extensive examination and problematisation (see Raynor & Robinson, 2005; Ward & Maruna, 2007), we hope that this chapter has convincingly argued for the need to develop methods that capitalise on the impacts of the physical, technical and social operation of the prison on successful rehabilitation.

References

Andrews, D. A., & Bonta, J. (2010). Rehabilitating criminal justice policy and practice. *Journal of Experimental Criminology, 4*, 451–476.

Andrews, D. A., & Dowden, C. (2006). Risk principle of case classification in correctional treatment: A meta-analytic investigation. *International Journal of Offender Therapy and Comparative Criminology, 50*, 88–100.

Andrews, D. A., Zinger, I., Hoge, R., & Bonta, J. (1990). Does correctional treatment work? A clinically relevant and psychologically informed meta-analysis. *Criminology, 28*(3), 369–404. https://doi.org/10.1111/j.1745-9125.1990.tb01330.x

Aresti, A. (2011). *Doing time after time: A hermeneutic phenomenological understanding of reformed prisoners' experiences of self-change, identity and career opportunities* (PhD). University of London.

Arrigo, B., & Milovanovic, D. (2009). *Revolution in penology: Rethinking the society of captives.* Rowman & Littlefield.

Auty, K. M., & Liebling, A. (2020). Exploring the relationship between prison social climate and reoffending. *Justice Quarterly, 37*(2), 358–381.

Barrett, P., Davies, F., Zhang, Y., & Barrett, L. (2015). The impact of classroom design on pupils' learning: Final results of a holistic, multi-level analysis. *Building and Environment, 89*, 118–133.

Beijersbergen, K., Dirkzwager, A., van der Laan, P., & Nieuwbeerta, P. (2016). A social building? Prison architecture and staff-prisoner relationships. *Crime and Delinquency, 62*(7), 843–874. https://doi.org/10.1177/0011128714530657

Bethell, B. (2020). You cease to be a man: masculinity and the gentleman convict, c.1870-1914. *Prison Service Journal, 249*, 11–16.

Bierie, D. M., & Mann, R. E. (2017). The history and future of prison psychology. *Psychology, Public Policy, and Law, 23*(4), 478–489. https://doi.org/10.1037/law0000143

Bird, J. (2017). Spatial autonomy and desistance in penal settings. Case study: The Barlinnie Special Unit (1973–1994). In E. L. Hart & E. van Ginneken (Eds.), *New perspectives on desistance.* https://doi.org/10.1057/978-1-349-95185-7_6

Blagden, N., Perrin, C., Smith, S., Gleeson, F., & Gillies, L. (2017). "A different world" exploring and understanding the climate of a recently re-rolled sexual offender prison. *Journal of Sexual Aggression, 23*(2), 151–166.

Bronfenbrenner, U. (1979). *The ecology of human development.* Harvard University Press.

Bunce, A. (2019). *"What we're saying makes sense so I've subscribed to it and I try to live by it": A qualitative exploration of prisoners' motivation to participate in an innovative rehabilitation programme through the lens of self-determination theory* (PhD). University of Surrey.

Byers, T., Imms, W., & Hartnell-Young, E. (2014). Making the case for space: The effect of learning spaces on teaching and learning. *Curriculum and Teaching, 29*(1), 5–19.

Casey, S., Day, A., Vess, J., & Ward, T. (2013). *Foundations of offender rehabilitation.* Routledge.

Crewe, B. (2009). *The society of captives: Power, adaptation and social life in an English prison.* Oxford University Press.

Crewe, B., Liebling, A., & Hulley, S. (2011). Staff culture, use of authority and prisoner quality of life in public and private sector prisons. *Australian & New Zealand Journal of Criminology, 44*(1), 94–115.

Day, A. (2020). At a crossroads? Offender rehabilitation in Australian prisons. *Psychiatry, Psychology and Law*.https://doi.org/10.1080/13218719.2020.1751335

Deci, E., & Ryan, R. (1985). *Intrinsic motivation and self-determination in human behavior*. Plenum.

Deci, E., & Ryan, R. (2000). The "what" and "why" of goal pursuits: Human needs and self-determination of behaviour. *Psychology Inquiry, 11*(4), 227–268.

Finnane, M. (2012). The origins of criminology in Australia. *Australian & New Zealand Journal of Criminology., 45*(2), 157–178. https://doi.org/10.1177/0004865812443682

Frannson, E., Giofre, F., & Berit, J. (2018). *Prison architecture and humans*. Cappelen Damm Akademisk.

Gillison, F. B., Rouse, P., Standage, M., Sebire, S. J., & Ryan, R. M. (2019). A meta-analysis of techniques to promote motivation for health behaviour change from a self-determination theory perspective. *Health Psychology Review, 13*(1), 110–130. https://doi.org/10.1080/17437199.2018.1534071

Gobbels, S., Ward, T., & Willis, G. (2012). An integrative theory of desistance from sex offending. *Aggression and Violent Behavior, 17*, 453–462.

Graham, H. (2018). *Rehabilitation work: Supporting desistance and recovery*. Routledge.

Grant, E., & Jewkes, Y. (2015). finally fit for purpose: The evolution of Australian prison architecture. *The Prison Journal, 95*, 223–243.

Green, M. (2012). So what exactly is transitional space? *Transitional Space "Enabling Change"*. http://changets.wordpress.com/2012/01/23/so-what-exactly-is-transitional-space/

Hammerlin, Y. (2018). Materiality, topography, prison and 'Human Turn'—A theoretical short visit. In E. Frannson, F. Giofre, & J. Berit (Eds.), *Prison architecture and humans*. Cappelen Damm Akademisk.

Hancock, P., & Jewkes, Y. (2011). Architectures of incarceration: The spatial pains of imprisonment. *Punishment & Society, 13*(5), 611–629.

Hannah-Moffat, K. (2005). Criminogenic needs and the transformative risk subject: Hybridizations of risk/need in penality. *Punishment & society, 7*(1), 29–51.

Hart, E., & van Ginneken, E. (2017). *New perspectives on desistance: Theoretical and empirical developments*. Palgrave Macmillan.

Heseltine, K., Day, A., & Sarre, R. (2011). *Prison-based correctional offender rehabilitation programs: The 2009 national picture in Australia*. Research and public policy series no. 112. Australian Institute of Criminology.

Hollin, C. (2019). What is Cognitive Behavioral Therapy (CBT) with offenders? In D. Polaschek, A. Day & C. Hollin (Eds.), *The Wiley international handbook of correctional psychology*. Wiley https://doi.org/10.1002/9781119139980.ch39

Irwin, J., & Owen, B. (2005). Harm and the contemporary prison. In A. Liebling & S. Maruna (Eds.), *The effects of imprisonment*. Willan Publishing.

Jewkes, Y. (2018). Just design: Healthy prisons and the architecture of hope. *Australian and New Zealand Journal of Criminology, 51*(3), 319–338. https://doi.org/10.1177/0004865618766768

Johns, D. (2018). Confronting the disabling effects of imprisonment. *Social Justice, 45*(1), 27–56. https://doi.org/10.2307/26677645

Johnsen, B., Granheim, P. K., & Helgesen, J. (2011). Exceptional prison conditions and the quality of prison life: Prison size and prison culture in Norwegian closed prisons. *European Journal of Criminology, 8*(6), 515–529. https://doi.org/10.1177/1477370811413819

Karthaus, R., Block, L., & Hu, A. (2019). Redesigning prison: The architecture and ethics of rehabilitation. *The Journal of Architecture, 24*(2), 193–222. https://doi.org/10.1080/13602365.2019.1578082

Laszlo, A., & Krippner, S. (1998). Systems Theories: Their Origins, Foundations, and development. Systems Theories and a Priori Aspects of Perception, 47–74. https://doi.org/10.1016/S0166-4115(98)80017-4

LeBel, T. P., Burnett, R., Maruna, S., & Bushway, S. (2008). The 'chicken and egg' of subjective and social factors in desistance from crime. *European Journal of Criminology, 5*(2), 131–159. https://doi.org/10.1177/1477370807087640

Lipsey, M. W., & Cullen, F. T. (2007). The effectiveness of correctional rehabilitation: A review of systematic reviews. *Annual Review of Law and Social Science, 3*, 297–320. https://doi.org/10.1146/annurev.lawsocsci.3.081806.112833

Lulham, R., Munro, B., Tomkin, D., Wong, G., & Kashyap, K. (2015). *Intensive learning centre building evaluation* (pp. 1–63). University of Technology Sydney & Corrective Services NSW partnership project, no. 3. University of Technology.

Maruna, S. (2001). *Making good: How ex-convicts reform and rebuild their lives*. American Psychological Association.

Maruna, S., & Toch, H. (2005). The impact of imprisonment on the desistance process. In J. Travis, & T. Vishner (Eds.), *Prisoner reentry and crime in America*. Cambridge.

McConville, S. (2000). The architectural realization of penal ideas. In L. Fairweather and S. McConville (Eds.), *Prison architecture: Policy, design, and experience*. Architectural Press.

McLeroy, K., Bibeau, D., Stecjler, A., & Glanz, K. (1988). An ecological perspective on health promotion programs. *Health Education Quarterly, 15*(4), 351–377.

McMurran, M., Fyffe, S., McCarthy, L., Duggan, C., & Latham, A. (2001). "Stop and think!": Social problem-solving therapy with personality-disordered offenders. *Criminal Behaviour and Mental Health, 11*, 273–285.

McNeill, F. (2016). The collateral consequences of risk. In C. Trotter., G. McIvor., & F. McNeill (Eds). *Beyond the risk paradigm in criminal justice*. Palgrave

McWaters, M. (2013). Poetic testimonies of incarceration: Towards a vision of prison as manifold space. In D. Moran (Ed.), *Carceral spaces: Mobility and agency in imprisonment and migrant detention*. Routledge.

Molleman, T., & Leeuw, F. (2012). The influence of prison staff on inmate conditions: A multilevel approach to staff and inmate surveys. *European Journal of Criminal Policy Research, 18*, 217–233.

Moran, D. (2013). Carceral geography and the spatialities of prison visiting: Visitation, recidivism, and hyperincarceration. *Environment and Planning D: Society and Space, 31*, 174–190. https://doi.org/10.1068/d18811

Moran, D., & Jewkes, Y. (2015). Linking the carceral and the punitive state: A review of research on prison architecture, design, technology and the lives experience of carceral space. *Annales de Géographie, 702–703*(2), 163–184. https://doi.org/10.3917/ag.702.0163

Moran, D., Jewkes, Y., & Turner, J. (2016). Prison design and carceral space. In Y. Jewkes, J. Bennett & B. Crewe (Eds.), *Handbook on prisons* (2nd Ed.). Routledge.

O'Donnell, S. (2016). The aims of imprisonment. In Y. Jewkes, J. Bennett & B. Crewe (Eds.), *Handbook on prisons* (2nd Ed.). Routledge

Petrich, D. (2020). A self-determination theory perspective on human agency, desistance from crime, and correctional rehabilitation. *Journal of Development and Life-Course Criminology*. https://doi.org/10.1007/s40865-020-00141-9

Polaschek, D. (2012). An appraisal of the risk–need–responsivity (RNR) model of offender rehabilitation and its application in correctional treatment. *Legal*

and Criminological Psychology, 17(1), 1–17. https://doi.org/10.1111/j.2044-8333.2011.02038.x

Rajendran, L. P. (2014). *An interdisciplinary socio-spatial approach towards understanding identity construction in multicultural urban spaces* (Unpublished doctoral dissertation). The University of Sheffield, England.

Raynor, P., & Robinson, G. (2005). *Rehabilitation*. Palgrave Macmillan.

Schinkel, M. (2014). *Being imprisoned: Punishment, adaptation and desistance.* Springer.

Stasch, J., Yoon, D., Sauter, J., Hausam, J., & Dahle, K.-P. (2018). Prison climate and its role in reducing dynamic risk factors during offender treatment. *International Journal of Offender Therapy and Comparative Criminology., 62*(14), 4609–4621. https://doi.org/10.1177/0306624X18778449

Stokols, D. (1992). Establishing and maintaining health environments: Towards a social-ecology of health promotion. *American Psychologist, 47*, 6–22.

Stevens, A. (2012). "I am the person now I was always meant to be": Identity reconstruction and narrative reframing in therapeutic community prisons. *Criminology and Criminal Justice, 12*(5), 527–547.

Tagiuri, R. (1968). The concept of organizational climate. In R. Tagiuri & G. Litwin (Eds.), *Organization climate: Explorations of a concept* (pp. 11–34). Harvard University.

van der Kaap-Deeder, J., Audenaert, E., van Mastrigt, S., Mabbe, E., & Vansteenkiste, M. (2017). Choosing when choices are limited: The role of perceived afforded choice and autonomy in prisoner's well-being. *Law and Human Behaviour, 41*(6), 567–578. https://doi.org/10.1037/lhb0000259

van der Kaap-Deeder, J., Audenaert, E., Van Petegem, S., Vandevelde, S., Van Mastrigt, S., Aelterman, N., & Vansteenkiste, M. (2019). The internalization of and defiance against rules within prison: The role of correctional officers' autonomy-supportive and controlling communication style as perceived by prisoners. *Motivation and Emotion, 43*, 771–785. https://doi.org/10.1007/s11031-019-09766-w

van Ginneken, E. F. J. C., & Nieuwbeerta, P. (2020). Climate consensus: A multilevel study testing assumptions about prison climate. *Journal of Criminal Justice, 69*, 1–13. https://doi.org/10.1016/j.crimjus.2020.101963

Walker, H., Calkins, C., Wehmeyer, M., Walker, L., Bacon, A., Palmer, S., Jesien, G., Nygren, M., Heller, T., Gotto, G., Abery, B., & Johnson, D. (2011). A social-ecological approach to promote self-determination. *Exceptionality, 19*, 6–18. https://doi.org/10.1080/09362835.2011.537220

Wapner, S., & Demick, J. (2000). Person-in-environment psychology: A holistic, developmental, systems-oriented perspective. In W. B. Walsh, K. H. Craik, & R. H. Price (eds.), *Person-environment psychology: New directions and perspectives*. Taylor & Francis.

Ward, T., & Maruna, S. (2007). *Key ideas in criminology. Rehabilitation: Beyond the risk paradigm*. Routledge. https://doi.org/10.4324/9780203962176

Waters, S. K., Cross, D. S., & Runions, K. (2009). Social and ecological structures supporting adolescent connectedness to school: A theoretical model. *Journal of School Health, 79*(11), 516–524. https://doi.org/10.1111/j.1746-1561.2009.00443.x

Weaver, B. (2019). Understanding desistance: A critical review of theories of desistance. *Psychology, Crime and Law, 25*(6), 641–658. https://doi.org/10.1080/1068316X.2018.1560444

Woessner, G., & Schwedler, A. (2014). Correctional treatment of sexual and violent offenders: Therapeutic change, prison climate, and recidivism. *Criminal Justice and Behavior, 41*(7), 862–879.

Wright, K., & Cesar, G. (2013). Toward a more complete model of offender reintegration: Linking the individual-, community-, and system-level components of recidivism. *Victims & Offenders, 8*(4), 373–398. https://doi.org/10.1080/15564886.2013.803004

Part III

Designing for Imprisoned Populations

15

How Prison Spaces Work on Bodies: Prison Design in the Norwegian Youth Units

Elisabeth Fransson

The Normative Demands behind "Child Friendly" Designs

The Norwegian youth units (YUs) are high security prisons for children and youths between 15 and 18 years of age. The units are organized under the umbrella of the Norwegian Correctional Services. The YUs are built upon two legal frames: the Norwegian Execution of Sentences Act[1] and the UN's Convention on the Rights of the Child that entered into

[1] https://lovdata.no/dokument/NLE/lov/2001-05-18-21?q=straffegjennomf%C3%B8ringsloven.

E. Fransson (✉)
Department of Correctional Studies, The University College of Norwegian Correctional Services (KRUS), Lillestrøm, Norway
e-mail: elisabeth.fransson@krus.no; elisabeth.fransson@vid.no

Faculty of Social Work, VID Specialized University, Oslo, Norway

force in Norway in 1991.[2] Pursuant to the Human Rights Act of 21 May 1999 No. 30 § 2 No. 4, the convention shall be applied as Norwegian law. This means that if there is a conflict between the Convention of the Rights of the Child and the Execution of Sentences Act, the Rights of the Child shall prevail.[3] According to the Convention of the Right of the Child, article 3 no. 1, *the best interest of the child* should be the leading principle. Article 37, no. b and c, states that the detention or imprisonment of a child shall take place in a lawful manner and shall only be used as a last resort and for the shortest possible period and that any child deprived of his or her liberty should be kept separate from adults. Article 40 no 1 states:

> States Parties recognize the right of every child alleged as, accused of, or recognized as having infringed the penal law to be treated in a manner consistent with the promotion of the child's sense of dignity and worth, which reinforces the child's respect for the human rights and fundamental freedoms of others, and which takes into account the child's age and the desirability of promoting the child's reintegration and the child's assuming a constructive role in society.

The UN Special Rapporteur on Torture and ill-Treatment of children deprived of their liberties emphasized in its 2015 report that children and young people are particularly vulnerable to human rights violations and that their threshold for when treatment or punishment is torture or ill-treatment is lower than that for adults.

Thus far, Norway has two YUs. They are placed in different regions of Norway and are both small institutions with four youths in each. A central political goal was that these units should be different than ordinary prisons. The difference was supposed to lie both in positioning the units away from other prisons in central areas and in the units' normative demands according to the principles of "the best interest of the child" that build upon the UN's Convention on the Rights of the Child, with a focus on care and rehabilitation:

[2] https://www.ohchr.org/en/instruments-mechanisms/instruments/convention-rights-child.
[3] General Comment No 5 (2003) § 20.

The units shall be operated according to milieu therapeutic principles and have interdisciplinary staffing supervised by an interdisciplinary team with high competence regarding the needs of vulnerable children and young people. (Mandate for interdisciplinary teams at the special units for offenders between 15 and 18 years, i.e., youth units, 15th of May 2012, author's translation)

Each unit is organized into a basis team and an interdisciplinary team. The basis team consists of 24–30 staff members. Half of the staff members are prison officers, and the other half specialize in social work that usually covers professions such as child welfare workers, social workers, and teachers. Prison officers in Norway are educated at the University College of Norwegian Correctional Service and have two years of education leading to a degree as a university college graduate in correctional studies.[4] The interdisciplinary team consists of one position as psychologist, one professional child welfare coordinator, and a school coordinator; one of the units also has a medical doctor for some hours each week. Both health, school, child welfare, and priests are in Norway imported services, which means that the representatives of these services are paid and organized by communes or regions but work inside prisons (Johnsen & Fridhov, 2018).

The principle of "normality" is a central normative demand both in the UN's Convention on the Rights of the Child, the Execution of Sentences Act, and Norwegian penal policy (White Paper 37 [2007–2008]).[5] This means that the punishment is the restriction of liberty. Beyond this, sentenced youths have the same rights as other youths regarding school, health, child welfare, and social services, and no one should serve their sentence under stricter circumstances than necessary. During the serving of a sentence, life inside should resemble life outside as much as possible.

Small units, few prisoners, enough well-educated staff, correctional services that build upon the normative principles of "the best interest

[4] Since 2019, KRUS also offers a supplementary course to achieve a bachelor's degree in correctional studies, and the political goal is that their future education becomes a bachelor's degree.
[5] White papers are programmes that come from the ministries.

of the child", "normality", and milieu therapeutic principles are all elements that may be connected to the concept Nordic penal exceptionalism (Pratt, 2008). This type of exceptionalism is connected to the Nordic welfare states that are characterized by an egalitarian and collaborative culture in which humanism is a central value. Comparing Norway with other countries may, on the other hand, overlook variations in Norway and reproduce discourses of Norway as exceptional (see Ugelvik & Dullum, 2012). It is also important to stress that there is often a gap between ideals and reality. In fact, the European Committee for the Prevention of Torture and Inhuman or Degrading Treatment of Punishment (CPT, 2011, 2018) has criticized Norway both for placing children together with adults in prison and for the use of isolation. As we are speaking youths under 18 years of age also sit in ordinary prisons in Norway together with adults (Interview staff). Since prison design does not necessarily work or function in compliance with normative principles, the various designs therefore must be studied empirically.

Ethnographic Prison Research

Ethnographic research focuses on specific contexts and complexities within these contexts. This involves being interested in social-material conditions, the use of space, what people do, how they act, and why, with reference to what normative arguments cause them to act the way they do. Ethnography often focuses on small situations and tries to understand what happens in time and space using thick descriptions (Drake et al., 2015; Geertz, 1973). In this chapter, attention is drawn to how prison design and prison space work on bodies and how staff and youths experience this design. Ethnography is both descriptive and interpretive work and requires the researcher to be able to see her own constructions, in addition to the material, and how she as an agent is part of the construction of the field (Herzog & Zacka, 2017). Ethnography usually requires a long immersion time, but in the Norwegian youth units, a long immersion time was impossible since doing so would have interfered too much with the everyday prison life. As in our case, an understanding may also be developed by examining texts and cultural

artefacts, conducting interviews, and having informal conversations or site visits (Drake et al., 2015). Since the empirical material does not speak for itself, how the researcher is able to connect normative values on various levels and combine these connections with academic reflections is important (Herzog & Zacka, 2017).

The material on which this chapter is based is a prison ethnographic study that stretched over five years, from 2013 to 2018.[6] The material consists of documents, topographical material, interviews, and site visits. The documents that were particularly relevant are White Paper 37 (2007–2008),[7] the Norwegian Execution of Sentences Act, and the UN's Convention on the Rights of the Child. The topographic material was obtained through satellite images from Google Earth Pro and provides information about the location of the units within their topographic landscape (Giofrè et al., 2018). In the period 2014–2018, we made 25 site visits to the two youth units and had interviews with 23 employees and 12 young people, some of whom we interviewed more than once. The interviews were of different natures. We had focus groups with employees and individual conversations with both employees and young people. In the conversations, we used an open interview approach. The initial conversations were recorded and transcribed; eventually, we switched to taking notes by hand. We assured the quality of the material by sending it to members of the research group to ensure that we captured what was said and that group members understood the material in the same way. At one of the units, we were present in overlapping meetings and during reports, and we also had lunch and dinners with the staff and young people. To catch up with changes within the youth units from 2018 until the current spring of 2021, the material has been enhanced with follow-up conversations with leaders, one youth, and a representative from the Directorate for Correctional Services that were conducted during the summer of 2020 and the spring of 2021. Also new photos have been taken. The research project was approved by the Norwegian Centre for Research Data (NSD), and I have actively related

[6] Fransson, E., Hammerlin, Y., & Skotte, S. E. (2019). *Children in Prison*, A KRUS Report (in Norwegian).

[7] White papers are programmes that come from the ministries.

the research to the national ethical guidelines for the social sciences and humanities.[8] Both the leaders, the youth, and the representative from the Directorate for Correctional Services who were interviewed during the summer of 2020 and the spring of 2021 have had the option to comment on the article and have done so.[9] To ensure anonymity, the current text remains at the institutional level and uses general terms such as employees and young people in YU West and YU East.

Sameness and Differences Between the Youth Units

YU West was established in 2009, and YU East was established in 2016. Both units had to address the specific demands in the Norwegian Sentences Act, as well as the UN's Convention on the Rights of the Child. Since the new guidelines on the execution of sentences for minors were not released until January 2018, this meant that the Sentences Act for adults was used as the main framework, even though the two units tried to find a balance between "stretching the penal code" and "making individual considerations" (Fransson et al., 2019). The prison units were established in two various regions with different cultures and within different economic budget situations.

Both YU West and YU East are located well outside major cities and are not a part of their local communities. This location prevents geographical integration with the local community, which is a central idea in modern prison architecture (Dalemark, 2020; Fagnoni, 2018). The positioning of the units makes it demanding for family and friends to visit and conflicts with the principle of normality, where youth should be able to be part of society. Table 15.1 illustrates examples of sameness and differences between YU West and YU East regarding prison design, regional influence, and local cultures.

[8] https://www.forskningsetikk.no/en/about-us/our-committees-and-commission/nesh/.

[9] A deep thank you to the youths, staff, and leaders for their important contributions to this article.

Table 15.1 An ideal-typical model illustrating the two prisons

	YU West	YU East
Prison design	Small and new building mass, school located in the same building, open spaces, large windows, wooden floor, new types of cell doors	Large and old building mass, school and gym are in another building, corridors, ordinary cell doors
Regional influence	Placed in a region where there is a more therapeutic culture	Placed in a region with a more traditional prison culture
Dress code	Ordinary clothes	Prison uniforms
Youth	Serious crimes, mostly young boys but also girls	Serious crimes, mostly young boys
Laws	Norwegian Sentences Act and the guidelines on the execution of sentences for minors and the UN's Convention on the Rights of the Child	Norwegian Sentences Act and guidelines on the execution of sentences for minors and the UN's Convention on the Rights of the Child
Type of correctional care	Correctional care inspired by trauma-based tools	Correctional care inspired by the good lives model
Ideal of staff	Being more than a prison	Accepting the idea that it is a prison

Youth Unit West

YU West is characterized by external curvilinear blue fences. Symbolically, linear barriers are perceived to mark strength in authority related to punishment and a separation between prison and society outside, while curvilinear fences usually give a less authoritarian and rigorous impression and to a greater extent signal more "open" and friendly surroundings (Giofrè et al., 2018) (Fig. 15.1).

YU West has a high proportion of green areas, with a sitting area and facilities for barbeques and a garden with training facilities. Inside, the new and modern spaces are built to a high prison standard, with an emphasis on movements, flexibility, light, and open spaces. The building has a minimalist aesthetic that is characterized by large, open living spaces that provide movement and a feeling of space, light that enters

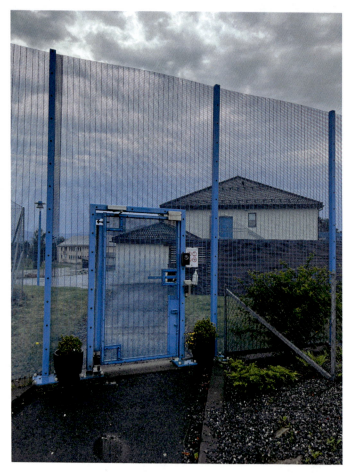

Fig. 15.1 YU West seen from the outside

through large windows without bars, wooden floors, some designer furniture, and elements of art. Having a solid and good wooden floor was a strong wish from the staff at this facility. The floor should give a "homely feeling and is appreciated both by youth and staff" and it is the same in all rooms including offices symbolically to illustrate equality between staff and youths (interview with staff) (Fig. 15.2).

The facility combines this openness with comprehensive digital and personnel surveillance. There are video cameras in all common rooms

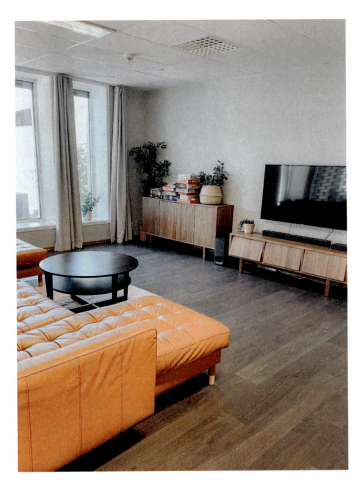

Fig. 15.2 YU West seen from inside

but not in prison cells. A large, long table forms the centre of the open living room, where there is also a kitchen, a circulation area, and a sofa corner with a TV. The youths have their own cells, with television in each cell (Figs. 15.3 and 15.4).

During the coronavirus pandemic, the youths also received an iPad in their room. The cell doors have a slightly different design from traditional cell doors and are quieter (Fig. 15.5).

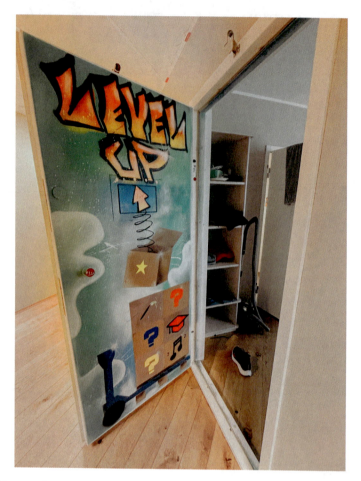

Fig. 15.3 A decorated cell door in YU West

The youth unit is located next to an adult prison, which provides support, for example, additional staff in emergency situations. The central goal for the unit was that it should be different from ordinary prisons. This difference is best expressed as a focus on change through correctional care and tools inspired by trauma-based care (Fransson, 2018, 2020; Fransson et al., 2019). The staff in this unit do not wear uniforms.

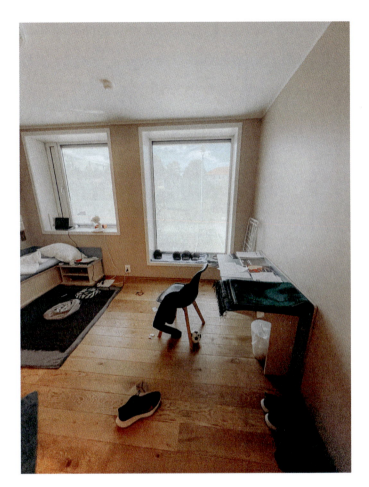

Fig. 15.4 A prison cell in YU West

Youth Unit East

YU East has straight green metal fences. The green colour coexists with the nature surrounding the facility (interview staff) (Fig. 15.6).

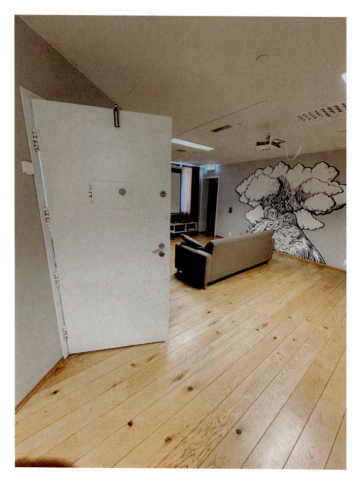

Fig. 15.5 A cell door

Additionally, this unit has a high proportion of green areas, with a sitting area and facilities for barbeques, benches, basketball hoops, volleyball nets, and outbuildings with roofs so that people can sit outside regardless of the weather (Fig. 15.7).

> We have football goals on a large lawn. We also have some exercise equipment with the option to take out mats from the gym when we have joint sessions. When it is nice outside, we also sometimes eat outside. Youths

Fig. 15.6 YU East seen from outside

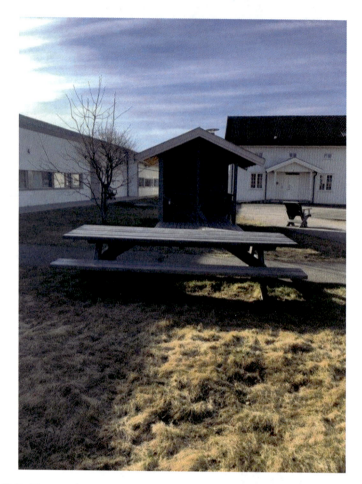

Fig. 15.7 The outdoor space in YU East

can use the outdoor facilities during the day. The prison is in the process also of improving the yard, building a ball area. A master's student is also working to make the outdoor area less like an institution. (Interview and E- mail correspondence with staff)

The prison has previously served as a retirement home and an asylum reception centre and is characterized by a mix between an old farmer's

house and a large building mass that consists of slightly older institutional architecture with long, yellow, and somewhat dark corridors. The overall cool institutional environment has been softened up with colourful textiles, plants, and sofa groupings.

The kitchen in the housing unit has large windows and a large table. In the early years, the kitchen was only open during its use for food preparation and at mealtimes; however, since this policy created conflicts between staff and youths, the kitchen is now open so that the youths can prepare food if they are hungry between meals. This approach functions well according to the staff and milieu work takes place in the kitchen regarding how to cook, etc. Youths can also keep their own food in the freezer in the kitchen. The kitchen is meant to be a place to gather and stay together (interview with staff). The cells are relatively large and have been painted by the staff in dark blue over the last year (Fig. 15.8).

The youths have received new Sacco bean bag chairs of different colours and notice boards in their cells, which have made the rooms more personalised. The youths also have a refrigerator, a Play Station, and their own cordless phones in their room. These items were introduced during the pandemic (interview with staff). YU East has a school and gym in another building, and during recent years, they have also added a library, a music room, and a conversation and hobby room in this building (Fig. 15.9).

As in YU West, the prison design is combined with comprehensive digital and personnel surveillance. YU East's mother prison is a distance away and the prison therefore must be more self-sufficient in maintaining their own security. The staff was from the opening clearer that this is a prison, and the pedagogic platform is correctional care with intentions of using the good lives model. The staff here wear uniforms.

Prison Designs in the Best Interests of the Child?

Statsbygg is the Norwegian government's building commissioner, property manager, and developer and is responsible for the building of prisons and child welfare institutions. In both units, Statsbygg has tried to

Fig. 15.8 A prison cell in YU East

15 How Prison Spaces Work on Bodies ... 429

Fig. 15.9 Hobby room in YU East

balance "the best interest of the child" from the UN's Convention on the Rights of the Child with the principles of "security" and "normality" from the Norwegian Sentences Act. As seen from pictures and texts, the units are in a continuing process of experiencing how these prison spaces work on bodies and working to adjust and make their spaces as functional and as one of the staff members says "as friendly" as possible (interview staff).

On a macro level, our study illustrates how prison design is deeply contextual and linked to history, law, specific criminal political contexts, economy, and culture. Furthermore, it demonstrates the normative demands lying within Norwegian penal ideology and how such demands are not only translated into design but also affect staff and youths. Structural normative demands are intertwined with local prison culture and are introduced through the people who work there and the youths who, for shorter or longer periods of time, serve a sentence.

In general, the prison design relates specific information about the normative values regarding how Norwegian society wants to relate to young prisoners. In YU West, this has from the beginning been illustrated by an open kitchen that helps to organize the communal space. The idea of a place to meet, talk, and be together can be seen as in accordance with normative demands, such as "in the best interest of the child", and in accordance with the principle of normality. Open kitchens are meant to create a community where staff and prisoners can meet, make food, hang around talking, or just being together. With different zones all having a wooden floor, the space presents itself as pleasant and inviting, as seen from a researcher's perspective. The design corresponds to a region that is considered to be ahead regarding public innovation and therapeutic ideas. Not using uniforms underlines this outlook and illustrates how design is intertwined with the economy, therapeutic traditions, and policy. What seems to be a problem now is that everything takes place inside one space.

The prison design in YU East is more traditional and was not initially designed for youths. The unit has been developed within a tighter economic budget and in a region that is characterized as a more correctional than therapeutic culture. The use of uniforms may be read as an expression of this outlook. These factors seemed in the beginning to

draw sociability in another direction and did not help the staff create a unit that seemed different from other prisons. The kitchen, which in the first period was closed, is now opened, and illustrates how the staff work together innovatively and how they over time have dealt with conflicts and tried to use the space in a new way. On the other hand, traditional buildings are more linked to the principle of normality. Having a school, gym, library, and music room in a separate building gives a normal rhythm of getting up, having breakfast, and going out of one's living area and over to activities in a separate place. This approach is well in line with the principle of normality and function (interview with staff).

Using prison ethnography as a method, it has been possible to analyse different challenges of the two prison designs. YU West functions well when the atmosphere is calm, and the basis team can use the environment in both a correctional and a more therapeutic manner. Problems within this prison space begin when there is tension and conflict. In such situations, what was open becomes tighter with more use of hard power (Crew, 2011) (Fig. 15.10).

When such events occur, staff who do not usually wear uniforms or security equipment also sometimes have to put them on, thereby changing the symbolic institutional logic of the unit being "different from an ordinary prison". In such situations, normality as a normative principle is replaced by a correctional safety logic (Fransson, 2018). The open space may also be narrowed in another way. One of the youths described situations where the staff had to separate a youth with the implication that some of the youths therefore could not use the kitchen zone:

> It was one youth that was excluded and the three most used rooms; the kitchen, the sitting room and the television section became closed for us. The rooms should have been more spread or that the one who was excluded could be another place. (Interview youth)

In this case, what was open and social became tight and narrow for the rest of the youths. The staff agrees that this might be a problem with this open space and see the need for a separate area where youths in custody,

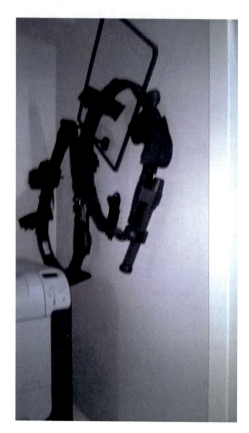

Fig. 15.10 Security equipment

that cannot be together with other youths, might stay without making complications for the others.

Another important aspect is the connection between prison design and comprehensive digital and personnel surveillance. One of the youths explained how unfree they feel being monitored and how this was experiences of unrest and distrust:

> There were cameras and the doors to the school room had to be open and often there was a staff member sitting outside. It is slightly overkill, you had cameras and security close to you. (Interview with youth)

The openness and togetherness also had other unintended consequences. One youth said that it is hard to eat at the table because of the dominance of the staff (Fransson et al., 2019), and regarding control a youth also said that he preferred not to have visitors because then afterwards he had to take his clothes off for a check of importation of drugs (interview youth). These are important aspects that illustrate how ideals regarding an open prison design are balanced by a high level of security and come to operate as a society of control (Deleuze, 1995).

Periods with different youths also challenge and make the prison design work in different ways. Both prisons maintain tight control over the youth. They are usually not left to themselves; in case they might hurt each other and to prevent situations from occurring (Fransson et al., 2019). It is also important to keep in mind that these prison designs are different from those of other prisons in that the units may house both boys and girls. Since girls are regarded as an especially vulnerable group, they must be protected from potential sexual harassment. One of the female youths says that the units are mostly arranged for male youths. She gives examples related to Play station and "games for boys" and that is a strict dress code, where you cannot have short skirts and take a sunbath which makes it boring during the summertime (interview youth).

An ongoing discussion among youths in both types of prison design is that they feel controlled and that they feel that they are always surrounded by staff. On the other hand, they also experience this social and territorial control as being for safety, for instance, if other youth are suffering from mental illness or if they feel that the atmosphere is threatening. Most of the youths say that they feel safe (Fransson et al., 2019).

The populations of youth in these two YUs have changed over time, with an increasing proportion of those who have committed serious crimes and who have severe psychological and psychiatric problems (interview with staff). A shifting youth "group" is a challenge to prison design and calls for flexible solutions. In both prisons, the characteristics of the youth dictate the work of the staff and how this work occurs (Fransson, 2020). Girls with psychological problems who have a tendency for self-harm require a different prison design than aggressive

young male gang members. The two prisons work differently, and the prison designs enable the staff to act differently, depending on the youth populations, constellations, and staff. The shift from care and treatment to correctional care based on control and safety is now clearly noticeable in YU West (interview with staff). With more young gang members, more violence, and greater insecurity, the idea of doing therapeutic work rooted in trauma-based care is experienced as being increasingly challenging. What is working best now at this unit is the use of an imam through group prayer and conversations with the youth (staff ibid.). This is an interesting input into the discussion of the need for flexible prison designs where rooms may be used in different ways in diverse periods.

A prison facility that works must correspond both to the prison design and to the specific therapeutic approaches within the concrete facilities. It is therefore crucial to find ways to study how specific prison designs encourage and underpin correctional care and therapeutic approaches. How the built environment works on the body, together with discourses in the various institutions, is important and requires further study.

One of the important future discussions might be how to develop flexible prison designs, for instance, regarding the cells, the cell doors, and the relationship between the cells and the spaces outside the cell (Fransson & Giofrè, 2020). While YU West has quite new and modern cells, YU East had less personalized rooms until recently. Painting the walls and giving every cell a notice board and Sacco bean bag chairs in different colours in different rooms, has made the cells seem more like rooms.

Another important issue is whether we think too traditionally about prison cells and cell doors. Are there ways to combine closeness and openness, security and care by making the space between rooms and corridors or open spaces more flexible? If correctional care and milieu work or milieu therapy are preferred methods, it might also be important to think that these qualities must be built into the prison design and discussed in the education of staff. Should a young person who does not sleep at night and has anxiety be able to sleep with the door open? In future research, it will be important to study how we can organize these spaces so that they can meet different needs, with the possibility of being open when that is possible and closed when needed, without closing the

spaces for others. It is also important to study whether prison design can be used more from a progression and re-entry perspective. Currently, there are no differences between the cells of youths in custody who are new and the cells of those who are nearing the end of their sentence. To have a flexible design makes it possible to hold youths in custody for a few days slightly apart from other youths, thereby preventing youths who are staying for a long time to have to be near newcomers coming and going. To have cells that are slightly separated may also prevent the youth prisons from using security cells and avoid the youths' becoming victims to violations and having to hear shouting and screaming (interview with staff).

Another issue is the number of youths. The youth units are small, housing only four youth, and the youths experience this as a very small group of other people to relate to in a social sense. On the other hand, they also feel safe with fewer youth and more staff members (interview with youths). This issue involves important sociological concepts such as closeness and distance. Staff are always around, but on the other hand, the environment must be secure for both staff and youth. This is a dilemma, and how future prison design with more flexible room solutions can help in creating enough closeness and distance might be an important focus.

A Prison Design that Supports "The Best Interest of the Child" and the Principle of "Normality"

A focus on prison design may have unintended consequences. One is that the design becomes an isolated issue that operates independently of how prison spaces in practice are used. More often the problem is that architects in Statsbygg have to suggest and make decisions based on budgetary limits and considerations regarding security and control which are dominant themes in the correctional care discourse. The risk is that normative demands and practical correctional care might not correspond. In other words, the designers' ideas can only partially meet the actual needs.

Another unintended consequence is that prison design in practice, due to security and control issues, does not focus enough on the science of how materiality works on the body. Both problems can lead to prison design hybrids in which young people suffer.

In her thesis, the architect Dalemark (2020) discusses how the normative demand of normalization is incorporated into various prison designs in Norway, how design reflects punishment ideology, and how ideas about normality can influence prison life, for instance, by dividing sleep and leisure from school and work. The organization of time and space is important. YU East has a separate school building with a library, a gym, and a music room. This approach obliges youths to eat breakfast, dress, and go to school, and it helps the staff to maintain their routines. In this way, daily activities are separated from eating, relaxing, and sleeping activities. According to staff, this prison design helps the staff create a daily rhythm with fewer conflicts (interview with staff).

In YU West, everything happens in the same place, and this is experienced by staff as being less functionally efficient (interview with staff). They feel that it would be better to "go out" and "come back" and to separate activities regarding time and space. This approach would also correspond more closely with the principle of normality. It is important for prison design to include corridors and meeting places outside of the cells (Fransson & Giofrè, 2020) and to enable outdoor activity to motivate youth to spend meaningful time out of their rooms (Johnsen, 2018).

Normality, according to the UN's Convention on the Right of the Child, is connected to the possibility for family and friends to visit and to spend time together. Furthermore, the pedagogical project is being focused on more than the punishment and the youths are being encouraged to be heard and enabled to use their rights in important matters. Not every youth wants to be part of a therapeutic culture, but for a unit to develop a therapeutic culture, the organization must be pedagogical and therapeutic and her prison design plays an important role. The current study uncovers dilemmas regarding prison designs for youth and shows how prison design is not only related to materiality but *comes into being* through various political choices, regional influences, organizations, educational cultures, and local cultures within units and bodies.

The staff do their best to create the most pleasant possible environment because they experience that doing so matters. More distant from what takes place within these units are the related structural elements such as what sort of buildings are provided by the state, where these buildings are placed, materials, the amount of money used inside and outside the prisons, and specific regional knowledge that influences the correctional care within these specific prisons. The knowledge traditions within which the leaders, prison staff, and milieu therapeutic staff are educated are important, as are the characteristics of juvenile delinquency. Prison design is therefore a complex matter.

The Implication of Ethnographic Studies for the Policy Level

The Norwegian sociologist Cathrine Holst (2020) points to three pitfalls regarding social scientists and whether and in what way they engage in the criminal political debate. The first pitfall is not to point to solutions but rather to leave them to politicians. The second pitfall is to present suggestions without connecting them to a method, and the third pitfall is to underestimate the difference between empirical analysis and policy recommendations. She argues for the importance of normative theory and for a discussion of the connection between research and theories of democratic legitimacy, moral demands, frames for implementation, and democratic processes. Following Holst (ibid.), we cannot move from how it is to how it should be without establishing a normative principle. Research and knowledge regarding prison design are closely linked to how knowledge production works and what is considered democratic and legitimate.

In modern democracies, many decisions are now delegated to public administrations (Vibert, 2007). Over the years, there has been an increase in politicians with a higher education (Bovens & Wille, 2017), and it is becoming increasingly important for politics to be knowledge-based or evidence-based. This makes it interesting to determine how research in general and ethnographic prison research in particular influence the policy level in Norway. A representative of the Norwegian

Directorate of Correctional Service approached this issue in the following manner:

> This is an interesting question, and you are right that there is not a straight line from research to policy development. Policy development is not only based on research (which is also often several perspectives and findings in research) but also on political guidelines, legal and economic frameworks, party cooperation, and not least, the taking of time - because sometimes it is about cultural change and the need for new knowledge both in the first line and the entire organization. (E-mail correspondence, spring 2021)

In Norway, there is a close relationship between the correctional service and Statsbygg. What works in prison design is therefore a complex question. The way in which research plays a large part in Norway regarding correctional care is when developing new politics. On the other hand, it is often numbers that matter and therefore mainly some kind of research that becomes useful (interview, representative for the Directorate). The type of research that is usually used is quantitative data, giving numbers and trends:

> We need fast results, numbers and easy access to Information, not English articles. (Interview, representative for the Directorate)

Numbers count, and the directorate does not have much time to read research-based articles and depend upon researchers presenting themselves and their work in an easy and accessible way. When directorates initiate new areas in which they themselves are taking initiative, research is usually important. In other situations, such as the building of Model 2015, where cost efficiency is important, research plays less of a role. Another important influence is the media. Critical aspects are noticed and play a role in ongoing policy (interview, representative for the Directorate). There is also another way of using research and that is what happens inside prisons and when different prisons talk together, for instance, as seen with the YUs. Here, reports and articles, especially if they are written in the Norwegian language, might become relevant.

Closing Comments

How prison spaces work on bodies has in this chapter been studied through ethnographic prison research. Using this method, it has been possible to describe and study staff and youths' experiences with two different prison designs in Norway. The chapter reveals that prison design is intertwined with normative demands at various levels. Not only how these demands are brought into the design but also how they are lived within various prison spaces. Prison design must build on theories of how materiality affects bodies, as well as knowledge regarding the pains of imprisonment. Prison design cannot take away this pain, but it can make the pain less difficult to adapt to and use design to create dignity and on its best contribute to a positive change in the lives of the youths.

Since research cannot tell us "What works" in a specific situation, we as a society instead need to make our own decisions based on a value system and what we think is right and moral. However, even then we arrive back at the same problem, i.e., if we want prison to be "normal" and "humane", what does this look like in practice and how do we know whether the design elements we think will deliver this function in actuality?

The most important principle in this chapter is to point to the important fact that prisons for youths should be based on the UN's Convention on the Right of the Child. The chapter points to how the Norwegian Sentences Act is still used as the legal framework and problematizes this approach. However, the chapter also demonstrates the importance of not only small units, well-educated staff, and a combination of flexibility but also the structured use of space dividing the living area and the activity area, such as school and leisure activities. Furthermore, the importance and the potential of the use of the outdoor space is a value in and of itself. Prison design that matters requires a broad collaboration between architects, designers, scientists, staff, and young prisoners and contact with the policy level. The important question regarding prison design is how future prison design can create hope and involve youths in processes that according to the UN's Convention on the Rights of the Child: reinforces the child's respect for the human rights and fundamental

freedoms of others and which considers the child's age and the desirability of promoting the child's reintegration and the child's assuming a constructive role in society.

References

Bovens, M., & Wille. A. (2017). *Diploma democracy: The rise of political meritocracy.* Oxford University Press.

Crew, B. (2011). Soft power in prison: Implications for staff—Prisoner relationships, liberty and legitimacy. *European Journal of Criminality,* 8(6), 455–468.

Dalemark, J. (2020). *Pønologi. Et soningssted. Hvordan skape arkitektur som svarer til norsk straffeideologi.* Arkitektskolen Aarhus.

Deleuze, G. (1995). Postscript on control societies. In M. Joughin (Trans.), *Negotiations* (pp. 177–182). Colombia University Press.

Drake, D. H., Earle, R., & Sloan, J. (2015). General introduction: What ethnography tells us about prisons and what prisons tell us about ethnography. In D. H. Drake, R. Earle, & J. Sloan, *The Palegrave handbook of prison ethnography.* Palgrave Macmillan.

European Committee for the Prevention of Torture and Inhuman or Degrading Treatment or Punishment (CPT). (2011). *Report to the Norwegian Government on the visit to Norway carried out by the European Committee for the Prevention of Torture and Inhuman or Degrading Treatment or Punishment (CPT).*

European Committee for the Prevention of Torture and Inhuman or Degrading Treatment or Punishment (CPT). (2018). *Report to the Norwegian Government on the visit to Norway carried out by the European Committee for the Prevention of Torture and Inhuman or Degrading Treatment or Punishment (CPT).*

Fagnoni, P. M. (2018). The city confined. In E. Fransson, F. Giofré, & B. Johnsen, *Prison, architecture & humans* (pp. 129–149). Cappelen Damm Akademisk.

Fransson, E. (2018). The Lunch Table: Prison space, action forces & the young imprisoned body. In E. Fransson, F. Giofré, & B. Johnsen, *Prison, architecture & humans* (pp. 177–199). Cappelen Damm Akademisk.

Fransson, E. (2020). *Dømt til hvilken kriminalomsorg? Helse og omsorgsregimer i de norske ungdomsenhetene*. Psyke & Logos nr. 1.

Fransson, E., & Giofrè, F. (2020). Prison cell spaces, bodies & touch. In V. Knight & J. Turner (Eds.), *The prison cell: Embodied & everyday spaces of incarceration*. Palgrave Macmillan.

Fransson, E., Hammerlin, Y., & Skotte, S. E. (2019). *Barn skal ikke i fengsel, men noen barn må. En kritisk studie av ungdomsenhetene i Norge*. Internrapport til KDI/Justisdepartementet, Halden Trykkeri.

Geetz, C. (1973). *The interpretation of cultures (1973)*. Basic Books.

Giofrè, F., Porro, L., & Fransson, E. (2018). Prisons between territory and space: A comparative analysis between prison architecture in Italy and Norway. In E. Fransson, F. Giofré, & B. Johnsen, *Prison, architecture & humans* (pp. 39–65). Cappelen Damm Akademisk.

Herzog, L., & Zacka, B. (2019). Fieldwork in political theory: Five arguments for an ethnographic sensibility. *British Journal of Political Science, 49*(2), 763–784.

Holst, C. (2020). Når samfunnsforskere anbefaler politikk. *Tidsskrift for Samfunnsforskning, Årgang, 61*(1), 67–70.

Johnsen, B. (2018). Movement in the prison landscape: Leisure activities—Inside, outside and in-between. In E. Fransson, F. Giofré, & B. Johnsen, *Prison, architecture & humans* (pp. 65–81). Cappelen Damm Akademisk.

Johnsen, B., & Fridhov, I. M. (2018). Resettlement in Norway. In F. Dünkel, I. Pruin, A. Storgaard, & J. Weber (Eds.), *Prisoner resettlement in Europe* (pp. 252–264). Routledge.

Pratt, J. (2008). Scandinavian exceptionalism in an era of penal excess part I: The nature and roots of Scandinavian exceptionalism. *The British Journal of Criminology, 48*(2), 119–137.

Ugelvik, T., & Dullum, J. (2012). *Penal exeptionalism? Nordic prison policy and practice*. Routledge.

Vibert, F. (2007). *The rise of the unelected*. Cambridge University Press.

Laws, Regulations and Mandates

Mandate for interdisciplinary teams at the special units for offenders between 15 and 18 years, i.e., youth units, 15th of May 2012, author's translation.

The European Committee for the Prevention of Torture and Inhuman or Degrading Treatment of Punishment, CPT 2010. https://www.coe.int/en/web/cpt

The Human Rights Act of 21 May 1999. https://www.ecolex.org/details/legisl ation/human-rights-act-no-30-of-1999-lex-faoc127929/

The Norwegian Execution of the Sentences Act. https://lovdata.no/dokument/ NLE/lov/2001-05-18-21#:~:text=A%20sentence%20shall%20be%20exec uted,satisfactory%20conditions%20for%20the%20inmates

The UN's Convention on the Rights of the Child. https://www.savethechild ren.org.uk/what-we-do/childrens-rights/united-nations-convention-of-the-rights-of-the-child#:~:text=The%20United%20Nations%20Convention% 20on,their%20race%2C%20religion%20or%20abilities

Torture and ill-Treatment of children deprived of their liberties, 2015, 28-th session of the Human Rights Council. A/HRC/28/68

White Paper 37. (2007–2008). En straff som virker. https://www.regjeringen. no/no/dokumenter/stmeld-nr-37-2007-2008-/id527624/

Elisabeth Fransson works as a professor in Social Studies at VID Specialized University in Oslo and professor II in the Department of Correctional Studies at The University College of Norwegian Correctional Service (KRUS). Her research in social studies and penology explores institutional spaces, technologies and the body in prisons and child welfare institutions. Franssons work is transdisciplinary and informed by theoretical developments within the philosophy of the body, prison sociology and carceral geography. Fransson is one of the authors of "Prison Architecture and Humans", an open access book from Cappelen Damm Akademisk.

16

Does Design Matter? An Environmental Psychology Study in Youth Detention

Rohan Lulham

Introduction

This chapter considers *if*, *how* and *what about* the physical design of youth detention facilities matters in interactions between staff and young people in youth detention centres, using affectcontrol theory and its methods. It seeks to qualify and quantify how the impressions and expectations of both staff and young people are influenced by the physical design of these facilities. It aims to contribute to the creation of conditions for a positive dismantling of the use of large carceral facilities for young people, while also addressing issues fundamental in the design of institutions and carceral facilities more broadly.

R. Lulham (✉)
School of Architecture, Design and Planning, University of Sydney, Sydney, NSW, Australia
e-mail: rohan.lulham@sydney.edu.au

The chapter opens by addressing the necessarily contested nature of youth detention, before discussing the literature and discourse related to three key themes: *does* design matter, *how* does design matter and *what about* design matters?[1] The specific physical context for this discussion is the collective living spaces within the accommodation units in youth detention. Affect control theory (Heise, 2007) is then briefly introduced before describing the methods employed in the study. The results are presented and discussed in relation to the three themes and the broader implications of the research.

A Necessarily Contested Context

As a place where young people who typically have traumatised and disadvantaged histories are held against their will by order of a court (Papalia et al., 2020), by staff who tread a line between caring youth worker and punitive security officer (Sichel et al., 2019), youth detention is a difficult and contested context. In larger configurations, youth detention commonly succumbs to the dysfunction long associated with total institutions (Goffman, 1961), exacerbating trauma, disconnection and criminal careers (Clancey et al., 2020). Despite regular policy and media focus, reform is often slow and piecemeal (Russell & Cunneen, 2017). First Nations and some minority groups are grossly over-represented in youth detention in many countries (Cunneen & Tauri, 2019); in Australia over 50% of young people in detention identify as First Nations despite constituting only 3% of the population (Australian Institute of Health & Welfare, 2021).

Youth detention begs questions of its necessity, whether it perpetuates systemic racism and colonial structures, and its use in broader law and order politics (Cunneen & Tauri, 2019). In some contexts, youth detention facilities have been closed and young people are successfully

[1] It is important to clarify in this chapter 'design' refers to physical design outcomes (buildings, landscapes, furniture, etc.) rather than 'design' as the process of designing. Conversely, Fairweather's (2000) chapter on prison architecture with the similar title, 'Does design matter', related to whether designing processes and practices mattered in the final architecture and how it is used.

managed within the community in smaller, home-like environments (Oostermeijer & Dwyer, 2019; Schiraldi, 2020). These jurisdictions do not have 'better' young people or fewer justice problems; they are progressive examples posing critical questions for societies like Australia about detaining young people in large institutions (McCarthy et al., 2016; White & Gooda, 2017). The social consequence is compounded where there is also gross over-representation of First Nations or minority young people.

Change clearly needs to occur in many youth justice jurisdictions across the world. We need to design far fewer youth detention facilities. But changing a youth justice system is difficult, political and often resisted (Antolak-Saper, 2020). It challenges power structures (and historical patterns of blame), the youth worker role and raises questions about how to become an affective, just and inclusive society. The current research offers insights into the role of design in changing the current system and supporting alternative and better models of youth justice.

Does Design Matter?

The question of whether design matters is both broad and fundamental. There is no denying that physical design shapes how people experience carceral environments including youth detention (Fairweather & McConville, 2000; Goffman, 1961; Toch, 1977; Werner et al., 1992). However, empirical 'evidence' establishing links between outcomes such as health, well-being, safety and organisational performance and particular design approaches or elements is lacking (Ulrich et al., 2010). This is apparent in reviews of design in youth facilities (Ray et al., 1982; Ulrich, 2019) as well as adult correctional facilities (Nadel & Mears, 2018; Wortley, 2002). The reasons include relatively few studies as well as the methodologies often employed. Often studies use methodologies where the affects of physical design are confounded with other important factors such as staffing, detainee characteristics or culture, limiting the ability to draw firm conclusions (Wortley, 2002). Of the studies in youth detention that investigate physical design relevant to the current research, two stand out. Ray et al. (1982) found that greater social

and spatial density of youth justice living units negatively influenced measures of social climate, school performance and participants' evaluations of detainees, staff and the unit. Peatross' (1994) study of spatial configuration of JDC living units using Space Syntax and behavioural mapping methods concluded that "… movement and interaction is configurationally driven—people move and talk where they can see and be seen by more people" (1994, p. 190).

The need for more specific evidence to inform decision-making is clear (Nadel & Mears, 2018; Ulrich, 2019). Without evidence, ideology and political currency can dominate decision-making as is the case in other areas of carceral practice (Antolak-Saper, 2020). While it is not feasible to have evidence about every aspect of the carceral environment, clear examples of where design impacts key outcomes can create possibilities for change (Moran et al., 2019).

How Does Design Matter?

Kurt Lewin's (1952, p. 169) often quoted phrase 'there is nothing as practical as good theory' is particularly relevant for design in carceral environments. While grounded research approaches are important, there is also a need for explanatory theory that builds ongoing, coherent ways of understanding how carceral design relates to social experience and behaviour (Fairweather & McConville, 2000). Explanatory theory can assist with integrating knowledge and offer clear, research-based rationales that can be utilised by designers and administrators (Davidoff, 2019). In the youth detention and carceral design fields, there is a critique about the lack of consensus and development of explanatory theory; examples include Peatross's (1994) explanation of how space relates to movement and surveillance in youth detention and Ulrich's (2019) propositions relating to physical design, stress regulation and supervision approaches. Wortley's (2002) situational control framework and Wener's (2012) socio-cultural approach to carceral design also provide useful broad frameworks through which to view the research literature. But more is needed.

One area requiring more theory relates to the common proposition that carceral design communicates information about staff, the incarcerated and the administration, which consequently influences people's impressions and expectations (Jewkes, 2018; Wortley, 2002). Carceral design is conceived as providing cues and prompts about what happens in these spaces and how people relate to them. This is a key premise of Goffman's (1961) work on institutions, Wener's (2012) model on prison design and assault, and much of the practice literature on youth detention design (Ricci et al., 1999). It is, however, also a proposition often criticised for lacking a coherent theoretical base and research foundation (Ulrich, 2019). The current research seeks to explicitly develop theory and research evidence about how physical design may influence impressions and expectations.

What About Design Matters?

There is complexity in the design of any physical context and how it is experienced. At a small scale, design can be experienced as texture while at a large scale it can be a landscape (Werner et al., 1992). What matters can be the presence or absence of features. It can also be the collection of design features rather than single elements that matter (Thompson et al., 1996). It may vary with the socio-cultural context and differ for individuals or groups depending on roles or relation to the context (Wapner & Demick, 2002). What matters about physical environments may not always be consciously understood and easily spoken about by a (research) participant (Bargh, 2014).

Notwithstanding the complexity, design guidelines provide recommendations about design qualities considered to be associated with well-being, safety and a positive social environment in youth justice facilities (Oostermeijer & Dwyer, 2019; Ricci et al., 1999). These relatively consistently recommend single rooms, small unit sizes with clear lines of sight and open staff stations in a campus-style configuration. Aesthetically and functionally, many guidelines also emphasise a normative and residential (rather than institutional and prisonlike) design approach. Drawing on research in adult facilities (Wener, 2012) as well

as other institutional facilities (Thompson et al., 1996), recommended approaches involve the provision of amenities, fixtures and layouts that reflect residential environments. The residential design approach is proposed to support staff and young people to have more positive, less stigmatised, impressions and expectations and is a key component of some alternative, community-based models of youth justice (McCarthy et al., 2016).

However, recently in both the youth justice (Ulrich, 2019) and adult correctional (Nadel & Mears, 2018) contexts, attention has been drawn to a lack of rigorous evidence about the affect of normative, residential design approaches. Describing normative design as 'interior decoration and visual embellishment', Ulrich (2019, 40) questioned the value of residential design approaches. Accordingly, an aim of the current research is to investigate and develop understanding about the influence of normative, residential design by researching staff and young people's responses to three different unit living spaces varying significantly in their degree of residential design.

Design as Social Meaning—Extending Affect Control Theory

This chapter develops affect control theory and its methods to investigate whether differences in physical design affect the impressions and expectations of staff and young people. A central tenet of affect control theory is that how we feel about people, places and events influences what we do, and how we understand situations and our emotions (Heise, 1979, 2007). The theory has a clear methodological framework for assessing people's feelings, impressions and expectations (Heise, 2010) and is also operationalised in the simulation programme Interact. The theory is actively being applied and developed in a range of research domains including social psychology, criminology, artificial intelligence and management (MacKinnon & Robinson, 2014).

Smith-Lovin's (1987) affect control theory (hereafter ACT) research is a critical factor in examining how people's affective meanings for physical settings influence what they do and how they feel in social situations. In

her research, and using validated survey methods, she included different settings as words (i.e. a home, office, bar) in hundreds of event sentences (i.e. a mother pleads with a daughter) to investigate how setting types impacted on people's impressions and expectations related to events. Through this research, it was possible to assess and simulate whether qualities of the settings, in combination with the qualities of the people involved, influenced what happened in social situations. This included the following key proposition:

> A hypothesis resulting from these simulations is that positively valued places constrain deviance. The simulations suggest that good settings inhibit bad, strong, fast behavior, and the more violent the expected behavior, the more powerful the control of settings may be. … It is interesting, though, that the affect control theory interpretation is different than the usual rationale that setting improvements intimidate deviants through increased risk of detection and control. Rather, the affect-control explanation is that bad acts disrupt good places so much that a deviant has to sacrifice some identity confirmation in order to maintain the meaning of the setting (assuming that the scene is viewed as good by the deviant actor himself). (Smith-Lovin, 1987, p. 95)

This is pertinent to *if* and *how* physical settings in youth justice facilities influence staff and young people's experience and behaviour. It suggests that young people, who are essentially in a negative detainee identity, are less likely to do 'bad, strong, fast behaviour' when the setting is affectively good. It suggests that the *social meaning* associated with the design of a setting may influence behavioural expectations.

However, although Smith-Lovin's (1987) research highlighted the potential influence of the design of the setting, it did not enable the specific investigation of this hypothesis. Like most ACT research, settings were operationalised as words only (i.e. school, home) without reference to the *design* of the setting. In the current study, we explicitly investigate the potential influences of differences in physical design by including visualisations of accommodation areas in youth justice facilities.

First, we outline ACT as it relates to understanding and investigating social interaction within physical settings, articulating the three

key research questions (an extended description of the theory and its development can be found in Lulham, 2007, pg 61–118).

Stepping Through the Theory and Situating the Research Questions

Central to ACT is the idea that people have both fundamental (relatively) stable feelings about different aspects of the social world as well as transient feelings that are specific to particular social situations.[2] **Fundamental sentiments** are our feelings about concepts based on past experience within a particular culture or cultures; these provide an affective reference of how different people, behaviours, places and other concepts generally feel. In the current study, we assume staff and young people in youth justice facilities have fundamental sentiments about their social world including what they feel about both the accommodation units and themselves. As such, the first research question is: What are staff and young people's fundamental sentiments for key aspects of situations in residential youth justice units?

Conversely, **transient sentiments**[2], often called **impressions**, are the feelings people have within actual social situations about interactants, behaviours and other elements of the situation. More specific, these may differ from how we *generally* feel about the person, behaviour or place. For example, we might regard teachers as good, strong people in general, but we may view a teacher berating a student quite differently. In ACT, the process whereby people develop impressions in situations is called **impression formation**, drawing on gestalt psychology (Gollob, 1968) and symbolic interactionalism (Mead, 1934). While some ACT research seeks to model impression formation process across diverse scenarios, the focus of the current research is how differences in physical design of the setting changes impressions of staff, young people about the unit and each other. Accordingly, the second research question is: Do differences

[2] Described further in the methodology section, both fundamental and transient sentiments are operationalised and measured in ACT using ratings scales that assess the three affective dimensions of goodness (evaluation), powerfulness (potency) and liveliness (activity) Heise, D. R. (2010). *Surveying Cultures: Discovering Shared Conceptions and Sentiments.* Wiley.

in the physical design of accommodation units influence the impressions of staff and young people?

The last aspect of ACT outlined here is **behavioural expectations** and the process of **affective control.** Building on perceptual control theory, affective control is the proposition that people want predictability and will behave (and expect others to behave) in situations to maintain their feelings about the situation. As such, people are assumed to be more likely to behave in ways that maintain or restore fundamental meanings about the situation. Smith-Lovin's above proposition that '*good settings inhibit bad, strong, fast* behaviour' is based on the findings from her research that people control meanings about affectively good settings. In the current study, we test an aspect of this proposition by investigating the third research question: Are staff and young people's behavioural expectations influenced by the physical design in youth justice accommodation units?

Methodology

This research uses a quasi-experimental approach, dynamic visualisations and survey methods adapted from affect control theory to address the aims and research questions. Groups of young people and staff in youth justice facilities were randomly allocated to one of three 'conditions'. In each condition, participants were shown a dynamic visualisation of one unit living space in an operating youth justice facility previously unknown to them. The three-unit living spaces varied markedly in physical design including along the residential-institutional dimension. Staff and young people in the three conditions completed the same questionnaire based on standard ACT methods to assess fundamental sentiments, impressions and expectations. The research was administered to groups of participants using a data projector to show the visualisations and survey questions. Questions were read out to participants and responses recorded by participants on a paper version of the survey. Finally, a propensity score matching approach was employed to minimise any pre-existing difference between the participant groups in each condition prior to the analysis.

The remainder of this section provides further description of the methodology but is necessarily brief. A full description with additional data and findings not reported in this chapter is available in Lulham (2007).

Visualisations of Youth Justice Spaces

Living spaces within the accommodation units of existing youth justice facilities were visualised using an interactive panoramic approach. While people's affective responses to photographs are often very similar to responses to the *actual* spaces (Stamps, 2013), more recent research indicates that psychological responses are more valid and feelings of presence greater for interactive panoramic images in comparison to photographs or virtual reality visualisations (Higuera-Trujillo et al., 2017). The interactive panoramic image approach is used in a range of research and business contexts and is similar to the method used in Streetview on Google Maps. In the current research images of each living space were taken, stitched together and then presented using a similar panning sequence across the three visualisations. Participants viewed a simulation on a data projector and a large 182 × 182 cm screen in full-screen mode and in half screen mode as shown in Fig. 16.4.

Selection of Youth Justice Spaces

Selection of three-unit living spaces from existing youth justice facilities involved ratings from three architects experienced in the design of such facilities. They were shown interactive panoramic visualisations of differently designed spaces (21 from facilities across Australia and one from the United States). Using an inventory based on Ricci et al. (1999), they rated the physical design of each across a range of domains[3]

[3] For more information about the inventory and selection method see Lulham 2007, pg 413–420).

including items relevant to the influence of normalised, residential design approaches.

Three living spaces were selected, referred to in the remainder of this chapter as the 'Institutional Unit', the 'Part-Residential Unit' and the 'Residential Unit'. Figure 16.1 displays a panoramic image of each, as well as a summary of architects' assessments across several domains. While ideally the selected living spaces would only vary in terms of normalised design, this was not possible using a real-world sample.

Survey Method

Drawing on typical ACT methods, a survey assessed staff and young people's fundamental sentiments, impressions and behavioural expectations. We first describe the scales for the measurements before articulating the broader structure of the survey and associated questions.

Affective Meaning Rating Scales

ACT assesses affective meaning as it relates to both fundamental sentiments and transient impressions using rating scales derived from Osgood et al. (1975). Extensive research on the cross-cultural universals of meaning has established that people attribute affective meaning to a wide range of concepts along the same three dimensions of evaluation (goodness), potency (powerfulness) and activity (liveliness). The typical rating scales used in ACT are shown on the left in Fig. 16.2. The mean, or average, sentiment ratings for a concept within a culture is considered the shared, affective meaning for the concept. Research has also validated the use of the scales with children as participants (di Vesta & Dick, 1966; Heise, 2010). Affect control theory has large dictionaries of affective meaning data for thousands of concepts collected through extensive surveys across multiple cultures. A similar approach has also been used in environmental psychology research to assess affective appraisals and aesthetic responses of physical environments (Russell, 1988; Stamps, 2013).

454 R. Lulham

Unit 1: Institutional, High Security Living Unit (Institutional Unit)

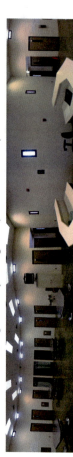

Normalized - Very Low Lighting - Very Low Familiar - Very Low
Hard security – Very High Visual security – Very High Closed control station – Very low

Unit 2: Normalized, Secure Living Unit (Residential unit)

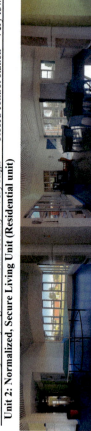

Normalized - High Lighting - High Familiar - Moderate
Hard security - Moderate Visual security - Moderate Closed staff station - Very High

Unit 3: Part-Normalized and Secure Living Unit (Part-Residential Unit)

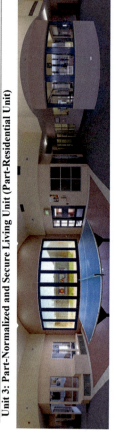

Normalized - Moderate Lighting - Moderate Familiar - Moderate
Hard security - High Visual security - Moderate Closed staff station – Very Low

Fig. 16.1 Full panoramic images and approximations of experts' ratings of the three visualised accommodation spaces

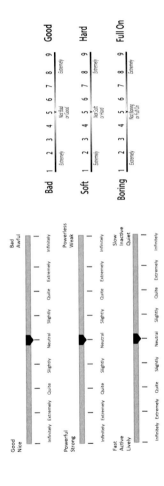

Fig. 16.2 Typical ACT semantic differential scales and the revised scales used in this study

A pilot study consisting of two focus groups with five young people in youth detention (who completed a draft questionnaire and then provided feedback) informed and validated the use of scales. Feedback revealed that multiple scale end descriptors (i.e. powerful, strong) and the words along the scale (i.e. slightly, quite) were confusing, and led to changes in the scale-end descriptors for the potency dimension to 'hard' and 'soft', and the activity dimension descriptors to 'boring' and 'full-on' (to better reflect how these were described in custody), resulting in the final version of the scales in Fig. 16.2.

Young people were also asked in the pilot to provide feedback about the wording of the questions. Typically, in ACT research participants would be asked, 'How do you feel about [concept]? Rate your feelings on the three scales below'. It became apparent that the idea of rating your 'feelings' was a red flag in youth detention (i.e. you don't share your feelings!). After some discussion, we identified the wording, 'What do you reckon [concept] is like?' made it easier for young people to engage in the task freely and was a significant breakthrough in the development of the methodology.

Survey Structure and Wording

After some instructions and practice questions, the final survey consisted of three main types of questions. The first section involved participants rating their fundamental sentiments about staff, detainees, the unit and themselves in youth detention in general. These questions were shown on the large screen as well as on a paper version of the survey with the layout shown in Fig. 16.3.

After the first section, participant groups were shown a two-minute full-screen visualisation of one of the three-unit living spaces which included two full 360-degree panning sequences. They were then asked to rate their impressions of what they *reckon* staff, detainees, the unit and themselves would be like in the visualised unit living space. While they answered, these questions were displayed alongside the visualisation as shown in Fig. 16.4.

Fig. 16.3 Screen set out of fundamental sentiment questions

The final section involved participants rating the likelihood of several events happening in the visualised unit. In total, there were six questions with a staff member the actor in three events (i.e. help, ignore, yell at) and a detainee the actor in three events (listen to, nag, abuse). An example of the question wording is shown in Fig. 16.5. The behaviours were selected so that both staff and detainees enacted one positive behaviour, one negative behaviour and one strongly negative behaviour. The inclusion of negative behaviours was important due to proposition that good places will constrain the enaction of negative acts.

Participants

Participants were 113 male young people between the ages of 12 and 21 residing in four youth detention centres, and 70 departmental staff working directly with young people in accommodation units in two youth detention centres. All participants came from the one-state jurisdiction in Australia. Relevant demographic information is shown in

Fig. 16.4 Examples of full-screen and half-screen presentations of the JDC unit visualisations

Fig. 16.5 Behaviour likelihood questions

Table 16.1. (Only period of employment data (displayed in Table 16.2) was collected for staff participants to preserve anonymity.)

Research Design and Propensity Score Matching

An important intention of this research was to assess the influence of differences in physical design of the visualised living units independent of other factors such as differences in the staff and young people cohorts. A quasi-experimental research design was used where groups approximating six detainees, or twelve staff members, were randomly allocated to one of the three conditions, with each condition involving the presentation of a different visualised living area. While the randomisation to conditions reduced any researcher bias in the allocation process, it was not adequate to ensure equivalence between the treatment conditions because groups rather than individuals were randomly assigned and there

Table 16.1 Counts and percentages for young people demographic items

Age				
Less than 13 years	14–15 years	**16–17 years**	18–19 years	20 years or more
5 (4.4%)	23 (20.4%)	**46 (40.7%)**	27 (23.9%)	12 (10.6%)

Home Location				
Major City	Regional City	Big Town	Small Town	
54 (47.8%)	9 (8.0%)	17 (15.0%)	33 (29.2%)	

Cultural Background				
Asian	Middle Eastern	**Caucasian**	European	Pacific Islander
15 (13.3%)	6 (5.3%)	**28 (24.8%)**	1 (0.9%)	13 (11.5%)
Aboriginal	American	Mixed/ Other		
32 (28.3%)	5 (4.4%)	13 (11.5%)		

Legal Order				
Remand	Control Order			
50 (44.2%)	63 (55.8%)			

Period in custody				
Less 1 Month	2–3 Months	4–9 Months	10 or more Months	
30 (26.5%)	24 (21.2%)	27 (23.9%)	32 (28.3%)	

Period until release				
Less 1 Month	2–3 Months	4–9 Months	**10 or more Months**	
28 (24.8%)	22 (19.5%)	22 (19.5%)	**41 (36.3%)**	

Admissions to custody				
First Time in Custody	1–2 Previous	3–4 Previous	**5 or More Previous**	
28 (24.8%)	21 (18.6%)	17 (15.0%)	**47 (41.6%)**	

Table 16.2 Counts and percentages for staff length of employment in Youth Justice facilities

Period of Employment			
less than 6 months	6 months–1 year	1–3 years	4 years or more
1 (1.5%)	6 (8.8%)	15 (22.1%)	46 (67.6%)

were not enough groups for the randomisation to minimise differences. As a result, a propensity score matching (PSM) method was employed to control for any pre-existing differences. As it is beyond the scope of this chapter to describe the PSM in any detail, we provide a brief outline below and direct the reader to Lulham (2007), pages 188–205 for a full description.

Propensity Score Matching

Propensity score matching (PSM) is a quantitative method for maximising the equivalence between treatment conditions in evaluation studies where experiments are impractical or unethical (Rosenbaum and Rubin 1983; 1984). ACT provided a strong basis to assume that maximising the equivalence in participants' fundamental sentiments between the three treatment conditions would assist in managing any pre-existing differences that may impact upon and bias the comparisons of impressions and expectations. Applying the methodology outlined by Caliendo and Kopenig, (2008; p. 45), we first derived propensity scores for each condition from the fundamental sentiment ratings and removed participants where their propensity scores did not match any of the participants in other treatment conditions. Then using K-means cluster analysis we derived a strata variable from the propensity scores to control for any additional pre-existing differences in the subsequent analysis. Finally, balance tests were conducted to assess for any differences after PSM between the three conditions on the fundamental sentiment items with all variables having p-values above 0.5 and most above 0.9. Table 16.3 provides the number of staff and young people in each condition after the PSM procedure.

Analysis Method

As fundamental sentiments and impressions are largely defined in ACT by the mean rating, analysis of variance techniques (ANOVA) were used to estimate and compare mean ratings between the conditions.

Table 16.3 Number of staff and young people in each condition

Participant groups	Condition			
	Unit 1	Unit 2	Unit 3	Total
Young people	30(4)	31(9)	31(8)	92(21)
Staff	20(3)	19(4)	17(4)	56(11)

Note the number in brackets are the cases excluded through propensity score matching

To control for pre-existing differences, strata variables derived through PSM were included in the ANOVA models. In the ANOVA models for young people the strata variable was included as a main affect and crossed with the treatment affect, while in the staff models it was only included as a main affect. Bonferroni correction for multiple comparisons was used when reporting the significance of differences between the treatment conditions. The word 'significant' is used in reporting the results where the associated comparison is statistically significant at $p < 0.05$. The reporting of the statistics associated with individual comparisons are only given where particularly relevant and will be kept to a minimum. (Full detail is available in Lulham, 2007)

Presentation of Descriptive Results

Reporting descriptive statistics including mean ratings is expected in social science research. Typically, the mean statistics are reported in tables; or, where the focus is on comparisons between conditions, in graphs. Graphs were used in Lulham (2007) to display the mean values and confidence intervals, but they are complicated and difficult to read as they report means values across the three treatment conditions for four concepts on the three affective dimensions. In this chapter, a graphic technique is used instead to aid in the comprehension of the results by a cross-disciplinary readership.

Implementing the graphic technique first involved recoding the affective meaning data so the midpoint of each bipolar scale was recoded to have a midpoint of 0 and ranged from −4 (infinitely bad) to 4 (infinitely good) as is typical for ACT data. Then each mean value was graphically

represented by the relative size of the scale-end descriptor as illustrated in Fig. 16.6. Using the word size to communicate both quality and magnitude of the mean rating assists the reader in making comparisons and identifying patterns across items.

Results

Fundamental Sentiments

The first research question asks: What are staff and young people's fundamental sentiments for key aspects of situations in youth justice accommodation units? While not relating specifically to the influence of physical design, this question is important because it provides an understanding of how people in youth justice facilities *generally* feel about staff, detainees, the units and themselves. These pre-existing sentiments are likely to influence how people experience and behave in youth detention, as well as their experience of other facilities in the future.

Figure 16.7 provides the mean fundamental sentiment values for young people and staff participants using the graphical method previously described. Young people's evaluative sentiments were only positive for themselves, with sentiments neutral for staff and bad for other detainees and the unit. Young people also viewed themselves as less potent than staff and particularly than other detainees. They viewed themselves as quite active and similar to other detainees, while the unit was slow and staff neutral.

Staff participants' evaluative sentiments for themselves and other staff were very good, while bad for detainees. Potency sentiments were relatively neutral, though staff viewed themselves as hard and slightly harder than detainees. Staff regarded detainees as very active, and themselves and other staff as quite active.

Comparing young people's and staff participants' fundamental sentiments, young people's sentiments about staff were significantly worse; harder and slower. Young people also rated other detainees as significantly

464 R. Lulham

Fig. 16.6 Illustration of how the word selection and scaled word size relate to the evaluation affective rating scale

16 Does Design Matter? An Environmental ...

Rated concepts	Affective Dimensions		
	Evaluation	Potency	Activity
Young people participants			
Staff	BAD	HARD	SLOW
Detainees	BAD	**HARD**	ACTIVE
Units	BAD	HARD	SLOW
Self	GOOD	HARD	ACTIVE
Staff member participants			
Staff	**GOOD**	HARD	ACTIVE
Detainees	**BAD**	HARD	**ACTIVE**
Units	BAD	HARD	—
Self	**GOOD**	HARD	ACTIVE

Figure Key:
Word Heights
Values: 0, 1, 2, 3, 4
Descriptors: Neutral, Quite, Very, Extremely, Infinitely

Fig. 16.7 Graphical representation of the mean fundamental sentiment values for young people and staff participants

harder, but similarly to staff participants in terms of detainee goodness and activity. Young people were also more negative about the units and regarded them as boring. While staff sentiments about themselves were significantly better, they viewed themselves similarly to young people in terms of their potency and activity.

Impressions

The second research question asks: do differences in the physical design of accommodation units influence the impressions of staff and young people? This question relates to the proposition that differences in physical design will independently influence the affective impressions of staff and young people in these facilities.

Figure 16.8, on the left-hand side, presents young people's impressions of staff, detainees, the unit and themselves situated in the three visualised living spaces. For the Institutional Unit, young people's impressions of staff, detainees and the unit (in particular) were *very bad* and *very hard*, with impressions of themselves also *bad* and *hard* but less so. Staff and the unit were also viewed as quite *slow*. In the Residential Unit condition, young people had positive, *very good* impressions for all concepts, and particularly for the unit and themselves. All concepts were relatively *neutral* in terms of potency, while staff, the unit and themselves were *active*. Then, in the Part-Residential Unit, evaluative impressions of the unit were *very good*, detainees and themselves *good*, but *neutral* for staff. Impressions of potency and activity were relatively *neutral* for all concepts in the Part-Residential Unit, except for staff who were assessed as *hard* and *active*.

Clearly, the physical design of living units strongly influences young people's impressions. ANOVA was used formally to test these differences between the unit conditions on each item as both a main affect and through pairwise comparisons between the conditions. The main affect is a test of whether the variation across the three conditions (irrespective of the condition) is greater than statistically expected by chance 95% of the time ($p < 0.05$ level). Across the twelve main affect tests (4 concepts by 3

16 Does Design Matter? An Environmental ...

Conditions		Rated concepts	Young people — Evaluation	Affective Dimensions Potency	Activity	Staff members — Evaluation	Affective Dimensions Potency	Activity
Institutional Unit		Staff	BAD	HARD	SLOW	GOOD	HARD	SLOW
		Detainees	BAD	HARD	SLOW	BAD	HARD	ACTIVE
		Units	BAD	HARD	SLOW	BAD	HARD	SLOW
		Self	BAD	HARD	—	GOOD	HARD	—
Residential Unit		Staff	GOOD	SOFT	ACTIVE	GOOD	SOFT	ACTIVE
		Detainees	GOOD	SOFT	—	GOOD	SOFT	SLOW
		Units	GOOD	SOFT	ACTIVE	GOOD	SOFT	—
		Self	GOOD	—	ACTIVE	GOOD	HARD	ACTIVE
Part-residential unit		Staff	—	HARD	ACTIVE	GOOD	SOFT	—
		Detainees	GOOD	SOFT	ACTIVE	GOOD	SOFT	ACTIVE
		Units	GOOD	—	ACTIVE	BAD	SOFT	ACTIVE
		Self	GOOD	—	—	GOOD	HARD	ACTIVE

Fig. 16.8 Graphical presentation of the mean impression values for young people and staff participants in the three accommodation unit conditions

affective dimensions) only three were not statistically different: detainee-activity, you-potency and you-activity. Indeed, there was strong statistical support for the finding that physical design influences young people's impressions.

Additionally, pairwise comparisons were conducted to investigate the differences in impressions between the unit conditions. As would be expected from Fig. 16.8, it was the differences between the Institutional Unit and both other Units that drove many of the main affects. Impressions of staff and the unit were significantly worse, harder and slower, impressions of detainees were worse and harder, and impressions of themselves were worse, for participants in the Institutional Unit than in the Residential and Part-Residential Units. But significant differences in young people's impressions were *also* identified between the Residential and Part-Residential Units, with the evaluative impressions of staff (MD = 1.57, SE = 0.53, $p = 0.012$) and themselves (MD = 1.58, SE = 0.58, $p = 0.024$) significantly better in the Residential Unit. Young people's impressions differed significantly *between* the two more Residential units *as well as* between these and the Institutional unit.

Now moving to discuss staff participant's impressions which are shown on the right side of Fig. 16.8. Staff participants' impressions in the Institutional Unit were good for other staff and themselves, but bad for detainees and the unit. Starkly, staff participants' impressions were very hard for all concepts, with impressions of the unit and themselves the hardest. In terms of activity, impressions of detainees were active and the unit slow. In the Residential Unit, staff participants' impressions of detainees were very good, but just good for staff, the unit and themselves. Staff and the unit were perceived as soft, and the potency of detainees and themselves were relatively neutral. The activity of all concepts was neutral. For the Part-Residential Unit, evaluative impressions of staff, detainees and themselves were good, but neutral for the unit. Staff participants' impression of potency of all concepts was relatively neutral, and on the activity dimension the unit and themselves were active, but staff and detainees neutral.

ANOVA was again used to formally test these differences with all main affects for potency items significant; staff-potency ($F (51,) = 7.75; p = 0.00$; partial $\eta^2 = 0.23$), detainee potency ($F (49,) = 3.37; p = 0.04$;

partial $\eta^2 = 0.12$), unit potency ($F(51,) = 6.09$; $p = 0.00$; partial $\eta^2 = 0.19$) and you-potency ($F(51,) = 4.16$; $p = 0.02$; partial $\eta^2 = 0.14$). The one additional significant main affect was for detainee-evaluation ($F(45,) = 6.54$; $p = 0.00$; partial $\eta^2 = 0.23$). Rather the differing between conditions, staff participants' evaluative impressions of other *staff* and themselves were actually very similar across the three conditions irrespective of their design, and significantly worse than their fundamental sentiments for other *staff* and themselves (see Fig. 16.9). One explanation for this finding is that the staff participants are aware that youth justice facilities are generally difficult places, and as such, are less likely to have positive sentiments about themselves or other staff in a facility with which they are not familiar.

Then the comparisons between young people's and staff participants' impressions across the three conditions. Main affects for six of the 12 items were statistically significant: staff-evaluation, staff-potency, detainee-activity, unit-evaluation, unit potency and you-evaluation. Pairwise comparison across the 36 items (12 concept-dimension items by 3 treatment conditions) found just six significant differences with young people participants rating staff and themselves as worse in the Institutional Unit, in the Residential Unit both the unit and themselves as better, and finally, in Part-Residential Unit, they rated the unit as better than staff participants.

Of particular interest was the similarity in young people and staff's impression ratings of detainee-evaluation and detainee-potency in the three living units. Mean values for young people verses staff impressions of detainee goodness in the Institutional (-1.6, -1.4), Residential (1.8, 1.7) and Part-Residential (0.8, 1.1) Units were very similar, as they were for detainee hardness across the Institutional (1.5, 2.0), Residential (-0.4, -0.6) and Part-Residential (0.0, -0.3) Units. As such, young people and staff both appear to interpret differences in physical design in very similar ways as they relate to affective impressions of detainees.

Ratings of	Fundamental sentiment			
Other staff	**GOOD**	GOOD	GOOD	GOOD
Themselves	**GOOD**	GOOD	GOOD	GOOD

Fig. 16.9 Graphical presentation of the mean evaluation ratings for staff participants' fundamental sentiments, and impressions in each condition, for *other staff* and *themselves*

Expectations

The third research question asks: Are staff and young people's behavioural expectations influenced by the physical design of youth justice units? This research question relates to Smith-Lovin's (1987) proposition that affectively good places constrain bad 'deviant' actors from doing bad, strong, fast behaviours.

Figure 16.10 presents young people and staff participants' mean likelihood ratings for six behaviours in each living unit using a similar graphic presentation method. Apparent on inspection of Fig. 16.10 is that participants' expectations did not vary as greatly as their impressions. Young people's expectations, however, did differ significantly between conditions on the item, 'a detainee nags a staff member', with a detainee in the Residential Unit rated as significantly less likely to nag in the Institutional Unit ($p = 0.005$) and the Part-Residential Unit where the difference approached statistical significance ($p = 0.08$). While individually not statistically significant, each of the other negative behaviour items (abuse, ignore and yell at) had a pattern of difference where the negative behaviour was less likely in the Residential Unit than both the Institutional and Part-Residential Units (which had very similar mean likelihood ratings). Due to this pattern across items, a multivariate ANOVA was performed with the four negative behaviours, comparing the likelihood ratings in Residential Unit with the Institutional and Part-Residential Units. This found a statistically significant difference across the items (Pillai's Trace value $= 0.115$, $F(4, 78) = 2.534$, $p = 0.047$, partial $\eta^2 = 0.115$). This indicated that a strongly *affectively good* Residential Unit in youth detention constrained detainees' expectations of negative behaviours.

Staff participants' expectations also differed significantly on one item, but rather than a negative behaviour, it was the positive behaviour 'a staff member helps a detainee'. Staff participants expected that *staff* in the Residential Unit would be more likely to help detainees than *staff* in the Institutional Unit (EMD $= 1.67$, SE $= 0.542$; $p = 0.010$). In the Residential Unit, where their impressions of *staff* were soft, and impressions of the detainees and the units were affectively good, staff participants expected more helping behaviour to occur. Considering many youth

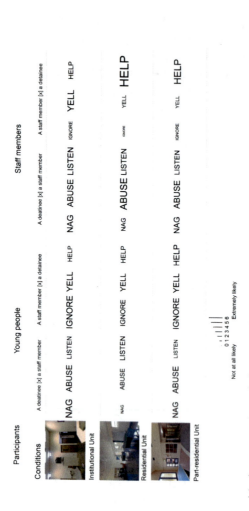

Fig. 16.10 Graphical presentation of the mean behaviour likelihood values for young people and staff participants in the three accommodation unit conditions

justice agencies want their staff to be more helpful in their interactions with young people, this is a significant finding. Finally, comparing participants' expectations, staff participants' rated *staff* as significantly more likely to help and less to ignore across the three conditions. While specific to the Residential Unit, staff participants rated detainees as significantly more likely to *nag* in comparison to young people participants.

Discussion

This chapter contributes to knowledge about how physical design influences interactions between staff and young people in youth detention, with the intention to assist with understanding the problems with the current youth justice system and its design and to develop knowledge that may inform alternative, community-based models of youth justice.

The theme of *if* design matters asks whether physical design in carceral settings has affects independent of other factors that may influence an outcome of interest. In this research, the outcome of interest was social impressions and interactions of young people and staff in youth detention. By using high-quality visualisations of actual youth justice living spaces, engaging young people and staff who reside or work in youth justice as participants, and using a propensity score matching method, it showed that differences in physical design *are* related to differences in impressions and expectations. This demonstration that physical design can and does influence young people and staff, when controlling for other factors, is a major research contribution. The use of visualisations rather than actually operating carceral spaces is an admitted limitation, and there would be considerable value in conducting similar research within and about several differently designed carceral facilities where sentiments and actual behaviour are recorded, to provide more contextual understanding.

The theme of *how* design matter contributes to theorisation of how physical design influences people, social groups and organisations, including in carceral contexts. Building on Smith-Lovin's (1987) study, this research introduces and extends affect control theory as a way

of understanding, researching and theorising about the role of physical design. ACT was demonstrated to be affective and productive for conceiving research that accommodates prior theory about situational (Wortley, 2002) and symbolic qualities (Werner, 2012) of carceral environments. It provides a way of quantitatively researching how affect and feelings play out in carceral spaces, and, through the simulation programme Interact, potentially a bridge to qualitive research (as has occurred in the health (Francis et al., 2020) and leisure fields (Lee & Shafer, 2002)). Relatively bound as a theory and method by the centrality of its use and operationalisation of affective meaning, ACT can be criticised as reductionist and trivialising multilayered, complex issues. However, as shown in this study and others (e.g. MacKinnon & Robinson, 2014), by operationalising relatively simply affective structures and processes ACT can inform understanding about complex social interactions and experience.

The theme of 'what' about design matters contributes to knowledge about the design qualities or attributes of youth detention facilities that support or hinder different outcomes. My particular focus was the influence of normalised, residential design approaches through the selection of living spaces that included a clearly normalised, 'residential' design, a partly normalised residential design, and an 'institutional', secure design. Staff and young people's impressions were strongly influenced by the normalised, residential design and, to a substantial degree, by the partly normalised, residential design, compared to the institutional, secure facility. Differences were also found between young people's impressions of the residential and part-residential units, with impressions affectively better for the normalised residential unit. However, the pattern of differences in young people's behavioural expectations for negative behaviours was quite different. Young people rated the likelihood of negative behaviours occurring in the normalised, residential unit as less than in the other two units. Indeed, the likelihood of negative behaviours occurring in the partly normalised residential unit and the institutional, secure unit were essentially the same.

Normalised, residential design that led to consistently good impressions did appear to constrain young people's expectations of negative behaviour, consistent with Smith-Lovin's (1987) hypothesis. A partly

normalised residential approach, however, did not appear to have any constraining affect, with negative behaviour expectations similar to the strong institutional, secure facility. There were, however, limitations to the research design that need to be considered with these findings, including the fact that the design of the visualised units varied on *other* design attributes that could *also* be related to some of these affects. Potential avenues for future research to address this limitation could include the use of 3D computer-generated models, or searching for carceral facilities where 'normalisation' differs but many other features stay the same. Both these avenues also have their own limitations and challenges and may require better definition of what is normalised, residential design in the carceral context (Ulrich, 2019).

In conclusion, I return to the necessarily contested nature of youth justice. In addition to the themes of *if*, *how* and *what* matters, carceral design research also needs to engage with theme of *why* in youth justice—what it is trying to achieve. If the purpose is to restore and enable young people to contribute in their communities, then youth detention is unlikely to succeed. This research highlights the dysfunctionality of the current system, with, for example, affective barriers between young people and staff where young people's hardness faces off against staff hardness. It also highlights that in Australia (where over 50% of young people in detention are Indigenous), any consideration of purpose needs to be led by Indigenous people. On reflection, Indigenous leadership of this research would have been valuable. If our purpose is to restore young people within their communities, then international evidence and best practice points to alternative, community-based models of youth justice. When places for new community-based models of youth justice are being established, this research encourages the careful and thoughtful consideration of how the physical design of these places can support their purpose to restore young people in their communities.

Bibliography

Antolak-Saper, N. (2020). The Adultification of the Youth Justice System: The Victorian Experience. *Law in Context. A Socio-Legal Journal, 37*(1), 1–15.

Australian Institute of Health and Welfare. (2021). *Youth detention population in Australia 2020* (Cat. no. JUV 135).

Bargh, J. A. (2014). Our unconscious mind. *Scientific American, 310*(1), 30–37.

Caliendo, M., & Kopeinig, S. (2008). Some practical guidance for the implementation of propensity score matching. *Journal of economic surveys, 22*(1), 31–72. https://doi.org/10.1111/j.1467-6419.2007.00527.x

Clancey, G., Wang, S., & Lin, B. (2020). Youth justice in Australia: Themes from recent inquiries. *Trends and Issues in Crime and Criminal Justice [Electronic Resource]*(605), 1–19.

Cunneen, C., & Tauri, J. M. (2019). Indigenous peoples, criminology, and criminal justice. *Annual Review of Criminology, 2*, 359–381.

Davidoff, F. (2019). Understanding contexts: How explanatory theories can help. *Implementation Science, 14*(1), 23. https://doi.org/10.1186/s13012-019-0872-8

di Vesta, F. J., & Dick, W. (1966). The test-retest reliability of children's ratings on the semantic differential. *Educational and Psychological Measurement, 26*(3), 605–616.

Fairweather, L. (2000). Does design matter? In L. Fairweather & S. McConville (Eds.), *Prison architecture: Policy, design, and experience* (pp. 61–67). Routledge.

Fairweather, L., & McConville, S. (2000). *Prison architecture: Policy, design, and experience*. Routledge.

Francis, L. E., Lively, K. J., König, A., & Hoey, J. (2020). The Affective Self: Perseverance of Self-Sentiments in Late-Life Dementia. *Social Psychology Quarterly, 83*(2), 152–173.

Goffman, E. (1961). *Asylums*. Penguin.

Gollob, H. F. (1968). Impression formation and word combination in sentences. *Journal of Personality & Social Psychology, 10*(4), 341–353.

Heise, D. R. (1979). *Understanding events: Affect and the construction of social action*. Cambridge University Press.

Heise, D. R. (2007). *Expressive order: Confirming sentiments in social actions*. Springer Science & Business Media.

Heise, D. R. (2010). *Surveying cultures: Discovering shared conceptions and sentiments.* Wiley.

Higuera-Trujillo, J. L., Maldonado, J.L.-T., & Millán, C. L. (2017). Psychological and physiological human responses to simulated and real environments: A comparison between Photographs, 360 Panoramas, and Virtual Reality. *Applied Ergonomics, 65*, 398–409.

Jewkes, Y. (2018). Just design: Healthy prisons and the architecture of hope. *Australian & New Zealand Journal of Criminology, 51*(3), 319–338.

Lee, B., & Shafer, C. S. (2002). The dynamic nature of leisure experience: An application of affect control theory. *Journal of Leisure Research, 34*(3), 290–310.

Lewin, K. (1952). *Field theory in social science: Select theoretical papers.* Tavistock.

Lulham, R. A. (2007). *Applying affect control theory to physical settings: An investigation of design in juvenile detention centres.* University of Sydney. https://uts.academia.edu/RohanLulham/Thesis

MacKinnon, N. J., & Robinson, D. T. (2014). Back to the future: 25 years of research in affect control theory. *Advances in group processes, 31*, 139–173.

McCarthy, P., Schiraldi, V. N., & Shark, M. (2016). The future of youth justice: A community based alternative to the youth prison model.

Mead, G. H. (1934). *Mind, self, and society.* University of Chicago.

Moran, D., Jewkes, Y., & Lorne, C. (2019). Designing for imprisonment: Architectural ethics and prison design. *Architecture Philosophy, 4*(1), 67–81.

Nadel, M. R., & Mears, D. P. (2018). Building with no end in sight: The theory and affects of prison architecture. *Corrections, 5*(3), 188–205.

Oostermeijer, S., & Dwyer, M. (2019). *Design guide for small-scale local facilities.* www.localtime.com.au

Osgood, C. E., May, W. H., & Miron, M. S. (1975). *Cross-cultural universals of affective meaning.* University of Illinois Press.

Papalia, N., Baidawi, S., Luebbers, S., Shepherd, S., & Ogloff, J. R. P. (2020). Patterns of maltreatment co-occurrence in incarcerated youth in Australia. *Journal of Interpersonal Violence,* (7–8). https://doi.org/10.1177/0886260520958639

Peatross, F. (1994). *The spatial dimensions of control in restricted settings.* Ph.D., Georgia Institute of Technology.

Ray, D. W., Wandersman, A., Ellisor, J., & Huntington, D. E. (1982). The affects of high density in a juvenile correctional institution. *Basic & Applied Social Psychology, 3*(2), 95–108.

Ricci, K., Maiello, L., & Zavlek. (1999). Juvenile housing. In L. Witke (Ed.), *Planning and design guide for secure adult and juvenile facilities*. American Correctional Association.

Russell, J. A. (1988). Affective appraisals of environments. In J. L. Nasar (Ed.), *Environmental aesthetics: Theory, research, and applications* (pp. 120–130). Cambridge University Press.

Russell, S., & Cunneen, C. (2017). Don Dale royal commission demands sweeping change–is there political will to make it happen? *The Conversation*, 17.

Schiraldi, V. N. (2020). *Can we eliminate the youth prison? And what should we replace it with?* The Square One Project, Issue. C. University. https://squareonejustice.org/wp-content/uploads/2020/06/CJLJ8234-Square-One-Youth-Prisons-Paper-200616-WEB.pdf

Sichel, C. E., Burson, E., Javdani, S., & Godfrey, E. B. (2019). Theorizing safety informed settings: Supporting staff at youth residential facilities. *American Journal of Community Psychology, 63*(3–4), 405–417.

Smith-Lovin, L. (1987). The affective control of events within settings. *Journal of Mathematical Sociology, 13*(1–2), 71–101.

Stamps, A. E. (2013). *Psychology and the aesthetics of the built environment*. Springer Science & Business Media.

Thompson, T., Robinson, J., Dietrich, M., Farris, M., & Sinclair, V. (1996). Architectural features and perceptions of community residences for people with mental retardation. *American Journal on Mental Retardation, 101*(3), 292–314. https://www.ncbi.nlm.nih.gov/pubmed/8933903

Toch, H. (1977). *Living in prison: The ecology of survival*. Free Press.

Ulrich, R. (2019). *Evidence-informed design recommendations for juvenile facilities in Sweden*. C. f. H. Architecture. http://www.chalmers.se/SiteCollectionDocuments/Centrum/CVA%20Centrum%20f%C3%B6r%20V%C3%A5rdens%20Arkitektur/publikationer/Ulrich_2019_Evidence-Informed_Design_Recommendations_for_Juvenile_Facilities_in_Sweden.pdf

Ulrich, R. S., Berry, L. L., Quan, X., & Parish, J. T. (2010). A conceptual framework for the domain of evidence-based design. *Health Environments Research & Design Journal, 4*(1), 95–114. https://doi.org/10.1177/193758671000400107

Wapner, S., & Demick, J. (2002). The increasing contexts of context in the study of environment behavior relations. In *Handbook of environmental psychology*. (pp. 3–14). John Wiley & Sons, Inc.

Wener, R. (2012). *The environmental psychology of prisons and jails: Creating humane spaces in secure settings*. Cambridge University Press.

Werner, C. M., Altman, I., & Brown, B. B. (1992). A transactional approach to interpersonal relations: Physical environment, social context and temporal qualities. *Journal of Social and Personal Relationships, 9*(2), 297–323.

White, R., & Gooda, M. (2017). Royal commission into the protection and detention of children in the Northern Territory. *Final Report*.

Wortley, R. (2002). *Situational prison control: Crime prevention in correctional institutions*. Cambridge University Press.

17

Prisoners with Severe Mental Illnesses and Everyday Prison Interior (Re)design

Kathryn Cassidy, Wendy Dyer, Paul Biddle, Louise Ridley, Toby Brandon, and Norman McClelland

Introduction

Designing an institution involves a complex array of processes and practices, which are not bound up solely in the period from the original commissioning to opening, but also often both pre-date the formal commissioning process and extend beyond the opening of a new facility. Much of the custodial estate in England and Wales today is the result of re-commissioning, re-designing and adapting current architecture and its interiors to meet the diverse and changing needs of the prison population. Frequently, these adaptations have emerged to meet physical,

K. Cassidy (✉) · W. Dyer · P. Biddle · L. Ridley · T. Brandon · N. McClelland
Northumbria University, Newcastle-upon-Tyne, UK
e-mail: kathryn.cassidy@northumbria.ac.uk

W. Dyer
e-mail: wendy.dyer@northumbria.ac.uk

mental and social care needs and range in scale from the building of specialist units such as those for prisoners with dangerous and severe personality disorders (DSPD) (Saradjian et al., 2013) to the renovation of existing wings and creation of day care centres for older prisoners (Moll, 2013; Turner et al., 2018). Indeed, given the complex array of public–private service provisions within the prison estate, commissioners are also not solely limited to prison authorities.

The prison design literature has highlighted the difficulties of accommodating the differentiated needs of prisoners (McConville, 2000). In particular, attention has focused on design solutions to the mental and physical harms prison buildings and interiors cause to prisoners (Jewkes et al., 2019, Jewkes et al., 2020, Söderlund & Newman, 2017, Grant & Jewkes, 2015). Although the increasing range, severity and complexity of mental health needs in prisons is widely recognised (Bebbington et al., 2017; Crichton & Nathan, 2015), the focus of literature on prison design in relation to mental health tends to be on general well-being rather than the treatment of acute illnesses (Jewkes 2018, Moran, 2019, Söderlund & Newman, 2017).[1] Meeting the needs of prisoners with serious mental illnesses forms an increasingly important part of decision-making regarding contemporary prison (re)design and adaptation (Cassidy et al., 2020).

In this chapter, we analyse the creation of a specialist unit commissioned by the National Health Service (NHS) for England in a large

P. Biddle
e-mail: p.biddle@northumbria.ac.uk

L. Ridley
e-mail: louise.ridley@northumbria.ac.uk

T. Brandon
e-mail: toby.brandon@northumbria.ac.uk

N. McClelland
e-mail: norman.mcclelland@northumbria.ac.uk

[1] 'Severe mental illness (SMI) refers to people with psychological problems that are often so debilitating that their ability to engage in functional and occupational activities is severely impaired' (Public Health England, 2018).

reception prison in the North of England. We follow the adaptation of a small wing to create the Unit and highlight three elements of the design process: firstly, we attend to *adaptation* to understand the complexities of re-designing existing interior spaces within the custodial estate to meet the needs of specific groups; secondly, we explore the opportunities presented by *indeterminacy*, as the Unit began operating when so many elements of its design, usage and regime were still unknown; finally, we elucidate the centrality of forms of *accommodation* in the re-design of the Unit, involving compromise and negotiation. Attuning analysis of prison design to the everyday processes and practices that shape much of the custodial estate enables insights to improve the re-design and adaptations of existing prisons.

Prison Interior Design

Rather than as a one-off event with a delineated start and finish, custodial design, even on individuated sites, is better understood as an ongoing set of processes and practices that shape the environment in which a prisoner may find themselves. Initial designs often emerge not from the vision of one commissioner or architect, or even as the process of one negotiation (or tender), but through a series of ongoing conversations, dialogues, shifts and changes over time (Grant & Jewkes, 2015). This processual approach applies not only to contemporary custodial design but also to the many historic buildings that comprise the penal estate in England.

In this chapter, we are specifically concerned with interior design. This field of research and practice is often expansive and relates to all elements of the design of spaces interior to buildings (Brooker & Weinthal, 2013), overlapping with architecture and cognate disciplines (Dodsworth & Anderson, 2015). Practice and theory encompass everything from the total re-design of an interior space, including changes to the interior architecture, to interior re-decoration, which does not involve structural adaptations (Dodsworth & Anderson, 2015). The case study analysed in this chapter did not involve major structural changes, as we shall see, but extensive re-decoration and re-purposing of an interior within an existing prison wing, which extended beyond interior re-decoration.

Whatever the scale of the design, however, it is clear that it involves much more than simply changing the aesthetic of the space. Analysis of interior design reveals the ways in which those involved might be seeking to question or challenge the current status quo by offering different possibilities and ideas for the way in which people are able to inhabit a space (Dodsworth & Anderson, 2015).

If the 'design of a prison reflects the penal philosophy of the prevailing social system' (Moran et al., 2016, pp. 114–115), then the additions, adaptations and changes to an original design (particularly interior) within existing prisons evidence not only how penal philosophy has changed, but also commitment to and prioritisation of any shifts by different authorities involved in making changes to the prison estate. As has been noted by a number of commentators (McConville, 2000, Moran et al., 2016), the main aims of contemporary incarceration in the UK are to provide security for the wider public, punish and rehabilitate. However, what constitutes punishment differs between countries (Moran et al., 2016) and impacts upon the conditions and, consequently, design *within* prisons, in particular. Designs should be developed that recognise these differing contexts (Grant & Jewkes, 2015).

However, the coherence of any penal philosophy in practice has been questioned (McConville, 2000) with clear gaps existing between wider public and political discourses and experiences within prisons. '[T]he actual connection between policy and design is often tenuous and [...] difficult to establish' (Dunbar & Fairweather, 2000, p. 46). The divergence can, to some extent, be explained by the lack of funding that would enable prison buildings to keep pace with the changes in penal philosophy (Dunbar & Fairweather, 2000). However, even when there is support for and intention to implement a particular idea or principle, practical difficulties frequently arise particularly in relation to design. Any penal reform agenda can be 'thwarted if it is not accompanied by a reform to the way that prison buildings are commissioned, designed, maintained and upgraded' (Karthaus et al., 2019, p. 196).

For example, the principle of 'equivalence' in the delivery of healthcare in prisons, i.e. that prisoners are expected to receive the same level of care as they could access in a community setting (Shaw & Elger, 2015), ignores the extent of the adaptations necessary to provide the same

level of care within a custodial setting (Niveau, 2007). Consequently, whilst such policy initiatives make demands that necessitate adaptations to the custodial estate, they are frequently not supported by budgeting or direct guidance to institutional management or healthcare providers to support implementation. Therefore, whilst custodial design is shaped by top-down policy-making, it is important to also consider 'grass-roots innovation […] led by innovative Governors, officers and ex-prisoners, in some cases supported by philanthropic organisations, charities and social enterprises' (Karthaus et al., 2019, pp. 198–199).

The need for *differentiation* between prison populations is not easily accommodated by the uniformity of prisons in England and Wales (Dunbar & Fairweather, 2000). Prisoners' safety needs differ (McConville, 2000). Prison policy and management, therefore, is often focused on the practicalities of classification and separation (McConville, 2000) in order to meet these needs. Yet, prisons designed to enable subdivision into more manageable group sizes and with in-built regime facilities did not begin to emerge in England and Wales until after 1945 and are limited in number across the prison estate as a whole (Dunbar & Fairweather, 2000).

Over-design of spaces within the custodial estate, i.e. designs pre-determining and consequently limiting the use of interiors, has the potential to lead to costly mistakes that may need to be corrected in the future if a space proves impractical (McConville, 2000). Therefore, there has been an overall shift in prison design in England and Wales towards under-designed, flexible and multi-use spaces (Dunbar & Fairweather, 2000), creating opportunities for differentiation through interior design. The role of interior design is somewhat marginalised within the prison design literature, although its importance is well-established in research in social psychology, criminology and cognate fields (cf. Sommer, 1971). Nonetheless, as we shall see in this chapter, the re-design of interior spaces is also marginalised in practices by prison authorities and commissioners. 'The object of interior design is to make the prison more attractive, brighter, more cheerful and personalised – in general less institutional' (Fairweather, 2000, p. 74). Paying attention to interior (re)design is particularly important when considering adaptations to existing interiors within the prison estate. The academic

literature is increasingly concerned with learning from healthcare settings (Jewkes, 2018), as well as exploring certain types of interventions such as nature/'green design' (Moran, 2019, Söderlund & Newman, 2017) and water/'blue design' (Jewkes et al., 2020). In this chapter, we seek to contribute to this growing literature by analysing the interior re-design of a wing to accommodate prisoners with acute mental healthcare needs.

Prison Interior Re-Design and Mental Health Care

Changes and adaptations to existing prisons are influenced by a range of external processes and pressures. Re-design may reflect shifts in standards and conditions of living (Dunbar & Fairweather, 2000), as well as a more generalised alteration in wider societal understandings of the composition and needs of prison populations (Cassidy et al., 2020). In the UK, the announcement of a 'rehabilitative revolution' by the then Justice Secretary in 2010 has shifted prison regimes away from an overall emphasis on punishment and surveillance to more subtle controls and 'learning'. Yet, as Henley (2003, p. 13) has highlighted, such shifts have been difficult to accommodate within the confines of the existing built custodial estate. Although some have argued that prison environments have become less repressive mentally and emotionally (Jewkes & Johnston, 2012), Ben Crewe (2011) has suggested that we need to be cautious in surmising that seemingly more efficient regimes of discipline and regulation are, in fact, less damaging for individual prisoners.

The impacts of imprisonment can often be most acutely felt by those who enter a penal environment with existing illnesses and conditions; not all prisoners are equally vulnerable to prison regimes and environments. Poor mental health, and importantly, complex and severe mental illness is a growing problem in penal settings in England and Wales (Bebbington et al., 2017; Cassidy et al., 2020). One study (Bebbington et al., 2017) found that in the year before imprisonment, 25.3% of respondents had used mental health services. In 2018, the Prison Reform Trust noted that over 16% of men said they had received treatment for a mental health problem in the year before custody, and 15% of men

in prison reported symptoms indicative of psychosis (compared with 4% in the general public). In 2017, the House of Commons Committee of Public Accounts identified record numbers of suicides and incidents of self-harm in English prisons. Mental health problems in prisons are also often compounded by related issues such as substance misuse and/or personality problems, as well as family and social difficulties (Crichton & Nathan, 2015).

Meeting these complex needs generally falls upon in-reach mental health teams,[2] contracted by the prison with a mixture of NHS and private providers across the country. These teams, comprised of mental health clinicians, deal with a very high numbers of referrals and are often too small to meet the demands and health needs of all prisoners (Jordan, 2011). The situation is compounded by external constraints, including a shortage of both high and medium security beds within the NHS (Sloan & Allison, 2014). Consequently, prisons increasingly use separation and isolation to manage the behaviour of some of their most mentally unwell prisoners, who are awaiting transfer to hospital (Dyer et al., 2020).

[2] Mental health in-reach teams provide support and treatment to prisoners within the mainstream prison environment. They emerged after 2006, when following a Department of Health strategy to improve mental health in prisons (published in 2001), the NHS took over providing mental health care in prisons (Brooker & Webster, 2017). Similar to Community Mental Health Teams (CMHTs) outside prisons, they carry out assessments on prisoners referred to them both on admission to the prison and during their time there, develop treatment plans and monitor prisoners, as well as make referrals on to specialist services and liaise with community-based teams prior to a prisoner's release.

A New Prison Mental Health Unit

Setting

The research presented here took place in a reception prison[3] in the North of England. Located close to the centre of a city, the prison was originally built and opened in the early nineteenth century. Started and re-started by two different architects, the building was finally finished by a third, who (according to local records) completed the work without much of the ornament envisaged by his predecessors. However, like many prisons built during this period, it has been adapted over the last two centuries; significant additions include the building of a maximum-security wing, a new gatehouse and reception centre in the 1960s, as well as a new healthcare wing that opened in 2017. Alongside these new additions, the internal design of the building has also been extensively modified. Some of these changes intentionally sought to hide the origins of the jail according to a local newspaper report from the early 2000s, 'millions of pounds have been spent refurbishing the wing to stop it looking like a Victorian[4] jail. Each cell has en-suite facilities, curtains adorn the bars on the windows and TV is allowed'.

This chapter is based upon research undertaken in a new mental health unit, which represents a unique development across the prison system in England and Wales (Dyer et al., 2020). The Unit occupies a small wing built in the 1990s and has the capacity to take 11 patient-prisoners (single cell), plus two prisoner peer workers (sharing a cell). The Unit provides a service for male remand and sentenced prisoners (adult and young offenders) with serious or severe mental illness (SMIs) across the

[3] The prison serves the court services of North East England and parts of the North West. It is where prisoners are transferred to if they are remanded into custody awaiting trial or following conviction and a custodial sentence. For those, who have been sentenced already, they are then, most often, transferred on to another regional prison. Those awaiting trial might stay in the reception prison until they appear in court, depending on how long they may have to wait for their trial date and on the severity of the possible punishment for their alleged crime (the prison does not hold high security or category A prisoners).

[4] The prison was actually opened in the late Georgian period, however the reference to a Victorian prison in the media is not related to the period as such, but more to evoke the austere aesthetic of some of England's older prisons.

region (excluding high security prisoners based upon the level of security). Mental health staff are on the wing Monday–Friday 8am–8 pm and Saturday–Sunday 8am–4 pm. Prison officers staff the Unit 24 hours a day, seven days a week. The development is funded by the regional offender health commissioner, NHS England, and the Unit opened in October 2017.

The creation of the Unit was driven by the growing number of prisoners within the region awaiting transfer to a secure mental health facility for treatment (Dyer et al., 2020). It was also underpinned by a logic of economic efficiencies due to the costs of keeping such prisoners either in the segregation unit or hospital wing for long periods of time (Cassidy et al., 2020). The managers of the local NHS trust contracted with in-reach mental health provision and the prison governors hoped that in addition to acting as a safe place for those awaiting transfer, that treatment within the Unit would reduce referrals to secure facilities by enabling more prisoners to be returned to mainstream prison locations.

Methodological Approach

The methodology sought to develop a deep understanding of the Unit and the contexts within which it began to operate. The project was informed by critical realism, recognising that the mechanism for change that is introduced (in this case the creation of a new mental health unit) can only be understood when analysed within the existing context, which includes both existing mechanisms and structures for mental health care, as well as wider, pre-existing economic, political, social and cultural conditions (Kazi, 2003). The research was planned in two phases, the first of which followed and proactively supported (see also Karthaus et al., 2019) the development of the Unit. Data collection was completed for this phase by the end of 2018. Phase two seeks to understand the context, mechanisms and outcomes produced by the Unit and began in October 2019.[5]

[5] Phase two of the project has been delayed as access to the prison has been restricted since the onset of the Covid-19 pandemic.

One member of the research team was embedded in conversations surrounding the development of the Unit from early on as a member of the steering group. This meant that the research team undertook participant observation at monthly Steering Group meetings from November 2016 to November 2018, which was supplemented by an analysis of relevant background documents, including minutes of meetings between stakeholders. As participant-observers, members of the research team were in attendance at initial meetings and able to ask questions and provide feedback on the development of the research design. Therefore, participation focused primarily on collecting data for use in the process analysis, which was a key part of the first phase of the research, as well as briefing the Unit manager (after appointment) on the practical implications for staff of the research, rather than on contributing directly to the design of the Unit. The findings from this phase of the research were not presented (both in written and oral format) to the steering group and staff on the Unit until Spring 2018. However, during the pre-opening phase, participant observation did extend to providing a summary of information that emerged in the literature review to the custodial manager on colour schemes for the interior decoration of spaces used for the detention of people with serious mental illnesses.

Once the Unit opened in October 2017, members of the research team were also able to undertake non-participant observation on the Unit until October 2018. This usually involved spending a few hours on the Unit, speaking primarily to the staff and prisoner-cleaners and observing activities in the communal, open areas of the Unit both when the patients and prisoners were unlocked and also when they were confined to their cells. In addition, a minimum dataset (MDS), recording information pertaining to referrals, activities and outcomes, was created by the research team and populated by healthcare staff working in the Unit. Semi-structured interviews with 16 key stakeholders were also undertaken between January and May 2018. A number of informal discussions with mental health team managers in the region's prisons were undertaken as part of phase two of the project towards the end of 2019 and in early 2020. These sought to gain different perspectives on how the Unit was operating.

Adaptation

As Brooker and Stone (2019, 1) have described, buildings can accommodate change; they evolve and are adapted 'as the needs and priorities of those who occupy them become different'. Attention has shifted over the last two decades or so to accommodate the needs of older prisoners (Moll, 2013; Turner et al., 2018), as well as improving specialist mental healthcare (Saradjian et al., 2013). In the twenty-first century, architects, designers, planners and other professionals engaged in shaping built environments, have become more readily engaged in a *tabula plena* approach (Brooker & Stone, 2019; Roberts, 2016), which involves the adaptation of existing buildings, rather than their removal and replacement. For many practitioners and theorists in these inter-related fields, the sustainability agenda has been key to this shift and interest in the transformative potential of adaptation (Ellin, 2012). In this section, we explore how the interior of an existing wing was adapted to create the Unit's interior environment. We argue that whilst there was an initial adaptation to the interior design of the Unit prior to opening, that this process was incomplete and, therefore, ongoing after the Unit became operational. Consequently, possibilities for adaptive co-design with patients as they moved onto the wing emerged.

Initial Adaptation

The wing allocated for the new Unit was itself the result of a previous, more extensive adaptation of the prison, which included the expansion of the current built environment through the addition of the wing in the 1990s. Although much smaller than the existing prison wings, the wing reflected some of the ideas dominant in prison architecture at the time (Dunbar & Fairweather, 2000). It had just two floors housing a small number of cells and there was also some open, multi-purpose space on both floors. The ground floor held the custodial staff's office and there was a group therapy room with little external light and part of which was cave-like in its appearance due to its proximity to the outer wall of the prison site. A number of smaller rooms used for one-to-one meetings

and storage completed the ground floor. Up on the first-floor landing, in addition to the remaining cells there were showers and then through a locked internal door, there was a large light-filled group room, as well as an office and common room with kitchen facilities that had been used by staff from the regional drug and alcohol recovery team (DART), who were the previous occupants of the wing.

In the weeks before opening, there were still considerable uncertainties over funding and the supply of materials, which would enable the interior re-design to be completed. Without any input from external specialists, local-level managers took decisions about how to re-design the space. The process was fragmented and population pressures meant that the space continued to be occupied by vulnerable prisoners whilst the re-design was being undertaken. During this time, the custodial manager was given a small budget for interior re-decoration and this work was undertaken by prisoners on his instruction. Furniture had to be ordered from another prison within the region where there were long delays in fulfilling orders. At the same time, once key healthcare staff had been appointed, they were engaged in reconfiguring and re-designating the different rooms within the wing. The wing had previously operated in a similar way to community-based residential rehabilitation facilities and was configured and designed to meet their needs, with a focus on group therapy rooms, the walls which were emblazoned with slogans familiar to recovery settings. The very different therapeutic regime from that operated by DART necessitated the creation of new facilities, as well as changes to the existing interior decoration, furniture and layout. For example, a ground-floor one-to-one meeting room had to be renovated to act as a dispensary with secure storage for medicines, washing facilities and healthcare supplies.

There were also changes to the staff work spaces. The separation of custodial and therapeutic staff, which had previously existed on the wing, was no longer feasible. The main reason for this was that the Unit was to offer enhanced observation to enable better diagnosis and treatment of mental health conditions. 'Any designated area within the prison will require necessary adjustments to ensure cell accommodation is suitable to conduct *constant supervision* and high levels of observation' (Project Proposal, 2017). Observation had to be led by healthcare

staff with support from their custodial colleagues, but the idea that this would involve adaptations to cell accommodation changed when it was decided that the Unit would operate a regime with prisoners unlocked from their cells during the day except for an hour after lunch. When healthcare staff were on the Unit, prisoners were often not in their cells, consequently healthcare staff could not be locked away from prisoners outside of formal sessions like their DART colleagues had been. Custodial colleagues made space for healthcare workers in the observation office on the ground floor. The upstairs group therapy room, office and kitchen were surplus to requirements and became occupied by the in-reach mental health team with whom staff on the Unit worked closely.

Ongoing Adaptation

The Unit opened with many of the planned interior adaptations incomplete. For example, the showers on the first floor had not yet been made safe and usable for the vulnerable occupants of the wing and the ordered furniture had not arrived. However, aside from these planned changes, the initial adaptation had also not touched some areas of the Unit. In this section, we analyse how this led to ongoing adaptation of the interior space of the wing once the new occupants started to arrive (Fig. 17.1).

The ground-floor communal area was not given a particular use during the initial adaptation of the Unit. It was situated immediately in front of the locked entrance corridor separating the Unit from the nearby prison wing. The wing's administrative office overlooked it on one side and to the rear was the exit to the outside space. The administrative office was the primary location in which to find staff during the day and also the key area in which healthcare staff and prison officers mixed without the prisoners and undertook observations of the prisoners when they were unlocked.

The adapted interior design of the communal area emerged as the result of the healthcare staff trying to manage the behaviour of one patient, who was using food to block the pipes in his cell. They, therefore, obtained a small table and chair and situated them in the area in front of the office, to enable them to watch him whilst he ate. The lead

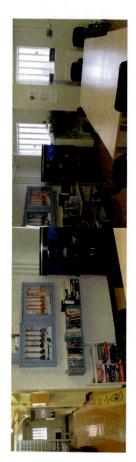

Fig. 17.1 The downstairs communal area on the Unit

nurse explained that after a few days, another patient sat down at the small table with this patient to eat with him and that this attracted other patients and prisoners and they brought in more tables and chairs from the large upstairs group room to accommodate them. There had not been any designated, freely accessible common space on the wing in which the patients and prisoners could interact with staff until this time. Meal times involved the prisoners eating in their cells. So, even though they were unlocked, the interior design of the wing inhibited the formation of relationships.

The tables were only part of what became the emerging materiality and ongoing adaptation of this centralised space on the wing. Analysis of this space can help us to better understand the competing priorities and constraints shaping custodial interior re-design, particularly within small units. Firstly, the cabinets with the locked utensils on the wall and the roll of institutional-size paper towel draw attention to the Unit as an institutional space, and not only that but an institution with a high level of control over the mundane aspects of the lives of those dwelling within it. In locking away the utensils in such a visible, but also practical, space, those using the communal area are reminded of the very intense and specific forms of control in operation on the Unit. In addition, these items also highlight two people, whose position was relatively marginalised in the planning and discussion of the operations of the Unit, but who in the context of everyday life is very visible in the material spaces of the Unit itself—the two prisoner-cleaners. The *work* being undertaken on the Unit is not solely that of the prison guards and healthcare staff, but also the prisoners themselves. During the initial phase of re-designing this space, the needs of the prisoner-workers had been neglected, as the NHS England manager also noted in the previous section.

The next two items of note are clustered in the corner of the communal area—the fish tank and the plant. These items were placed in this area prior to the Unit opening and signify efforts on the part of the healthcare staff to introduce design elements found in other therapeutic spaces. In particular, the use of these items demonstrates an attunement to interior re-design that is beneficial to the mental health and well-being of the patients through 'green' (Moran, 2019,

Söderlund & Newman, 2017) and 'blue' (Jewkes et al., 2020) design. However, once the communal area began to develop, they became somewhat marginalised, as the specific care needs of the prisoners were determined and they were able to assert their own preferences in relation to the organisation of space and material objects.

A closer look at the wall upon which the utensils are hanging also highlights the increasing recreational use of the communal area after occupancy. The original shelf filled up with books and games and an additional small white unit of shelving had to be added to accommodate these materials. The growth of the communal area for recreational purposes was indicative of the *differential spatial* regime on the Unit, i.e. that the space of the wing was used and occupied differently than by prisoners elsewhere in the prison. This differentiation was primarily due to the patients and prisoners spending most of the day out of their cells, which as we have argued elsewhere (Cassidy et al., 2020) should not be interpreted as them being subject to less control than elsewhere in the prison.

Yet, the interior re-design of the communal spaces did not end with the area in Fig. 17.1, but began to shape neighbouring spaces on the ground floor. The unlocking of prisoners during the day shifted relationships between them and the prison officers (Cassidy et al, 2020). The ground-floor area became insufficient to accommodate the recreational activities integral to these relationships. The Unit went from having a handful of board games to a pool table and also table football (see Fig. 17.2), reproducing the recreational materiality often found elsewhere in prisons.

Although small, the original design and layout of the wing had left open, flexible, multi-use space that could be developed through interior re-design.

Adaptive Co-Design

Approaches to custodial design within architecture tend to understand co-design as part of a more formal engagement with service users during the commissioning and planning of a building (Karthaus et al.,

Fig. 17.2 Pool table and table football on the ground floor of the Unit

2019). However, as noted in the section on the initial adaptation of the wing, the re-design had to take place relatively rapidly and whilst other prisoners were living there. Consequently, engagement with users—both patients and the prisoner-workers—developed after the Unit had opened. In part, each of the prisoners that came to the Unit for assessment and treatment informed and shaped the unfolding design in smaller but also sometimes quite significant ways, as the example of the downstairs communal area illustrates.

> The quiet room has been used by two poorly lads for time-out rather than going back to their cells. However, the usage is variable and depends on who is on the unit. The current lads have decided to move the 'comfy' furniture down to the big room for acupuncture […]. The prisoners on the unit decide themselves how to use the space and furniture. (lead nurse, October 2019)

This was enabled both by the original design of the wing, which had some flexible, multi-use spaces, as well as spaces left incomplete during its adaptation that provided prisoners and staff with opportunities to meet individual needs as they emerged. Such elements were not just ad-hoc but came to form a key part of the re-design of the interior space and its usage. We would argue, therefore, that this approach to co-design is understood as *adaptive co-design* developed through the ongoing nature of the adaptation process on the wing. In the following section, we explore how this adaptation was facilitated by an underpinning indeterminacy in relation to the interior re-design of the wing.

Indeterminacy

> [T]he notion of indeterminacy within architecture and the city not only halted the project of Modernism but also spawned several trajectories of design that embraced flexible, soft, dynamic and transforming systems to respond to the new needs of the expanding city and its pluralistic inhabitants. (Kol & Zarco Sanz, 2014, p. 193)

In their analysis of Rem Koolhaas' work, Kol and Zarco Sanz (2014) argue that for architects, underpinning projects with indeterminacy involves the development of strategic tools that forces designers to think through how to make space for user improvisation and ongoing cultural mutations. Such an approach in architectural practice involves recognition of users as not simply passive or reactive, but as creative in their interactions with a space (Hill, 2003). In this section, we explore how indeterminacy develops within a differing context, i.e. through experimental commissioning to address mental healthcare needs within prisons. Here, indeterminacy is less part of architectural practice and individual approaches to design and more the result of a confluence of the different actors involved in the commissioning and operationalising of the Unit.

The under-design that emerged from the initial adaptation phase and created potentiality for further adaptation of the wing was shaped by indeterminacy in the commissioning of the Unit. For us, the indeterminate approach can be viewed as a successful and replicable element of the Unit's interior design.

> There were two potential models but then we were offered one wing in [prison] because it is a remand prison. If there was unlimited funds, I would build a new wing. A designated hospital within the prison is the way it is going. The advantage is the process of moving people with acute need would be smoother and it would be dedicated for prison transfer. (service manager, NHS Trust, April 2018)

The service manager suggested that there were two potential models developed for the Unit, one of which was to commission and build a new wing within a regional prison. However, it was clear that the key manager within the commissioning body had some reservations, which meant that the development of this model was not supported.

> At first, I did not like the idea. I was worried it would become a mini-hospital [...] and that it and the prisoners would be stigmatised. However, I agreed to a trial and in hindsight it has worked well. (manager, NHS England, April 2018)

Consequently, the project proposal focuses on identifying a space within the local remand prison that could be used for the Unit. The nature of the re-design and how that might specifically meet the needs of the prisoners were not defined in the proposal itself. The indeterminacy shaping the interior design of the Unit emerged not so much as part of a strategic approach by a designer (Kol & Zarco Sanz, 2014) but as a strategy driven by the healthcare provider.

> The first step in this project will be to identify a specific area within [prison] that could potentially be used to care for and manage those prisoners with acute mental health needs, including those prisoners where an 'Access Assessment' may be required for transfer to secure hospitals. It is anticipated that this area/environment may require some changes/alterations to provide and promote specialist assessment, care and treatment. (Project Proposal, 2017)

This indeterminacy in terms of the re-design was due, in part, to no specific area having been identified prior to the development of the proposal. However, it was also the result of an approach that was based upon highlighting and identifying problems and gaps in current prison environment for assessing and treating prisoners with SMIs, rather than one which focused on clearly defining alternatives.

> Currently, there are no evidence-based guidelines to assist healthcare professionals and prison staff in making decisions about where a prisoner with often unmet mental health needs is managed within the prison, nor is there a designated area within the prison to offer enhanced therapeutic mental health care and observation, including specialist assessment, care and treatment. The healthcare unit in [prison name] has not been designed to manage prisoners with an acute mental illness and associated risks. Equally, the SACU/Segregation Unit is not a suitable environment to manage prisoners with an acute mental illness or on an open ACCT Plan (at risk of self-harm/suicide), and often placing patients there can exacerbate their problems and increase risk. (Project Proposal, 2017)

The project proposal refers specifically to the ways in which the healthcare unit's design excluded healthcare for SMIs. In contrast, the environment of the SACU is described as being harmful to these prisoners. Consequently, the focus for the proposers from the NHS Trust and the prison seemed to be on securing space and funding for the Unit, leaving the re-design of any space to be determined at a later date. Nonetheless, the proposal does explicitly acknowledge that adaptation will be necessary. This is reflective of interior design practice, as there is a need to know and work with the existing interior design and architecture in order to identify and prioritise changes for the re-design of the space.

As Tsing (2015, p. 47) has argued, '[o]ur daily habits are repetitive, but they are also open-ended, responding to opportunity and encounter'. In order for design to respond to the opportunities presented in everyday encounters, there has to be recognition of a level of indeterminacy embedded within the process, as Kol and Zarco Sanz (2014) explain. This is particularly the case in small units within prisons, which attempt to adopt an experimental approach (McGeachan, 2019), and offer the potential to develop strategic tools for interior design that address diverse needs in situ.

> Generally the environment is more comfortable, less chaotic. There is more access to trained nursing staff and increased levels of observation. [...] The key aim is to alleviate mental distress. [...] It has an assessment function, to make a more thorough assessment and therefore a more reasoned identification of need. (Unit consultant psychiatrist, April 2018)

As the psychiatrist explains, the determination of need is based upon the individual, rather than existing, top-down, generalised understanding that has informed some elements of prison architecture (Moran, 2019, Jewkes, 2018, Söderlund & Newman, 2017). This is very important when we consider moving custodial design away from generalised ideas of health and well-being for the wider population to thinking about those with SMIs. Even amongst the 11 prisoners receiving care on the Unit,[6]

[6] After opening, the cells quickly became occupied. The Unit ran at full occupancy for most of the time due both to demand for the specialist services but also because of wider pressures and over-crowding in the region's prisons as a whole.

there is considerable variation in terms of their specific symptoms, diagnoses and treatment needs. The interior re-design of the Unit needed to enable this determination: a determination, whose complexity could not be within the purview of a custodial manager charged with interior re-decoration or even healthcare clinicians with experience of secure mental health care. For the psychiatrist, the Unit should offer comfort, quiet, calm, access to staff and opportunities for observation. The key impact is to alleviate the distress that makes determining needs difficult in the wider prison. Indeterminacy in this context, therefore, created space in which diagnoses and treatment could become determined through intensive observation and assessment, as well as creating possibilities for prisoners to co-design the Unit alongside the staff. Nonetheless, there were still gaps in the interior design, which made it difficult to meet the needs of prisoners with SMIs.

Accommodation

The Unit was re-designed upon a foundation of *accommodation*, as it sought to create a safer space within the prison for those who were awaiting transfer to secure mental health units within the NHS. Our understanding of accommodation here draws together not only the creation of a physical space for prisoners with SMIs to reside within the prison, but also an acknowledgement that the Unit itself represented an arrangement that was not seen to be optimal by any of the actors involved. The optimal solution for these prisoners was that which was inaccessible to them—transfer to a secure hospital setting. This reflects an over-arching theme in the literature on prison design, in which architects highlight that they cannot conceive of a 'good prison', but seek instead to offer design alternatives that are better than those currently on offer (Karthaus et al., 2019). The positioning of the Unit as *between* prison and hospital had a significant influence over subsequent decisions on how the wing was re-designed and which elements of both types of institutions and regimes were incorporated. We, therefore, draw upon sociological conceptualisations, which analyse accommodation as

the processes and practices of relational adaptation that take place in a new context or setting.

The Unit is like a bail hostel or a halfway house—'a stepping stone halfway between prison and hospital' (mental health in-reach team manager, another regional prison, May 2018). The term halfway house was used to describe the Unit by a number of different actors. The implication was that the Unit occupied a position between a prison and a secure mental health unit, meaning that it possessed some, but not all, the design elements of each. During the process of designing the space for the Unit, managers were forced to make decisions surrounding which features of each setting were to be prioritised. In some cases, this meant having less of a particular design feature. 'We've only got two safer custody cells.[7] And I think, in an ideal world […] everyone would be a safer custody cell […] but whether they have the funds to do it, I don't know' (manager, NHS England, April 2018).

This decision to include only a small number of safer custody cells reflects the approach we have seen elsewhere in the prison estate in England and Wales, when seeking to *accommodate* prisoners with severe disorders (Saradjian et al., 2013). Here, a manager from the commissioner, NHS England, recognises that the Unit does not have all the features that would be expected in a secure unit. The manager's supposition that this was due to funding is confirmed in a conversation with a colleague from the NHS trust tasked with providing the service on the Unit.

> We are aware that the Unit does not meet [NHS] standards but that would be impossible without millions of pounds to bring it up to date. The point is that the environment is not any worse than anywhere else in the prison estate. (service manager, NHS Trust, January 2018)
> There are still ligature points in the cells, like pipes that are not boxed in. The prison is arguing these are 'known and manageable risks'. These are the functioning prison cells in an old Victorian prison, and the prison

[7] Safer custody cells are designed to make suicide or self-harm more difficult, for example through the removal of any ligature points. On the Unit these cells were also fitted with smart glass to enable constant watch/observation.

> is limited by contracts. We were quoted approximately two thousand pounds per cell just to box the pipes in. (lead nurse, October 2019)

Therefore, in accommodating the Unit on the wing, managers also required nursing staff to *accommodate* the absence of features that were considered foundational within secure units, thus shifting their professional practice, and also recognising wider constraints on re-design caused by the prison's contractual arrangements with service providers. The Unit did not offer a suitable alternative to a hospital setting for those patients at risk of suicide due to the existence of ligature points in the majority of the cells.

> We do this through offering a unique approach within the prison. We run a regime that has been developed to provide a therapeutic "ward-type" atmosphere whilst maintaining some of the prison routines to help people both get the support they need but also continue to have some of the routines needed to manage in prison. (Service Operational Policy, 2019)

The official documents relating to the Unit also highlight that it does not offer all of the services found in a hospital setting. The operation policy describes a 'ward-type' atmosphere, i.e. something which is, in part, intangible.

The Unit not only lacked elements of secure unit design, but also some of those found in the wider prison. Whilst we might assume that departures from the design of the prison would be welcome, this was not always the case, as the manager from NHS England explained when asked about changes s/he would like to see to the Unit.

> I would say, probably, a more suitable environment for them to do the servery. They struggle to [...] do the dishes and wash the things that they use on a daily basis. They've got to go through [neighbouring] wing, where it would be so much easier for the lads if they had, maybe, a sluice room, and then another area where they could do... not pots and pans, but you know, the... the dishes and stuff like that.

The size of the Unit (Cassidy et al., 2020) meant that it remained dependent on the wider prison and made it difficult for the Unit's two prisoner-cleaners to carry out their duties effectively. They, like the healthcare staff, were also expected to *accommodate* these absences and resolve them through changes to their working patterns. These *accommodations*, in turn, shaped the physical environment of the Unit. The servery had to be stored under the stairs when it was not in use and was moved into the main communal area on the ground floor at meal times. Cleaning products and equipment often over-flowed into other areas of the Unit. Issues relating to the (re)design of the Unit were also evident outside.

> And possibly a bigger, more functional exercise yard. We've got a little, sort of, triangle out the back there. Whereas the other ones have got a big area with different machines and whatever on. And we've got a little triangle. (manager, NHS England, April 2018)

Being situated *between* prison and hospital as a *transitional* space, it became apparent that the Unit lacked both some of the utilities of the wider prison, which limited its functionality, as well as the security of a hospital. Thus, in accommodating its in-between positioning, the commissioners and managers responsible for making decisions about the re-design of the Unit also imposed certain accommodations on the practices of staff and prisoners.

Custodial and healthcare staff working on the Unit found it difficult to accept these accommodations. They spoke frequently of alternative models for prisoners with specific care needs that they felt not only represented more radical re-designs of the custodial estate, but demonstrated a clearer understanding of the scale of the issues they were being faced with. As the manager of the custodial staff on the Unit stated, 'It needs to be bigger. I would have liked to see a brand-new unit like DSPD [Dangerous and Severe Personality Disorder]'.

Yet lead clinicians did not see the solution as lying within the custodial estate. For them, this was not solely a compromise in design emerging from economic constraints, but one that sought to navigate legal and ethical issues as well.

> In order to maintain a therapeutic atmosphere, we are limited. We are not a hospital, not a medium secure unit for legal and ethical reasons. [...]There has to be throughput. We have to move people. It's not a standalone unit. (Unit consultant psychiatrist, April 2018)

Referring once more to the therapeutic atmosphere, the lead psychiatrist also describes a need for throughput; the design of the Unit needed to reflect that it is not, in fact, a hospital setting, but part of the prison estate. In the psychiatrist's analysis, the Unit could prevent some of the trauma of moving between these two very different design settings by incorporating elements of both.

> The [Unit] provides a 'halfway house' between main location and specialist NHS locations [...] This makes transfer to and from [the Unit] less stressful for prisoners (especially discharge back to prison) as the environments are not too different [...] The switch between NHS and prison regimes can be traumatic for prisoners. [The Unit] can reduce this trauma. (Unit consultant psychiatrist, December 2019)

However, the psychiatrist also spent just half a day every week on the Unit, speaking to patients and staff. S/he had little exposure to the everyday difficulties arising from the accommodations made in re-designing the Unit. It was apparent that the Unit itself represented a compromise, an accommodation, which led in turn to other accommodations that clearly unsettled some of the staff and did not offer the best options—design or otherwise—for seriously unwell prisoners. Nonetheless, the Unit offered a significant improvement on the existing arrangements for accommodating these prisoners (Dyer et al., 2020). The accommodations embedded in the Unit could only be realised through under-design (Dunbar & Fairweather, 2000), which was supported by the wing's layout from its construction in the 1990s. In the next section we explore further how this under-design was able to emerge.

Conclusions

In this chapter, in response to the question of what works in custodial design, we have argued for a processual approach that is inclusive of re-design and adaptation of the existing prison estate and analysis of everyday processes and practices shaping prison interiors. Whilst larger developments might offer the most transformative potential, within England and Wales, such smaller re-designs and adaptations also offer potentiality for changes that can significantly improve the custodial experiences of certain groups of prisoners. Re-design can create collaborative solutions that support minoritised groups for whom prison is particularly harmful, i.e. prisoners with severe mental illnesses. The potential of smaller adaptations does not match that of wholesale re-designs and new buildings, which can greatly improve the general health and well-being of the prison population. However, given the lengthy processes involved in such larger-scale changes (Karthaus et al., 2019) within England and Wales, it is particularly important for those for whom existing environments are harmful—even fatal—that we remain open to the possibility of significant improvements to their safety through smaller, everyday interior re-design.

Our analysis highlights the potentiality for adaptive co-design within the re-design of interior spaces for mental healthcare within the prison estate. However, we have also suggested that the Unit within which the research was conducted was successful because of indeterminacy, which offered created scope for these ongoing practices of co-design of the wing's interior to emerge once it was operational, offering enhanced opportunities to meet the needs of specific prisoners and help them move on from acute mental health crises. Nonetheless, we have also acknowledged that everyday interior re-design is embedded in multi-layered processes and practices of accommodation. These accommodations involve not only making space for prisoners with SMIs within the existing prison estate (Cassidy et al., 2020) but also sub-optimal arrangements from a healthcare and custodial perspective that changed professionals' practices.

References

Bebbington, P., Jakobowitz, S., McKenzie, N., Killaspy, H., Iveson, R., Duffield, G., & Kerr, M. (2017). Assessing needs for psychiatric treatment in prisoners 1: Prevalence of disorder. *Social Psychiatry Psychiatric Epidemiology, 52*, 221–229. https://doi.org/10.1007/s00127-016-1311-7

Brooker, G., & Stone, S. (2019). *Re-readings: 2* (1st ed.). RIBA Publishing.

Brooker, C., & Webster, R. (2017). Prison mental health in-reach teams, serious mental illness and the Care Programme Approach in England. *Journal of Forensic and Legal Medicine, 50*, 44–48. https://doi.org/10.1016/j.jflm.2017.07.010

Brooker, G., & Weinthal, L. (2013). Introduction. *The Handbook of Interior Architecture and Design* (7–12) Bloomsbury.

Cassidy, K., Dyer, W., Biddle, P., Brandon, T., McClelland, N., & Ridley, L. (2020). Making space for mental health care within the penal estate. *Health & Place, 62*, 102295–102295. https://doi.org/10.1016/j.healthplace.2020.102295

Crewe, B. (2011). Depth, weight, tightness: Revisiting the pains of imprisonment. *Punishment & Society, 13*(5), 509–529. https://doi.org/10.1177/1462474511422172

Crichton, J., & Nathan, R. (2015). The NHS must manage the unmet mental health needs in prison. *The Health Service Journal*, 18th August 2015. Available at: https://www.hsj.co.uk/leadership/the-nhs-must-manage-the-unmet-mental-health-needs-in-prison/5087856.article (accessed 24 April 2019).

Dodsworth, S., & Anderson, S. (2015). *The fundamentals of interior design*. Bloomsbury Publishing.

Dunbar, I., & Fairweather, L. (2000). English prison design. In L. Fairweather & S. McConville (Eds.), *Prison architecture: Policy, design and experience Great Britain* (pp. 16–30). Architectural Press.

Dyer, W., Cassidy, K., Ridley, L., Biddle, P., McClelland, N. & Brandon, T. (2020). The development of a prison mental health unit in England: Understanding realist context(s). *International Journal of Forensic Mental Health*, 1–17. https://doi.org/10.1080/14999013.2020.1830890

Ellin, N. (2012). What is good Urbanism? *Journal of Architecture and Urbanism, 36*(4), 247–251. https://doi.org/10.3846/20297955.2012.756216

Fairweather, L. (2000). Psychological effects of the prison environment. In L. Fairweather & S. McConville (Eds.), *Prison architecture: Policy, design and experience Great Britain* (pp. 31–48). Architectural Press.

Grant, E., & Jewkes, Y. (2015). Finally fit for purpose: The evolution of Australian prison architecture. *The Prison Journal, 95*(2), 223–243. https://doi.org/10.1177/0032885515575274

Henley, S. (2003). The 21st century model prison. In *Proceedings of the Fourth International Space Syntax Symposium*. Available at: http://www.spacesyntax.net/symposia-archive/SSS4/fullpapers/03Henleypaper.pdf (accessed 24 April 2019).

Hill, J. (2003). *Actions of architecture: Architects and creative users*. Routledge.

Jewkes, Y. (2018). Just design: Healthy prisons and the architecture of hope. *Australian & New Zealand Journal of Criminology, 51*(3), 319–338. https://doi.org/10.1177/0004865818766768

Jewkes, Y., & Johnston, H. (2012). The evolution of prison architecture. In Y. Jewkes (Ed.), *Handbook of prisons* (pp. 174–196). Willan Publishing.

Jewkes, Y., Jordan, M., Wright, S., & Bendelow, G. (2019). Designing 'healthy' prisons for women: Incorporating Trauma-Informed Care and Practice (TICP) into prison planning and design. *International Journal of Environmental Research and Public Health, 16*(20), 3818. https://doi.org/10.3390/ijerph16203818

Jewkes, Y., Moran, D., & Turner, J. (2020). Just add water: Prisons, therapeutic landscapes and healthy blue space. *Criminology and Criminal Justice, 20*(4), 381–398. https://doi.org/10.1177/1748895819828800

Jordan, M. (2011). The prison setting as a place of enforced residence, its mental health effects, and the mental healthcare implications. *Health & Place, 17*(5), 1061–1066. https://doi.org/10.1016/j.healthplace.2011.06.006

Karthaus, R., Block, L., & Hu, A. (2019). Redesigning prison: The architecture and ethics of rehabilitation. *The Journal of Architecture, 24*(2), 193–222. https://doi.org/10.1080/13602365.2019.1578072

Kazi, M. (2003). Realist evaluation for practice. *British Journal of Social Work, 33*(6), 803–818. https://doi.org/10.1093/bjsw/33.6.803

Kol, Z., & Zarco Sanz, C. (2014). Collaborating with indeterminacy: A framework to intervene. *Revista Europea De Investigacion En Arquitectura, 2*(2014), 193–203. https://hdl.handle.net/11268/3561

McConville, S. (2000). The architectural realization of penal ideas. In L. Fairweather & S. McConville (Ed.), *Prison architecture: Policy, design and experience Great Britain* (pp. 1–16). Architectural Press.

McGeachan, C. (2019). "A prison within a prison"? Examining the enfolding spatialities of care and control in the Barlinnie Special Unit. *Area, 51*(2), 200–207. https://doi.org/10.1111/area.12447

Moll, A. (2013). *Losing track of time: dementia and the ageing prison population: Treatment challenges and examples of good practice*. Mental Health Foundation. https://www.mentalhealth.org.uk/sites/default/files/losing-track-of-time-2013.pdf

Moran, D. (2019). Back to nature? Attention restoration theory and the restorative effects of nature contact in prison. *Health & Place, 57*, 35–43. https://doi.org/10.1016/j.healthplace.2019.03.005

Moran, D., Jewkes, Y., & Turner, J. (2016). Prison design and carceral space. *Handbook on prisons* (pp. 114–130). Routledge.

Niveau, G. (2007). Relevance and limits of the principle of "equivalence of care" in prison medicine. *Journal of Medical Ethics, 33*(10), 610–613. https://doi.org/10.1136/jme.2006.018077

Sommer, R. (1971) The Social Psychology of the Cell Environment. *The Prison Journal 51*(1) 15–21. https://doi.org/10.1177/003288557105100104

Roberts, B. (2016). *Tabula Plena: Forms of urban preservation*. Lars Mueller Publishers.

Saradjian, J., Murphy, N., & McVey, D. (2013). Delivering effective therapeutic interventions for men with severe personality disorder within a high secure prison. *Psychology, Crime and Law, 19*(5–6), 433–447. https://doi.org/10.1080/1068316X.2013.758972

Shaw, D., & Elger, B. (2015). Improving public health by respecting autonomy: Using social science research to enfranchise vulnerable prison populations. *Preventive Medicine, 74*, 21–23. https://doi.org/10.1016/j.ypmed.2015.01.024

Sloan, A., & Allison, E. (2014). We are recreating Bedlam: The crisis in prison mental health services. *The Guardian*, 24 May 2014. Available at: https://www.theguardian.com/society/2014/may/24/we-are-recreating-bedlam-mental-health-prisons-crisis (accessed 24 April 2019).

Söderlund, J., & Newman, P. (2017). Improving mental health in prisons through biophilic design. *The Prison Journal, 97*(6), 750–772. https://doi.org/10.1177/0032885517734516

Tsing, A. L. (2015). *The mushroom at the end of the world: On the possibility of life in capitalist ruins*. Princeton University Press.

Turner, M., Peacock, M., Payne, S., Fletcher, A., & Froggatt, K. (2018). Ageing and dying in the contemporary neoliberal prison system: Exploring

the 'double burden' for older prisoners. *Social Science & Medicine, 212,* 161–167. https://doi.org/10.1016/j.socscimed.2018.07.009

18

Autoethnographic Analyses of Prison Design's Impacts

Douglas N. Evans, Abdullah Al-Muwahid, Sincere Allah, Michael Bright, Sean Kyler, Ibn Loyal, Anthony Martin, Shantai Rogers, Aaron Sheppard, and Harold Thompson

Imagine living in a space that is 10 feet long, seven feet wide, and nine feet high. Imagine that space having a single unit sink and toilet made of stainless steel. Imagine having to eat there, in a slightly larger than average bathroom. That's exactly what it's like living in this cell that I'm in right now—Sincere, September, 2019.

D. N. Evans (✉) · S. Allah
Fairleigh Dickinson University, Teaneck, NJ, USA
e-mail: devans@jjay.cuny.edu

A. Al-Muwahid · M. Bright · I. Loyal · A. Martin · A. Sheppard · H. Thompson
Rutgers University, New York, NY, USA

S. Kyler
Vera Institute, Brooklyn, NY, USA

S. Rogers
Mercy College, Dobbs Ferry, NY, USA

© The Author(s), under exclusive license to Springer Nature Switzerland AG 2023
D. Moran et al. (eds.), *The Palgrave Handbook of Prison Design*, Palgrave Studies in Prisons and Penology,
https://doi.org/10.1007/978-3-031-11972-9_18

In this chapter, several currently and formerly incarcerated men and women, along with a college instructor who teaches in multiple prisons, describe how prison structure, organization, and design within the United States (U.S.) arrests the daily interactions, perceptions, feelings, and communications of individuals incarcerated inside, stunts their rehabilitative growth, and agitates their psyche through the monotony of a sterile environment, often sparking episodic outbursts of violence. We use an autoethnographic framework to explicate general design and architectural features of prisons and cogitate about their influence on conditions of confinement and incarcerated existence. Our observations, reflections, and writings coalesce to question the architecture of the prison environment and how it regulates inmates' minds and bodies. Influenced by life experience and knowledge cultivated over the years and shared during a university undergraduate corrections course that several authors completed, the team of contributing authors discussed and wrote about perceptions of the built custodial environment, how the architecture of correctional institutions has shaped our lives, and the problems with custodial facility design and its consequences. "What works" in custodial design differs widely depending on motives and priorities of stakeholders. The desires of correctional staff and legal system administrators—oriented primarily towards control and safety—conflict with the aspirations of many inmates, who wish to be productive and prepare for successful post-release life.

Critical reactions to sundry aspects of the designed prison environment forged over more than a century of combined confinement across all authors inform this chapter. The correctional goal of rehabilitation underlies our analyses as we explore how custodial design influences the resources available for and the motivation to prepare for a positive lifestyle after release. We use Cullen and Gendreau's (2000) definition of rehabilitation, which includes three criteria: (1) deliberate intervention (2) focused on an aspect that causes criminality and (3) intended to reduce recidivism (p. 112). An alternative punitive lens inevitably intrudes our analysis, serving as a constant reminder that prisons are intended to be intolerable so that inmates are horrified, disgusted, and deterred from ever breaking the law and risking return. Several aspects of custodial facility design—prison cells and their capacity, the

toilet as a cell's centrepiece, colour schemes of prison walls, the lack of windows in many secure facilities, exterior appearance of the prison, and secure borders and boundaries that isolate prisons from surrounding society—will be discussed in relation to the intended outcomes of correctional design.

Prisons vary in size, structural build, and amenities, but there are commonalities among secure facilities in the U.S. Inside prison walls are structures housing cell blocks or secure dormitories, spaces for meeting outside visitors, phone banks that enable communication to loved ones outside, outdoor spaces (i.e. the yard), kitchens for cooking, eating places, medical vicinities, and administrative buildings. Some prisons house classrooms, auditoriums, vocational rooms, mental health units, solitary confinement cells, and places for spiritual worship. Despite their nuanced architectural differences, prisons are designed for control, efficiency, and security (McConville, 2000) so they evoke similar feelings among those who previously did or currently live in them. The tedium of interior design, including redundant cell layouts, lighting ranging from too dim to overpowering, poor ventilation, and predictably functional furniture arrangement adds to the doldrums of incarcerated life (McConville, 2000). Over several months we cogitated on the prison environment, internally and externally, and the impact of its design aspects. After substantiating use of the autoethnographic research method, our amalgamated writings reveal the personal impacts of custodial design and question their relevance in a system that proclaims to promote rehabilitation.

Autoethnography

Criticisms

Published research on prison design is largely historical, tracing developments over time. Despite recent qualitative work that has considered the perspectives of incarcerated persons (Moran & Turner, 2019; Jewkes & Laws, 2020), their voices are largely excluded from research. This

chapter begins to address that gap and also builds on research that prioritizes the perspectives of those with lived experience (see *The Journal of Prisoners on Prisons*), including convict criminology (Richards & Ross, 2001). We use autoethnography, a qualitative method that emphasizes researchers' subjective perceptions and emotions that academic investigations of incarceration generally ignore (Jewkes, 2012). While most qualitative research relies on secondhand accounts of study participants, autoethnography focuses on the personal experiences and detailed descriptions of researchers, which is especially useful for examining prisons. Lived experience of inmates and others who have spent extensive time inside prison imparts detailed knowledge that other methods cannot yield. Giving currently and formerly incarcerated individuals platforms to share and analyse their own and similarly situated others' experiences offers answers to questions that the legal system has not sufficiently considered: What aspects of custodial life facilitate or detract from the rehabilitative goals of incarceration? How can prisons be designed to enhance preparation for reintegration into the community while upholding security measures? To what extent can prisons be re-designed to shift from warehouses that incapacitate millions to facilities that promote positive change?

Before discussing its usefulness, it is necessary to mention criticisms of autoethnography. Chief among them are lack of scientific rigor, inherent bias, and prioritization of emotions (Coffey, 1999). Some have accused autoethnography of lacking objectivity, which is essential to scientific endeavours. Although these criticisms are reasonable, they overlook the reality that all research is to some degree influenced by emotions and reliant on subjective perspectives of researchers. Most scientists do not acknowledge their own passion for their research in written reports, choosing to write from an ostensibly detached perspective. Researchers make choices about what phenomena are worthy of investigation, select a theoretical foundation over other possible theories to frame their studies, and decide how to interpret and present results (St. John et al., 2019). Such choices are not always explicitly stated in relation to disregarded options.

Methodological Precedent

Autoethnography addresses the black box underlying research by being transparent in its subjectivity, recognizing that researchers both reflect and influence whatever field is under study. We argue that research on incarceration—limited to the extent that it overlooks inmates' and prison staff's firsthand analyses, and especially, emotions—would benefit from autoethnographic perspectives. Ellis (2009) and Jewkes (2012) stress the importance of considering the emotional component often neglected in criminological research. Newbold and colleagues (2014) also advocate for emotional experiences in research and point to inevitable influence of subjectivity on research engagement. However, "[p]rovided it does not unrealistically skew the researcher's perception or analysis, insider input may…be regarded as an essential thread in the tapestry of criminological inquiry" (Newbold et al., 2014, p. 441). Correctional research that considers the emotions of those affected by the system offers an impassioned examination of a system that mechanically strips life and freedom from people it ensnares.

Much can be learned about the impacts of custodial design from the women and men who have been or remain incarcerated. Formerly incarcerated authors have acknowledged but not delved deeply into prison design's impact on their experiences inside. Shook (2014) claimed that the architecture adds to the brutality of the incarcerated environment and creates a power imbalance by physically elevating correctional staff higher than inmates. He called for architectural, cultural, and procedural changes to reduce the inclination of those locked inside towards anger and violence. Academics have begun utilizing autoethnographic perspectives to scrutinize prison environments. For example, a recent study explored volunteer visitor and staff perspectives of space, layout, and setting of prison environments and their effect on those inside (St. John et al., 2019). We believe that prioritizing the viewpoints of those who are or have been incarcerated can add legitimacy to studies and compel more carceral researchers to include viewpoints of those most affected.

Current Approach

A class on contemporary issues in corrections in a northeastern U.S. prison during the fall semester of 2019 provided the genesis for this research. The prison is a medium security level constructed in 1987 with a campus design in which large perimeter walls surround separate housing units and other buildings. Most but not all authors spent time in this facility as well as numerous others they were transferred to and from during their sentences. Thus, the topics discussed here principally centre on this facility but inevitably include experiences during stays at other medium- and maximum-security facilities.

Prior to beginning work on this chapter, the first author and course instructor exposed his students to autoethnographic expositions and criticisms. Students read several articles about autoethnography and discussed the method's strengths and weaknesses as a group. We used this research method to study prison life throughout the semester. Each week students would suggest and eventually agree on a subtopic (e.g. living conditions, visitation, relationships). They would then create an analysis plan consisting of self-reported experiences, reviews of available custodial documents, and/or unstructured observations and interviews with peers to supplement experiential knowledge. The various methods each author employed depended on the suitability of each technique to a particular subtopic and the availability of documents and contemporaries willing to speak on them. We wrote several pages of analysis on each subtopic and shared writings with the class during subsequent meetings while others took notes.

It was not until this chapter opportunity arose towards the end of the semester that these writings and discussions made our contribution to this book possible. After debating pursuit of this publication, multiple students expressed interest in contributing. The instructor averred that voluntary contributors would have writings compiled into a chapter for this edited volume.[1] The facility did not closely monitor students' papers, and, because students noted precedents of other inmates publishing while incarcerated, the authors deemed the project minimal risk. Due

[1] Some students declined and other students' writings were not included.

to limited class time to fully expand on each author's autoethnographic analyses, the instructor recruited two formerly incarcerated individuals who had participated in college education programs during their time in prison to review the material and contribute their own. Authors received the benefit of authorship for their contributions and the opportunity to influence discussions of prison design and ideas for advancement.

Authors of this chapter—one female and nine males—range in age from late 30 s to early 60 s. As the only member of the authorship team who has not been incarcerated, the instructor amalgamated the writings of co-authors and used collaborative witnessing (Ellis & Rawicki, 2013) to analyse their narratives in deeper ways, typically understood only after years of training, to connect their works to broader literature and to add professional legitimacy to the work. With so many voices to include and the impossibility of identifying common threads across all writings of each author, the instructor focused on subjectively "important" arguments while neglecting those less developed or not directly associated with prison architecture and design.

We elected to use analytic autoethnography instead of evocative ethnography, privileging synthetic analysis over evocation through storytelling. Analytic autoethnography uses more traditional qualitative analysis and acknowledges that researchers are part of the social realm being studied and are aware of their relationship with the research setting (Anderson, 2006). Researchers using this method inject their experiences and emotions into writings, engage in dialogue with others from the environment under study, and commit to an analytic agenda (Anderson, 2006). This method provided the authorship team with a template to conduct research on perspectives of custodial design. Unless another source is cited, it is the authors' autoethnographic texts and written notes during class discussions that informed the following sections. Quotes are from course papers. Currently incarcerated authors recommended several proposals for facility design changes, asserting that humanizing the prison environment would facilitate rehabilitation. By *humanize* we mean any feature that demonstrates respect for individuals who seek to serve their time in peace, exhibit prosocial behaviour, or improve their character prior to release. *Why* humanizing prisons should facilitate

positive change in inmates is less important a question than considering that dehumanizing carceral environments obliterate motivation for compassion, growth, and self-actualization.

Reflections

If one of incarceration's goals is to rehabilitate men and women convicted of crimes, we believe the current design is insufficient. Living spaces are not constructed for comfort or productivity but solely for incapacitation. "Cells [were] built for single occupancy but irresponsible policies led to a prison population boom and most cells ended up squeezing another person into a space for one," creating persistent tension. Cell toilets within a few feet of beds make for unsanitary conditions. Discomfort of using the toilet with a cellmate nearby and limited privacy outside the cell bars challenges personal senses of decency and can force inmates to question their own humanity. Blandly coloured or grey cinder blocked prison walls stifle creativity and instigate perpetually depressive mindsets. Fluorescent lighting floods hallways and common areas contrast with poor cell lighting that makes reading, writing, and creative activity arduous. Razor wire is a constant reminder of exclusion from the outside world and a barrier that if traversed could end one's life. We expand on specific design aspects below.

Facility Perimeters

Prisons generally are isolated within the communities in which they are located. Whether they are located in rural areas far from residential and commercial establishments or built in close proximity to neighbourhoods, prisons are detached from public view. Their separation from public space suggests that inmates must be kept separate from other citizens and that society is no longer their community. An array of security features—thick perimeters of "30-foot-high solid concrete or fences heavily laced with razor wire," guard towers loaded with military-grade weaponry, metal gates and large windows with metal-meshed

coverings—is the first image visitors see, connoting "Warning. Stay out. Something very bad is taking place inside. KEEP OUT." Insiders see the same security features and perceive the opposite implication: "YOU ARE TRAPPED."

The unwelcoming façade of the structure alerts visitors to impending layers of fortification, and high walls made of rock, stone, or brick engulfed in barbed and razor wires foreshadow being "maimed, cut, sliced, and possibly bleeding to death" for attempting to escape. Living under lock and key with layered security measures sends a message that those sentenced to serve time inside "must be unmanageable risks [to public safety, and by extension, a] danger to staff and other inmates." Prison design and grounds subliminally reinforce formal legal convictions and informal labels (e.g. convict, prisoner, inmate, felon, violent), initiating for some the very antisocial behaviour the system purports to rehabilitate.[2] Sharp wired barriers manifest as emotional and "psychological barriers between inmates and their families and friends on the outside." Research has not addressed the psychological effects of living in a space surrounded by razor wire border, but "it may reveal various levels of trauma."

Besides forewarning visitors and reconstructing inmate identities over years or decades, the design of prison facilities creates "a black box that shields the outside world from knowing exactly what could be occurring on the inside." Historically, punishments were violent public spectacles. Prisons offered a means of civilizing castigation by removing outsider visibility (Fiddler, 2007). "Prisons shroud the inner workings of facilities in mystery." Facilities are physically opaque so that "passersby are left to wonder what depraved acts take place behind the fortified walls." Despite contributing to funding the construction, maintenance, and functioning of prisons, the actions of correctional departments are kept highly secretive and remain invisible to the taxpaying public because of the fortified exterior structures of prison facilities. Invisibility is enforced by exterior surveillance used to control and limit entry onto property surrounding prison grounds (Schept, 2014). Since most people have never visited a

[2] Labelling theory posits that words used to describe individuals (e.g. intelligent, difficult, funny) influence their identities and behaviours. Persons labelled internalize these labels over time and gradually act in a way that reinforces the label (Becker 1963; Lemert 1967).

prison (Cecil, 2019), the public's curiosity about its interior is often satisfied through television shows and movies that depict fictionalized images and actors' portrayals of prisoners or documentaries filmed in actual prisons with inmates. These media can influence preconceived notions of what prison structures represent, which has incited public opposition to the construction of new prisons that bring unwanted strangers and an aura of despair into the community (Armstrong, 2014).

Cell Design

The metaphor of a "caged animal" is cliché but an accurate depiction of how many inmates feel. Cell bars, concrete floors, furniture consisting of a "metal bunk bed, metal desk, metal stool" bolted to walls or floors, and cramped space within prison cells as small as six by eight feet can make even the strongest feel claustrophobic. "The centrepiece of the cell is the metal sink and toilet," which are physically connected, contributing minimal amenity to interior life. Dim lighting in cells imbues feelings of darkness and loneliness that for multiple authors led to suicidal thoughts and/or engaging in heavy drug or alcohol use. The prison cell is constructed not for healthy living but as a confined space that houses up to one, two, or several humans, seemingly favouring maximum capacity over individual space.

Prisons lack personal spaces, which nullifies privacy. Staff can enter cells at any time. Inmates have limited means to adorn their cells, rendering them akin to a public space (Wener 2012). They are forced to adapt to the spaces in prisons and cope with the lack of personal areas by creating real and imaginary spaces that act as their own (Sibley & Van Hoven, 2009). Privacy in prisons is rare so female inmates in Russia create their own personal space through working in silence, hiding behind a book, or violating rules to be sent to solitary punishment (Moran et al., 2013). Others avoid conversation to feel a semblance of solitude (Milhaud & Moran, 2013).

Several authors have lived in cells "slightly larger than an average bathroom," and many were forced to share living space with a cellmate. Housing two individuals in cells as small as 48 square feet can be a

precipitating factor for violent outbursts at the slightest note of tension depending on a cellmate's mindset and predilection towards physical aggression. Screening for physical and mental health issues becomes even more paramount when two individuals are confined in a small space. Lack of physical and mental health assessment and appropriate placement could lead to worsening physical conditions. Inmates not screened for mental health issues, those with untreated mental illness, and unnecessary confinement in a small cell with another person "could result in behavioural outbursts, physical conflicts, and possible injuries or death." If cellmates are not properly screened for communicable diseases, physical contact or transmission through shared space could lead to the immediate spread of disease. Lack of living space is especially problematic during a pandemic, as the COVID-19 outbreak in 2020 has demonstrated. In prisons that house two or more inmates in a single space, any inmate that contracts a virus would drastically increase the risk of spreading infection to a cellmate. The inadequate space inside prisons makes social distancing nearly impossible for inmates and staff alike.

The colour of interior cell blocks and external walls leaves a strong impression. Prison walls are mostly drab and pallid, without decoration or anything that arouses the visual sense. Research on rehabilitative effects of colour on mood is lacking, particularly in prisons, but vivid colours can certainly diminish the monotony of the interior (Wener, 2012) and stimulate positive emotions supportive of resocialization (Wu, 2018). When there are wall adornments, as is the case in facility entryways or common spaces for staff, they are usually cork boards containing endless printed pages filled with facility procedures and rules, typed in small text that cannot be read from afar. Lighting inside facilities can range from luminous to murky depending on the location. "The typical cell has no sunlight," which only adds to the situational depression that even the most mentally sound men and women experience from time to time. The lack of visual indicators of light–dark cycles affects circadian rhythm and can lead to prolonged health consequences (Lockley et al., 2007).

Being forced to adjust to life inside a prison cell threatens rehabilitation. Authors were in near unanimous agreement that cell life does not prepare inmates for a productive and law-abiding life on the

outside following their release. However, one author (currently incarcerated) believes that prisons must be designed as horridly as possible to deter prisoners from ever coming back. Still, this author also recognizes the unavoidable outcomes of intentionally designed tight living spaces —agitating inhabitants and serving as a catalyst for violence between inmates.

Prisons can retain their secure layout while still providing spaces conducive to rehabilitation and positive engagement between inmates and staff. Cells smaller than 100 square feet should hold only one person, and those that must hold multiple inhabitants should be at least double the size, which would reduce conflict and violence between cellmates housed together in tightly cramped quarters. Prisons should provide room to facilitate peaceful activities, including "meditation, yoga, and prayer," which would require at least one room of sufficient size within the facility. Windows and lighting that inmates can adjust can provide fresh air, outdoor views, and illumination for reading and writing as well as a small but meaningful sense of control over their small living space. Contact with and views of nature, periods of lighting and darkness that support wakefulness and healthy sleep, and minimization of loud noises support positive mental and physical health (Moran 2019a). Cleanliness through the ability to sanitize one's living space gives occupants a sense of responsibility over their environment. A still confined author who had views of nature from a cell in a prior prison felt "invigorated and encouraged" to improve his circumstances through "substance abuse treatment programs and [other rehabilitative opportunities available] in the prison." Facilities that incorporate certain design features show respect for the rehabilitative ideology (St. John & Blount-Hill, 2018; St. John, 2020). Prisons that are constructed and maintained with aesthetics in mind, that contain spaces inside that balance security with the ability to gather socially, and those located close to the communities of inmates would demonstrate value and respect for inhabitants and staff, which would enhance the perceived legitimacy of prisons (St. John & Blount-Hill, 2018; St. John 2020).

The Toilet

"The act of relieving oneself is such a vulnerable and intimate moment that societies strategically design and place toilets in such a way that maintains the privacy of their occupants." Private bathrooms in residential, commercial, and even outdoor facilities have surrounding walls and locks on doors. Public restrooms contain stalls to shield occupants from public view. However, inhabitants of prison cells are afforded no such expectation of seclusion when using their toilets. Cells with barred fronts position inmates in full view of anyone who walks by their cell at that moment they use the toilet. Likewise in Polish prisons, curtains to shield toilet use from observers are considered a luxury (Kaminski, 2004).

"The toilet inside each cell is its most significant amenity, having particular meaning" beyond its obvious utility. Inmates sleep, eat, read, write, think, and spend most of their time within arm's reach of the unsanitary metal bowl meant to dispose of human waste. To simplify the plumbing, many prison cells contain a combination toilet and sink. Inmates wash their hands, brush their teeth, urinate, and defecate in this all-in-one fixture.

One author who entered his prison cell for the first time was immediately fixated on the toilet, its functionality, and indicators of its uncleanliness:

> The toilet alters the way I see my myself, the way I think of my own humanity. The toilet's existence in this living space renders it unfit for human habitation. As much as it would be abnormal to find someone living in their bathroom, it is equally abnormal and immoral to force me to share this small living space with a toilet…No normal human being would choose to live in a bathroom. Being forced to eat only feet away from a toilet is an assault on every part of my being that makes me human; it suggests that there is something uncivilized, savage about me.

He soon learned that "the appearance of a toilet in a cell indicates the degree to which the cell's occupant has maintained or relinquished his or her connection to civility," and by proxy, implicates the state of their mental health. Sometimes, maintaining the cleanliness of the toilet is

outside of their control. Inspections of U.K. prisons revealed toilets located near beds yet so filthy they could not be fully cleaned, many lacking lids that led to the spread of germs and caused inmates to use makeshift lids (HM Inspectorate of Prisons, 2017). Plumbing malfunctions and clogged interconnected pipes could create septic disasters. When someone flushes their toilet, wastewater or faecal matter could surface in neighbouring cells. One author was so traumatized by multiple instances of dirty brown water pouring from faucets that the sound of a flush on the block triggered an abrupt retreat from the sink.

The toilet's precise location in a cell can be stress-inducing and can even create the potential for punitive consequences associated with its use. Toilets can either be located towards the front or the rear of a cell, and each position can feel distinctly dehumanizing. Cells with toilets in the rear allow a direct line of visibility from the walkway outside of the cell to the individual using the toilet. "Having to defecate in full or even partially obstructed view of [correctional officers, administrators, staff, or civilians] walking by is inherently humiliating." What makes bathroom use more degrading is the inmate's inability to know when someone is about to walk in front of their cell. This becomes even more problematic, particularly for men, when toilets are located in close proximity to the cell bars. Although men are socialized to stand up while urinating, they risk violating prison rules if correctional officers see them doing so. This leaves them with two options. They can sit down to urinate, which is a subtle form of de-masculinization, or they can risk standing to use the bathroom. However, if prison staff (especially female officers) observe them "standing up" to urinate, it could lead to their being charged and labelled a sexual offender. Ironically, other research indicates that trans-feminine inmates are punished for exhibiting femininity, such as sitting to pee, with harassment, isolation, or assault (Rosenberg & Oswin, 2015).

Being forced to defecate and urinate in close proximity to a cellmate, within arm's reach of where one sleeps and eats some meals, is demeaning at best and dehumanizing at worst. Even with a sheet temporarily affixed to the ceiling to separate cellmates on either side of the toilet and the

bunkbed, the sounds and smells still permeate. This "stinking up the cell" can lead to violence between cellmates. The toilet's close existence in this living space renders it unhealthy for civilized human habitation.

Communication Spaces

The means to engage with family and friends is the most valuable currency for many incarcerated men and women. Prisons provide space for in-person visitations, rows or booths of landlines to make phone calls to the outside world, and, in some cases, there are areas that support technology for computer-aided video or email contact. Visitations are a treasured highlight for inmates, representing an escape from the monotonous routines of prison life (Moran 2013). However, prison design can make the visitation process uncomfortable for loved ones wishing to visit. Several authors spoke with their loved ones to include their perspectives in this analysis. They reinforce prior qualitative research findings that visitors often endure long waits during check-ins, invasive security checks, disrespect from staff, and expectation that they will adhere to lengthy and sometimes unwritten rules (e.g. wearing a wire bar is prohibited) that if violated can result in termination before the visit ever happens (Trahan & Evans, 2020). Research supports our finding that visitors could be denied entry for wearing sexually suggestive clothing (Comfort et al., 2005). Although the ability to engage with family and friends while incarcerated is priceless and cherished immensely, the process of visitation deters outsiders from trekking to the facility for only a few hours, at most, of heavily supervised visitation.

A recurring theme among authors was the lack of space, privacy, and supplemental amenities during engagements with loved ones. Regardless of the size of the room, space in visiting rooms is limited due to the large number of people who wish to participate, which forces an inmate and his or her visitor(s) to sit in close proximity to other inmates and their loved ones. The noise in the room can make intimate conversations difficult at best and inaudible at worst. Crowded and noisy visiting spaces in prisons have also been noted in U.K. facilities (Moran & Disney, 2018). Security protocols restrict physical touching, so inmates are generally

allowed only a brief moment at the beginning and end of visits to hug or kiss significant others or children. Most facilities' visitation rooms lack colour and decoration and thus are not designed to be inviting to children, which coupled with invasive security checks prior to entry could make the experience traumatic for young people. Some prison visitation areas contain vending machines, which offer mostly unhealthy eating options for those that can afford them, while others offer no snacks or beverages to visitors who might spend several hours at the facility. Visiting areas can be located inside or outside, but space restrictions apply to both settings. We did not discuss long-term, or conjugal visiting spaces because not every author had that experience, but studies have shown that inmates generally feel that overnight visitation spaces are more reminiscent of home and life on the outside (Moran, 2013).

Because inmates are limited to the number of in-person visitations they can receive, phones and computers with internet access are essential to their communication with loved ones. Inmates are allowed a limited amount of time to make phone calls and send emails, but there are rarely enough phones and internet kiosks to meet the demand. One facility included in our analysis has a row of about 10 telephones outside, each often with long lines of inmates waiting to place a call. Crowding by phones leads to constant raucousness, making dialogue audibility difficult while also negating conversational privacy. Scarcity and contiguity of phones and lack of formal time limits for calls create tension between inmates, sometimes resulting in physical conflicts. Officers are not required to ensure that all inmates have equal access to phones and computers, which exacerbates hostility. Fights can result in inmates receiving a higher custody status, forcing them into more secure areas of the prison that increase the cost of their supervision.

Familial support and involvement are essential to effective inmate rehabilitation, so visitation areas should be altered to minimize discomfort to family members and significant others who visit. Prisons should have access to body scanning technology to replace pat-down searches. Visitors may perceive physical full body pat-down searches as overly invasive, which could discourage them from future visits. Overaggressive searches could also instigate conflict between staff and visitors, which could jeopardize a visitor's ability to gain entry into the facility. Visiting

rooms should be sufficiently large to allow for some degree of privacy between visitor groups. Cameras installed in the room could lessen the need for constant proximal surveillance by correctional officers and close contact between them and inmates and their visitors. The visiting hall should be designed with a variety of colours and decorations to stimulate peace and contentment. This could make children feel more at ease and less anxious about visiting their parents in confinement. An alternative to indoor visiting rooms could be outdoor gardens, which are child-friendly, home-like, and improve visits (Toews et al., 2020). Some prison visiting rooms have snack machines, which are mostly filled with high sodium and high sugar food options. To promote nutrition and allow inmates to share a meal with their family members, healthy food vendors should be welcomed into the facility to serve food at a reasonable cost to visitors. An area of the room could be dedicated to family picture taking so that children could have positive images of their incarcerated parents. San Quentin's visiting space, for instance, has a painted wall used as a backdrop for picture taking (Comfort et al., 2005). Another area could provide safe toys and games for young children to play with their parents. Clean and accessible restrooms and a medical station would also promote a safe and positive visitation environment. These adjustments could have a de-stigmatizing effect on inmates and families of incarcerated persons over time.

Common Areas

Most prisons have outdoor spaces for exercise and recreation. Often referred to as "the yard," these areas allow inmates to engage in recreation while under the supervision of correctional officers. The concrete or dirt grounds are surrounded by large walls with armed officers observing from strategically placed lookout towers far above ground level. Razor wire fences engulf the perimeter and the yard contains some or all of the following features: tiered and raised rows of benches, picnic tables, basketball courts, phone kiosks, outdoor shower stalls, drinking fountains, and in at least one facility a small mounted television screen that may or may not function. Depending on the facility, the yard may

host special events and facility holidays like Memorial Day and American Independence Day that can make inmates feel connected to the outside world. Spending time outdoors and breathing fresh air can stimulate imagination and offer peace and sanity. However, concrete grounds in most prison yards are disconnected from nature. Trees and plants would provide inmates with connection to nature and responsibility for landscape maintenance could offer skills and a sense of responsibility over the external environment. Outdoor green spaces offer health benefits and have calming and restorative effects for inmates (Moran 2019b; Moran & Turner, 2019). Exposure to nature reduces aggression, enhances prosocial behaviour, and offers mental health benefits, all of which could contribute to recidivism reduction (Reddon & Durante, 2019; Söderlund & Newman 2017).

The mess hall, or chow hall, in many prisons is a common space where inmates eat one to three meals per day. Small for the amount of people who eat there, those who dine in the mess hall are often forced to eat elbow to elbow with others with whom they may or may not have positive relationships. The dining area is usually not far from the kitchen where inmate cooks prepare the food. The kitchens contain large vats necessary to cook enough food to feed inmate populations that number in the hundreds or low thousands. Smells of cooking and constant conversation flood the room with odours and loud noise. Correctional officers supervise the mess hall from entry and exit points, sometimes walking around the room to deter or respond to behavioural infractions. Outdoor eating spaces could offer more space and comfort during meals.

Showering areas are filled with stalls that are separated by steel barriers on three sides, and those who are not afforded a shower curtain or stall have no privacy while they shower. To compensate, men generally shower in their boxer shorts to protect their dignity or to minimize sexual assault attempts. Large prison bathrooms are not always well maintained and often smell like mildew and have the appearance of uncleanliness.

Conclusion

Given the number of authors that contributed to this writing, there were bound to be more ideas, experiences, and suggestions than space allows. We included those well-developed ideas and concepts that were touched on by multiple authors, which meant omitting less commonly shared thoughts that did not easily connect to our primary topics. Author interviews with many other incarcerated men and women exposed additional concerns tangentially related to facility design, including overcrowding from too many inmates in spaces not sizeable enough to house all of them, unhealthy internal air quality due to rampant mould and asbestos that has yet to be removed, water that occasionally runs so brown and dirty that it is rendered undrinkable, food containing almost no nutritional value, and inside temperatures that are freezing in the winter and boiling hot in the summer when the heating and air conditioning breaks down, which these systems are prone to do.

Throughout, suggested proposals to enhance prison design as formulated by individual authors sought adherence to the correctional system's goal of rehabilitating inmates and encouraging prosocial behaviour following release. They also align with research that indicates giving inmates more positive and less negative experiences and ensuring that they are not environmentally deprived enhances perceptions of the legitimacy of the criminal legal system (Franke et al., 2010). When people view the system as legitimate they are more likely to comply with its demands, regardless of whether they believe punishment was deserved. To enhance the legitimacy of incarceration, cell size and design must account for the number of individuals to be housed inside. Toilets should be outside of cells or at least distant from beds and eating spaces. Walls should have stimulating interior colours. The ability to decorate one's own space would allow some degree of autonomy during incarcerated life. Because education is an important component of rehabilitation, adequate space and lighting are the bare minimum for reading, writing, and studying. To truly enhance the likelihood of inmate rehabilitation, we concurred, would require feeling respected. The bar for respect is currently so low that small changes related to those already mentioned

could yield substantial benefit in inmate behaviour both during and following incarceration.

Custodial design has many implications for those housed inside prisons. Inmates are locked up in small cells for the majority of their sentences and subject to the will of correctional officers, administrators, and the conditions of their warehousing with minimal oversight or ability to contest their maltreatment. The conditions of confinement in old and/or poorly constructed facilities can result in consequences that counteract rehabilitative intentions of incarceration, including limited or poor communication between inmates and other inmates or staff that can lead to stress and possibly violent interactions, deteriorating mental health over the course of lengthy incarcerations, development of physical health problems like diabetes or respiratory illness, deficits in mental and physical healthcare, poor and under-resourced rehabilitative programming, lack of quality education programs, and unnecessary or over-prescription of psychotropic medications to manage inmate populations. The focus on security reinforces barriers between inmates and their families and loved ones on the outside, making visitation and communication difficult and minimizing the ability to maintain healthy relationships between parents and their children on the outside. The environmental deficits within prisons are determined in large part by their design. Until policymakers and taxpayers critically consider the impact of prison architecture and design, rehabilitation will remain nothing more than an unfulfilled goal and the correctional system's broken promise to the world.

Several authors noted the inherent problem of proposing and advocating for improvements to prison design: reforms reinforce the system's over-reliance on incarceration. Given that facility design has only some ability to reduce inmate behavioural infractions and does not appear to significantly impact violent misconduct (Morris & Worrall, 2014), custodial design is only part of the reason that prisons are not rehabilitative. While modifications to facilities could create a calmer environment that facilitates constructive interactions and enhances rehabilitation, such changes do not address the root causes of why people are sentenced to prison. Instead of spending millions to refurbish existing facilities or billions to design and construct new prisons that *may* be more

rehabilitative, taxpayer money could be allocated for re-investment in areas of high-risk communities that are correlated with incarceration: job training, education, healthcare, nutrition, and positive role models and nurturing environments for children. Prison re-design only reaffirms society's need for high-security institutions and diverts from a shift towards alternatives to incarceration. Until prison populations are drastically reduced to include only those who truly pose a risk to the safety of communities, research on the problems of current prison design and recommendations for improved design will remain largely disconnected from the policymakers who have the authority to implement it.

References

Anderson, L. (2006). Analytic autoethnography. *Journal of Contemporary Ethnography, 35*(4), 373–395.

Armstrong, S. (2014). Siting prisons, sighting communities: Geographies of objection in a planning process. *Environment and Planning A, 46*(3), 550–565.

Becker, H. S. (1963). *Outsiders: Studies in the sociology of deviance*. The Free Press.

Cecil, D. K. (2019). Newsworthiness of reform: Prison news stories in an era of change. *Journal of Crime and Justice, 42*(2), 221–235.

Coffey, A. (1999). *The ethnographic self: Fieldwork and the representation of identity*. Sage.

Comfort, M., Grinstead, O., McCartney, K., Bourgois, P., & Knight, K. (2005). "You can't do nothing in this damn place": Sex and intimacy among couples with an incarcerated male partner. *Journal of Sex Research, 42*(1), 3–12.

Cullen, F. T., & Gendreau, P. (2000). Assessing correctional rehabilitation: Policy, practice, and prospects. In J. Horney (Ed.), *Policies, processes, and decisions of the criminal justice system* (pp. 109–175). National Institute of Justice.

Ellis, C. (2009). Fighting back or moving on: An autoethnographic response to critics. *International Review of Qualitative Research, 2*(3), 371–378.

Ellis, C., & Rawicki, J. (2013). Collaborative witnessing of survival during the Holocaust: An exemplar of relational autoethnography. *Qualitative Inquiry, 19*(5), 366–380.

Fiddler, M. (2007). Projecting the prison: The depiction of the uncanny in The Shawshank Redemption. *Crime, Media, Culture, 3*(2), 192–206.

Franke, D., Bierie, D., & MacKenzie, D. L. (2010). Legitimacy in corrections: A randomized experiment comparing a boot camp with a prison. *Criminology & Public Policy, 9*(1), 89–117.

HM Inspectorate of Prisons (2017). *Life in prison: Living conditions*. London: Author. Retrieved from https://www.justiceinspectorates.gov.uk/hmiprisons/wp-content/uploads/sites/4/2017/10/Findings-paper-Living-conditions-FINAL-.pdf

Jewkes, Y. (2012). Autoethnography and emotion as intellectual resources: Doing prison research differently. *Qualitative Inquiry, 18*(1), 63–75.

Jewkes, Y., & Laws, B. (2020). Liminality revisited: Mapping the emotional adaptations of women in carceral space. *Punishment & Society*. 1462474520959623.

Kaminski, M. M. (2004). *Games prisoners play: The tragicomic worlds of Polish prison*. Princeton University Press.

Lemert, E. M. (1967). *Human deviance, social problems and social control*. Prentice Hall.

Lockley, S. W., Arendt, J., & Skene, D. J. (2007). Visual impairment and circadiam rhythm disorders. *Dialogues in Clinical Neuroscience, 9*(3), 301–314.

McConville, S. (2000). The architectural realization of penal ideas. In L. Fairweather & S. McConville (Eds.), *Prison design: Policy, architecture and experience* (pp. 1–15). Routledge.

Milhaud, O., & Moran, D. (2013). *Penal space and privacy in French and Russian prisons*. Carceral spaces: Mobility and agency in imprisonment and migrant detention (pp. 167–182).

Moran, D. (2013). Between outside and inside? Prison visiting rooms as liminal carceral spaces. *GeoJournal, 78*(2), 339–351.

Moran, D. (2019a). Back to nature? Attention restoration theory and the restorative effects of nature contact in prison. *Health & Place, 57*, 35–43.

Moran, D. (2019b). How the prison environment can support recovery. *Prison Service Journal, 242*, 44–49.

Moran, D., & Disney, T. (2018). 'You're all so close you might as well sit in a circle…'Carceral geographies of intimacy and comfort in the prison visiting room. *Geografiska Annaler: Series B, Human Geography, 100*(3), 179–194.

Moran, D., Pallot, J., & Piacentini, L. (2013). Privacy in penal space: Women's imprisonment in Russia. *Geoforum, 47*, 138–146.

Moran, D., & Turner, J. (2019). Turning over a new leaf: The health-enabling capacities of nature contact in prison. *Social Science & Medicine, 231*, 62–69.

Morris, R. G., & Worrall, J. L. (2014). Prison architecture and inmate misconduct: A multilevel assessment. *Crime & Delinquency, 60*(7), 1083–1109.

Newbold, G., Ian Ross, J., Jones, R. S., Richards, S. C., & Lenza, M. (2014). Prison research from the inside: The role of convict autoethnography. *Qualitative Inquiry, 20*(4), 439–448.

Reddon, J. R., & Durante, S. B. (2019). Prisoner exposure to nature: Benefits for wellbeing and citizenship. *Medical Hypotheses, 123*, 13–18.

Richards, S. C., & Ross, J. I. (2001). Introducing the new school of convict criminology. *Social Justice, 28*(1 (83), 177–190.

Rosenberg, R., & Oswin, N. (2015). Trans embodiment in carceral space: Hypermasculinity and the US prison industrial complex. *Gender, Place & Culture, 22*(9), 1269–1286.

Schept, J. (2014). (Un) seeing like a prison: Counter-visual ethnography of the carceral state. *Theoretical Criminology, 18*(2), 198–223.

Shook, J. (2014). Business as usual. *Journal of Prisoners on Prisons, 23*(2), 10–22.

Sibley, D., & Van Hoven, B. (2009). The contamination of personal space: Boundary construction in a prison environment. *Area, 41*(2), 198–206.

Söderlund, J., & Newman, P. (2017). Improving mental health in prisons through biophilic design. *The Prison Journal, 97*(6), 750–772.

St. John, V. J. (2020). Placial justice: Restoring rehabilitation and correctional legitimacy through architectural design. *SAGE Open, 10*(2). https://doi.org/10.1177/2158244020919503.

St. John, V. J., & Blount-Hill, K. (2018). Spatial justice: Legitimacy through openness, transparency and inclusiveness in correctional design. *Corrections Today*. American Correctional Association.

St. John, V. J., Blount-Hill, K., Evans, D. N., Ayers, D., & Allard, S. (2019). Architecture and correctional services: A facilities approach to treatment. *The Prison Journal, 99*(6), 748–770.

Toews, B., Wagenfeld, A., Stevens, J., & Shoemaker, C. (2020). Feeling at home in nature: A mixed method study of the impact of visitor activities and preferences in a prison visiting room garden. *Journal of Offender Rehabilitation, 59*(4), 223–246.

Trahan, A., & Evans, D. N. (2020). Social exchange and the formation of prison visitation communities. *Journal of Qualitative Criminal Justice & Criminology, 8*(2), 235–256.

Wener, R. (2012). *The environmental psychology of prisons and jails: Creating humane spaces in secure settings*. Cambridge University Press.

Wu, D. (2018). Harmonious coexistence: Multi-values of prison environment color design to prisoners' psychological treatment. In *3rd International Conference on Contemporary Education, Social Sciences and Humanities* (pp. 562–567). Atlantis Press.

19

Culture Change Within Facilities that Incarcerate

Hugh D. Lester and Christine Tartaro

One of the most closely watched jail system projects in the United States, the Borough-based Jail programme in New York City, has been embroiled in a multi-year planning and political process. New York City's Rikers Island was born in the 1930s and is now in deep decay. The buildings are hopelessly out of date, the remote location delays court processing and makes it difficult for attorneys and family members to visit, and the organizational culture fosters violence and neglect (Jacobson et al., 2018). According to Steve Martin, who was appointed to oversee the jails as part of a Federal Consent Decree, Rikers is

H. D. Lester (✉)
Urbahn Architects, PLLC., New York, NY, USA
e-mail: lesterh@urbahn.com

C. Tartaro
Stockton University, Galloway, NJ, USA
e-mail: Christine.Tartaro@stockton.edu

"…deeply dysfunctional with a violent culture that has been entrenched for decades. In jails like this, he said, things often get worse before they get better (Rodriguez, 2019)." The Independent Commission on New York City Criminal Justice and Incarceration Reform (i.e., the Lippman Commission) made numerous recommendations with the goal of reforming the New York City Corrections System. Many of the recommendations are in the process of being implemented, including a plan to close Rikers Island and replace it with smaller, more modern jails in city boroughs by the end of 2027. A particularly controversial recommendation came from the Commission's Culture Change Working Group that sought to address the negative organizational culture throughout the system. While some recommendations, such as hiring a new HR Director and utilizing a profile of an "ideal candidate" for hiring have been implemented, there has been some pushback on other culture change attempts by the Correctional Officers Benevolence Association (COBA), the labour union for line staff. Given the high probability of transference of NYC Department of Correction's dysfunctional organizational culture to the replacement facilities, policy, staffing, and administrative measures are under consideration (Jacobson et al., 2018).

Correctional facilities are people-driven, whether by the organizational culture of those that operate them or by emergent inmate culture. Organizational culture, or "the beliefs, assumptions, and values that guide an organization's operations and affect how its members think and act," (Jacobson et al., 2018, p. 379) is organic and requires buy-in at all levels. It evolves, including in response to attempted interventions from within or without, and often proves policy resistant. Externalities likewise impact organizational culture.

Culture change is a critical issue for the replacement jail system in NYC and elsewhere. Allowing the existing culture to be transplanted into the new facilities would undermine a "once in a generation opportunity" and associated massive investment in new facilities. The goal is nothing less than to reinvent corrections in the City of New York and become a model for jurisdictions everywhere. This is much less likely to occur unless implementable culture change, the maintenance of a new organizational culture, and the reigning in of COBA's outsized influence are

supported in every way possible (Lester, 2018). Construction of the new jails alone will not create the necessary change.

Designers of spaces for justice system processes have limited levers to influence organizational culture. Their designs can support these processes via functionality, adequate flows of people and materials, and environments that promote wellness, but the adoption of inmate supervision paradigms—especially the extent to which administrators commit to full implementation—are what really drive organizational culture. Podular direct supervision facilities, which combine purpose-built architectural design and proactive inmate management strategies, have been associated with reduced violence, vandalism, suicides, lower levels of inmate stress, and increased officer job satisfaction (Bayens et al., 1997; Farbstein et al., 1996; Jackson, 1992; Nelson, 1986; Senese, 1997; Wener, 1993; Williams et al., 1999; Yocum et al., 2006; Zupan & Stohr-Gillmore, 1988). These improved outcomes, however, only occur when everyone up the chain of command fully commits to all the principles of direct supervision, and that commitment is sustained.

When transitioning from an old jail to a new one, the "old way of doing things" may gradually reassert itself or may overtly be transferred to the new facility. The degradation of organizational culture, the potential for improving organizational culture, and the measures that might contribute to the sustainment of organizational culture will be explored in this chapter. We will review some of the major developments in both design and supervision. We will also profile resistance to change and measures to counteract intransigence. Since design alone cannot achieve desired goals, there must be concurrent cultural change across the organization.

Podular Direct Supervision Design

The 1970s saw a paradigm shift in facility design. The United States Federal Bureau of Prisons (BOP) commissioned four new jails, known as Metropolitan Correctional Centres (MCCs). These institutions departed from the more traditional linear intermittent and podular indirect supervision designs. Linear intermittent units consist of cells lining long

corridors. The corridors lack sightlines into the individual cells, meaning that officers can only see inside the cells during their periodic, or intermittent, tours through the corridors. Podular indirect supervision facilities array cells around a shared control room. The control room, or officer station, is typically enclosed in security glazing, so officers have a full view of the dayrooms around it but are separated from the inmates. From the control room, officers can see all the cell doors, but since the doors are only partially glazed, views into the cells are poor unless they enter the pod and approach the cell fronts and look directly into the cells. In linear intermittent and indirect supervision, the cells and dayrooms are essentially inmate territory, as officers typically only enter these spaces in response to an incident.

The architects working with the BOP proposed a new design, called podular direct supervision (PDS). Like the podular indirect facilities, PDS jails had rooms or cells arranged around dayrooms, but the remaining design features and the entire management plan were quite different. The new PDS facilities adopted the unit management approach to make each pod as self-contained as possible. The goal was to provide services efficiently on the pod, limiting inmate movement, and allowing staff to focus on smaller groups of individuals rather than the entire facility. Podular direct supervision emphasizes staff control of dayrooms (Gettinger, 1984; Kerle, 1998; Nelson, 1983, 1986; Parrish, 2000). Rather than observing dayrooms from hermetically sealed control rooms, officers spend their shifts inside the dayrooms, interacting directly with the inmates. This placement of officers in the same space as inmates reflects an important shift in expectations for both inmates and officers. Gettinger (1984) characterized living units in podular indirect and linear intermittent facilities as power vacuums. The lack of a constant presence of officers in these spaces prompts inmates to fill the leadership void, and this frequently resulted in antisocial behaviour and exploitation of weaker inmates. PDS requires active and engaged staff that establish and maintain order and expect inmates to refrain from destructive behaviours. Swift and certain sanctions in response to rule violations are critical.

While the layout of PDS and indirect supervision units are often similar, the interior of the dayrooms and cells are very different. Indirect supervision and linear intermittent facilities require jail-specific

vandal-resistant fixtures and furnishings. Crime prevention scholar Oscar Newman (1972) warned public housing architects about the potential unintended consequences of using vandal-resistant fixtures. He remarked, "Instead of being provided with an environment in which they can take pride and might desire to keep up, they are provided with one that begs them to test their ability in tearing it down" (Newman, 1972, p. 105). Rather than specifying institutional fixtures that communicate to inmates that they are expected to behave badly, PDS pods are outfitted with commercial-grade materials typical of school dormitories or office waiting rooms. PDS jails often have carpeted or tile floors rather than concrete, which both improves their appearance and absorbs the noise prevalent in institutional environments. The furniture is made of wood or plastic rather than steel bolted to the floor. Toilets and sinks are more likely to be porcelain instead of stainless steel. Dayrooms in these jails generally offer unfettered access to telephones, televisions, vending machines, and microwaves. Such "normalized" living environments communicate expectations of prosocial behaviour from inmates. Jails with interiors that look less like jails and more like other community settings present inmates with a choice. They can behave, and remain in these units, or fail to live up to expectations for prosocial behaviour and be moved to a more restrictive and less comfortable living unit elsewhere (Wener & Farbstein, 1989; Gettinger, 1984; Kerle, 1998; Wener et al., 1985; Zupan & Stohr-Gillmore, 1988).

The PDS model requires a *combination* of architectural and management strategies to produce positive outcomes. The transition is more than just building a new facility. It includes providing communication skills training to help officers adapt to their new roles inside the dayrooms. It also requires culture change at all levels from the reactive approach to supervision common in traditional facilities to the engaged, proactive approach necessary in PDS jails. This is particularly challenging for officers used to working in legacy facilities.

The new model was met with so much scepticism from officers that the New York MCC administration pre-purchased partitions on the assumption that separation of inmates from officers was key to officer safety. The head of the local corrections officer union predicted that the inmates would destroy the dayrooms' non-institutional fixtures and then

attack the officers (Wener, 2012). Fortunately, those dire predictions did not come true. The New York MCC, as well as those in San Diego and Chicago, enjoyed reductions in violence and vandalism (Wener et al., 1993).

Despite encouraging findings, elements within the corrections community remained pessimistic regarding the applicability of PDS to county jails. Federal facilities in the United States are perceived as housing white-collar offenders who pose less institutional risk than the "street criminals" held in county jails. However, starting with Contra Costa County (CA), counties gradually began adopting podular direct supervision with similar levels of success (Bayens et al., 1997; Jackson, 1992; Senese, 1997; Wener et al., 1993; Williams et al., 1999).

The PDS model was founded on eight direct supervision principles adopted by the American Jail Association (AJA) in 1982, including effective control, effective supervision, competent staff, safety of staff and inmates, manageable and cost-effective operations, effective communication, classification and orientation, and justice and fairness (American Jail Association, 2013). Over the years, as the founding administrators in the PDS jails started to retire, the AJA added a ninth principle, ownership of operations, to reflecting the importance of staff investment in the facility's mission (American Jail Association, 2013; Kerle, 1998; Perroncello, 2005).

Strong leadership and the adoption of the PDS principles by the entire staff is critical, otherwise PDS jails revert to buildings with extra amenities. PDS officers are expected to regularly interact with inmates, to actively correct inmates' behaviour, and to promote prosocial activities. A common way for officers to subvert PDS principles is to simulate their erstwhile control rooms by claiming a dayroom table as "staff territory" and remaining there the entire shift. Additionally, officers tend to congregate inside the pods and interact with each other instead of with the inmates (Wener, 2012). This contravenes direct supervision principles.

Today, Tampa's 3,300-bed Falkenburg Road Jail is widely considered a high-performing direct supervision facility in the United States with respect to key performance indicators like inmate-on-inmate or inmate-on-staff violence. It houses inmates in 1:72 direct supervision open dorms. Emergency response teams muster to incident locations

via wide covered sidewalks. During a recent incident documented on CCTV, a direct supervision officer was attacked. The officer fended off the attack, and with the help of other inmates and staff who responded from outside the unit, restrained the attacker. Inmates' willingness to enter the fray to assist the officer is a testament to the organization's ability to earn both staff and inmate buy-in to the positive culture in the facility (ABC Action News, 2017; HCSOSheriff, 2017; WFLA News Channel 8, 2017). Management at this jail has demonstrated a strong commitment to the nine principles of direct supervision.

Another high-performing facility is the Santa Ana Jail in the City of Santa Ana, California. It is publicly owned and operated as a 97% revenue-generating, self-supporting business. The facility has a reputation for holding co-defendants on Racketeer Influenced and Corrupt Organizations Act (RICO) charges due to its proximity to federal courts and its track record of court-friendly operations. Far from typical outsourcing and privatization, outcomes at this direct supervision facility are tied to incentives, disincentives, feedback loops, and stewardship or leadership that succeeds on metrics at all scales. Santa Ana sets a high bar for other jurisdictions, such as their history of extremely low lawsuit claims. Over the course of 18 years, only $158,000 was paid out for jail-related claims, placing it in the top echelon of facilities nationwide (Lester, 2013). This exemplary record speaks volumes about the conditions of confinement and the consistent care and custody maintained by correctional staff.

Challenges to Success

There is evidence that podular direct supervision can produce individual units and facilities that are safer for both staff and inmates. Every model has varying levels of robustness, though, and corrections professionals have cautioned that piecemeal adaptation of PDS is unlikely to be effective. Podular direct supervision facilities were first built in the mid-1970s, so there is ample documentation of their introduction and ongoing operations in hundreds of facilities, including after the founding leaders

retired. It appears that there are three factors that threaten the continued viability of PDS facilities: failure of implementation, failure to train, and failure to maintain necessary leadership and culture.

Failure to Fully Implement the PDS Model

By 2000, there were nearly 300 jails in the United States that managers identified as direct supervision (Harding et al., 2001), but a number of factors influenced the extent to which these jails fully embraced the paradigm. First, in the forty-five years since the opening of the first PDS facilities, governments periodically experienced fiscal crises that limited correctional budgets. Budget constraints can force cuts to staffing levels, programmes, and training. Second, the inmate population increased exponentially in the United States starting in the early 1980s. Third, the "get tough on crime" movement beginning in the 1980s made it politically dangerous to support anything that appeared to make the lives of inmates easier (Liebert, 1996), so it was not uncommon for planning commissions to object to any plans that seemed to appear soft on crime. As a result of these changes, some aspects of traditional PDS design never made it to the implementation phase in individual jurisdictions.

In a study of nearly 650 jails with different designs, Tartaro (2003) found no differences between PDS jails and other facilities in preventing suicides. This was an unexpected finding, since so many initial evaluations of PDS jails reported reduced suicide attempts and suicides. A closer look at the direct supervision facilities responding to Tartaro's survey revealed that many lacked key components of the original model. Specifically, most offered a maximum of two days of communication skills training for officers who were then expected to be able to manage pods from inside the dayroom. Additionally, most of the facilities had institutional instead of normalized environments (Tartaro, 2002, 2006), meaning that the PDS jails had dayrooms that more closely resembled older indirect supervision pods. Tartaro and Levy (2008) studied 150 direct supervision jails and found that those that maintained a more institutional setting in the living areas were more likely to have at least one suicide during the study year. Hours of communication

skills training were not associated with the odds of facilities experiencing suicides in that year.

After conducting several audits of direct supervision jails, Liebert (1996) observed that some were having to cut programming due to staffing and budget shortages. Peter Perroncello, former President of the American Jail Association (2005), while serving on an architectural jury for the American Institute of detected that jurisdictions were backsliding on their commitment to constructing non-institutional interiors, and some facilities appeared to be relying more on warehousing inmates than on programming to reduce recidivism.

Several administrators and researchers cautioned that PDS facilities are not immune to the strain resulting from overcrowding (Bayens et al., 1997; Kenhold, 2008; Leone & Kinkade, 1994; Liebert, 1996), although Tartaro and Levy (2007) did not find levels of crowding to be a significant predictor of violence in PDS jails. Liebert (1996) noted that crowding of pods can lead to administrators placing more than one officer in units. While this might initially appear to be a positive development, it is contrary to the original tenets of direct supervision and poses a threat to the officer-inmate dynamics inside the pods (Liebert, 1996). Wener (2012) observed that when multiple officers are placed in a pod in response to an increased census, they tend to congregate and spend more time together than interacting with the inmates. Crowding can also limit availability of inmate programmes.

Failure to Train

As the American Jail Association's (2013) principles of direct supervision indicate, successful operation relies on the performance of staff. New officers must be trained in how to be proactive in inmate management and de-escalate using negotiation and empathy rather than commands and hands-on control. Seasoned officers also need training, as they have grown accustomed to the reactive approach to inmate management found in linear intermittent and podular indirect supervision. A good illustration of the role of training in facility success was provided by Zupan and Stohr-Gillmore (1988). The researchers collected data from

four direct supervision facilities and three linear intermittent facilities. They also chronicled one jurisdiction's transition from linear intermittent to a new PDS facility. Overall, inmate perceptions of the podular direct supervision facilities were much more positive, with inmates reporting feeling less stress and experiencing fewer symptoms of anxiety. There was one exception to these findings, and that was a direct supervision facility that did not provide adequate training. While officers in the other direct supervision facilities received 6 to 8 weeks of training, officers in the atypical PDS facility only were provided two weeks of training. Additionally, the training in the atypical facility was focused on more traditional tactics of physical control rather than the communication skills needed in direct supervision. When the facilities opened, the atypical facility was operated in a manner analogous to the non-PDS facilities, with officers locking inmates in their cells during officer break times. Inmate self-reported stress levels at the atypical PDS facility were analogous to those found in the linear intermittent facilities.

In 1995, three individuals involved in the rollout of some of the first PDS jails expressed concern about jurisdictions opening their facilities without proper training and orientation of the personnel (Nelson & Davis, 1995). The authors provided examples of facilities that opened, failed to operate by the principles of direct supervision, and then had highly publicized security incidents. These incidents included a complete loss of control over two general population pods and significant property damage, assaults on officers, an inmate death that was not discovered for 48 hours, and escapes. At the jails where these incidents occurred, administrators were given only a brief orientation to direct supervision. Additionally, the administrations experienced pressure to open the facilities early, even before the training officers had become proficient in teaching direct supervision principles. The result was that officers who were not yet clear on how to work in direct supervision were placed in the pods. Since the administrations had not learned about and embraced PDS principles, they did not appreciate the importance of communication skills training, nor did they understand the need for continuity and unit management in the pods. Officers in these jails were repeatedly moved from pod to pod, resulting in inmate frustration with the lack of consistency of rule enforcement. Communication between officers and

inmates is key in all facilities, especially in PDS designs. Since swift and certain sanctions for negative behaviour are an essential element of direct supervision, the resulting inconsistency of rule enforcement likely had a negative impact on inmates' behaviour.

In Hillsboro County, Florida David Parrish's transition team was aware of the challenges other jails had faced due to inadequate training. Not only did they provide extensive training to their line staff, but they mandated that all non-commissioned officers (corporals and sergeants in the United States) complete a 56-day rotation as direct supervision officers in pods. This allowed management to understand the challenges that all officers face in direct supervision, and it helped to foster better communication up the chain of command (Kerle, 1998, 2003; Parrish, 2000).

One of the most wide-ranging observers of county jails over a fifty-year period—Kenneth E. Kerle, the former editor of *American Jails*—placed the issue in proper perspective, arguing that, "…if a government jurisdiction spends millions of dollars on an architecturally designed direct supervision facility, it makes no sense to stint on the training" (1995, p. 5).

Maintaining Organizational Culture Over Time

The available research suggests that many of the first facilities to introduce direct supervision experienced positive outcomes in reductions of violence and vandalism (Bayens et al., 1997; Jackson, 1992; Senese, 1997; Wener et al., 1993), reductions in suicides and attempted suicides (Bayens et al., 1997; Jackson, 1992; Wener et al., 1993), more positive working environments for staff (Wener & Farbstein, 1989; Nelson, 1986; Yocum, et al., 2006) and inmates (Farbstein et al., 1996; Yocum et al., 2006; Williams et al., 1999; Zupan & Stohr-Gillmore, 1988). With few exceptions, facilities exhibiting positive outcomes appear to have fully adopted direct supervision. Over the years, the original leaders of these facilities and the officers who supported them retired or moved on to other careers. This turnover of staff presented challenges to the

continuity of leadership that is important for the success of these facilities. After conducting audits of several direct supervision facilities, Liebert (1996) observed that the new administrators were unfamiliar with the direct supervision philosophy and/or did not support it to the same extent the first generation of leaders had. A possible explanation for this is that the transition teams that helped orient all staff to the PDS system were disbanded after the new facilities became fully operational. When the transition teams were disbanded without assigning important duties to others, gaps in training and knowledge resulted. Liebert observed that, without the transition team, no one was updating policy and procedure manuals, nor were new staff trained on them, resulting in inconsistent enforcement of policies and procedures. Peter Perroncello, former President of the American Jail Association, warned that he had colleagues "who proudly vocalize that they operate direct supervision, but have no clue about what the principles are because the officers were never trained" (2005, p. 17). After spending decades observing and evaluating PDS facilities, Wener (2012) noted reports of backsliding, with successful facilities experiencing challenges once the original administrators retired. While some counties gravitate towards choosing PDS as the approach for their new facilities because it is considered "state of the art," it is unlikely to be successful unless there is appropriate buy-in and training at all levels (Liebert, 1996). Failure to continue to embrace the nine Principles of Direct Supervision is likely to result in staff reverting to a more traditional punitive and reactionary orientation to inmates (Krauth & Clem, 1987; Parrish, 2000).

Moving Forward—Preparing for a New Facility or Changes to Existing Institutions

For the remainder of the chapter, we are going to address measures that will help correctional administrators make significant changes to their way of operating. Keeping with the theme of this book, we acknowledge the importance of facility design. We realize, however, that not every jurisdiction is able to afford design changes, so we provide some

management strategies appropriate for older jails. Additionally, we want to emphasize that interventions other than facility alterations or new construction can impact the success of correctional institutions.

Facility Design

The preferred design for jails today is podular direct supervision. If it is at all possible, we recommend that jurisdictions either build new jails or renovate existing ones to adopt PDS designs. The layout of the facility, plus adoption of the nine PDS principles, will likely improve conditions for both staff and inmates.

Is it feasible to have a well-run facility in the absence of optimal architectural design? Yes. One option is to create Behavioural Management Units. This approach seeks to maximize the facility's efficiency while creating a safe environment for both staff and inmates (Hoke, 2013a) by implementing a six-point plan. Step 1 highlights the need for staff to properly assess all inmates' risks and needs using valid and reliable assessment instruments. Step 2 requires using the information found in Step 1 to inform classification decisions, so inmates are assigned to housing appropriate to their security and treatment needs. In Step 3, management must confirm that inmates' basic needs are being met, meaning that they are physically safe and have adequate social interaction, including with those outside the facility. Step 4 is about communication of expectations for appropriate behaviour. This starts at orientation, where inmates are informed of all the rules. Officers reinforce behavioural expectations by communicating with inmates in a respectful way, maintaining high standards for order and cleanliness on the units, sanctioning negative behaviour, and incentivising positive behaviour (Hutchinson et al., 2009).

Only after Steps 1 through 4 have been implemented should one move on to 5 and 6. In Step 5, inmates must be fully accountable for their behaviour. A challenge, however, is that some facility designs make it difficult for officers to properly supervise inmates. PDS facilities are in the best position to achieve this. In podular indirect supervision facilities, where officers are typically in a control room physically separated from

the inmates, an officer trained in direct supervision should interact with the inmates inside the pods. For linear intermittent facilities, placement of duty stations next to the inmate housing areas allows staff to aurally supervise units between more frequent and intentionally interactive, mandated guard tours. In Step 6, the facility needs to provide inmates with structured and unstructured activities to occupy idle time and mitigate negative behaviour. Unstructured activities consist of reading, art, writing, and television availability on the pod. Structured activities can be held both on and off the pods and can include work assignments and rehabilitation programmes (Hutchinson et al., 2009). Programming is the last step in the implementation of behavioural management, because it is only after the safety and basic needs of inmates are met that both staff and inmates have the time and attention to focus on programmes (Wener, 2012).

Hoke (2013a) evaluated the introduction of a behavioural management programme at the Northampton County Prison in Easton, Pennsylvania. In the 21 months following implementation of the programme, there was a 69% reduction in formal misconduct reports and a 73% reduction in informal misconduct incidents. The Brazos County Jail in Bryan, Texas introduced a similar programme in their facility. There was an initial monthlong spike in total misconduct reports, but that was likely an artifact of the increased supervision and contact officers had with inmates. Afterwards, the facility saw overall reductions in misconduct, including predatory behaviour (threatening or assault), nuisance misconduct, and disrespectful behaviour. Hoke (2013b), the evaluator chronicling the changes, noted that this facility's physical design was not at all conducive to inmate supervision or inmate–officer interaction, so the positive results here are noteworthy in that they were able to modify inmate behaviour in a legacy facility with an outdated design. This provides evidence that, with the right leadership and appropriate policies and procedures, staff can overcome some of the barriers presented by antiquated designs or inadequate or inappropriate supervision.

There are other examples, outside of implementation of a BMU model, where interventions helped produce a safe and efficient jail, even where PDS was not economically feasible. The new Bates County Law Enforcement Center in Butler, Missouri is a podular indirect supervision

facility. The original 1920s jail on the third floor of the courthouse it replaced was monitored by dispatchers/jail officers conducting intermittent guard tours between 9-1-1 calls and radio calls. Deputies patrolling in vehicles are directed to incident locations in the community. Bates County felt that a combined dispatch/central control would work in the replacement facility, and the design team could not convince them otherwise. Unfortunately, the controlling officer's primary focus proved to be protecting the community by answering 9-1-1 calls and dispatching road deputies to incident locations instead of the inmate supervision task. The result: the inmates "ran the facility." When visiting the facility several months later, the lead author witnessed a roving correctional officer entering each pod and interacting directly with inmates, one pod at a time. It was not clear whether this was official policy/procedure or adopted procedure, but it represented an excellent strategy to mitigate the shortcomings of indirect supervision.

The Lafayette County Jail replacement in Lexington, Missouri was part of the consolidation of justice system elements into a Justice Center complex on the courthouse square. The existing 1930s jail was completely replaced in two phases, resulting in a radial podular, indirect supervision facility with mezzanine level control for enhanced sightlines. During design, the county was clear in its support of this approach, but the transition team installed a staff station on the ground floor in one of the pods which was operated as an interim intake, transfer, and release area in concert with a roving officer proceeding through the balance of the pods one by one, interacting with the inmates. Camera views from the unstaffed mezzanine control were monitored from the interim ITR staff station. As the full facility came online, the roving officer approach was continued, and mezzanine control remained unstaffed, although the option to staff it during an incident or periods of overcrowding remained. Higher levels of staff engagement and reduced levels of violence and negative behaviours resulted from this operational regime.

The Hinds County Penal Farm Replacement project in Raymond, Mississippi was under resourced and understaffed to the extent that extreme solutions were required. Based on the need to hold a "roving officer" in reserve for staff emergency response and baseline staffing of

three officers per shift, the staff-to-inmate ratio in the pods defaulted to 1:200. In response, the designer proposed "V" shape wings with unobstructed sightlines from back-to-back, open staff stations. Each side of a "V" was a 100-man wing that was physically, visually, and somewhat aurally separated from the other side, providing twice as much classification (separation of inmates of varying security levels) while reducing the staff-to-inmate ratio to effectively 1:100. This arrangement forced direct supervision officers to adapt to the absence of security barriers by maintaining inversely proportional levels of professionalism and vigilance. Hearing and vision—both critical to effective direct supervision—drove a design that accommodated both sensory modalities via optimized sightlines and placement of problematic toilet/shower areas adjacent to the staff stations for aural proximity. Although direct supervision best practice has officers remain mobile within pods, this arrangement yielded excellent results, as it was named the lowest incident jail in the United States for sexual harassment and abuse by the Bureau of Justice Statistics (2010). Sheriff Malcom McMillin attributed the low rates of sexual victimization in his facility to correctional officer training, facility design, inmate population characteristics, and community-based work programmes (Wilkinson et al., 2012).

Setting Goals

Proposed interventions should involve reach goals, meaning goals that are difficult yet possible to achieve. The NYC BBJ programme is predicated on dramatically reducing the use of detention in New York City. NYC Department of Correction facilities incarcerated almost 22,000 in 1991, but after a series of reforms, the facilities held 8,397 in 2018 (NYC MOCJ, 2020a). The reach goal is to further reduce the use of detention to achieve a daily census of 3,300 by 2027 (NYC Office of the Mayor, 2017; NYC MOCJ, 2020b). This would place the rate of incarceration at 56 per 100,000, which will be the lowest rate in over seventy years. Only a reach goal will drive collective behaviours that will allow the Mayor's goal to dramatically reduce incarceration in New York City to become a reality.

Brennan (1999) studied organizational change in corrections and recommended that the pre-implementation phase consist of not only problem recognition and goal setting but work towards political acceptance of the needed changes. The goal is to have a clear plan and to start working on buy-in from all levels of staff from the beginning. Brennan emphasized the importance of developing a solid, comprehensive plan, something that he believes has been missing in criminal justice. Brennan notes that "The traditional 'seat of the pants' approach to implementation remains widespread among criminal justice managers. This common approach has been characterized as disjointed, poorly conceived, half-hearted, and is often conducted with poor planning and inadequate support" (p. 10). During the planning process, it is important to engage stakeholders, including representatives from all ranks, community members, community organizations, and legislative groups (Bardach & Patashnik, 2020; Brennan, 1999). This type of collaborative effort increases the chances of generating buy-in from involved parties.

Corrections agencies often face the dilemma that rehabilitation and custody goals are at odds. In custodial institutions, security takes precedence, so rehabilitation programmes must be modified or cancelled due to lockdowns or restrictions on movement within facilities. Until recently, American politicians and policymakers were under tremendous pressure to maintain a "tough on crime" stance and eschew anything, including rehabilitation efforts, that made incarcerated life more liveable for inmates. While the climate has improved over the past ten years, there remains a disconnect between the goals of treatment and custody staff inside many prisons and jails in the United States. Agency leaders will need to address, in the planning stages, how they intend to integrate the two functions so treatment and custody staff can work together to achieve shared goals (Jacobson et al., 2018), as it is not always a given that they will do so, at least in the United States. Cross-training may be helpful here, so custody and rehabilitation personnel can break down barriers between the two professions (Farabee et al., 1999). Jacobson and colleagues (2018) also suggest recruiting custody staff who have social work and mental health backgrounds to help shift the thinking of officers regarding their role in shaping behaviour beyond baseline custody operations.

In order to implement plans, it is essential that the agency identify change agents who can provide stable leadership during the transition and beyond (Brennan, 1999; Jacobson et al., 2018). Jail management should ideally be focused on organizational leadership instead of paperwork. Direct supervision and behavioural management programmes will backslide over time if the philosophy is not consistently upheld by jail leadership. A culture of correctional professionalism must be actively promoted on an ongoing basis so that the mission permeates all levels of the organization.

Staffing, Training, and Re-Training

A commitment to hiring the best and constantly fighting to improve skills and abilities contributes to better outcomes and retention, so it is the cheapest investment that a jurisdiction can make, at least within the correctional regime that we are suggesting. The hiring process is a time when recruiters can carefully screen individuals and weed out those who have potential to be problematic in the future. An analysis of Rikers Island's recruiting over the years revealed that the government was hiring officers with obvious potential red flags, such as histories of domestic violence or failed psychological evaluations (Jacobson et al., 2018). While hiring is an opportunity to bring in fresh staff who have not yet been exposed to a problematic organizational culture, they can, and likely will, either adopt the existing culture or leave for other employment opportunities. For that reason, hiring new staff cannot be the sole strategy for changing the existing culture.

The tendency of the status quo to resist change should not be underestimated. Corrections is a policy-resistant domain. Regardless of their reasons, actors throughout the justice system attempt to optimize their outcomes and tend towards the familiar and manageable. Labour unions polarize line staff in this regard. Proper hiring, training, and re-training can help to promote culture change, but only if there is strong leadership to promote and sustain the drive for change.

Vigilance is key, as it is easy for staff to adopt and then continue bad habits. Periodic re-training is likely to help, but only if staff know

that management expects adherence to agency policies and intends to hold people accountable. Consider use-of-force policies and procedures. Although the policy of many facilities is to periodically rotate staff assignments to mitigate personal relationships and favouritism between direct supervision officers and inmates, use of force is a more slippery slope. It can escalate over time as frustrations accrue in housing units. At the Santa Ana Jail, the Operations Manager, Ms. Christina Holland, believes that "getting out on the floor more"—knowing all the staff members on a personal level—and constantly taking the pulse of the facility—is the key to leadership that supports sustainable organizational culture (Lester, 2013).

Promoting and Maintaining Change with Incentives and Disincentives

Both inmates and custody staff respond to incentives for compliance and disincentives to deter poor performance or negative behaviours. At the Santa Ana Jail, inmates are responsible for cleaning their housing units, and the administrator inspects units on a weekly basis. A highly rated unit earns a movie night with popcorn. Units that score two consecutive 100% inspections are provided fried chicken or pizza with their movie. These incentives are based on the theory that environment cues behaviour. This facility has not had an incident of inmate-on-staff violence on a housing unit in decades. More prosaically, the carpet in these units has never had to be replaced (Lester, 2013).

For staff at all levels, there needs to be accountability and continued adherence to the new policies and cultural norms. Be cognizant of the potential impact of changes in management, as the loss of leaders who believed in the mission can cause backsliding, even after years of success. There can never be a let-down, especially when an agency's reach goal is within sight. Justice systems are complex adaptive systems (CAS). A recent paper on the pursuit of culture change enumerated "…factors impacting jail outcomes, such as organizational culture, inmate characteristics, the jail census, and justice system drivers such as criminal law, prosecutorial and judicial discretion, case processing speed,

rules surrounding discovery, parole violation terms, and societal mores evolving over time" (Lester & Miller, 2019). Given that, many emergent properties exhibited by CAS display even less predictability. The best response to CAS is to constantly adapt and adjust; only the motivations and level of engagement of all stakeholders can be influenced.

Collective Bargaining Considerations

Never underestimate the extent that the underlying agenda of labour unions and their rank and file will be in direct opposition to the larger goals of justice system and correctional system reform. Sometimes the only way to deal with entrenched municipal employee unions is to start over. This was the case for the Camden, New Jersey Fraternal Order of Police. This may also be the case with NYC's COBA, where current staff-to-inmate ratios eclipse Arlington County, Virginia, one of the highest performing facilities nationwide, which has a staff-to-inmate ratio of 0.33:1. While the NYC DOC staff-to-inmate ratio recently skyrocketed to 1.6:1, use-of-force incidents counterintuitively increased by 30% (Rodriguez, 2019). COBA may well be irrecoverable.

Considering the Jail Within the Context of the Larger Justice System

The jail is a necessary component of the local justice system. However, it is an expensive necessity, and society's resources would be better spent keeping people out of jail in the first place. That said, optimizing the jail really means optimizing all the relationships between the jail and the larger community, especially other county agencies that impact jail use.

Any intervention that targets the larger system within which the jail functions should include outreach to the public. The issues faced by the jail should be "top of mind" with the public. Public information campaigns that stress the legal requirement to provide safe, secure, and constitutional detention would help to counteract common depictions of jails in popular culture focused on violence, rape, death in custody and the like, instead of the prevailing reality of boredom, lives

wasted, and opportunities to "turn people around" squandered due to lack of resources. Volunteers should also be sought via such channels of communication.

The best means of controlling average length of stay, average daily population, and jail budgets, is to have the Sheriff, the District/County Attorney, and the Ranking Judge meet regularly to coordinate. When these three individuals are aware of the pressures on the entire jail system, it mitigates judicial and executive branch actions that drive jail populations. Invitations to sit in on the meetings should be extended to local, state, and even national politicians and legislators so they better understand the context and constraints within which the justice system operates on the local level. This may cause them to become moderating voices and legislate based on their enriched perspectives.

Conclusion

Designers and planners of jails and prisons are not in control of policy, legislation, judicial findings, or available funding. Operators work with what they have unless they can convince elected officials to allocate additional resources. However, all involved can attempt to procure and operate facilities in a manner that mitigates negative outcomes for everyone who becomes justice system involved. Reducing the potential for abuse and violence—inmate-on-inmate, inmate-on-staff, and staff-on-inmate—and improving conditions of confinement through design and incentivization will blunt the negative outcomes of potential future misuse. The work cannot end after the buildings are constructed, and it is necessary to address entrenched cultural issues that may negatively impact safe and effective operations.

References

ABC Action News. (2017). Detention deputy attacked by inmate with a towel [video]. YouTube. https://www.youtube.com/watch?v=vgZnJlnZluY

American Jail Association. (2013). *American Jail Association resolution: Direct supervision jails.* https://www.americanjail.org/content.asp?contentid=142

Bardach, E. & Patashnik, E. (2020). *A practical guide for policy analysis* (6th ed.). Sage.

Bayens, G., Williams, J. & Smykla, J. (1997). Jail type makes difference: Evaluating the transition from a traditional to a podular, direct supervision jail across ten years. *American Jails., 11*(2), 32–39.

Beck, A., Harrison, P., Berzofsky, M., Caspar, R. & Krebs, C. (2010). *Sexual victimization in prisons and jails reported by inmates, 2008–09: National Inmate Survey, 2008–09.* Washington, DC: U.S. Department of Justice, Office of Justice Programs, Bureau of Justice Statistics. NCJ 231169.

Brennan, T. (1999). *Implementing organizational change in criminal justice: some lessons from jail classification systems.* Northpoint Institute for Public Management, Inc.

Farabee, D., Prendergast, M., Cartier, J., Wexler, H., Knight, K. & Anglin, M. (1999). Barriers to implementing effective correctional drug treatment programs. *Prison Journal., 79*(2), 150–162.

Farbstein, J., Liebert, D. & Sigurdson, H. (1996). *Audits of podular direct-supervision jails.* Washington, D.C.: U.S. Department of Justice, National Institute of Corrections.

Gettinger, S. (1984). *New generation jails: An innovative approach to an age-old problem.* NIC Jails Division.

Harding, B., Linke, L., Van Court, M., White, J. & Clem, C. (2001). *2001 Directory of direct supervision jails.* National Institute of Corrections.

HCSOSheriff. (2017). *Inmate attacks detention deputy* [video]. YouTube. https://www.youtube.com/watch?v=CNflMTKI4ks&has_verified=1

Hoke, S. (2013a). *Inmate behaviour management: Northampton County Jail Case Study.* National Institute of Corrections.

Hoke, S. (2013b). *Inmate behaviour management: Brazos County Jail case study.* National Institute of Corrections.

Hutchinson, V., Keller, K. & Reid, T. (2009). *Inmate behaviour management: The key to a safe and secure jail.* National Institute of Corrections.

Jackson, P. (1992). *Detention in transition: Sonoma county's new generation jail.* National Institute of Corrections.

Jacobson, M., DeWolf, E., Egan, M. & Hafetz, D. (2018). Beyond the Island: Changing the culture of New York City Jails. *Fordham Urban Law Journal., 45*(2), 373–436.

Kenhold, D. (2008). Managing direct supervision jails when they become overcrowded. *American Jails, 22*(1), 83–88.

Kerle, K. (1995). Direct supervision: The need for evaluation. *American Jails, 9*(3), 5.

Kerle, K. (1998). *American jails*. Butterworth-Heinemann.

Kerle, K. (2003). *Exploring jail operations*. American Jail Association.

Krauth, B. & Clem, C. (1987). Direct supervision jails: Interviews with administrators. *Corrections Information Series*. NIC Information Center.

Leone, M. & Kinkade, P. (1994). New designs, new ideas, and new problems: An analysis of the effects of non-smoking policies on a 'new generation' jail. *Justice Professional., 8*(2), 1–21.

Lester, H. (2013). Maintaining a balance. *American Jails, 27*(6), 36–40.

Lester, H. (2018). *Psychological drivers influence architectural design: The Hinds County, Mississippi penal farm replacement*. PSYCON 3: University of Wolverhampton, UK.

Lester, H. & Miller, M. (2019). Discrete event simulation of jail operations in pursuit of organizational culture change. In K. Sako, S. Schneider, & P. Ryan (Eds.), *ESORICS 2019: 24th European symposium on research in computer security, Luxembourg, September 23–27, Proceedings, Parts I and II (Workshops Supplement)*. Springer: Cham (CH). https://doi.org/10.1007/978-3-030-29962-0

Liebert, D. (1996). Direct supervision jails—The second decade: The pitfalls. *American Jails, 10*(4), 35–37.

Nelson, R. (1983). New generation jails. *Corrections Today*, pp. 108–112.

Nelson, W. (1986). *Can cost savings be achieved by designing jails for direct supervision inmate management?* Proceedings of the First Annual Symposium on Direct Supervision Jails.

Nelson, W. & Davis, R. (1995). Podular direct supervision: The first twenty years. *American Jails, 9*(3), 11–22.

NYC Mayor's Office of Criminal Justice. (2020a). *Data story: Average daily jail population in New York City*. City of New York. https://criminaljustice.cityofnewyork.us/individual_charts/average-daily-jail-population-in-nyc/

NYC Mayor's Office of Criminal Justice. (2020b). *Rikers Scorecard Jan/Feb 2020b*. City of New York. Available at: https://criminaljustice.cityofnewyork.us/wp-content/uploads/2020b/04/Rikers-scorecard_Jan-Feb-2020.pdf

NYC Office of the Mayor. (2017). *Smaller safer fairer: A roadmap to closing Rikers Island*. City of New York.

Newman, O. (1972). *Defensible space*. Collier Books.

Parrish, D. (2000). The evolution of direct supervision in the design and operation of jails. *Corrections Today, 62*(6), 84–87, 127.

Perroncello, P. (2005). Beyond the ninth principle? *American Jails*, pp. 16–20.

Rodriguez, C. (2019). *Federal monitor says violence persists at Rikers*. WNYC News. https://www.wnyc.org/story/federal-monitor-says-violence-persists-rikers/

Senese, J. (1997). Evaluating jail reform: A comparative analysis of podular/direct and linear jail inmate infractions. *Journal of Criminal Justice, 25*(1), 61–73.

Tartaro, C. (2002). Examining implementation issues with new generation jails. *Criminal Justice Policy Review, 13*(3), 219–237.

Tartaro, C. (2003). Suicide and the jail environment: An evaluation of three types of institutions. *Environment and Behaviour, 35*(5), 605–620.

Tartaro, C. (2006). Watered down: Partial implementation of the new generation jail philosophy. *The Prison Journal, 86*(3), 284–300.

Tartaro, C., & Levy, M. (2007). Density, inmate assaults, and direct supervision jails. *Criminal Justice Policy Review, 18*(4), 395–417.

Tartaro, C., & Levy, M. (2008). Predictors of suicide in new generation jails. *Justice Research and Policy, 10*(1), 21–37.

WFLA News Channel 8. (2017). *Hillsborough detention deputy injured when inmate tries to strangle him* [video]. YouTube. https://www.youtube.com/watch?v=tTKt6CcmhiY

Wener, R. (2012). *The environmental psychology of prisons and jails*. Cambridge University Press.

Wener, R., Farbstein, J. & Frazier, B. (1985). Three generations of environment evaluation and design. *Environment and Behavior. 17*:71–95.

Wener, R., & Farbstein, J. (1989). Evaluating and comparing direct and indirect supervision facilities. American Jail Association Conference: Hollywood, Florida.

Wener, R., Frazier, F. & Farbstein, J. (1993). Direct supervision of correctional institutions. In National Institute of Corrections (Eds.), *Podular, direct supervision jails* (pp. 1–8). NIC Jails Division.

Wilkinson, R., Christensen, G., Seymour, A. & Mazza, G. (2012). *Report on sexual victimization in prisons and jails*. U.S. Department of Justice, Review Panel on Prison Rape.

Williams, J., Rodeheaver, D. & Huggins, D. (1999). A comparative evaluation of a new generation jail. *American Journal of Criminal Justice., 23*(2), 223–246.

Yocum, R., Anderson, J., DaVigo, T. & Lee, S. (2006). Direct-supervision and remote-supervision jails: A comparative study of psychosocial factors. *Journal of Applied Social Psychology, 36*(7), 1790–1812.

Zupan, L. & Stohr-Gillmore, M. (1988). Doing time in the new generation jail: Inmate perceptions of gains and losses. *Policy Studies Review., 7*(3), 626–640.

20

Gendered Inconsiderations of Carceral Space

Lindsay Smith

The rate of incarceration for women within the United States (U.S.) has increased by 750% in the last three decades, surging from the 1980s total of 26,378 women incarcerated to 225,060 as of 2017 (The Sentencing Project, 2019). Of those incarcerated women, 117,000 are housed within jails.[1] Considering the majority of jails are mixed gendered and house significantly more men than women, the phrase "it's a men's jail" is an overarching theme and is particularly apparent in the purposive design of these facilities, given the patriarchal structure (i.e., male-dominated, but

[1] The term jail refers to a correctional facility where those individuals awaiting a trial or being held for minor crimes (i.e., misdemeanours) are confined.

L. Smith (✉)
Department of Criminology, Law, and Society, George Mason University, Fairfax, VA, USA
e-mail: lsmith67@gmu.edu

also male-constructed) in which they are situated. Incarcerated women receive inadequate attention because, simply, men outnumber them, even though their incarceration growth rate is twice that of men (The Sentencing Project, 2019). This inattentiveness to women results in a spatial deficit and inconsiderate design for the institutions they inhabit.

The criminal justice system (CJS) employs what might be called the "masculinization" theory (Chesney-Lind & Eliason, 2006) of women's criminal offending. The law, which often follows suit from societal gender norms, does not focus on gender specifically as a stand-alone, but rather attempts to just add women and stir. The theory assumes that the same forces that propel men to commit crime will also propel women, once they are freed from the constraints of their gender. Although, women's criminal histories tend to be short-lived and less violent in nature than their counterparts who are men (Greenfeld & Snell, 1999; Steffensmeier, 1993), serving less than a year for most often misdemeanour offences (Lynch et al., 2012). In fact, two-thirds of women in prison are convicted for nonviolent offences (Covington & Bloom, 2003). However, it is imperative to understand that women who are incarcerated for violent offences are often bound to intimate partners who may abuse them (Bowker, 1981; Covington & Bloom, 2003; Lauritsen et al., 2009; Mann, 1990; Norland & Shover, 1977; Steffensmeier et al., 2006). Specifically, women's offence types usually fall into four distinct categories: 37% violent offences, 29% property crimes, 25% drug crimes, and 8% public disorder (Carson & Anderson, 2015). The simple assertion that women commit crime just like men, does not tell the whole story; it neglects to consider any bit of complexity in women's lives that may come from past victimization and results of trauma. This contributes to our understanding of the "blurred boundaries" theory which argues that women's offending is intimately linked to their earlier victimization(s) (Daly, 1992), that often causes trauma. Trauma, according to the fifth edition of the Diagnostic and Statistical Manual of Mental Disorders (DSM), is experiencing an event that falls outside the range of a normal human experience which would be distressing to most people (APA, 2013). For women, this most often includes various forms of sexual violence such as adult or child sexual abuse and intimate partner or personal violence (Miller & Najavits,

2012). This may contribute to their decisions to persist in or desist from crime. For instance, individuals with histories of sexual abuse are more frequently arrested (Hubbard, 2002) and often continue to experience some form of trauma (Council of State Governments, 2005). More importantly, it brushes over the needs which require addressing in order for women to leave the CJS entirely.

The physical environment in which incarcerated populations live drastically impacts carceral residents' everyday routines, accessibility to services, as well as their safety and security. For women, the design of the correctional facility acts as a barrier because the majority of these facilities are not designed to meet their specific needs (e.g., trauma-informed care, mentoring relationships, child reunification re-entry services, gynaecological services, motherhood training, STD screenings), especially since these differ significantly from the needs of incarcerated men. These gendered differences exist both in type/variety and amount/quantity of need. For women who are incarcerated, prior research indicates women in prisons and jails express greater needs for services than men do (Lattimore & Visher, 2009; Lattimore et al., 2009; Lindquist et al., 2009). Similarly, in a pre- and post-test study of incarcerated individuals entering a jail, men and women were offered an equal number and broad variety of programmes; however, programming predominantly satisfied men, while women perceived programming to be negative as it related to social connectedness, activity level, and emotional feedback (Jackson & Stearns, 1995). Even upon re-entry up to 15 months post-release, Lattimore and Visher's (2009) study indicates that among individuals who participated, men needed about 40–45% of all the post-release services, whereas women needed about 45–50% of all the services post-release. Upon recent reintegration (i.e., up to 30 days post-release) from confinement, the same study by Lattimore and Visher (2009) asked participants to identify their needs among 28 different services. Women had significantly higher needs than men did, selecting 19 of the 28 identified services. Women mostly reported being in need of education, employment, a mentor, a driver's licence, access to clothing and food, and childcare services (Lattimore & Visher, 2009). Among men, the levels of expressed need are highest for education, job training, and employment, followed by the need for various transitional and health-related

services (Lattimore & Visher, 2009). This indicates both the number of needs and the variety of needs differ between justice-involved men and women.

Despite trying to provide equal treatment to incarcerated men and women, women experience fewer benefits because of the gendered nature of carceral environments which are not specifically designed with them in mind, including the programming that is provided to them. Flawed architectural design, meaning facilities are inadequately built, primarily by men, to fit the services women need due to lack of space and due to inconvenient layouts, makes transporting women to and from services exceedingly difficult. Although correctional programmes are on the rise, the disconnection in access to these resources is gendered at its core which is based on the inconsiderate spatial layout of correctional institutions—in both transportational terms of access to programmes and in the creation of living quarters that lack multipurpose functions—in that it is not specific to the needs of women occupying the same space that is inherently designed for men residents. In this way, resources are not situated within institutional walls in locales that are convenient, or even accessible, for women to utilize on a daily basis. The decisions made about space, design, and layout of correctional institutions often prioritize safety and security rather than rehabilitation, which reinforces the message that carceral stakeholders devote sparse effort to a consideration of women's needs. Institutional design is meant to provide the necessary infrastructure for programming, but gendered organizational logic (Britton, 1997)—or the gender-neutral approach—neglects to plan for the provision of treatment specifically appropriate for women (e.g., trauma-informed care, mentoring relationships, child reunification re-entry services, gynaecological services, motherhood training, STD screenings). This directly contributes to an inequitable experience for women because the experiences of men are at the forefront. Consequently, if the basic needs which are not met outside cannot be satisfied within a correctional institution because of inconvenience and inaccessibility—or are simply non-existent, women will fail to meet the critical threshold for stability that assists in keeping them out of the system.

Gendered inconsiderations of carceral design disadvantage women in the struggle to meet their needs, while these needs may overlap with

men's, relating in type of need—with some exceptions, they do not always overlap in terms of the magnitude of need. For instance, 80–90% of incarcerated women have substance use problems (Belknap, 2007; Fazel et al., 2006) and 73% have a mental health disorder, which is a rate three to five times higher than both the general population and incarcerated men (Drapalski et al., 2009; Hills et al., 2004; James & Glaze, 2006). More specifically, incarcerated women report higher levels of depression and anxiety than incarcerated men, even when controlling for potential confounders (Lindquist, 2000). Overall, women who use substances often endure comparatively more emotional distress, psychosomatic symptoms, depression, and self-esteem issues than men (De Leon & Jainchill, 1982; Falkin et al., 1994; McClellan et al., 1997; Ransom et al., 1996). Furthermore, 80–90% of incarcerated women experience some form of abuse (i.e., physical or sexual) as either children or adults (Covington & Bloom, 2003; Miller & Najavits, 2012; Women in Prison Project, 2008). This makes them three times more likely to incur victimization throughout their lives compared to incarcerated men (Belknap, 2007; Belknap & Holsinger, 2006; Covington & Bloom, 2003; Greenfeld & Snell, 1999; Pollock, 2002). These staggering numbers have remained steady over the last few decades, and as this chapter will highlight, design malfunctions of correctional institutions negate the possibility for women to obtain necessary resources to remedy their disparate issues compared to men. As a result, unmet needs (e.g., substance use treatment, access to feminine hygiene products, nutritious food during pregnancy, sufficient amounts of exercise) lead to higher rates of recidivism among women jail residents (Salina et al., 2004), ranging from as low as 40% (Langan & Levin, 2002) to upwards of 52% (Greenfeld & Snell, 1999). Thus, inconsideration for gender-specific design elements within correctional institutions acts as a barrier to resource connection and a catalyst for returning to the CJS.

This chapter will dissect how the space, layout, and design of one jail in the U.S. shapes its practices and procedures meant to guide the daily routines of women living in one unit, across three blocks. More specifically, it will detail the gendered oversight in ensuring the needs of women are met in congruence with the needs of men in an equitable manner. Granted, carceral space "is a physical manifestation of society's

goals and approaches for dealing with arrested and/or convicted men and women, and it is a stage for acting out plans and programmes" meant to address their future livelihoods (Wener, 2012, p. 7); but, these goals are usually security-oriented in nature rather than rehabilitative and the approaches are often gendered upon manifestation in a patriarchal society, particularly within America.

Literature Review

There is a niche of research on how institutional design impacts the experiences of incarcerated individuals within a carceral space (Jewkes, 2018). Previous studies which have examined carceral design have primarily focused on the following types of spaces and the activities that occur within it: bed space (Mitchelson, 2014), safety (Morin, 2013), flirtation space (De Dardel, 2013), visitation spaces (Moran, 2013), health care spaces (Stoller, 2003), green space (Moran et al., 2020), sport space (Norman & Andrews, 2019), and personal space (Sibley & van Hoven, 2009). Then there is solitary confinement, also referred to as restricted housing, the "SHU," the "hole," among other names, which is a research niche in and of itself. The layout of these confinement spaces produces varied, but important, influence on the daily lives of incarcerated individuals that reside within them.

As a secondary layer of examination, and one that is quite sparse within this niche, is the body of carceral space research focused on populations of justice-involved women (Carp & Davis, 1989; Jewkes et al., 2019; Moyer, 1984; Pallot et al., 2012; Stoller, 2003), especially focusing on their specific needs such as trauma-informed care (Jewkes et al., 2019) and increased health care services (Stoller, 2003). Generally, it is known that women are often confined in women's facilities that are much farther away, geographically, from their homes than men, simply due to the smaller proportion of incarcerated women, but also the smaller number of institutions with which to house them (Jewkes et al., 2019). The facilities themselves are also often physically different in terms of appearance compared to men's facilities in that women's institutions resemble other types of spaces (e.g., farmhouses, college campuses, hospitals, castles,

hotels) (Moyer, 1984). Within this literature base, a gendered lens has yet to be used to offer a feminist-based theoretical approach to carceral space, to present a women-centred institutional layout within custodial facilities, and/or to propose practical and updated gender-specific applications to correctional institutions regarding design.

To begin, acknowledging how institutions' designs, distributions of space, and neglectful layouts are structural barriers (i.e., physical and systematic) for the residents inside them is crucial. A structural barrier is an obstacle or hurdle that makes it exceedingly difficult, either physically or through system navigation to access something such as resources, services, and programmes. Structural barriers may include the jail's policies and practices, financial instability, security-level classification, layout and design of the jail, lack of physical space, limited programming options, and relying on others to gain access to resources, among others. The engrained disregard for the experiences of women in designing correctional facilities stems from the patriarchal society from which it is derived. When women are left out of organizational conversations and submissively positioned from a patriarchal lens (i.e., oppressed), their needs are more often ignored. In this way, even when a distinctly different society is produced inside correctional facility walls (Sykes, 1958), it will sustain male-dominated ideals. Jails are male-dominated—both in terms of staff and residents (Morash et al., 1998). This is primarily because throughout carceral history, men primarily design, build, and operate these institutions (Jessie, 2019). Thus, they are male-centred at their core, meaning women are often oppressed within them. In this way, the carceral space reflects the patriarchal system from which it was extracted outside institutional walls because the same power structures are maintained (Chesney-Lind, 2006). Overall, these barriers result in women jail residents leaving the CJS with the same needs that they had upon entering, while potentially experiencing additional harm in between (Green et al., 2005).

Privacy

Due to the fact that almost all incarcerated women experience some form of abuse (i.e., physical or sexual) throughout their lifetimes (Covington & Bloom, 2003; Women in Prison Project, 2008), it is not surprising that a deep-seated desire to obtain a sense of safety is a top priority among women; this necessity may be obtained through increased privacy in carceral spaces. Comparatively, women are more likely to incur victimization than incarcerated men (Belknap, 2007; Belknap & Holsinger, 2006; Covington & Bloom, 2003; Greenfeld & Snell, 1999; Pollock, 2002), thus the need for increased privacy is exponentially greater for women. In this way, a need to secure a custodial environment that is protected from potential harm, and future victimization, is important for women who are confined. It has become increasingly clear that young women face a "sexual abuse-to-prison pipeline" (Saar et al., 2015). In order to guard oneself from the likelihood of being victimized, an establishment of privacy in carceral spaces is necessary, especially in one's cell, the bathroom, and programming spaces; however, this is often an insurmountable objective. Women are often exposed to the gaze of correctional staff and while this coincides with the goal of establishing and maintaining safety and security, women may have more concerns related to privacy than men. The inherent design of a prison or jail that makes monitoring bathrooms, including the showers, necessary for correctional officers is one design aspect rooted in a security-based mindset which is inattentive to the majority of women who enter the jail with trauma histories who have heightened self-awareness and desperately desire privacy. This lack of privacy not only makes daily confinement tasks cumbersome, but also produces emotional distress among women (Crewe et al., 2017). In this way, the need to ensure the right to privacy for women during confinement is essential.

Overcrowding

Overcrowding is not an uncommon problem in correctional institutions, as evidenced by the rise in correctional populations since the 1990s. On

any given day, one out of 109 U.S. women are under some form of correctional supervision (Holtfreter & Morash, 2003). More specifically, 15% of those women are incarcerated in prisons or jails (Holtfreter & Morash, 2003). However, as a well-known strain of incarceration, overcrowding is inherently linked to increased victimization such as assault due to lack of space (Gaes & McGuire, 1985; Lahm, 2008; McCorkle et al., 1995; St. John et al., 2019). It has also been linked to an increased risk of suicide among women (Sharkey, 2010). Yet, solutions to overcrowding are situated in a spatial argument. When there is more physical space available in an institution, there is increased room to house carceral residents and overcrowding is diminished. As a result, the likelihood of victimization to be significantly decreased is possible (St. John et al., 2019). Given that women are victimized at higher rates throughout their lifetimes, trauma resources are increasingly necessary, and thwarting overcrowding is paramount. For instance, nearly 57% of women have severe physical and/or sexual abuse histories in their lifetimes prior to entrance into the system (Enders et al., 2005; The Sentencing Project, 2007), 25% of which are abused before the age of 18 (Finkelhor et al., 1990). This means women are likely to experience victimization more frequently throughout their lives than men, at a rate that is three-fold (Belknap, 2007; Belknap & Holsinger, 2006; Covington & Bloom, 2003; Greenfeld & Snell, 1999; Pollock, 2002). Yet, trauma services are not widely available for women even though there is some evidence to suggest such treatment produces successful outcomes for women with histories of trauma (Morrissey et al., 2005).

Programming

When it comes to correctional programming, matching the treatment to the individual is crucial. This is primarily because in using a gendered lens to examine programming, it is important to understand that "treating people the same is not equal treatment if they are not the same" (Tannen, 1992, p. 4). It is not equitable treatment if the populations that exist to receive such programming are inherently different. Additionally, male-specific treatment programmes are not appropriate

for women and often result in negative outcomes due to gendered differences that are not accounted for in the development of these programmes (Messina et al., 2006; Pelissier et al., 2003). There is a fundamental problem in evaluation research which tests the effectiveness of programming almost solely with populations of men (Acoca, 1998). Until the last two decades, new developments in correctional programming have been intended for and evaluated on male populations almost solely (Belknap, 2015; Dowden & Andrews, 1999). Thus, from a historical perspective, correctional programming is not gender-specific to women's needs (Hills et al., 2004) because using men's experiences has become the standard (Belknap, 2015); as a result, women often receive minimal services compared to men (Teplin et al., 1996). For example, it has been argued that the comparably small number of women in jail makes the individual cost per woman too high to provide them with the services they need, particularly mental health services (Feinman, 1994). Women suffer from an equal treatment model because a gender-neutral mask means the women's status is ultimately measured against a dominantly male norm (Daly & Chesney-Lind, 1988; MacKinnon, 1991; Nagel & Johnson, 1994). To steer clear of a one size fits all approach that is inherently patriarchal, or male-centred, a further examination of correctional programming is needed to ensure they overlap with the specific needs of women (Rafter, 1990). Equitable treatment for men and women does not necessarily mean identical treatment, services, and/or programming. A more targeted and understanding approach to services and programming that takes into consideration the gender-related life circumstances of women (Morash et al., 1998) will indicate a need for different treatment components based on gender in order for more successful outcomes to be realized (Messina et al., 2006; Pelissier et al., 2003; Staton-Tindall et al., 2007).

Women-Specific Treatment

In order to implement effective programming, more work is necessary to understand how women's needs can be met most successfully. Prior

literature suggests interventions which focus on trauma using a cognitive behavioural approach have the largest effects (Tripodi et al., 2011). This includes training staff to be cognizant of trauma's impact, while also trying to minimize the extent of retraumatization (Miller & Najavits, 2012). Specifically, this means using an "empowerment" model to help women gain their own sense of independence (Koons et al., 1997) and using a women-focused case management model specific to addressing their needs (Orbis Partners, 2006). To do so, targeting several needs at once, while also providing a gender-inclusive environment that promotes well-being generally is important. Scholars posit that greater staff sensitivity to women by hiring additional women staff (Koons et al., 1997; Morash et al., 1998) and including programme staff who were previous substance users and previously justice-involved (Koons et al., 1997) helps to facilitate an institution that bolsters care that is imperative for women in need. In addition, there is a necessity to implement individualized treatment plans for women (Covington et al., 2004) and any correctional programming should use women-only groups (Covington et al., 2004). The programme implementation elements that are most beneficial to women consider the texture of their lives by actually taking into account the individual circumstances of women for treatment purposes and individuals that work with women must be understanding, but also inspiring.

Physical Health Needs

Ironically, jail staff often indicate that the only way that women can get their needs met, such as shelter, food, medication, and counselling, is by being incarcerated (Belknap et al., 2016). Incarceration further allows women to escape domestic violence, drug abuse, sex work, homelessness, and engagement in criminal activities (Blackburn et al., 2008; Bui & Morash, 2010). For instance, 5–6% of residents come into correctional facilities, pregnant due to inconsistent birth control usage and unplanned pregnancies that stem from lack of adequate knowledge about birthing, prenatal nutrition, and parenting (Bloom et al., 2003; Clarke et al., 2006; Greenfeld & Snell, 1999; Koons et al., 1997; Mumola, 2000;

Powell & Nolan, 2003). As such, an issue which is specific to women is the role of motherhood, which is often directly related to the patriarchal society that would suggest women are the primary responsible party for taking care of children. According to some research, roughly 70% of incarcerated women are mothers, and are the primary caretakers of their children prior to being incarcerated (Glaze & Maruschak, 2008; Greenfeld & Snell, 1999; Mumola, 2000; Phillips & Harm, 1998). This means offering education surrounding STDs and confidential testing (Singer et al., 1995) and appropriate gynaecological services and screenings (Carp & Davis, 1989; Lindquist & Lindquist, 1999; Singer et al., 1995) are a specific necessity of women that correctional institutions should offer. Further, this includes an added need of ensuring privacy in rooms where these services take place (Carp & Davis, 1989).

Women who are victims of abuse are twice as likely to need medical attention (Koss et al., 1991). As a result, incarcerated women have significantly more health concerns like diseases, illnesses, and injuries than incarcerated men (Bloom et al., 2003; Langan & Pelissier, 2001; Maruschak & Beck, 2001), which puts them at a distinct disadvantage in an environment which is deprived in nature. Generally, women experience health issues such as asthma, diabetes, hypertension, chronic poor nutrition, anaemia, hypertension, obesity, STDs, diabetes, tuberculosis, and dental problems (Langan & Pelissier, 2001; Richie, 2001). Even though women are more likely to use health-related services during incarceration, they still leave the system with unmet medical needs which constrain their ability to reintegrate into society successfully (Bloom et al., 2003; Richie, 2001). Women are required to pay exuberant fees for in-house services, most typically for health care (Acoca, 1998), which burdens indigent women who cannot afford to leave the system with an excessive bill post-release. Moreover, women report more difficulty in accessing health services while incarcerated, but also in the community (Lindquist & Lindquist, 1999). Though women and men's general symptomology are quite similar (e.g., exhaustion, stiff/achy, joints, backaches, skin rash), incarcerated women tend to have additional symptoms simultaneously (Lindquist & Lindquist, 1999). With the existence of more prior health conditions in combination with overcrowding and victimization within correctional institutions, the symptoms among already

disadvantaged populations of women are only exacerbated; this indicates a need to implement gender-specific services designed to prevent or treat disorders particularly salient to women, and that stem from trauma primarily (Lindquist & Lindquist, 1999).

Mental Health & Substance Use Needs

There are often economic, social, cultural, and health-related issues to combat before gender-specific programming can be ensured. The other issue stems from the sameness approach, which often fails to translate programmes designed for men into programmes appropriate for women. Since women's mental health disorders primarily stem from past trauma, their mental health needs exceed their counterparts. Over 15% of individuals entering the CJS are in need of mental health services; however, women's mental health needs are twice that of men's (Magaletta et al., 2009). In addition, only 15–23% of incarcerated women receive the necessary medication for their mental health disorders (Greenfeld & Snell, 1999; Snell & Morton, 1991) denoting a lack of access. Further, prior victimization was found to put women at a greater likelihood to need both inpatient and outpatient psychiatric treatment than non-victimized women (Bergman & Brisman, 1991). Similarly, women with histories of abuse have a greater likelihood of turning to substances to deal with their trauma (Fedock & Covington, 2017; Owen, 2005). Yet, only about 25% of women obtain access to substance use treatment (General Accounting Office, 1999) and as a result, are forced to detox inside jails. Upon release, women with untreated substance use problems often have a difficult time finding a positive social network of people who do not use any substances (Salina et al., 2011), and thus they frequently return to the same environment(s) where they began using drugs (Richie, 2001; Salina et al., 2011; Schilling et al., 1991). In this way, programming does not take into consideration the influences of gender on mental health or substance abuse, resulting in the neglect of social and cultural impacts on women's behaviour. Therefore, mental health and substance use resources offered to women must be steeped in the social inequalities that texture their lives specifically (Pollack, 2005).

Lastly, typical correctional programming focuses on addressing only one problem, while ignoring the severity or intensity of others (Ritter et al., 2000). As noted above, women have a hard time accessing mental health disorder and substance use disorder treatments while incarcerated, as simply independent issues (General Accounting Office, 1999; Greenfeld & Snell, 1999; Snell & Morton, 1991). However, scholars note that by treating the singular issue, it may complicate trying to treat other conditions or disorders that women may have simultaneously (Teplin et al., 1996). For instance, women who have co-occurring disorders might receive necessary resources for their substance use disorder, but because programming often does not target both disorders at once, their mental health disorder is still neglected in terms of obtaining the appropriate services needed to address both and their mental health symptomology may be exacerbated. Women with co-occurring disorders are at an even greater risk of recidivism due to the inability of treatment services to target both needs simultaneously (Abram & Teplin, 1991). Therefore, research suggests that the needs of women are often not met in correctional settings due to their disproportionate needs, especially because incarcerated women have higher rates of co-occurring disorders than incarcerated men (James & Glaze, 2006; Zlotnick et al., 2008), and they most often stem from their trauma histories (Salina et al., 2007).

Moving forward, it is important to understand the population presented in the case study below. To start, while there is considerable literature on justice-involved men, and some topics discussed in the case study below may overlap, the primary focus of this piece is on women incarcerated in jail specifically. In addition, the existing literature on men mostly pertains to prisons, rather than jails. Furthermore, the disproportionate disadvantages laid out previously suggest that it would be difficult to compare these two populations because they significantly differ. As it relates, the various demographics of women in the case study differ by age, security level, and race, but the only salient difference in interview responses discussed by the women was a systematic issue, security level. That means that security level was the defining factor in differential experiences discussed by women, rather than other key demographics such as race or age. Also, for sake of confidentiality, women were not asked about their sexual orientations and so while some women presented in

the case study may identify as part of the LGBTQ+ community, and some did, based on interviews with them, no specific differences based on this identity were asked about or came about organically in discussions with women. Therefore, the following case study will highlight incarcerated women more broadly as a group, rather than by distinct identities or demographics, and illuminate the varied experiences of women classified under different security levels.

Case Study

This case study examines the spatial necessity to fulfil incarcerated women's needs during confinement through personal, qualitative interviews. Through this examination, the design elements of one correctional facility will be dissected into *programming space*, *private space*, and *security space*. Before now, few previous studies have detailed the important types of carceral spaces that exist and the variety of activities that occur within them (see above); but even less so, the extent of the literature that understands which spaces are inhabited and utilized by incarcerated women in particular is scant. Further, this case study will breakdown the purposes of the spaces and the design issues that emerge for women living within a jail.

Furthermore, it is important to investigate how women jail residents' needs may vary by security level (i.e., high, medium, low), a common structural barrier. The reason for examining this difference is due to high security jail residents in the institution of study being housed in a relatively confined space (see Fig. 20.1) and therefore receiving limited access to programming. Therefore, it is important to understand whether this particular group has their needs adequately met in comparison to lower security-level women housed in a much larger space in the same unit, but in a different block.

The following research questions guided this case study: (1) do the characteristics of the built environment "work" for the intended (or unanticipated) purpose in which planners and designers curated?; and (2) what characteristics of the built environment "work" well (or not) for women who are incarcerated?

Methodology

The study site is a jail in the U.S. containing over 1,000 incarcerated individuals. There is one women's unit in the jail including one programming dorm, one general population dorm, two smaller high security dorms, and one smaller medical/psychiatric dorm. There was a total of 104 women held in custody at the time of the study. This case study includes 29 women (28% of the women jail resident population). In terms of security level, 74% of the women in the entire jail are classified as low, 7% are medium, and 19% are high security. The breakdown in this study's sample is roughly the same: 76% low ($n = 22$); 10% medium ($n = 3$); and 14% high security women ($n = 4$). However, there is another layer of security level to consider; of the 76% low security-level women, 14% of them were considered "trustees" at the time of the interview, while an additional 14% had previously been a trustee before. Trustees are considered the lowest security level in the jail because they are entitled to insider worker duties (e.g., laundry).

The race/ethnicity breakdown of incarcerated women in the jail population is predominantly White (57%), followed by Black (30%), and a minority of other races/ethnicities such as Asian, Latinx/Hispanic, or mixed race (13%). In the study sample, the women are White (52%), Black (24%), Latinx/Hispanic (14%), and mixed-race (10%). Lastly, a break down by age of the sample indicates that younger women were more often participants of the study than older participants. The sample included nine participants between 20 and 25 (31%), five participants between 26 and 30 (17%), eight participants between 31 and 35 (28%), one participant between 36 and 40 (3%), two participants between 41 and 45 (7%), two participants between 46 and 50 (7%), and two participants between 51 and 55 (7%). However, the jail population is more varied in terms of age, with women between the ages of 18–20 (6%), 20–30 (30%), 30–40 (44%), 40–50 (15%), 50–60 (3%), and 60–70 (2%).

Research Protocol

This study uses qualitative interviews of women who are incarcerated. The strategy used to sample the women jail resident population consisted of recruiting the entire women jail resident population. Since there is a disproportionate number of women in the jail (n~100) compared to men (n~900), all of the women were recruited for an interview (Baker & Edwards, 2012). To ensure a sufficiently large sample was collected to accurately reflect the women jail resident population and obtain a saturation point for the interview topic, a minimum of twenty women was the target goal for a final sample. While there is typically no numerical threshold of interviews necessary for qualitative studies, this number became the target so that roughly 20% of the available population was sampled. While gender-based scholarship necessitates smaller sample sizes due to often "hard-to-reach" populations surrounding "niche" social problems, there is no theoretical saturation point that can be logistically defined by a quantified number of interviews. Within the women's unit, all three blocks were sampled with the purpose being that enough women from various backgrounds and intersecting identities were included in the final sample. By ensuring representativeness of the sample with the jail's population, it assured the complexity of information pertaining to justice-involved women's needs was thoroughly captured—and to do so was aligned with the feminist research approach taken by the researcher for intersectional reasons. Data collection began in June of 2019 and ended in September of 2019. For each data collection visit, I entered the jail and collected information in one dorm of the women's unit. Each day at the jail, I spent two to four hours collecting data. For participant recruitment, I went cell-to-cell or bunk-to-bunk in each dorm that houses women and presented the purpose of the study, while making a record of only those willing to participate. Once completing a participant list over several weeks, an effort to interview everyone who volunteered to participate was undertaken.

Due to short visiting hours at the jail (i.e., four-hour increments), I completed roughly two to three interviews per day. The jail is locked down for count (i.e., when all jail residents must be accounted for by jail staff) and shift changes. The interviewing process took 12 weeks to

complete. I went to the jail two times a week during visitation hours. This included Sunday nights (7:00PM to 10:00PM) and Monday afternoons (12:00PM to 3:00PM). Over the course of this process, there were three days on which I arrived and none of the women on the participant list were available or willing to interview. However, on subsequent days when I went to the jail, these same participants agreed to be interviewed. The only instance in which jail residents on the original list were not interviewed was if the resident was released prior to the interview taking place. The women's programme coordinator suggested that Sunday evenings would be the best time for interviews since no other programmes were happening at the time. However, this meant that the women were often completing homework, doing laundry, hanging out in the dayroom, or using the telephone, all of which often deterred some from wanting to interview.

I interviewed women in every dorm to ensure that those in general population, programming dorms, and high security-level women were all interviewed, if they wished. Once the women verbally consented to the interview, the interviews began and lasted for approximately 25–30 minutes each. This study used a semi-structured interviewing approach to collect data. An interview guide streamlined the process and included the following topics: (1) perceived needs (i.e., pre-incarceration, during incarceration, and post-incarceration); (2) facilitators and barriers to needs; (3) security-level variation in needs; and (4) connections to women officers.

Analysis

This study used a hybrid approach: a deductive protocol and inductive data analysis. There was a need to mould the quantitative and qualitative approaches (i.e., asking both closed and open questions) to match the population in my sample. Jail residents often move in and out of the facility fairly quickly, since they are in a pre-sentencing phase, and thus the protocol could not be extremely lengthy to ensure greater participation rates. Furthermore, asking for participants does not guarantee willing individuals; this was a major barrier experienced on scheduled

data collection days when no participants agreed to partake in an interview. Therefore, making sure the protocol was not labour intensive was crucial. Lastly, it was not believed that a survey would produce the rich information necessary to capture the breadth of women's needs. Having one list their needs is simple, but more complex is having one discuss their unmet needs in relation to the overall incarceration experience. Thus, the protocol was more of a face-to-face survey with room for growth and extension. Therefore, the protocol was not a fully grounded approach, nor semi-grounded, because upon entering the field, I had a focus on the needs of women in jail and a hypothesis that needs may be influenced by security level.

The interview protocol I used was semi-structured in nature in that the topics were laid out prior to interviewing, but there were no limits to conversation. I used this hybrid method in order to remain as open as possible to what the women had to say, regardless of my topic of interest. This approach allowed for the use of the constant comparative method; as data collection continued and data analysis began, topics and ideas took new form in the semi-structured interview protocol (Glaser, 1965). I took detailed notes during the interviews with women, as the jail did not permit recording devices. Per previously successful ethnographic methods (Emerson, 2001; Emerson et al., 2011; Morrill, 1995), increasingly detailed notes were typed out immediately following the interviews. These notes were then transcribed and entered into Atlas.ti (8), a qualitative data management software, for coding and analysis (Muhr, 1991). During analysis, a line-by-line coding method was used in order to assign a specific code to each line of interview notes (Charmaz, 2006).

The coding process occurred in three parts, beginning with the development of an initial coding list that was revised over time as the constant comparative method was utilized and the grounded theory approach considered. The initial code list contained: (1) jail residents' needs (i.e., before, during, and after incarceration); (2) facilitators and barriers to needs being met; (3) met versus unmet needs; and (4) security-level variation in needs. In the second round of coding, the nuances of needs that women jail residents discussed were parsed out by security-level. The

third and final round of coding revealed the barriers and facilitators of women's needs and compared which of those were met and unmet.

Findings

In this case study presented of one jail, even with an expansion in progress, the strategic plans for placement of carceral residents are gendered. For every nine men, there is one woman and thus the space allotted to women for living quarters, programming classrooms, and medical services is significantly smaller than that allocated to men. While logically consistent with the expansive literature that denotes men significantly outnumber women in carceral settings, this disproportionality has subsequent consequences that are inherently negative for women. The programming and services offered and accessible to incarcerated women are not sufficient to meet their varied needs. Lastly, the security levels of the women subject them to overcrowded blocks that reduce their privacy and potentially increase their likelihood of victimization. There is a need to address the inequality in the jail related to its priorities in serving its residents who are men, over those who are women. So frequently stated by women, "this jail is for men" became a motto among the women jail residents.

Space, Design, & Layout

One size fits all programming does not suffice for women given that their needs are significantly different from men, in kind and proportion. For this particular case study, the jail study sought out a variety of programming for both men and women. Women are offered classes pertaining to motherhood, trauma, and shoplifting, while the men are offered fatherhood, employment certifications, life skills, and anger management. This does not mean that women would not benefit from employment certifications, life skills, or anger management, but there is simply not enough room on the one floor of the jail, within one unit, that has only three blocks inside of it to hold each of these programmes for women. It is

also purported in the literature that women are typically only offered correctional programmes that match their stereotypical gender roles of being "housewives" or "stay-at-home moms," which means vocational trainings are not offered to women as often (Moyer, 1984). The differences in focus area and sheer quantity of programming offered to jail residents indicate a mismatch between the severity and the magnitude of needs that women have in comparison to men; the focus is instead on serving the population with the greatest numbers simply due to space. Women's needs span further than the intended programming can cover. While women are offered programming for mental health, substance use, and re-entry services, they lack access to the means to obtain a high school education and to increase their employable skills via certifications—two opportunities afforded to men. For instance, 34% of women in the sample expressed a need to obtain their GED but indicated that no such programme existed in the jail. Therefore, there is a clear issue with *programming space* in that there is a spatial difference between what men have access to and what women need access to; this mismatch contextualizes the issue of programming potential, but underwhelming success for women.

In the jail selected for study, over 400 hours of programming takes place each month between men and women. The most common programmes among the women include substance dorm, FREE dorm (i.e., religious-focused), LIFT programme (i.e., mental health-focused), and trustee (i.e., inside workers). Women in this case study participated in several of the most popular programmes in the jail which often have wait lists for women to enrol because of classroom size or programming dorm space (i.e., not enough housing cells in dorms). More specifically, seven women are/were participants in the substance dorm, eight are/were trustee members, six are/were participants in the LIFT programme, and 12 are/were living in the FREE dorm. The need for wait lists for programming was due to the utter lack of space in the jail within the women's unit for women to participate—a structural barrier barring access to resources that meet women's needs. Most women attributed this to the fact that, as Lily puts it, "Jail is a male world; they get more space and there is more of them." This is due to the fact that

men and women do not participate in programmes together, as the residents are physically separated by floor levels (i.e., women on one floor and men on the other floors). As such, their programming space is encapsulated within their residential space, so they cannot participate together physically speaking nor according to jail policy. Therefore, women have sufficiently less space; the problem is that the space is inadequate to fulfil their needs. However, it is important to note that several women who could participate indicated the growth they experienced after having completed a programme; more specifically, after completing the FREE dorm, Rebecca said, "I really feel peaceful; this programme has helped me immensely." This suggests that there is a dire need for women to engage in programming because it has a positive impact on women's lives and has the potential to tear down other barriers which make it harder to have their needs met—there needs to be space allotted to accomplish this though.

There were several unmet needs that women personally experienced during incarceration. These were more readily discussed during the interviews: education/GED (14%); medical services (7%); mental health treatment (7%); food/nutrition (7%); recreation (7%), and more. There is a necessary balance—a threshold for maintaining stability—between the needs which should be met in jail and other needs which simply cannot be met inside facility walls, but it does not appear that women in this particular jail are meeting the minimum standard of care. For instance, in this sample of 29 women, over 20% of the women had not completed a single programme.[2] The other 26 women in the study had completed or were enrolled in at least one programme (38%), two programmes (42%), or even three or more programmes (7%). The reason for this discrepancy is inequitable access to programming based on security level; five of the six women who had not completed a programme in this sample were high security-level women. However, there was frustration surrounding this classification and subsequent inequality. As stated by Olivia, "If I could programme from the time I woke up until the time I go to sleep, I would;" yet, this is not plausible, and it is not for lack

[2] Only one woman was low security-level among this group of women who had not completed a programme; the rest were high security-level women.

of effort. Women shared stories of attempting to enrol in programmes at the jail but illuminated how certain structural barriers (e.g., designed isolation based on security-level, inability to maintain "keep separates,"[3] lacking space for shorter sentence/unsentenced women to participate) barred their access.

Even when low security-level women weighed in on whether they believed medium and high security-level women had their needs met, the answer was overwhelmingly "no." Of the women in this sample, 49% indicated that higher security-level women's needs were not met for a variety of reasons. In fact, Jacqueline was quick to say that high security-level jail residents, "don't have access to what they need; they're stuck on the block all the time." Thus, as Diane puts it, the concept of high security-level is "just a housing system," instead of a place to receive services or participate in programming. This housing system is what blocks women's opportunities to get their needs met for 23 hours a day, when they are locked down in their blocks (see Fig. 20.1). The high security-level women asked if they could have programmes brought into their blocks so as to reduce the issue of not being able to leave for security reasons (i.e., 23 hours a day/7 days a week lockdown), and this request was denied. By having a programme take place in a common space, one that is no larger than a 10' by 10' room, means there is not a distinct choice for those in the block to choose to do something else if they do not wish to participate in the programme—and programming is a voluntary resource. Yet, given that there were only a handful of medium and high security-level women interviewed ($n = 7$), the number of needs they report is quite high during incarceration (i.e., 14 for medium security women and 12 for high security women), rather than before or after incarceration. The problematic nature of this need gap is best stated by Missy, "I just feel trapped," became the overarching theme about how medium and high security-level women feel inside jail—their experiences represent what it feels like to be caged in a cell no larger than 5' by 8' almost all day, every single day. As indicated by Judy and four other women, "They're not getting needs met because they don't have access."

[3] To designate residents as "keep separates" means to classify two women as needing to be kept away, physically, from one another due to various reasons such as being co-defendants, being in a relationship, or having been in an verbal argument or physical altercation.

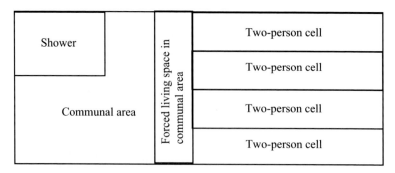

Fig. 20.1 High security-level women's block layout

There was an attitude of unfairness expressed by high security women regarding jail policies related to access based on security levels. In trying to understand unequal access based on security-level, Becky asked, "Why do lows get what they need and they're about to get out and that stuffs on the outside too?" In another sense, there was irritation expressed in that sentencing requirements could not be met because of jail policies; Karen explained, "We can't even do court-ordered programmes if we're in orange[4] because of the jail's policy." The structure of this institution is thus preventing a particular class of jail residents from getting their needs met.

As such, there were also several issues with *personal space* as well, due to overcrowding in the high security-level blocks. For instance, women on high-security status are subject to blocks that house women in the common area because of tight living quarters. That means the women sleeping in the spaces meant for everyone are forced to function on the schedules of all the other women in the block who choose to use the space when they desire, despite the women who have to sleep there. This is an issue of "private space" where some women, due to lack of space, are not offered a sense of privacy—what little privacy they have in jail. An added barrier arises, where women residents are not allowed to hug one another because the camera angles in the cell blocks obstruct the views

[4] In the jail of study, jail residents wear orange if they are considered high security-level.

of all the women at one time due to the restrictive design of the residential spaces and correctional staff cannot verify whether or not nefarious activity is occurring; therefore, anytime an officer sees women hugging in higher security-level blocks, they are written up for "horse play" as a continuous means to try to keep it from happening, but this can add days to women's already longer sentences than women on low security. Patty explained how the need for personal space is key, but when another woman is crying and they clearly need comfort, women do not believe it is fair to be written up for something so petty. Since women tend to be more deeply connected to their cellmates than men (Carp & Davis, 1989), the "grey area" for personal space is one that requires more consideration in the context of designing carceral spaces for women. In this way, there is a fine line between what space in the jail should be used for according to women in this case study, especially in terms of defining what the best use of the spaces should be, how much space is necessary, and how the spaces should be designed or laid out in an optimal way.

Women have a plethora of needs; however, as women seek to access the resources and services needed to appropriately address their needs, they face barriers that make it exponentially harder to do so. The most common barriers are expressed by women of all security levels, but primarily higher security levels, and they are most often related to jail policy surrounding movement inside the jail's space and "keep separates" between women that dictate who can occupy which spaces at what times for security reasons. This highlights an issue of *security space*. One high security woman, Lorraine, explained examples of keep separates, "I have a co-defendant, or if you feel uncomfortable around someone, or you get in a fight," but in justifying her need for access, explained that "We need programmes too, even if they just made a schedule that was like every other day for us so "keep separates" aren't together." The jail's policies about "keep separates" systematically denies equal access to programmes to certain women jail residents because there simply is not enough space for everyone to participate if women are not allowed to be in the same location simultaneously; this issue is most likely not as problematic for the incarcerated men spread across several floors of the jail. Further, the jail's layout is not able to accommodate the transportation of women to and from programmes without potentially causing a security issue

between women who are deemed to engage in conflict upon contact; therefore, all of them lose access to services in the jail in order to be fair, even if it appears unfair to the women.

The same barriers were also issues for low security-level women as well, denoting the gravity of the situation in that the jail's design and layout impacts all of the roughly 100 women in the jail who need resources. An over-surveillance of women in a predominantly male space, women must be escorted to various resources (e.g., medical department, recreation space) in the jail while men have the power to walk freely within it, so long as they are classified as low-security. During this process, all "traffic" or "transports" of men in the jail are required to halt so that women can move about the jail. Due to this, a number of women explained their failed attempts to access the medical department (31%). While 24% of women in the sample indicated a need for exercise, they also discussed their lack of access to recreation when the weather is poor (14%). Women are allowed to use the outside recreation space when it is not raining; but if it rains, they are usually transported to the inside recreation space, otherwise identified as the gymnasium. However, since men are allowed to use the gym throughout the day during their free time, women are often declined access to the gymnasium for reasons unbeknownst to them, but that they assume is because "it's a men's jail." This was frustrating to several women because residents insisted that they are supposed to be able to obtain access to the inside gymnasium in lieu of the outside yard when it rains, but this rarely, if ever, occurs. The two main spaces that women typically need to access most—the medical department which the above studies suggest women need to access more often than incarcerated men and the gymnasium that they are supposed to be able to use on a daily basis for up to an hour—are often inaccessible because of where they are located in the jail. This illustrates that the layout and design of the jail does not match its policies in that women are unable or extremely limited in their ability to access what they need in jail but are supposed to have access to, and this is increasingly problematic for women with the greatest needs.

Conclusion

In sum, spatial barriers, design impracticalities, and layout inattentiveness are limiting the potential of justice-involved women to have their needs addressed. Specifically, there is not enough space in correctional institutions, and what does exist is poorly designed or laid out in an inconvenient manner. To fit the services necessary for women or the facilities' procedural expectations, more thought has to be put into gender-specific correctional designs. The spatial make-up of correctional institutions can either be a catalyst for more harm or a potential reform effort. This case study has detailed why limited space is problematic. By maximizing space in carceral spaces for women in particular, countless benefits for reducing their justice involvement are possible. However, simply increasing the space is not enough, because designing it in a way that ensures the layout is feasible, practical, and suitable for women's needs takes a newfound effort that has yet to be allocated for this particular issue.

Practical Implications

The space, design, and layout of institutions acts as a structural barrier that effectively limits the ability to meet the needs of women residents through resources and services. Given that women only live on one floor of the jail in this particular case study, there is not enough physical space to hold adequate programming in the jail for women, nor was the initial design or layout created with women in mind. By increasing the amount of space in a jail, more programmes and services can operate to adequately address women's needs such as those pertaining to gynaecological care, trauma services, and more. To do so well would mean not only offering more space, but ensuring that the women's floor has all the appropriate outlets to needed resources: offering a separate corridor that leads outside to recreation that men cannot access so jail "traffic" does not have to stop during transport; allowing women to walk across the hall to medical services as long as they buzz in at both entrances for security reasons; offering video visitation to all security

levels of women; utilizing the unfilled solitary confinement space in the women's unit for higher security-level women currently sleeping in common areas of their blocks; designating space for programming in higher security-level blocks at certain hours of the day; and creating a separate hallway that runs parallel to the only hallway that exists in the women's unit to decrease "keep separate" safety issues. These solutions would reduce overcrowding in higher security-level blocks, improve the privacy within women's personal spaces, reduce potential victimization of women with "keep separates," and improve the convenience and security measures for transporting women to necessary resources. While there is currently a design flaw in correctional institutions that is inherently situated in the patriarchal structure of our society, this case study has implications for future criminal justice actors such as jail administration, carceral architects, and justice practitioners with expertise in correctional programming, who can use this jail as an example for new, or evolving, carceral spaces. In future plans, there should be a special niche carved out in blueprint designs that specifically seeks to meet the unique needs of its women residents, or at the very least, a plan that keeps them in mind. This may include having a previously incarcerated woman on the planning team to provide important lived experience in recommendations for spatial necessity, layout concerns, and design elements specific for women's institutions (Jewkes et al., 2019). First, however, there must be a change in correctional culture by more actively trying to support justice-involved women. To do so would mean seeking to understand which integral pieces of design ameliorate trauma symptomology within confinement spaces meant for women.

As an added consideration, the security level of women, which is based on behaviour, risk-level, offence type, and other factors, makes a significant difference in the number and variety of programming received. Thus, there is an apparent inequity between security-level groups of women. This arises because of jail policy that focuses less on the needs of women and more on the security of the jail; this leads to a limitation in accessible space which sends a message to women about what is most important to the jail administration: the safety of staff. Furthermore, when women cannot complete their sentencing requirements (i.e., mandated programmes by a judge) because of this structural barrier, an

internal evaluation of the true goals of the jail is necessary. In addition, even the highest security-level women deserve the necessary resources to be able to meet their needs—in hopes of succeeding once released. Therefore, a shift in jail policy that works to reallocate space and improve layout may be a step in the right direction. In order to accomplish this, programmes specifically targeted at higher security-level women are needed. Given that these women are only allowed out of the block for up to one hour a day, they should have programmes brought to them. Women in such blocks would then have the opportunity to participate given that an instructor would be present in their space, negating the need for them to be transported to an alternative space. If the jail is reluctant to do this based on funding issues for programming, an issue noted in the literature above, visitation is one potentially cost-effective method for offering a service to women but maintaining the safety of the facility (Mears et al., 2012). In the jail of case study, visitation services are not allowed for high security-level women even though visits take place via video conferencing. Instead, women should be allowed out of their high security-level blocks, to walk across the hall to the visiting booth cell to partake in video visitation for the time they are allowed out of their blocks. Inconsideration for certain carceral residents' needs ultimately boils down to institutional values and unsavvy design planning. It is possible to meet the needs of underserved carceral residents by being a little more intentional about the operations of facilities, in terms of service provision, design elements, security-level placement layout, programme offerings, and space allotment.

Future Research

Future research on justice-involved women's needs should narrow the scope to needs that arise during incarceration specifically for translating research into effective institutional policy and practice within corrections. For instance, several extensions of the current study may include: (1) cross-comparison between men and women and their reasons for accessing medical care; (2) gendered perceptions of desired forms of recreation; (3) effectiveness of individual versus group counselling for

women; (4) evaluations of gender-specific programming in meeting the needs of women; (5) experimental examination of the optimal transportation route for accessing services in correctional institutions based on their unique designs, and (6) matched design of high and low security-level women and their daily movements in jail and their perceptions of space.

The inconsiderate nature of penal design results in a vast oversight of the needs of justice-involved women. Consequently, this leaves them with little opportunity to desist from crime. The systemic failure that traps them within carceral walls is due in part to a spatial layout that bars them access from needed resources, which is highlighted in a quote by Paulina, "You lose everything you own—and I only been in jail a month." This produces an unfortunate cycle, where she says, "…you're thrown out on the streets when you get out and you look for fast money because you have no other choice, and you end right back up inside jail." Therefore, it is crucial to take necessary action to ensure that women have basic access to programming that is rehabilitative in nature and gender-specific. One of the key purposes of incarceration is to rehabilitate; but if the carceral environment is not designed to achieve this, then the goal of incarceration is effectively moot (Karthaus et al., 2019). With a more focused approach to tearing down the structural barriers that deny women's needs, the potential to propel women towards a life free of crime and increased rehabilitation is far greater. The only thing standing in the way is a mindset that fails to fully recognize the gendered nuances of criminality and successfully prepare an environment that can adequately care for them.

References

Abram, K. M., & Teplin, L. A. (1991). Co-occurring disorders among mentally ill jail detainees: Implications for public policy. *American Psychologist, 46*(10), 1036–1045. https://doi.org/10.1037/0003-066X.46.10.1036

Acoca, L. (1998). Defusing the time bomb: Understanding and meeting the growing health care needs of incarcerated women in America.

Crime & Delinquency, 44(1), 49–69. https://doi.org/10.1177/0011128798044001005

American Psychiatric Association. (2013). *Diagnostic and statistical manual of mental disorders* (5th ed.). American Psychiatric Association.

Baker, S. E., & Edwards, R. (2012). *How many qualitative interviews is enough? Expert voices and early career reflections on sampling and cases in qualitative research.* National Centre for Research Methods.

Belknap, J. (2007). *The invisible woman: Gender, crime, and justice* (3rd ed.). Wadsworth Publishing.

Belknap, J. (2015). *The invisible woman: Gender, crime and justice* (4th ed). Cengage Learning.

Belknap, J., & Holsinger, K. (2006). The gendered nature of risk factors for delinquency. *Feminist Criminology,* 1(1), 48–71. https://doi.org/10.1177/1557085105282897

Belknap, J., Lynch, S., & DeHart, D. (2016). Jail staff members' views on jailed women's mental health, trauma, offending, rehabilitation, and reentry. *The Prison Journal,* 96(1), 79–101. https://doi.org/10.1177/0032885515605485

Bergman, B., & Brisman, B. (1991). A 5-year follow-up study of 117 battered women. *American Journal of Public Health,* 81(11), 1486–1489. https://doi.org/10.2105/AJPH.81.11.1486

Blackburn, A. G., Mullings, J. L., & Marquart, J. W. (2008). Sexual assault in prison and beyond: Toward an understanding of lifetime sexual assault among incarcerated women. *The Prison Journal,* 88(3), 351–377. https://doi.org/10.1177/0032885508322443

Bloom, B., Owen, B., & Covington, S. (2003). *Gender-responsive strategies: Research, practice, and guiding principles for women offenders* (p. 146). National Institute of Corrections.

Bowker, L. (1981). *Women and crime in America.* Macmillan Publishing Company, Inc.

Britton, D. M. (1997). Gendered organizational logic: Policy and practice in men's and women's prisons. *Gender & Society,* 11(6), 796–818.

Bui, H. N., & Morash, M. (2010). The impact of network relationships, prison experiences, and internal transformation on women's success after prison release. *Journal of Offender Rehabilitation,* 49(1), 1–22. https://doi.org/10.1080/10509670903435381

Carp, S. V., & Davis, J. A. (1989). *Design considerations in the building of women's prisons.* National Institute of Corrections, US Department of Justice.

Carson, E. A., & Anderson, E. (2015). *Prisoners in 2014*. US Department of Justice, Office of Justice Programs, Bureau of Justice Statistics, NCJ, 247282, 2.

Charmaz, K. (2006). *Constructing grounded theory: A practical guide through qualitative analysis*. Sage.

Chesney-Lind, M. (2006). Patriarchy, crime, and justice: Feminist criminology in an era of backlash. *Feminist Criminology, 1*(1), 6–26.

Chesney-Lind, M., & Eliason, M. (2006). From invisible to incorrigible: The demonization of marginalized women and girls: *Crime. Media, Culture*. https://doi.org/10.1177/1741659006061709

Clarke, J. G., Hebert, M. R., Rosengard, C., Rose, J. S., DaSilva, K. M., & Stein, M. D. (2006). Reproductive health care and family planning needs among incarcerated women. *American Journal of Public Health, 96*, 834–839.

Council of State Governments. (2005). *Violence against women with mental illness*. Consensus Project. Justice Center of the Council of State Governments, Washington, DC.

Covington, S., & Bloom, B. (2003). Gendered justice: Women in the criminal justice system. In B. Bloom (Ed.), *Gendered justice: Addressing female offenders* (pp. 1–14). Carolina Academic Press.

Covington, S. S., Bloom, B. E., & Rohnert Park, C. A. (2004, November). Creating gender-responsive services in correctional settings: Context and considerations. In *American society of criminology conference, Nashville, Tennessee*.

Crewe, B., Hulley, S., & Wright, S. (2017). The gendered pains of life imprisonment. *British Journal of Criminology, 57*(6), 1359–1378.

Daly, K. (1992). Women's pathways to felony court: Feminist theories of lawbreaking and problems of representation. *Southern California Review of Law and Women's Studies, 2*, 11–52. https://heinonline.org/HOL/P?h=hein.journals/scws2&i=17

Daly, K., & Chesney-Lind, M. (1988). Feminism and criminology. *Justice Quarterly, 5*(4), 497–538.

De Dardel, J. (2013). Resisting 'bare life': Prisoners' agency in the new prison culture era in Colombia. In D. Moran, N. MGill, & D. Conlon (Eds.), *Carceral spaces: Mobility and agency in imprisonment and migrant detention* (pp. 183–198). Ashgate Press.

De Leon, G., & Jainchill, N. (1982). Male and female drug abusers: Social psychological status two years after treatment in a therapeutic community. *American Journal of Drug and Alcohol Abuse, 9*, 465–497.

Dowden, C., & Andrews, D. A. (1999). What works for female offenders: A meta-analytic review. *Crime & Delinquency, 45*(4), 438–452.

Drapalski, A. L., Youman, K., Stuewig, J., & Tangney, J. (2009). Gender differences in jail inmates' symptoms of mental illness, treatment history and treatment seeking. *Criminal Behaviour and Mental Health, 19*(3), 193–206. https://doi.org/10.1002/cbm.733

Emerson, E. (2001). *Challenging behaviour: Analysis and intervention in people with severe intellectual disabilities*. Cambridge University Press.

Emerson, R. M., Fretz, R. I., & Shaw, L. L. (2011). *Writing ethnographic fieldnotes* (2nd ed.). University of Chicago Press.

Enders, S. R., Paterniti, D. A., & Meyers, F. J. (2005). An approach to develop effective health care decision making for women in prison. *Journal of Palliative Medicine, 8*(2), 432–439. https://doi.org/10.1089/jpm.2005.8.432

Falkin, G., Wellisch, J., Prendergast, M., Kilian, T., Hawke, J., & Natarajan, M. (1994). *Drug treatment for women offenders: A systems perspective*. U.S. Department of Justice.

Fazel, S., Bains, P., & Doll, H. (2006). Substance abuse and dependence in prisoners: A systematic review. *Addiction, 101*(2), 181–191. https://doi.org/10.1111/j.1360-0443.2006.01316.x

Fedock, G., & Covington, S. S. (2017). Correctional programming and gender. In G. Fedock & S. S. Covington (Ed.), *Oxford research encyclopedia of criminology and criminal justice*. Oxford University Press. https://doi.org/10.1093/acrefore/9780190264079.013.89

Feinman, C. (1994). *Women in the criminal justice system*. ABC-CLIO.

Finkelhor, D., Hotaling, G., Lewis, I., & Smith, C. (1990). Sexual abuse in a national survey of adult men and women: Prevalence, characteristics, and risk factors. *Child Abuse & Neglect, 14*, 19–28.

Gaes, G. G., & McGuire, W. J. (1985). Prison violence: The contribution of crowding versus other determinants of prison assault rates. *Journal of Research in Crime and Delinquency, 22*(1), 41–65.

General Accounting Office, U. S. G. G. D. (1999). *Women in prison: Issues and challenges confronting U.S. correctional systems* (United States; Report GGD-00-22). UNT Digital Library; United States. General Accounting Office. https://digital.library.unt.edu/ark:/67531/metadc293932/m1/1/

Glaser, B. G. (1965). The constant comparative method of qualitative analysis. *Social Problems, 12*(4), 436–445.

Glaze, L. E., & Maruschak, L. M. (2008). *Bureau of Justice Statistics special report: Parents in prison and their minor children*. Bureau of Justice Statistics.

Green, B. L., Miranda, J., Daroowalla, A., & Siddique, J. (2005). Trauma exposure, mental health functioning, and program needs of women in jail. *Crime & Delinquency, 51*(1), 133–151. https://doi.org/10.1177/0011128704267477

Greenfeld, L. A., & Snell, T. L. (1999). *Women offenders* (p. 14). Bureau of Justice Statistics. https://www.ncjrs.gov/app/abstractdb/AbstractDBDetails.aspx?id=175688

Hills, H., Sigfried, C., & Ickowitz, A. (2004). *Effective prison mental health services: Guidelines to expand and improve treatment*. Mental Health Law & Policy Faculty Publications. https://nicic.gov/effective-prison-mental-health-services-guidelines-expand-and-improve-treatment

Holtfreter, K., & Morash, M. (2003). The needs of women offenders. *Women & Criminal Justice, 14*(2–3), 137–160. https://doi.org/10.1300/J012v14n02_07

Hubbard, D. J. (2002). *Cognitive-behavioral treatment: An analysis of gender and other responsivity characteristics and their effects on success in offender rehabilitation* (Doctoral dissertation, University of Cincinnati).

Jackson, P. G., & Stearns, C. A. (1995). Gender issues in the new generation jail. *The Prison Journal, 75*(2), 203–221.

James, D. J., & Glaze, L. E. (2006). *Mental health problems of prison and jail inmates: (557002006–001)*. American Psychological Association. https://doi.org/10.1037/e557002006-001

Jessie, B. O. (2019). *On the Patio: Serving time in a women's correctional facility*. Waveland Press.

Jewkes, Y. (2018). Just design: Healthy prisons and the architecture of hope. *Australian & New Zealand Journal of Criminology, 51*(3), 319–338.

Jewkes, Y., Jordan, M., Wright, S., & Bendelow, G. (2019). Designing 'healthy'prisons for women: Incorporating trauma-informed care and practice (TICP) into prison planning and design. *International Journal of Environmental Research and Public Health, 16*(20), 3818.

Karthaus, R., Block, L., & Hu, A. (2019). Redesigning prison: The architecture and ethics of rehabilitation. *The Journal of Architecture, 24*(2), 193–222.

Koons, B. A., Burrow, J. D., Morash, M., & Bynum, T. (1997). Expert and offender perceptions of program elements linked to successful outcomes for incarcerated women. *Crime & Delinquency, 43*(4), 512–532. https://doi.org/10.1177/0011128797043004007

Koss, M. P., Koss, P. G., & Woodruff, W. J. (1991). Deleterious effects of criminal victimization on women's health and medical utilization. *Archives of*

Internal Medicine, 151(2), 342–347. https://doi.org/10.1001/archinte.1991.00400020092019

Lahm, K. F. (2008). Inmate-on-inmate assault: A multilevel examination of prison violence. *Criminal Justice and Behavior, 35*(1), 120–137.

Langan, P. A., & Levin, D. J. (2002). Recidivism of prisoners released in 1994 recent state reforms II: The impact of new fiscal and political realities: DOJ statistical studies. *Federal Sentencing Reporter, 15,* 58–65. https://heinonline.org/HOL/P?h=hein.journals/fedsen15&i=60

Langan, N. P., & Pelissier, B. (2001). Gender differences among prisoners in drug treatment. *Journal of Substance Abuse, 13,* 291–301.

Lattimore, P. K., Steffey, D. M., & Visher, C. A. (2009). *Prisoner reentry experiences of adult males: Characteristics, service receipt, and outcomes of participants in the SVORI multi-site evaluation.* RTI International.

Lattimore, P. K., & Visher, C. A. (2009). *The multi-site evaluation of SVORI: Summary and synthesis.* RTI International.

Lauritsen, J. L., Heimer, K., & Lynch, J. P. (2009). Trends in the gender gap in violent offending: New evidence from the national crime victimization survey. *Criminology, 47*(2), 361–399. https://doi.org/10.1111/j.1745-9125.2009.00149.x

Lindquist, C. H. (2000, September). Social integration and mental well-being among jail inmates. *Sociological Forum, 15*(3), 431–455.

Lindquist, C. H., Barrick, K., Lattimore, P. K., & Visher, C. A. (2009). *Prisoner reentry experiences of adult females: Characteristics, service receipt, and outcomes of participants in the SVORI multi-site evaluation.* RTI International.

Lindquist, C. H., & Lindquist, C. A. (1999). Health behind bars: Utilization and evaluation of medical care among jail inmates. *Journal of Community Health, 24*(4), 285–303.

Lynch, S. M., Fritch, A., & Heath, N. M. (2012). Looking beneath the surface: The nature of incarcerated women's experiences of interpersonal violence, treatment needs, and mental health. *Feminist Criminology, 7*(4), 381–400. https://doi.org/10.1177/1557085112439224

MacKinnon, C. (1991). Difference and dominance: On sexual discrimination. *Feminist legal theory* (pp. 81–94). Routledge.

Magaletta, P. R., Diamond, P. M., Faust, E., Daggett, D. M., & Camp, S. D. (2009). Estimating the mental illness component of service need in corrections: Results from the mental health prevalence project. *Criminal Justice and Behavior, 36*(3), 229–244. https://doi.org/10.1177/0093854808330390

Mann, C. R. (1990). Black female homicide in the United States. *Journal of Interpersonal Violence, 5*(2), 176–201. https://doi.org/10.1177/088626090005002004

Maruschak, L. M., & Beck, A. J. (2001). *Medical problems of inmates, 1997*. U.S. Department of Justice, Office of Justice Programs, Bureau of Justice Statistics.

McClellan, D. S., Farabee, D., & Crouch, B. M. (1997). Early victimization, drug use, and criminality: A comparison of male and female prisoners. *Criminal Justice and Behavior, 24*(4), 455–476.

McCorkle, R. C., Miethe, T. D., & Drass, K. A. (1995). The roots of prison violence: A test of the deprivation, management, and "not-so-total" institution models. *Crime & Delinquency, 41*(3), 317–331.

Mears, D. P., Cochran, J. C., Siennick, S. E., & Bales, W. D. (2012). Prison visitation and recidivism. *Justice Quarterly, 29*(6), 888–918.

Messina, N., Burdon, W., Hagopian, G., & Prendergast, M. (2006). Predictors of prison-based treatment outcomes: A comparison of men and women participants. *The American Journal of Drug and Alcohol Abuse, 32*(1), 7–28.

Miller, N. A., & Najavits, L. M. (2012). Creating trauma-informed correctional care: A balance of goals and environment. *European Journal of Psychotraumatology, 3*(s1), 17246. https://doi.org/10.3402/ejpt.v3i0.17246

Mitchelson, M. L. (2014). The production of bedspace: Prison privatization and abstract space. *Geographica Helvetica, 69*(5), 325–333.

Moran, D. (2013). Carceral geography and the spatialities of prison visiting: Visitation, recidivism, and hyperincarceration. *Environment and Planning D: Society and Space, 31*(1), 174–190.

Moran, D., Jones, P. I., Jordaan, J. A., & Porter, A. E. (2020). Does nature contact in prison improve well-being? Mapping land cover to identify the effect of greenspace on self-harm and violence in prisons in England and Wales. *Annals of the American Association of Geographers, 111*(6), 1779–1795.

Morash, M., Bynum, T. S., & Koons, B. A. (1998). *Women offenders: Programming needs and promising approaches* (p. 11). U.S. Department of Justice.

Morin, K. M. (2013). Distinguished historical geography lecture: Carceral space and the usable past. *Historical Geography, 41*, 1–21.

Morrill, C. (1995). *The executive way: Conflict management in corporations*. University of Chicago Press.

Morrissey, J. P., Jackson, E. W., Ellis, A. R., Amaro, H., Brown, V. B., & Najavits, L. N. (2005). Twelve-month outcomes of trauma-informed interventions for women with co-occurring disorders. *Psychiatric Services, 56*, 1213–1222.

Moyer, I. L. (1984). Deceptions and realities of life in women's prisons. *The Prison Journal, 64*(1), 45–56.

Muhr, T. (1991). ATLAS/ti—A prototype for the support of text interpretation. *Qualitative Sociology, 14*(4), 349–371. https://doi.org/10.1007/BF0 0989645

Mumola, C. J. (2000). *Incarcerated parents and their children (Bureau of Justice Statistics Special Report NCJ 182335)*. US Department of Justice, Office of Justice Programs.

Nagel, I. H., & Johnson, B. L. (1994). The role of gender in a structured sentencing system: Equal treatment, policy choices, and the sentencing of female offenders under the United States sentencing guidelines symposium: Gender issues and the criminal law. *Journal of Criminal Law and Criminology, 85*(1), 181–221. https://heinonline.org/HOL/P?h=hein.journals/jcl c85&i=191

Norland, S., & Shover, N. (1977). Gender roles and female criminality: Some critical comments. *Criminology, 15*(1), 87–104. https://doi.org/10.1111/j. 1745-9125.1977.tb00050.x

Norman, M., & Andrews, G. J. (2019). The folding of sport space into carceral space: On the making of prisoners' experiences and lives. *The Canadian Geographer/le Géographe Canadien, 63*(3), 453–465.

Orbis Partners. (2006). *Women offender case management model* (p. 66). National Institute of Corrections. https://nicic.gov/women-offender-case-management-model

Owen, B. (2005). Afterword: The case of the women. In *The warehouse prison: Disposal of the new dangerous class* (p. 318). Roxbury Publishing Company.

Pallot, J., Piacentini, L., & Moran, D. (2012). *Gender, geography, and punishment: The experience of women in carceral Russia*. Oxford University Press.

Pelissier, B. M., Camp, S. D., Gaes, G. G., Saylor, W. G., & Rhodes, W. (2003). Gender differences in outcomes from prison-based residential treatment. *Journal of Substance Abuse Treatment, 24*(2), 149–160.

Phillips, S., & Harm, N. (1998). Women prisoners: A contextual framework. *Women & Therapy, 20*(4), 1–9.

Pollack, S. (2005). Taming the shrew: Regulating prisoners through women-centered mental health programming. *Critical Criminology, 13*(1), 71–87. https://doi.org/10.1007/s10612-004-6168-5

Pollock, J. M. (2002). *Women, prison, and crime* (2nd ed.). Cengage Learning.

Powell, M. A., & Nolan, C. M. (2003). *California state prisoners with children: Findings from the 1997 survey of inmates in state and federal correctional facilities*. California State Library, California Research Bureau.

Rafter, N. (1990). *Partial justice: Women, prisons and social control* (2nd ed.). Routledge.

Ransom, G., Schneider, J., & Robinson-Sanford, K. P. (1996). Drug dependent women in boot camp programs: Practical considerations. *Alcoholism Treatment Quarterly, 14*(2), 79–87.

Richie, B. E. (2001). Challenges incarcerated women face as they return to their communities: Findings from life history interviews. *Crime & Delinquency, 47*(3), 368–389. https://doi.org/10.1177/0011128701047003005

Ritter, C., Hobfoll, S. E., Lavin, J., Cameron, R. P., & Hulsizer, M. R. (2000). Stress, psychosocial resources, and depressive symptomatology during pregnancy in low-income, inner-city women. *Health Psychology, 19*(6), 576. https://doi.org/10.1037/0278-6133.19.6.576

Saar, M. S., Epstein, R., Rosenthal, L., & Vafa, Y. (2015). *The sexual abuse to prison pipeline: The girls' story*. Georgetown Law, Human Rights Project for Girls, Ms. Foundation for Women.

Salina, D. D., Hill, J. L., Solarz, A. L., Lesondak, L., Razzano, L., & Dorenda, D. (2004). Feminist perspectives: Empowerment behind bars. In *Participatory community research: Theories and methods in action* (pp. 159–175). American Psychological Association.

Salina, D. D., Lesondak, L. M., Razzano, L. A., & Parenti, B. M. (2011). Addressing unmet needs in incarcerated women with co-occurring disorders. *Journal of Social Service Research, 37*(4), 365–378.

Salina, D. D., Lesondak, L. M., Razzano, L. A., & Weilbaecher, A. (2007). Co-occurring mental disorders among incarcerated women: Preliminary findings from an integrated health treatment study. *Journal of Offender Rehabilitation, 45*(1–2), 207–225.

Schilling, R. F., el-Bassel, N., Schinke, S. P., Gordon, K., & Nichols, S. (1991). Building skills of recovering women drug users to reduce heterosexual AIDS transmission. *Public Health Reports, 106*(3), 297–304. https://www.ncbi.nlm.nih.gov/pmc/articles/PMC1580245/

Sharkey, L. (2010). Does overcrowding in prisons exacerbate the risk of suicide among women prisoners? *The Howard Journal of Criminal Justice, 49*(2), 111–124.

Sibley, D., & Van Hoven, B. (2009). The contamination of personal space: Boundary construction in a prison environment. *Area, 41*(2), 198–206.

Singer, M. I., Bussey, J., Song, L. Y., & Lunghofer, L. (1995). The psychosocial issues of women serving time in jail. *Social Work, 40*(1), 103–113.

Snell, T. L., & Morton, D. C. (1991). *Survey of state prison inmates*. Bureau of Justice Statistics.

St. John, V. J., Blount-Hill, K.-L., Evans, D., Ayers, D., & Allard, S. (2019). Architecture and correctional services: A facilities approach to treatment. *The Prison Journal, 99*(6), 748–770. https://doi.org/10.1177/0032885519877402

Staton-Tindall, M., Royse, D., & Leukfeld, C. (2007). Substance use criminality, and social support: An exploratory analysis with incarcerated women. *The American Journal of Drug and Alcohol Abuse, 33*(2), 237–243.

Steffensmeier, D. (1993). National trends in female arrests, 1960–1990: Assessment and recommendations for research. *Journal of Quantitative Criminology, 9*(4), 411–441.

Steffensmeier, D., Zhong, H., Ackerman, J., Schwartz, J., & Agha, S. (2006). Gender gap trends for violent crimes, 1980 to 2003: A UCR-NCVS comparison. *Feminist Criminology, 1*(1), 72–98. https://doi.org/10.1177/1557085105283953

Stoller, N. (2003). Space, place and movement as aspects of health care in three women's prisons. *Social Science & Medicine, 56*(11), 2263–2275.

Sykes, G. M. (1958). *The society of captives*. Princeton University Press.

Tannen, D. (1992). How men and women use language differently in their lives and in the classroom—ProQuest. *The Education Digest, 57*(6). https://search.proquest.com/openview/4820c8002938e0c4389396839440efd0/1.pdf?pq-origsite=gscholar&cbl=25066

Teplin, L. A., Abram, K. M., & McClelland, G. M. (1996). Prevalence of psychiatric disorders among incarcerated women: I. Pretrial Jail Detainees. *Archives of General Psychiatry, 53*(6), 505–512. https://doi.org/10.1001/archpsyc.1996.01830060047007

The Sentencing Project. (2007). *Women in the criminal justice system* (Briefing Sheets, p. 10). The Sentencing Project.

The Sentencing Project. (2019). *Incarcerated women and girls* (p. 6). https://www.sentencingproject.org/publications/incarcerated-women-and-girls/

Tripodi, S. J., Bledsoe, S. E., Kim, J. S., & Bender, K. (2011). Effects of correctional-based programs for female inmates: A systematic review. *Research on Social Work Practice, 21*(1), 15–31.

Wener, R. (2012). *The environmental psychology of prisons and jails: Creating humane spaces in secure settings*. Cambridge University Press.

Women in Prison Project. (2008). *Women in prison fact sheet* (p. 4). Correctional Association of New York. https://www.correctionalassociation.org/recent-news

Zlotnick, C., Clarke, J. G., Friedmann, P. D., Roberts, M. B., Sacks, S., & Melnick, G. (2008). Gender differences in comorbid disorders among offenders in prison substance abuse treatment programs. *Behavioral Sciences & the Law, 26*(4), 403–412.

21

A Cultural Competence Framework for Corrections in Hawai'i

Cathi Ho Schar

Native Hawaiians make-up nearly 40% of Hawai'i's correctional population, while they only comprise approximately 20% of the general population. This overrepresentation is consistent across all stages of Hawai'i's criminal justice system (OHA, 2012). Over the past decade, multiple legislative task force reports have called for a new model that addresses this inequity, through a new justice system that draws from Native Hawaiian cultural values and practices. In line with this call to action, the State of Hawaii Department of Public Safety (DPS) established a partnership with the University of Hawai'i Community Design Center (UHCDC) to explore a planning and design approach to a new culture and place-based corrections model that draws from Hawai'i's unique geographic, indigenous, and multicultural context. This paper

C. H. Schar (✉)
University of Hawai'i at Mānoa, Honolulu, HI, USA
e-mail: cathi@hawaii.edu

© The Author(s), under exclusive license to Springer Nature Switzerland AG 2023
D. Moran et al. (eds.), *The Palgrave Handbook of Prison Design*, Palgrave Studies in Prisons and Penology,
https://doi.org/10.1007/978-3-031-11972-9_21

describes the development of this approach through teaching, outreach, and research. The chapter also presents outcomes of this effort, a cultural competence framework for corrections that includes goals and tools that support the design of a more equitable system, just processes, and restorative environments.

Background

The disproportionate number of Native Hawaiian and Pacific Islanders in Hawai'i's correctional system is indicative of the larger global overrepresentation of indigenous people in prisons throughout the world, such as in Australia, New Zealand, the United States, and Canada. Across the United States, 19 states have a disproportionate percentage of indigenous people in their correctional populations (Sakala, 2014). While in some places criminal justice policies have begun to address these social, economic, and racial inequities, the planning and design of correctional facilities largely ignores the racial and cultural make-up of the incarcerated population. In 2016, the House Concurrent Resolution No. 85, H.D.2, S.D.1 established a task force to make recommendations on the future of corrections in Hawai'i. The resultant HCR 85 Task Force report recommended transitioning from a punitive to a rehabilitative system, calling for a new model that draws from cultural practices that restore and strengthen harmony between individuals, their ohana (family), community, akua (spiritual realm), and 'āina (land) (HCR 85 Task Force, 2018). This call to action frames the complimentary lines of inquiry in this project, encompassing cultural, indigenous, and decolonizing approaches to the planning and design of correctional facilities in Hawai'i.

Teaching: Fourth Year Concentration Design Studio

In 2017, the author of this paper taught a fourth year undergraduate design studio in a Bachelor of Environmental Design programme that

served as an entry point into this topic area. The studio began with a multicultural lens, to connect to the multicultural make-up of the student cohort. The studio explored the potential for a carceral environment to function as a cultural landscape, relevant to any cultural or ethnic group. First, students were asked to chronicle their own identity and connections to place. Students diagrammed the spaces or relationships which allowed them to feel most "at home" or most connected to Hawai'i at multiple scales; S, M, L, XL. They documented these relationships in plan and section, using conventional orthographic drawings to represent these spatial experiences. For example, students depicted "wearing a flower above their ear," "wearing slippers," "talking-story in the kitchen," plus various spaces under trees, near the ocean, in the ocean, and overlooking valleys and ridgelines. The diagrams offered a rich patchwork of spatial typologies, tied to life activities, that represent places or spaces of belonging. See Fig. 21.1. The students considered how these types of spaces, activities, and associations might be integrated into correctional programmes and facilities to nurture similar senses of belonging for displaced individuals.

Students were then asked to develop new programmatic and facility models that considered a social, cultural, educational, economic, and environmental, bottom lines. They were also asked to design these models for the specific demographic make-up of Hawai'i's correctional population. This inspired students to more fully research indigenous values, knowledge, and practices. Final studio outcomes included hybrid facility types: a native reforestation and wood-working camp, an aquaculture centre reviving native fishing practices, a culinary institute celebrating local ethnic cuisines, a flower farm to support lei-making and floral arrangements, and a therapy community based on the Native Hawaiian kauhale (communal living) model, just to name a few.

Outreach: Decolonizing Cities Symposium

Following this fourth-year studio, UHCDC co-organized the second University of Hawai'i at Mānoa *Decolonizing Cities Symposium*, jointly hosted by the Department of Urban and Regional Planning, the School

Fig. 21.1 Diagrams by Fall 2017 ARCH 415 students

of Hawaiian Knowledge, and Interisland Terminal, a non-profit arts organization. The keynote speaker, Māori architect and advocate Rau Hoskins, presented his work on the Te Aranga Principles, a set of Māori-derived planning and design principles that are fully adopted into the Auckland Design Manual, representing a global precedent for decolonizing planning efforts worldwide. The symposium also gathered Hawai'i-based speakers who shared their efforts to integrate a Native Hawaiian worldview into local planning and design practices. The convening of these practitioners and thought leaders allowed common approaches to come through: foundations in indigenous values and principles, new processes involving indigenous representation and authority, and strengthened relationships between indigenous people and place.

The symposium, as it was intended, helped to connect theory to practice. In her book *Decolonizing Methodologies: Research and Indigenous Peoples*, Linda Tuhiwai Smith notes that decolonizing efforts focus primarily on cultural revitalization and the reorganization of political relations with the state (Smith, 2012). Her words emphasize the important relationship between decolonizing approaches and political transformation. Applied to planning and design, Tuhiwai's approach suggests the need to explore *both* the design of place and space and the design of process and power structures. The symposium keynote speaker Rau Hoskins presented the development of the Te Aranga Principles, now adopted by the City of Auckland, which identifies clear requirements for the inclusion of Maori people and perspectives in the city design process. This emphasis on process and power likewise relates to a review of prison architecture by Moran and Jewkes, which argues for methodologies that challenge and reflect on the design process itself rather than designed space (Moran & Jewkes, 2015). In line with these assertions, the work described in this paper reflects decolonizing or cultural design approaches that target institutions, processes, knowledge, networks, and resources as a precursor to spatial outcomes.

Methods

The team began with a literature review related to contemporary prison design, most of which focused on the humanizing and greening of jails and prisons, with little to no mention of how the racial and cultural make-up of incarcerated individuals might impact design. The Sustainable Justice Guidelines produced by the AIA Academy of Architecture for Justice include various design principles for corrections at the scale of the facility. None of these principles relate to cultural values, identity, or practices. This makes the West Kimberley Regional Prison (WKRP) even more exceptional. WKRP is a facility in West Australia that houses a large Aboriginal population in self-contained housing units, organized by family ties, language, and security ratings, around an ovular Australian-rules football field. The facility invests in spaces that maintain individual connections to the landscape, family, and kin, demonstrating the government's investment in more appropriate accommodations for high numbers of Aboriginal people (Grant, 2008). In addition, the planning of the facility involved a community working group and two architecture firms; one specializing in correctional project types, the other on indigenous projects. The integration of indigenous perspectives in various decision-making roles and the resultant built form, offers an important precedent for Hawai'i.

The team began gathering more in-depth cultural perspectives through a series of one-on-one hour-long talk-story interviews with Native Hawaiian, Samoan, and Filipino cultural experts, practitioners, and community leaders (focusing on the three most overrepresented ethnic groups in Hawai'i's corrections population). In line with the themes shared in the Decolonizing Cities symposium, the interview prompts focused on identifying cultural values, principles, processes, practices, and knowledge resources applicable to the rehabilitation of incarcerated individuals. The team analysed the talk stories using an adapted version of qualitative methodology derived from grounded theory to produce emerging themes. The themes that emerged included: alignment of cultural values; connection to place, family, and spirituality or sacredness; focusing on the collective over the individual, and the importance of relationships.

21 A Cultural Competence Framework for Corrections in Hawai'i

The interviewees also provided insights on two Native Hawaiian cultural practice models that offer alternatives to current punitive practices: puʻuhonua and hoʻoponopono. Historically, a puʻuhonua acted as a sacred refuge, established by the ruling aliʻi (chief). It operated in conjunction with a heiau (temple) whose gods protected the place and kahuna (priests) who ran it. A kapu (law) breaker could escape death if they made it to a place of refuge. Once inside, they would ask for a second chance at life. The kahuna would perform a ceremony of absolution, which would allow the rule breaker to return home. The second model is the enduring cultural practice of hoʻoponopono, which, simply translated, means "to correct" (Pukui & Elbert, 1992), and refers to a Native Hawaiian traditional and contemporary process of reconciliation and healing. The process starts with a prayer, *pule*, problem identification, sharing of feelings, and cooling off period, which alternates until forgiveness is given, entanglements are removed, and there is mutual release. At the end of the process, the entanglement is *oki*—cut off (Shook, 1985). While the two practices have been a part of prior corrections-related convenings and discussions, there has been little movement towards integrating these or any other cultural concepts or practices into corrections in a holistic way.

To address the lack of follow-through, the outcomes of this project were conceived as a framework and toolkit to address the roadblocks to indigenous and restorative justice approaches: lack of political will, institutional alignment, knowledge, resources, and a road map. The resultant Cultural Competence Framework for Corrections acts as a simple roadmap for transformation. The term, cultural competence, emerged in expert interviews, leading us to look deeper into its role in social work and public health. More common to these two helping professions, cultural competence is understood as a set of behaviours, attitudes, and policies that enable systems, agencies, or professionals to work effectively in cross-cultural situations (Hurdle, 2002), Learning from different cultural competence frameworks, the team developed six framework goals aimed at building cultural competence across the corrections, through adjustments to the agency, its partnerships, knowledge, processes, programmes, and facilities. Each goal prompted the

development of a tool, i.e. an instrument to help the institution to work towards the goal. These goals and tools are described in the following sections. The development of this framework is diagrammed in Fig. 21.2.

Tool #1—Strategic Planning

UHCDC hosted a strategic planning session with a small group of participants from DPS to establish a clear mission, vision, and values for the project. The team guided participants through a series of wall-mounted worksheets and exercises to draft new mission and vision statements, define core values, identify priorities, and brainstorm primary roadblocks to transformation. The team identified strategic planning as a necessary precursor to all spatial planning to align the project with evolving stakeholder mission, vision, and values.

Tool #2—Community Directory

To support increased community partnerships, the team assembled a community organizations directory based on information gathered from interviewees and existing sources. The directory emerged as a resource to connect newly released individuals to re-entry support services. While this directory was only presented in a preliminary form, the work contemplates an important role for service design and information design. These emerging design disciplines collectively offer methodologies to address social challenges which often result from a lack of information, services, and resources for marginalized communities.

Tool #3—Culturally Integrative Capital Improvement Project Process

The state's capital improvement project (CIP) planning and design process defines generic scopes of work for professional consultants for

21 A Cultural Competence Framework for Corrections in Hawai'i

Teaching	Outreach	Literature Review	Primary Research	Emerging Themes	Cultural Competency Framework	Tools
ARCH 415	Decolonizing Cities Symposium	• Facilities • Programs • Agencies • Industry Practices and Standards • HI/NH Policy Documents • Indigenous and Multi-cultural Precedents • Indigenous Policies and Resources	• Agency Alignment • Expert Interviews	• Pilina — Building Relationships • 'Ohana Reunification • 'Ōlelo, Mo'olelo, Mo'okū'auhau • Aloha 'Āina • Values • Continuum of Services and Resources • Educational Pathways • Equitable Agency Practices • Holistic Mindset & Preventative Approaches To Health	Align the Agency	Mini Strategic Planning Session
					Partner with the Community	Community Partner Directory
					Create Equitable Exchange & Representation	Cultural Design Review Process
					Share Cross Cultural Knowledge	Cultural Design Resource Funding for Indigenous & Multicultural Projects
					Promote Holistic Health	Native Hawaiian Health & Well Being
					Design for Relationships	Pilina Strategies

Fig. 21.2 Cultural competence framework development

all state agencies across six phases. The team asked interviewees to envision a more culturally integrative CIP process, giving some consideration to existing regulatory requirements. Their feedback shaped a new CIP process diagram that added a relationship-building phase, establishment of community working groups, compensation for community participation, deeper context analysis, shared design decision-making authority, and post-occupancy follow-ups. One interviewee suggested a circular diagram for this process, to ensure that all phases can be seen and informed by the others and to illustrate a cyclical and continuous process. See Fig. 21.3.

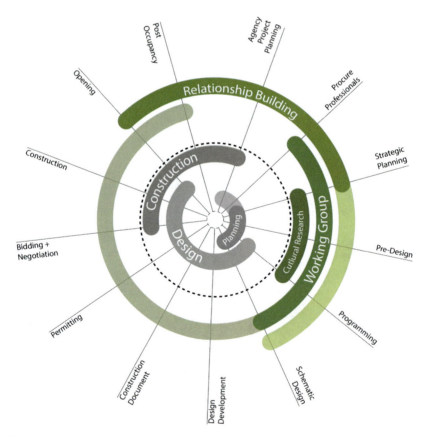

Fig. 21.3 Culturally integrative capital improvement project process

Tool #4—Cultural Design Resource

In the helping professions, Hurdle describes knowledge-building and sharing as important steps to building cultural competence (2002). To support this sharing, the team produced a Cultural Design Resource, a multicultural primer for planners and designers. The resource compiles simple graphic diagrams and notes in three sections focused on: cultural values (axiology), ways of knowing (epistemology), and ways of doing (methodology). The values section gathers examples of Native Hawaiian, Filipino, and Samoan values, offered to the reader as a sampling of values that vary across different cultural enclaves. The knowledge section connects to the fields of study that access traditional ecological knowledge (TEK) or ancestral ecological knowledge (AEK) to access cumulative bodies of knowledge, beliefs, and practices developed through generations of people living with their local environment (Houde, 2007). Our resource includes Native Hawaiian approaches to research, which often begin with gathering Native Hawaiian place names, moʻolelos (Native Hawaiian stories, songs, chants, and myths), and moʻokuauhau (place genealogies). The design methodology section compiles multi-ethnic indigenous approaches to the built environment at four scales: land planning and development, siting and orientation, building design, and interior design. Each method is described by simple illustrations. For example, the Native Hawaiian use of loʻi kalo for food production and watershed management, Fig. 21.4; loko iʻa for aquaculture, Fig. 21.5; and the ahupuaʻa, a social, political, and ecological model for land division and resource management, Fig. 21.6.

Tool #5—Indigenous Health and Well-Being Framework

In an article about Native Hawaiian contemporary health, spirituality, and cultural trauma, Bud Pomaikaʻi Cook and his co-authors advocate for health care practices that recognize a history of "cultural wounding." These practices incorporate methods of cultural healing that address mental, spiritual, and physical well-being (Cook, 2003). According to

614 C. H. Schar

Fig. 21.4 Lo'i Kalo

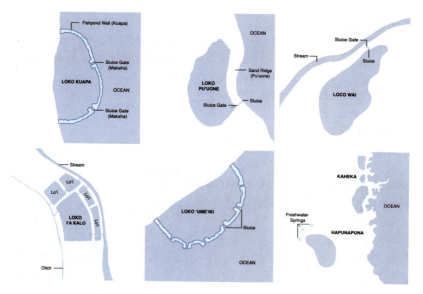

Fig. 21.5 Loko i'a

21 A Cultural Competence Framework for Corrections in Hawai'i

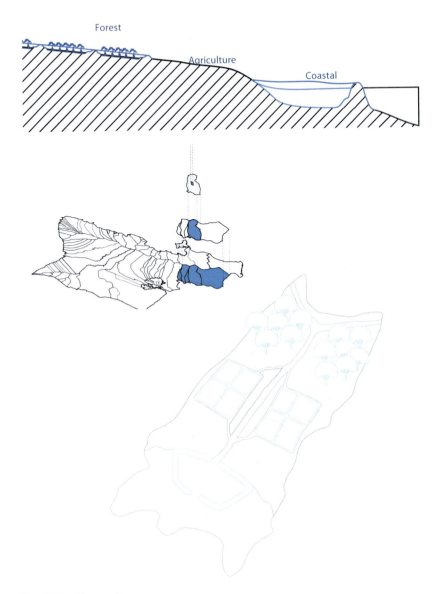

Fig. 21.6 Ahupua'a

Handy and Pukui, Native Hawaiian well-being was assessed by the quality of an individual's relationship with his or her own family, community, environment, and spiritual realm (1958). One diagrammatic interpretation of this, the "Ecological Model for Native Hawaiian Health and Well-being" locates the kanaka (person) at the center of concentric circles, surrounded by ʻohana, ʻāina, and akua, articulating fundamental and nested attachments to family (children, parents, elders, ancestors), nature, and the gods and spirits (McGregor et al., 2003). Another interviewee described a "Three Piko Framework" shared to him by Kekuni Blaisdell that articulates the importance of maintaining an individual's connection to their three pikos (navels or belly buttons): the piko poʻo or manawa at the head, which connects to the spiritual realm and ancestors; the piko waena at the navel, which connects to parents and a gut feeling; and the piko maʻi, at the genitals, which connects to future generations. These two models help to illuminate the difference between indigenous and western understandings of health and well-being, offering a new lens for design.

Tool #6—Design Strategies

Finally the last framework tool offers a set of design strategies, "Designing for Pilina," aimed at Native Hawaiian health and well-being, as described above. The Hawaiian word "pilina"—meaning "association," "relationship," "union," or "joining"—emerged as a repeated theme in our interviews (Pukui & Elbert, 1992). Like Christopher Alexander's pattern language, these pilina strategies explore how specific design choices help to build better relationships. The pilina strategies shift our focus from people and their environments to people and their *relationships*. We targeted the three relationships that our research deemed fundamental to Native Hawaiian health: kanaka-ʻohana, kanaka-akua, and kanaka-ʻāina. The strategies focus on strengthening these three connections. Some of the strategies relate specifically to corrections, including family-oriented multi-generational visitation spaces, more welcoming community frontages, providing places of retreat and refuge, and spaces for hoʻoponopono. Others are more general, like

maintaining visual and tactile connections to the āina, the land, and wai, the water.

Conclusion

These six tools reflect project outcomes that anticipate future work. The final component of this project will involve proof-of-concept designs that will allow our team to introduce our framework and tools to three different facilities and stakeholder groups, including incarcerated individuals, a critical missing voice in this research so far. The tools will then be refined and submitted as a final living document. Given this timing, there is no evidence yet, to prove that these approaches will lead to greater cultural competence for DPS or less incarceration of Native Hawaiian and other ethnic groups.

The project does, however, align with the discourse on correctional environments for indigenous people elsewhere. The needs of Australian Aboriginal prisoners represented in architectural anthropologist Elizabeth Grant's doctoral research (2008), and the needs and interests of Native Hawaiian and Pacific Islanders communities summarized above, are remarkably similar. Both research efforts highlight the importance of an inclusive design approach that focuses on people, culture, and place. Both acknowledge the need for continued connections to family, kin, community, the land, the spiritual world, and cultural spaces and practices that support this. These cross-country commonalities reinforce the global relevance of this way of thinking.

Finally, while this work focuses on transforming an institution, the transformation of the criminal justice system remains a critical first step. Hawai'i needs criminal justice reform; new bail and sentencing policies, public agency alignment, and community-based alternatives to alleviate Hawai'i's overburdened corrections system. Understanding the need to transform this larger ecology, UHCDC facilitated a grant writing exercise that mobilized the School of Law, School of Hawaiian Knowledge, and College of Social Sciences around a proposal to develop community-based alternatives to peace-keeping, adjudication, diversion, and re-entry. While the team did not receive the grant, the effort informed a State of

Hawai'i House of Representatives bill to fund a new university center partnering the School of Law with the School of Hawaiian Knowledge and UHCDC to work towards these goals. Regardless of whether this bill gets passed, these efforts have begun to bring people and resources together to address the incarceration of Native Hawaiian and Pacific Islanders in a more holistic way. As work and relationships continue to mature, all efforts point towards multi-disciplinary and community-partnered work to concurrently address disparities on both sides of the fence.

Bibliography

Cook, B. P. I., Withy, K., & Tarallo-Jensen, L. (2003). Cultural trauma, Hawaiian spirituality, and contemporary health status. *Californian Journal of Health Promotion, 1*, 10–24. https://doi.org/10.32398/cjhp.v1isi.554

Grant, E. (2008). Prison environments and the needs of Australian aboriginal prisoners: A South Australian case. *Australian Indigenous Law Review, 12*(2), 66–80.

Handy, E., & Pukui, M. (1958). *The Polynesian family system in Ka'u Hawaii* (p. 259). The Polynesian Society Inc.

HCR 85 Task Force. (2018). *Creating better outcomes, safer communities: Final report of the house concurrent resolution 85 task force on prison reform to the Hawai'i legislature 2019 regular session.* Honolulu. Available from https://www.courts.state.hi.us/wp-content/uploads/2018/12/HCR-85_task_force_final_report.pdf. Accessed October 2021.

Hurdle, D. E. (2002). Native Hawaiian traditional healing: Culturally based interventions for social work practice. *Social Work, 47*(2), 183–192. https://doi.org/10.1093/sw/47.2.183

Houde, N (2007). The six faces of traditional ecological knowledge: Challenges and opportunities for Canadian co-management arrangements. *Ecology and Society, 12*(2) https://doi.org/10.5751/es-02270-120234

Moran, D., & Jewkes, Y. (2015). Linking the carceral and the punitive state: A review of research on prison architecture, design, technology and the lived experience of Carceral space. *Annales de géographie, 702–703*(2), 179. https://doi.org/10.3917/ag.702.0163

McGregor, D. P., Morelli, P. T., Matsuoka, J. K., Rodenhurst, R., Kong, N., & Spencer, M. S. (2003). An ecological model of native Hawaiian well-being. *Pacific Health Dialog, 10*(2), 106–128.

Office of Hawaiian Affairs. (2012). The Native Hawaiian Justice Task Force report. Honolulu.

Pukui, M., & Elbert, S. (1992). *New pocket Hawaiian dictionary*. University of Hawai'i Press.

Sakala, L. (2014). Breaking down mass incarceration in the 2010 census. www.prisonpolicy.org. Available from https://www.prisonpolicy.org/reports/rates.html. Accessed October 2021.

Shook, V. (1985). *Ho'oponopono: Contemporary uses of a Hawaiian problem-solving process*. University of Hawaii Press.

Smith, L. T. (2012). *Decolonizing methodologies: Research and indigenous peoples*. Zed.

Part IV

Custodial Design for Spaces and Functions

22

From Grey to Green: Guidelines for Designing Health-Promoting Correctional Environments

Julie Stevens, Amy Wagenfeld, and Barb Toews

Introduction

Nature nurtures, heals, and provides meaning and purpose to our daily lives. Substantial literature demonstrates the important relationships between nature and human physical, emotional, behavioural, and social well-being (e.g. Bratman et al., 2015; Frumkin et al., 2017). A small

The original version of this chapter was revised: Order of Figures 1 to 4 has been corrected. The correction to this chapter is available at https://doi.org/10.1007/978-3-031-11972-9_27

J. Stevens (✉)
College of Design, Iowa State University, Ames, IA, USA
e-mail: jstevens@iastate.edu

A. Wagenfeld
Seattle, WA, USA
e-mail: amy.e.wagenfeld@gmail.com

B. Toews
University of Washington Tacoma, Tacoma, WA, USA
e-mail: btoews@uw.edu

© The Author(s), under exclusive license to Springer Nature Switzerland AG 2023, corrected publication 2023
D. Moran et al. (eds.), *The Palgrave Handbook of Prison Design*, Palgrave Studies in Prisons and Penology,
https://doi.org/10.1007/978-3-031-11972-9_22

subset of this literature indicates that the positive benefits of nature hold true for incarcerated individuals and those who work inside custodial and correctional institutions. Much of what is known about the impact of nature in custodial settings is limited to nature-oriented programmes such as horticultural and nature simulation programmes (Nadkarni et al., 2017; Van Der Linden, 2015), with little attention given to the natural landscape surrounding the facility and which incarcerated individuals and staff are able to engage with throughout the course of their day.

Access to natural landscapes should not be considered a luxury for incarcerated individuals. Rather, access to the natural landscape should be intentionally designed and built into the correctional environment, not only as a basic tenet of humanity that should be afforded to all but also as a feature that may facilitate the achievement of custodial and rehabilitative goals. Intentionally transforming the metaphorical and literal grey correctional environment to a green one subsequently holds great promise for the individual physical, emotional, and social health of incarcerated individuals while living in the institution and upon their return to the community. In this chapter we explore what it means to go "from grey to green" and present guidelines on ways in which biophilic design and Attention Restorative Theory, in conjunction with therapeutic, sensory focused, and universal design principles associated with health-promoting environments can be applied to outdoor prison design as a means to support well-being for incarcerated individuals.

The Grey

We, the authors, have more than 30 years of combined experience working in custodial contexts. We have been in tens of facilities for men and women, in urban and rural settings, and with minimum through maximum security levels. We have noticed some similarities, and differences, in the landscape across the different types of facilities. For example, custodial facilities are often sited on large expanses of land designed with little more than lawn, the occasional flower garden set against a backdrop of cold colours and hard materiality of the buildings. Building interiors often reflect the exterior—e.g., void of natural

life and sad or non-existent views out of windows. This correctional landscape reflects a public perception that prisons should be unrelenting spaces for punishment which, if made too pleasant, might lead people to want to stay there. For example, Stevens (first author) has designed landscapes at a women's prison. In its beginning stages, the project received negative press and pushback from members of the public who expressed that prisons, if made too pleasant, might lead people to want to stay there. Yet, the barren prison environment has the potential to threaten the already compromised physical, mental, and social health of those living within their walls, thus working against correctional goals of rehabilitation and reduced recidivism (James & Glaze, 2006).

We have also noticed that the specifics of the custodial landscape vary across facilities and multiple factors impact the degree to which incarcerated individuals have access to that landscape. For instance, urban facilities may lack any outdoor natural landscape for viewing or engagement. Yards may be cement open-air "rooms," where the landscape of the surrounding neighbourhood, if any, is blocked from view. A rural facility, however, may have landscaping on the prison campus—though this is often just large expanses of lawn interrupted by small flower beds—and views of natural surroundings such as forests or fields. The exercise yard may be fully outside. Individuals incarcerated in facilities consisting of a campus of multiple buildings will have more opportunities to engage with the landscape as they go about their day, whereas those incarcerated in single-building facilities may have no interaction with the landscape as they do not need to go outside unless they go to the yard. The presence and size of windows also matters. When incarcerated individuals look out windows, what do they see—a natural landscape, cement sidewalks, or a building? Small and narrow windows limit the degree to which someone can view the available landscape. Windows located in the upper wall of cells often only offer views to the sky or make the landscape viewable only to the person on the top bunk (Wener, 2012).

The interrelatedness of the natural and built environment, and the health benefits of interaction with nature (e.g., Kellert, 2008; Kaplan, 1995), suggests that the landscape should be an integral consideration in the planning, design, and building of custodial facilities. Jail and prison design guides articulate the need for outdoor spaces for exercise, visits,

emergency egress/refuge area, gardening, and "general landscaping for aesthetic and therapeutic purposes and the creation of buffers between the building and the public" (Kimme et al., 2011, p. 22; ICRC, 2020). While commendable, we believe that the limited discussion of the design of such spaces and the lack of contextualization of the outdoors and natural environment within physical, mental, and social health does little to encourage correctional administrators to take the landscape and its benefits seriously, let alone budget for the design, construction, and maintenance of therapeutic landscapes.

The lack of access to nature and the natural landscape is being challenged by those involved in criminal justice reform efforts. For instance, The Vera Institute notes the lack of nature in the current correctional environment as part of their re-imagining incarceration (Delaney et al., 2018). Reporting about the conditions of isolation units in Georgia, Haney (2018) cites the lack of sunlight through windows and the industrial, versus natural, design of yard spaces. Incarcerated individuals have sued the San Francisco Sheriff's Office, citing deprivation of sunlight and access to outdoor exercise yards (Dinzeo, 2019). Prisons currently receiving global praise for their more humane designs—such as Halden and Bastoy Island—are sited within expansive natural environments. Thoughtful considerations for enriching and balanced biophilic connections with nature, both inside and outside, have the potential to enhance the physical, emotional, and social health capacity of those living in correctional institutions.

The Green

The grey-ness of custodial and detention facilities can be transformed to green through intentional design, construction, and use of the natural landscape. When supported by health-oriented design theories, principles, and elements, the natural landscape can be used to meet the complex needs of incarcerated individuals, many of whom are dealing with trauma histories and mental health conditions (Lynch et al., 2014; Moran, 2019; Moran & Turner, 2019; Reddon & Durante, 2018).

Overall, the natural landscape has the potential to enhance the therapeutic, learning, social, and recreational capacity of custodial institutions.

In Iowa, we attempted to address the greyness of the custodial landscape by employing several design theories and associated research findings to offer a way to envision these environmental changes. Central to foundation of the landscape design is biophilia and biophilic design (Kellert, 2008; Wilson, 1984) as well as Attention Restoration Theory (ART) (Kaplan, 1995), supported by other health-oriented design theories including universal design (Mace, 1985), therapeutic design (eg., Cooper Marcus & Sachs, 2013; Winterbottom & Wagenfeld, 2015), and sensory design (Hussein, 2012; Wagenfeld et al., 2019). The primary framework from which we approach this topic is through biophilia and biophilic design. In the next section we introduce biophilia, biophilic design, and ART as the central environmental theories to apply when designing natural landscapes in custodial institutions and discuss additional supporting health-oriented theories. This is followed by a case study exploring how these theories were applied at women's prison in Iowa.

Biophilia and Biophilic Design

Biophilia, or "the love of life or living things" provides an explanation for our desire to connect with nature; that is, humans have an innate emotional bond to other living organisms (Wilson, 1984) and that connections to nature are vital for our survival due to its relationship to health, defined as "state of complete physical, mental, and social well being..." (WHO, 1946). Extensive research finds in support of the health benefits, across these three domains, of the biophilic experience. They include reduced blood pressure and heart rate, decreased stress, enhanced learning, sensory regulation, attention, focus, creativity, and increased social interaction and user comfort (Bratman et al., 2015; Calogiuri & Hildegunn, 2015; Capaldi et al., 2014; Hansen et al., 2017; Wang & MacMillan, 2013). Conversely, limited exposure to nature is associated with poorer physical and mental health, increased obesity, reduced problem-solving abilities, and lack of social connections (Haluza

et al., 2014; White et al., 2019). Overall, being in and connecting with nature is calming and restorative across the three domains of health. These findings are situated in non-custodial settings (e.g., hospitals) but, even so, are applicable to and can inform decisions made in the custodial environment.

While literature about the health benefits of nature within custodial environments is less prolific, there are a few researchers who focus specifically on the health benefits of nature in the custodial context, straddling physical, mental, and social well-being outcomes. Incarcerated individuals' nature engagement within this setting occurs in a variety of ways, including formal horticultural and gardening programmes and nature simulation rooms as well as informal or short-term engagements such as plant transplanting events. Mental health outcomes include improved emotional health and mood, feelings of calm, happiness, and peacefulness as well as a sense of meaning and purpose and the ability to reflect and express identities other than "prisoner," such as "mom" or "daughter" (Moran, 2019; Moran & Turner, 2019; Nadkarni et al., 2017; Toews, 2016; Toews et al., 2020; van der Linden, 2015). Socially, nature engagement facilitates a decrease in behavioural infractions and improvement in prisoner–staff relationships (Nadkarni et al., 2017), instils a sense of belonging, engenders cooperation and helping behaviours, and improves relationships among incarcerated individuals (Toews et al., 2020). Involvement in gardening-related programmes has also shown to reduce recidivism (van der Linden, 2015). These programmes and activities have the potential to develop and hone incarcerated persons' nature-based technical skills as well as the community-based relationships and soft skills necessary for employment upon release, thus improving overall health when in the community (Arimoto & Michaux, 2020).

These positive outcomes are typically associated with organized and often long-term programmes and activities, which are typically limited in scope in terms of who and how many individuals can participate. Less is known about the impact of nature exposure outside the context of programming—for instance, window views and visiting a garden. Early research found that incarcerated men with views of nature out of their cell windows made fewer sick calls than those who had views of buildings (West, 1986). Waikus (2004) examined outcomes associated with the use

of a prison yard where a garden had just been built. The results showed that the transformed yard provided refuge, reduced stress, and created a sense of hope and possibility for change. More recently, research on the impact of the use of a visiting room garden showed that both incarcerated women and their visiting family and friends (including children) engaged in physical activity and play, together, creating a positive affective visiting experience. This improved the mood of the children and the women and they were able to interact with their children as they would have at home. Garden visitors also noted that using the garden contributed to better quality visits and parent–child relationships during their time together (Toews et al., 2020). These findings suggest that formal programmes are not necessary to achieve the well-being outcomes associated with nature engagement. The day-to-day being in, seeing, and interacting with nature has the potential to impact a larger number of people and in more comprehensive ways when the correctional landscape, as a whole, is intentionally designed and built to take advantage of the health benefits of nature.

Biophilic design is largely focused on bringing nature elements inside buildings and cities and while all landscapes should inherently contain a plethora of biophilic attributes, the built environment has, unfortunately, destroyed many opportunities for nature connections. Thus we seek to reintroduce biophilia through design by way of the elements and attributes as defined by Stephen Kellert et al. (2008). The six elements include: (1) environmental features; (2) natural shapes and forms; (3) natural patterns and processes; (4) light and space; (5) place-based relationships and; (6) evolved human–nature relationships (Kellert, 2008, pp. 6–14). Within the six biophilic elements, Kellert (2008) identified 72 attributes—such as sunlight, plants, habitats and ecosystems, indigenous materials, and spatial harmony to name a few. While some attributes overlap, each contributes to the goal of creating a healthy nature-based environment. Several of these attributes are identified in Figs. 22.1, 22.2, and 22.3, suggesting how they are operationalized.

Attention Restoration Theory

Biophilia establishes that connections to nature are a human neccessity while the Attention Restoration Theory (ART) brings critical perspective as it is concerned with understanding and creating environments that respond to stress and attentional fatigue. Given the trauma experiences of people who are incarcerated (DeHart & Iachini, 2019) and the stress that incarcerated people may experience due to lack of social support, constant surveillance, and hypervigilance against violence or other physical or psychological assaults (Porter, 2018), ART has the potential to facilitate healing and self-regulation among those who are incarcerated.

ART posits that time spent in or viewing nature reduces the deleterious effects of sustained mental focus and hypervigilance to one's surroundings (Kaplan, 1995). Four components associated with a restorative environment include: (1) being away (one can get away from what has required attention); (2) fascination (environment is interesting); (3) extent (environment is rich and engaging); and (4) compatibility (environment attends to needs so one can let their guard down) (Kaplan, 1995). ART research finds that nature engagement rejuvenates and restores attention but a clear consensus does not exist, largely due to methodological issues (Ohly et al., 2016).

Additional Design Theories

The design of natural landscapes also draws on several other health-oriented design theories, which introduce concerns that are not explicit in biophilic design or ART. While there is overlap between the theories discussed in this chapter, each additional theory draws attention to specific concerns not inherent to the others.

Universal design (UD), a necessary design approach to maintain environmental health, welfare, and safety, seeks to design environments that are "usable by all people…without the need for adaptation or specialized design" (Mace, 1985, p. 147), thus accommodating a wide range of people, regardless of age, ability, or preference. It aims to enhance an individual's ability to participate in activities in ways that they find to be

meaningful through the application of seven principles: (1) equitable use; (2) flexibility in use; (3) simple and intuitive use; (4) perceptible information; (5) tolerance for error; (6) low physical effort; and (7) size and space for approach and use (NC State University, 1997). UD calls attention to the reality that incarcerated individuals vary in their abilities, strengths, and limitations, be they physical, cognitive, and/or emotional. Applied in the custodial landscape, UD may take the form of horticultural activities that occur at raised planting beds with roll under capacity to accommodate individuals in wheelchairs, outdoor seating with armrests, which enable people to sit and stand safely, and eight feet wide garden pathways to enable wheeled mobility users to travel in tandem or pass without one having to vacate the pathway.

Therapeutic design (TD) brings a comprehensive understanding of disease and disability, and its impact on participation in any environment to meet a wide range of physical, mental health, sensory, social, and cognitive needs for people of all ages (Cooper-Marcus & Sachs, 2013; Winterbottom & Wagenfeld, 2015). This means designers and healthcare professionals, such as occupational, physical, and speech therapists and nurses work together to design the environment to best meet client needs. TD is supportive because it respects the full range of human experience and promotes physical and emotional well-being and functionality. Like universal design, TD eliminates the stigma of differences and enables individuals, with and without disabilities to engage in daily activities in a space, equitably, and with dignity. In outdoor spaces, this is reflected in features that support choice such as inclusion of spaces for group activity and movement, quiet spaces for contemplation, and options to be in the shade or sun.

Sensory focused design (SFD) acknowledges that information from the environment must be taken in, processed, and organized through the sensory systems in order to learn, manage our behaviours, and to understand the world and recognizes that the eight sensory systems guide every action that humans participate in during their daily lives. Sensory design provides opportunities for touch (tactile), smell (olfactory), see (visual), hear (auditory), taste (gustatory) (as appropriate), movement (proprioception), balance (vestibular), and internal regulation (interoception) experiences (Hussein, 2012; Wagenfeld et al., 2019). When all

eight systems are considered in design, individuals are better able to self-regulate, manage emotions, and effectively engage in activities (Hong and Hong, 2016; Martini et al., 2016). SFD is particularly important for those who are incarcerated given the prevalence of trauma (DeHart & Iachini, 2019) and the relationship between trauma and a dis-regulated interoceptive system (Payne et al., 2015). The five basic senses (tactile, olfactory, visual, auditory, and taste) can be addressed through plant selection. Proprioception and vestibular enrichment can be provided through elements such as glider chairs, varied paving materials, a combination of curved and angled pathways, and incremental grade changes. Interoception can be addressed through inclusion of, for example, shade structures, drinking fountains and restrooms, and ample seating.

We contend that custodial landscapes, which have been designed with biophilic design and ART as guiding theories, coupled with universal, therapeutic, and sensory-focused design approaches, can serve multiple purposes. Such landscapes, when designed to ensure that they are safe and useable by all, can provide the necessary life-sustaining nature–human connection, offer relief from stress and trauma, and facilitate physical, social, and emotional healing.

Landscape Design in Custodial Settings

Our experience suggests that few custodial environments have been designed to incorporate biophilic, ART, or other health-oriented design approaches, thus limiting the therapeutic benefits for incarcerated individuals. Even as new custodial facilities are built to be more humane, therapeutic, or trauma-informed, little attention appears to be given to the surrounding landscape. The Iowa State Penitentiary (ISP), a maximum security men's prison which opened in 2015 to replace its original 1836-built location, serves as an example. We conducted a review of this facility by evaluating the presence of each of the 72 biophilic design principles. This review revealed that only 2.5 out of 72 biophilic attributes were identified across indoors and outdoors: light and air and to a lesser degree, views (Fig. 22.1).

Associate professor of landscape architecture Julie Stevens (author), familiar with the institution notes many design and engineering decisions impeded application of biophilic attributes. For example, cells appear to have windows with outside views when in reality, they look into a utility corridor. In many cases, cell windows do not line up with corridor windows thus not allowing for even a fractured landscape view. The interior courtyards, intended for easy and safe access to fresh air and natural light, are concrete boxes without living elements. The administration building blocks most incarcerated individuals from the beautiful views of the Mississippi River valley. The outdoor recreation yard is immediately adjacent to a landfill. Many acres on which the facility sits are off limits to the incarcerated individuals, excepting the large recreation yard.

The Iowa Correctional Institution for Women (ICIW) offers an example of a custodial landscape which intentionally incorporated biophilic and ART design, as well as UD, TD, and SFD elements into its design. The current ICIW campus opened in 2014, more than doubling the size of the former campus which served as a girl's reform school beginning in the 1880s until becoming Iowa's first all-women's prison in 1982. When the new facility was being designed and built, the design team did not employ a landscape architecture professional. The result was that the landscape simply consisted of a vast grass lawn. Budget may have played a role in this omission but in reality, a well-designed landscape could have saved money. For example, the landscape could have been graded to slow and infiltrate water rather than over-engineering an extensive storm sewer system. The buildings could have been sited to enhance views to the surrounding landscape—costing no more than the resulting design. And if the priority of the administration and the design team was about bettering the lives of those incarcerated, or employed there, the buildings could have used more indigenous materials, such as locally sourced limestone, and created more biophilic interiors and the nearly 30-acre campus could have been seeded with less lawn and more native plants to make a stronger ecological connection.

Despite the missed opportunities, ICIW is indeed an example of how biophilic, restorative, and health-oriented design can be woven throughout the custodial landscape, even after the buildings are constructed. From 2013 to 2019, Stevens, students from Iowa State

634 J. Stevens et al.

Fig. 22.1 Despite being relatively new, the Iowa State Penitentiary missed nearly every opportunity to bring biophilia and biophilic design prinicples into the facility design (*Credits*—Photographs: Julie Stevens. Graphic Layout: Victoria Troutman)

University's landscape architecture department, and incarcerated individuals teamed up to design, construct, and later maintain the landscape at ICIW. In total, the team designed and constructed several gardens around the facility campus, transforming the landscape as a whole: a Multipurpose Outdoor Classroom, multiple production gardens, a healing garden outside the mental health units, and a garden/park area outside the visiting room.

The Multipurpose Outdoor Classroom (MOC) is a landscape space that exemplifies the proposed design approach. The MOC is a one-acre site that is divided by circulation routes and offers spaces to accommodate individuals and small groups in an Aspen grove, a lawn mound, a native prairie, and limestone-walled open-air classrooms of varying sizes. Figures 22.2 and 22.3 illustrate a review of the biophilic and ART attributes of the MOC. Our review of the MOC using Kellert's (2008) framework indicates that the MOC achieves all six principles and approximately 39 of 72 biophilic attributes (Fig. 22.2). The MOC also achieves all four principles of ART in a variety of ways (Fig. 22.3). The three supplementary design approaches are also visible in the following ways:

- Universal design through features such as level pathways, varied seating options, and easily understood outdoor spaces that incorporate local plants and materials and are reflective of regional character.
- Therapeutic design through features such as group spaces for socialization and quieter spaces for contemplation, places to sit in the sun and the shade and plants that provide positive natural distractions through colour, movement, and by attracting birds and butterflies.
- Sensory-focused design through features such as plantings with varied colours, textures, and smells, as well as varied opportunities to move.

Taken together, the MOC exemplifies a biophilic, restorative, and health-oriented natural environment. The other gardens situated throughout the facility campus expand the reach of the health benefits of the natural landscape.

The landscape at ICIW does not have to be a lone example of applying biophilic, ART, or other health-oriented design approaches

into the custodial environment. Such elements can be applied in the prison environments in countless ways—e.g., creating immersive and safe gardens, designing with plants that attract birds and butterflies, directing views to the landscape beyond the prison, and providing life-sustaining elements like water, shelter/shade, and edible plants. Urban custodial facilities lacking outdoor campuses can provide indoor nature connections through, for instance, fish tanks and living green walls with plants and introduce natural light via skylights and windows. The design can include curvilinear elements that mimic natural shapes, such as curved seating (vs. angular) or curved corridors and pathways (vs. straight), and finishing materials reflective of nature, such as wood trim, and colours in pale greens, blues, and yellows. Facilities with acreage can intentionally design and install gardens and landscapes that provide therapeutic benefits, develop vocationally oriented gardening programmes, or simply encourage people to be in nature. While some biophilic elements are more evident and others more subtle, thoughtful considerations for biophilic design enhance the therapeutic capacities of custodial facilities.

Guidelines for Designing Health-Promoting Custodial Environments

The natural landscape holds great potential to facilitate the physical, mental, and social well-being of incarcerated individuals. Creating a health-promoting landscape requires intentionality on the part of custodial administrators. We offer a nested framework of guidelines to guide the process of designing and constructing outdoor custodial environments (Fig. 22.4).

The process centres the *incarcerated person* and their health, experiences, and needs. These experiences and needs are embedded in the design of the physical *institution*. Incarcerated persons' ability to use and benefit from the landscape is supported by the *policy*, including procedural and budget, context of the institution. Supporting each level is the creation of *alliances* with designers and the engagement of key stakeholders. We discuss each level in more detail below.

22 From Grey to Green: Guidelines for Designing ...

Elements: Attributes
Environmental Features: Air, sunlight, plants, habitats, etc.
Natural Shapes and Forms: Simulation of natural, features, biomorphy, and geomorphology
Natural Patterns and Processes: Sensory variability, information richness, bounded spaces, patterned wholes, transitional spaces, etc.
Light and Space: Natural Light, filtered and diffused light, light and shadow, warm light, spaciousness, and spatial variability
Place-Based Relationships: Geographic connection to place, ecological connection, indigenous materials, landscape ecology, etc.
Evolved Human-Nature- Relationships: Prospect and refuge, order and complexity, curiosity and enticement, change and metamorphosis, etc.

ATTRIBUTES 39/72

Fig. 22.2 The Multipurpose Outdoor Classroom at ICIW balances biophilic design in the landscape with security to provide nature exposure for incarcerated individuals (*Credits*—Photographs: Kris Gaspari [left] and Julie Stevens [right] Graphic Layout: Victoria Troutman)

Fig. 22.3 The Attention Restoration Theory was a critical framework for the design of the landscape at ICIW (*Credits—Photograph:* Julie Stevens *Graphic Layout:* Victoria Troutman)

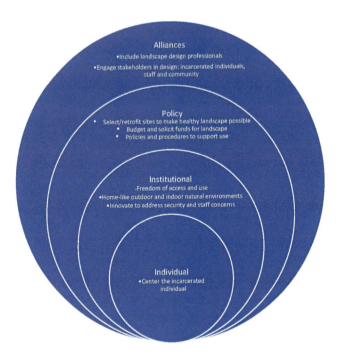

Guidelines for developing health-promoting custodial environments

Fig. 22.4 Guidelines for developing health-promoting custodial environments

Individual Outcomes Level in Nested Model

Centres the Individual Who is Incarcerated

Designing to meet the needs of incarcerated individuals requires a commitment to understanding that, regardless of circumstance, the incarcerated individual has physical, psychological, and spiritual needs. Meeting these needs is a positive step towards empathic and equitable design that holds meaning and purpose and a space for the individual to achieve their goals.

A typical concern about the custodial experience is the occupational deprivation that many incarcerated people experience; a lack of or limited opportunity to engage in activities that are meaningful and purposeful. Lacking meaning and purpose, people may become bored, angry, depressed, or stressed (Reitz et al., 2020). Nature-based activities that support meaning, purpose, and agency can be provided through choices of passive and active garden programmes including the installation and care of production and therapeutic gardens. Active, hands-on, participation can include tasks such as planting, building, tending and maintaining the garden, or exercising outdoors. Passive engagement might involve sitting quietly, or participating in stress reduction activities that help regulate the interoceptive system such as meditating, yoga, or Qi-gong in a therapeutic garden.

A focus on the needs of incarcerated individuals and the goals one seeks to achieve during a period of incarceration introduces design geared towards pro-social support and teamwork opportunities for incarcerated individuals; to work together for the common good of growing produce to eat, to save seeds for future planting, and to gain important interpersonal and vocational skills useful while incarcerated and also upon release from the custodial institution. Such considerations support a sense of agency and autonomy and is empowering in a culture that typically offers little. Designing the outdoor custodial campus with the intention of conveying hopefulness through supportive and intentionally designed outdoor spaces that enhance physical, psychological, and spiritual health, rather than the hopelessness typically associated with bleak and stark prison campuses where outdoor work may be equated with punishment is necessary to reduce stress, increase coping skills, and encourage a culture of wellness.

Institutional Design Level of Nested Model

Freedom of Access and Use

To fully realize the benefits of nature for health and well-being, incarcerated individuals require access to the landscape, ideally from sunrise until

sunset, and should be encouraged to explore it. Access that is restricted (e.g., a lawn one cannot sit on) or used as a reward or punishment does little to reap the therapeutic benefits of nature engagement. The ICIW's MOC offers an example of how to design for access and use. The wayfinding and circulation routes encourage incarcerated individuals to move through the landscape as they go about their day. A variety of spaces within it provide choices for incarcerated individuals to decide whether they wish to stay within the landscape and sit in sun or shade, in larger or small groups, and in social or secluded spaces. The plants, materials, and forms within the MOC reflect the local and regional character and ecological typology to maximize the phenomenological events that elicit repeat visits and evoke a sense of wonder—e.g., light and shadow throughout the day, colour changes throughout the season, and migratory birds and butterflies.

Freedom of access and use varies across settings within the facility and the varying needs of incarcerated individuals. For example, those living in mental health units may need additional safety features and protection from potential unwanted interpersonal interactions within the general prison population. As we found at ICIW with the design and construction of a healing garden outside the mental health units, a smaller, more accessible secure garden, both in terms of proximity to the living unit and accessibility by those with physical and/or cognitive challenges was necessary.

Create a Home-Like Outdoor and Indoor Natural Environment

Life in prison presents an extreme recipe for unrelenting stress, offering little environmentally to relieve that stress, inspire change, or reflect each individual's worth. After working side-by-side with hundreds of incarcerated people, it is clear that home is where they wish to be. By using the word "home," we are not referring to the type of housing or home life actually experienced as a child or adult, which for many who are incarcerated are places and experiences of negative emotions, poverty, abuse, and trauma (Briere et al., 2016; Facer-Irwin et al., 2019). "Home," rather, is

the experience of feeling free to be ourselves, able to let our guard down, rest from life stress, and build relationships and community. It is a place of autonomy where we can maintain our identity. In home, we begin to envision a future of hope and wholeness. Ideally, home is where we feel the greatest sense of control. This type of experience with "home" support incarcerated individuals in their rehabilitative and therapeutic goals.

We recognize that the design of one's "home" (as an experience) is subjective and shaped by personal experiences with violence and trauma as well as social inequities related to race, economics, and education. Further, the physical environment of one's actual home as a physical place, as children and adults, varies among incarcerated individuals. Coupling environmental psychology research, such as Kaplan, Kaplan and Ryan's theory of preferred environments and other theories with a more regional character, with a rigorous design process that not only centres the users but actually allows them to be the designers can ensure an environment that supports the need for the feelings of "home" in the most idealist sense—a place of control, autonomy, hope, and love. A one-size-fits-all suburban backyard approach will not work in all custodial settings. Rural custodial settings, such as ICIW, benefit from expansive landscapes and views to create an experience of "home." Urban prisons, which rarely have the space to create gardens and often offer no more than a view of the sky, would need to engage in a rigorous design process to determine what the incarcerated individuals there want and need in the physical environment to experience "home."

We encouraged the sense of control and hope through the design process as well. At ICIW, student and resident designers worked together through a lengthy process of gathering design ideas and developing plans. We did not anticipate that the result would be a garden that evoked a sense of home or neighbourhood park but research findings revealed this intriguing and unexpected benefit. This is a testament to the power of a design process that truly centres the incarcerated individuals. Regardless of the physical home environment from which the woman came prior to incarceration, their vision for the experience of home parallels what for many is a physical environment of a safe and healthy home.

While the resulting design certainly does not look like home and still looks like a prison to those who use it, it employs several principles, such as choice and freedom of movement to support the purposes associated with a home-like landscape. The scale is smaller. The gardens, despite the grand scale of many rural prison campuses, should feel like a backyard or neighbourhood park, rather than a large unattended landscape. The elements within them should activate the landscape, including bird feeders, small colourful plantings, and allow for choices such as seating areas for just a few people in both sun and shade. The activities available within them should also reflect a home-like environment. For example, the garden in the ICIW visiting room includes a looped walking path, play equipment, and musical instruments, similar to what may be found in a neighbourhood park. The garden also accommodates activities that families can engage together—balls, wagons, and bocce ball sets.

Innovate to Address Security and Staffing Concerns

Few security and staffing standards or policies address landscape features or allow for change from the typical lawn and concrete landscape. Creating therapeutic landscapes requires developing an innovative set of guidelines that ensure everyone's safety and addresses staffing concerns. Maintaining security is crucial to everyone's safety in the prison landscape and can be approached as a collective effort rather than a punitive standpoint. Generating these guidelines necessitates open and creative dialogue with all who are impacted, including security staff and incarcerated individuals. In our work at ICIW, we found that security administrators understood how to maintain security standards but more importantly, incarcerated individuals understood what it was like to live with and without threats to their well-being. Throughout the design process, resident designers provided the most critical feedback regarding their personal safety and innovated ways to maintain safety while introducing new and complex landscapes.

This work at ICIW highlighted four categories of safety concerns: sightlines, contraband, weapons, and staffing. *Sightlines* can be maintained by employing both security cameras and security staff physically

stationed in the landscape. Trees and plants should not block sightlines along pathways and seating areas. To ensure clear sightlines, the tree canopy should be limbed up and the mature height of herbaceous and smaller vegetation is best kept at 45 cm or less. If one is to reap the benefits of the landscape, maintaining sightlines requires a balance between the user seeing (prospect) their environment so they can let their guard down while feeling like they are not being seen (refuge) (Appleton, 1996). Trees can be incorporated into the landscape in such a way to create this experience without compromising security. Attention was given to elements in the landscape that can be used as *weapons*—e.g., the heavy stone walls were fused with a masonry glue as to not be picked up and thrown, wood structures were designed to eliminate deconstruction, and smaller stones that can be thrown or put in a sock and used as a bludgeon were avoided entirely. Not typically thought as a weapon but plants with thorns and toxic plants can be used to cause harm to self or others, and therefore should be avoided. Gardens are prime locations for hiding *contraband*, hence the landscape needs to be designed in a way that eliminates cracks and crevices in which small items can be hidden.

The overall design at ICIW offers a variety of landscape types and strives to balance more intensive landscapes with areas that are easier to maintain. The gardens require more knowledge, skills, tools, and time to maintain when compared to the previous expanse of lawn. These resources also require a budget for staffing and materials. Food produced in the garden can offset some of these budget concerns when done well and at a scale that provides a large amount of fresh produce to the prison kitchen. With some offset from the garden, a committed administration and a reasonable budget, incarcerated individuals can learn the skills to construct and maintain the landscape.

Additionally, gardens and naturalized landscapes might invite welcomed and unwelcomed wildlife into the prison. At ICIW, the gardens are home to many rabbits, which are loved by most incarcerated individuals who occasionally relocate them from the vegetable gardens to the native prairie beds. Many birds and pollinators have flown into the gardens which, for some incarcerated individuals, is problematic as they

fear being stung or pecked. These concerns are valid and more consistent education is needed to help residents understand the benefits and minimal risks posed by pollinators and birds.

Policy

Select or Retrofit Facility Sites to Make Healthy Landscape Design Possible

The health and integrity of the landscape is rarely considered when siting new or retrofitting older facilities. Facilities that are newly built next to landfill or toxic waste sites are particularly egregious examples of such disregard. Waste sites tend to emit strong and unpleasant odours, toxic fumes such as methane gas, and carcinogens leading to serious health disparities for people living and working on or near such sites. Adjacency to toxic sites reduces the likelihood that people will want to be outdoors. Furthermore, locating a prison on or near a toxic site communicates that incarcerated individuals are little more than trash. The soil surrounding toxic sites is typically ill-suited for plants and gardens, especially production gardens. Like any community adjacent to a major roadway system, when prisons are built near freeways, those living and working within them suffer from "reduced lung function, asthma, cardiovascular disease and even death" (epa.gov).

Retrofitting facilities brings its own limitation. The footprint of urban facilities is often so small that they do not allow for outdoor access and windows are so small that landscapes views can barely be seen. Roof gardens hold potential in these highly urban setting, but are limited by structural loads, physical access, and security constraints. Whether siting new facility or retrofitting an existing facility, attention to the landscape is necessary to ensure that the building, or campus of buildings, takes advantage of the landscape and respects the local and regional landscape character where most of the incarcerated individuals lived prior to arrest. This means, for instance, considering everything from the quality of the soil to how buildings are positioned on the site to the size and positioning of windows in the building. Will soil quality support a healthy natural

landscape? Are the buildings positioned to allow for the development of the land into a usable natural environment? Does movement between the buildings encourage engagement with the landscape? Are windows situated to facilitate nature views? When retrofitting existing facilities, administrators are challenged to explore how to improve nature access as a part of renovations and ensure that upgrades do not interrupt or reduce nature access. Without clear intentions to create a healthy and diverse landscape, both new and retrofitted facilities risk offering less landscape access than the older prisons they seek to replace or improve.

Budget and Solicit Funds to Support the Landscape

While there may be discretionary money for simple landscaping, such as planting shrubs and small flower gardens, few custodial budgets allocate money specifically for large-scale landscape design. The landscape is typically viewed as an unaffordable or undeserved "luxury," especially when compared to the priority of maintaining security. Given the health benefits of the landscape, however, the landscape contributes to other prison programming and offers a therapeutic resource for those who are ineligible for or choose not to participate in programmes. Research shows that access to simulated nature reduces disciplinary infractions (Nadkarni et al., 2017), a finding which holds promise for reducing security costs that come with the ability to self-regulate. The design-build process and landscape maintenance requirements also offer vocational-educational opportunities. Investing in the landscape is an investment in incarcerated individuals and their success in and out of prison.

Landscape budgets include funds for the design, construction, and ongoing maintenance of the landscape. These funds cover design time, plants and other building materials, maintenance supplies and time, and security costs associated with the building and use of the landscape. Some of these expenses already exist in custodial budgets, albeit in smaller amounts than is likely needed for a comprehensively designed landscape. Creativity may be required to fund the design, build, and maintenance of the landscape. In Iowa, for example, the state custodial budget funded

some aspects of the projects at ICIW while other funds or in-kind contributions came through the partnership with the Iowa State University (e.g., faculty and student labour) and plant donations from university and community programmes and businesses.

Develop Policies and Procedures to Support the Landscape

Custodial policies and procedures guide institutional functioning and aim to create a safe and secure custodial environment, both for those incarcerated there and employees. They dictate who can enter the facility, when and with what supplies, and who among incarcerated individuals is permitted to work with designers to design and build the landscape. It outlines which incarcerated individuals can be employed to maintain the landscape, when, and using what tools. It specifies who can be outside in the landscape, when and for how long, and while engaging in what activities. These policies and procedures necessarily guide the design-build process and maintenance and use of the landscape.

The creation of an intentionally therapeutic landscape will, if not should, challenge some policies and procedures, especially related to use. For example, use of the landscape should not be tied to disciplinary records or granted as a reward or denied as punishment. Rather, it should be treated as similar to access to drinking water or three meals a day. For maximum benefit, access to the landscape may need to be more frequent and longer than originally allowed. Even better, outdoor use can be integrated into the daily functioning of the facility, minimizing the need for scheduled use. For example, the landscape can be designed so people experience and subsequently benefit from it as they traverse between buildings for programs, dining and other activities. The landscape can include "outdoor classrooms," where vocational, educational, and therapeutic staff are encouraged to deliver their programmes. Special consideration should be given to people who are typically denied outdoor access. For example, if someone is combative and argumentative spending time outside may be more calming than sending them to

segregation. Or, if segregation is deemed necessary, there can be specialized outdoor environments within that unit. Similarly, a healing garden can be specifically designed for use by those in a mental health unit, ensuring it is within view, if not accessible, to those on suicide watch.

Alliance

Involve Landscape Design Professionals from the Outset

All too often, landscape professionals are invited into the design process after a building or campus of buildings has been finalized and approved, if at all. The landscape is treated as an add-on—or worse, a way to hide undesirable architecture and utilities—rather than a comprehensive and purposeful experience that has as much influence on the user as the building environment. At best, this approach reveals missed opportunities to develop a health-promoting landscape and, at worst, the landscape itself is detrimental to the health of people who interact with it and environmental sustainability.

Facility and campus design requires active partnership with landscape architects and designers as their expertise intersects with and can positively inform the design and engineering of the built environment (Stevens et al., 2018). Whether urban or rural, prison environments should be designed with a commitment to the health and well-being of incarcerated individuals which means making a commitment to providing opportunities to be in, work in and look at gardens and biophilic environments. A master plan can make best use of the landscape while meeting safety requirements. For example, creating a circulation system that weaves through gardens provides easy opportunities for people to reap the benefits of nature exposure as they go about their day. Wide fire lanes can be strategically placed to serve multiple purposes—a walkway wide enough to accommodate wheelchair use and separation for walking and jogging. Landscape designers can also look for opportunities to create diverse ecological habitats within the facility campus. Instead of engineering storm water conveyance in a way that makes the

landscape unusable, ecological storm water management gardens that are both beautiful and functional can be designed. Overall, landscape designers strategically and artfully design the environment in order to build therapeutic relationships between people, their daily activities, and the landscape.

Engage Stakeholders in Participatory Design Processes

Designing and building landscapes that facilitate health requires active engagement from those who will interact with it. The effective design teams understand users' needs, preferences, and even critiques, the more likely the design of the landscape will meet those needs and actually be used. Stakeholder involvement also serves to solicit their buy-in for the project, a commitment which may become useful when faced with later challenges. Three stakeholder groups are particularly important in the custodial setting—incarcerated individuals, custodial staff at various levels, and community.

Incarcerated individuals are the primary stakeholders in the design of the custodial landscape since its design is centred around their rehabilitative and therapeutic goals. Incarcerated individuals are experts of their needs and have design ideas of how to meet those needs, and how to do so within a secure facility, thus making them an integral part of the design team. They also bring existing skills and a desire to learn new ones, which also make them integral to the building and care of the landscape. Our experience at ICIW demonstrates that these "resident designers" benefit when they have ownership of the design process and the power to design the best possible space for health, healing, and relationship building. Designing, like gardening, is an act of hope and an opportunity to create a better future.

Custodial staff also interact with the natural landscape, for instance walking through the campus during the course of the work day or during breaks. They may be responsible for maintaining the landscape or offer programmes within it. Security staff may provide oversight of the landscape when in use and are responsible for ensuring that there are no

security breaches. Custodial staff offer a multifaceted view of the landscape, its benefits, and its risks to the functioning of the institution. Their active engagement in the design project ensures that their wisdom and concerns are addressed in the final design, build, and maintenance of the landscape. Design professionals are wise to educate custodial staff about the benefits of nature while genuinely acknowledging the difficulties of managing a more intensively designed landscape in a secure facility.

Community stakeholders also interact with the landscape. For example, family and friends visit their incarcerated loved ones and could benefit from an intentionally designed landscape during those visits (Toews et al., 2020). Volunteers facilitate programmes and could use the landscape in the course of programme delivery. Even crime victims and community members who do not enter the facility have a vested interest in the design of the custodial landscape; they want incarcerated individuals to return to the community as healthy and productive community members. Unfortunately, many community members view a beautiful landscape as a luxury that wastes tax money on "undeserving criminals." Engaging the community, even just by educating them on the therapeutic benefits of nature, can minimize negative community backlash.

Conclusion

The custodial landscape holds great promise for the physical, mental, and social well-being of incarcerated individuals. When designed with intention, using evidenced-based design principles, the custodial landscape can serve as a therapeutic and rehabilitative intervention available to and beneficial for everyone, regardless of whether they actively interact with it, view it from a window, or as they move about the facility. The benefits of this nature of engagement can extend into the community when the individual returns home. The success of transformation from grey to green requires the commitment of custodial administrators and a new kind of investment in the design of the custodial facility as well as the well-being of those under their care. The impact of this investment

is exponential as staff also benefit, both in their interactions with incarcerated individuals and from their own engagement in the landscape, which may serve to minimize the stress and fatigue associated with the work (Wagenfeld et al., 2018).

We dream of a world where prisons and jails do not exist, and the landscape may provide a path towards realizing this dream. Interaction with the natural environment has already been found to reduce recidivism, which will reduce the number of people at risk of incarceration and lessen the need for custodial facilities. More is required, however. Just as custodial environments are grey, so are the communities from which many incarcerated individuals come (Spatial Design Information Lab, 2008). Privileged communities have ready access to health-promoting landscapes while other communities are deemed unworthy and are rarely afforded the "luxury" of such landscapes. The landscape and criminal and social justice are inextricably interconnected. We dream of a world where everyone has access to the physical, mental, and social health benefits of nature and believe that in such a world, offending behaviour would be rare and, if it occurred, banishment to a grey environment would not be the response. The transformation from grey to green requires a commitment and investment from all of us.

References

Appleton, J. (1996). *The experience of landscape*. Wiley.

Arimoto, M., & Michaux, M. B. (2020). Community partnership through transformative justice: The healing garden project at the Oregon State Penitentiary. In M. Arimoto & M. B. Michaux (Eds.), *Higher education accessibility behind and beyond prison walls* (pp. 281–301). IGI Global.

Berto, R. (2014). The role of nature in coping with psycho-physiological stress: A literature review on restorativeness. *Behavioral Sciences, 4*(4), 394–409. https://doi.org/10.3390/bs4040394

Bratman, G. N., Daily, G. C., Levy, B. J., & Gross, J. J. (2015). The benefits of nature experience: Improved affect and cognition. *Landscape and Urban Planning, 138*, 41–50. https://doi.org/10.1016/j.landurbplan.2015.02.005

Briere, J., Agee, E., & Dietrich, A. (2016). Cumulative trauma and current posttraumatic stress disorder status in general population and inmate sample. *Psychological Trauma: Theory, Research, Practice and Policy* (pp. 439–446).

Calogiuri, G., & Hildegunn, N. (2015). The potential of using exercise in nature as an intervention to enhance exercise behavior: Results from a pilot study. *Perceptual & Motor Perceptual & Motor Skills: Exercise & Sport, 121*(2), 350–370.

Capaldi, C. A., Dopko, R. L., & Zelenski, J. M. (2014). The relationship between nature connectedness and happiness: A meta-analysis. *Frontiers in Psychology, 5*(976), 1–15.

Cooper-Marcus, C., & Sachs, N. A. (2013). *Therapeutic landscapes: An evidence-based approach to designing healing gardens and restorative outdoor spaces.* Wiley.

Corwin, M. L., McElroy, J.R., Estes, M.L., Lewis, J., & Long, M. A. (2020). Polluting our prisons? An examination of Oklahoma prison locations and toxic releases, 2011–2017. *Punishment & Society.* https://doi.org/10.1177/1462474519899949

DeHart, D., & Iachini, A. L. (2019). Mental health & trauma among incarcerated persons: Development of a training curriculum for correctional officers. *American Journal of Criminal Justice, 44*, 457–473. https://doi.org/10.1007/s12103-019-9473-y

Delaney, R., Subramanian, R., Shames, A., & Turner, N. (2018). Reimagining prison. Vera Institute. www.vera.org

Dinzeo, M. (2019). *Judge wades into debate over conditions at San Francisco jails.* Courthouse News Service. https://www.courthousenews.com/judge-wades-into-debate-over-conditions-at-san-francisco-jails/

Facer-Irwin, E., Blackwood, N., Bird, A., Dickson, H., McGlade, D., Alves-Costa, F., & MacManus, D. (2019). PTSD in prison settings: A systematic review and meta-analysis of comorbid mental disorders and problematic behaviors. *PLoS ONE, 14*(9), e0222407.

Frumkin, H., Bratman, G. N., Breslow, S. J., Cochran, B., Kahn, P. H., Jr., Lawler, J. J., Levin, P. S., Tandon, P. S., Varanasi, U., Wolf, K. L., & Wood, S. A. (2017). Nature contact and human health: A Research Agenda. *Environmental Health Perspectives, 125*(7), 075001. https://doi.org/10.1289/EHP1663

Gould, D. D., Watson, S. L., Price, S. R., & Valliant, P. M. (2013) The relationship between burnout and coping in adult and young offender center

correctional officers: An exploratory investigation. *Psychological Services, 10*(1), 37–47. https://doi.org/10.1037/a0029655

Han, K.-T. (2017). The effect of nature and physical activity on emotions and attention while engaging in green exercise. *Urban Forestry & Urban Greening, 24*, 5–13. https://doi.org/10.1016/j.ufug.2017.03.012

Haney, C. (2018). Expert report and declaration of Professor Craig Haney, Ph.D., J.D. United States District Court for the Middle District of Georgia, Macon Division. https://www.schr.org/files/post/2018.05.02%20Expert%20Report%20of%20Dr.%20Craig%20Haney%20%28REDACTED%29.pdf

Hansen, M. M., Jones, R., & Tocchini, K. (2017). Shinrin-Yoku (forest bathing) and nature therapy: A state-of-the-art review. *International Journal of Environmental Research and Public Health [Internet], 14*(8), 851. https://doi.org/10.3390/ijerph14080851

Haluza, D., Schönbauer, R., & Cervinka, R. (2014). Green perspectives of public health: A narrative review on the physiological effects of experiencing outdoor nature. *International Journal of Environmental Research in Public Health, 11*, 5445–5461. https://doi.org/10.3390/ijerph110505445

Hong, E., & Hong, S.-Y. (2016). The relationship between sensory processing and emotional regulation: A literature review. *Journal of Korean Society of Sensory Integration Therapists. Korean Academy of Sensory Integration, 14*(11), 50–59. https://doi.org/10.18064/jkasi.2016.14.1.050

Hussein, H. (2012). The influence of sensory gardens on the behaviour of children with special education needs. *Social and Behavioral Sciences, 38*, 343–354. https://doi.org/10.1016/j.sbspro.2012.03.356

International Committee of the Red Cross (ICRC). (2020). *Towards humane prisons*. https://www.icrc.org/en/publication/4286-towards-humane-prisons

James, D. J., & Glaze, L. E. (2006). Mental Health Problems of Prison and Jail Inmates U.S. Department of Justice. Office of Justice Programs. NCJ 213600. http://www.ojp.usdoj.gov/bjs/mhppji.htm

Kaplan, S. (1995). The restorative benefits of nature: Toward an integrative framework. *Journal of Environmental Psychology, 15*, 169–182. https://doi.org/10.1016/0272-4944(95(90001-2

Kaplan, R., Kaplan, S., & Brown, T. (1989). *With people in mind design and management of everyday nature*. Island Press.

Kellert, S. R. (2008). Dimensions, elements, and attributes of biophilic design. In S. R. Kellert, J. Heerwagen, & M. Mador (Eds.), *Biophilic design: The theory, science and practice of bringing buildings to life* (pp. 3–20). Wiley.

Kellert, S. R., & Wilson, E. O. (1993). *The biophilia hypothesis*. Island Press.

Kimme, D., Bowker, G., & Deichman, R. (2011). Jail design guide third edition. U.S. Department of Justice, National Institute of Corrections, NIC Accession number 024806.

Lynch, S. M., DeHart, D. D., Belknap, J. E., Green, B. L., Dass-Brailsford, P., Johnson, K. A., & Whalley, E. (2014). A multisite study of the prevalence of serious mental illness, PTSD, and substance use disorders of women in jail. *Psychiatric Services, 65*(5), 670–674. https://doi.org/10.1176/appi.ps.201300172

Mace, R. (1985). Universal design, barrier free environments for everyone. *Designers West, 33*(1), 147–152.

Martini, R., Cramm, H., Egan, M., & Sikora, L. (2016). Scoping review of self-regulation: What are occupational therapists talking about? *American Journal of Occupational Therapy, 70*(6), 7006290010p1–7006290010p15. https://doi.org/10.5014/ajot.2016.020362.

Massoglia, M., & Remster, B. (2019). Linkages between incarceration and health. *Public Health Reports, 134*(1_suppl), 8S–14S. https://doi.org/10.1177/0033354919826563

Moran, D. (2019). Back to nature? Attention restoration theory and the restorative effects of nature contact in prison. *Health & Place, 57*, 35–43. https://doi.org/10.1016/j.healthplace.2019.03.005

Moran, D., & Turner, J. (2019). Turning over a new leaf: The health-enabling capacities of nature contact in prison. *Social Science & Medicine, 31*, 62–69. https://doi.org/10.1016/j.socscimed.2018.05.032

Nadkarni, N. M., Hasbach, P. H., Thys, T., Crockett, E. G., & Schnacker, L. (2017). Impacts of nature imagery on people in severely nature-deprived environments. *Frontiers in Ecology and the Environment, 15*(7), 395–403. https://doi.org/10.1002/fee.1518

NC State University. (1997). *Principles of universal design.* https://projects.ncsu.edu/ncsu/design/cud/about_ud/udprinciplestext.htm

Ohly, H., White, M., Wheeler, B., Bethel, A., Ukoumunne, O., Nikolaou, V., & Garside, R. (2016). Attention Restoration Theory: A systematic review of the attention restoration potential of exposure to natural environments. *Journal of Toxicology and Environmental Health, Part B, 19*(7), 305–343.

Opsal, T., & Malin, S. A. (2019). Prisons as LULUs: Understanding the Parallels between Prison Proliferation and Environmental Injustices. *Sociological Inquiry.* https://doi.org/10.1111/soin.12290

Payne, P., Levine, P. A., & Crane-Godreau, M. A. (2015). Somatic experiencing: using interoception and proprioception as core elements of trauma

therapy. *Frontiers in Psychology,* 6(Article 93), 1–18. https://doi.org/10.3389/fpsyg.2015.00093

Porter, L. C. (2018). Being "on point": Exploring the stress related experiences of incarceration. *Society and Mental Health,* 1–17. https://doi.org/10.1177/2156869318771439

Poulsen, D. V., Stigsdotter, U. K., & Djernis, D. (2016). 'Everything just seems much more right in nature': How veterans with post-traumatic stress disorder experience nature-based activities in a forest therapy garden. *Health Psychology Open, 20*(6), 1–14. https://doi.org/10.1177/2055102916637090

Raanaas, R. K., Evensen, K. H., Rich, D., Sjøstrøma, G., & Patila, G.. (2011). Benefits of indoor plants on attention capacity in an office setting. *Journal of Environmental Psychology, 31,* 99–105. https://doi.org/10.1016/j.jenvp.2010.11.005

Rhineberger-Dunn, G., Mack, K. Y., & Baker, K. M. (2016). Comparing demographic factors, background characteristics, and workplace perceptions as predictors of burnout among community corrections officers. *Criminal Justice and Behavior, 44*(2). https://doi.org/10.1177/0093854816666583

Reddon, J. R., & Durante, S. B. (2018). Prisoner exposure to nature: Benefits for wellbeing and citizenship. *Medical Hypotheses, 123,* 13–18. https://doi.org/10.1016/j.mehy.2018.12.003

Reitz, S. M., Scaffa, M. E., Commission on Practice, & Dorsey, J. (2020). Occupational therapy in the promotion of health and well-being. *The American Journal of Occupational Therapy, 74*(3), 7403420010p1–7403420010p14. https://doi.org/10.5014/ajot.2020.743003

Spatial Information Design Lab. (2008). *The pattern: Million dollar blocks.* Columbia University. http://www.spatialinformationdesignlab.org/publications.php

Stevens, J., Toews, B., & Wagenfeld, A. (2018). Designing the correctional landscape: An invitation to landscape architecture professionals. *Landscape Journal, 37*(1), 55–72. https://doi.org/10.3368/lj.37.1.55

Toews, B. (2016). "This backyard is my serenity place": Learnings from incarcerated women about the architecture and design of restorative justice. *Restorative Justice: An International Journal, 4*(2), 214–236. https://doi.org/10.1080/20504721.2016.1197528

Toews, B., Wagenfeld, A., & Stevens, J. (2020). Feeling at home in nature: A mixed method study of the impact of visitor activities and preferences in a prison visiting room garden. *Journal of Offender Rehabilitation,* 1–24. https://doi.org/10.1080/10509674.2020.1733165

Ulrich, R. S., Simons, R. F., Losito, B. D., Fiorito, E., Miles, M. A., & Zelson, M. (1991). Stress recovery during exposure to natural and urban environments. *Journal of Environmental Psychology, 11*(3), 201–230. https://doi.org/10.1016/S0272-4944(05)80184-7

United States Environmental Protection Agency. Research on Near Roadway and Other Near Source Air Pollution. https://www.epa.gov/air-research/research-near-roadway-and-other-near-source-air-pollution

Van Der Linden, S. (2015). Green prison programmes, recidivism and mental health: A primer. *Criminal Behaviour and Mental Health, 25*(5), 338–342. https://doi.org/10.1002/cbm.1978

Waitkus, K. E. (2004). *The impact of a garden program on the physical environment and social climate of a prison yard at San Quentin State Prison.* Masters Thesis, Pepperdine University.

Wang, D., & MacMillan, T. (2013). The benefits of gardening for older adults: A systematic review of the literature. *Activities, Adaptation & Aging, 37*(2), 153–181. https://doi.org/10.1080/01924788.2013.784942

West, M. (1986). *Landscape views and stress response in the prison environment.* Master thesis, University of Washington, Seattle.

White, P. M., Alcock, I., Grellier, J., Wheeler, B. W., Hartig, T., Warber, S. L., Bone, A., Depledge, M. H., & Fleming, L. E. (2019). Spending at least 120 minutes a week in nature is associated with good health and wellbeing. *Scientific Reports, 9*, 1–11. https://doi.org/10.1038/s41598-019-44097-3

Wilson, E. O. (1984). *Biophilia.* Harvard University Press.

Wagenfeld, A., Sotelo, M., & Kamp, D. (2019). Designing an impactful sensory garden for children and youth with autism spectrum disorder. *Children, Youth and Environments, 29*(1), 137–152. https://doi.org/10.7721/chilyoutenvi.29.1.0137

Wagenfeld, A., Stevens, J., Toews, B., Jarzembowski, S., Ladjahasan, N., Stewart, J., & Raddatz, C. (2018) Addressing correctional staff stress through interaction with nature: A new role for occupational therapy. *Occupational Therapy in Mental Health, 34*(3), 285–304. https://doi.org/10.1080/0164212X.2017.1385435

Wener, R. E. (2012). *The environmental psychology of prisons and jails.* Cambridge University Press.

Winterbottom, D., & Wagenfeld, A. (2015). *Therapeutic gardens: Design for healing spaces.* Timber Press.

23

Does Nature Contact in Prison Improve Wellbeing? Greenspace, Self-Harm, Violence and Staff Sickness Absence in Prisons in England and Wales

Dominique Moran, Phil I. Jones, Jacob A. Jordaan, and Amy E. Porter

Introduction

In this chapter we summarise and extend recent quantitative research demonstrating a robust and statistically significant connection between greenspace and the wellbeing of prisoners and prison staff—research which supports prior findings of qualitative and ethnographic work in much smaller numbers of prison establishments (e.g. Moran, 2019).

D. Moran (✉) · P. I. Jones
School of Geography, Earth and Environmental Sciences, University of Birmingham, Birmingham, UK
e-mail: d.moran@bham.ac.uk

P. I. Jones
e-mail: p.i.jones@bham.ac.uk

J. A. Jordaan
School of Economics, Utrecht University, Utrecht, The Netherlands
e-mail: J.A.Jordaan@uu.nl

The developing literature on nature contact in prison builds upon research into the restorative characteristics of the built environment in general. Ulrich's (1984) study of the effects of nature views on patients' recovery from surgery led to subsequent work demonstrating the effects of a variety of built environment features on health and wellbeing (see Huisman et al., 2012). Within this literature, nature contact is often identified as a health-enabling element, producing calming effects, reducing stress and tension, and improving health outcomes. Authors have hypothesised about the potentially positive effects of nature contact in prison (e.g. Lindemuth, 2007; Reddon & Durante, 2019), but until relatively recently the evidence base has been limited. Moore (1981) reported fewer sickness calls made by prisoners with a view of nature from their cell, and since then knowledge about the impact of nature contact in prison has been advanced, including by Nadkarni et al. (2017), who found self-reported reductions in negative emotions, as well as reductions in violence and improvements in behaviour and communication in their experimental study of otherwise entirely nature-deprived solitary-confined prisoners viewing nature videos in one US facility. In addition, Moran and Turner (2019) considered the self-reported effects of nature contact for prisoners in two facilities in the UK and Norway, finding increased feelings of calm; Moran (2019) found in a study of prisoners in one UK facility that outdoor green spaces and whole-wall photographic images of the natural environment were self-reported to enable restorative effects, and to increase feelings of calm and the ability to reflect; and in the present volume, Johnsen (2022) and Stevens et al. (2022) explore aspects of the same relationship. However, there have been relatively few studies which have considered the impacts of nature contact on the wellbeing of prison staff (although see Moran & Turner, 2019). In much of this work, access to or views of nature are considered to affect wellbeing through mechanisms considered within Attention Restoration Theory (ART) or Stress Reduction Theory (SRT).

A. E. Porter
Department of Archaeology, University of Birmingham, Birmingham, UK
e-mail: AEP514@student.bham.ac.uk

ART holds that nature contact facilitates recovery from directed attention fatigue (Kaplan, 1995; Kaplan & Kaplan, 1989), whereas SRT posits that exposure to nature promotes stress recovery, based on positive psychophysiological responses rooted in evolutionary processes (Ulrich, 1981; Ulrich et al., 1991). However both consider that natural landscapes facilitate restoration from mental fatigue, stress and negative mood.

The interviews or surveys at one or two establishments commonly deployed in these prior studies mean that their findings are limited in transferability, and lack articulation with the trends of prisoner self-harm and violence, and staff absence and attrition that preoccupy prison managers and policymakers. In essence, at present we lack a prison greenspace evidence base of the type most likely to carry weight with those responsible for designing, building or maintaining prisons. Public opinion is perceived by policymakers to demand 'a triple bottom line of cost, safety and security' (Moran & Turner, 2019, 64) meaning that provision of green spaces is severely limited (Moran et al., 2016). In the UK, lawns, shrubbery and trees are considered expensive to install and maintain, and to pose a potential security risk, either for incidents at height, or for the concealment of contraband. Without robust evidence of the effects of greenspace, these arguments are difficult to counter, and in conjunction with concern that green spaces might look like too much of a 'luxury' to the tax payer, their inclusion tends to be minimised (Moran & Turner, 2019).

This chapter therefore summarises and extends recent research (e.g. Moran et al., 2021) which addressed this need to identify any statistically significant relationship between the presence of greenspace (defined as the percentage of vegetated landcover such as grass, bushes and trees within prison establishments)—and prisoner and staff wellbeing (using the proxies of low levels of prisoner self-harm and violence, and of staff sickness absence). This research used published data from prisons in England and Wales alongside a new dataset generated using GIS software. Since the details of statistical methodologies are covered in detail in the prior publications, this chapter focuses on the novel GIS methodology deployed, as well as the overall findings of this research and its implications.

First we turn to the notion of wellbeing in prison and the proxy variables used to approximate it in the reported analysis.

Self-Harm, Violence and Staff Sickness Absence as Proxies for Prisoner and Prison Staff Wellbeing

In the absence of any published direct statistical measures of 'wellbeing' for either prisoners or prison staff in England and Wales, the reported research instead utilised published data for prisoner self-harm and violence, and prison staff sickness absence, as proxies. In other words, for the purpose of enabling statistical analysis it was assumed that high levels of prisoner self-harm and violence, and of prison staff sickness absence, broadly equate to low levels of wellbeing among those groups (and vice versa). These data also reflect a current crisis. Prisoner self-harm and violence reached record levels in our study context (HMIP, 2020), with over 64,500 incidents of self-harm in the year to June 2020, up 11% from the previous year. These numbers represent both incarcerated individuals in deep crisis and prison staff witnessing their distress (Walker et al., 2017). Over the same period there were over 30,000 prisoner-on-prisoner assaults reported—many of which would have required de-escalation by prison staff—and almost 10,000 direct assaults against prison staff. There is something of a vicious cycle at work here—the dangerousness of prison work contributes to staff absence (Lambert, 2006; Lin, 2017; Tewksbury & Higgins, 2006), and record levels of self-harm and violence are *themselves* widely attributed to, and implicated in, loss of staff.[1] There are clearly wider political and economic forces at play, in terms of sentencing policy, prison funding levels and prison policy, but in this context, understanding the importance of environmental factors in alleviating the stresses and tensions which undergird these statistics is of critical importance.

[1] https://www.independent.co.uk/news/uk/home-news/prison-officers-experience-exodus-loss-jails-crisis-justice-governor-moj-a8929421.html. Accessed 30 January 2020.

Prison Greenspace and Prisoner and Staff Wellbeing

In the reported research (Moran et al., 2021, 2022a) we compiled publicly available data for all adult prisons in England and Wales on levels of self-harm (HMPPS, 2019a), prisoner-on-prisoner and prisoner-on-staff assaults (HMPPS, 2019b), and staff sickness absence, as well as published prison-level data about the size, age, type,[2] level of crowding and level of staffing for all establishments operational at the time of analysis.[3] Given the complexity of the prison estate, the data were cleaned, excluding prisons with incomplete statistical datasets.

A novel prison greenspace dataset was created using Ordnance Survey Mastermap Topography Layer, 'sense-checked' using aerial photographs.[4] This allowed the total area within the prison perimeter to be calculated and compared against the total area identified in the Mastermap database as constituting greenspace, thus generating a greenspace percentage for each prison (Fig. 23.1). The resulting dataset showed substantial variation in greenspace percentages, from 0% to more than 75%, with an average of 36% (Moran et al., 2021).

[2] Type included (for men) Local (holding both short-sentenced prisoners and those awaiting trial or sentencing), High Security/Category A, Category B (medium-high security), Category C (medium-low security), and Open/Category D; Young Offenders' Institutes (YOI) for men aged 18–20; Female prisons, and those specializing in accommodating sex offenders (HMPPS, 2019c), were also collated and whether they were purpose-built as prisons or converted from other types of buildings such as military bases, orphanages or stately homes. This latter information was obtained from individual information webpages for prisons in England and Wales hosted at http://www.justice.gov.uk/contacts/prison-finder/. Accessed 5 May 2019.

[3] Given multiple changes in type, mergers and other changes, especially since 2012 (between 2012 and 2014 two new prisons opened, two prisons merged, 11 prisons closed, four changed role, and another temporarily closed, awaiting change of role) trends in these dependent variables were considered as averages for 2014 (or later for prisons opening after 2014) to 2018. For full details see Moran et al. (2021).

[4] This is a vector map layer with polygons at the building scale (1:1250) that allows for highly accurate analysis of land-use. Polygons labelled as either "multiple" or "natural" in the layer's "make" category were designated as greenspace for the purpose of analysis. The sense-checking revealed that the "multiple" category described non-natural greenspaces such as back gardens and playing fields. These types of green areas are mostly excluded from the OS Mastermap Greenspace Layer, which is why that dataset was not used in this analysis.

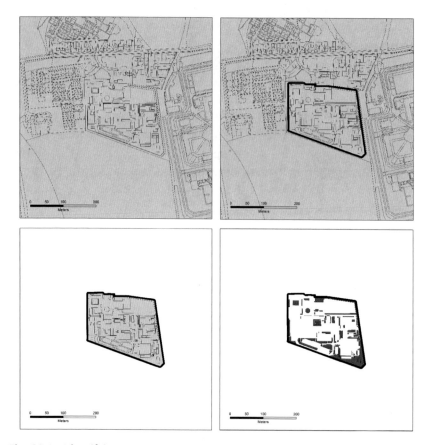

Fig. 23.1 Identifying greenspace within the prison envelope Mastermap topographic layer showing a prison (upper left); prison perimeter highlighted, with boundary exaggerated for clarity (upper right); polygons within the prison envelope isolated (lower left); all areas of greenspace within the prison wall identified (lower right). (*Source* Contains OS data © Crown copyright and database right [2020])

Prison Layout Type

In the analysis presented in this chapter, we extend the reported research by conducting exploratory investigations on whether and how the inclusion of prison layout type might impact on the wellbeing effects of greenspace. There have been various attempts made to classify 'types' of

prison layout, to draw inferences about the possible effect of different layouts on internal functionality and environment, and to deploy these types in assessments of their differential outcomes, but no universal classificatory system exists.

In their study in Texas, Morris and Worrall (2014) identified two main layout 'types': the 'telephone pole' characterised by rows of parallel multi-storey buildings connected by corridors; and the 'campus', comprising freestanding housing units. In the Netherlands, Beijersbergen et al. (2016) identified six layout types—panoptical, radial, rectangular, courtyard, high-rise and campus. However, in both prior studies, researchers had difficulty applying their typologies. Many prisons, especially those incrementally added to over time, effectively form a 'hodge-podge of buildings laid out in no particular order or theme' (Morris & Worrall, 2010, 1087). In the Texas study such prisons had to be excluded from analysis. In the Netherlands, very rare access to individual prisoner data enabled researchers to determine in exactly which building *within* prisons research participants had been accommodated (during a fairly brief remand period), and to classify individual buildings rather than whole prisons (Beijersbergen et al., 2016).

In our study, we faced the same 'hodge-podge' problem, but lacked individual prisoner data. So rather than considering *overall* prison layouts (which would have meant excluding most prisons from analysis) we instead developed a layout categorisation based on the angle of articulation of individual elements of buildings—using the following three categories; less than, equal to or greater than 90°. In other words, buildings in the shape of crosses or in H shapes are categorised as 90°; radial buildings or K-shaped buildings, with wings articulated at acute angles, are categorised as less than 90°; and buildings with no articulation at all—i.e. long straight buildings, or those with sections articulated at obtuse angles, are categorised as greater than 90°. The rationale for using this type of classification is that the angle of articulation of buildings may influence the ingress of natural light and the view of external spaces. For example, cell windows positioned close to the acute angle of articulation of a radial prison will predominantly look out over adjacent buildings, rather than into open spaces, and may receive less natural light due to shading from those adjacent buildings.

Even though some prisons exhibit more than one type of angle, examining aerial photographs, and selecting the angle most commonly deployed removed a significant degree of the subjective judgement needed to apply existing typologies, and overcame the 'hodge-podge' problem, thus enabling all prisons to be included in analysis.

Greenspace and Prisoner and Prison Staff Wellbeing

We have previously reported (Moran et al., 2021, 2022a) evidence of the relationship between the percentage greenspace and prisoner self-harm, prisoner-on-prisoner assaults, prisoner-on-staff assaults and staff sickness absence using regression analysis, a powerful statistical method that enables examination of the influence of one or more independent variables on a dependent variable. This method enabled us to determine the effect of greenspace on these proxies for wellbeing, while controlling for the effects of other factors which might also affect wellbeing, such as prison age, size, type (male/female/young people/sex offenders), level of crowding, security categorisation and whether or not a prison was purpose-built (rather than having been converted from another use such as a military base).

The results of the regression analysis presented in Moran et al. (2021) show that greenspace promotes prisoner wellbeing, as it reduces self-harm, prisoner-on-prisoner and prisoner-on-staff assaults in prisons in England and Wales. The inclusion of other factors capturing size, age and type of prisons did not eliminate the estimated impact of greenspace on self-harm and prison violence, meaning that the effects of greenspace materialise in all types, sizes, ages and origins of prisons, and regardless of their level of crowding.[5] Overall, these findings indicate that even though several prison characteristics are associated with higher or lower levels of self-harm and prison violence, the negative and significant effect of greenspace on lack of wellbeing—i.e., its propensity to

[5] Using the sample mean values of self-harm and greenspace, a 10% increase in greenspace would result in a 3.5% reduction in prisoner self-harm. For prisoner-on-prisoner assaults and prisoner on staff assaults, a 10% increase of greenspace would generate reductions of 6.6% and 3.2% (see Moran et al., 2021).

reduce self-harm and violence—remains statistically robust. Additional cause-and-effect analysis also shows that prisoner-on-prisoner assaults and prisoner-on-staff assaults both increase the level of self-harm, indicating that greenspace *not only* has a direct effect on self-harm and prisoner assaults *but also* an indirect effect, by lowering prison violence which in turn reduces self-harm (Moran et al., 2021).

In related work (Moran et al., 2022a) we showed that prisons with a higher proportion of greenspace also exhibit lower levels of prison staff sickness absence—a perennial operational challenge for prison systems (Lambert, 2001). Behind prison officer sick leave statistics potentially stand a wide range of factors and circumstances. High levels of stress may make absence more likely (Lambert et al., 2005, 2010, 2011; Stoyanova & Harizanova, 2016). Stress may also affect prison officers' job involvement, reducing their commitment to the service, and rendering them less likely to internalise a culture of presenteeism (Camp & Lambert, 2006; Kinman et al., 2019), leading to absence. Prison officers are often at risk of assault, with resulting physical injuries and psychological stress sometimes necessitating absence from work. The relationship between levels of sickness absence and the physical and/or mental health of prison officers is not straightforward, and although we cannot directly conflate (lack of) sickness absence and 'wellbeing' more generally, in our prior work (Moran et al., 2022a) we deploy prison staff sickness absence as a loose proxy for prison staff wellbeing.

Similar to the research on the impact of greenspace on prisoner wellbeing, we find that prisons with a higher level of greenspace are characterised by higher prison staff wellbeing, evidenced by an estimated significant negative effect of greenspace on prison staff sickness absence. This effect persists when we control for prison size, type, age and levels of crowding. The estimated effect of greenspace is *also* robust to the inclusion of indicators of self-harm and violence among prisoners, and assaults against prison staff, factors which all exercise positive impacts on prison staff sickness absence. Taken together, these findings demonstrate that the presence of greenspace within prisons works to reduce staff sickness absence, even in prisons with high levels of prisoner self-harm, prisoner-on-prisoner assaults (which are known to cause considerable emotional

distress to staff) and assaults on staff (which may cause them actual bodily harm).

Greenspace, Wellbeing and Prison Layout

Given the robust findings discussed above that reveal the importance of greenspace for prisoner and prison staff wellbeing, we next move to consider the potential effect of prison layout within the regression models used to derive our prior results.

Looking at our classification of the prisons within our dataset according to their angle of articulation, 14 prisons have an angle of articulation of less than 90% (type 1), 69 prisons are articulated at 90 degrees (type 2) and 23 prisons are articulated at angles greater than 90% (type 3). To explore the possible effect of the angle of articulation of houseblocks, we re-estimated the main regression models used in our two previous studies (Moran et al., 2021, 2022a) to consider the effects both of the angle of articulation and of the interaction between greenspace and the angle of articulation to assess whether the effects of greenspace on prisoner and prison staff wellbeing are influenced by the type of prison layout. Before embarking upon estimations of this kind, we would usually have a clear working hypothesis that a change in a particular independent variable would reasonably be expected to lead to a change in a dependent variable. This was the case when we analysed the effects of greenspace on self-harm and violence, for example: prior research into the wellbeing effects of greenspace clearly suggested that we could hypothesise that an increase in greenspace would result in a fall in self-harm and violence, which is indeed what we found. However, in the case of angle of articulation, we have no such working hypothesis; there are no comparable indications within extant literature that any particular type of angle should have better or worse outcomes for prisoner or staff wellbeing, when approximated through the proxies of self-harm, violence or sickness absence. However, given the considerable challenges of isolating the effects of prison layout on wellbeing, as indicated by Morris and Worrall (2010) and Beijersbergen et al. (2016), we

proceed here in an exploratory manner, and view the results of these estimations in this light.

Building on Moran et al. (2021), we estimate the following regression model to identify the effects of greenspace and prison layout on prisoner wellbeing:

$$\begin{aligned} Y_i = \beta_0 &+ \beta_1 Greenspace_i + \beta_2 Angle_i \\ &+ \beta_3 Greenspace_i * Angle_i + \beta_4 Centuryold_i \\ &+ \beta_5 Opcap_pop_i + \beta_6 Population_i + \beta_7 Prisontype_i \\ &+ \beta_8 Sexoffenders_i + \beta_9 Purposebuilt_i + \varepsilon_i \end{aligned} \quad (23.1)$$

This regression model posits prisoner wellbeing Y of prison i as a function of greenspace, prison angle of articulation, some other prison characteristics, dummy variables identifying the various prison types (female prison, young offenders institute, etc.), whether a prison houses sex offenders, whether a prison is purpose-built and an idiosyncratic error term. Y is the prisoner-averaged number of self-harm incidents, prisoner-on-prisoner assaults or prisoner-on-staff assaults (averaged for the period 2014–2018). We use two different ways to capture the prison layout: the log of the value of the angle of articulation (lnAngle) or dummy variables that classify prisons as type 1, 2 or 3—(Angle_1, Angle_2, Angle_3). The variable Centuryold is a dummy variable identifying prisons that first opened in the nineteenth century; Opcap_pop is an indicator of overcrowding, measured as the operational capacity of a prison divided by its number of prisoners in 2014; Population is the log of a prison's number of incarcerated in 2014.

Table 23.1 shows the results when we add the angle of articulation to the original regression models from Moran et al. (2021) that estimate the effects of greenspace on prisoner self-harm and prisoner-on-prisoner and prisoner-on-staff assaults. Column 2 reports the results from including the variable 'lnAngle' and its interaction with greenspace (lnAngle*Greenspace). Doing so renders the direct effect of greenspace to turn insignificant; the estimated effects of lnAngle and lnAngle*Greenspace are also insignificant. The limited number of observations makes it difficult to interpret estimated coefficients in models

with interaction variables such as lnAngle*Greenspace. Therefore, in the bottom rows of Table 23.1 we also report the marginal effects of the variables capturing greenspace and the angle of articulation. These capture the average marginal effects of the variables; so for instance for greenspace, the marginal effect represents its estimated average effect that incorporates both its direct impact on the dependent variable and its effect through the interaction with lnAngle. Looking at the bottom of column 2, the marginal effect of greenspace is significant and negative. The marginal effect of LnAngle is insignificant.

The results in column 3 represent the findings when we control the effect of prison layout by including the dummy variables for the angle of articulation categories. We use angle category 1 as reference category. Looking at the results, greenspace, the angle category dummy variables and their interaction with greenspace all carry significant effects. The estimated direct effect of the angle categories is positive, whereas their interactions with greenspace create negative effects. The reported marginal effects indicate that the marginal effect of greenspace is not significant, and that prisons with 90 degree and obtuse angles have a significantly lower level of self-harm compared to prisons with acute angles.

Looking at the marginal effects that we obtain when estimating the models with the alternative dependent variables (prisoner-on-prisoner assaults and prisoner-on-staff assaults), the findings show in most cases that greenspace exercises a significant negative effect, (i.e. reducing the level of these incidents), whereas the effect of the angle of articulation is insignificant in most cases.

Table 23.2 contains the results from the estimations on drivers of prison staff sickness absence. Following Moran et al. (2022a), we estimate regression model (1) using as dependent variable the days lost to staff sickness per FTE (full time employee) in the prisons for the 12 months up to the end of March 2019. We control for the effects of prison layout by using the angle type dummy variables. The estimated effect of greenspace is significant and negative in all estimations, in line with our previous findings. As for the effect of the prison layout types, there is some mild evidence that the interaction between greenspace and prison layout influences the dependent variable. Looking at the marginal

Table 23.1 Drivers of prisoner wellbeing

Dependent variable	Self-harm 1	Self-harm 2	Self-harm 3	Prisoner on prisoner assaults 4	Prisoner on prisoner assaults 5	Prisoner on prisoner assaults 6	Assaults on staff 7	Assaults on staff 8	Assaults on staff 9
Greenspace	−0.51*** (0.17)	1.63 (1.70)	1.53*** (0.56)	−0.46** (0.16)	−4.08*** (1.61)	−0.34 (0.43)	−0.08** (0.03)	0.40 (0.38)	0.15 (0.10)
lnAngle		0.16 (0.19)			−0.08 (0.09)			0.04 (0.04)	
lnAngle*Greenspace		−0.44 (0.37)			0.77** (0.33)			−0.11 (0.08)	
Angle_2			0.19** (0.09)			0.02 (0.07)			0.03 (0.02)
Angle_3			0.44** (0.20)			−0.001 (0.10)			0.07* (0.04)
Angle_2*Greenspace			−1.73*** (0.50)			−0.24 (0.35)			−0.21** (0.09)
Angle_3*Greenspace			−2.26*** (0.64)			0.23 (0.42)			−0.29** (0.12)
Centuryold	−0.14** (0.06)	−0.09 (0.06)	−0.06 (0.07)	−0.12** (0.05)	−0.17** (0.07)	−0.17** (0.07)	0.001 (0.01)	0.002 (0.01)	0.004 (0.01)
Opcap_pop	−0.16** (0.08)	−0.16* (0.09)	−0.20** (0.09)	−0.02 (0.10)	0.02 (0.08)	0.01 (0.08)	−0.03** (0.014)	−0.036** (0.018)	−0.04** (0.02)
Lnpopulation	−0.15** (0.07)	−0.15** (0.07)	−0.18** (0.07)	−0.16** (0.08)	−0.10* (0.06)	−0.10* (0.06)	−0.006 (0.01)	−0.008 (0.01)	−0.01 (0.01)
Female prison	0.46** (0.23)	0.26 (0.19)	0.24 (0.21)	−0.29** (0.11)	−0.27** (0.10)	−0.27** (0.10)			
Catbtrain				−0.10** (0.04)	−0.11** (0.05)	−0.14** (0.06)	−0.02 (0.013)	−0.017 (0.015)	−0.026 (0.017)
Catctrain				−0.09** (0.04)	−0.08** (0.04)	−0.08** (0.04)	−0.03*** (0.01)	−0.03*** (0.01)	−0.03*** (0.01)
High security				−0.20*** (0.05)	−0.20*** (0.05)	−0.21*** (0.05)	−0.03** (0.015)	−0.045*** (0.01)	−0.05*** (0.01)

(continued)

Table 23.1 (continued)

Dependent variable	Self-harm 1	Self-harm 2	Self-harm 3	Prisoner on prisoner assaults 4	Prisoner on prisoner assaults 5	Prisoner on prisoner assaults 6	Assaults on staff 7	Assaults on staff 8	Assaults on staff 9
YOI				1.02*** (0.19)	1.25*** (0.24)	1.23 *** (0.24)	0.08 ** (0.04)	0.11*** (0.02)	0.11 *** (0.02)
Sex offender	−0.12 (0.09)	−0.13 (0.10)	−0.15** (0.07)	−0.15*** (0.03)	−0.14*** (0.04)	−0.14*** (0.04)	−0.03*** (0.01)	−0.025** (0.01)	−0.03 *** (0.009)
Purpose built	0.02 (0.07)	−0.02 (0.07)	−0.03 (0.07)	−0.10** (0.05)	−0.03 (0.05)	−0.03 (0.06)			
F	3.53 (0.00)	2.48 (0.00)	3.34 (0.00)	10.17 (0.00)	10.10 (0.00)	10.57 (0.00)	7.22 (0.00)	13.40 (0.00)	11.42 (0.00)
Adj. R square	0.32	0.21	0.32	0.77	0.84	0.84	0.41	0.48	0.50
N	91	81	81	102	91	91	96	86	86
Marginal effects									
Greenspace		−0.37** (0.19)	−0.05 (0.21)		− 0.56*** (0.20)	−0.46** (0.20)		− 0.08** (0.04)	−0.04 (0.04)
lnAngle		0.015 (0.11)			0.18** (0.07)			0.005 (0.02)	
Angle_2			−0.40*** (0.11)			−0.07 (0.06)			−0.04* (0.02)
Angle_3			−0.32** (0.15)			0.08 (0.09)			−0.03 (0.03)

*** $p < 0.01$, ** $p < 0.05$, * $p < 0.10$; robust standard errors in parentheses. Columns 1, 4 and 7 replicate findings from Moran et al. (2021)

effects, the importance of greenspace in lowering prison staff sickness absence is clearly confirmed. Furthermore, according to the results in the last two columns, the marginal effects of the angle category dummies are significant and positive. This suggests that features of the prison layout appear to lower prison staff wellbeing. Further research on this particular effect is necessary, as there may be a range of factors related to prison layout types that can impact on working conditions that negatively influence the wellbeing of prison staff.

Given the exploratory nature of this analysis, and particularly given the lack of a clear rationale for why the angle of articulation might be expected to affect the dependent variables of self-harm, violence and staff sickness absence, these inconclusive and slightly incongruous results are not unexpected. Overall, including the angle of articulation in our existing regression models does not produce results that differ strongly from our earlier findings. In most of the estimations, the angle variables carry insignificant coefficients, as do interaction variables with greenspace. Occasionally there are significant effects which may be worthy of further investigation (such as the suggestions that acute-angled prisons may have higher levels of self-harm, and that right- and obtuse-angled prisons may have higher levels of staff sickness absence), but in most cases the estimated effects of the angle of articulation variables are not significant. This is *not* to say that prison layout is not important at all, but given the nature of the dataset available to us and the way we have approximated layout through angle of articulation, its effects cannot be clearly identified in our analysis. Having said this, although the effects of prison layout remain challenging to discern, these additional empirical findings serve to reconfirm the overall significance of greenspace for prisoner and prison staff wellbeing, approximated by levels of self-harm, violence and staff sickness absence.

Implications and Conclusions

Previous studies have suggested a potential link between nature contact and improved wellbeing in individual prisons, but because of their small scale and largely qualitative methodologies, these findings are not

Table 23.2 Drivers of prison staff absence

Dependent variable	Staff absence	Staff absence	Staff absence	Staff absence	Staff absence
Greenspace	−7.40*** (2.40)	−18.62** (8.40)	−21.37** (9.82)	−21.08*** (7.57)	−21.64*** (7.60)
Self-harm		−0.05 (0.39)			0.16 (0.38)
Violence between prisoners			2.80** (1.11)		
Violence towards staff				4.85*** (1.80)	5.06*** (1.95)
Angle_2		0.09 (1.04)	−0.61 (1.30)	−0.12 (0.92)	−0.14 (0.92)
Angle_3		−0.98 (1.44)	−1.19 (1.49)	−0.87 (1.14)	−0.87 (1.16)
Angle_2*Greenspace		9.07 (8.63)	13.41 (10.22)	12.69 (7.97)	13.24* (7.99)
Angle_3*Greenspace		12.74 (8.82)	14.72 (10.07)	14.09* (7.82)	14.42** (7.84)
High security	−3.10*** (0.77)	−2.80** (0.99)	−2.32** (0.99)	−2.53*** (0.98)	−2.49** (0.99)
YOI	3.03*** (0.98)	2.54** (1.03)	−1.66 (1.77)	0.62 (0.99)	0.60 (0.97)
Population	0.20 (0.54)	0.21 (0.63)	0.48 (0.61)	0.82 (0.71)	0.94 (0.79)
Opcap	0.75 (0.62)	0.74 (0.53)	0.77* (0.45)	0.99* (0.50)	1.06** (0.52)
Crowded	0.13*** (0.04)	0.15*** (0.04)	0.15*** (0.04)	0.14*** (0.04)	0.14** (0.04)
Opcap*Crowded	−0.15*** (0.03)	−0.17*** (0.04)	−0.17*** (0.03)	−0.16*** (0.03)	−0.16*** (0.03)

Dependent variable	Staff absence	Staff absence	Staff absence	Staff absence	Staff absence
Century old	0.26 (0.80)	0.17 (0.96)	0.56 (0.92)	0.51 (0.89)	0.53 (0.89)
Sex offenders	−2.72*** (0.90)	−2.96** (1.17)	−2.49** (1.11)	−2.72** (1.09)	−2.67** (1.11)
Purpose-built	−0.20 (0.63)	−0.41 (0.68)	−0.31 (0.68)	−0.57 (0.71)	−0.56 (0.71)
F	6.93 (0.00)	6.44 (0.00)	8.04 (0.00)	9.42 (0.00)	8.87 (0.00)
Adj. R square	0.42	0.49	0.53	0.54	0.54
N	81	73	73	73	73
Marginal effects					
Greenspace		−9.64*** (2.68)	−8.82*** (2.55)	−9.19*** (2.43)	−9.29*** (2.43)
Angle_2		3.32 (2.40)	4.19 (2.75)	4.42** (2.29)	4.58** (2.32)
Angle_3		3.57 (2.42)	4.07 (2.71)	4.16*** (2.27)	4.28** (2.27)

*** $p < 0.01$, ** $p < 0.05$, * $p < 0.10$: robust standard errors in parentheses. Column 1 replicates findings from Moran et al. (2022a)

easily generalisable. Prior studies also tended to focus exclusively on the wellbeing of incarcerated populations to the exclusion of prison staff. Our analyses therefore provide the first robust, statistically significant evidence that the presence of greenspace has a measurable impact on wellbeing of *both* prisoners *and* prison staff. This evidence has major implications for prison design and policy, and could positively influence the wellbeing of incarcerated individuals and prison officers worldwide.

The specific effects of greenspace on the dependent variables used as proxies for (lack of) wellbeing—self-harm, violence between prisoners and against staff, and staff sickness absence—are also noteworthy. Prison systems vary in their punitive philosophy, their sizes and types of establishments, and their modes of operation, and in some jurisdictions a highly punitive penal philosophy means that *prisoner* wellbeing may not *itself* be a policy objective. However, even in such jurisdictions, there is likely to be a concern for the wellbeing of prison staff, and also an acknowledgement that self-harm and violence in prisons have implications for the retention of staff, as well as potentially severe financial consequences in healthcare costs and litigation. Our findings suggest that, whatever the policy imperative for the adoption of increased greenspaces in prisons, such an intervention would likely increase the wellbeing of both imprisoned and employed populations. We therefore argue that inclusion of greenspace should be a key element of design of new prisons, and that existing prisons should have the space within their perimeters 'greened' via planting of vegetation wherever possible.

Our analyses also open avenues for further exploration. We used self-harm, violence and sickness absence data as proxies for *lack* of wellbeing simply because they were available; our study context lacks an available dataset measuring wellbeing itself either for prisoners or prison staff. If such a database can be generated, there is clearly scope for analysis of the effects of greenspace to be repeated and for these findings to be tested using such data measuring wellbeing positively, rather than as the absence of 'ill-being'.

The strength of our analyses is in the macro-level analysis, progressing beyond the single-facility studies of nature contact in prison that have characterised previous research. A disadvantage of our approach, though, is that we implicitly assume that all prisoners and prison staff at

each establishment have equal opportunity (within these cohorts) to benefit from any greenspace present within the prison. Given varied sites, different views afforded from different accommodation units, and different working patterns for staff, this is unlikely to be the case. In other words, future studies could usefully determine what the views from individual cells or staff offices might be, how often incarcerated persons or prison staff might otherwise see green spaces which are out of sight from the units in which they spend most of their time (for example while moving from one part of the prison to another), and whether some prisoners might have a view to green space beyond the prison perimeter (for example if they have a view over the prison wall). In further work (Moran et al., 2022b) we explored such effects of green space beyond the prison perimeter, and other future work could productively explore the differential effects of different views.

In the present analysis we also implicitly assume that all individuals are equally sensitive to the impact of greenspace, whereas it is likely that its effects will to some extent depend on prisoner and staff characteristics, which (other than prisoner gender and sex-offender status, by virtue of prison type) were not considered in the work reported here. For instance, there is some evidence of gender differences in the positive health outcomes associated with access to natural environments (Richardson & Mitchell, 2010), and there may also be differential benefits for different socioeconomic and ethnic groups (Browning & Rigolon, 2018; Ruijsbroek et al., 2017). Our findings suggest that further research at individual prisons could usefully explore whether levels of wellbeing vary according to the accessibility or visibility of greenspace, and the characteristics of prisoner and prison staff populations.

Bibliography

Beijersbergen, K. A., Dirkzwager, A. J., van der Laan, P. H., & Nieuwbeerta, P. (2016). A social building? Prison architecture and staff–prisoner relationships. *Crime & Delinquency, 62*(7), 843–874.

Browning, M. H., & Rigolon, A. (2018). Do income, race and ethnicity, and sprawl influence the greenspace-human health link in city-level analyses? Findings from 496 cities in the United States. *International Journal of Environmental Research and Public Health, 15,* 1541–1563.

Camp, S. D., & Lambert, E. G. (2006). The influence of organizational incentives on absenteeism: Sick-leave use among correctional workers. *Criminal Justice Policy Review, 17(*2), 144–172.

HMPPS. (2019a). *Safety in custody: Self-harm in prison custody 2004 to 2018.* https://assets.publishing.service.gov.uk/government/uploads/system/uploads/attachment_data/file/797076/safety-in-custody-self-harm-dec-18.ods. Accessed 29 January 2020.

HMPPS. (2019b). *Safety in custody: Assaults in prison custody 2000–2018.* https://assets.publishing.service.gov.uk/government/uploads/system/uploads/attachment_data/file/797077/safety-in-custody-assaults-dec-18.ods. Accessed 29 January 2020.

HMPPS. (2019c). *The prison estate in England and Wales, including public and contracted prisons, HMPPS immigration removal centre operated on behalf of the Home Office and secure training centres.* Revised 1 July 2019. https://www.gov.uk/government/publications/prisons-and-their-resettlement-providers. Accessed 29 January 2020.

HMIP. (2020). Annual Report 2019-20 London: HMSO.

Huisman, E. R. C. M., Morales, E., van Hoof, J., & Kort, H. S. M. (2012). Healing environment: A review of the impact of physical environmental factors on users. *Building and Environment, 58,* 70–80.

Johnsen, B (2022). Designing green prisonscapes in Norway: Balancing considerations of safety and security, rehabilitation and humanity, In D. Moran, Y. Jewkes, K-L. Blount-Hill, & V. St John (Eds.), *The palgrave handbook of prison design,* Palgrave.

Kaplan, R., & Kaplan, S. (1989). *The experience of nature: A psychological perspective.* Cambridge University Press.

Kaplan, S. (1995). The restorative benefits of nature: Toward an integrative framework. *Journal of Environmental Psychology, 15*(3), 169–182.

Kinman, G., Clements, A. J., & Hart, J. (2019). When are you coming back? Presenteeism in UK prison officers. *The Prison Journal, 99*(3), 363–383.

Lambert, E. G. (2001). To stay or quit: A review of the literature on correctional staff turnover. *American Journal of Criminal Justice, 26*(1), 61–76.

Lambert, E. G. (2006). I want to leave: A test of a model of turnover intent among correctional staff. *Applied Psychology in Criminal Justice, 2*(1), 57–83.

Lambert, E. G., Hogan, N. L., & Altheimer, I. (2010). An exploratory examination of the consequences of burnout in terms of life satisfaction, turnover intent, and absenteeism among private correctional staff. *The Prison Journal, 90*(1), 94–114.

Lambert, E. G., Hogan, N. L., & Dial, K. C. (2011). The effects of job involvement on private correctional staff: A preliminary study. *Journal of Applied Security Research, 6*(2), 158–183.

Lambert, E. G., Hogan, N. L., Paoline, E. A., & Clarke, A. (2005). The impact of role stressors on job stress, job satisfaction, and organizational commitment among private prison staff. *Security Journal, 18*(4), 33–50.

Lindemuth, A. L. (2007). Designing therapeutic environments for inmates and prison staff in the United States: Precedents and contemporary applications. *Journal of Mediterranean Ecology, 8*, 87–97.

Lin, Y. (2017). Is this the right job for me and my children? Turnover intention and parental correctional career endorsement among correctional officers in Taiwan. *Asian Journal of Criminology, 12*(3), 217–230.

Moran, D. (2019). Back to nature? Attention restoration theory and the restorative effects of nature contact in prison. *Health and Place, 57*, 35–43.

Moran, D., & Turner, J. (2019). Turning over a new leaf: The health-enabling capacities of nature contact in prison. *Social Science and Medicine, 231*, 62–69.

Moran, D., Turner, J., & Jewkes, Y. (2016). Becoming big things: Building events and the architectural geographies of incarceration in England and Wales. *Transactions of the Institute of British Geographers, 41*, 416–428.

Moran, D., Jones, P. I., Jordaan, J. A., & Porter, A. E. (2021). Does nature contact in prison improve wellbeing? Mapping land cover to identify the effect of greenspace on self-harm and violence in prisons in England and Wales. *Annals of the American Association of Geographers.* https://doi.org/10.1080/24694452.2020.1850232

Moran, D., Jones, P. I., Jordaan, J. A., & Porter, A. E. (2022a). Nature contact in the carceral workplace: Greenspace and staff sickness absence in prisons in England and Wales. *Environment and Behavior, 54*(2), 276–299.

Moran, D., Jones, P. I., Jordaan, J. A., & Porter, A. E. (2022b). Does prison location matter for prisoner wellbeing? The effect of surrounding greenspace on self-harm and violence in prisons in England and Wales. *Wellbeing Space and Society, 3*, 100065. S2666558121000385. https://doi.org/10.1016/j.wss.2021.100065

Moore, E. O. (1981). A prison environment's effect on health care service demands. *Journal of Environmental Systems, 11*(1), 17–34.

Morris, R. G., & Worrall, J. L. (2014). Prison architecture and inmate misconduct: A multilevel assessment. *Crime & Delinquency, 60*(7), 1083–1109.

Nadkarni, N. M., Hasbach, P. H., Thys, T., Crockett, E. G., & Schnacker, L. (2017). Impacts of nature imagery on people in severely nature-deprived environments. *Frontiers in Ecology and the Environment, 15*, 395–403.

Reddon, J. R., & Durante, S. B. (2019). Prisoner exposure to nature: Benefits for wellbeing and citizenship. *Medical Hypotheses, 123*, 13–18.

Richardson, E. A., & Mitchell, R. (2010). Gender differences in relationships between urban green space and health in the United Kingdom. *Social Science and Medicine, 71*, 568–575.

Ruijsbroek, A., Droomers, M., Kruize, H., Van Kempen, E., Gidlow, C. J., Hurst, G., Andrusaityte, S., Nieuwenhuijsen, M. J., Maas, J., Hardyns, W., Stronks, K., & Groenewegen, P. P. (2017). Does the health impact of exposure to neighbourhood green space differ between population groups? An explorative study in four European cities. *International Journal of Environmental Research and Public Health, 14*, 618–632.

Stevens, J, Wagenfeld, A., & Toews, B. (2022). From grey to green: Guidelines for designing health promoting correctional environments, In D. Moran, Y. Jewkes, K-L. Blount-Hill, & V. St John (Eds.), *The palgrave handbook of prison design*, Palgrave.

Stoyanova, R. G., & Harizanova, S. N. (2016). Assessment of the personal losses suffered by correctional officers due to burnout syndrome. *The International Journal of Occupational and Environmental Medicine, 7*(1), 33.

Tewksbury, R., & Higgins, G. E. (2006). Prison staff and work stress: The role of organizational and emotional influences. *American Journal of Criminal Justice, 30*(2), 247–266.

Ulrich, R. S. (1981). Natural versus urban scenes: Some psychophysiological effects. *Environment and Behavior, 13*(5), 523–556.

Ulrich, R. S. (1984). View through a window may influence recovery from surgery. *Science, 224* (4647), 420–421.

Ulrich, R. S., Simons, R. F., Losito, B. D., Fiorito, E., Miles, M. A., & Zelson, M. (1991). Stress recovery during exposure to natural and urban environments. *Journal of Environmental Psychology, 11*(3), 201–230.

Walker, T., Shaw, J., Hamilton, L., Turpin, C., Reid, C., & Abel, K. (2017). 'Coping with the job': Prison staff responding to self-harm in three English female prisons: A qualitative study. *The Journal of Forensic Psychiatry and Psychology, 28*, 811–824.

24

Designing Green Prisonscapes in Norway: Balancing Considerations of Safety and Security, Rehabilitation and Humanity

Berit Johnsen

Introduction

Prison design in Nordic countries focuses on green outdoor spaces more than prison design in Anglophone countries (see, e.g., Jewkes, 2018; Moran & Jewkes, 2014; Moran & Turner, 2018). The therapeutic potential of these spaces, as well as harmful experiences when these spaces are created for visual effect only, has been discussed (ibid., see also Jewkes, 2020). This chapter presents a study of the building of two closed prison departments (high security) for men—Mandal and Froland—that were built simultaneously and are located at two sites approximately 120 kms apart in the southern part of Norway. The departments constitute parts of Agder Prison, a split-site prison with a total of four departments.[1] In

[1] The other two are Evje Department, holding women prisoners, and Solholmen Half-way house for both women and men.

B. Johnsen (✉)
University College of Norwegian Correctional Service, Lillestrom, Norway
e-mail: Berit.Johnsen@krus.no

© The Author(s), under exclusive license to Springer Nature Switzerland AG 2023
D. Moran et al. (eds.), *The Palgrave Handbook of Prison Design*,
Palgrave Studies in Prisons and Penology,
https://doi.org/10.1007/978-3-031-11972-9_24

this building project, non-traditional ideas for constructing the prison yards were welcomed by the Norwegian Correctional Service and "Statsbygg"—a public sector administration company that was responsible for building the departments. The idea was to pursue the greening of the outdoor spaces of the departments, open them up and make them available to prisoners for movement, exercise and other leisure activities. The study reported in this chapter explores the process of planning and operationalising the prison landscapes, or "prisonscapes" (Schept, 2014), in these two departments by analysing how the green open spaces were talked about and narrated by different actors involved—prison leaders, prison officers, architects, engineers and landscape designers.

A question that emerged during the study relates to the opinions of prison staff about the open yards and the free movement of prisoners in them. For prison staff, controlling where prisoners' bodies are at all times is essential for reasons of safety and security (Kantrowitz, 2012). Having those bodies in spaces that are not easily controllable, strictly defined and segregated may make staff feel a loss of control. Prison officers are trained to search for and minimise risk factors by being in a state of readiness to control them. The officers may experience some situations, such as the free flow of bodies in open yards, as so complex that they do not know how to handle all the risk factors they identify. It is therefore interesting to study how staff regard the free movement of bodies in outdoor spaces.

The data in this study derive from participant observations (Wadel, 2014) of inter-agency meetings with representatives from Statsbygg, the Directorate of the Correctional Service, the leadership of Agder Prison, staff unions and the staff chief safety representative. I was a member of this inter-agency group as a consultant due to my earlier work on sport and movement in prison (Johnsen, 2001, 2018); therefore, I informed the other members about the study and asked if the observations could be used as data. They all gave their consent. Data were also collected during visits to the building sites, where I observed the building process and had informal conversations with staff from Statsbygg and the Correctional Service. In addition, I conducted semi-structured interviews with two representatives from Statsbygg and two from the Correctional Service who have experience with planning and building prisons. Before

the data are presented and discussed, a brief theoretical overview of the study is provided.

Theoretical Approach

I have previously presented a theoretical approach to how the movement of bodies in a prisonscape can be analysed and understood (Johnsen, 2018). The approach is inspired by the work of the French philosopher Gilles Deleuze and his colleague Félix Guattari, a French psychoanalyst. This is, of course, one of many approaches that can be used, but I chose it because of its dynamic and relational potential.

The prisonscape—composed of buildings, fences, walls, gravel, asphalt, vegetation (trees, grass, flowers, etc.) and spaces in between these components—is itself an agent. The human body interacts with this agent and creates relations that enable it to *affect* and be *affected* (Deleuze & Guattari, 1987; Fox, 2011; Massumi, 1987), where affect is a change or variation occurring prior to an idea or perception (Colman, 2010). By being in constant interaction with its own parts and surroundings, including other bodies, the body creatively and continuously produces itself (see also Markula, 2018). The focus is not what a body *is* but what a body can *do* and its capacities to affect and be affected (Fox, 2011). What defines a body is not only biology or materiality but also the relational confluence of biology, culture and environment (Deleuze & Guattari, 1983, 1987; Fox, 2011). What emerges in this confluence of relations is a broader understanding of the body that is not only biological or material but also social, with no single aspect taking precedence (Buchanan, 1997; Deleuze & Guattari, 1987; Fox, 2011; Zourabichvili, 2012).

Complex constellations of bodies, things, expressions, etc., constitute *assemblages* that different forces struggle to territorialise and deterritorialise (Deleuze & Guattari, 1987; Liversey, 2010). The prisonscape in a closed prison constitutes an assemblage that is territorialised primarily by forces of safety and security, through which visible and invisible borders define where and when prisoners can move. The borders define what relations a body can make, what it can do, and its possibilities of being

affected. They also define when prisoners are "in place" and "out of place" (Douglas, 2002/1966; Philo, 2001). Bodies in place are docile bodies (Foucault, 1979), while bodies out of place are considered a risk because there is no control over what they might do, e.g., escape, hide drugs or other contraband goods or assault someone. Even if the forces of safety and security dominate the territorialisation of a prisonscape in a closed prison, they are constantly challenged by other forces trying to shape the prisonscape. Prisoners themselves may also define what force should territorialise the spaces they create (see, e.g., Crewe et al., 2014 on how prisoners regulate their expressions of feelings in different spaces in the prison).

According to Robène and Bodin (2014), a force that may contribute to territorialising the design of a prisonscape is general public opinion and its definition of how comforting and pleasurable a prison should be. To avoid provocation, decisions regarding how "nice" or "good" a prison should be, e.g., the facilities for outdoor exercise, in most cases will not contradict a society's idea of punishment. Halden Prison in Norway, for example, has received much attention from abroad and its green prisonscape with a wild nature—often presented as a park by foreign media—is regarded as a space where Nordic/Scandinavian Exceptionalism is materialised, i.e., where humanity is embedded in the design (see, e.g., Pratt & Eriksson, 2013). When the prison was built, however, it was flat-screen TVs and tiles in the bathrooms that provoked the Norwegian public. The governor of the prison responded to this critique by underlining that tiles in bathrooms were standard in public buildings in Norway and that "thick-screen" TVs were no longer sold. The green prisonscape did not cause any domestic reaction, and one reason may be that access to nature, either "wild" or in cultural landscapes, has long-standing traditions and is deeply embedded in Norwegian (and Scandinavian) culture (see, e.g., Henderson & Vikander, 2007). Being in nature for the sake of recreation or experiencing or enjoying it is a natural part of many people's lives, and it is generally understood that outdoor life affects people positively and leads to pleasant experiences and good health.

Particular forces may also define what meaning or effect an assemblage should have, and the design of a prisonscape with opportunities for prisoners to exercise and pursue sport and other leisure activities

may generally be accepted and legitimised outside the prison if rehabilitative values are emphasised (Johnsen, 2018). At an individual level, it is difficult to predict the effects of leisure activities and according to Elias and Dunning (1986), a characteristic of leisure activities is that they are primarily for the benefit of the individual rather than the interests of others. Research shows that prisoners' involvement in sport is based on a desire to be affected, to create relations that are experienced as meaningful and in some sense to create wellbeing (Gallant et al., 2015; Johnsen, 2001; Martos-García et al., 2009; Robène & Bodin, 2014). This means that prisoners become involved in exercise and leisure activities for the same reasons that other people do, for example, to avoid weight gain or do something pleasurable. Prisoners also exercise to retain sanity in an insane place (Sabo, 2001) or as a kind of self-therapy (Johnsen, 2018).

The Prisonscape

Froland and Mandal Departments are both located on the outskirts of areas dominated by commercial enterprises. Before the sites contained prisons, they consisted of woodland, but no natural landscape was preserved. On my first visit, immediately after the Froland site was prepared, I stood in the middle of it looking at a large "desert" of stones and gravel surrounded by an uneven landscape consisting of trees, moss and heath. There, I had a flashback to my first visit to the site of Halden Prison and the careful treatment of nature to enable it to stay alive during the building process. I asked our guide at Froland why some of the original landscape had not been preserved, and he replied, *This is how we build nowadays*. One interviewee (SB), however, expressed the following:

> A lesson learned from Halden Prison is the difficulties of running a prison with a lot of forest – that is why so many fences were put up there [making the forest unavailable to prisoners]. The outdoor area of a prison has to work in a practical sense; it will be easier to control this area in Mandal and Froland.

"Wild" nature is messy and difficult to control (Johnsen, 2018) and does not behave according to a grand plan (Möystad, 2018). Removing it allows for full control of the space, which expresses how forces of safety and security operate when territorialising a prisonscape.

The main prison building, which houses most of the prisoners, was constructed according to a standardised model—"Model 2015".[2] The building was labelled "the star building" by staff, as the model consists of a four-pointed star formed by a block with three floors divided into eight units of twelve single cells on the first and second floors (see the white buildings in pictures 1 and 2). *It is the function that gives the building form* (Interviewee SB), or "form follows function" (Möystad, 2018: 44), and architecturally, the model may be interpreted as a "typical repressive old[-fashioned] prison" (Moran & Jewkes, 2014: 351). Mandal houses one block and can hold 100 prisoners, while Froland houses two blocks and can hold 200 prisoners. Workshops, the school and the health department are located on the ground floor, which means that the prisoners do not leave the block for work, school or appointments with health personnel. The visiting area, special units for difficult or vulnerable prisoners, a central health department, the library, the multi-faith centre, facilities for physical training (gym and weight training room) and the shop are located in other buildings that prisoners can reach by crossing the yard. The departments have a self-catering system (prisoners make their own food), which harmonises well with the principle of normality; i.e., prison life should be as similar to ordinary life outside the prison as possible (see Johnsen & Fridhov, 2018).

The sites at both departments are relatively flat due to universal design requirements[3] and the need to build Model 2015 on flat ground, as the block has no basement. However, the sites have different levels to make them somewhat diverse and make them fit into the surrounding landscape. In this way, forces of aesthetics have also contributed to the territorialisation of the prisonscape. The levels are utilised by placing

[2] All new prisons in Norway will be built according to "Model 2015". The model can be categorised as a "rapid-build prison" (Jewkes 2018), as there is no need for calls for tenders or design competitions.

[3] Meaning that everyone should have access to the common areas in the prison, also those with mobility limitations.

buildings on the higher levels and football and basketball pitches on the lower levels (see Figs. 24.1 and 24.2). This distinguishes the different levels but also makes some of the blocks quite dominant in the landscape, especially in Mandal (see Fig. 24.2).

When the interviewees described the prisonscapes, they often referred to "quality". They used the concept to define certain criteria of durability and permanency in materials and standards in the design of the outdoor area but underlined that the quality was not extraordinary, as it reflected the "Norwegian standard" used in the construction of public buildings. Outdoor spaces must comply with many technical standards, such as drainage of water, storage of snow in wintertime and access for fire engines and ambulances. However, *the most challenging issue in constructing prisons is safety and security; here, the requirements are high* (Interviewee SB). High requirements imply certain standards for equipment, such as hyper-modern cameras surveilling every inch of the common areas in the prison, fences and LED lighting in the outdoor areas, and the total design of the area to make it manageable and controllable. Even if *safety and security permeate the whole project—it is the most important argument of all* (Interviewee SB), quality also refers to humanity and rehabilitation:

> It is right to build a prison of high quality. It is important to include the mentality of rehabilitation and facilitate in order to stimulate the prisoners in a positive way. ... We [the CS and SB] have never discussed this; we have simply silently agreed upon it. We have worked together to make this prison as good as possible, and we haven't disagreed upon this. (Interviewee SB)
>
> This prison will give the prisoners possibilities to participate in activities. The living conditions and the terms of serving a sentence should be good. This concerns rehabilitation and reducing recidivism. It's about showing the prisoners respect and decency. The quality is good, but the prison is not too nice. It should look decent; people are going to live there for a long time. (Interviewee CS)

Referring to quality standards, as the governor of Halden Prison did, is a way of opposing the force of public opinion in its attempt to territorialise the prisonscape as not too nice. Even so, the interviewees were

Fig. 24.1 Prisonscape, Froland department (*Photo Author*)

Fig. 24.2 Prisonscape, Mandal department (*Photo Author*)

aware of this force and concerned with finding a balance in order to not provoke it. Therefore, this force does have an impact. At the same time, the interviewees referred to forces of rehabilitation and humanity and claimed that these forces also have obvious legitimacy. Below, we will see how these forces have negotiated their way and somewhat challenged and deterritorialised the forces of safety and security in the design of the prisonscape.

Access to Space and Green Space

The total size of the prisonscape is approximately 950,000 square metres in Froland and 650,000 square metres in Mandal. The areas surrounding the blocks constitute approximately 2/3 of the departments' total areas and, with some exceptions to which I will return, define the yards. Because the spaces are so large, *it has been important to bring in enough vegetation* (interviewee SB). Again, quality has been vital, with detailed specifications of types of vegetation and their form, such as how large the circumference of trees should be. Trees are rare in prisons, and there are many arguments, supporting the forces of safety and security for not having them there: They obstruct sight lines, prisoners may climb them and fall and hurt or even kill themselves, and branches could be used as weapons or aid an escape (Moran & Turner, 2018). However, the Correctional Service has been positive about trees, and there are actually more trees in the yards than anticipated, as the forces of safety and security have been somewhat deterritorialised by the argument *Let's try, let them grow, and if they become a problem, we'll trim them or cut them down* (Interviewee SB).

Deterritorialisation is made possible by careful planning of the outer space. The grounds consist of lawns, asphalt, gravel and some artificial materials, and in addition to trees, there are areas with flowers and bushes. The planning is discreet, as the territorialisation of the forces of safety and security is hardly noticeable. The bushes are somewhat withdrawn from the pathways, which prevents prisoners from easily hiding contraband in them, and when looking at the trees, one hardly

realises that they are situated some distance from the fences and meticulously planted to ensure that they do not obstruct sight lines. The yards are multi-functional with different constellations. Prisoners can choose where to be; if one zone is occupied, they can select another one, and there is enough space for them to be alone. This discreet design gives the yard a "spatial economy" (Lefebvre, 1991) in which there is a capacity of increased intensity and territorialisation of safety and security measures if prisoners' bodies cross borders and become out of place. Trees may be cut down, bushes may be removed and additional fences may be installed to better control prisoners' movements. A common reaction among officers entering the yard for the first time is *Wow, this is big; how are we supposed to keep control here?* (Prison officer), but staff members' feeling of safety was a central issue in designing the yards. In becoming familiar with the prisonscape, many officers have realised that the yards are not as complex as the first impression may imply; they actually have a good overview.

The careful planning is perhaps most visible in the visiting area and the special units, where artificially constructed hills, bushes, flowers, lawns and trees create an uneven landscape, giving a green and soft impression and a feeling of privacy as they, together with some screens, shield certain areas from view. Here, other forces manifest themselves, such as consideration for children visiting their fathers or relatives. However, this landscape seems to be for the eye only, as the playgrounds are separated from the green areas by fences, although there is some grass in the playground areas. As there are gates in the fences, it is possible to deterritorialise the safety and security forces in this space even further, which may have value, especially when older children are visiting. They may find it difficult to relate to their father/relative when sitting around a table in a small visiting room, but if they can use this area to do something together, such as playing croquet or football, they will all become players of croquet or football and may find it easier to relate to one another.

Constructing such large outdoor spaces is unusual and costly. The expenses are related primarily to the size and not to extraordinarily expensive materials, as they are, again, standard. Even though the interviewees mentioned that they had overheard comments such as *Why should the greatest park in Agder County be in a prison?* (Interviewee SB),

there have been no objections to "inessential" costs (Moran & Turner, 2018) in the design of the yards. This may be due to a general understanding among the public of the importance of access to nature, and all prison staff and interviewees underlined the importance of having nature in the prison as well: *It is a generally accepted view that nature and "the green" are important for us* (Interviewee SB).

As different professionals were involved in the design and construction of the prisonscape, perspectives on why nature is important were elaborated:

> Nature is an easy thing to care for. You don't need any knowledge about relations or other things to be in or enjoy nature. It doesn't claim something back. You can love it without behaving in a certain way. At a micro-level, it has no commitment – nature is without reservations. It doesn't categorise people. You don't need any specific competence at all. You can communicate with it without anyone else. (Interviewee SB)

Our bodies easily create relations with nature, and nature immediately affects us because we do not need any specific capacity, or capital (Bourdieu, 2010/1984), to be affected by it. Being outdoors in spaces with nature, we "connect", and in this interaction, we experience good health, which continues in the longer term as we remember it and feel the effects. Moran, Jones, Jordaan and Porter (2021), Moran and Turner (2018) and Moran and Jewkes (2014) have documented the health-enabling capacities of contact with nature in prison, but they have also discussed the negativity of having nature and trees in a prison but not being able to be in nature, touch it or feel it (see also Jewkes, 2020). According to Lefebvre (1991: 162), "it is by means of the body that space is perceived, lived – and produced". This means that we do not perceive, live or produce space by just looking at it. To be affected, our bodies need to be *in* that space and use all our senses in becoming part of it. We must smell it, touch it and feel it. In Mandal and Froland, *the trees are going to be available for the prisoners; it will be possible to sit in the shadow of them and lie in the grass* (Interviewee CS). The fact that we experience spaces through the position of our bodies is recognised in the planning of the prisonscape:

> A prison would mostly be watched from the inside. It is experienced from the ground, and it should be experienced as good. ... Stimulation of the senses is important, and in this respect, variation is important. ... There are trees with colours in the autumn, trees that blossom, trees with different crowns and vegetation that has different heights in the growing season. ... It is nice to see seasons change and get a sense of life. (Interviewee SB)

An important aspect of "quality" is ensuring that green outdoor areas are as self-maintainable as possible. Nevertheless, they need to be taken care of, and maintenance requires labour. Here, the force of rehabilitation has territorialised the prisonscape, as an important purpose of designing the outdoor areas in Mandal and Froland has been to facilitate prisoners in educating themselves as landscape gardeners while taking part in the preservation and development of the prisonscapes. In addition to giving the prisoners possibilities in the labour market after they have served their sentence, engaging them in the preservation and further design of the prisonscape may affect them and give them new experiences of the prisonscape. It may also give them a sense of ownership, responsibility and pride in ensuring that the prisonscape is well kept. For some prisoners, this may be a pleasant occupation, as nature is easy to relate to and does not meet them with any prejudices about who they are or what they have done (see quotation above).

Access to Movement and Exercise

The pains of imprisonment have been well documented (see, e.g., Sykes, 1958), and according to Jewkes (2020), limited access to movement and use of the prisonscape can also be identified as pains. In the planning of the prisonscape of Mandal and Froland, the freedom and ability of prisoners to move have been vital. Technological installations, such as key cards and CCTV cameras, allow prisoners to move alone in and between authorised indoor and outdoor spaces. To justify the large prison sites, it has been important to make the outdoor spaces available to the prisoners, and in designing the yards to be as large as possible, the blocks have been

placed at the outskirts of the sites (see Pictures 1 and 2). However, the areas at the back of the blocks (towards the double outer fences) are not included in the yards. Here, the domination of the forces of safety and security is total, as fences (borders) block these areas for two purposes: They make it impossible for prisoners to "hide" behind the blocks, and they meet the required state of readiness for fire in such institutions. My mission in the inter-agency group was to influence and keep as much of the area as possible accessible to prisoners. I spoke enthusiastically of jogging tracks along the back sides of the blocks to make them longer and more stimulating, but this suggestion did not challenge the forces of safety and security.

On a visit to the prison, I also reacted to the fences surrounding the football, basketball and volleyball pitches. Wherever I was in the yards, I had to relate to the fences, and what might have been stunning parks were somewhat destroyed by them, in my eyes. These fences are also expressions of the territorialisation of the safety and security forces, as the fences divide the space in the yards and it is possible to shut the pitches off by locking the gates. However, the staff has agreed to leave the gates open to make the whole yard available for the prisoners during exercise, which means that the prisoners' bodies may be in place both outside and inside these fences. These enclosed areas may also function as evacuation zones in case of fire, and they may also be locked to help an officer keep control if (s)he is alone in the yard, e.g., playing basketball with prisoners. On my visits, I did not spot any invisible borders in the yards, but these tend to occur when prisoners start to use a place.

Jogging tracks of certain lengths; football, basketball and volleyball pitches; calisthenic parks; and facilities for table tennis should inspire prisoners to move and exercise. Variation and sensory stimulation are important in this respect; for example, on their way around the yard, prisoners will walk/run upwards and downwards, step on different ground surfaces—grass, gravel and asphalt—and encounter different kinds of vegetation, which will affect them in different ways. According to Andrews et al. (2014), landscapes and spaces have an impact on the individual in producing senses and feelings. One interviewee (CS) agreed with this, saying, *To have space and the possibility for bodily movement do*

something to people, and it is important that the outdoor area is green and nice and appears inviting (see Fig. 24.3).

A pleasant outdoor space, with nature and facilities for exercise and leisure, gives prisoners the possibilities of creating and being part of different assemblages, such as a group of people playing soccer. In the game, they interact with each other and their surroundings, such as the good football pitch, which likely creates a positive affect in each of them. Additionally, inwards relations that happen in their bodies during exercise, such as increased pulse and sweat, create affects, as do situations in the game, resulting in feelings such as mastery when scoring a goal or anger when being tackled. In a match, the players feel a sense of collectiveness, as they are a team, and after the match, they may be tired, which makes it easier for them to fall asleep in the evening (Johnsen, 2001). In the longer term, some players may lose weight, while others may avoid gaining weight, in both cases making them feel fit. It is a well-documented fact that many prisoners experience unfavourable weight gain during incarceration due to, among other issues, limited opportunity for physical activity (Gebremariam et al., 2017),

Regular physical exercise promotes health, both physical and mental, and Woodall and South (2012), in their discussion on "health promoting prison", refer to the WHO (1986) and the importance of considering the physical environment and the "layout" of the prison, which should include the design of the outdoor space. As discussed above, effects that occur in prisoners' relationships with the prisonscape may result in health improvements, especially if the design of the prisonscape is pleasant and inspires movement and exercise. A health effect of movement may be wellbeing (Atkinson & Scott, 2015).

Even if one could wish for the facilitation of movement and exercise in green yards to have a rehabilitative effect, this force has not been dominant in territorialising this space. Several forces have been in play here, but the focus has been on affect rather than effect. The argument in challenging the forces of safety and security has always been to expand what a body can do in prison and allow it to create assemblages that are experienced positively. In this way, forces of humanity, especially health and wellbeing, have been central, and together, they have challenged and deterritorialised the forces of safety and security.

Fig. 24.3 Yard, Mandal department (*Photo* Author)

Access Time

To experience and enjoy nature and the possibilities for movement and exercise in the yards, the prisoners need time to be in them. Access to the yards is regulated by daily schedules that specify carceral timespace (Moran, 2012, 2015), i.e., where the prisoners' bodies are supposed to be at any time. In detailed daily schedules, timespace is regulated very strictly, with clear definitions of when and where the prisoners' bodies are in or out of place, whereas in more "loose" daily schedules, there may be a more "free-flowing regime" (Liebling et al., 2020) in which prisoners can move between several spaces and be in place in a given period of time. In Froland and Mandal, the daily schedules have been under negotiation since 2017. According to an officer, these negotiations have been characterised by discussions between two different staff cultures: one promoting safety and security forces and the other promoting rehabilitative forces. The more traditional security-oriented staff have been sceptical about the free flow of prisoners in the prisonscape and have asked, *How will we be able to control where the prisoners are at any time? Where can prisoners move while we control where they are?* The more progressive, rehabilitation-oriented staff, however, have spoken in favour of less detailed control and more free flow of prisoners between spaces.

In these negotiations, the staff have realised that the self-catering regime requires time and a certain openness. Prisoners need to go shopping for their groceries, but no more than a certain number of prisoners can be in the shop at the same time. This arrangement is more complex in Froland, which has twice as many prisoners as Mandal. The results of the negotiations are daily schedules that are territorialised by a combination of safety and security and rehabilitative forces, with the prisoners on the second floor separated from those on the third floor. Prisoners on the third floor work full days and have access to the yard from 3 to 5 pm. In this period, they must do their shopping, but they can move freely between the shop, the yard and their living unit. While the 48 prisoners on the third floor of Mandal have access to the yard for two hours every day on weekdays, the 96 prisoners on the third floor of Froland cannot be in the yard at the same time, as there cannot be more than 72 prisoners in the yard simultaneously. Therefore, every other day on

weekdays, prisoners on the third floor of Froland have access to the yard for only one hour, between 5.30 and 6.30 pm. All units may use the yard between 6.30 and 8.30 pm, but the prisoners must sign up in a booking system. In this period, the prisoners may also participate in different activities, e.g., organised training in the calisthenics park. Prisoners on the second floor do not work full days and can move between the shop, yard and units between 9 and 10 am or 12 pm and 1.30 pm, which means that prisoners on the second floor have less access to the yard. This is intended, as they are encouraged to move to the third floor, and more access to the yard functions as an incentive in this respect. What happens if too many prisoners want to live on the third floor or if some prisoners are not able to fulfil the criteria and move to the third floor are questions that have yet to be answered. In addition, using access to the outdoor prisonscape as an incentive for prisoners to govern themselves in a rehabilitation process (Foucault, 2002) may be ethically questionable. On weekends, prisoners have access to the yard for one to one and a half hours each day. Prisoners located in special units also have access to the large yards at certain periods.

The question is whether such detailed regulation, with actually quite a few hours in the yard at the disposition of each prisoner for "free activities", will create problems. Too many prisoners wanting access to the same facilities at the same time may lead to conflicts that are less likely to occur in more free-flowing regimes, e.g., in Norgerhaven Prison – the prison Norway rented from the Netherlands in 2015–2018. Prisoners in this prison could spend several hours in the yard each day, and one prisoner said, *They give you activity time. There are no conflicts, and we have enough space and time. If we want to play tennis and the tennis court is taken, there is no stress. We can wait.*[4] Sensitive CCTV cameras should justify a more free-flowing regime. The prisoners' experience of the design and what the yards can offer will be influenced by the time they can spend in them.

[4] The quotation is from a study of Norgerhaven Prison during the rental period (see Liebling et al., 2020).

Closing Comments

The narratives of the different professionals involved in the design of Froland and Mandal show that the process of planning and operationalising the green prisonscapes in these prison departments has been complex. In this process, different forces have been put into play and dynamically negotiated their way to territorialising the prisonscapes. The force of standards represents certain qualities of different material substances, such as trees, bushes, grass, flowers and sport facilities, which constitute central elements in the yards. In addition, this force draws a line for what public opinion has to tolerate of material qualities in a prison. Embedded in the force of standards is a scope of opportunity for the forces of aesthetics, rehabilitation and humanity, including wellbeing and health, to create possibilities for what a body can do and how it can affect and be affected.

Experienced professionals know how to utilise this scope of opportunity, and by using arguments and perspectives, they put different forces into play. At the same time, a shared attitude and understanding between the professionals of the importance of rehabilitation and enabling prisoners to experience positive stimuli make it easier for the forces of rehabilitation and humanity to challenge the forces of safety and security and somewhat territorialise the prisonscape. Even if nature and possibilities for movement are visible when standing in or looking at the prisonscape, it is not possible to notice the full range of how the forces of rehabilitation and humanity have territorialised it. They are interwoven in the landscapes as a possibility for the education of landscape gardeners or as considerations for how the yards and the nature in them are experienced from the ground by the body. This discreet design adds quality to the prisonscape.

Concerning quality, a relevant question is whether the preservation of wild nature on the prison sites could have added quality. In this building project, the force of environmental protection has not been able to challenge the forces of present-day building traditions and the forces of safety and security. However, in the future, this might change, and removing nature and immediately afterwards bringing it back again may be considered unnecessary and costly. For wild nature to add quality to a prison,

it must be available to the prisoners, and the challenge in this respect is to adapt the function to the form in such a way that the forces of safety and security can be discreetly served.

The forces of rehabilitation and humanity in the prisonscapes of Mandal and Froland have downscaled the number of borders. The force of humanity has especially dominated the facilitation of sport and other leisure activities where the body can move freely in a quite large space, create relations and be positively affected. The focus on affect rather than how these activities work (effect) is in line with Elias and Dunning's (1986) understanding of the concept of "leisure activities", where prisoners themselves can territorialise these activities and define their meaning. However, the strict limitations of access to the yards regarding time represent an additional border, and there is a risk that the green prisonscape for prisoners will mostly be a pleasure for the eye.

Even if the multiple stakeholders had reached a balance among different forces before the prisoners entered the prison, these and other forces will always struggle and negotiate with each other to territorialise the prisonscape. As a consultant for the facilitation of sport and movement in the prison yards, I hope that the forces that create possibilities for what a body can do territorialise the prisonscape even further and remove more borders. This especially concerns the removal of fences in prison yards and in visiting areas to make these areas available to prisoners and visitors. In addition, I hope staff find that the yards work so well that they may "loosen" the carceral timespace somewhat and make it possible for prisoners to spend more time in the yards.

References

Andrews, G. J., Chen, S., & Myers, S. (2014). The 'taking place' of health and wellbeing: Towards non-representational theory. *Social Science & Medicine, 108*, 210–222.

Atkinson, S., & Scott, K. (2015). Stable and destabilised states of subjective well-being: Dance and movement as catalysts of transition. *Social & Cultural Geography, 16*(1), 75–94.

Bourdieu, P. (2010) *Distinction: A social critique of the judgement of taste*. Routledge. (Orig. published in English 1984).

Buchanan, I. (1997). The problem of the body in Deleuze and Guattari, or, what can a body do? *Body & Society, 3*(3), 73–91.

Colman, F. J. (2010). Affect. In A. Parr (Ed.), *The deleuze dictionary* (Revised, pp. 11–14). Edinburgh University Press.

Crewe, B., Warr, J., Bennett, P., & Smith, A. (2014). The emotional geography of prison life. *Theoretical Criminology, 18*(1), 56–74.

Deleuze, G., & Guattari, F. (1983). *A thousand plateaus*. University of Minnesota Press.

Deleuze, G., & Guattari, F. (1987). *Anti-oedipus: Capitalism and Schizophrenia*. University of Minnesota Press.

Douglas, M. (2002). *Purity and danger*. Routledge. (Orig. published 1966).

Elias, N., & Dunning, E. (1986). *Quest for excitement: Sport and leisure in the civilizing process*. Basil Blackwell.

Foucault, M. (2002). *Forelesninger om regjering og styringsmakt*. Cappelen Akademisk Forlag.

Foucault, M. (1979). *Discipline and punish: The birth of the prison*. Penguin Books.

Fox, N. J. (2011). The Ill-health assemblage: Beyond the body-with-organs. *Health Sociology Review, 20*(4), 359–371.

Gallant, D., Sherry, E., & Nicholson, M. (2015). Recreation or rehabilitation? Managing sport for development programs with prison populations. *Sport Management Review, 18*, 45–56.

Gebremariam, M. K., Nianogi, R. A., & Arah, O. A. (2017). Weight gain during incarceration: Systematic review and meta-analyses. *Obesity Reviews, 19*, 98–110.

Henderson, B., & Vikander, N. (2007). *Nature first: Outdoor life in the Friluftsliv way*. Natural Heritage Books.

Jewkes, Y. (2020). "An iron fist in a silk glove": The pains of Halden Prison. In B. Crewe, A. Goldsmith, & M. Halsey (Eds.), *Power and authority in the modern prison: Revisiting the society of captives*. Claredon Press.

Jewkes, Y. (2018). Just design. Healthy prisons and the architecture of hope. *Australian & New Zealand Journal of Criminology, 51*(3), 319–338.

Johnsen, B. (2018). Movement in the prison landscape: Leisure activities—Inside, outside and in-between. In E. Fransson, F. Giofrè, & B. Johnsen (Eds.), *Prison, Architecture & Humans* (pp. 65–85). Cappelen Damm Akademisk.

Johnsen, B. (2001). *Sport, masculinities and power relations in prison.* Norges idrettshøgskole.

Johnsen, B., & Fridhov, I. M. (2018). Resettlement in Norway. In F. Dünkel, I. Pruin, A. Storgaard, & J. Weber (Eds.), *Prisoner resettlement in Europe* (pp. 252–264). Routledge.

Kantrowitz, N. (2012). *Close control: Managing a maximum security prison. The story of Ragen's Stateville penitentiary.* Harrow and Heston Publishers.

Lefebvre, H. (1991). *The production of space.* Blackwell Publishing.

Liebling, A., Johnsen, B., Schmidt, B. E., Rokkan, T., Beyens, K., Boone, M., Kox, M. & Vanhouche, A-S. (2020). Where two 'exceptional' prison cultures meet: Negotiating order in a transnational prison. *British Journal of Criminology, 61,* 41–60. https://academic.oup.com/bjc/advance-article/; https://doi.org/10.1093/bjc/azaa047/5892706?guestAccessKey=cc8 88588-fac5-4014-980e-56067496d077

Liversey, G. (2010). Assemblage. In A. Parr (Ed.), *The Deleuze dictionary* (Revised, pp. 18–19). Edinburgh University Press.

Massumi, B. (1987). Translator's foreword: Pleasures of philosophy. In G. Deluze & F. Guattari (Eds.), *Thousand plateaus* (pp. ix–xv). University of Minnesota Press.

Markula, P. (2018). What is new about new materialism for sport sociology? Reflections on body, movement and culture. *Sociology of Sport Journal, 36*(1), 1–11.

Martos-García, D., Devís-Devís, J., & Sparkes, A. C. (2009). Sport and physical activity in a high security Spanish Prison: An ethnographic study of multiple meanings. *Sport, Education and Society, 14*(1), 77–96.

Moran, D. (2015). *Carceral geography: Spaces and practices of incarceration.* Ashgate.

Moran, D. (2012). "Doing time" in Carceral space: Timespace and Carceral geography. *Geografiska Annaler: Series b. Human Geography, 94*(4), 305–316.

Moran, D., Jones, P. I., Jordaan, J. A. & Porter, A. E. (2021). Does nature contact in prison improve well-being? Mapping land cover to identify the effect of greenspace on self-harm and violence in prisons in England and Wales. *Annals of the American Association of Geographers.* Published online 22 February 2021. https://doi.org/10.1080/24694452.2020.1850232.

Moran, D., & Turner, J. (2018). Turning over a new leaf: The health-enabling capacities of nature contact in prison. *Social Science & Medicine, 231,* 62–69. https://doi.org/10.1016/j.socscimed.2018.05.032

Moran, D., & Jewkes, Y. (2014). "Green" prisons: Rethinking the 'sustainability' of the Carceral Estate. *Geographica Helvetica, 69,* 345–353.

Möystad, O. (2018). *Cognition and the built environment*. Routledge.

Philo, C. (2001). Accumulating Populations: Bodies, Institutions and Space. *International Journal of Population Geography, 7*, 473–490.

Pratt, J., & Eriksson, A. (2013). *Contrasts in punishment: An explanation of anglophone excess and nordic exceptionalism*. Routledge.

Robène, L., & Bodin, D. (2014). Sport, prison, violence: On imprisonment and confinement conditions—'French Prison Sport' and the instruments of the world's good conscience. *The International Journal of the History of Sport, 31*(16), 2059–2078.

Sabo, D. (2001). Doing time, doing masculinity: Sports and prison. In D. Sabo, T. A. Kupers, & W. London (Eds.), *Prison masculinities* (pp. 61–66). Temple University Press.

Schept, J. (2014). (Un)seeing like a prison: Counter-visual ethnography of the carceral state. *Theoretical Criminology, 18*(2), 198–223.

Sykes, G. M. (1958). *The society of captives*. Princeton University Press.

Wadel, C. (2014). *Feltarbeid i egen kultur*. Cappelen Damm Akademisk.

WHO (World Health Organisation). (1986). *Ottawa Charter for Health Promotion*. WHO.

Woodall, J., & South, J. (2012). Health promoting practices: Dilemmas and challenges. In A. Scriven & M. Hodgins (Eds.), *Health promoting settings principles and practice* (pp. 170–185). Sage.

Zourabichvili, F. (2012). *Deleuze: A philosophy of the event—Together with the vocabulary of deleuze*. Edinburgh University Press.

25

Prioritizing Accountability and Reparations: Restorative Justice Design and Infrastructure

Barb Toews

Introduction

Think back to a time when you hurt someone. This harm does not have to be criminal; as fallible humans, we hurt people, intentionally and unintentionally and in small and big ways, in the course of living our lives and being in relationship with others. Now imagine you have decided to take responsibility for what you did and talk with the person you harmed. Where would you have this likely emotional and difficult conversation? What would the space look and feel like? How would the design of the space support your ability to be accountable and repair the harms you caused?

It is doubtful that you envisioned a custodial facility for this conversation. If you are like many other people, you imagined a comfortable

B. Toews (✉)
University of Washington Tacoma, Tacoma, WA, USA
e-mail: btoews@uw.edu

living room, a garden patio, park, or a comparable domestic or natural location. You likely sought the familiarity and physical and emotional safety that these spaces can provide, making it possible for you to be vulnerable, honest, and open to what you may hear from the person you hurt. You may have imagined a space in which you feel like you can be your best and most creative self, able to create a plan for meaningful accountability for the harms you caused. You may have sought a space where people who care for you can be present to support you in the difficult conversation. In imagining this space, you envisioned a space that supports restorative justice.

Each year, more than 2 million U.S. citizens are incarcerated for the crimes they committed (Sentencing Project, 2020), a sentence which is intended to punish and, at best, rehabilitate. Custodial design is an architectural representation of this punitive orientation which seeks to right the scales of justice through pain and retribution. Examples of such design include the lack of privacy, small cells or crowded dormitories, hard and cold materiality, and lack of nature access (Jewkes, 2018; Toews, 2016; Wener, 2012). The restorative justice (RJ) philosophy offers a different justice orientation, grounded in the goal of "making things right" for the damages caused by harmful actions and values such as respect and interconnectedness, upon which to build new spaces designed to support restorative justice experiences, processes, and community infrastructure (Toews, 2018a, 2018b). Despite what we wish for ourselves in terms of taking responsibility for harming other people, custodial design does not include elements intended to facilitate this type of accountability and may even create obstacles to achieving it (Toews, 2016, 2018a). RJ design (RJD) creates the environmental conditions in which an individual can safely explore accountability for the harms they caused. With this new foundation, restorative justice design (RJD) serves as a means through which to design our way out of incarceration and into just and equitable communities.

Restorative Justice: Philosophy and Practice

The contemporary criminal justice system rests on the largely unquestioned foundation of punishment (Goshe, 2019). Restorative justice offers a new foundation on which to build a justice response in the face of harm. Howard Zehr (2015) distinguishes between the contemporary criminal justice philosophy and restorative justice by outlining the questions that each seeks to answer in the course of doing justice (Table 25.1). The questions that guide contemporary criminal justice focus on the law, the offender, and punishment. In contrast, restorative justice inquires first about the people who have been hurt by the crime, the harms they have experienced, and their resulting needs. The justice response then emerges from those harms and needs in the form of accountability and "making things right." This process is relational and community-oriented, actively engaging the harmed person and the person who caused those harms and involving other people who have been indirectly impacted by the crime or who otherwise have a vested interest in the person who caused harm, the person harmed, or justice outcome. Justice is co-created by the parties most concerned with it, not dictated by an outside authority. The goal of harms repair also lays the foundation for an inquiry into the causes of crime and harmful behaviour, whether those causes be individual, interpersonal, or structural. The end result is a justice response that seeks to build strong communities (Toews, 2006; Turner, 2020).

Table 25.1 A comparison of justice questions (Zehr, 2015)

Contemporary Criminal Justice	Restorative Justice
1. What law was broken?	1. Who is hurt?
2. Who did it?	2. What do they need?
3. What do they deserve?	3. Whose obligation are those needs?
4. What process is most likely to deliver these deserts?	4. Who has a stake in the situation?
	5. What are the causes?
	6. What is the best process to make things right?

Restorative justice is guided by values that also sit in contrast to the contemporary justice system (Pranis, 2007). Justice is typically understood to be about tit-for-tat punishment and getting even—"you hurt me so I am going to hurt you back." It is a competition with winners and losers. Restorative justice, on the other hand, is guided by a belief in the *interconnectedness* of people and *respect* for both harmed individuals and the individuals who caused harm. The restorative spirit is that of *healing* and *transformation* for all involved. It values a *non-hierarchical* stance and seeks active *engagement* from impacted individuals and communities. It is these values, which do not put the person who caused harm on the defensive nor disregard the victim's experience and needs, that invite them to explore the repair of harms and making things right. One could argue that it is a justice approach grounded in *love*, which is compassionate and recognizes the purpose, worth, and shared humanity of both the person who was harmed and the person who caused harm[1] (Fetzer Institute, 2021).

As a philosophy with guiding questions and values, one can "do" or "practice" restorative justice in myriad of ways. The most common restorative justice practice is victim-offender dialogue in its many forms (Zehr et al., 2015). These dialogues bring together the harmed individual, the individual who caused the harm, and other stakeholders (e.g., families and community members) for a face-to-face conversation about what happened, the resulting harms and, to the degree appropriate, what is needed for repair. These dialogues are used in all kinds of crimes, including violent and non-violent and those with juvenile and adult offenders, and at various stages of the criminal justice process, from the point of arrest to pre-sentencing to post-sentencing to during a period of incarceration or after release from prison.

While engagement is a value, not all restorative justice practices involve dialogue between a victim and the person who harmed them. Practices can range from being fully restorative to only partially restorative (Van Ness & Strong, 2015; Zehr, 2015) and can engage with just individuals, two or more people interpersonally, or with the wider

[1] Fetzer Institute (FI) is cited as the source of the definition of love as FI funding supported the start of this work by the author and architect colleague, Deanna Van Buren.

community (Toews, 2006). The implication is that restorative justice can be applied in as many different ways as there are people and unique harms and needs, as long as the process is consistent with restorative goals and values.

Restorative justice takes on many forms in the custodial context (Presser, 2014; Swanson, 2009; Toews & Harris, 2010; Van Ness, 2007). Victim-offender dialogues between a violence survivor and the person who harmed them frequently occur inside prisons or outside in the community during periods of parole. Circles involving the harmed person(s), the individual who caused them harm, and others in their communities have also been convened to create or contribute to sentencing decisions and assist an incarcerated individual and their family to prepare for their release. Incarcerated individuals, survivors, and community members, who do not share a criminal event, may meet to engage in workshop-like dialogues about their experiences with victimization, offending, and justice. Incarcerated individuals participate in programmes "designed to develop behaviour inspired by insight, accountability, and compassion" as part of process preparing for release (Insight Prison Project, 2020, paragraph 2). Some prison administrators have created living units in the prison where daily life is guided by restorative values and practices. Circles of Support and Accountability welcome those who have committed sexual violence back into the community after incarceration in such a way as to reduce their risk of re-harming others. This variety sets the stage for the need for a variety of spaces to support these processes.

As indicated by restorative justice question five in Table 25.1, restorative justice is also concerned with personal, interpersonal, and social causes of, and conditions which give rise to, harmful behaviour. Trauma and social/racial injustice are two such causes and conditions which are of particular concern to restorative justice. Trauma theory and research suggest unhealed trauma may result in harming others, in the form of aggression or violence, and/or harming oneself through, for instance, substance abuse and risky behaviours such as sex work (Yoder, 2020). Research further shows that those who are incarcerated have experienced trauma and been diagnosed with PTSD at higher rates than those who have not been incarcerated (Briere et al., 2016; Facer-Irwin et al.,

2019). These findings suggest a connection between trauma, harmful behaviour, and incarceration. It is important to note that drug-related behaviours and sex work have been criminalized, meaning that both harming others and oneself puts one at risk of punishment and incarceration. Restorative justice seeks to transform this trauma, where the person who caused harm is simultaneously viewed as a victim or survivor deserving of vindication and repair on the part of others.

There is a social dymanic to trauma—e.g., homelessness and poverty are traumagenic experiences, where one may experience the condition as traumatic, rather than just stressful (Yoder, 2020). Trauma is also racialized (Menakem, 2021). Black, Indigenous, and People of Color (BIPOC) have experienced centuries of trauma in the form of white supremacy, genocide, slavery, lynchings, residential schools, internment camps, and basic human rights violations. The criminal justice system and incarceration have been inextricably intertwined with this history and used as a tool of racial oppression (Alexander, 2012; Davis, 2019; Goshe, 2019; Kaba, 2021). Today, it remains the primary tool of oppression, as evidenced by the disproportionate number of who are incarcerated (Alexander, 2012; Sentencing Project, 2020). Restorative justice seeks to address these social and racial inequities, recognizing them as traumagenic and traumatic experiences that require healing at the individual level and structural transformation at the social level. Davis likens this duality to a warrior-healer, where there is "activism as a form of social healing and interpersonal healing as a form of social justice. Transform and heal yourself as you transform and heal the world" (Davis, 2019, p. 95).

Restorative Justice and Design

Restorative justice as a design theory and application is relatively new (Mass Design Group, 2020; Pointer, 2019; Toews, 2018a; Van Buren, 2009) and, like restorative justice theory, restorative justice design (RJD) presents a critical paradigm shift in how we understand justice architecture (that is, the design of physical spaces in which justice processes occur or justice-related services are provided). Figure 25.1, for example,

a collage created by a group of incarcerated men who had committed violence, shows architectural features of a justice based on punishment (left side) and a justice grounded in love (right side) (Designing Justice + Designing Spaces, 2015). There are stark differences between the two sides in colour, texture, transparency, openness, and nature access. Like the physical foundation that supports all buildings, the foundation of RJD is love, from the ground to the roof. It is not simply adding restorative design elements to existing punitive architecture, as the punitive foundation is not designed to support love.

The foundation of RJD is an orientation towards the *goal* of restorative justice—repairing the harms of crime and making things right. Instead of designing spaces that represent what those who have offended deserve, an RJ-designed space offers support and safety to those impacted by and involved in crime so the harms can be identified and repaired. Starting from this foundation automatically leads to a different design approach. We no longer consider how to design spaces of punishment, putting the person who caused harm on the defensive and sidelining the person who was harmed; rather, we ask how to create an environment that facilitates openness, vulnerability, and empathy that supports accountability and inspires people to engage in personal, interpersonal, and structural healing and transformation.

The RJD foundation is cemented with restorative *values*, aligning the goal of design with its spirit, the messages users receive, and the qualitative experiences they have while in the space. RJD spaces, for instance, use architectural features, furnishings, and accessories to recognize the humanity of all users and communicate their worth, be they the person who caused harm, the person who experienced harm, their communities of care, or other community members. The design brings users into relationship with each other and sends the message that all are equal. It communicates the possibility for healing and transformation and offers the safety people need to work towards it. The energy in the space inspires their active participation in the work of justice that occurs inside it. The visual representation of these values creates a space that users experience as unique and distinct from other spaces in their lives, inspiring them to embody and enact the very values incorporated in its design (Pointer, 2019).

Fig. 25.1 Collage of magazine images created by incarcerated men to depict justice based on punishment (left side) and love (right side) (Designing Justice + Designing Spaces, 2015)

Restorative Justice Design Principles

The application or practice of restorative justice takes on many forms, thus requiring different types of spaces to accommodate varying needs, situations, and practices. These spaces may be rooms inside buildings, outside in the natural environment, or straddle both the built and natural environments. Preliminary theory development and research identify five emerging RJD principles that guide the design of these spaces, turning the restorative justice design theory into practice (Pointer, 2019; Toews, 2018a; Van Buren, 2009).

Relational and Flexible

RJD prioritizes personal and interpersonal relationships, in terms of acknowledging how people and relationships are harmed by crime and how those harms can be repaired. Thus, the environment calls for relational markers, from siting to rooms to furnishings. RJD spaces (RJDS) are located within the context of relationships such that the space is part of the fabric of community and everyday life, familiar and easy to access and use. This stands in contrast to, for instance, a justice centre located outside the community and everyday life, creating physical and psychological distance. Internally, the RJDS facilitate relationships by offering spaces for different sized gatherings—e.g., small spaces for a dialogue of 2–4 people up to larger spaces for circles of 20 or more people. This variety may come through a collection of rooms or the ability to divide a larger room into smaller, designated spaces through furnishings or other décor. RJDS also provide access to eating and cooking spaces, be it a snack and coffee table or kitchen, for sustenance but, perhaps most importantly, to facilitate fellowship and the breaking of bread together that can enhance the formal work of restorative justice. Furnishings that mark relational space are moveable so they can be configured to accommodate different types and sizes of dialogue. In particular, they can be positioned into the shape of a circle for dialogue, thus symbolizing non-hierarchy and equality among restorative justice participants. Notably, this principle is consistent with supportive design which, in the medical

context, expedites physical healing and increases patients' participation in their care (Ulrich et al., 2008), empirical findings that are relevant for a healing-oriented justice process which requires active engagement from those impacted by crime.

Natural and Organic

Design theory argues for and empirical research has long demonstrated that interaction with nature improves physical, mental, emotional, and social health (Kaplan, 1995; Kellert, 2018; Ulrich et al., 2008) in ways that can benefit those involved in the justice system and support the work of restorative justice. Violence survivors, for instance, experience reduced trauma symptomology and a sense of hope through nature engagement (Moore & Van Vliet, 2019; Toews, 2020). People who have offended experience calm and improved relationships and behaviour after interaction with nature (Moran & Turner, 2019; Nadkarni et al., 2017; Toews, 2016; Toews et al., 2018, 2020; Van Der Linden, 2015). Restorative justice theory also speaks to the relationship between humans, the natural world, and justice (Davis, 2019). Taken together, there is a strong argument to be made for prioritizing the presence of nature within RJDS. RJDS may be located fully outside, with fresh air, open skies, trees, fire, and water integral to the experience. RJDS may straddle the outside, making it possible to move between inside and natural environments, or may bring nature inside the built space. There are several levels at which to consider participant engagement with nature. The natural outdoor landscape on which a RJDS sits can be designed for use in a restorative justice experience (e.g., to walk in during a meeting) or instil the spirit of RJ as participants approach and enter the RJDS or view from it from windows inside the space. Natural and organic elements in the entry, such as a lobby, can similarly instil RJ values and a sense of welcome or put people at ease (Van Buren, 2009), serving as a clear "marker of separation" from every day spaces (Pointer, 2019). Intentional consideration of window placement, size, views, and the position of furniture in relation to those windows ensures that participants can reap the benefits of nature access while engaged in the work. Nature access can be created in

the interior design through, for instance, the presence of table top and floor plants, water features, nature sounds, and artwork of nature scenes.

Private and Nested

Privacy—the ability to control one's interactions with others—is critical for human psychological health as it contributes to one's ability to heal from social harms, be reflective, and problem solve, all outcomes relevant for restorative justice (Toews, 2016). For those who caused harm, privacy has been found to offer relief from the stress of living in a custodial facility as well as to create emotional and mental space to reflect on their past, present, and future lives and plan for new lives (Moran et al., 2013; Toews, 2016). Victims also seek privacy, for instance, during breaks from court proceedings in order to process emotions and prepare for ongoing hearings (Casey & Lowney, 2015; Toews, 2020). Nesting complements the experience of privacy. When nested, an individual is contained, or embraced, by a space in such a way that they feel safe, validated, and supported (Designing Justice + Designing Spaces, 2016). The markers of containment are permeable or symbolic—e.g., curtains creating a nook in the corner of large room or a seat on a tree branch, partially obscured by the canopy of leaves. In the context of restorative justice, privacy and nesting provide participants the space in which to be reflective, repair harm, and transform their experiences, away from the judgement of others but in the presence of support and validation. Private and nested experiences can be designed in a variety of ways. A collection of smaller rooms off a larger room can provide breakout and private spaces for use during an RJ process. Larger rooms can be subdivided to create nooks for individuals to sit in during the process or retreat to during breaks. Furniture and accessories can allow the user to create their own experience of nesting or privacy—e.g., throw blankets under which to cuddle, pillows to hug, or bean bag chairs to sink into.

Transparent and Open

Participation in restorative justice processes requires openness, honesty, trustworthiness, and a sharing of oneself with others. In the context of RJD, transparency and openness refer to the siting, accessibility, and the envelope of the space as well as what the environment offers the user in terms of engagement. RJDS are visually and physically accessible to the user and the wider community, as they may also be participating in the restorative process. They are embedded in the community and community members have access to and use them as part of community life. Entry ways into the space are welcoming, where relationships provide dynamic security, minimizing the need for the usual mechanisms of security (e.g., metal detectors) (Van Buren, 2009). Instead of a building envelope that creates a barrier between people and the RJ work inside the space, the envelope creates a connection between the space, people, and community. For example, abundant windows provide visual access to natural light, nature, and even fresh air for those inside the space while also allowing those outside the space to symbolically connect with and understand the work occurring inside (Van Buren, 2009). This spatial transparency and openness also offer long distance views, off into the horizon or along paths. Violence survivors in particular have expressed a preference for such views for their symbolism of a hopeful future (Toews, 2020). Such views have also been found to relieve mental fatigue (Kaplan, 1995), which may be beneficial for those who caused harm, those who experienced harm, and community members alike when engaged in a restorative process. When coupled with the private and nested principle, transparency and openness create an experience of prospect-refuge, a critical environmental experience for survival (Appleton, 1996), where one feels safe and protected and can let their guard down while still feeling the safety of being able to see and be part of the wider community.

Domestic and Cultural

As a relational approach aimed at transformation, restorative justice design seeks to create spaces which offer the experience of "home," be it through the physical appearance of a domestic setting as well as the presence of cultural and spiritual artefacts and symbols. The intent is to create a space in which someone can relax, safely let their guard down, and feel supported as they do the challenging work of accountability and repair. It is an engaged space, showing signs of creativity and life (Toews, 2018a). For some, this feeling of safety may be new while for others it may be familiar. This vision towards domesticity within RJD is consistent with current trends towards the "normalization" of custodial environments (Wener, 2012) and spaces for violence survivors (Lygum et al., 2012, 2013, 2018; Refuerzo & Verderber, 1989; Toews, 2020; Verderber, 2001; YWCA Pierce County, 2020). A domestic design is oriented towards the use of smaller, intimate spaces and spaces in which people can prepare and eat food together. Furniture is similar to that used at home—e.g., couches, easy chairs, and dining tables and chairs. Accessories remind one of home, with throw blankets, pillows, candles, artwork, books, and musical instruments. Textures are soft and inviting. Occupants can connect to their cultural and spiritual roots through, for instance, supplies and ventilation for smudging ceremonies (Candace House, 2020) or symbols of Christian faith, such as angels (Toews, 2020).

Both those who have committed violence against others and those who have survived violence (or work with those who have) have offered a vision for what an RJD space could look like. In the course of participating in a prison-based restorative justice workshop, men convicted of violence and serving life sentences created, using a markers on a flipchart, a "do no harm room" where they imagined feeling safe enough to face the harms they caused and take steps towards accountability. Their room included, for example, a big window, mountain view, comfortable furniture, plants, and a fishtank. The men's original drawing is long gone but a reasonable visual comparison is the interior of a mountain lodge. Figure 25.2, selected by violence survivors, represents a "haven" or "refuge" to which to retreat during court proceedings (Toews, 2020);

again, we can see RJD principles. That the survivors' haven and the incarcerated individuals' "do no harm room" look similar makes sense for RJD; making things right requires active engagement in some way with both the person harmed and the person who did harm to understand harms, needs, and a vision for accountability and both benefit from the restorative values embodied in the process. These spaces look and feel different from how we typically imagine justice architecture and design; anyone walking into these rooms could immediately tell that the justice experience here will be different than the usual (Pointer, 2019).

Restorative Justice Design and Custodial Environments

As Figs. 25.1 and 25.2 suggest, justice spaces designed using RJD principles would look and feel radically different than the typical contemporary justice building, from the foundation to the roof. They certainly do not exhibit any of the punitive characteristics that make up the design of custodial facilities. Hard and cold materiality would be replaced with natural textures and warm colours. Small and sparse windows without nature views would be switched out for large and abundant windows and open-air spaces that look out on gardens and native landscapes. Metal furniture bolted to the floor would be exchanged for soft couches and dining room sets. These design features are not novel, given the current trends towards the normalization of custodial interiors and the siting of facilities within natural environments (Wener, 2012)—e.g., Halden and Bastoy Island prisons (Norway), Okimaw Ohci Healing Lodge (Canada), and Missouri River Correctional Facility (United States). While these and other more humane and therapeutic prison designs are less architecturally punitive, they are not examples of the application of RJD principles to custodial design. There are no such examples because it is not possible to have a "restorative prison," "restoratively designed prison," "restorative justice prison," or any such moniker bringing together restorative justice, design, and spaces of confinement.

Restorative justice design is more than just the visible application of the design principles; as discussed earlier, it is also the foundation in

25 Prioritizing Accountability and Reparations … 717

Fig. 25.2 Photograph representation of a respite space selected by violence survivors that includes elements of restorative justice design (Toews, 2020; image from Peace and Justice Cards designed by Designing Justice + Designing Spaces)

restorative justice goals and values. By their very nature, custodial facilities are built on a punitive, or at best rehabilitative, foundation. This foundation does not disappear once the RJD principles are applied to building design. Take, for example, the basement of a house, which typically contains the electrical box, furnace, water heater, and water pipes. The electricity, heat, and water originate in the foundation and flow throughout the rest of the house. So it is with a punitive foundation. The lights in the upper floors are charged with punitive electricity. The plumbing facilitates the flow of punishment in drinking and bathing water. The heat radiates punishment into the air. No matter how restoratively the upper floors are designed, the punitive foundation facilitates the experience that one has inside the space. The punitive foundation is not designed to support the accountability and transformative work that occurs in an upper RJD space, thus risking the collapse of the restorative goals and values. Or, much like how a house settles into its foundation, restorative justice goals may settle into, and become co-opted by, punishment. The reverse—restorative justice rooms transforming the punitive foundation—is unlikely; while foundations can crack under the weight of upper floors or due to engineering flaws, foundations are typically repaired or rebuilt better, rather than radically re-engineered in novel and new ways. This risk of collapse and co-optation is even greater when renovating an existing facility. Attempts to make the design more restorative are the equivalent of adding a coat of paint or updating the wiring. Even with a new electrical box, old knob and tube wiring still bring light to the living spaces. The promise of restorative justice design requires that we dig up the punitive foundation and replace it with one built from restorative justice goals and values.

It is possible, however, to design spaces inspired by restorative justice theory and conducive for restorative justice practices that occur inside custodial facilities, making them "minimally harmful and maximally restorative" (Presser, 2014, 22). These spaces serve as an adjunct to the punitive custodial design. For example, if victim-offender dialogues are happening in the facility, design a room using the five principles in which these dialogues will occur. If administrators offer programmes related to victim empathy or trauma healing, design programme spaces using

the design principles. If a cell block is dedicated to living by restorative justice principles, use the RJD principles to create an interior design consistent with the values residents will live by and that can facilitate the embodiment of those values. Visiting rooms are another space to consider; research finds that design characteristics consistent with RJD can be supportive of family relationships—e.g. access to outdoor spaces and comfortable furniture arranged to facilitate conversation (Moran & Disney, 2018; Toews et al., 2020). Doing so raises several critical questions, however. If one area of the prison is going to be designed using RJD for the purpose of facilitating accountability and the repair of harms, why not design the whole environment like that? If we value accountability and the repair of harm, why are we not designing environments to achieve that goal all the time and for all, versus designing spaces of punishment and only selectively offering opportunity for accountability and repair? If we value accountability and repair, why are we even designing and building prisons if they don't support those ideals?

Digging a New Foundation

Digging up the old punitive foundation and replacing it with a restorative justice one can be difficult to imagine as it challenges fundamental beliefs that we have about what justice looks like. We may feel like we are caught inside during an earthquake, feeling the earth shake beneath us and watching everything crumble and fall down around us. This is scary, for sure, and, at the same time, creates an exciting opportunity to start from scratch and envision a new justice infrastructure that meets the needs of those who cause harm, those who experience harm, and the community. With this new foundation, our attention would necessarily shift away from custodial facilities and towards spaces that support those harmed by crime, facilitate the relationships and safety necessary to face the harms one has caused, and take steps towards meaningful accountability and repair. Such a justice infrastructure also extends beyond criminal justice spaces and into spaces that support the work of social institutions that intersect with crime and justice issues—e.g., education, health, and economics. A comprehensive restorative justice infrastructure

would provide space for the creation and support of just and equitable social structures, with a goal of ending mass incarceration (Designing Justice + Designing Spaces, 2020b). I offer four guideposts through which to develop this restorative justice foundation and infrastructure.

Remove Detention and Custodial Facilities from the Design Discussion

Restorative justice design is concerned with *what* we design, not just *how* we design. The subsequent first step is to be brave and disrupt the discourse that punishment, especially through detention and incarceration, is a necessary, if not natural, response to harm-doing (Goshe, 2019; Kaba, 2021). It is not necessary or even effective at creating an experience of justice. Research, for example, shows that incarceration does not reduce recidivism (Cook & Haynes, 2020) nor is it universally desired by violence survivors, especially when they are offered a restorative justice approach instead (Sered, 2019). Further, only 41% of violent crimes are reported to police, of which only 46% are solved. The statistics for property crime, for which some perpetrating individuals risk incarceration, are even more dismal—only 33% are reported and only 17% are closed (Pew Research Center, 2021). The implication is evident—the majority of people who violently harm others, including singular or serial acts of violence, are not punished, let alone incarcerated. All the while, victims' needs are largely ignored; those needs do not magically disappear just because the person who hurt them is not caught or convicted. Community experiences, needs, and obligations are similarly sidelined and the racialized context of incarceration remains intact.

The overreliance on incarceration, which doesn't achieve what we want to believe that it does, blinds us to other ways of achieving justice and responding to harm-doing that are more inclusive of and responsive to the experiences of those who cause harm, those who are harmed, and the communities in which they live and who care about them. Instead of asking "how do we design more restorative correctional facilities?," one can ask restorative justice design questions:

How do we design restorative spaces to support the work of a justice grounded in accountability and the repair of harm?
How do we design justice spaces to address the harms experienced by survivors and meet their needs?
How do we design spaces to create the conditions in which those who have offended can safely explore the harm they caused and repair it?
How do we design spaces to create just and equitable communities that address the personal, interpersonal, and social root causes of crime?

Taking prison off the design table is challenging, if not scary. We, as a society, do not have a shared vision or language around which to imagine what justice looks like without it. The remaining three guideposts invite us to dream and explore how to answer these questions.

Several organizations offer leadership in making this question shift. Architects/Designers/Planners for Social Responsibility (ADPSR) are outspoken critics of design professionals engaged in carceral design generally, with specific campaigns targeting design involvement in spaces for solitary confinement and executions (ADPSR, 2020a). The New York chapter of the American Institute of Architects (Fedderly, 2020) and Design as Protest (2020) have both issued calls for architects and designers to stop designing prisons and jail. Designing Justice + Designing Spaces (DJDS), an architecture and real estate development firm founded by architect Deanna Van Buren, works "to end mass incarceration by building infrastructure that addresses its root causes….[and] counters the traditional adversarial and punitive architecture of justice—courthouses, prisons, and jails—by creating spaces and buildings for restorative justice, community building, and housing for people coming out of incarceration" (Designing Justice + Designing Spaces, 2020a, paragraph 1). Van Buren is adamant that DJDS will not engage in projects or scholarship that considers the design or re-design of detention or custodial facilities, even if motivated by restorative justice. Instead, their work focuses on the design of RJD spaces to support restorative justice efforts across multiple community-based domains related to social, economic, and racial justice (discussed in more detail in Guidepost 4).

Design to Address Victims' Needs

Restorative justice centres the harms experienced by and the resulting needs of the victim. This alone represents a new foundation on which to build the justice response and calls forth different types of spaces in which to do justice. Instead of firstly and automatically designing for the offending individual, start with designing spaces that serve victims and address their needs. What spaces are necessary to facilitate their safety in the immediate aftermath of crime? What spaces do they need to support their healing and transformation? How can existing justice spaces (e.g., police stations and courthouses) be designed to create an experience of validation and respect? How can victim service and advocacy spaces be designed to empower victims and promote healing and transformation? What spaces exist in the community to support victims and what new spaces are needed? How do we ensure that these spaces are available for victims when the person who hurt them is not identified or not yet ready to take responsibility? Answering these questions shifts our focus away from custodial facilities.

Scant theoretical, empirical, and practical attention has been given to the environmental needs of victims. Established design theories—e.g., biophilia, supportive design, sensory design, attention restoration theory—have not specifically been applied in survivor-oriented spaces, though trauma-informed design (Trauma-Informed Oregon, 2019) is bringing more attention to victims' experiences in the criminal justice context. A recent study found that violence survivors experience courthouse design as cold, lacking in privacy, and contributing to feelings of insignificance and an overall inability to move through their emotions (Toews, 2018b). Though safe and secure victim/witness waiting rooms within courthouses have been mandated across jurisdictions and there are basic design guidelines (Carey & Lowney, 2015; National Center for State Courts, 2017; Wallace et al., 2013), no research has been done on their design or impacts. A collection of studies has explored the design of domestic violence shelters and their outdoor environments (Lygum et al., 2012, 2013, 2018; Refuerzo & Verderber, 1989; Verderber, 2001) and the impact of nature on trauma symptomology among sexual assault survivors (Moore & Van Vliet, 2019). While the

body of literature is growing, it is clear that victims' environmental needs require more attention and commitment. Candace House, an example of a survivor-oriented space, "offers a safe and comforting home-like day refuge...for victims, survivors, and families attending court proceedings" (Candace House, 2020, paragraph 1). The space was designed to attend to survivors needs and empirically grounded design preferences (Toews, 2020), many of which are incorporated into the RJD principles.

Design to Facilitate Meaningful Accountability and Address Causes of Harmful Behaviour

With the prioritization of victims' harms and needs comes a new way of understanding meaningful accountability—e.g., taking steps for concrete amends making and harm repair and opening oneself to do individual reflection and work. Their obligations may be to the direct victim of the crime and extend to family members, others in their communities of care, and the wider community. No longer based in punishment, accountability requires different types of spaces.

With prison off the design table, we may initially feel stymied to identify spaces which facilitate accountability. We may quickly turn to spaces such as probation offices, day reporting centres, and community corrections centres. These spaces are worthy of RJD but they are sites also built on the punitive foundation and connected to incarceration by serving as alternatives to or supplements after it. They also keep us trapped in thinking that we have to design "criminal justice spaces," versus opening us to the question of "what space do we use to facilitate meaningful accountability?" Given that restorative justice influences community relationships and social structures, we can broaden the scope of settings in which we facilitate accountability. Indeed, the restorative justice value of interconnectedness suggests we look to community spaces. Our communities are full of spaces which can be used for accountability purposes— e.g. community centres, schools, houses of worship, and parks, to name a few. These types of locations, regardless of design, embody the restorative justice value of interconnectedness by situating the expectation and fulfillment of accountability within the community. When RJD is

applied, these spaces can embody other critical restorative justice values. Some communities choose to design and construct new spaces to facilitate accountability, such as circle centres or community-based justice centres. For example, the Near Westside Peacebuilding Project, run out of a community-based centre designed by Designing Justice + Designing Spaces with extensive community involvement (Designing Justice + Designing Spaces, 2016), offers Navajo-based peacemaking processes, facilitated by trained community people, which "enable those affected by a dispute to 'talk it out' and reach agreement about restitution and repair" for quality-of-life crimes (Center for Court Innovation, 2020). Given the relationship between trauma and harmful behaviour, others may look to the availability and design of community-based trauma centres, which create conditions for both exploring accountability for the harm one inflicted on others and work through the harm they have experienced at the hands of others.

The restorative justice approach to accountability is relational, thoughtful, slow, and multi-dimensional. For example, an individual may not be able to acknowledge, let alone repair the harm they caused, until the root causes of their harmful behaviour are addressed, and vice versa. After repairing the harms of one offence, an individual may harm another person; a restorative justice response invites the offending individual to repair the new harms and engage in more work related to causes. The challenge to RJD is to create the environmental conditions in which an individual who has harmed another can let down their defences, face the harm they caused, explore what accountability could look like, and consider the personal, interpersonal, and structural sources of their actions. This requires spaces designed for emotional and physical safety, relationship, and healing, as well as a commitment to be in relationship with someone who has caused harm, including when they are not ready to be accountable. Indeed, this relationship that provides support for accountability and the space in which it occurs may be the key to reduced recidivism and public safety (Clarke et al., 2017), akin to dynamic security within a custodial context (United Nations Office on Drugs and Crime, 2015). The spaces designed for survivors (Guidepost 2) provide for their safety and the community seeks to build safe and just relationships among themselves and for those who caused harm and those who were harmed (Guidepost 4) during this period.

Design Infrastructure for Social Justice

Restorative justice seeks to strengthen communities by addressing the root causes that contribute to crime, violence, and other harmful behaviours, especially social harms that create and sustain inequitable and unjust community structures. The RJD counterpart focuses on designing the infrastructure for, for instance, social justice and race, economic, health, and gender equity. Such a focus transforms the daily lived experience of community members, empowers and builds community, and makes visible the way in which injustice and oppression has been spatially designed for centuries. For example, prisons and jails emerge from the rubble of historic spaces of oppression—e.g., slave ships, slave quarters, internment camps, and residential schools. Today's "million dollar blocks," city blocks where more than $1 million is spent each year incarcerating its residents, are home to economically disadvantaged people of colour and are void of the healthy environmental conditions afforded wealthier and whiter communities (Spatial Design Information Lab, 2008). The school-to-prison pipeline, which disproportionately impacts young people of colour, starts in school buildings but is inextricably linked to police stations, courthouses, probation offices, and detention facilities. Without seeing spatial inequity and oppression, historic and modern, we risk repeating it in future designs or simply making oppression more beautiful and "therapeutic" in design, thus more palatable.

Several organizations are leading the way in creating a new restorative justice infrastructure to support social justice. DJDS' vision for a "restorative justice city," where restorative justice is the primary response to social injustice, is achieved through a hyper-local, distributed network of resources. They envision a local infrastructure that promotes nature access, food justice, restorative criminal justice systems, community conflict resolution and problem-solving, and services related to economics, education, health, and housing (Designing Justice + Designing Spaces, 2020b). Design as Protest, with a strong racial justice mission, seeks to "revers[e] the violence and injustice that architecture, design, and urban planning principles have inflicted upon Black people and communities…. [and champion] the radical vision of racial,

social, and cultural reparation through the process and outcome of design" (Design as Protest, 2020, paragraph 1). Their nine demands include reallocating police funding into community services and spaces, re-defining what neighborhood "affordability" means, creating policies to support accessible, non-oppressive public spaces, and incorporating community voice in project development and accountability measures (Design as Protest, 2020). ADPSR also takes a wider view on social justice, including campaigns opposed to building anything related to human rights violations and "immigration enforcement infrastructure, including but not limited to walls, checkpoints, Immigration and Customs Enforcement (ICE) office, detention facilities, processing centers, or juvenile holding centers" (ADPSR, 2020b, paragraph 2). The Near Westside Peacebuilding Project offers a space which represents this type of new infrastructures for its hyper-local and community engagement response to harm (Van Buren, 2020) as does the B.R.E.A.T.H.E Collective, a collective of black and brown womyn dedicated to "a healing praxis, [to] co-create pathways for people, especially our sistas, to experience a liberating revolutionary love and healing rooted in community" (B.R.E.A.T.H.E Collective, 2020a, paragraph 1). The design of the House of B.R.E.A.T.H.E, the space in which they do their restorative justice and food-oriented work, represents a sacred and healing space that supports their liberatory work (B.R.E.A.T.H.E Collective, 2020b). The intended end result of these efforts is the creation of strong, just, and equitable communities.

Conclusion

Restorative justice design offers a new framework through which to approach the design of physical and natural spaces in which justice work occurs. It does not offer, however, a way to design prisons and jails. Rather, it brings into focus the ways in which design can serve those who have been harmed by crime by facilitating the experience of harms repair and transformation. It calls attention to offending individuals' obligations for meaningful accountability and reparations and the ways in which the environment can contribute to the fulfillment of that

obligation. It creates space to examine unjust community structures that contribute to and cause harmful behaviour and to use design to bring about just and equitable communities.

Not everyone is ready to take incarceration and custodial facilities off the design table, though I expect most reading this chapter agree that the design of such facilities needs to change. Take what you will of the five restorative justice design principles and the four design guideposts and use them. Recognize, however, the limits of their applicability without challenging the use of incarceration. RJD fundamentally challenges the foundation on which the criminal justice system and society as a whole is built. It begs us to ask what kind of society we want, not what kind of prison we want. In the words of Mariame Kaba, "It's time for a jailbreak of imagination in order to make the impossible possible" (Kaba, 2021, p. 25).

References

ADPSR [Architects, Designers, and Planners for Social Responsibility]. (2020a). *Boycott zero-tolerance immigration policy* [online]. ADPSR [viewed 16 November 2020]. https://www.adpsr.org/yesimmigrants

ADPSR [Architects, Designers, and Planners for Social Responsibility]. (2020b). *Home* [online]. ADPSR [viewed 16 November 2020]. https://www.adpsr.org

Alexander, M. (2012). *The new Jim Crow*. The New Press.

Appleton, J. (1996). *The experience of landscape* (Rev. ed.). Wiley.

B.R.E.A.T.H.E Collective. (2020a). *Mission* [online]. B.R.E.A.T.H.E Collective [viewed 16 November 2020]. https://www.thebreathecollective.org/copy-of-about

B.R.E.A.T.H.E Collective., (2020b). *The house of B.R.E.A.T.H.E* [online]. B.R.E.A.T.H.E Collective [viewed 16 November 2020]. https://www.thebreathecollective.org/the-space

Briere, J., Agee, E., & Dietrich, A. (2016). Cumulative trauma and current posttraumatic stress disorder statss in general population and inmate sample. *Psychological Trauma: Theory, Research, Practice and Policy*, 439–446.

Candace House. (2020). *Healing Haven* [online]. Candace House [viewed 16 November 2020]. https://www.candacehouse.ca/healinghaven

Carey, P., & Lowney, L. (2015). *Separate and secure waiting area task force: Implementation progress report* (Prepared for Massachusetts Legislature). Executive Office of the Trial Court.

Center for Court Innovation. (2020). *Peacemaking Program* [online]. Center for Court Innovation [viewed 16 November 2020]. https://www.courtinnovation.org/programs/peacemaking-program

Clarke, M., Brown, S., & Völlm, B. (2017). Circles of support and accountability for sex offenders: A systematic review of outcomes. *Sexual Abuse, 29*(5), 446–478.

Cook, A., & Haynes, S. H. (2020). Imprisonment pains, reentry strains, and perceived likelihood of reoffending. *Criminal Justice Studies*, 1–17.

Davis, F. (2019). *The little book of race and restorative justice*. Good Books.

Design as Protest. (2020). *Home* [online]. Design as Protest [viewed 16 November 2020]. https://www.dapcollective.com

Designing Justice + Designing Spaces. (2015). *Designing from the inside out: Santa Rita Jail Workshop*. Designing Justice + Designing Spaces.

Designing Justice + Designing Spaces. (2016). *Community engagement report: Near Westside Peacemaking Project*. Designing Justice + Designing Spaces.

Designing Justice + Designing Spaces. (2020a). *Our mission* [online]. Designing Justice + Designing Spaces [viewed 16 November 2020]. https://designingjustice.org/about/#mission

Designing Justice + Designing Spaces. (2020b). *Restorative justice city* [online]. Designing Justice + Designing Spaces [viewed 16 November 2020]. http://designingjustice.org/restorative-justice-city/

Facer-Irwin, E., Blackwood, N., Bird, A., Dickson, H., McGlade, D., Alves-Costa, F., & MacManus, D. (2019). PTSD in prison settings: A systematic review and meta-analysis of comorbid mental disorders and problematic behaviors. *PLoS One, 14*(9).

Fedderly, A. (2020, October 19). *AIA NY takes strong stand against designing American jails and prisons* [online]. Architectural Digest [viewed 16 November 2020]. https://www.architecturaldigest.com/story/aia-ny-takes-strong-stand-against-designing-american-jails-and-prisons

Fetzer Institute. (2021). *About: Our mission* [online]. Fetzer Institute [viewed 24 May 2021]. https://fetzer.org/about

Goshe, S. (2019). The lurking punitive threat: The philosophy of necessity and challenges for reform. *Theoretical Criminology, 23*(1), 25–42.

Insight Prison Project. (2020). *Who we are* [online]. Insight Prison Project [viewed 16 November 2020]. http://www.insightprisonproject.org/who-we-are.html

Jewkes, Y. (2018). Just design: Healthy prisons and the architecture of hope. *Australian & New Zealand Journal of Criminology, 51*(3), 319–338.

Kaba, M. (2021). *We do this 'til we free us: Abolitionist organizing and transforming justice*. Haymarket Books.

Kaplan, S. (1995). The restorative benefits of nature: Toward an integrative framework. *Journal of Environmental Psychology, 15*(3), 169–182.

Kellert, S. R. (2018). *Nature by design: The practice of biophilic design*. Yale University Press.

Lygum, V., Poulsen, D., Djernis, D., Djernis, H., Sidenius, U., & Stigsdotter, U. (2018). Post-occupancy evaluation of a crisis shelter garden and application of findings through the use of a participatory design process. *Health Environments Research & Design Journal, 12*(3), 153–167.

Lygum, V., Stigsdotter, U., Konijnendijk, C., & Hojberg, H. (2012). Outdoor environments at crisis shelters in Denmark. *Journal of Therapeutic Horticulture, 23*(22), 8–21.

Lygum, V., Stigsdotter, U., Konijnendijk, C., & Hojberg, H. (2013). Outdoor environments at crisis shelters: User needs and preferences with respect to design and activities. *International Journal of Architectural Research, 7*(1), 21–36.

Mass Design Group. (2020). *Restorative justice design lab* [online]. Mass Design Group [viewed 16 November 2020]. https://massdesigngroup.org/restorative-justice

Menakem, R. (2021). *My grandmother's hands: Racialized trauma and the pathway to mending our hearts and bodies*. Penguin.

Moore, C., & Van Vliet, K. (2019). Women's experiences of nature as a pathway to recovery from sexual assault. *Journal of Humanistic Psychology*, 1–28. https://doi.org/10.1177/0022167819847094

Moran, D., & Disney, T. (2018). 'You're all close you might as well sit in a circle': Carceral Geographies of Intimacy and Comfort in the Prison Visiting Room. *Geografiska Annaler B, 100*(3), 179–194.

Moran, D., Pallot, J., & Piacentini, L. (2013). Privacy in penal space: Women's impri- sonment in Russia. *Geoforum, 47*, 138–146.

Moran, D., & Turner, J. (2019). Turning over a new leaf: The health-enabling capacities of nature contact in prison. *Social Science & Medicine, 31*, 62–69. https://doi.org/1016/j.socscimed.2018.05.032

Nadkarni, N. M., Hasbach, P. H., Thys, T., Crockett, E. G., & Schnacker, L. (2017). Impacts of nature imagery on people in severely nature-deprived environments. *Frontiers in Ecology and the Environment, 15*(7), 395–403. https://doi.org/10.1002/fee.1518

National Center for State Courts. (2017). *The virtual courthouse: A guide to planning and design* [online]. National Center for State Courts [viewed on 16 November 2017]. https://www.sji.gov/virtual-courthouse-planning-guide/

Pew Research Center. (2021). *What the data says (and doesn't say) about crime in the United States*. Pew Research Center [viewed 30 May 2021]. https://www.pewresearch.org/fact-tank/2020/11/20/facts-about-crime-in-the-u-s/

Pointer, L. (2019). *Justice performed: The normative, transformative, and proleptic dimensions of the restorative justice ritual* [Ph.D. thesis]. Victoria University of Wellington.

Pranis, K. (2007). Restorative values. In G. Johnstone & D. Van Ness (Eds.), *Handbook of restorative justice* (pp. 59–74). Willan Publishing.

Presser, L. (2014). The restorative prison. In F. T. Cullen, C. L. Jonson, & M. Stohr, *The American prison* (pp. 19–32). Sage.

Refuerzo, B., & Verderber, S. (1989). Effects of personal status and patterns of use on residential satisfaction in shelters for victims of domestic violence. *Environment and Behavior, 21*(4), 413–434.

Sentencing Project [The]. (2020). *Criminal justice facts* [online]. The Sentencing Project [viewed on 16 November 2020]. https://www.sentencingproject.org/criminal-justice-facts/

Sered, D. (2019). *Until we reckon: Violence, mass incarceration, and a road to repair*. The New Press.

Spatial Information Design Lab. (2008). *The pattern: Million dollar blocks*. Columbia University. https://c4sr.columbia.edu/sites/default/files/publication_pdfs/ThePattern.pdf

Swanson, C. (2009). *Restorative justice in a prison community*. Lexington Books.

Toews, B. (2006). *The little book of restorative justice for people in prison*. Good Books.

Toews, B. (2016). "This backyard is my serenity place": Learnings from incarcerated women about the architecture and design of restorative justice. *Restorative Justice: An International Journal, 4*(2), 214–236.

Toews, B. (2018a). Architecture and restorative justice: Designing with values and well-being in mind. In T. Gavrielides (Ed.), *Routledge international handbook of restorative justice* (pp. 279–296). Routledge.

Toews, B. (2018b). "It's a dead place": A qualitative exploration of violence survivors' perceptions of justice architecture. *Contemporary Justice Review, 21*(2), 208–222.

Toews, B. (2020). 'I see all the life': Designing spaces of respite for survivors of violence. *Contemporary Justice Review, 23*(3), 205–221. https://doi.org/10.1080/10282580.2020.1783256

Toews, B., & Harris, K. (2010). Restorative justice in prisons. In E. Beck, N. Kropf, & P. M. Leonard (Eds.), *Social work and restorative justice: Skills for dialogue, peacemaking, and reconciliation* (pp. 118–148). Oxford University Press.

Toews, B., Wagenfeld, A., & Stevens, J. (2018). Impact of a nature-based intervention on incarcerated women. *International Journal of Prisoner Health, 14*(4), 1–12.

Toews, B., Wagenfeld, A., Stevens, J., & Shoemaker, C. (2020). Feeling at home in nature: A mixed method study of the impact of visitor activities and preferences in a prison visiting room. *Journal of Offender Rehabilitation, 59*(4), 223–246.

Trauma-Informed Oregon. (2019). *Considerations for a trauma-informed environmental scan* [online]. Trauma-Informed Oregon [viewed 16 November 2020]. https://traumainformedoregon.org/considerations-for-a-trauma-informed-environmental-scan/

Turner, J. (2020). Creating safety for others. In E. Valandra (Ed.), *Colorizing restorative justice*. Living Justice Press.

Ulrich, R., Zimring, C., Zhu, X., DuBose, J., Seo, H., Choi, Y., Quan, X., & Joseph, A. (2008). A review of the research literature on evidence-based healthcare design. *HERD: Health Environments Research and Design Journal, 1*(30), 61–125.

United Nations Office on Drugs and Crime. (2015). *Handbook on dynamic security and prison intelligence*. United Nations.

Van Buren, D. (2009). *Restorative justice design: Developing new typologies for social change* [unpublished item].

Van Buren, D. (2020). *Personal correspondence* [unpublished item].

Van Der Linden, S. (2015). Green prison programmes, recidivism and mental health: A primer. *Criminal Behaviour and Mental Health, 25*(5), 338–342. https://doi.org/10.1002/cbm.1978

Van Ness, D. (2007). Prisons and restorative justice. In G. Johnstone & D. Van Ness (Eds.), *Handbook of restorative justice* (pp. 312–324). Willan Publishing.

Van Ness, D., & Strong, K. (2015). *Restoring justice: An introduction to restorative justice* (5th ed.). Routledge.

Verderber, S. (2001). Recent trends in the design of shelters for victims of domestic violence. *Loyola Law Review, 47*(2), 457–470.

Wallace, A., Blackman, D., & Rowden, E. (2013). Reconceptualizing security strategies for courts: Developing a typology for safer court environments. *International Journal for Court Administration, 5*(2), 3–9. https://doi.org/10.18352/ijca.13

Wener, R. (2012). *The environmental psychology of prisons and jail: Creating humane spaces in secure settings.* Cambridge University Press.

Yoder, C. (2020). *Little book of trauma healing.* Good Books.

YWCA Pierce County. (2020). *Emergency Shelter* [online]. YWCA Pierce County [viewed 16 November 2020]. https://www.ywcapiercecounty.org/emergency-shelter

Zehr, H. (2015). *The little book of restorative justice: Revised and updated.* Good Books.

Zehr, H., Macrae, A., Pranis, K., & Amstutz, L. (2015). *Big book of restorative justice.* Good Books.

26

Made in Prison: Understanding Knowledge Exchange, Co-design and Production of Cell Furniture with Prisoners to Reimagine Prison Industries for Safety, Well-Being and Sustainability

Lorraine Gamman and Laura Caulfield

Introducing the Cell Furniture Design Brief

In response to record high levels of both self-harm and assaults in prisons, in September 2018, the British Ministry of Justice (MoJ) provided funding for the Design Against Crime Research Centre (DACRC) to generate a new range of cell furniture for HMPPS (Her Majesty's Prison and Probation Service) run prisons across England and Wales. Working

L. Gamman (✉)
Design Against Crime Research Centre, University of the Arts London, London, UK
e-mail: l.gamman@csm.arts.ac.uk

L. Caulfield
Institute for Community Research and Development, University of Wolverhampton, Wolverhampton, UK
e-mail: L.Caulfield@wlv.ac.uk

with HMPPS's Public Sector Prison Industries, Catering, PE & Retail (PSPI) team, the ambition of the 18-month "Cell Furniture" project was to engage with HMPPS staff and prisoners via co-creation processes. The overall aim was to improve safety, functionality, robustness and sustainability of prison furniture that was often destroyed—what prisoners term "flat packed".[1]

The context of creating more robust prison furniture was indirectly linked to the Safer Locals Programme (see Evaluation by Liebling et al., 2005), which outlines ways of preventing self-harm and suicide in cells; also, by implication, to use design to innovate new furniture to reduce criminal damage and deter use of furniture in violence. The Safer Locals report had resulted in many new protocols for Safer Cells[2] but this was not the only catalyst. Cell furniture redesign advocacy had also been informed by the outrage following the 2006 Public Inquiry into the death in custody of Zahid Mubarek.

On 21 March 2000, Mubarek, a British Pakistani teenager, a first-time prisoner for a minor crime, just five hours from being released from a 90-day sentence, was attacked in his cell by a racist cellmate and later died from his injuries. The cellmate, Stewart, clubbed Zahid using a wooden table leg that he had detached from furniture in the cell (later it was reported that Stewart had made previous attacks using cell furniture[3]). This led Zahid's distraught parents to advocate for change and successfully demand an Inquiry. The Mubareks wanted to reform the prison services that had missed so many intervention opportunities to protect Zahid from violent assault and to create new staff protocols to ensure

[1] Flat packing is a phrase used by prisoners we engaged with at Standford Hill Prison to describe the destruction of cell furniture back to component parts or worse.

[2] "Safer Cells are designed to make the act of suicide or self-harm by ligature as difficult as possible. It is achieved chiefly by reducing known ligature points as far as is possible and by installing specialist 'anti-ligaturev' furniture and fittings as an integral part of the cell fabric. Cells are either designated 'normal accommodation' or 'Safer Cell'. Reduced risk cell is not a recognised term in relation to Safer Custody and must not be used." Quote from: http://iapdeathsincustody.independent.gov.uk/wp-content/uploads/2011/06/QTLB-Safer-Cells-Issue-4.pdf.

[3] "The fact that Stewart had used cell furniture as weapons before did not get into the Security Department's computerised system, and that could potentially have been a highly significant omission in the light of how Stewart was subsequently to attack Zahid." (p. 629, 2006) (Report on gov.uk: https://www.gov.uk/government/publications/report-of-the-zahid-mubarek-inquiry).

that this would not happen to future prisoners. The unprecedented decision by the Law Lords to allow the Mubarek Inquiry to happen in 2006 produced 88 operational recommendations for the Prison Service to ensure future prisoner safety, including ON3 recommendations about cell furniture design found in UK prisons. Recommendation 18 (of 88) states:

> As soon as practicable, the Prison Service should assess the popularity of the bolted-down furniture made from white wood which is currently being trialled. It should then formulate a policy about the most appropriate form of furniture for use in cells, balancing the need to keep prisoners safe from their cellmates against the need for prisoners to live in cells which have a measure of homeliness, and taking into account prisoners' preferences and cost. (Keith, 2006)

Numerous prison reform initiatives made change happen. Safer cell furniture gradually emerged throughout the prison estate, although there are no formal records that we were able to access, making it difficult to document the precise history. For example, a new whitewood furniture range was launched after Mubarek's death but before publication of the Inquiry report, and thus we could not ascertain whether they were directly connected. Nonetheless, the Inquiry mentions cell furniture and appears to have reinforced operational understandings about the widespread implementation of what is now known as the "whitewood" range of cell furniture (see Fig. 26.1).

What we can be certain of is that between approximately 2001 and 2010 best practice advice about safety changed and new designs of cell furniture were produced and distributed throughout UK prisons. Today furniture made in UK prisons includes: metal bunk beds (Fig. 26.2), a sturdy white plastic chair (Fig. 26.3), and the whitewood furniture range (Fig. 26.1)—although mattresses for all prison beds (Fig. 26.4) are currently manufactured outside of UK prison industries.

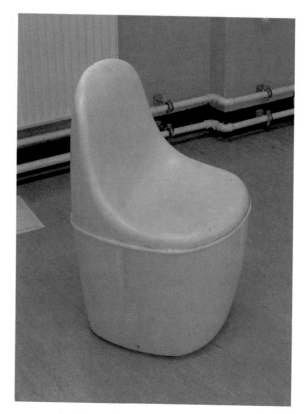

Fig. 26.3 The existing plastic cell chair, photographed in a UK Category C prison visited by the DACRC team in 2019

When discussing cell furniture with MoJ colleagues, with whom we went on to co-create the Cell Furniture project design brief,[4] we understood that we would need to address many safety concerns. Specifically, the MoJ drew our attention to the Mubarek Inquiry and we were asked to address Safer Cell recommendations and improve upon the whitewood furniture range. Our designs would need to avoid being easily destroyed, be unusable as criminal weapons, and unable to support suicide in any way. They should also be comfortable and easy to use

[4] See p. 9 "Cell Furniture Catalogue", 2019. See www.designagainstcrime.com

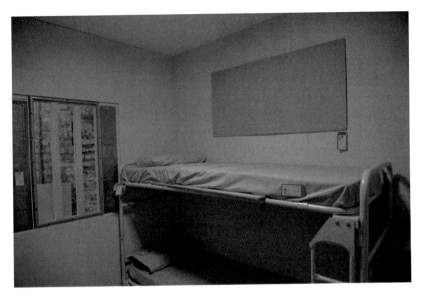

Fig. 26.4 Prison metal bunk bed included in a full-scale mock-up cell located at Central Saint Martins in 2019 as a student empathy tool for design research

and clean, and even more robust and sustainable than previous designs, perhaps by incorporating new materials that are kind to the planet. Additionally, this new furniture would need to be easy to mass produce and transport, robust, hard-wearing, inexpensive, and developed with a pleasant aesthetic style to create positive improvements to life within harsh prison cell environments in order to promote positive feelings and well-being. No small challenge! The DACRC team accepted the brief and consulted with the University of Wolverhampton for support in figuring out how to evaluate outcomes.

Project Context

The Cell Furniture project aimed to build on what Manzini (2015, p. 53) calls "diffuse" design—in this case design delivered by prisoners with no previous design experience, facilitated by expert designers. Such an approach in UK prisons had been pioneered as part of the Makeright

design education programme between 2014 and 2018. Makeright, a world first, enabled prisoners to collaboratively learn about design "thinking" and design against crime "making", subsequently leading to a number of design awards.[5] As outlined by Gamman and Thorpe (2018), Makeright incorporated a restorative approach enabling prisoners to pay something back to society while learning new skills to support resettlement (we hoped to emulate Makeright creative teaching and learning processes regarding co-design of cell furniture with prisoners). Makeright eventually led to the development of a range of anti-theft bags and accessories sold by Abel & Cole to raise profits for charity. The project also received positive feedback from prisoners, who reported that they had found the creative learning experience meaningful.[6]

The PSPI, the department primarily responsible for helping prisoners to learn vocational skills, was approached by DACRC in order to take the Makeright co-design approach further. Within many other UK government contexts such as health, policy and civic sectors—as Buchanan (2020) has pointed out—co-production with service users and "strategic design"[7] had been going on for many years. The discussion with the MoJ that followed was full of exciting ideas about whether it would be possible in public prisons to facilitate open learning, with prisoners using participatory design methods to co-create designs against crime in prison

[5] In 2017 DACRC were awarded Runner-up for the N.I.C.E. (Network for Innovations in Culture and Creativity in Europe) by the European Centre for Creative Economy (ECCE). Also that year the Makeright project attracted a British Council INDIA-UK Excellence Award for Collaborations in Higher Education under the 'Innovative Partnerships' category. In 2016 Makeright was awarded Best Design Initiative 2016 by Sublime Magazine.

[6] https://makerightorg.wordpress.com/interviews/list-of-interviews/.

[7] Design has many different definitions and with Camilla Buchanan (2020) we understand "strategic design activity" to mean (1) the planning and deliberate conception of various design outputs (tools, techniques, products, services) which takes place through logical, intentional and constructive design processes aimed at instigating forms of change; (2) that such design activities may involve both professional "expert" designers and non-designers in co-production processes; and (3) that in strategic contexts design activity is likely to be diverse, embracing graphic, products, furniture and service design, but also might have a new role in both defining and implementing new strategies.

industries, which was also subject to an open design licence.[8] The discussions also considered whether this type of project could enable prisoners to learn a diverse range of new vocational skills to enable their reintegration in society. Discussions further considered the potential to find new uses for "design against crime" approaches and products, already used in wider society to protect people from theft and other crimes, because the idea that anti-crime products were "made in prison" by people who knew about crime had some novelty value.

There are currently over 83,000 people in prison in England and Wales (MoJ, 2020), close to the operational capacity of the prison estate. Prisons are full and incidents of self-harm and prisoner-on-prisoner assaults are high. In 2019 HMPPS reported that violence had increased in more than half the prisons inspected and the number of self-inflicted deaths and incidents of self-harm had increased substantially in the past year. An HM Inspectorate of Prisons (2017) report of prisoners being locked in their cells due to limited access to education, or association, recognised that such long lockdown periods "leave prisoners very vulnerable". At the time of writing this book chapter, the UK has been hard hit by the COVID-19 pandemic, resulting in significant further restrictions in prisons. Many prisoners are now unable to attend work or education classes and increased restriction affects the day-to-day lives of prisoners (Prison Reform Trust: CAPTIVE, 2020/Chief Inspector of Prisons, 2020). Over 48% of UK prisoners are either confined in overcrowded cells or left on their wing 23 hours a day (HM Inspectorate of Prisons, 2017).

Recognition of the role of the prison cell as a site of confinement as well as a "refuge" is evident from documentation by former prisoners (including those featured on BBC Radio 4 podcasts, 2019), as well as in accounts written by criminal justice academics (notably by Jewkes, 2013, 2018). Furthermore, Herrity (2020) points out that power relations surrounding the prison cell often mean that sabotage of cell space can be an expression of distress. Yet this functional implication of misuse of prison furniture is rarely discussed, nor is everyday use, with a few

[8] Open Government Licence for public sector information (2019). The National Archives. [online]. Available at: http://www.nationalarchives.gov.uk/doc/open-government-licence/version/3/.

notable exceptions: Baer's (2005) discussion of how display of everyday commodities in prison cells can be linked to decorative personalisation and pride is an exception. Actual cell furniture designs and how they are produced in the UK via prison industries, and used and customised by prisoners, are virtually undocumented, as there is no easy access to a visual catalogue of cell furniture designs in use. Although there is acknowledgement, however, by HMPPS (2019) that the physical prison environment—including cell furniture and cell space—can have a significant impact on prisoner experience and well-being, and consequently impact on prison culture and well-being of prison staff:

> Prison is a stressful place to live and work, but the environment can add to this tension. For prisoners, overcrowding, poor conditions, lack of access to nature, poor lighting, and noise can impact on disorder and violence, mental and physical health, potential future reoffending. Poor prison conditions are also associated with reduced staff wellbeing. (HMPPS, 2019)

Large numbers of people in prison present significant emotional, personal and mental health issues (Caulfield, 2016) that can be taken out on the furniture, and experiencing incarceration has been found to exacerbate existing mental health problems. For example, Sered and Norton-Hawk (2008) found in their research with women recently released from prison that factors such as losing their children and interruption of medication regimes and psychotherapy exacerbated existing mental health issues. These significant stressors can be compounded by prison creating situational precipitators—which can be defined as aspects of the immediate environment that create triggers, or frustrations—that intensify the motivation to commit crime (Wortley, 2016).

One of the aims of the Cell Furniture project was to see whether or not strategic design activity—through a collaborative design process with prison staff, prisoners, expert designers and design students—could generate furniture produced by democratic participatory design methods, and whether the qualities of this furniture designed to respond to prisoner needs could impact positively on mental well-being.

Creating a Collaborative, Democratic Environment

The DACRC team recognised that to deliver participatory design, an environment conducive for collaboration between prisoners, prison staff and designers would be important, if challenging to create. It is known that positive relationships between staff and prisoners may be a key factor that can prevent prison suicide and improve well-being (Howard League for Penal Reform, 2014) and we wanted to build on this. We were also aware of evidence that creative programmes in criminal justice settings provide opportunities for new, respectful relationships to form between peers, facilitators and staff (Caulfield et al., 2019). Yet overcrowding, reduced budgets, staffing shortages and tightened security in prisons in England and Wales have led to negative systemic issues (Howard League, 2014, 2017) and so we also knew, despite best intentions, that it would not be easy to go inside, engage and make a difference.

The Cell Furniture project aimed to engage prison staff and prisoners as "experts of their own experience" (Beresford & Branfield, 2006) to work collaboratively with professional designers, via "open innovation" (Chesbrough & Appleyard, 2007), which describes an approach to knowledge sharing within external parties. Here prisoners and staff would be able to discuss the design with external partners and participate equally in design decision-making; in this environment a sense of equality and a culture of enquiry would be promoted (Parker, 2007). Ultimately our team wanted to create a friendly studio atmosphere where respect for everyone's opinion and listening and sharing information are the norm, and where external knowledge and people are introduced to open up discussions that are usually closed off by hierarchical relations. For example, prisoners who participated in the co-design workshops were asked to pitch their concepts to a panel (see Fig. 26.5) made up of prisoners from the group (who changed places) as external designers as well as HMP and PSP specialists, and vice versa. In this way a participatory design approach opened up decision-making to include prisoner participation. In so doing, it offered a pathway to cultural innovation and design justice within the prison setting, where principles of prisoner agency, power and equity are generally suppressed in the prison

context (*Agency* is the ability to make decisions; *Power*, the ability to action decisions; and *equity*, the idea that equal access to decision-making and power is possible). All three are important to transformative change because they challenge what Costanza-Chock (2020) defines as the "matrix of domination" that underpins hierarchy and prevents design justice.

We went into HMP Standford Hill with our eyes open and high expectations. We realised to build relationships that could inform design justice would require a number of factors that we might not be able to control, given that prisons are inherently hierarchical places, operating according to control-oriented organisational models (Douglas & Caulfield, 2014). To contextualise, when exploring the experiences of prison officers working in democratic prison environments, Douglas and Caulfield had found a number of challenges for staff adapting to democratic principles, because what we are calling the open innovation participatory design approach is contrary to standard officer training. Staff reported in previous studies confusion at first, and took time to adapt. We anticipated similar issues for the Cell Furniture project.

Abrahams et al. (2012) note that the spaces within creative programmes, where there is no wrong or right answer, is very different to traditional prison education programmes, which are often highly structured, have specified outcomes, and rarely allow social barriers to be broken down. Creative teaching and expertise expresses itself very differently to these approaches. The research literature generally also notes that participants value creative facilitators' professionalism and personality (Eagle, 2008). The skills shown by all facilitators, and the collaborative techniques they utilise, have been argued to be essential in the successful delivery of programmes (McLewin, 2006) and levels of engagement are linked to how relevant participants deem the project to be, who seems to be behind the process, and whether or not they feel they belong there for any purposeful reason (Daykin et al., 2014). The Cell Furniture project aimed to create conditions for participation that support open communication and constructive "empathic dialogue" (that recognises feelings as well as facts, described by Koskinen et al., 2014). In addition to acknowledging the challenges this might present for staff, and the importance of the skills of facilitators (in this project delivered by the design team),

26 Made in Prison: Understanding Knowledge Exchange ...

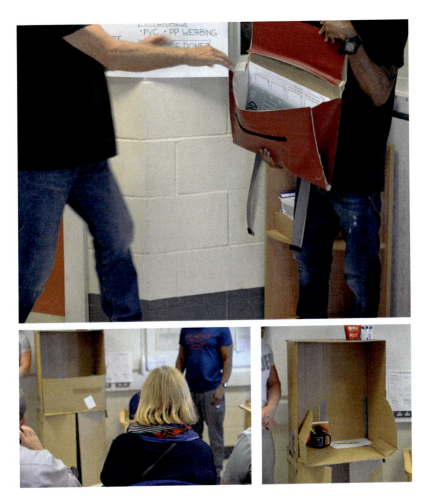

Fig. 26.5 Prisoner co-design participants pitching their co-designed cell furniture ideas to HMP staff and the design team using prototypes they created during the design workshops

there were important considerations about programme quality. Recent research on the development and implementation of innovative, creative programmes in criminal justice settings, for example, also highlights that high programme quality is essential to aid successful engagement and promote positive outcomes (Caulfield et al., 2019; Massie et al., 2019).

If participants perceive the programme as high quality, they are more likely to see value, and invest and engage.

Coproduced Design and Criminal Justice

Gamman and Hughes (2003) as well as Gamman and Thorpe (2016) argue that designers have traditionally not taken account of how product design can unwittingly aid criminal activity. This might be by failing to actively anticipate factors that allow crime to happen, or the ways that "innocent" objectives and design affordances are embedded in objects and services that can be repurposed for criminal activities (like hacking a driverless automated car to cause an accident).[9]

Gamman and Thorpe (2011) have also discussed neurodiversity and the "dark side of creativity". They acknowledge that significant proportions of artists, entrepreneurs and prisoners are dyslexic, for example, compared to the wider population. They also note that creative understandings and respect for neurodiverse learning styles can work better than traditional education techniques. A similar point has been made by psychologists, including Armstrong (2010), who, in trying to understand what the best learning experience for neurodiverse people with dyslexia, ADHD, autism, etc., might be, points heavily towards visual and creative approaches. Gamman and Thorpe draw on Johnson (1983) to argue that in order to "design against crime" it is necessary for creatives to understand the perspectives and mindsets of offenders. The DACRC team therefore adopts user-centred and participatory design techniques as well as a co-production methodology to engage with people who use (and abuse) products, in order to create better understandings about crime opportunities and produce more sustainable design (Gamman & Thorpe, 2009). The DACRC methodology draws on numerous creative techniques, including creating empathy probes and immersive engagements, "scripting", and role-playing drawn from theatre and other disciplines (Gamman et al., 2015) to understand crime scenarios and to introduce broad understandings about the materiality of "things" in

[9] https://www.forbes.com/sites/jamiecartereurope/2019/03/05/hacked-driverless-cars-could-cause-collisions-and-gridlock-in-cities-say-researchers/.

order to enable prisoners to playfully engage with tools and techniques used to design against crime.

We saw that introducing design and designers into prison workshops constituted an unprecedented opportunity to "innovate inside" in relation to safer custody furniture and to introduce frontline prison staff to design against crime creativity techniques and student engagement.[10] The Cell Furniture project therefore aimed to do this and become a prototype for future activities, leveraging the potential of *staff and prisoner-powered innovation* to address prison challenges. However, it was important to acknowledge our concerns about a "broken" prison service (Howard League, 2019) because we recognised that fixing this was beyond the reach of the Cell Furniture project, and also that our attempts to give prisoners more power, equity and agency would be somewhat compromised by other systemic issues…

Knowledge Exchange During the Cell Furniture Project

Reciprocal learning through collaborative knowledge exchange, linked to strategic design research activity, enabled the sharing of skills and expertise ("nouse"[11]) in order to generate new cell furniture designs. In taking a collaborative design approach and involving prisoners, officers and managers, HMPPS staff and evaluators in strategic design activities the DACRC team sought to involve participants in a porous ecosystem of knowledge exchange. It allowed individuals to understand rich accounts of how others experience their everyday lives (often discussed in regard to the material culture created by cell furniture), what problems they face, what issues/responses they prioritise, and what their unmet needs might be. All this rich information was generated through conversation, interviews, mapping and creative design exercises linked to sessions inside and outside of prison. These design-led research activities

[10] See "Cell Furniture Catalogue", 2019 on www.designagainstcrime.com.
[11] "Nouse" in urban dictionaries is understood as "know how", and practical skill derived from life experience.

enabled knowledge exchange to take place and informed the following design research stages:

1. Visualisation and mapping of HMPPS' existing capacity and capabilities for furniture design, production and distribution. For this purpose, a system map was generated that did not exist previously.
2. DACRC created a historical review of cell furniture design found in UK prisons, something that did not exist previously. This detailed understandings of types of furniture already used and the manner in which they are used, as well as misused and abused, including insights into the motivations that contribute to these scenarios.
3. Knowledge exchange occurred (i.e. via diverse presentations, interviews, Q&A sessions, design assessments, etc.) between design facilitators, prison staff, ex-prisoners and design students.
4. Definitions/personas/needs about human-centred requirements for cell furniture emerged, drawn from collaborative design workshops in prison with prisoners, designers and prison staff. These had not been documented before.
5. Insight from conversations and design expertise from many partners and external consultants, including a range of material specialists who helped the team ascertain how cell furniture might become more sustainable, fire resistant and safer, and ultimately contribute to an ecologically sustainable prison.
6. Our DACRC designers engaged with HMPPS/PSPI expert technicians and engineers specialising in industrial practices, plastic materials and manufacturing, fire safety, waste management, recycling, metalworking and woodworking. This technical expertise and knowledge of prison staff regarding in-house industrial operations was crucial to the project.
7. Generating prototype designs. Some were catalysed in design sprints (short but intense bursts of activity) with product design students, and some were generated in co-design sprints with prisoners and expert designers from DACRC. One expert furniture designer (Rock Galpin) also generated his own range. All helped to create a solutions pool of designs that could be drawn upon.

8. Evaluation staff independently assessed how the co-design process affected prisoners and staff in order to understand how it had worked for those involved. This also indirectly informed project outcomes, and could impact on future thinking and the innovative R&D capacity of prison industries, staff and prisoners and the prison estate. The evaluation staff made recommendations for future data collection to understand the impact of the new furniture designs on safety, security and well-being (see the following section of this chapter).

Some of the above activities involved information-gathering that was compiled and documented on a password-protected "Cell Furniture" website. As well as documenting the history of cell furniture and why safety issues need to be prioritised, the information on this website helped DACRC identify and document complex issues faced by prisoners, staff and the HMP estate regarding the use and implementation of cell furniture. These operational (systems-based) and qualitative (e.g. motivations, use/misuse/abuse-case scenarios) understandings were visualised and fed back to diverse HMPPS staff and prisoners. All of this information was shared with students on the Cell Furniture project and professional designers at DACRC. The early stages of research helped DACRC better understand and address the complex issues faced by prisoners, staff and the HMP estate that result from interconnected factors of cell furniture production, supply, management, maintenance and use, misuse and abuse. DACRC's subsequent insight sessions and collaborative design workshops, held at HMP Standford Hill, built on these early research insights, and ultimately led to some collaboratively generated cell furniture design proposals with prisoners and staff, including Flip Chair (2020), Fig. 26.6, photoshopped alongside current UK prison furniture located in a mock-up cell built by the DAC team at Central Saint Martins as a student research/empathy tool (2019).[12] The Flip Chair, which was not generated by students but was co-designed by prisoners and staff at HMP Standford Hill with the DAC team, offers different height options depending on which way it is turned over. It

[12] Access to prisoners was strictly limited, so the mock-up cell was built by the DACRC team so that students could get a better understanding of the spatial constraints of prison cells and current furniture used in them.

started out as a cardboard prototype created during workshops at the prison (see Fig. 26.7). It was devised because prisoners said they wanted two chairs (one for comfort and one to work at a desk), but were allowed only one, because cell space could not accommodate this, hence the need for a new design. The Fllip Chair was subsequently worked up further by our design team outside of the prison context, and eventually photographed in the "mock" prison cell at Central Saint Martins.

To uncover experiential and aspirational insights that led to this, it should be explained that before we started prototyping with prisoners the DACRC supplemented interviews we had undertaken with prisoners inside and outside of prison with "insight worksheets". We provided visual stickers to help the prisoners who were not comfortable with drawing to articulate and depict the world that they inhabited. These insights informed our understanding of use, misuse and abuse and what was missing in terms of well-being experiences. Primarily we applied our design methods to work together with prisoners and staff

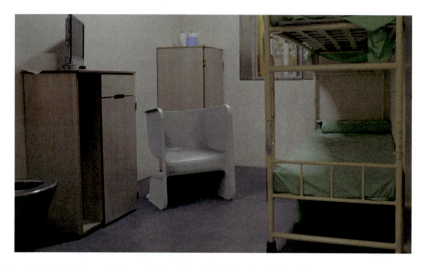

Fig. 26.6 A 3D rendering of the Flip Chair in the full-scale mock-up cell located at Central Saint Martins in 2019. The chair can be flipped to be used as either a low-height lounge chair or a desk chair. This concept was developed with prisoners staff in Spring 2019 and at the time of writing is undergoing prototyping and testing with HMPPS

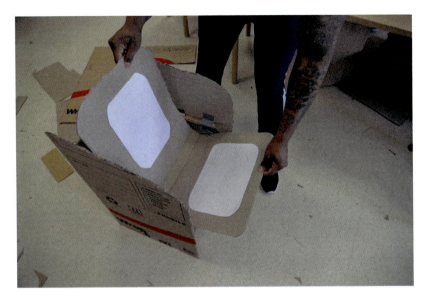

Fig. 26.7 A cardboard prototype of an adjustable chair co-designed with prisoners in 2019, that was later developed into the Flip Chair

to create personas and corresponding sets of human-centred furniture requirements (the co-defined brief). With prisoners and staff we visualised "personas"—semi-fictional characters representing the attitudes, behaviours and experiences of real prisoners—whose needs we would address with cell furniture ideas. We defined the persona's likely needs with "Persona-building Sheets" that we worked on in small groups of designers and prisoners. The sheets provided a detailed description, akin to a narrative, depicting the world that the prisoner personas inhabit (e.g. what the prisoner persona might do in their everyday lives in the cells, their hobbies, routines, likes and dislikes). All of this description, based on real people, was to help ascertain what qualities the new furniture ideas would need to incorporate to address human-centred needs. We then rapidly prototyped and generated cell furniture ideas (ideation) with staff and prisoners using these collaboratively defined needs as a set of objectives and loose constraints.

These human-centred insight worksheets and engagement processes referred to above, we call "design tools", because they are created to

promote empathic consciousness raising, and to build on ethnographic information and real-world prison scenarios, and then to frame new design ideas. In terms of cell furniture, getting prisoners to design for another imaginary person, rather than for him or herself, was a significant shift. The human-centred methodology we used also inspires positive thinking, by looking at how to support or enable pro-social behaviour rather than eliminating misuse and abuse at the expense of the forms of use that are essential for well-being. For example, instead of making it difficult to exercise in cells, prison staff and prisoners imagined how furniture could aid such positive engagement, before turning ideas into concepts and prototypes. This collaborative approach clearly impacted on empathic learning, as documented in accounts of this project written by Gamman and Thorpe (2019) and subsequently Patsarika (2020).

At every stage of the project the DACRC team endeavoured to share as much information as possible with all involved to influence operational and innovative capacity. Ultimately the Cell Furniture project was the second time the design against crime methodology had been used in prison (see earlier discussion of Makeright). When applied to cell furniture, this process has proven once again to be successful, in as much as it has produced a range of plausible co-designed furniture/product outputs, new material specifications and a digital design research archive. To be specific, at the time of writing the Cell Furniture project has achieved the following anti-crime and pro-safety outputs:

- Two proposals for multi-purpose in-cell chairs, one of which is the Flip Chair, are being prototyped and at the time of writing are undergoing rigorous testing by HMP
- Metal single and bunk bed design proposals which may be prototyped in the prison industry
- Storage-type furniture and hangers made of cardboard
- A proposal for a multi-functional and multi-material unit that can be used for storage or workspace, which also proposes a new model for distribution and manufacture by the HMP estate
- Toilet seat covers with odour-absorbing charcoal filters

- Cork and velcro storage units and accessories, which could be used not just to produce furniture, but to catalyse sustainable cork recycling in prison
- A system model and industry connections that could expand HMP's recycling programme
- Proposal (with potential partnership) for improved prison mattresses and/or cushions
- A model for successful co-design with prisoners, prison staff and designers
- A proposal for future data collection to allow HMPPS to better understand the impact and sustainability of prison furniture (see the following section of this chapter).

From the above design proposals, a multi-purpose chair, metal bunk bed design and cardboard furniture were selected for prototyping and testing by HMPPS. We anticipate that these items will be tested/evaluated with prisoners in 2021 although COVID-19 has impacted on deadlines. We understand that in 2022/2023 the HMPPS will share our new catalogue containing up-to-date designs (beyond student work circulated in 2019 that has already attracted strong press coverage[13]).

Evaluation and a Framework for Measuring Impact

Evaluation research was built into the Cell Furniture project design and undertaken concurrently with the project to understand the process and impact of taking part in a collaborative design approach, for both prisoners and prison staff (Caulfield & Jolly, 2020). The evaluation sought to understand *if* and *how* the project was developing better conditions for a safer and more productive environment, and to identify any barriers to success. The evaluation asked three key questions:

[13] https://www.theguardian.com/lifeandstyle/2019/sep/29/trends-for-autumn-whats-new-in-the-world-of-design; https://www.dezeen.com/2019/06/19/central-saint-martins-prison-cell-furniture-for-prisoners/.

1. How successfully has this new model of collaborative, design-thinking and design against crime-led work been implemented?
2. What is the impact of this model of working on prisoners, prison staff and the prison environment?
3. Are the new furniture designs safer than current prison furniture?

To explore research questions 1 and 2, data were collected using a structured observation method and a series of semi-structured interviews. Observational data were collected during six participatory workshops at HMP Standford Hill, which were attended by a member of the research team. Continuous, in-person monitoring took place during each workshop session. Subsequent to the workshops, semi-structured interviews were conducted with participants from the MoJ who had been involved in the project at different stages of development, from initial planning, to attending co-design workshops, to evaluating student designs.

The evaluation demonstrated that the implementation of a new model of collaborative, design-thinking-led work in prisons had successfully achieved prisoner engagement and directly contributed to new designs for prison furniture aimed at reducing violence and self-harm among prisoners. This innovative model of working has had a positive impact on prisoners. There is clear learning about the success of this approach and the value of engaging prisoners as "experts of their own experience" (Beresford & Branfield, 2006).

The aim of creating an environment conducive for collaboration between HMPPS staff and prisoners, that leverages their experience and creativity, was in part achieved, but there are ways in which this could be further developed. The evaluation report, submitted to the MoJ, details this and provides a number of recommendations (Caulfield & Jolly, 2020) and some of these points are explored in the next section of this chapter. The impact on prisoners of participating in the project is clear: it raised self-esteem and empowerment, as well as providing an educational experience. The contribution to the project of prisoners' experience, knowledge and creativity is clear in terms of both the design process and resulting designs.

The duration of the project limited the opportunity for longitudinal evaluation of outcomes. Therefore, our approach to evaluation question

3 was to design a template for future data collection and to recommend that HMPPS implement this alongside the introduction of the new furniture designs to understand their effectiveness and impact, linked to the furniture's contribution to improving safety, security and well-being. We proposed that HMPPS collect evidence to show whether the designs are viable, feasible and desirable in social, economic and environmental terms—and highlighted the need to establish baseline data collection protocols that will allow for follow-up data to be collected in the future to understand the longer-term impact of the project.

Our proposed framework (Caulfield & Chopra, 2020) is—at the time of writing—under review by the MoJ and includes recommendations for measuring impact on psychological factors (well-being), behavioural factors and durability, as far as possible utilising data routinely collected in prisons. The framework for measuring the success of the furniture designs was underpinned by a review of the existing literature. A clear data collection framework will enable understanding of the impact of the furniture designs and enable testing of the relationship between factors. Placing this within the existing research literature will enable us to assess the short, medium and longer-term impact. A clear framework will enable the collection of robust data from the implementation of the designs and in the future.

Challenges and Learning Within the Cell Furniture Project

The biggest challenge for the DACRC team when co-generating designs for this project was the "one size must fit everyone" policy that is currently operational when trying to generate new cell furniture. It became clear very early on that, despite different categories of prisoners and prisons, operational policies in place to protect safety and life also prevent address to diversity. This was disappointing because even the 2006 Mubarek Inquiry acknowledges the different requirement of high security and category C prisoners:

At present, the Prison Service is trialling a compromise solution, which retains the security feature of having the furniture bolted down, but which avoids the sense of the clinical which metal furniture inspires. These new cells are being fitted with fixed furniture made from inexpensive white wood. To put this furniture into a cell costs about £1,800 a cell. It will be interesting to see how prisoners react to this furniture, and it would be premature for me to make any recommendations which assume that a particular approach is preferable. *But it goes without saying that what is appropriate for a high security prison will be very different from what is appropriate for a category C or an open prison.* (p. 462, 2006 italics our emphasis)

We were told by prison staff and their managers, in no uncertain terms, that we had to design as though all prisoners were high risk, even though some of the furniture would be used in open prisons. We could not simply assume that category C prisoners we worked with would be less likely to misuse or abuse furniture, or harm themselves or others with it, as there had been previous precedents. We asked if new policy recommendations on this could be put forward, but prison staff we discussed this matter with were not hopeful, stating negative media coverage of prison "mistakes" as relevant here. We were also unable to place within our plans the fact that many of the men we were worked with at HMP Standford Hill (an open/category C prison) had the technical skills to repair furniture and could easily have used the wood shop there to kit out cells by building approved designs and/or repairing existing furniture.[14] We were told that even in an "open" prison secure furniture was needed because the protection of life at all costs was at all times a primary mission. Our plea to generate furniture designs for diverse needs and to reflect different circumstances was deemed not worth the risk. Although we found this fact very troubling, we accepted it.

There were other problems too. While the evaluation highlighted the success and benefits of the co-production model, it also surfaced that some of the MoJ and HMPPS staff had time management problems with

[14] We are setting up a ROTL placement with Standford Hill but Covid 19 has at time of writing caused delays.

the process. While both staff and prisoners appeared to enjoy engagement, some outcomes-driven staff struggled and became impatient (see earlier discussion of work by Douglas & Caulfield). They had pushed back other work deadlines to accommodate co-creation potential that had no guarantee of results, which resulted in tension for them. We realised that some prison colleagues were not used to open-ended generative discussions, and saw little point in imagining that we could design for local needs of category C prisoners, or future scenarios, when there were already very strict rules in place that prevented this. We recognised too that for some staff reflective processes are not always possible in the busy turnover of daily prison life. Yet the sort of reflection we facilitated (that Schön, 1983, describes as "reflection in action") could lead to "reflective actions" that would be useful to prison staff and worth the time invested. This provided useful points of learning for us about working with prison staff to help them make the most of their involvement in this type of process.

Despite some conflicts, prison staff did enthuse about the design process and it appeared to help these staff gauge insights and make new decisions. Discussions about the problems with cell lighting, for example, led one entrepreneurial prison manager to add LED bookmarks to the list of things prisoners could buy in prison. He found an independent way to resolve some of the complaints he heard during our sessions from men who wanted to read at night (when their cellmate wanted the lights off). We were glad to see staff using their agency to change things quickly, rather than passively waiting for new designs to be generated through the project. We also noticed that the cork designs generated by the students, although not selected for further development, raised rich discussions by HMPPS staff about whether recycling management schemes and the potential for creating vocational work for prisoners (DACRC's research into new mattress materials contributed to this debate too). Positive discussions about the value of co-creating a sustainable prison industry drew enthusiasm from all involved. These discussions were often provoked and led by talented HMPPS managerial staff, who were already fully switched-on about the value of creating vocational work within the prison estate. They articulated their views

on this with insight and passion, although security issues always dominated because the need to protect life above all other issues came first. Similarly, the olfactory furniture designs that were also not selected by HMPPS for further development resulted in fruitful discussion. These discussions acknowledged prisoner complaints about unsanitary smells and how this might be better addressed in future with affordable existing products such as charcoal smell-absorbing bin liners, which prison staff learned from our students were already available on the market, as well as the value of some essential oils in diluting negative smells (courtesy of our olfactory design specialist). These offer examples of how, even outside of the core objectives of the Cell Furniture project, the discussions and shared knowledge exchange resulted in positive learning.

We also became concerned about the top-down approach to current cell furniture management, whereby some furniture design is outsourced and shipped to an HMPPS holding factory in Branston and stored there before distribution to over 100 UK prisons.[15] We had identified, when visualising a system map of the process, that this approach produced inevitable bottlenecks and needed alternatives. The negative cycle, where so much furniture is destroyed by angry men and women within the prison estate, means that there is constant demand on the system to replace furniture. We tried to argue for a more networked and distributed manufacturing system, where furniture could be produced locally in individual prisons via designs sent to CNC machines, or mended in local prison workshops. This process could contribute useful vocational learning for prisoners and would improve upon furniture shortages, as well as create the positive systemic change needed in prison. However, these arguments were not heard. No surprise, for as Jewkes (2013, 2018) has consistently pointed out there need not be tensions between maintaining a secure custodial setting and producing a human environment IF the design needs of prisoners and staff are adequately and humanely addressed. However, even though we tried to explain how design could do this and make a difference we were informed of the many operational and security reasons why the changes we suggested could go

[15] There are 117 prisons in England and Wales. HMPPS runs most of these (104) while three private companies operate 13: G4S and Sodexo manage four prisons each, and Serco manages five (including HMP Thameside, with whom we had previously worked).

wrong and put lives at risk. We were repeatedly told that this was why, for example, distributed and decentralised making and mending of cell furniture across the prison estate was not possible.

Implications of Co-production Linked to Design Activity Within the Criminal Justice Context: A Future Call to Action

Looking at ways to improve the production of cell furniture to reduce its role in violence, vandalism and self-harm, while trying to address issues raised by cost, efficiency and well-being, raised many rich discussions about difficult operational issues and also about the overall value of prison and its ability to correct attitudes and facilitate rehabilitation. The Cell Furniture project was successful in as much as it prototyped a way of engaging with prisoners to involve them in the co-production of useful new cell furniture designs that may contribute to better daily living for future prisoners, as well as many other positive benefits of co-production within the criminal justice system.

There were of course limitations and challenges with our project. The reason cell furniture gets damaged is often linked to the wider frustrations of prisoners with the criminal justice system. The team recognised early on that we were addressing effects (to furniture), rather than the underlying causes of problems. The biggest challenge we faced was the impossibility of resetting prison industry agendas and redesigning the operational landscape that precipitates criminogenic problems. Rather we were able to produce a process that encouraged some of the prisoners who we worked with to experience more power and agency. Several returning citizens, for example, contacted the Design Against Crime team once they had left prison. Two former prisoners who co-designed cell furniture with us are now working one day a week, outside of prison, on further development of the Makeright project as paid employees.

The Cell Furniture project also led us to create some strong co-design techniques and some plausible co-designed furniture generated with prisoners and prison staff as new furniture that could better support

an already flawed prison system. We adhered to the significant design brief we co-created and consoled ourselves with the knowledge that at least thanks to our strong brief new furniture designs could make some difference to prisoners' real lives—if they are produced. However, to achieve change on a larger scale the bigger issues around prisoner well-being and mental health would, of course, need more than furniture to address. However robust the new furniture designs we generated were, and whatever contribution they could make to prisoner well-being, design would be unlikely to completely stop the furniture being abused and misused until some underlying frustrations with unreasonable and inhuman prison system failures abate and the situation improves.

While involving prisoners in creative endeavours that democratise innovation is certainly possible—such as co-creating cell furniture that improves on previous design—and has other benefits, as the Cell Furniture project has demonstrated, its value is of course determined by scale of activity. We recommend therefore that co-production, and its relationship to prison industries, is a site for further review and possible systemic change, that should be further explored by prison industries as well as the UK's crime and justice agencies.

Co-production can help provide meaningful and aspirational activity, aid vocational learning and be enjoyable, and can lead to elements of individual transformation that are not always possible in prison. New designs generated through co-production can help provide positive material cultural benefits, including new ways of communicating, that are very much needed in the harsh prison environment. Such design learning and co-production processes may be labour intensive, but this should not be a barrier because manpower in prison is an asset that could be better leveraged. Co-production should be more seriously assessed as a workable strategy, even within current operational prison constraints. It could be linked, for example, to cost-effective D Schools[16] in prison

[16] D. School helps people develop their creative abilities. It's a place, a community and a mindset, linked to "learning through doing", rather than from traditional classroom learning based on theories or books.

industries based on a version of the Stanford model,[17] or Maker movements (Dougherty, 2012) linked to ideas about "fab labs"[18] as well as the European network of Living labs.[19] Here design is used to bring people together in important relational ways, to develop creative potential, all warranting more systemic review by prison industries than we could instigate on a project aimed at designing cell furniture to be made in prison. We also propose setting up "designers in residence" schemes to find new ways to work in prison industries to facilitate co-production.

Allowing new co-production organisational models to be further trialled and assessed in prison industries is one of the key recommendations we have developed from our work on the Cell Furniture project. Design-led co-production spaces (often called Maker initiatives) should be seriously considered as having a role in prison because they could help address and improve some of the systemic failures that HMPPS is dealing with at present, and could also offer a way of rejuvenating prison industries. Prison industries have to deal with ever-changing norms about vocational education, because industrial machines and tools go out of date very quickly, and are not linked to generative learning or adaptive skills that returning citizens may need to draw upon to successfully resettle in society. Ultimately the goal of creating more sustainable ways of understanding, producing and making should urgently be encouraged to reduce the human, environmental and economic costs of prison. Reimagining future prison industries as a site of different types of co-production and vocational learning, including maker movement activity, where sustainable and co-creative learning happens as a matter of course, appears to us to be a sure step in the right direction. This could certainly help improve, by design, not just the quality of cell furniture available

[17] The Hasso Plattner Institute of Design, Stanford outline their account of how to start D. Schools here: https://dschool.stanford.edu/how-to-start-a-dschool.

[18] Fab Lab, or digital fabrication laboratory, is a place to play, to create, to learn, to mentor, to invent: a place for learning and innovation. Fab Labs provide access to the environment, the skills, the materials and the advanced technology to allow anyone anywhere to make (almost) anything.

[19] Living Labs (LLs) are defined as user-centred, open innovation ecosystems based on a systematic user co-creation approach, integrating research and innovation processes in real life communities and settings.

"Living Lab", European Network of Living Labs, 2018, http://openlivinglabs.eu/livinglabs.

in prison but the material culture apparent within UK prisons, and its impact on returning citizens.

Bibliography

Abrahams, F., Rowland, M. M., & Kohler, K. C. (2012). Music education behind bars: Giving voice to the inmates and the students who teach them. *Music Educators Journal, 98*(4), 67–73.

Adamson, S. (2003). *Youth crime: Diversionary approaches to reduction* (Norther Crime Consortium Research Report 5). https://extra.shu.ac.uk/ndc/downloads/reports/RR5.pdf

Armstrong, T. (2010). *The power of neurodiversity—Unleashing the advantages of your differently wired brains.* Da Capo Press.

Baer, L. D. (2005, April). Visual imprints on the prison landscape: A study on the decorations in prison cells. *Journal of Economic and Human Geography, 96*(2).

Bason, C. (2010). *Leading public sector innovation: Co-creating for a better society.* Policy Press.

Bason, C. (Ed.). (2014). *Design for policy.* Gower

BBC Radio 4. (2019). *What's it really like to be in prison* [podcast]. Law in Action. Available at: https://www.bbc.co.uk/programmes/m000bfhd. November 2019.

Beresford, P., & Branfield, F. (2006). Developing inclusive partnerships: User-defined outcomes, networking and knowledge—A case study. *Health and Social Care in the Community, 14*(5), 436–444.

Binder, T., Brandt, E., Ehn, P., & Halse, J. (2015). Democratic design experiments: Between parliament and laboratory. *CoDesign, 11*(3–4), 152–165.

Bovaird, T. (2007). Beyond engagement and participation: User and community coproduction of public services. *Public Administration Review, 67*(5). Available at: https://doi.org/10.1111/puar.2007.67.issue-5

Brown, T. (2009). *Change by design: How design thinking transforms organisations.* HarperCollins.

Buchanan, R. (1995). Wicked problems in design thinking. In R. Buchanan & V. Margolin (Eds.), *The idea of design.* MIT Press.

Buchanan, C. (2020, July). *What is strategic design? An examination of new design activity in the public and civic sectors* (PhD for Lancaster University).

Buchanan, C., Amatullo, M., & Staszowski, E. (2019). Building the civic design field in New York City. *Revista Diseña, 14*, 158–183.

Caulfield, L. S. (2016). Counterintuitive findings from a qualitative study of mental health in English women's prisons. *International Journal of Prisoner Health, 12*(4), 216–229.

Caulfield, L. S., & Chopra, I. (2020). *An evaluation of the cell furniture project: Evaluating a collaborative, design-thinking led model with prisoners and staff*. Institute for Community Research and Development. Report for the Ministry of Justice.

Caulfield, L. S., & Jolly, A. (2020). *An evaluation of the cell furniture project: Evaluating a collaborative, design-thinking led model with prisoners and staff*. Institute for Community Research and Development. Report for the Ministry of Justice.

Caulfield, L. S., Sojka, B., & Massie, R. (2019). *A creative approach to working with young people*. Institute for Community Research and Development.

Chesbrough, H. W., & Appleyard, M. M. (2007). Open innovation and strategy. *California management review, 50*(1), 57–76.

Costanza-Chock, S. (2020) *Design justice—Community led practices to build the worlds we need*. MIT.

Daykin, N., de Viggiani, N., Moriaty, Y., & Pilkington, P. (2014). *Musical pathways: An exploratory study of young people in the criminal justice system, engaged with a creative music programme* (online). Available at: http://www.artsevidence.org.uk/evaluations/musical-pathways-exploratory-study-young-people-cr/. Accessed 1 November 2020.

Dougherty, D. (2012). The maker movement. *Innovations: Technology, Governance, Globalization, 7*(3), 11–14.

Davey, C., Wootton, A., & Marselle, M. (2011). Engaging young people in designing against crime. *Swedish Design Research Journal, 1*(12), 28–38.

Douglas, S., & Caulfield, L. S. (2014). Controlled or controlling? Staff experiences of control in a therapeutic community prison. *Prison Service Journal, 213*, 24–29.

Drakeford, M., & Gregory, L. (2010). Transforming time: A new tool for youth justice. *Youth Justice, 10*(2), 143–156.

Eagle, S. (2008). *Evaluation of the miss spent programme 2008* (online). Available at: http://www.artsevidence.org.uk/media/uploads/evaluation-downloads/clean-break-miss-spent-2008.pdf

Fox, A., Fox, C., & Marsh, C. (2013). Could personalisation reduce re-offending? Reflections on potential lessons from British social care reform

for the British criminal justice system. *Journal of Social Policy, 42*(4), 721–741. Available at: https://doi.org/10.1017/S0047279413000512

Gamman, L., & Hughes, B. (2003). Thinking thief—Designing out misuse, abuse and 'criminal' aesthetics. *Ingenia, 15*, 36–43.

Gamman, L., & Thorpe, A. (2009). Less is more—What design against crime can contribute to sustainability. *Special Issue of Built Environment Journal, 35*(3). Editors R. Armitage & L. Gamman. *Sustainability via security: A new look.*

Gamman, L., & Thorpe, A. (2011). Criminality and creativity: What's at stake in designing against crime? In *Design anthropology: Object culture in the 21st century* (pp. 52–67). Springer.

Gamman, L., *& Thorpe, A. (2016). What is "socially responsive design and innovation"? In F. Fisher & P. Sparke (Eds.), *Routledge companion to design studies*. Routledge.

Gamman, L., & Thorpe, A. (2018). Makeright—Bags of connection: Teaching design thinking and making in prison to help build empathic and resilient communities. *She Ji, the Journal of Design Economics and Innovation, 4*(1), 91–110.

Gamman, L., & Thorpe, A. (2019). Why design for prison? *Cell Furniture Project Catalogue 2018–2020.* 9–10.

Gamman, L., & Thorpe, A., Malpass, M., & Liparova, E. (2015). Hey Babe—Take a walk on the wild side! In *Why role-playing and visualization of user and abuser "scripts" offer useful tools to effectively "think thief" and build empathy to design against crime, design & culture* (pp. 181–193).

Herrity, K. (2020) in J. Turner & V. Knight (Eds.), *The prison cell: Embodied and everyday spaces of incarceration* (pp. 239–260). Palgrave studies in prisons and penology. Palgrave.

HM Inspectorate of Prisons. (2017). Life in prison—Living condition by HM Inspectorate of Prisons. https://www.justiceinspectorates.gov.uk/hmiprisons/wp-content/uploads/sites/4/2017/10/Findings-paper-Living-conditions-FINAL-.pdf

HM Inspectorate of Prisons. (2021). *What happens to prisoners in a pandemic? A thematic review by HM Inspectorate of Prisons.* https://www.justiceinspectorates.gov.uk/hmiprisons/inspections/what-happens-to-prisoners-in-a-pandemic/. Accessed 12 February 2021.

HM Prison & Probation Service. (2019). *Annual report 2018–19.* https://assets.publishing.service.gov.uk/government/uploads/system/uploads/attachment_data/file/814689/hmip-annual-report-2018-19.pdf

Howard League. (2014). *Breaking point: Understaffing and overcrowding in prisons*. Howard League for Penal Reform [online]. Available at: https://howardleague.org/wp-content/uploads/2016/03/Breaking-point-10.07.2014.pdf. Accessed 1 November 2020.

Howard League. (2017). *Our evidence to Parliament's inquiry into mental health and deaths in prisons*. Howard League for Penal Reform [online]. Available at: https://howardleague.org/blog/our-evidence-to-parliaments-inquiry-into-mental-health-and-deaths-in-prisons/. Accessed 1 November 2020.

Howard League. (2019). *How the system is broken*. Howard League for Penal Reform. [online]. Available at: https://howardleague.org/why-the-system-is-broken/. Accessed 1 November 2020.

Jewkes, Y. (2013). On carceral spaces and agency. In D. Moran, N. Gill & D. Conlon (Eds.), *Carceral spaces: Mobility and agency in imprisonment and migrant detention* (pp. 127–131). Farnham Ashgate.

Jewkes, Y. (2018). Just design: Healthy prisons and the architecture of hope. *Australian & New Zealand Journal of Criminology, 51*(3), 319–333.

Johnson, J. (1983). *Criminality, creativity, and craziness: Structural similarities in three types of nonconformity*. In W. S. Laufer & J. M. Day (Eds.), *Personality theory, moral development, and criminal behaviour* (pp. 81–105). D.C. Heath.

Junginger, S. (2013). *Design and innovation in the public sector: Matters of design in policy-making and policy implementation*. In Proceedings from the 10th European Academy of Design Conference, 'Crafting the Future'. Gothenburg, April, 2013: European Academy of Design.

Junginger, S. (2017). Design research and practice for the public good: A reflection. *She Ji, the Journal of Design, Economics and Innovation., 3*(4), 290–302.

Keith, B. (2006). Report of the Zahid Mubarek inquiry (Vols. 1 and 2) (Vol. 1082). *The Stationary Office* (online). Available at: https://www.gov.uk/government/publications/report-of-the-zahid-mubarek-inquiry. Accessed 1 November 2020.

Kimbell, L., & Bailey, J. (2017). Prototyping and the new spirit of policy-making. *CoDesign, 13*(3), 214–226.

Koskinen, I., Mattelmäki, T., & Vaajakallio, K. (2014). What happened to empathic design? *Design Issues., 30*(1), 67–77.

Liebling, A., Tait, S., Durie, L., Stiles, A., & Harvey, J. (assisted by Gerry Rose). (2005). An evaluation of the safer locals programme—Final Report. Cambridge Institute of Criminology Prisons Research Centre, January, Revised June 2005.

Manzini, E. (2015). *Design, when everybody designs*. MIT Press.
Manzini, E., & Staszowski, E. (2013). *Public and collaborative*. DESIS Network.
Massie, R., Jolly, A., & Caulfield, L. S. (2019). *An evaluation of the Irene Taylor Trust's sounding out programme*. Irene Taylor Trust.
McLewin, A. (2006). *What's the point: Using drama to engage young people at risk* (online). Available at http://webarchive.nationalarchives.gov.uk/201602 04123159/http://www.artscouncil.org.uk/advice-and-guidance/browse-adv ice-and-guidance/whats-the-point-using-drama-to-engage-young-people-at-risk
Ministry of Justice. (2020). *Prison population figures. Population bulletin: Monthly March 2020*. Ministry of Justice.
Mulgan, G. (2014). *Design in public and social innovation: What works and what could work better*. [pdf] Nesta. Available at: http://media.nesta.org.uk/documents/design_in_public_and_social_innovation.pdf. Accessed August 2019.
Osborne, S. P., Radnor, Z., & Strokosch, K. (2016). Co-production and the co-creation of value in public services: A suitable case for treatment? *Public Management Review, 18*(5), 639–653. https://doi.org/10.1080/14719037.2015.1111927
Parker, M. (2007). *Dynamic security: The democratic therapeutic community in prison*. Jessica Kingsley Publishers.
Patsarika, M. (2020). Learning through design—Mapping designer and stakeholder insights and as in Knowledge Exchange (KE) and design research—Case study: Cell furniture, published by Social Design Institute, University of the Arts London.
Renauer, B. C., Duffee, D. E., & Scott, J. D. (2003). Measuring police-community co-production trade-offs in two observational approaches. *Policing: An International Journal of Police Strategies Management, 26*(1), 9–28.
Sanders, E., & Stappers, J. P. (2008). Co-creation and the new landscapes of design. *CoDesign, 4*(1), 5–18.
Sangiorgi, D., & Prendiville, A. (Eds.). (2017). *Designing for service*. Bloomsbury.
Savage, M., & Burrows, R. (2007). The coming crisis of empirical sociology. *Sociology, 41*(5), 885.
Schön, D. A. (1983). *The reflective practitioner: how professionals think in action*. Basic Books.

Sered, S., & Norton-Hawk, M. (2008). Disrupted lives, fragmented care: Illness experiences of criminalized women. *Women and Health, 48*(1), 43–61.

Sorrentino, M., Sicilia, M., & Howlett, M. (2018). Understanding co-production as a new public governance tool. *Policy and Society, 37*(3), 277–293. Available at: https://doi.org/10.1080/14494035.2018.1521676

Staszowski, E., Sypek, A., & Junginger, S. (2014). *Public and collaborative: From participatory design to design for participation.* In Design Management Institute: Proceedings from the 19th DMI, Design Management in an Era of Disruption. London, September, 2014: DMI.

Thom, K., & Burnside, D. (2018). Sharing power in criminal justice: The potential of co-production for offenders experiencing mental health and addictions in New Zealand. *International Journal of Mental Health Nursing, 27*(4), 1258–1265. Available at: https://doi.org/10.1111/inm.12462

Weaver, E. (2016). Coproducing desistance from crime: The role of social cooperative structures of employment. *ECAN Bulletin, 2016*(28), 12–24.

Weaver, B., Lightowler, C., & Moodie, K. (2019). *Inclusive justice: Co-producing change.* University of Strathclyde.

Wortley, R. (2016). Situational precipitators of crime. In R. Wortley & M. Townsley (Eds.), *Environmental criminology and crime analysis* (2nd ed.). Routledge. ISBN 9781138891135.

Correction to: From Grey to Green: Guidelines for Designing Health-Promoting Correctional Environments

Julie Stevens, Amy Wagenfeld, and Barb Toews

Correction to:
Chapter 22 in: D. Moran et al. (eds.), *The Palgrave Handbook of Prison Design*, Palgrave Studies in Prisons and Penology, https://doi.org/10.1007/978-3-031-11972-9_22

The original version of this chapter was previously published with incorrect order of images in Chapter 22, which has now been corrected. The chapter has been updated with the changes.

The updated original version of this chapter can be found at https://doi.org/10.1007/978-3-031-11972-9_22

Index

A

Aesthetics 2, 57, 63, 65, 66, 69, 70, 72, 88, 89, 108, 111, 146, 174, 180, 264, 284, 287, 295, 297, 302, 332, 376, 398, 419, 453, 484, 488, 524
Air quality, internal 531
Architect 7, 79, 83, 96, 98, 99, 111, 115, 132, 145, 153, 206, 252, 288, 299, 436, 483, 607, 721
Assault 13, 63, 117, 125, 207, 231, 272, 283, 293, 305, 397, 447, 526, 530, 546, 550, 571
Attention Restoration Theory (ART) 627, 630, 638, 658, 722

B

Barriers 9, 61, 62, 68, 275, 289, 297, 361, 366, 376, 395, 419, 475, 520, 521, 530, 532, 550, 552, 553, 565, 567, 569, 577, 580–590, 592
Bentham, Jeremy 29, 30, 34, 305, 315
Biophilia 627, 629, 630, 634, 722
Boredom 180, 556

C

Carceral geography 165, 306
Caretaking 6, 60
CCTV 53, 65, 69, 151, 250, 276, 543
Cells 13, 17, 29, 32, 34, 35, 38, 62, 65, 67, 68, 111, 113, 115, 116, 118, 119, 121, 125, 131, 134, 137, 138, 151, 152, 178, 179, 200, 201, 204, 206, 207, 211, 215, 232, 234, 240, 244,

245, 248, 252, 253, 264, 265, 272, 277, 292, 293, 325, 396, 419, 421–424, 427, 428, 434–436, 488, 490–493, 495, 496, 501, 503, 504, 514, 515, 520, 522–526, 531, 532, 539, 540, 546, 570, 583, 585, 586, 591
Chairs 117, 303, 427, 434, 493, 495
Children 3, 12, 89, 122, 276, 303, 345, 391, 413, 414, 416, 453, 528, 529, 532, 533, 567, 574
Circadian rhythms 523
Classification 485, 542, 549, 552, 569, 584
Colour 59, 65, 118, 121, 122, 126, 145, 252, 274, 296, 323, 360, 423, 427, 434, 490, 515, 523, 528, 529, 531
Communal space 298, 430, 496
Communication 58, 61, 68, 70, 84, 152, 210, 220, 235, 245, 266, 267, 297, 514, 515, 528, 532, 541, 542, 544, 546, 547, 549, 557
Control 9, 12, 23, 38, 39, 41, 42, 55, 58, 61–63, 66, 67, 70, 111, 118, 166, 197, 201, 204, 213, 231, 264, 269, 270, 274, 276, 277, 287, 298, 305, 342, 377, 395, 433–435, 443, 444, 446, 451, 461, 462, 486, 495, 496, 514, 515, 521, 524, 526, 540, 542, 545, 546, 549, 551, 557, 573
Cooking 357, 361, 515, 530
COVID-19 165, 314, 489, 523
Criminology 5, 51, 52, 54, 59, 266, 274, 352, 448, 485, 516

Crowding 55, 61, 62, 65, 269, 376, 528, 545

D

Daylight 11, 119, 200, 214, 221, 349, 368, 376
Depression 283, 304, 523, 567
Direct supervision 65, 68, 70, 305, 539, 542–548, 550, 552, 554, 555
Discipline 33, 36, 51, 52, 63, 64, 72, 166, 184, 238, 289, 483, 486
Doors 53, 125, 296, 360, 365, 366, 419, 421, 422, 424, 434, 492, 525, 540
Dormitory housing 62, 65, 272

E

Environmental psychology 10, 51, 58, 288, 295, 301, 368, 376, 453
Ethics 111, 269, 352
Exercise yards 116, 119, 252, 296
Expectations 6, 23, 24, 41, 45, 54, 59, 61, 121, 130, 192, 202, 246, 266, 319, 389, 443, 447–449, 451, 453, 461, 471, 473–475, 525, 527, 540, 541, 549, 589

F

Fixtures, fittings, furnishings 14, 117, 541
Foucault, Michel 29, 30, 51, 53, 164, 174, 305

Fresh air 35, 65, 524, 530
Furniture 6, 17, 58–60, 70, 117, 122, 252, 298, 302, 332, 367, 368, 420, 444, 492, 493, 515, 522, 541

G

Gang membership 276
Gardening 114, 117, 122, 138, 419
Gardens 15, 349, 376, 529
Gender 26, 30, 563, 564, 567–569, 571, 572, 575, 582, 583, 591, 592
Goffman, Erving 51, 55, 59, 164, 292, 444, 445
Green space 11, 15, 16, 111, 376, 530, 568

H

Hard architecture 57–59
Health 8, 12, 13, 23, 26–28, 34, 35, 40, 41, 52, 56, 60, 62, 66, 69, 98, 114, 116, 137, 177, 195, 199, 210, 211, 213, 217, 221, 231, 266, 269, 276, 277, 284, 286, 287, 291, 293, 296, 297, 325, 343, 347, 349, 350, 368, 376, 390, 395, 415, 445, 474, 482, 486–490, 492, 493, 495, 500–503, 507, 515, 522–525, 529, 530, 532, 553, 567, 568, 572, 574–576, 583, 584
Healthcare 12, 109, 137, 484–486, 488, 490–493, 495, 499–502, 505, 507, 532, 533
Historical context 219
Holding cells 51

Howard, John 5, 25–28, 30, 34
Human dignity 10, 209, 213, 315, 317, 320, 324, 326, 329–332
Humane design 106, 110, 113, 159, 166

I

Infection 523
Institutional design 368, 566, 568
Institutionalisation 115, 134
Isolation 62, 115, 181, 240, 293, 295, 297, 304, 322, 330, 341, 416, 487, 526, 585

J

Jewkes, Yvonne 4, 6, 7, 21, 44, 45, 53, 58, 61–63, 69, 83, 93, 106–110, 122, 123, 126, 159, 171, 185, 316, 333, 386, 390, 398, 402, 403, 447, 482–484, 486, 496, 501, 515–517, 568, 590

K

Kitchen 115, 138, 155, 179, 204, 250, 298, 302, 349, 361, 363, 367, 377, 421, 427, 430, 431, 492, 493, 515, 530

L

Labelling theory 59, 521
Labour. *See* Work
Landscaping 15, 89, 108, 145, 178, 179, 301, 368, 417, 444, 447, 530

Index

Lighting 11, 29, 63, 65, 118, 349, 376, 515, 520, 522–524, 531
Location 11, 26, 55, 57, 65, 67, 83, 105, 120, 175, 176, 179, 182, 264, 300, 304, 317, 324, 346, 347, 355, 357, 359, 365, 417, 418, 489, 493, 523, 526, 537, 542, 551, 587

M

Mental fatigue 659, 714
Mental illness 12, 35, 107, 113, 293, 433, 482, 486, 488, 490, 500, 507, 523
Misconduct 42, 55, 56, 61, 63, 65, 66, 70, 72, 265–268, 270, 274, 277, 303, 347, 532, 550
Morality 26, 35
Moran, Dominique 16, 21, 45, 60, 63, 96, 107–110, 160, 165, 167, 171, 185, 232, 233, 240, 248, 266, 277, 301–303, 333, 390, 391, 403, 446, 482, 484, 486, 495, 501, 515, 522, 524, 527, 528, 530, 568

N

Nature contact 658, 671, 674
Neurodiversity 746
Noise 63, 69, 231, 264, 265, 349, 376, 524, 527, 530, 541
Normalisation 123, 165, 402, 475

O

Odour. *See* Smell
Older prisoner 482, 491

P

Pains of imprisonment 3, 44, 55, 246, 439
Penal philosophy 390, 484, 674. *See also* Punitive philosophy
Penal reform 22, 24, 35, 98, 165, 217, 253, 484
Personalisation 11
Personal space 61, 62, 67–69, 231, 366, 376, 522, 568, 586, 587, 590
Philanthropy 485
Plants 113, 250, 265, 302, 427, 495, 530
Podular design 67, 276
Post-occupancy evaluations (POE) 10, 285, 287–289, 304
Privacy 11, 13, 61, 62, 67–69, 73, 231, 232, 249, 253, 298, 327, 349, 368, 377, 520, 522, 527–530, 570, 574, 582, 586, 590
Programming 54, 55, 66–68, 70, 160, 266, 286, 298, 532, 545, 550, 565, 566, 569–573, 575–578, 582–585, 589–592
Public-Private Partnership (PPP) 111, 191, 192, 202–205, 207–209, 214, 216
Punishment 2, 5, 7, 15, 22, 25, 27, 35, 36, 43, 51, 53, 62, 83, 85, 98, 107, 110, 119, 126, 134, 146, 148, 160, 162, 165, 183, 197, 200, 230, 232, 240, 241, 243, 246, 252, 253, 266, 289, 295, 303, 315–317, 323, 325, 327, 330, 333, 387, 388, 390, 394, 403, 414, 415, 419, 436, 484, 486, 488, 521, 522, 531

Punitive philosophy 4, 674. *See also* Penel philosophy

R

Rape 305, 556
Recidivism 2, 6, 31, 80, 96–98, 185, 210, 243, 266, 267, 341, 514, 530, 545, 567, 576
Recreation 65, 343, 349, 496, 529, 584, 588, 589, 591
Re-design 13, 299, 481, 483, 485, 486, 492, 495, 496, 498, 500–502, 504–507, 516, 533
Rehabilitation 2, 6, 7, 9, 11, 16, 36, 37, 53, 54, 56, 59, 96, 107, 109, 123, 130, 131, 155, 176, 178, 185, 191, 197–200, 202, 207, 209, 210, 213, 216, 220, 221, 231, 238, 242–244, 250, 253, 266, 275, 286, 289, 305, 306, 317, 320, 322, 324, 329, 339, 349, 350, 385–392, 394–401, 403, 404, 414, 492, 514, 515, 519, 523, 524, 528, 531, 532, 550, 553, 566, 592
Restorative justice (RJ) 16, 17, 183, 352
Retrofitting 645, 646

S

Safety 6, 17, 26, 53–55, 60, 62, 67, 68, 205, 214, 231, 266–269, 284, 287, 296, 300, 327, 330, 345, 349, 392, 431, 433, 434, 445, 447, 485, 507, 514, 533, 541, 542, 550, 565, 566, 568, 570, 590, 591

Sanitation 238
Security 5, 7, 8, 11, 14, 16, 17, 26, 53, 55, 60, 62, 89, 108, 109, 114, 130, 150–152, 159, 162–164, 168, 175–177, 179, 185, 191, 198, 199, 201–203, 210, 211, 213, 220, 230, 234, 235, 237, 238, 240, 244, 248, 251, 253, 266, 267, 276, 287, 296, 298, 300, 329, 340, 343, 345, 348, 352, 353, 359, 360, 366–368, 375–378, 392, 400, 427, 430–435, 444, 484, 487–489, 505, 515, 516, 518, 520, 521, 524, 527, 528, 532, 540, 546, 549, 552, 553, 565, 566, 570, 577, 578, 585–587, 589, 590
Segregation 115, 118, 125, 126, 294, 489, 500
Self-harm 114, 115, 117, 277, 349, 433, 487, 500, 503
Showers 115, 204, 492, 493, 529, 530, 552, 570
Sickness absence 659–661, 664–666, 668, 671, 674
Silent system 35
Sleep 231, 250, 297, 302, 315, 434, 436, 524–526, 584, 586, 590
Smell 527, 530, 631, 690, 758
'Softening' spaces 117
Solitary confinement 10, 13, 32, 34, 35, 38–41, 111, 115, 125, 126, 167, 293–296, 515, 568, 590
Staffing 112, 219, 270, 538, 544, 545, 551
Staffing culture 107, 445

Stakeholders 42, 80–82, 84, 87, 88, 97–99, 101, 208, 286, 304, 490, 514, 553, 556, 566
Stigma 59, 402
Stress 56, 61–64, 68, 69, 126, 152, 178, 243, 266, 303, 329, 349, 446, 517, 532, 539, 546, 556
Suicide 10, 34, 40, 205, 266, 283, 290–294, 487, 500, 503, 504, 539, 544, 545, 547, 571
Sunlight 35, 329
Surveillance 8, 29, 53, 69, 166, 168, 203, 213, 231, 244, 251, 276, 305, 420, 427, 432, 446, 486, 521, 529

T

Tables 297, 303, 462, 495, 529
Telephones 138, 152, 246, 250, 349, 528, 541, 580
Television 298, 302, 349, 421, 522, 529, 541, 550
Temperature 63, 69, 118, 264, 287, 332, 531
Territoriality 61
Therapeutic environment 114, 124
Toilets 13, 119, 200, 201, 204, 515, 520, 525–527, 531, 541, 552
Total institution 51, 54, 111, 164, 444
Trauma-informed design 17, 722
Trees 122, 235, 368, 530

V

Vandalism, Vandalisation 52, 57, 60, 539, 542, 547

Vegetation 178, 644, 674, 681, 688, 692
Views 6, 7, 9, 13, 15, 22, 43, 46, 58, 59, 66, 80, 98, 110, 113, 115, 124, 134, 159, 161, 167, 174, 177–179, 183, 221, 265, 314, 317, 357, 358, 365, 368, 378, 386, 388, 389, 398, 446, 450, 520, 524–526, 531, 540, 551, 586
Violence 16, 23, 38, 40, 52, 55, 57, 110, 114, 115, 117, 118, 123, 125, 194, 203, 205, 207, 242, 246, 268, 299, 304, 306, 315, 349, 434, 514, 517, 524, 527, 537, 539, 542, 545, 547, 551, 554–557, 564, 573
Visibility 58, 65, 68, 70, 161, 168, 208, 265, 299, 300, 521, 526
Visiting rooms 13, 122, 205, 250, 527, 529
Visits 10, 26, 35, 87, 89, 93, 113, 117, 122, 125, 131, 137, 142, 177, 204, 272, 277, 302, 303, 346, 347, 350, 359, 376, 391, 392, 417, 418, 436, 527–529, 537, 579, 591

W

Walls 38, 58, 60, 70, 88, 89, 96, 99, 113, 119, 126, 145, 177, 179, 193, 244, 250, 252, 278, 329, 331, 360, 365, 434, 491, 492, 495, 496, 515, 518, 520–523, 525, 529, 531, 566, 569, 584, 592
Warehousing 532, 545

Water 24, 26, 117, 162, 238, 288, 303, 395, 486, 526, 531
Weapons 58, 66
Wellbeing 12, 17, 27, 40, 44, 52, 81, 99, 101, 263, 325, 339–343, 345, 349, 350, 378, 482, 495
Wener, Richard 51, 53, 54, 58, 60, 264–266, 349, 446, 447, 522, 523, 539, 541, 542, 545, 547, 548, 550, 568
Window bars 252, 420, 488
Windows 59, 60, 65, 66, 69, 70, 111, 119, 122, 134, 214, 216, 264, 265, 296, 360, 361, 365, 366, 368, 419, 420, 427, 515, 520, 524
Work 3, 6, 8, 9, 13–16, 22, 33, 35, 45, 64, 80, 82, 99, 113, 114, 116, 119, 131, 133, 155, 161, 165, 171, 174, 177, 179, 181, 182, 210, 221, 231, 234, 241, 245, 251, 274, 276, 296, 300, 302, 316, 319, 320, 330, 342, 344, 349, 352, 355, 359, 365, 367, 385, 387, 415, 416, 430, 433, 434, 436, 438, 447, 488, 492, 499, 515, 518, 519, 546, 550, 552, 553, 557, 572, 573, 577, 607, 609, 610, 617, 618, 624, 631, 640, 642, 643, 647, 649, 651, 657, 658, 660, 665, 675, 680, 681, 684, 695, 696, 698, 707–709, 712, 714, 715, 719, 724, 726, 742, 743, 746, 750, 753, 757, 761

Y

Youth imprisonment 439

Printed in the United States
by Baker & Taylor Publisher Services